T0259364

Digital Moving Pictures -
Coding and Transmission on ATM Networks

Series Editor: J. Biemond, Delft University of Technology, The Netherlands

ADVANCES IN IMAGE COMMUNICATION 3

Digital Moving Pictures - Coding and Transmission on ATM Networks

Jean-Pierre Leduc
IRISA/INRIA
Campus de Beaulieu
Rennes
France

ELSEVIER
Amsterdam – London – New York – Tokyo 1994

ELSEVIER SCIENCE B.V.
Sara Burgerhartstraat 25
P.O. Box 211, 1000 AE Amsterdam, The Netherlands

ISBN: 0 444 81786 7

This book is printed on acid-free paper.
Transferred to digital printing 2006
Printed and bound by CPI Antony Rowe, Eastbourne

*Now this is not the end. It is
not even the beginning of the
end. But it is, perhaps, the end
of the beginning.*

Sir Winston Churchill
in The "End of the Beginning", 1943.

*We stand today on the edge of a
new frontier.*

John F. Kennedy
in "Vital Speeches", 1960.

INTRODUCTION TO THE SERIES
"Advances in Image Communication"

Image Communication is a rapidly evolving multidisciplinary field focussing on the evaluation and development of efficient means for acquisition, storage, transmission, representation and understanding of visual information. Until a few years ago, image communication research was still confined to universities and research laboratories of telecommunication or broadcasting companies. Nowadays, however, this field is also witnessing the strong interest of a large number of industrial companies due to the advent of narrowband and broadband ISDN, digital satellite channels, digital over-the-air transmission and digital storage media. Moreover, personal computers and workstations have become important platforms for multimedia interactive applications that advantageously use a close integration of digital video compression techniques (MPEG), Very Large Scale Integration (VLSI) technology, highly sophisticated network facilities and digital storage media. At the same time, the scope of research of the academic environment on Image Communication has further increased to include model- and knowledge-based image understanding techniques, artificial intelligence, motion analysis, and advanced image and video processing techniques and lead to a diverse area of applications such as: access to image data bases, interactive visual communication, TV and HDTV broadcasting and recording, 3D-TV, graphic arts and communication, image manipulation, etc. The variety of topics on Image communication is so large that no-one can be a specialist in all the topics, and the whole area is beyond the scope of a single volume, while the requirement of up-to-date information is ever increasing.

In 1988, the European Association for Signal Processing EURASIP together with Joel Claypool & Ir. Hans van der Nat, at that time Publishing Editors at Elsevier Science Publishers, conceived several projects to meet this need for information. First of all a new EURASIP journal, "Signal Processing: Image Communication", was launched in June 1989 under the inspired Editorship of Dr. Leonardo Chiariglione. So far, the journal has been a major success not in the least due to the many special issues devoted to timely aspects in Image Communication, such as low/medium/high bit rate video coding, all digital HDTV, 3D-TV, etc. It was further decided to publish a book series in the field, an idea enthusiastically supported by Dr. Chiariglione. Mr. van der Nat approached the undersigned to edit this series.

It was agreed that the book series should be aimed to serve as a comprehensive reference work for those already active in the area of Image Communication. Each volume author or editor was asked to write or compile a state-of-the-art book in his area of expertise, and containing information until now scattered in many journals and proceedings. The book series therefore should help Image Communication specialists to get a better understanding of the important issues in neighbouring areas by reading particular volumes. At the same time, it should give newcomers to the field a foothold for doing research in the Image Communication area. In order to produce a quality book series, it was necessary to ask authorities well known in their respective fields to serve as volume editors, who would in turn attract outstanding contributors. It was a great pleasure to me that ultimately we were able to attract such an excellent team of editors and authors.

The Series Editor wishes to thank all of the volume editors and authors for the time and effort they put into the book series. He is also grateful to Ir. Hans van der Nat and Drs. Mark Eligh of Elsevier Science Publishers for their continuing effort to bring the book series from the initial planning stage to final publication.

Jan Biemond
Delft University of Technology
Delft, The Netherlands
1993

Future titles planned for the series "Advances in Image Communication":

– Wavelets in Image Communication	M. Barlaud, Editor
– Subband Coding of Images	T.A. Ramstad, S.O. Aase
– Motion Estimation for Coding Applications	G. Tziritas, C. Labit
– HDTV Signal Processing	R. Schäfer, G. Schamel
– Magnetic Recording	M. Breeuwer, P.H.N. de With
– Image Deblurring; Motion Compensated Filtering	A.K. Katsaggelos, N. Galatsanos
– Colour Image Processing	P.E. Trahanias, A.N. Ventsanopoulos

Preface

This textbook treats of two complementary topics, namely the *coding algorithms made to compress the data rate of digital moving-picture sequences* and the *transmission on Asynchronous Transfer Mode (ATM) networks*. The digital moving-picture sequences refer to video-telephony, television (TV) and high-definition television (HDTV) and ATM networks to packet-switching transmission media.

The algorithms to compress the data rate of digital moving-image sequence have been a topic of research for about two decades. The thrust towards designing coding algorithms to process the digital TV and HDTV started in 1982 when the encoding parameters to produce the contribution digital television were defined by the CCIR Recommendation 601. The CCITT issued its initial recommendations for the ISDN standardization in 1984. They were based on multiplexing 64 kbit channels for video-telephony transmissions. A first hierarchy of digital TV and HDTV formats was defined within the European EUREKA research action to embody progressive and interlaced formats with several levels of definitions. Resulting from the activity of numerous teams, the research in that field of image coding has progressed rather quickly during the past decade. Recently, the introduction of new concepts like multiresolution and compatibility have open the way to transmissions of scalable video information. The research on digital signal analysis is a related fundamental on-going topic which has never ceased to feed the toolbox with refined operators.

The idea to develop and to drive the packet-switched technology came out of works initiated and funded by the Advanced Research Project Agency (ARPA) of the U.S. Department of Defense. This pioneering research work, which established a data communication network called ARPAnet, began in the late 1960's. This experiment spawned many models worldwide. The idea of transmitting small packets on asynchronous transfer channels grew out of these experiments. The main advantage of ATM networks is *to provide the users with asynchronous transmissions at either constant or variable rates*. The ATM network statistically multiplexes different sources in order *to exploit the available bandwidth more efficiently* and *to transparently transmit any kind of information at its own rate of generation*. Accordingly, the ATM networks will be a support of multimedia communications with the goal to transmit any kind of service (data, voice, image and any other on demand) on the same support in a transparent way i.e. with an identical processing taking no particular consideration of the content of the packets except for their destination and for the level of transmission quality.

Like speech and audio, the moving-picture signals are intrinsically non-stationary variable rate generators of information. Especially, to transmit TV at constant subjective image quality, variable rate transmissions are the major consequence to be faced with.

As defined here above, the ATM networks are transmission media provided with the asynchronous transfer mode and with statistical capabilities to carry non-stationary and stochastic sources (data, speech and video merged into the channel) in order to enhance the transmission efficiency and offer a unique support of transparent communications. The challenge consists now of demonstrating that matching *variable-rate moving-picture information and ATM ability to transmit variable rate services works more efficiently than transmitting the same signal on any other type of media*. The outcome of that subject is an important issue in the field of ATM transmissions in the sense that the transmission of fine resoluted images and, especially, of TV and HDTV pictures, will request the presently largest available bandwidths. On one end of the scale, a HDTV programme requires bit rates ranging from 30 Mbit/s up to 140 Mbit/s depending on resolution. On the other end, speech and audio transmissions require rates ranging from a few tens of Kbit/s up to 2 Mbit/s.

As major achievement, *this textbook aims at covering the whole transmission chain to encompass the coding and transmission solutions which reach global optimums*. The book is built on seven chapters whose content may be outlined as follows.

Chapter 1 presents the ATM concepts and the features susceptible to influence the compression and the transmission of the digital image sequence information. The foundations of the ATM architecture, the packet-switching and the traffic equations are analyzed into details. Sources models are provided in a coherent modeling construction effort which extends from data and speech sources to join still images, single and multiple scene video sources.

Chapter 2 presents the coding schemes and the architectures used to encode and transmit in an ATM environment. The aspects of the present research in the field are also presented and some particular attention will be devoted to the tools of digital signal analysis and their on-going developments. Procedures like quantization, variable length entropy coding are also addressed in this chapter as part of the core compression action. The concept of multiresolution is defined and related coding schemes are addressed as an important support for multimedia applications.

Chapter 3 deals with modeling variable cell rate sources as they have to be expected at the output of a TV codec. A multiresoluted time-scales approach is investigated to describe data rates ranging bottom up from the microscopic network level of the inter-arrival times between consecutive packets up to the macroscopic image coding functions processing images along scenes and programmes. The statistical analyses of bit rates and cell inter-arrival times presented in that chapter have been carried out on database built by processing actual-time TV sources on built-in-hardware coders. The study aims at supporting final models, estimating parameters and eventually refining our knowledge about TV sources behavior.

Chapter 4 returns to coding problems and considers the special aspects of the coding regulation to transmit at constant and variable bit rates. Different solutions will be developed to cope optimally with the non-stationary nature of TV entropy sources studied in the third chapter and to balance the requirement of graceful variations of image quality with the limited capacity of the encoder output buffers. A first regulation scheme with a simple regulator is considered to impose elementary coder responses in image quality during the transient periods of the input sources. A *state-of-the-art control algorithm* is

thereafter presented which optimally balances the search to uniform image quality with the need to limit the fluctuations of the encoder buffer occupancy. Both constant and variable bit rate transmissions are examined and finally integrated in one single general control scheme which can manage the whole coder and take into account eventual policing functions installed on the network.

Chapter 5 steps ahead to network considerations and study the statistical multiplexing characteristics of several TV sources to be transmitted in a free variable bit rate mode on an ATM network. In this chapter, the multiplexing characteristics of the TV sources are combined with adequate queueing models to estimate the transmission performances through one single ATM network node. Those are namely the cell loss rate, the transmission delay and the gain in statistical multiplexing.

Chapter 6 goes back to coding aspects. Exploiting the knowledge acquired on the multiplexing drawbacks, strategies are put forward to protect the information transmission against cell losses by using error correcting codes. Solutions are also proposed to cope with the asynchronous and random transmission delays to resynchronize the decoding process at the receiver side.

Chapter 7 investigates the way to transmit the video information on the ATM channels and to combine variable bit rate sources with enforcement functions. The effects of policing functions will be studied in some details. Two points of view are considered, namely the bandwidth allocation for variable bit rate sources and the control of local congestions. The first topic allows deriving the source traffic descriptors negotiated at call set-up and used to efficiently allocate transmission bandwidth. The second allows characterizing the source traffic parameters to be policed to foresee, control and avoid the occurrence of congestions into the network. At the end, the whole transmission chain of TV information is encompassed to deduce the optimum coding-transmission conditions.

This book is the outgrowth of the author's Ph.D. thesis which was defended in March 1993 at the Université Catholique de Louvain in the Laboratoire de Télécommunications et Télédétection at Louvain-la-Neuve in Belgium. The research works on the topic have been carried out in the RACE-HIVITS or RACE-1018 project from 1988 until 1993. The RACE projects are managed by the European Commissions in DG XIII. At that time, the research has been also partly supported by the Belgian Broadband Association. The achievement of the textbook has been supported by the grant ERB4001GT930967 of the Human Capital and Mobility at the Institut de Recherche en Informatique et Systèmes Aléatoires (IRISA) located in Rennes, France. The Human capital and Mobility is managed by the European Commissions in DG XII. IRISA belongs to the Institut National de la Recherche en Informatique et Automatique (INRIA) of the French State.

The author wishes to acknowledge the contributions of people in the preparation of this book. I would like to acknowledge Professor G. De Ghellinck Vaernewyck for fruitful discussions, Professor D. Barba and Professor M. El Zarki to have accepted to review the manuscript. I am also particularly thankful to Mr. P. Louarn who has brought his expert support on the use and the design of the LATEXtools and environments with an endless care to solve all these editing problems. The author is grateful to Mr. E. Picheral for his advices when scanning the old personal materials. Thanks are due to my wife, Nicole

Ravalinghien, for her patient and perseverant reading of the manuscript, for her support during the long period of writing and also for her numerous and useful remarks. My thanks are also directed to the Editor, Professor J. Biemond who accepted the publication of this book in his series on Advances in Image Communications.

The book was typewritten by the author using LaTeX. The figures were designed with *Matlab* and *Xfig*. The experiments referred in the textbook were performed on two different hardware prototypes, namely the Alcatel-Bell-SDT TV coder and the RACE-HIVITS TV coder. For presentation purpose, the former experimental test set is referred to as *coder-model 1* and the latter as *coder-model 2*. Statistical results on the MPEG-II coder are also presented, they were obtained by computer simulations on TV built-in sequences. The experiments and the simulations were performed at the Laboratoire de Télécommunications et de Télédétection at Louvain-la-Neuve.

Jean-Pierre Leduc

Rennes, France

Contents

Contents *xiii*

Contents *xv*

6　ATM Adaptation Layer　453

7　Transmission on ATM Networks　487

List of Figures

List of Figures

List of Tables

Chapter 1

Introduction to ATM Networks

1.1 Introduction

This chapter intends to lay down the explanatory foundations of the ATM networks and to present the issues originating from the current research activity which are susceptible to deal with the transmission of the digital TV. More particularly, the topics to be treated refer to the embedding concepts of the Broad-band-ISDN; these are namely the potential user sources or services, the ATM-OSI layers, the switching elements, the multiplexing buffer architectures, the concept of priority, the management architecture, the traffic models, the traffic descriptors, the enforcement actions, the admission and congestion controls,... Some of these topics will serve as an introduction to the development of more advanced materials presented in the following chapters of this textbook and give a first context description to important achievements derived from the past research in ATM networks. Other basic results analyzed in the present chapter like the traffic models, the ATM global management algorithms, the enforcement functions will be subsequently refined along the textbook with respect to the specificities of the Television (TV) and the High-Definition Television (HDTV) source characteristics. A state-of-the-art link between encoding the TV video signals and transmitting on ATM networks is intended to be studied in whole depth in the textbook. Other outstanding summaries of the ATM concept can be found in several References [7], [13], [9] and [11]. The standardization work on the Broad-band-ISDN and the ATM is carried out concomitantly to the research work carried out by the CCITT Committee; related information is provided in References [2], [3], [4], [5] and [6].

1.2 Data Communications on Networks

This introduction to data communications on networks depicts the trends in data telecommunications starting with a brief historical overview on the progresses accomplished during the past century. It proceeds with the present data networking facilities and ends up with an orientation towards the future integrated broad-band technologies.

The need for networks arose early in telephone history as a powerful support when hundreds, thousands and millions of users tried to communicate with each other. As a

matter of fact, providing direct wire connections between any two users requires a tremendous amount of individual connections, precisely, a total of $\frac{n(n-1)}{2}$ wires would be needed if n different telephone users were involved. At that epoch, the efficient and convenient solution has consisted of connecting all the local users to one single access network, called a *local phone exchange center*. This center was in charge of interconnecting on demand any two short distance users. The use of wire cables for the transmission of the information has never ceased to expand since the installment of the first telephone exchange, a historical event reported to have taken place in 1878 at New Haven, Connecticut, USA. This date can be considered as one of the starting point of the age of telecommunications. Historically speaking, the switching machinery has been supported successively by man-made, mechanical and, eventually, electronic procedures requiring only n connections from user to phone center to be put in exploitation. As a local economical optimum, this efficient concentration of switching operations into one single exchange center has replaced a paramount effort to install numerous remote interconnections among users. Obviously, a similar problem has to be solved to provide far remote users with communications between different areas already equipped with distinct local phone exchange centers. Trunks were necessary to convey large amounts of simultaneous communications between pairs of local exchanges. Instead of connecting these local centers two by two, a new layer in the network has been implemented by connecting each local exchange center to a new common exchange center. This created a long distance networking support of communications. This reasoning extended on larger and larger scales leads to a whole exchange network based on a thorough hierarchical structure. Hence, each layer in that networking hierarchy corresponds or covers particular geographic areas and distance ranges and aims at concentrating all the traffic issued from the lower layers. Restated in other words, all the exchange centers located at a given layer switch the user traffic of the users which communicate between two distinct exchange centers of the lower layer. In the graph representation of a network, an exchange center will naturally be referred to as a *node* in the graph and the links or trunks as arcs. The network hierarchical organization reduces drastically the connection cost at the expense of a switching investment. This explains how hierarchical networks were introduced in the early stages of the developments and have lead to pyramids of communications. As a matter of fact, in the networks described so far, the communication paths are established and individually allocated between any pair or group of users without any possibility of sharing the resources which remain reserved as long as the transmission is held on. Such systems are referred to as circuit-switched networks and characterize the presently ubiquitous telephone networks.

Several new technologies have come separately to maturation during the past decades and have initiated the thrust towards Broad-band Integrated Service Digital Networks (B-ISDN). Among all the new transmission technologies, it is worth mentioning the fiber optics with laser sources, the satellite communications, the cable TV in metropolitan areas, the digital communications and the digital signal processing, the frequency and time division multiplexing communication techniques and the fast multi-stage packet switching.

A strong interest to communicate on optical frequencies ranging from about 50 nm (ultraviolet) to approximatively 100 μm (far infrared) has been created with the advent of the laser technology which made available coherent optical sources. Since the optical frequencies are of the order of $5^{14}Hz$, the laser has a theoretical information capacity

exceeding that of microwave systems by a factor 10^5. The support of optical technologies, for instance based on Gallium Arsenide alloy, has extended the reliable transmissions up to hundreds of Gbit/s. Furthermore, optical switching is a subject under research for many years which should allow building thorough optical networks to replace in a long term future the present electronic switching technology.

In contrast to terrestrial fiber optics, satellite communications provide users with intercontinental communications and turn out evidently to be a complementary tool for short distance cabled networks. The use of satellites for worldwide communications has been expanding tremendously over the past years. Telephone traffic is now routinely carried out through satellite among the member nations of the Intelsat organization. Although having referred first to voice traffic and data transmissions, the present satellite facilities have as well stated to offer a significant support to the TV broadcast applications. Various frequency bands have been allocated to commercial satellite use; for instance, the most common one consists of a 500 MHz wide band centered at 6 GHz in the up-link direction towards satellite and at 4 MHz in the down-link direction towards the earth. Various modes of accessing a satellite have been developed. The most common procedure is called *frequency-division multiple access* (FDMA); nevertheless, more recent techniques to handle the traffic have emerged recently, they are referred to as the *demand assignment multiple access* (DAMA) and the *time-division multiple access* (TDMA).

Digital signal processing is a technology-driven field which dates its growth as a separate discipline from the mid-1960's when computers and other digital circuitry became fast enough to process large amount of data. In conjunction to the development of data communications, it opened the age of the transmission supported end-to-end by binary information.

The distribution of commercial TV broadcasts by coaxial copper cables in many cities has led to installing new networks and services distributed concomitantly and independently to the already existing telephone networks. Immediately after their deployment, the demands for additional and accessory services never ceased to increase; among them, let us mention the access to local video databases or libraries of documents (a document may be in whole generality composed of video, audio, textes, data and fixed pictures).

Furthermore, the desire to transmit not only voices but also watching signals, alarms, control and computer data as well as audio, fax, still picture, video-conference and TV, all of them on one single network has rapidly emerged in order to increase communication efficiency and to concentrate the access of numerous services on one single entry gate. These new ideas have contributed to introduce a new network philosophy aiming at universally supporting the transmission of any kind of service provided that the characteristics of the individual service be clearly defined at the call establishment and remain valid until the relinquish of the demand. These networking facilities gather all the previously mentioned technologies to achieve in the field of telecommunications a new technological challenge known under the appellation of *multi-media* wherein the transmission support will be ensured by the future broad-band-ISDN (Integrated Service Digital Network). Multi-media connections can be

1. *point-to-point* or *multi-point* whether the set-up involves two or more people.

2. *distributive* or *interactive* whether the transmissions are one-way or allow mutual

exchanges.

3. *multirate* or *multi-resolution* to provide the receivers with an access to lower levels of resolution.

These connections should also satisfy additional requirements and be provided with the ability of being reconfigured many times within the duration of the call. Data, voice and video transmissions may be combined and extracted in any manner according to local demands. The development of these technologies will force progresses to be accomplished in the switching and multiplexing techniques which have already been defined in telecommunications, namely the space division, the time division, and the frequency division. Future networks are likely to make a simultaneous use of all these three techniques.

The need to handle variable rate, stochastic and non-stationary services has led to use a packet-switched technology, in which information is fractioned into blocks of data called packets to be transmitted on an individual basis from source to destination like letters through the postal services. Packets from multiple users share the same distribution and transmission facilities. The major thrust towards developing packet-switched technology came out of a work initiated by the Advanced Research Projects Agency of the U.S. Department of Defense. That pioneering effort began in the late sixties. The basic concept behind the work was at that time the computer utility. A similar work of research started in France in the late seventies under the appellation of ATD (Asynchronous Time Division) to design networks providing undedicated slots. The implementation of the ideas developed for the ATD technique has been carried out in the *PRELUDE* project during the eighties.

With the move towards integrated networks, which are able to handle any type of traffic, modern digital-circuit switches are being designed to support hybrid technologies, namely circuit-switched calls as well as packet-switched transmissions. Two modes of packet-switched data transmission are coming into application, successively the *connection oriented mode* and the *connectionless mode*. The connection oriented transmissions will the first networking version to be developed. As an intermediate mode of transmission between circuit-switched and connectionless operations. In connection oriented procedures, a path is first set up end to end through the network to guarantee what is called a virtual circuit. After that call establishment phase, user packets are able to traverse the network following the path initially chosen and arrive at the destination node in the sequence in which they were transmitted. Along the way in the network, the packets share links and switch facilities with other transmission under process. In connectionless procedures, the packets are forwarded randomly through the network following individual routes on a basis which depends on the momentary network load repartition. The routing at intermediate nodes is based essentially on the destination address and on the network congestion previsions. Packets arrive at destination out of order as a price to be paid to a higher networking efficiency.

This brief introduction to the history of communications has intended to lay down the framework description of how the broad-band technologies and, more particularly, the ATM will be deployed in the future communication networking facilities. Broad-band-ISDN is supposed to make use of synchronous and asynchronous transmission resources. The object of the next section consists of comparing both principles.

1.3 Broad-band ISDN

The fundamental achievement of the Broad-band ISDN is to enable all the user services to share a single broad-band transmission medium with a whole guarantee of communication privacy. Two modes are involved in the Broad-band ISDN: the Synchronous Transfer Mode and the Asynchronous Transfer Mode.

1. The *Synchronous Transfer Mode* (STM) assumes a common time reference among the users. This reference is termed a *frame reference* and the resource assigned to each user is called a *circuit*. A slot or window assignment within the frames is further required. It is performed on the basis of the peak transfer rate and, therefore, this way of allocating bandwidth is well suited for fixed bit rate services. It requires a *frame timing* and a *slot or window timing* with a corresponding synchronization. To allow a multi-rate environment, the network divides the channel frame capacity into K individually allocatable windows. In this framework, the concept of *basic channel rate* has been developed to balance the waste of bandwidth and the difficulty of assigning a broad range of windows. The basic channel rate corresponds to the k^{th} portion of the frame capacity and represents the least common multiple unit of all the allocatable bandwidths such that the individual user bandwidths exploit rates equal to integer multiples of the basic channel rate. As evidenced in this brief description, STM still suffers from inefficiency and from a lack of flexibility to cope with variable bit rate sources.

2. The *Asynchronous Transfer Mode* (ATM) assumes no frame reference among the users. It enables a flexible sharing of the resource which can be adapted on demand. The allocated bandwidth is called a *virtual circuit* on which the information is transmitted by packets, especially, by small packets of fixed size called *cells*. The services are called asynchronous in the sense that they do not share any common time reference other than a time slot references. The cells are subdivided into a header field and a data field; the header contains the information about both the destination and the class of service (type and priority) and some error check and correcting codes. ATM is suited for both Constant Bit Rate (CBR) and Variable Bit Rate (VBR) services. The drawbacks of the transmissions on ATM networks are the occurrence of cell losses and the random propagation delays. Both characteristics concur to define a resulting network Quality of Service (QOS).

To clarify the different characteristics of these transmission strategies, Figure 1.1 outlines a hierarchical classification of the Synchronous and the Asynchronous Transfer Modes. The network transmission capacity is subdivided into slotted and unslotted structures. Time slots have well-delineated and fixed length units of information; they correspond to the cell size in ATM. Slotted traffics can be decomposed into framed and unframed options: the frame is a common structure in which slots are grouped; they stake by means of synchronization patterns the time axis into intervals of convenient duration; they are used mainly in STM communications. In the framed structure, either a static or a dynamic slot assignment can be considered. STM networks carry out static slot allocations; ATM networks cover all the other possibilities. Another distinction of relevance when

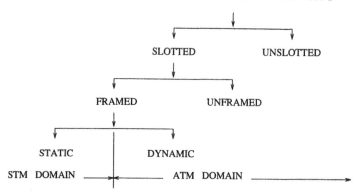

Figure 1.1: A hierarchical classification of STM and ATM.

characterizing an ATM network is the recourse to connection oriented or connectionless transmission mode. These topics have already been defined.

The main advantages and disadvantages of STM are as follows. It is well-suited for all kinds of continuous and constant rate information transfer, fixed transmission delay, conventional non-blocking switching and network structures. The disadvantages of STM are essentially an inefficiency utilization of the transmission capacity, the need for different switching matrices for different groups of services, the lack of flexibility to potential changes of source bit rate, STM is also not amenable to the immediate introduction of new classes of services needing bit rates different from those for which the network has been designed.

When comparing to STM, ATM reverses the characteristics of STM. The main advantages of ATM are the universality of the network with respect to the introduction of new services or coders and to changes and removals of service, the ability to provide better network utilization, since the transmission bandwidth is not dedicated permanently to any service, the unique switching network supporting all the services, the independence of bit rate sources. The drawbacks of ATM are as follows: random transmission delays, losses of packets due to queueing overflows in the multiplexers, decrease in network utilization due to the header size, inefficiency for services with constant bit rates.

As a matter of consequence, hybrid architectures combining both STM and ATM are very likely to exist. The fact is that they can advantageously support the option of circuit switching in conjunction with that of packet switching. The circuit switching ability provides a compatible outcome with the previous networks, a guaranteed bandwidth and fixed transmission delays. The packet switching ability provides efficiently allocated virtual bandwidths at the expense of variable transmission delays and cell losses.

The ATM concept originates from the data transmissions where the traffic is essentially of variable rate, bursty and non-stationary. Comparing ATM to STM, ATM allocates slots on demand and can therefore accommodate variable bit rate services with such an efficiency and a flexibility that STM cannot offer. The ATM networks are provided with queues performing a statistical multiplexing of the transmissions and, as a

consequence, should be better matched to transmit stochastic sources with non-stationary variable bit rates. The STM networks use only flexible and deterministic methods to allocate and to transmit the same sources of information. Let us here notice that the variable rate sources like data, voice and images will constitute all the potential types of service to be transmitted on a broad-band channel.

The most important challenge of ATM within the Broad-band-ISDN is to demonstrate that its performances are higher than those of the competing STM transmission mode. The goal of this textbook is to supply the adequate materials and arguments to yield that important objective. To succeed in this venture, one major point will consist of allocating and to controlling as accurately as possible the user bandwidths and traffics to achieve the expected multiplexing gains of efficient ATM transmissions.

1.4 Potential User Services

The future ATM networks will support a lot of different classes of service as one of the supports of multimedia communications. Conversational exchanges, messages and retrievals are examples of applications. Any exchanges may mix at will data, images (fixed, mobile, video sequences), audio and voice. These applications or exchanges may be classified in three distinct modes: the distributive applications which involve a passive transfer from a source to various receivers, the interactive applications which allow two or several users to interact with each other, the consultative applications which allow users to access generalized databases or libraries. According these general definitions, let clarify the status of particular application of multimedia. Remote control belongs to the class of interactive applications where one user is a remote engine to be controlled. Surveillance can be seen as a part of the remote control or as a consultative application. Alarm transfer is a distributive application.

The object of the ATM networks will be to statistically multiplex all those different types of sources on the same transmission links. According to their potential average and peak bit rates, the potential user services can be enumerated as presented in Table 1.1.

1.5 ATM-OSI Layers

A layered protocol for data communications over networks must be universally agreed to impose functional requirements at any user stations to ensure the correct transmission and delivery of the information. In fact, a general reference model for Open System Interconnection (OSI) has already been approved in 1983 as an international standard by ISO and CCITT and stands for all data transmissions on networks. Its content is first abridged in this section to enlight the subject and the necessary junction between OSI layers and ATM networks will be thereafter presented. In Chapter 2, an extension of the OSI philosophy will be presented in the scope of the video coding algorithms.

Information	Service	Bandwidth
data	1. interactive data (low speed) 2. bulk data (medium speed) (high speed)	64 kb/s 2 Mb/s 10 Mb/s
Voice	Telephony HQ stereophony	32-64 kb/s 2 Mb/s
Audio	High fidelity audio	768-2000 kb/s
Still picture	1. Video file transfer	384 kb/s
	2. high-definition	\vdots
	still-picture	\vdots
	3. High-speed facsimile	\vdots 1.5 Mb/s
Full-motion video	1. video-telephony	$p \times$ 64kb/s
	2. video-conference (two points)	4 Mhz 1.5 Mb/s
	3. video-conference	\vdots
	(multipoints)	\vdots
	4. video lecture	10 Mb/s
	5. entertainments video distribution	4 Mhz 4 Mb/s
	6. remote	\vdots
	surveillance	\vdots
	7. video transmission	34 Mb/s
	8. video transmission	4 Mb/s
	9. HDTV	20 MHz
	10. video signal	\vdots
	retrieval	140 Mb/s
	11. super HDTV	> 140 Mb/s
	12. stereoscopic TV/HDTV	> 140 Mb/s

Table 1.1: Video, audio and data services.

1.5.1 Layered Architectures in OSI Standard

The OSI standard applies to any kind of networks, namely the circuit-switched or the packet-switched technology, the STM or the ATM transmission, the connection-oriented or the connectionless mode. According to the OSI philosophy, an architecture composed of seven layers (Figure 1.2) has been defined and the layers are enumerated hereafter top down and subdivided in a higher and a lower group. Four higher protocol layers are referred to as being resident in the host user systems. These are top down

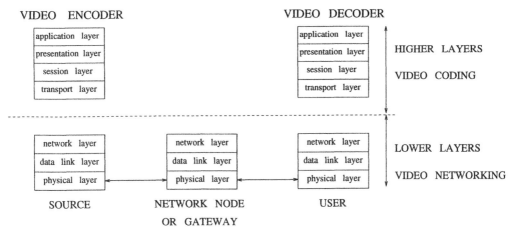

Figure 1.2: Structure of the OSI architecture.

1. the Application Layer.

2. the Presentation Layer.

3. the Session Layer.

4. the Transport Layer.

The three lower protocol layers are relevant to the network functions; they are successively

5. the Network Layer.

6. the Data Link Layer.

7. the Physical Layer.

The three lower layers are implemented in each network node. The substrate of the physical bottom layer is the physical medium of transmission which can be made of any kind of support; for instance, optical fibers, coaxial cables, electro-magnetic waves, microwaves, satellite communications,... The seven layer are described in the following paragraphs; they are implemented at both sides, in the transmitter and the receiver. Inverse functions are carried out in the corresponding layers of the receiver end. The

ideas behind the layered OSI philosophy are that each layer operates independently of the higher ones and that the protocol implemented in each of the seven layers has to take care only of the characteristics of the lower ones.

The *application layer* deals with the semantic of the transmitted data. This layer is highly specific to each particular application. In video coding and communication, this layer is the location where the video formats are converted or generated prior to coding and transmitting. This can be also a possible location where a splitting is performed into several levels of resolution.

The *presentation layer* handles the syntax of the data to be transmitted. It is in charge of mapping the original data stream into the required syntax for transmission. In video coding applications, the encoding and decoding algorithms for bit rate compression are resident in this layer; the mapping aims at compressing the data rate which originates from the formatted digital video. The mapping is not completely reversible in the sense that it degrades the original image quality. The reduction of bit rate adapts the incoming rate of video information to the admissible rates on the network and maintains a highest level of image quality. Another task devoted to the presentation layer is to handle and correct the errors and the lost parts of the transmitted information with graceful degradations. In video decoding, these functions are generally referred to as the concealment algorithms. The presentation layer is also in charge to initiate and terminate the connection session. Below this layer, the semantic and the syntax of the data stream is no more interpretable; the information is considered as a variable rate bit stream.

The *session layer* provides the user transmissions with the synchronization service. The procedure consists in introducing synchronization marks or uniquely decipherable words to split the data stream into segments which usually correspond to physical timing periods. For instance, in video communications and coding, synchronization words delimit the frames, the fields and also small portions corresponding to fractions of images. Since the synchronization words are designed as uniquely decipherable marks, they provide the decoding process with points where to restart the work in case of errors or losses; the data of the impaired segments is discarded. In video coding, synchronization words are normally introduced on an image by image basis and, even more, after encoding small image portions like eight consecutive lines or less. The task of establishing or relinquishing a connection session is also accomplished by the session layer.

The *transport layer* is the effective interface to the network, consequently, it is in charge of providing reliable, transparent and protected data-transfer mechanisms. It packetizes the data according to the network type and generate appropriate error correction codes to protect the transmission against cell losses and bit errors. Thus, this layer is responsible of the resulting transmission quality that will be called the end-to-end users quality of service. Below this layer, the information is even no more available and the only remaining interpretability is contained in the cell header.

In ATM, any cell which belongs to a given level of service is operated equivalently without any possibility of knowing its origin and the type of service. The cell arrivals occur therefore purely at random since it is no more possible to given any explanation on the content. Consequently, the stochastic processes are the only available tools to deal with traffic problems.

The *network layer* is the level where packet are handled i.e. picked up, routed, switched and multiplexed. Access in the packet header is provided in this level to check destinations and errors.

The *data link layer* provides the physical link transmission with services like synchronization, sequence number, error detection and correction, and control data.

The *physical layer* is in function of supporting the data transmission (modulation, time and frequency multiplexing) and to guarantee reliable transfer across the physical links.

The definition of slots and frames becomes clear when considering the OSI layer structure. A slot stands for the elementary information field available for transmission at the network layer and seizable by the user. Restated in other words, the slot is the time window where to launch a packet or a cell. Usually, slots and packets have identical sizes. Frames are handled at the data link layer as a field grouping a given shielded set of packets to be transmitted on the physical medium. The ATM design can be thought of as implementing slotted or unslotted versions as well as framed or unframed structures.

1.5.2 Layered Architecture in ATM Networks

The B-ISDN ATM protocol reference model (PRM) is presented in Figure 1.3. An additional subdivision in planes transforms the two-dimensional OSI representation into a three-dimensional sketch. The content of the three highest OSI layers corresponding to the video processing will be detailed in Chapter 2. The OSI transport layer will be here referred to as the ATM adaptation layer (AAL). As a matter of fact, the AAL is incorporated in the video coders. This section furnishes a general description of the different AAL structures whose specificities and algorithmic aspects for video coding are provided in Chapter 6 which is totally devoted to the subject. The following description proceeds thereafter with the lower ATM network layers.

1.5.2.1 Plane Description in the B-ISDN ATM Protocol

Several planes have been added by the CCITT to refine the layered description of the B-ISDN ATM protocol. These have been referenced respectively as the user plane, the control plane, the management plane, the plane management and the layer management. They are in charge of the functions which follow

1. the *user plane* provides the user information flow with associated controls, verifications and retransmissions.

2. the *control plane* handles the call control and the connection control information; it deals with the signalling flow necessary to set up a call connection, to vary its characteristics and, finally, to disconnect the call connection.

3. the *management plane* is divided into two portions. The first is responsible for the layer management functions and the second for the plane management functions.

4. the *layer management* functions perform the management relative to the resources and the parameters resident in the protocol of the layer entities under control. It

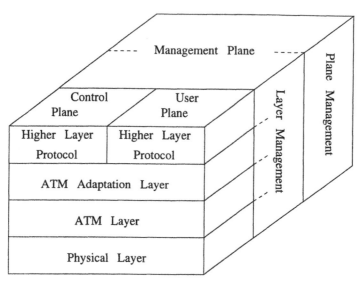

Figure 1.3: B-ISDN ATM Protocol Reference Model.

handles also the operational and maintenance information messages.

5. the *plane management* functions perform the management related to the coding and communication system taken as a whole (i.e. a unique entity) and provide the coordinations between all the planes. Some aspects of this management will be investigated in Chapter 7.

1.5.2.2 ATM Adaptation Layer

The ATM Adaptation layer is service-resident. It provides the users with the required support to enable the network transmission and to enhance the network QOS by performing error corrections and digital clock recovery. The classification of the different classes of services provided by ATM services is presented in Table 1.2 as proposed in CCITT rec. I.362 under four classes.

	Class A	Class B	Class C	Class D
Timing relation between source and destination	Required		Not required	
Bit rate	Constant		Variable	
Connection mode	Connection oriented			Connectionless

Table 1.2: AAL service classes.

Four service classes of ATM transmission have so far been defined, to support these classes, some additional functions need to be performed inside the AAL. Four types of AAL's have been therefore defined and refer to as types 1, 2, 3 and 4 to correspond to the classes A to D. The real time services like audio and video transmission are easily transmitted on AAL types 1 and 2 as either constant (1) or variable bit rate (2) source with a

time relation provided between source and destination. Nevertheless, as demonstrated in Chapter 6, the variable bit rate video services can be transmitted as well without major difficulties through class C and D i.e. through channels without any timing with either connection oriented or connectionless data transfers. The ALL functions are organized in the following sublayers: *Segmentation and Reassembly Sublayer* (SAR) and *Convergence Sublayer* (CS). To take an example from the CCITT standardization, let the ATM adaptation layer for class 2 service be presented. The services provided by the ATM adaptation layer for this class are

1. transfer of the variable bit rate information service data units i.e. packetization in cells.

2. transfer of the timing relation between source and destination.

3. indication of the lost or errored information which is not recovered by the AAL.

The following indications may be passed from the ATM adaptation layer in the user plane to the management plane

1. the errors in user information field.

2. the lost or misdelivered cells.

3. the cells with errored AAL.

4. the loss of timing/synchronization.

The following functions are performed in the AAL in order to support the user QOS

1. segmenting and reassemblying the user information.

2. handling the random variations in cell transmission delay.

3. handling the lost and misdelivered cells.

4. recovering the source clock at the receiver.

5. monitoring the user information field for bit errors and possible corrective action.

Segmentation and Reassembly Sublayer (SAR)

Segmentation and reassembly are performed on a cell-by-cell basis. As the SAR accepts variable length CS-PDU's from the Convergence sublayer, the SAR-PDU's may be partially filled. The proposed SAR-PDU structure is presented in Figure 1.5.

The *Sequence Number* field (SN) has 4 bits and is used to detect lost or misdelivered cells. The *Cell Type* (CT) field is made of 4 bits and its purpose is to indicate various useful information about the cell content precisely, if the segment corresponds to a Beginning of Message, to a Continuation of Message, to an End of Message, to the timing information and, also, to the components of the video or audio signal. The length indicator (LI) field uses 6 bits and indicates the length of the useful payload of partially filled cells. The Forward Error Correction (FEC) field uses 10 bits and enables the correction of up to two correlated errors.

Convergence Sublayer

The following functions are devoted to the Convergence Sublayer

1. clock recovery for variable bit rate audio and video services by means of the insertion of time stamps, a real time synchronization word in the CS-PDU. The sequence number processing is performed at this sublayer to detect the lost and misdelivered cells. The handling of the lost and misdelivered cells is also performed in this sublayer.

2. for audio and video services, a Forward Error Correction (FEC) may be performed by the use of the SAR-PDU FEC and the Sequence Number (SN), combined with the use of a parity cell every $n \times 16$ cells and provides protection and correction for multiple bit errors and cell losses.

1.5.2.3 Lower ATM Network Layers

Two layers have been described in the PRM at the level of the ATM network. Top down, it is composed of the *ATM layer* and of the *physical layer* further subdivided into two sublayers which are termed the *transmission convergence sublayer* and the *physical medium sublayer*. Each layer is responsible for a specific interaction with the network transmission quality of service.

1. the ATM layer corresponds to the OSI network layer and, in that framework, it is in charge of transporting cells along the network. Hence, it performs the following functions: (1.) network management, (2.) cell multiplexing and demultiplexing, (3.) priority access management, (4.) cell header generation and extraction, (5.) appending and checking head error control, (6.) cell rate decoupling by suppression and insertion of idle cells.

 Due to its statistical multiplexing action, this layer is responsible of network QOS in terms of cell loss occurrence and of transmission delay (maximum value and jitter).

2. the Physical Layer is in charge of coding the information at the bit level. It is subdivided in two sublayers with the following functionalities

 2.1. the transmission convergence sublayer converts the cells into a bit stream to be transmitted and performs the related functions: cell delineation, header error check and correction, scramble and unscramble.

 2.2. the physical medium sublayer corresponds to the medium of transmission with the corresponding modulation techniques, the bit timing and the synchronization necessary to the transmission.

According to the OSI philosophy, the transmission convergence sublayer is merely close to the definition of the data link layer and the physical medium sublayer to the definition of the physical layer. The physical medium sublayer is responsible of the network QOS in terms of the bit error occurrence. In the case of transmissions on optical fibers, the expected bit error rates do not exceed values higher than 10^{-10} up to 10^{-9}.

1.6 Cell Structure

The problem of the ATM cell size stood as one of the first major questions to be solved in the early stages of the network definition. Would it be more efficient to use variable or constant cell lengths and what should be the range of the optimum sizes? The answer to those questions is thoroughly developed in [11] and will be shortly discussed here before starting the description of the standardized cell structure.

1.6.1 Fixed and Variable Length Cells

To argue on the first question dealing with whether the size should be fixed or variable, the intervening elements have been the achievable switching performances and transmission bandwidth efficiency.

1. the switching performances are function of both the switching speed and the hardware complexity. The switching speed depends mainly on two factors, namely the header processing and the queue memory management. As a matter of fact, handling variable size cells requires higher processing speeds. The queue memory size requirement in the variable size strategy will be more intricated and, in case of an optimum dimensioning, the memory size requirement depends upon the configuration of the characteristics of the aggregated traffic.

2. the transmission bandwidth efficiency is defined by the ratio

$$\frac{\text{number of bytes dedicated to information}}{\text{number of bytes dedicated to information} + \text{number of bytes dedicated to overhead}} \quad (1.1)$$

Figure 1.4 presents the efficiency for both variable and fixed length cells. In the latter case, the size is fixed at 48 bytes of useful information and 5 bytes of header. The transmission bandwidth efficiency has a saw-tooth shape with the lowest optimum at 48 bytes of information. High speed data, voice and TV will exploit the major network resources since they require high cell rates. Nearly all the transmitted cells will be completely filled up depending on the temporal splitting of the data stream in lying-together portions and the efficiency will be close to the optimum.

To conclude, the gain in transmission efficiency when using variable length cells is rather limited since the major broad-band traffic will be made of high cell rate sources. Fixed length cells are also preferred against variable length cells which require more complex implementations.

1.6.2 Cell Size

The relevant parameters in the choice of the cell length have been the following: the transmission efficiency already discussed in the previous subsection, the transmission delay including packetization, queueing, jitter and depacketization, and the implementation complexity.

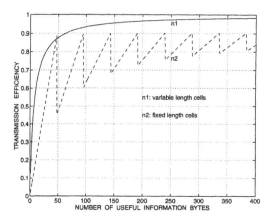

Figure 1.4: Transmission efficiency.

1. the packetization for constant rate transmission increases with the cell size under the assumption that the cells are completely filled. That delay is an important factor to preserve transparency when dealing with low cell rate sources like voice at 32 and 64 Kbits/s.

2. the overall network delay has to be limited to 24 ms for voice applications to avoid installing echo cancellors. Cells with lengths of 32 to 64 bytes turn out to be acceptable; longer cells will require too long delays and jeopardize the use of ATM.

3. the implementation complexity involves a trade-off between the cell handling speed and the cell size. The argumentation may be outlined as follows. The larger the cell size, the larger the memory requirement will be. The header processing is performed once per cell; therefore, the longer the cell, the lower the speed requirements will be.

As a matter of conclusions, optimum cell length should range in between 32 and 64 bytes. Lower sizes increase the speed of the hardware handling and multiplexing the transmissions and decrease the transmission efficiency which presents a first optimum at a cell length of 48 bytes with a five-byte header.

1.6.3 Cell Structure

The ATM cell is composed of 53 bytes of which 5 are dedicated to network purposes and called the header field; the 48 remaining bytes constitute the information field. Figure 1.5 sketches the cell content and the header structure. The distinction between virtual path identification and virtual circuit identification is of major importance and discussed in the section devoted to the network architecture.

Besides user information cells, other types of cells are intended to be transmitted within the network for management purposes. Some of them remain at the network physical layer only, others proceed up the ATM layer. Among those cells, the CCITT has already assigned specific types referred to different tasks and known as the *unassigned*

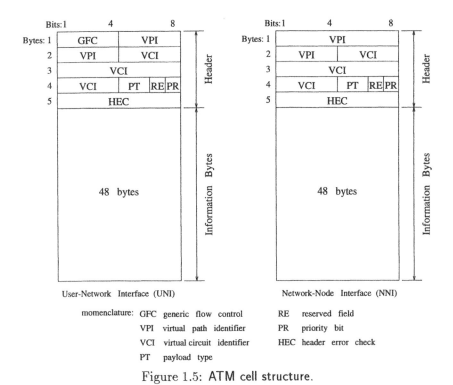

momenclature: GFC generic flow control · RE reserved field
VPI virtual path identifier · PR priority bit
VCI virtual circuit identifier · HEC header error check
PT payload type

Figure 1.5: ATM cell structure.

cells, the *idle cells*, the *meta-signalling cells*, the *general broadcast cells*, the *physical layer OAM cells*. Idle cells are visible only to the physical layer in contrast to unassigned cells which are interpreted at the ATM and physical layers. The meta-signalling cells are used to signalling resources and virtual path identifications. The physical layer OAM cells carry maintenance information in the physical layer.

1.7 ATM Switching Techniques

During the 1980's, numerous structures of switching elements have emerged in the literature dealing with routing ATM cells [1] and the research activity has been rapidly evolving. Conceptually, a *space-division packet switch* is a process 1.6 with M input and N outputs that routes the packets arriving on its inputs to the appropriate outputs. Among all the early circuit switching techniques, the crossbar switches remain attractive since they are internally non-blocking and also very simple. Hence, they have been considered as a first base of switching fabric to operate the packet-switched networks. As the crossbar matrices have the property of a square growth in complexity, they are unfortunately not economical for large switching fabrics. Other ATM switching elements have been devel-

[1] the words *switching*, *switching fabric* and *switching network* will be used equivalently to describe the routing organizations and techniques used into one node (inlets to outlets) of a *telecommunication network*, here the ATM network.

oped during the 1980's in the framework of advanced research projects like *PRELUDE* and *ORWELL*; it is also worth mentioning the Coprin switch (CNET-1987), the Knockout switch (ATT-1987), the Roxanne switch (Alcatel-1990) and the Athena switch (Alcatel-1987). It is out of the scope of this textbook to describe all these techniques, therefore one single promising approach is presented in the sequel and the interested reader is urged to prolong the study in the papers given in reference.

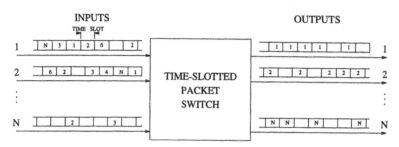

Figure 1.6: Overview of a switching network.

Most recent proposals in the literature for high performance and high switching capacity have been based on a principle known as fast packet switching. This technique employs a high degree of parallelism, distributed control and routing performed at the hardware level. The purpose of this section is to present a survey of these high-performance switch fabrics which incorporate fast packet switching to handle various types of traffic. A detailed overview is given on some switch families and the underlying classifications. Three successive switching fabrics will be examined; they are namely the multistage interconnection networks, the sort-Banyan network and the time division fabrics with common packet memory.

1.7.1 Multistage Interconnection Networks

The need to process very fast large amounts of data in real time has emerged in many scientific and military applications and created the concept of parallel processing through distributed computers. The name of *interconnection networks* has been given to special fast switching structures which interconnect the processors to exchange the partly processed data. This problem was recognized to be similar to the basic function of broadband switching networks and has conducted to the concept of *Multistage Interconnection Network* (MIN). The MIN is composed of several switching stages i.e. a switching fabric able to connect any arbitrary input taken among a large number of inlets to an arbitrary output chosen within a large set of outlets. It is composed of a large number of identical switching elements. The switching elements are connected to each other by means of *links*. A *path* between an inlet and an outlet consists of a recursive sequences of links and switching elements. As ATM is a variant of the Fast Packet Switching technique, all types of MIN's may be as well studied for ATM switching purpose. MIN's can be classified as any switch into different types referring to common properties like *buffered* versus *unbuffered*, *blocking* versus *non-blocking*, *unicast* versus *multicast*, *input queued* versus *output queued*. Moreover, according to their topological structures, MIN's can be mainly classified into

two families, namely the *single path networks* and the *multipath networks* to give rise to the hierarchical structure depicted in Figure 1.7. All the definitions of those different types will be precised along the section. Let us begin with analyzing the unbuffered and the buffered MIN's

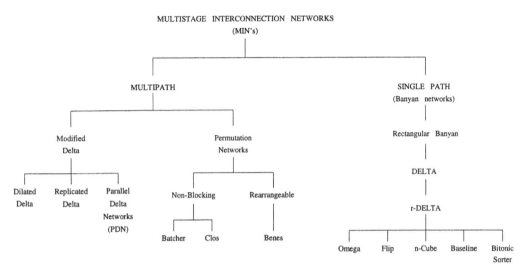

Figure 1.7: Classification of multistage interconnection networks.

1. the *unbuffered MIN's* utilize the basic mode of operation of circuit switching. According to this methodology, a physical path is actually established for the duration of a cell between a given inlet-outlet pair.

2. the *buffered MIN's* use the classical packet switching technique. A cell moves stage to stage as links between stage become available. The connection through the switch has not to be established prior cells enter the switching network, but a path is established on a link-by-link basis through the stages. Therefore, it is necessary to have buffers at every switching stage in order to store cells which are waiting for the availability of the outgoing link. Buffered structures turn out to be preferred to reach fast switching performances.

As buffered MIN's establish a connection on a link-by-link basis, they provide an easy mean to route the cells by themselves, that property is called *self-routing*. The concept of self-routing is considered as a key feature for ATM B-ISDN. Single path and multipath networks are successively addressed in the following.

1.7.1.1 Single Path Networks

The single path networks are MIN's in which a unique path exists between a given inlet-outlet pair. Switching elements have any size and links can exist also between non adjacent stages. Such types of networks are also called *Banyan networks*. A subset of Banyan

networks is given by the *Rectangular Banyan*. They are characterized by the following properties

1. interstage links exist only between adjacent stages.

2. all the switching elements have the same $n \times n$ size.

These conditions imply that each stage is composed of $\frac{N}{n}$ switching elements and the number of stage (S) is tied to the number (N) of network inlets and outlets by the relation $S = log_n N$.

A particular class of rectangular Banyan is composed of the digit controlled interconnect networks generically known as *Delta networks*. They are characterized by the *self-routing property* (also called the *bit controller property*) which can be explained as follows. Since $S = log_n N$, each network outlet can be coded with a pattern composed of S n-radix digits; these patterns represent the destination addresses of cells crossing the networks. The bit controlled property assures that the path between any inlet and a given outlet can be found in S step. In each of them, a switching element examines the digit of the destination address which corresponds to the stage under process and, on the basis of its value, it establishes the routing towards the next stage. An example of this procedure is given in Figure 1.8. In this case, the destination address is composed of three bits. A switching element routes a cell towards the upper output if the corresponding bit is 0, otherwise, it selects the lower one. It is worth noting that such a routing mechanism allows an outlet to be reached from any inlet; for example, Figure 1.8 shows the paths connecting the inlet 2 and 6 with the outlet 2 (010). It is worth noting that, in Delta (digit controlled) networks the bit controlled property is not valid any more if the set of inlets and outlets are exchanged between each other. The class of Delta networks in which the bit controlled property applies in both direction (i.e. from inlets towards outlet and vice versa) is called *reversed-Delta* or *r-Delta*.

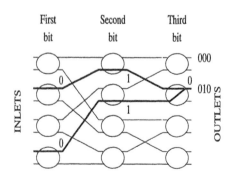

Figure 1.8: Bit controlled property and routing.

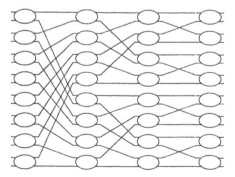

Figure 1.9: Baseline network.

Delta (Digit Controlled) Topologies

Although many different topologies exist (Omega, Flip, N-cube, Baseline as in Figure 1.9,..), it can be shown that all Delta networks are topologically and functionally equivalent. Restated in other words, a particular delta can be obtained from another one by simply re-ordering the switching elements of the intermediate stages and, eventually, by properly renumbering either the inlets or the outlets.

Three basic permutations can be utilized to characterize the switching topologies; they are qualified as perfect shuffle (Ω), unshuffle (Ω^{-1}) and β. They are defined as follows. Let $C_j = (i_{S-1}, i_{S-2}, i_{S-3},, i_1, i_0)$ be the bit pattern representing the i^{th} inlet-outlet of a switching stage

1. the shuffle permutation (Ω) is defined by

$$C_j = (i_{S-1}, i_{S-2}, i_{S-3},, i_1, i_0) \Longrightarrow C_i' = (i_{S-2}, i_{S-3}, i_{S-4},, i_0, i_{S-1})$$

2. the unshuffle permutation (Ω^{-1}) is defined by

$$C_j = (i_{S-1}, i_{S-2}, i_{S-3},, i_1, i_0) \Longrightarrow C_i' = (i_0, i_{S-1}, i_{S-2},, i_2, i_1)$$

3. the β_k permutation establishes that the i^{th} outlet of a stage has to be connected to the j^{th} inlet, of the successive stage, wherein

$$C_j \Longrightarrow \beta_k(C_i) = \beta_k(i_{S-1}, i_{S-2}, i_{S-3}, .., i_k, .., i_1, i_0) = (i_{S-1}, i_{S-2}, i_{S-3}, .., i_0, .., i_1, i_k)$$

For instance, by utilizing the previous permutations, the following Delta topologies can be defined

1. *Omega* where each switching stage is preceded by a shuffle permutation of the interstage.

2. *Flip* where each switching stage is followed by an unshuffle permutation of the interstage links.

3. *N-Cube* where the first switching stage (s=0) is preceded by an unshuffle permutation, whereas the s_{th} stage ($1 \leq s \leq S - 1$) is preceded by a β_{S-s} permutation.

4. *Indirect N-Cube* as a Delta network in which the s^{th} stage ($0 \leq s \leq S-2$) is followed by a β_{s+1} permutation, whereas the last stage ($s = S - 1$) is followed by a shuffle permutation.

5. *Switching Banyan or Bitonic Sorter* as a Delta network in which the s^{th} stage ($0 \leq s \leq S - 2$) is followed by a β_{s+1} permutation. Restated in other words, it is equal to an Indirect N-Cube in which the shuffle permutation is missing.

6. *Reverse Switching Banyan* as a Delta network in which the s^{th} stage $(1 \leq s \leq S-1)$ is preceded by a β_{S_s} permutation. In other words, it is equal to an N-Cube in which the unshuffle permutation is missing.

All these Delta networks have topological and functional equivalence; this implies that their throughput and delay performance are completely independent from the particular topology. From this point of view, any topology can be chosen for implementation of an ATM-switch.

1.7.1.2 Multipath Networks

In multipath networks, more than one path exists between an inlet/outlet pair. Unlike the single path networks which are highly blocking, multipath ones can be implemented in order to minimize the blocking probability or, in some case, in non-blocking fashion. However, these better performances are paid with greater hardware complexity and, in most cases, with a loss of the self routing property which makes necessary a centralized routing unit to be provided.

Two classes of MIN's have been identified as

1. the *permutation networks*.

2. the *modified delta*.

Both classes are now examined in detail.

Permutation Networks

The class of permutation networks comprises those structures which are able to guarantee all the $(N!)$ inlet/outlet permutations, meaning that those networks that can connect their inputs to their outputs in any arbitrary way as long as two inlets want the same outlet. A permutation network is said *rearrangeable* if it can perform all possible connections between inlets and outlets by rearranging its existing connections so that a path for a new input-output pair can always be established. Instead, if a new connection can always be established without any rearrangement of the existing connections, the network is called *non-blocking*.

A classical rearrangeable structure is the *Benes network*. It is given by the juxtaposition of a baseline and a reversed baseline network in which the last stage of the first and the first stage of the second are merged together. The resulting network has $(2 \log_n N - 1)$ stages and offer $\frac{N}{n}$ multiple paths between any pair of inlets and outlets.

The *Clos network* in Figure 1.10 represents the most important example of non-blocking structure. It has been very successfully employed in the present digital exchange. It is typically composed of three stages; the first and the last ones have $r_1 n \times m$ crossbar switching elements, whereas the middle stage has $r_s r_1 \times r_1$ switching elements. A three-stage Clos network offers r_2 paths between any inlet/outlet couple and is strictly non-blocking if $m \geq 2n - 1$, moreover the minimum number of crosspoints is obtained if $n = \sqrt{N}$.

In both Benes and Clos networks, the routing of a cell has to be handled by a centralized unit which knows the status of the network and is able to find the free path from the inlet to the proper outlet.

A non-blocking, distributed control structure is represented by the *Batcher network* (Figure 1.11). This structure, also called *Sorting network*, is able to pass, to the outlets, any arbitrary sequence of incoming cells, present at its inlets, according to their destination addresses.

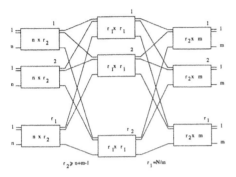

Figure 1.10: Clos network. Figure 1.11: Batcher network.

Each switching element compares the address of the incoming cells and routes the cell with the highest address towards the high output and the cell with the lowest address towards the low one. As the routing is obtained stage by stage by means of a comparison between addresses, this network does not need a centralized control unit. However, the distributed control is paid with a very large number of stages. In fact, an $N \times N$ Batcher network is composed of $(\frac{\log_n N[\log_n(N+1)]}{2})$. An example of an 8×8 Batcher network is shown in Figure 1.11.

Modified Delta Networks

The modified Delta Networks are based on the simple Delta topologies, but adopt some expedients in order to create multiple paths so that the basic delta throughput performances are improved. Three basic strategies can be employed, namely the dilatation of the links, the replication of identical Delta and the addition of extra stages. The first strategy consists in replacing each link of the network by k distinct links. A cell entering a switching element may exit using any of the k links outgoing to the desired successor switching element at the next stage. The structures using this strategy are called Dilated Delta network and provide k^{S-1} multiple paths between paths between an inlet/outlet pair, wherein S is the number of stages of the original Delta.

The networks resulting from the adoption of the second strategy are called *Replicated Delta* and are composed of k distinct copies (called layers) of a basic Delta network. Each network inlet is connected to every layer and each layer is connected to all the network outlets. A replicated Delta network provides k multiple paths. It is important to be noted that, if k is high enough, an unbuffered replicated delta can be non-blocking. In particular, the non-blocking condition for an unbuffered replicated Delta is given by $k \geq n\lfloor\frac{S}{2}\rfloor$.

The third strategy consists in adding new stages (distribution stages) in front of the Delta network in order to create alternative paths between an inlet/outlet pair. If k stages are added, the resulting number of the multiple paths is n^k. A further strategy can be generated by mixing Replicated Delta networks with distribution stages. This new strategy is adopted in case of the so-called *Parallel Delta Networks* (PDN).

An $N \times N$ PDN is built up by inserting

1. L Delta networks in parallel, called the layers.

2. one additional switching stage composed of $n \times n$ switching element, called the distribution stage.

3. two complementary stages being respectively, the expansion stage and the concentration stage.

A PDN provides $P = n \times L$ different paths between one input/output pair and it is non-blocking if the number L of layers is greater than or equal to $n^{\lceil \frac{S}{2} \rceil - 1}$, wherein S is the number of stages composing a single layer.

1.7.2 Sort-Banyan Based Fabrics

As earlier mentioned, one drawback of the Banyan networks is the possibility of internal blocking in the sense that two packets destined for two different outputs may collide in one of the intermediate nodes. However, if packets are first sorted on basis of their destination addresses and, then, routed through the Banyan network, the internal blocking problem can be avoided completely. This is the basic idea behind the sort-Banyan type networks. Consequently, cascading a sorting network (Batcher network) with a routing network (Banyan) provides the switching procedure with an internal non-blocking property. Moreover, the switch has an internal self-routing property since a cell can make at any node a local routing decision based on its output address. Self-routing avoids the processing bottleneck of a centralized path finding algorithm for all cells.

By definition, a sorting element is an $m \times m$ node which fulfills the property that when a number is presented at any of the m inputs to the node, this number will appear in a sorted order at the m outputs of the node. Furthermore, a sorting network is a network composed of sorting elements for which any number at the set of inputs I would appear in a sorted order at the set of outputs J. If these numbers to be sorted constitute a permutation of 1 to N, where N is the number of output of an $N \times N$ switch, that each number is actually the output address of the cells at the input, the operation of sorting the addresses will establish paths for each cell from input to addressed outputs. As a consequence, sorting network is also a switching network provided to having a full set of addresses arriving at the node. To illustrate the realm of sorting network constructions, a three-dimensional modular sort-Banyan network is depicted in Figure 1.12. This example has been developed by J. Hui in Reference [24]. Let each vertical first stage be called a module. A module consists of three parts referred to being a sort, a branch and a route function. In this example, q modules have been considered with p inputs. Each module is connected to p horizontal merge planes. A module is connected to each of these merge

planes by q edges. The switching is operated as follows. The input (x, y) is to be delivered to the output (x', y'). For the moment, we assume that the destinations are distinct. The functions of the modules and the merge planes are given by the modular routing algorithm

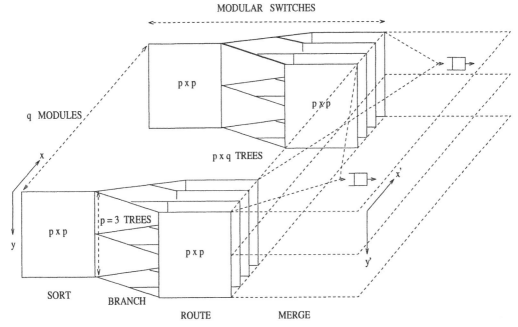

Figure 1.12: A modular sort-Banyan switch.

1. *sort*: the cells in the module x are sorted according to the y' address contained in the least significant bits.

2. *branch*: after sorting by column for each module, the cells are self-routed and branched through p horizontal $1 \times q$ binary trees according to the address x'. Subsequently, the cell with destination (x', y') will appear at an input to the vertical Banyan routing network x' in the module x.

3. *route*: there are q Banyan networks for the different x'. The cells with the same x' form a sorted set of y', due to the sorted subsequence property. Subsequently, these cells with the same x' are routed through the vertical Banyan network x' to the outputs y'. The sortedness of y' for a given x' guarantees non-blocking delivery to the output of the Banyan network x' in the module x.

4. *merge*: the sort-branch-route module effectively switches the connection (x, y) to (x', y') for inputs with the same x. Subsequently, cells with the same (x', y') have to merge from different modules. This is accomplished by horizontal merge planes for transferring cells with the same x'. Consequently, up to q cells with the same (x', y') may arrive at that output, necessitating the use of output queues.

Since output buffering resolves output conflicts for cells originating from different modules, output conflict resolution is also necessary only for cells originating from the same module with the same address y' in the sorting module. This is easily resolved by introducing queues at the sort module output. Due to the attractive non-blocking and self-routing properties of the sort-Banyan networks, it can be anticipated that it is worth continuing research to generate novel and even more efficient architectures.

1.7.3 Conclusions on the ATM Switching Techniques

Given the broad range of bit rates (or bandwidths) susceptible to load the switching resources and given the possibility of changing rapidly the connection pattern of broadband services, most of the conventional circuit switching are too slow, with respect to the cell length, to set up such transfer paths of the ATM links. Consequently, fast packet switching architectures have been proposed in the literature to avoid such a processing bottleneck. The category of interconnection networks that have been studied for the ATM switching purpose is known under the appellation of Multistage Interconnection Network (MIN) and has been presented in this section as providing promising switching mechanisms. Among them, a self-routing switching architecture, called the non-blocking sort-Banyan network, has emerged as one example of ATM switching fabric. This specialized topic is so diversified that this section has been restricted to the description of one single family of admissible architecture. Other switching elements have been cited and a set of related references is provided at the end of this chapter. The enumeration of the different positions of the queueing systems in a switching network leads, in the following section to a general classification of the ATM switches.

1.8 ATM Multiplexers

Two topics closely related to switching are addressed in this section, namely the queueing architecture and the priority implementation. Due to the stochastic nature of the ATM traffic, queueing the cells which traverse a switching fabric is compulsory procedure to be performed somewhere to avoid contentions within the switching whenever two cells try to access the same resource at the same moment. A priori, queueing should be necessary at the switching input, output and at some intermediate switching positions. The object of this study is examine these different schemes independently of the algorithms and of the technologies of switching. The aim is primarily to determine which queueing architecture leads to optimize the efficiency of both the switching and the multiplexing procedures. The concept and the use of priority in ATM stand in an early beginning phase where only two levels are foreseen and can be presently exploited. The existence of multiresolution coding algorithms for video transmissions appeals merely the design of networks allowing multiple priority levels and might initiate a generalization of the present state-of-the-art ATM networks.

1.8.1 Queueing Architectures

As defined earlier, a *space-division packet switch* is a process with N inputs and N outputs that routes the cells arriving on its inputs to the appropriate outputs. At any time, internal switch points can be set to establish paths from inlets to outlets according to the routing information (i.e. the final destination) contained in the header. The cells may have to be buffered within the switch until appropriate connections are made available. The location of the buffers and the amount of buffering required depend on both the switch architecture and the statistics of the offered traffic. Clearly, congestion can occur if the switch is a blocking network or, restated in other words, if there are not enough switch points to provide simultaneously independent paths between arbitrary pairs of inputs and outputs. A Banyan switch, for example, is originally a blocking network; nevertheless, it has been shown how to transform a Banyan switch into a sort-Banyan switch which is non-blocking. Even in non-blocking interconnects, some queueing is unavoidable, fundamentally, since the ATM switch acts as a statistical multiplexer on asynchronous variable rate services.

Four conceptually different approaches may be considered when dealing with the problem of queueing cells in a switching fabric is tackled; these methods are namely the *input queueing*, the *input smoothing*, the *output queueing*, the *completely shared buffering*. Those four designs will be compared on the point of view of their respective performances i.e. the cell loss probability, the expected waiting time in switch fabric and the throughput. The throughput is defined as the number of cells passing through the switching network per slot time unit and per input. The cell arrival process also called traffic is modeled[2], in the present case, by a Poisson process. The queueing occupancy process observed at service departure times defines a Markov chain (M). Such queueing models built with one (1) server and a deterministic constant service time (D) are referred by the notation M/D/1 according to Kendall notations. N inputs and outputs are considered in the switches.

Figure 1.13: Output versus input queueing.

It seems intuitively reasonable to think that the mean queue lengths and, hence the mean waiting times, will be greater for queueing on inputs than for queueing on outputs. When queueing is done on inputs, a cell that could traverse at once the switch to reach an idle output during the current time slot may have to wait in queue behind a cell whose output is currently busy. The intuition that, when possible, queueing on the outputs is

[2]The Kendall notations for a general queueing system are of the form A/B/C. The symbol A represents the arrival distribution, B represents the service distribution, and C denotes the number of servers used.

N	Saturation Throughput
1	1.000
2	0.750
3	0.683
4	0.655
5	0.640
6	0.630
7	0.623
⋮	⋮
∞	0.586

Table 1.3: Throughput in the input queueing architecture.

better than queueing on the inputs of a space-division cell switch applies also to practical live when considering for example two circumstances as follows. The configuration where a single road leads simultaneously to a big store and a sport area yields worst waiting performances than in the case where bypass roads allow dedicated access to each resource. In the first configuration, one shopper may be stuck in a file trying to access the sport area and inversely.

1.8.1.1 Input Queueing Scheme

In the case of input queueing architectures (Figure 1.14), a specific buffer is located at each input of the switch to collect the entering traffic. The queueing discipline is FIFO. Each packet has first to enter the buffer and to wait that the buffer empties before accessing the switch fabric. The input queueing architecture enjoys simple structures but suffers from a rapid convergence to an asymptotic throughput of 0.586 when the number N of inputs tends to infinity. The input queue analyses with the Markov chains taken as queueing model (M/D/1) have furnished the results presented in Table 1.3.

Figure 1.14: Input queueing architecture. Figure 1.15: Input smoothing architecture.

1.8.1.2 Input Smoothing Scheme

In this queueing scheme (Figure 1.15), the traffic entering the switching network is not really queued but smoothed in the input ports. At each input port, the cells contained in a frame of b consecutive time slots are stored at the input port in b distinct buffers and simultaneously launched into a b-fold switching fabric. Identically, b cells can be

Chapter 1. Introduction to ATM Networks

simultaneously received at each output. Any cells in excess of b destined to the same output at the same moment are dropped out from the switch. In this architecture, low cell loss probabilities can be obtained for large values of b. The switch fabric complexity increases with the factor $[Nb \times Nb]$ leading to a prohibitive cost. Moreover, the mean delay increases proportionally to b. To give an example of the inefficiency of this scheme, at a working load of 0.85, a buffer size b equal to 60 offers a cell loss probability as high as 10^{-2}.

Figure 1.16: Output queueing architecture. Figure 1.17: Completely shared buffer scheme.

1.8.1.3 Output Queueing Scheme

In the output queueing architecture (Figure 1.16), the queueing procedure is performed at the output ports of the switching networks with one distinct queue dedicated to each output. The queueing discipline is FIFO. The output queued ATM switches have intrinsically better delay and throughput performances at the expense of a more complicated interconnection network. The mean waiting time is minimized in this configuration. Little's theorem shows that only small mean waiting times of 2 to 3 cells are involved at a load of 0.85. The congestion eventually caused by any particular channel degrades selectively the performances of its corresponding output buffer and cannot interfere directly with the other streams crossing the switch. The reference Markov M/D/1 queueing models demonstrate that a queue size of 60 cells allows to guarantee a cell loss probability of 10^{-9} with loads ranging up to 0.85. The memory size is Nb in the case of N outputs built with queues of b cells.

1.8.1.4 Completely Shared Buffer Scheme

The architecture of a completely shared buffer is close to the output queueing scheme; in this case, instead of exploiting a separate buffer for each output, all the queueing mem-

ory is pooled into one completely shared output buffer (Figure 1.17). When compared to the separate output queueing option, completely shared buffers achieve the optimum throughput-delay performances but at the expense of increasing the switch size to $[N(b+1)$ inputs $\times N(b+1)$ outputs]. Intuitively speaking, the resulting gain stems from an effective gain per cell in the mean accessible queueing space leading to a decrease of the cell loss probability. A drawback of shared buffer is the possibility of interferences due to one potential heavily loaded output on the performances of others, for instance, the potentiality of cross cell losses induced by the statistical trespassing of one important source (a HDTV source at 70 Mbit/s compared to video-conference or bulk data transmissions at 1 Mbit/s). At a load of 0.85, the gain in memory of a shared output buffer structure relatively to a separate one (previous architecture) to achieve a cell loss probability of 10^{-9} is of a factor 6 requesting a buffer size of 10 cells per output.

1.8.1.5 Classification of the ATM Architectures

Additional definitions of ATM switching properties for broad-band services in conjunction with the queueing schemes lead to a classification of the ATM non-blocking architectures. A switching network is termed *unicast* if it ensures point-to-point input output connections and *multicast* in the case of point-to-multipoint connections. These options provide four possible kinds of non-blocking switches, namely input-queued unicast switches [25], output-queued unicast switches [39], input-queued multicast switches [30], and output-queued multicast switches. These four kinds of switches do not have buffering inside the switching network and are distinct from other switch families requiring internally buffered networks as those mentioned in [37], [9], [14]. A switch is called *truck grouped* [54] if each output address corresponds actually to a set of outputs instead of a single link, termed a *trunk group*. At an input, a cell requests delivery to a trunk group. Hence, a path from the input to any output in the requested trunk suffices for the delivery of the cell.

1.8.1.6 Conclusions on the Queueing Architectures

To conclude, the output-queued switch schemes achieve the optimum ratio 'throughput to delay' and best fit for the ATM purpose. This study is of major importance to model the cell multiplexing (Chapter 5) performed in a network node since this implies that the ATM multiplexer is an output queueing system fed by cells of the different services trying to access the same node-to-node transmission link after having been routed in the node by the switching fabric. As the performances of the input-queued systems can be enhanced by parallelism, some constructors are developing partly input and output queued switches. If the dedicated output-queued switches (Section 1.8.1.3) are compared to the shared buffer schemes (Section 1.8.1.4), the first scheme minimizes the size of the switch fabric and the cross interference between the different output ports. This is an interesting property when dealing with HDTV sources. The output shared buffer scheme only minimizes the size of the buffers at the expense of a more complex switching structures. Nevertheless, the shared architectures fit also for broadcast purpose. Separate queueing schemes will be more suited to transmit TV sessions requesting different levels of quality.

1.8.2 Priority Concept

The ATM standardization bodies have dedicated one particular bit located within the cell header to declare two levels of priority. The user should therefore have the opportunity to assign one level of priority among two. The goal of the priorities is to improve the utilization of the network resources. Only two levels of priorities are presently under discussion for the application within the ATM networks. Three different schemes can be designed, namely a common buffer with a push-out algorithm, a common buffer with partial sharing and separate routes for each level of priority.

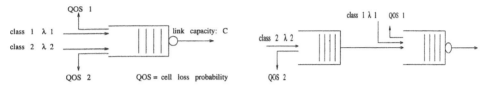

Figure 1.18: Push-out mechanism. Figure 1.19: Partial sharing.

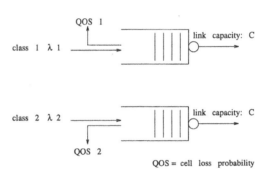

Figure 1.20: Separate routes.

1.8.2.1 Common Buffer Scheme with Push-out Algorithm

The push-out mechanism (Figure 1.18 where the QOS holds for the cell loss probability) implies a complicated buffer management which can be outlined as follows. When the queue is overloaded, a replacement strategy has the task to substitute the already queued low priority cells by the arriving high priority cells with the constraint to preserve the cell sequencing order of each user service accessing the multiplexing buffer.

1.8.2.2 Common Buffer Scheme with Partial Sharing

The partial buffer sharing mechanism (Figure 1.19 where the QOS stands for the cell loss probability) consists in granting differently the access of the buffer with respect to the class. Accordingly, the higher-priority channel can access the whole buffer memory in contrast to the lower-priority cells which are accepted into buffer up to an adaptive threshold S beyond which they are discarded. Restated in other words, within the lower

occupancy queueing space, namely those ranging from level 0 up to S, no deletion occurs and, within the higher queueing space, namely those ranging from level S up to the buffer capacity, the arriving low priority cells are discarded. The threshold S can be adapted according to the global load and the relative utilization load of both priority levels.

1.8.2.3 Separate Routes

The separate route mechanism (Figure 1.20 where QOS represents the cell loss probability) implies that the two priority levels follow different connections with different levels of QOS. This mechanism displaces the priority handling from the traffic control task to the traffic management algorithm which allocates the bandwidth at the call connection and to the user in charge of synchronizing and resequencing both channels.

1.8.2.4 Comparative Performances for Priority Algorithms

The comparisons confirm the higher performances obtained when using priorities in the ATM networks. In any case, the admissible queue load increases to very high values (0.91-0.92) even if the admissible load without implemented priority is already high (0.85). The system with partial buffer and adaptive threshold seems to optimize the compromise between the gain in performances and the complexity of the implementation. To compare the three schemes, a case with two services has been considered where class 1 provides a 10^{-10} cell loss probability and class 2 a 10^{-6}. If the admissible load is sketched as a function of the buffer size, the common buffer with a push-out mechanism is the most efficient scheme except at very low queue size (lower than 10 cells). Sub-optimum results are obtained by the buffer scheme with partial sharing. The network without any priority always admits lower load at equal cell loss quality. In any case, more than 5% of the network utilization is gained with the use of the priorities up to a load of 0.85. When drawing in Figure 1.21 the admissible load in function of the cell loss probability of the class 2 ranging from 10^{-10} up to 10^{-3} (the class 1 being maintained at 10^{-10} and the queue size is of 64 cells), the increase of the admissible load is nearly linear up to 10^{-3}: 12% are gained by the two first priority mechanisms at the latter value of the cell loss probability value (an admissible load of 0.96 at 10^{-3} against 0.84 at 10^{-10} with the class 1 still providing 10^{-10}) and only the half gain is obtained for the route separation mechanism.

1.9 ATM Network Architecture

This section intends to describe an overall layered approach of a broad-band network based on the ATM principle. The switching elements are localized in the network nodes; they have already been described in the preceding section. The physical internodal connections are supported mostly by optical fibers and satellite communications. The ATM network will be deployed on a worldwide basis in hierarchical structures of star patterns as depicted in Figure 1.22 with configurations similar to those constructed in the old telephone communications. As a matter of fact, the base of the hierarchy will be composed of local exchanges to interconnect clusters of local users and services. An example to illustrate what a local exchange center could be in an ATM network is provided in this section

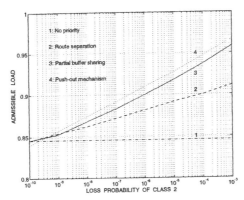

Figure 1.21: Admissible overall load versus allowed loss probability of class 2.

as presently implemented in a field trial. The intermediate levels of the hierarchy cover essentially with fiber optical links areas of medium distance scale like states or portion of states. At the top of the pyramid, the switching nodes should interconnect continents with each other by means of satellite communications. As previously mentioned, the ATM and STM solutions are foreseen to be conjugated together to support the future broad-band-ISDN. To complete the description, it is worth mentioning that connections are also susceptible to be established with other networks at any layer of the ATM pyramid. For instance, gateways can be used to interconnect B-ISDN with packet networks for mobile communications with cars, trucks, trains, planes, ships,... Moreover, the local exchanges located at the bottom layer of the pyramid structure may be connected with existing local structures, namely the Local Area Networks (LAN), the Metropolitan Area Networks (MAN) and the narrow-band-ISDN. Prolonging the ATM pyramid locally with MAN's and LAN's turns out to be feasible and allows generating new pyramid structures of local data transmissions. As a consequence, one part of this section will be devoted to giving insights to MAN's and LAN's to finalize the complete architecture of data communications where video transmissions will play a major role with respect to the importance of their traffic.

1.9.1 Layered Architecture for ATM Data Transmissions

As already noted in the introduction to data communications, any network, and especially the ATM networks, can be portrayed topologically in form of a mesh of nodal switching modules interconnected by transmission facilities. The network is structured in a hierarchy of layers at the bottom of which local exchanges provide clustered users with all the local and remote services currently available on the whole network. At any layer of the network, connections can be established with other networks through so-called gateways. Protocols are installed into the gateways to translate the ATM cell content into other techniques of carrying packets and to handshake the different signalizations. Buffers can be implemented especially if different bit rates or bandwidth are available. This leads to a network graph representation as that taken for example in Figure 1.22. That network graph is tree-like structured for long range communications, the bottom leaves represent

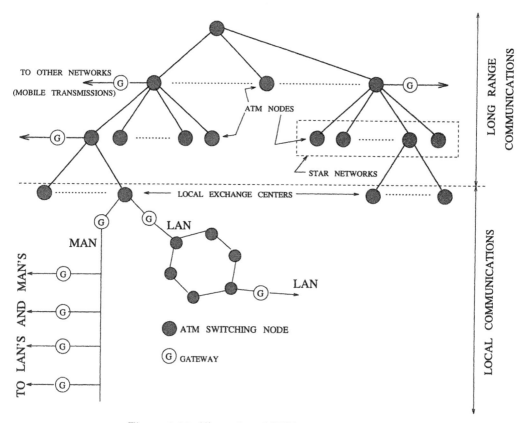

Figure 1.22: Hierarchy of ATM communications.

local exchange centers. So far, it is important to refine the concepts of *virtual path* and *virtual circuit* whose identification field have been described in the cell addressing structure description. The user transmissions from one local exchange to another are in fact grouped into virtual circuits to interconnect one set of local users to the other set of remote users. The virtual circuits have a local significance since they are gathered on the communication tree in dedicated virtual paths according the specific long range interconnection. This mean that the upper tree nodes are switching virtual paths only. This virtual path switching and routing is usually fixed on long term by the ATM management. The virtual circuit switching and the allocation in virtual path is performed at the bottom layer of the tree in the local exchange centers and arranged on short-term time scale according to local criteria. This distinction between virtual circuit and virtual path leads to splitting the ATM layer into two sublayers, the higher one provides and handles circuit connections and the lower one deals with path connections. This explain the double identification of routing contained in the cell header depicted in Figure 1.5.

At the bottom layer, the data communications can be extended locally from the local exchange centers through Local Area Networks (LAN) and/or and Metropolitan Area Networks (MAN).

1.9.1.1 Local Area Networks

Typically, the capabilities of the LAN's are limited in distance and in bandwidth since LAN's aimed originally at interconnecting clusters of computers, data processing units and storage equipments gathered in one building, for instance, a university campus, a factory,.. Here again, a hierarchical structure can developed within the LAN according to clustered configurations of the computer resources (For instance, university resources are usually structured into faculties, departments and research centers. Each research center gathers a set of internal computers and equipments characterized by a specific local traffic limited to its own needs. In order to avoid loading the whole network with heavy local traffics, local clusters of users are gathered into specific sub-networks; bridges guarantee further accesses to higher layers and provide connections to other resources or research centers via the established hierarchy of sub-networks). The Ethernet or the CSMA/CD Local Area Networks stand as one example of local network structure; examples of Ethernet configurations are depicted in Figure 1.23. Bandwidth requirement on LAN ranges up to tens of Mbit/s. Internal LAN interconnections can display various topologies such as stars, multistars, buses, rings,.. The LAN's may be connected directly to an ATM exchange center or to an entry with a hierarchy of MAN's.

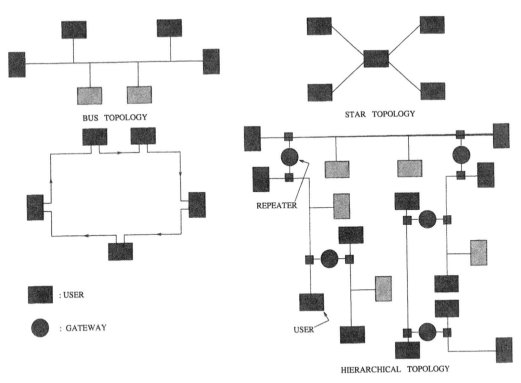

Figure 1.23: LAN architectures.

1.9.1.2 Metropolitan Area Networks

The Metropolitan Area Networks (MAN) are networks able to span over surfaces larger than those covered by usual LAN's. They can easily provide interconnections to groups of LAN's. MAN's are able to transport all kinds of services i.e. constant and variable rate data, speech and video services. MAN's suffer from some limitations of traffic capacity and from the unability to provide user oriented connections (private communications) since access to the network transmissions is commonly shared by all the users. The ATM switching can provide easy interconnections to MAN's due to the fact that the packets have identical size in both networks. Some additional details about MAN's are furnished in the sequel. For further and precise specifications, document [10] should be consulted.

The MAN's are based on a protocol called Distributed Queue Dual Bus (DQDB). In principle, the DQDB network is composed of two buses, one for forward and another for backward transmissions. Both buses are fed by a specific slot generator. All the users, numbered from 1 to N in Figure 1.24, are connected in parallel on both buses by a bidirectional link. The slot generators feed continuously the buses with frames composed of slots for the user transmissions. All the slots are composed of 53 bytes in which a five-byte header is available for control information.

It turns out immediately that the MAN provides the users with a data transmission framework able to support distributed accesses, broadcast and multicast applications. Unfortunately, the MAN's are less functional and efficient than the ATM networks, especially in terms of switching and of information privacy preservation (all the users share and access all the network slots), the extensions of one user bandwidth are achieved to the detriment of all the others. Upgrade and interconnection of MAN's is not an easy task due to the rigidity of the design. Nevertheless, due to the similarity between the DQDB protocol and the ATM protocol, ATM turns out to be an efficient tool to interconnect MAN's and an ATM local exchange can be easily extended with local MAN in cities, factories,... The slot structure of the DQDB being highly compatible with the structure of ATM cells, connections can easily be established between remote MAN's via an ATM network. Furthermore, since MAN's were originally designed to interconnect LAN's, a whole hierarchy of networking operations is now built up to ensure data communications through a structure covering top down a pyramidal ATM network, a MAN hierarchy and a system of LAN's. Video communications are possible on LAN's but at adjusted lower resolutions.

1.9.2 The ATM Local Exchange

The ATM local exchange contains a functional ATM core performing the cell switching which is termed a *broad-band switching network*. The technology of these switching networks has already been explained in Section 1.7. As previously described, the ATM local exchange connects the local users to each other and also to the local and remote services offered on the whole network. The ATM local exchange plays a role similar to that of the old telephone local exchanges. Similar broad-band switching networks and multiplexing operations are performed in any node of the ATM network. In the higher layers of the ATM communication networks, the connections are essentially established to other switching nodes located in the lower layer. To provide examples of connections

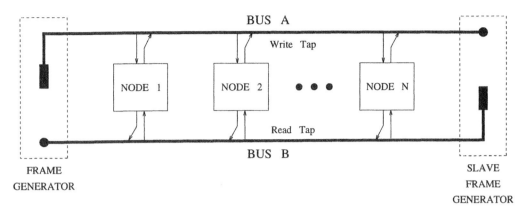

Figure 1.24: MAN configuration.

to which an ATM local exchange may be usually interfaced, let us mention the following possibilities among many others

1. the interfaces to subscriber lines.

2. the accesses to audio, TV, HDTV broadcasters, computer database as well as to audio and video libraries.

3. the exchanges with narrow-band-ISDN networks dealing with low bandwidth services as video-telephony.

4. the gateways to MAN's and LAN's.

5. the interfaces which enable the ATM local management to perform functions such as control, maintenance and administration on the core broad-band switching network.

6. interface modules to allow long distance interconnections via trunks to nodes of the higher ATM network layer or to other remote Local exchange centers .

One example of putting ATM to work is the Belgian Broad-band Project (BBA - BELGA-COM). The BBA experiment is summarized in Figures 1.25, 1.26, 1.27, 1.28, 1.29. The prototype BBA has been thought of as a local switching network structured in a multi-layered star to support both public and business communications. The different services taken into account in the trial are the narrow-band-ISDN (2 Mbit/s), the data transmissions (2 Mbit/s), the digital TV (25 Mbit/s in mean) and HDTV (up to 140 Mbit/s), the video-telephony and video-conference (2 Mbit/s in mean), the access to video library (25 Mbit/s in mean), the stereophonic audio of high quality (0.5 Mbit/s).

1.9.3 Conclusions on the ATM Network Architectures

A thorough hierarchical interworking structure has been here overviewed. It shows the capacity of the ATM B-ISDN networks to support the whole family of integrated services in a

Figure 1.25: The ATM local exchange: a general overview as in the BBA experiment ©.

whole hierarchy of communications starting from the local exchange which plays a key role in two directions by extending the exchanges up to worldwide interconnections and down to lower communication layers composed of MAN's and LAN's. The ATM transmission hierarchy will rely on both terrestrial communications based on optical fibers and satellite links based on microwave channels. Gateways located at any level of this ATM pyramid will moreover supply interconnections with additional networks of narrower bandwidths, for instance mobile data networks. That opportunity to extend ATM communications is another incentive towards developing multi-resoluted video transmissions to enable gateway protocols to capture lower resoluted portions of the digital HDTV signals transported through the ATM network and to broadcast those low resolution fractions through the network of lower bandwidth to which they provide connection.

Chapter 1. Introduction to ATM Networks

Figure 1.26: The ATM local exchange: the BBA experiment configuration ©.

1.10 Traffic Models

This section is devoted to an introduction on modeling asynchronous cell traffics. The *traffic* is by definition the occurrence of cells passing at any given point of observation in the network; the traffic may be composed of cells originating of either one single source or the merging of several multiplexed sources. The theoretical bases and the first elementary models are examined in the light of the current literature in the field. Contrary to the STM traffic models where the cells occupy deterministic locations (or slots) within the frames, the individual sources and the aggregate traffics, transported through the ATM connections are, by their intrinsic nature, stochastic processes describing cell arrivals. Among these stochastic processes, the most simple is the Bernoulli process. This discrete-time process will be the starting point towards other processes namely the Poisson process and the Gaussian process which are both continuous-time processes. These three processes provide elementary models to characterize traffics generated by simple sources as those involved in computer data transfers. Proceeding one step further to voice sources, single-scene video sources and aggregate traffics, it will turn out rapidly that, inherently to the nature of the carried information, the arrival processes require more intricated and request more general modeling tools. This forces to take into account general inter-arrival time distributions and serial correlations among consecutive arrivals. The motivation to develop accurate models leads to exploiting new families of arrival processes, namely the

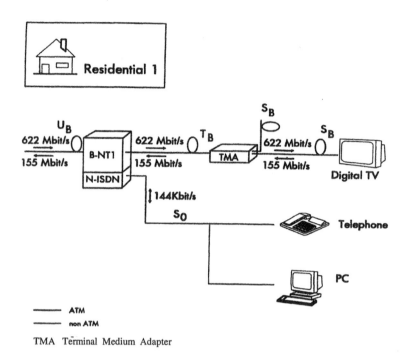

Figure 1.27: The ATM local exchange: the distribution center (BBA experiment ©).

renewal and the point processes. Both are introduced in this chapter and extensively used in Chapters 3, 5 and 7. A thrust towards generalizing the theory developed in the field of the stochastic arrival processes has lead Neuts to build a general stochastic model of point arrivals called the N process which embodies all the families of arrival processes studied in this textbook. The great intelligence and novelty of the N process hold in the fact that it offers not only a framework of analytically and numerically tractable modeling tools, especially when studying queueing systems, but also a generalization of all the theory developed around the Poisson process projected in the realm of point processes. The N process is sometimes referred to as a versatile arrival process. The properties of the N process are examined in Chapter 5.

According to the time scale of observation, any arrival process can be investigated with two companion versions, namely the inter-arrival process which models the time intervals between two consecutive cell arrivals and the counting process which models the number of arrivals within fixed time spans of observation. Both stochastic processes have their own statistics that are uniquely related to the primitive process. Hence, this section will begin with an introduction to some important topics resurrected from the theory of probability and progressively proceed to the definition of basic arrival processes and their asymptotic theorems, and continue with the traffic modeling to end up with an overview of the interrelations among all the families of stochastic arrival processes used in this textbook.

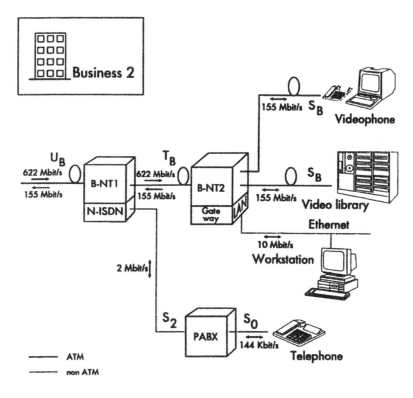

Figure 1.28: Business user (BBA experiment ©).

1.10.1 Introductory Theory

The aim of this short introduction is to review some important concepts of the theory of probability to support, latter, the study of the main traffic models and the character-ization of the sources transmitting on ATM networks. The presentation is built up in a constructive way to lay down the foundations of the theory developed for video sources in Chapters 3, 5 and 7. The Bienaymé-Tchebychev inequality, the characteristic functions, and the stochastic convergence theorems are first reviewed. The reader is nevertheless asked to acquire a prerequisite knowledge in Markov processes, birth-death processes, semi-Markov processes and in moment generating functions as provided in Çinlar [41], Kleinrock [48] and Papoulis [53].

1.10.1.1 Bienaymé-Tchebychev Inequality

Let y be a random variable and a function g of another random variable x, $y = g(x)$, such that $g(x) \geq 0$, $\forall x \in \mathbf{R}$. \mathbf{R} is the set of the real numbers. Let $G(y)$ and $F(x)$ be the distribution functions of y and x respectively. Let also d be a real number with $d \geq 0$; and W_i the intervals of the real axis \mathbf{R} where $g(x) \geq d$ (Figure 1.30). Therefore,

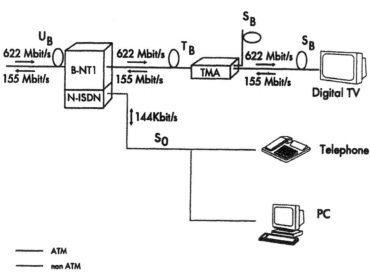

Residential 1

U_B
622 Mbit/s
155 Mbit/s
B-NT1
N-ISDN

622 Mbit/s
155 Mbit/s
T_B

TMA

S_B

S_B
622 Mbit/s
155 Mbit/s
Digital TV

144Kbit/s
S_0
Telephone

PC

—— ATM
- - - non ATM
TMA Terminal Medium Adapter

Figure 1.29: Home user (BBA experiment ©).

$S = \bigcup_i W_i = \{x : g(x) \geq 0\}$. Taking the first moment of $g(x)$, the Stieltjes integral allows writing

$$
\begin{aligned}
E[g(x)] &= \int_{\mathbf{R}} y\,dG(y) & (1.2)\\
&= \int_{\mathbf{R}} g(x)dF(x) & (1.3)\\
&\geq \int_{S} g(x)dF(x) & (1.4)\\
&\geq d\int_{S} dF(x) & (1.5)\\
& & (1.6)
\end{aligned}
$$

where $E[\]$ represents the mathematical expectation. Reminding that

$$
\int_{S} dF(x) = Pr[g(x) \geq d] \tag{1.7}
$$

the Bienaymé-Tchebychev inequality is directly derived as

$$Pr[g(x) \geq d] \leq \frac{E[g(x)]}{d} \qquad (1.8)$$

This inequality stands for a fundamental result of probability and finds numerous applications, for instance to derive the Chernov bound presented latter in this chapter and to predict the potential existence of gains in the ATM multiplexing. The truthful significance of the inequality stands in the fact that it holds in whole generality for any $g(x) \geq 0$.

Figure 1.30: Application of Bienaymé-Tchebychev inequality.

1.10.1.2 Characteristic Functions

The *characteristic function* of a random variable x with PDF $f(x)$ is by definition the integral

$$\Phi(\omega) = E[e^{j\omega x}] = \int_{-\infty}^{+\infty} f(x)e^{j\omega x}dx \qquad (1.9)$$

As $\Phi(-\omega)$ is the Fourier transform of $f(x)$, the properties of the characteristic functions are essentially the same as those demonstrated for the Fourier transform. Since $f(x) \geq 0$, $|\Phi(\omega)| \leq \Phi(0) = 1$. Clearly, we see that if

$$y = ax + b \qquad \text{then} \qquad \Phi_y(\omega) = e^{jb\omega}\Phi_x(a\omega) \qquad (1.10)$$

An important theorem is the moment theorem obtained by differentiating $\Phi(\omega)$ n times to obtain at the origin

$$\Phi^{(n)}(0) = j^n E\{x^n\} \qquad (1.11)$$

As a matter of fact, expanding $\Phi(\omega)$ into a series near the origin, the moment decomposition follows

$$\Phi(\omega) = \sum_{n=0}^{\infty} (j\omega)^n \frac{E\{x^n\}}{n!} \qquad (1.12)$$

The decomposition is valid if and only if all the moments of X are finite and if the series converges absolutely near the origin. Levy (1925) demonstrated that the inverse formula is nothing else that the inverse Fourier transform and, as a straightforward consequence, deduced that the characteristic function defines uniquely the distribution of X.

The moment-generating function of the random variable x is defined as

$$\Phi(s) = E[e^{sx}] = \int_{-\infty}^{+\infty} f(x)e^{sx}dx \tag{1.13}$$

This function plays an important role which will be examined in the sequel.

1.10.1.3 Stochastic Convergence Theorems

The object of this paragraph is to define the different convergence modes of random variable sequences $\{X_i; i \in \mathbf{R}\}$ towards a random variable X. Four types of convergence will be successively defined in this section to clearly understand the meaning and the actual position of the convergence in distribution to be met several times in this textbook.

Convergence in Probability

Let the event $A_n(\epsilon)$ be defined as $A_n(\epsilon) : \{\omega : |X_n(\omega) - X(\omega)| > \epsilon\}$ with $\epsilon > 0$. X_n converges in probability to X according to what follows

$$X_n \xrightarrow{i.p.} X \quad \text{if} \quad \lim_{n \to \infty} P\{A_n(\epsilon)\} = 0 \tag{1.14}$$

Similarities between the stochastic and the calculus convergences are worth mentioning here, for instance the *convergence in probability* corresponds to the *convergence in measure* of calculus theory and it is to be considered de facto as a weak law of convergence.

Convergence in Mean Square

X_n converges in mean square to X

$$X_n \xrightarrow{m.s.} X \quad \text{if} \quad \lim_{n \to \infty} E\{X_n - X\}^2 = 0 \tag{1.15}$$

It corresponds to the *convergence in norm* of calculus theory; as a matter of fact, $||X|| = E(X)^2$ is a norm in the probability space.

Convergence Almost Surely

X_n converges almost surely to X

$$X_n \xrightarrow{a.s.} X \quad \text{if} \quad \lim_{n \to \infty} E\{X_n - X\}^2 = 0 \tag{1.16}$$

It is referred to as a strong convergence i.e. a convergence with probability, it is equivalent to the *convergence almost everywhere* already defined in calculus theory.

Convergence in Distribution

X_n converges in distribution to X

$$X_n \xrightarrow{\mathcal{D}} X \quad \text{if} \quad \lim_{n \to \infty} F_n(x) = F(x) \tag{1.17}$$

where $F(x)$ and $F_n(x)$ are the distributions of X and X_n respectively. This convergence is the weakest of all the four criteria of convergence defined in this section and the way according to which the four modes of convergence relate to each other is depicted in Figure 1.31. Several applications of the convergence in distribution are found in the statement of important theorems.

Figure 1.31: Convergence theorems.

Convergence of Characteristic Functions

Levy's theorem relates the convergence in distribution with that of the characteristic functions. In fact, assuming that $\Phi_{X_n}(t)$ is the characteristic function of the random variable X_n, that $\lim \Phi_{X_n} = \Phi(\omega)$ and that the real part of $\Phi(\omega)$ is continuous near the origin, Levy theorem states that $\Phi(\omega)$ is a characteristic function and that $X_n \xrightarrow{\mathcal{D}} X$. The study of the convergence in distribution of a random variable is governed by that of convergence of the related characteristic functions.

1.10.1.4 Revisiting the Moment-Generating Functions

The moment-generating functions have been defined for continuous random variables of PDF $f(x, t)$. Similar expression holds for discrete random variable. Clearly, the moment-generating functions allow deriving moments, these are for the k^{th} moment of x $E[x^k]$ i.e., for continuous variables, $\int_{-\infty}^{+\infty} x^k f(x, t) dx$ and, for discrete variables, $\sum_i x_i^k Pr[x = x_i, t]$. The *joint moment* $E[x^k y^m]$ of two continuous random variables x and y being defined as

$$E[x^k y^m] = \int\int_{-\infty}^{+\infty} x^k y^m f_{x,y}(x, y; t, s) dx dy \tag{1.18}$$

where $f_{x,y}$ is the joint PDF of x and y and $n = k + m$ is the order of the moment.

In *the continuous realm*, differentiating the moment-generating function enables extracting the moments as

$$\Phi^{(n)}(s) = E[x^n e^{sx}] \tag{1.19}$$
$$\Phi^{(n)}(0) = E[x^n] \tag{1.20}$$

this justifies the appellation of *moment-generating function*. Moreover, denoting $\Phi(s_1, s_2) = E[x^n e^{s_1 x + s_2 y}]$ the moment-generating function of x and y, the moment theorem provides the following result

$$\frac{\partial^k \partial^r}{\partial s_1^k \partial s_2^r} \Phi(0,0) = E[x^k y^r] \tag{1.21}$$

obtained by expanding $\Phi(s_1, s_2)$ and using the linearity of expected values.

In *the discrete realm*, let p_n be the probability that the system be in state n with $n : 0 \to \infty$, the z-transform $G(x)$ is given by

$$G(x) = \sum_{n=0}^{\infty} p_n z^n \tag{1.22}$$

The basic properties of the moment-generating function may be summarized as follows

$$G(1) = \sum_{n=0}^{\infty} p_n = 1 \tag{1.23}$$

$$\frac{dG(z)}{dz}\Big|_{z=1} = \sum_{n=0}^{\infty} n p_n = E(n) \tag{1.24}$$

$$\frac{d^2 G(z)}{dz^2}\Big|_{z=1} = E(n^2) - E(n) \tag{1.25}$$

$$\sum_{n=1}^{\infty} p_{n-1} z^n = z G(z) \tag{1.26}$$

$$\sum_{n=0}^{\infty} p_{n+1} z^n = z^{-1}[G(z) - p_0] \tag{1.27}$$

These properties are rather readily verified and indicate why the function $G(z)$ is called the moment-generating function. They will used also in matrix notation. More generally, when dealing with multivariate functions, the cross moments are derived by the corresponding cross derivations (Appendix 3.A of Chapter 3). An important theorem concerns the sum of independent discrete-time random variables $y = \sum_{i=1}^{n} x_i$ for which the moment-generating is obtained by the product of the individual moment-generating functions as

$$G_y = \prod_{i=1}^{n} G_{x_i}(z) \tag{1.28}$$

All these properties will be exploited in the coming chapters.

1.10.2 Bernoulli Process

The *binomial variable* is the discrete-time variable defined by

$$P(X = i) = \binom{n}{i} p^i (1 - p)^{n-i} \tag{1.29}$$

This elementary variable stems when considering n consecutive slots from the combinatorial analysis of the probability to observe i filled slots with (n-i) empty slots in any order. The slots are filled with a data cell with probability p, others are empty with probability $q = 1 - p$. This defines a *Bernoulli trial* where the observations are considered as being independent trials in an experiment where p and q are constant. Developing $i = 0$ to n spans the whole binomial distribution $B(n, p)$ as

$$
\begin{array}{llll}
P(X = 0) & = & \binom{n}{0} (1 - p)^n & (1.30) \\
P(X = 1) & = & \binom{n}{1} p^1 (1 - p)^{n-1} & (1.31) \\
& & \cdots \cdots & \\
P(X = i) & = & \binom{n}{i} p^i (1 - p)^{n-i} & (1.32) \\
& & \cdots \cdots & \\
P(X = n) & = & \binom{n}{i} p^n & (1.33)
\end{array}
$$

with $\sum_{i=0}^{n} P(X = i) = 1$.

A *Bernoulli process* is an infinite sequence of experiments with two possible outcomes of fixed probability. In this case, the inter-arrival time process has a geometric density function (meaning both independence and memoryless) expressed with p the probability of observing a cell and $q = 1 - p$ the probability of no arrival

$$Pr[x = k] = q^k p \qquad m = \frac{q}{p} \qquad \sigma^2 = \frac{q}{p^2} \qquad \mu_3 = \frac{q}{p^3} \tag{1.34}$$

where $Pr[x = k]$ is the probability of observing k consecutive empty slots followed by one cell, m is the mean, σ^2 the variance and μ_3 the third order moment. The counting process is given by the probability $Pr[n, k]$ of observing k cells into n time slots

$$Pr[n, k] = \binom{n}{k} p^k q^{n-k} \qquad m = np \qquad \sigma^2 = np(1 - p) \qquad \mu_3 = np(1 - p)(1 - 2p) \tag{1.35}$$

Besides the Bernoulli process, the Poisson process and other families of processes enable modeling the cell traffics. Before deriving the important asymptotic relationships linking Bernoulli, Poisson and Gaussian processes, the presentation keeps on defining the two other processes.

1.10.3 Poisson Process

A *Poisson random variable* with parameter λ is a discrete-time variable which takes

$$Pr[x = i] = e^{\lambda \Delta t} \frac{(\lambda \Delta t)^i}{i!} \tag{1.36}$$

to signify the probability to observe i arrivals in the interval Δt. λ is the arrival rate expressed in a number of events per unit of time. The moment-generating function is given by $\Phi(\omega) = e^{-\lambda(1-e^{\omega})}$; therefore,

$$E\{x\} = \lambda \quad E\{x^2\} = \lambda^2 + \lambda \quad \sigma^2 = \lambda \tag{1.37}$$

A Poisson process $x(t)$ is a continuous-time process characterized by a Poisson random variable with parameter $\lambda \Delta t$ and, using the arrival points t_i, the stochastic process is defined as a counting process

$$x(t) \;=\; n[0, \Delta t] \qquad Pr[k, \Delta t] \;=\; e^{\lambda \Delta t}\frac{(\lambda \Delta t)^k}{k!} \tag{1.38}$$

where Δt is the counting time interval. $Pr[k, \Delta t]$ represents the probability to observe k arrivals within the time interval Δt. This is a discrete-state process taking forms of staircase functions when drawing $x(t)$ in terms of δt.

The inter-arrival time version of the Poisson process is given by the negative exponential PDF expressing the memoryless property

$$f(t) \;=\; \lambda e^{-\lambda t} \tag{1.39}$$

of which the two firsts moment are given by the moment generating function $\Phi(\omega) = \frac{\omega}{\lambda-\omega}$

$$E\{x\} = \frac{1}{\lambda} \quad E\{x^2\} = \frac{2}{\lambda^2} \quad \sigma^2 = \frac{1}{\lambda^2} \tag{1.40}$$

The Poisson process supposes independent inter-arrivals characterized by negative exponential PDF's. If x has a negative exponential density, then the probability $\beta(t)dt$ that the event occurs in the interval $(t,\ t + dt)$, assuming that it did not occur prior to t, is independent of t. The past has no effect on the statistics of the future. Restated in other words, the process is *memoryless* or, equivalently, generated at *constant birth rate* $\beta(t) = f(t|x \geq t) = c$. Three properties are mutually equivalent, namely the negative exponential PDF, the memoryless and the constant birth rate. This leads to the remarkable memoryless triangle displayed in Figure 1.32.

Figure 1.32: The memoryless triangle.

1.10.4 The Gaussian Process

The Gaussian or normal PDF was defined in 1778 by Laplace who was studying observation errors in astronomy. The continuous-time PDF is given by

$$f(x) = \frac{1}{\sqrt{2\pi}\sigma} e^{-\frac{1}{2}(\frac{x-m}{\sigma})^2} \tag{1.41}$$

One verifies easily that the parameters m and σ^2 stand for mean and variance. To deduce the characteristic function of a normal random variable with mean m and variance σ^2 denoted $[N(m, \sigma)]$, it is worth reminding that

$$\frac{1}{\sigma\sqrt{2\pi}} \int_{-\infty}^{+\infty} e^{\frac{-x^2}{2\sigma^2}} e^{j\omega x} \, dx = e^{\frac{-\sigma^2\omega^2}{2}} \tag{1.42}$$

therefore, the moment generating function for a normal random variable of mean m and variance σ^2 is expressed as

$$\Phi(\omega) = e^{jm\omega} e^{\frac{-\sigma^2\omega^2}{2}} \tag{1.43}$$

Therefore, expanding into series, the odd moments are all equal to zero

$$\mu_{2k+1} = E[x^{2k+1}] \qquad k > 0 \tag{1.44}$$

and the even moments have the form of

$$\mu_{2k} = E[x^{2k}] = \frac{(2k)!}{2^k k!} \sigma^{2k} \qquad k > 0 \tag{1.45}$$

As demonstrated in the following, the normal PDF plays an important asymptotic role known as the central limit of other PDF's obtained when summing independent and identically distributed variable. Finally, a process $x(t)$ is called normal if the random variables $x(t_1)$, $x(t_2)$,, $x(t_n)$ are jointly normal for $\forall n$ and $t_1,...., t_n$.

1.10.5 The Asymptotic Theorems

The *asymptotic theorems* present a great interest not only in the theory of probability but also in traffic theory for ATM transmissions. They relate the three previous stochastic processes to each other. As a major point of theory, they lay down the basic foundations to model variable traffics and to justify the gain to be expected when multiplexing variable cell rate sources. Enlargements to more intricated stochastic arrival processes will be nevertheless necessary to take into account general traffic behaviors with serially correlated arrivals.

1.10.5.1 Law of Large Numbers

The *law of large numbers* is founded on several theorems. Among them, *Kintchine theorem* will be demonstrated in this section. Let again $\{X_i; \; i = 1 \text{ to } n\}$ be independent and identically distributed random variables such that $E\{X_i\} = m < +\infty$. Kintchine theorem states that the random variable S_n converges in distribution to the mean m, therefore,

$$S_n = \frac{X_1 + X_2 + \ldots + X_n}{n} \xrightarrow{D} m \tag{1.46}$$

Indeed, owing to the independence hypothesis, the characteristic function factorizes into

$$\Phi_{S_n}(\omega) = [\Phi(\omega)]^n \tag{1.47}$$

where $\Phi(\omega)$ is the characteristic function of a random variable X_i. The moments of S_n are given by

$$\Phi_{S_n}(\omega) = \left[1 + \frac{j\omega m}{n} + \mathcal{O}(\frac{\omega}{n})\right]^n \tag{1.48}$$

and,

$$\lim_{n \to \infty} \Phi_{S_n}(\omega) = e^{j\omega m} \tag{1.49}$$

where $e^{j\omega m}$ is nothing else that the characteristic function of the random variable X such that $P[X = m] = 1$. Therefore,

$$S_n \xrightarrow{D} m \tag{1.50}$$

and thus,

$$S_n \xrightarrow{D} m \quad \longleftrightarrow \quad Pr[|S_n - m| \geq \epsilon] \leq \delta \quad \text{for all} \quad n \geq n_0 \tag{1.51}$$

Hence, as a noticeable fact, the convergence in distribution demonstrated in a first stage implies, in this particular case, a convergence in probability which is a stronger law of convergence.

The law of large numbers applies directly in the field of broad-band communications supporting stochastic variable sources to explain that the aggregated traffics generated by a large number of different services will inevitably converge in probability to the resulting mean value. This phenomenon is observed from the effect of averaging out the aggregated traffic resulting in the concentration of the global PDF around the mean. Restated in other words, the aggregation of a large number of variable sources will diminish the global probability to observe occurrences of aggregated bit rates that exceed given thresholds or given shifts away from the mean. This is clearly the positive effect actually anticipated when deploying the ATM B-ISDN.

To proceed one step further in cogent arguments in favor of deploying the ATM B-ISDN, it turns out that a squeeze effect on the PDF's has to be effectively expected when aggregating variable traffics as it will be evidenced in the following by a direct application of Bienamé-Tchebychev inequality.

1.10.5.2 Variance Concentration

Bienaymé-Tchebychev inequality applies in broad-band traffics to provide the bit rate PDF's resulting from an aggregation with an upper bound on the value of the probability that a bit rate be outside a given threshold s. The inequality measures the concentration of the bit rate near its mean. To demonstrate that the bit rate PDF squeezes around the mean when multiplexing, let $Y = G(X) = [S_n - E(S_n)]^2$. Let Y be a random variable expressing the square deviation of S_n around its mean value. As a matter of fact, the mean of Y is given as

$$
\begin{aligned}
E(Y) &= E(S_n^2) - E(S_n)^2 & (1.52) \\
&= V(S_n) & (1.53) \\
&= \frac{V(X_i)}{n} & (1.54)
\end{aligned}
$$

It follows by applying the inequality to Y that

$$
Pr[Y \geq s] \leq \frac{V[X_i]}{ns} \tag{1.55}
$$

This demonstrates that the PDF of the sum of n independent and identically distributed random variables rescaled by a factor \sqrt{n} will squeeze around the mean as n increases. This simple demonstration supports the main idea that one of the major advantage offered by the ATM B-ISDN networks is to offer, as ciphered in Chapter 5, a gain of transmission bandwidth when statistically multiplexing variable bit rate TV sources. Restated in other words, when multiplexing a very large number of variable sources (and realistic previsions for the next century foresee to multiplex more than 300 different TV sources at the international levels), the bandwidth required to support all the services will converge to the sum of the individual mean bit rate with an ATM technology instead of requiring the sum of the individual peak bit rate with a STM technology. Let us remark that, for the shake of simplicity, identically distributed sources have been considered. The deduction applies in whole generality. Nevertheless, the variance plays an important role which can be depicted as follows. If the source standard-deviation-to-mean ratio tends to increase, the multiplexing gain decreases to lower performances. This is actually observed in the coding practice since increasing the compression efficiency diminishes the mean bit rate value at the expense of a faster increase of the instantaneous bit rate variability. This explains the necessity of introducing buffer capability in the coders to prevent the variability from inflating and degrading the statistical multiplexing performances. If buffer were of infinite capacity, there would be no need to transmit at variable bit rate to yield a constant-quality coding since the transmission could be constant and equal to the long-term mean. Physical constraints of capacity and delay impose the variability to achieve constant coding quality levels. Optimum consideration leads to buffering as much as possible in the encoder according to the physical constraints to smooth the resulting traffic, increase the multiplexing performances and be as fast as possible close to the asymptotic behavior where it is only required to allocate long-term mean bit rate to reach a constant-quality coding and transmission property.

1.10.5.3 Central Limit Theorem

The normal PDF $N(0,1)$ with characteristic function $\phi_{N(0,1)} = e^{-\frac{t^2}{2}}$ plays a central role in the theory of probability. Let $\{X_i; i : 1 \ to \ \infty\}$ be independent and identically distributed random variables with first moment $E\{X_i\} = m$ and variance $\sigma^2 = E\{(X_i - m)^2\} < \infty$, and, let also \bar{S}_n be the mean of the partial sum of n variable X_i

$$\bar{S}_n = \frac{\sum_{i=1}^{i=n} X_i}{n} \tag{1.56}$$

The central limit theorems study the conditions under which

$$\frac{\bar{S}_n - E[\bar{S}_n]}{\sqrt{E\{(\bar{S}_n - E[\bar{S}_n])^2\}}} \xrightarrow{\mathcal{D}} N(0,1) \tag{1.57}$$

One classical version of the central limit theorem, known as the Lindeberg-Levy theorem, will be demonstrated in the following. It states that

$$\frac{\bar{S}_n - m}{\sigma\sqrt{n}} \xrightarrow{\mathcal{D}} N(0,1) \tag{1.58}$$

This can be demonstrated easily when considering the characteristic functions as

$$\Phi_{\frac{X_i - m}{\sigma\sqrt{n}}}(\omega) = 1 + \frac{j^2}{2}n\omega^2 + \mathcal{O}(n\omega^2) \tag{1.59}$$

Hence, for a sum of n random variables,

$$\Phi_{\frac{S_n - m}{\frac{\sigma}{\sqrt{n}}}}(\omega) = \left\{1 + \frac{j^2}{2}n\omega^2 + \mathcal{O}(\frac{\omega^2}{n})\right\}^n \tag{1.60}$$

and, taking the limit, the convergence in distribution allows writing

$$\lim_{n\to\infty} \Phi_{\frac{S_n - m}{\frac{\sigma}{\sqrt{n}}}}(\omega) = e^{-\frac{\omega^2}{2}} = \Phi_{N(0,1)}(\omega) \tag{1.61}$$

The Demoivre-Laplace theorem is simply a particular case of the Lindeberg-Levy theorem in case of a Bernoulli distribution where

$$\frac{X - np}{\sqrt{np(1-p)}} \xrightarrow{\mathcal{D}} N(0,1) \tag{1.62}$$

under the assumptions that $n \to \infty$, $p \to 0$ and $np \to \infty$. Restated in other words, the convergence means that the counting processes of dense traffics evaluated on finite time interval can be approximated by Gaussian PDF i.e. $\binom{n}{k} p^k q^{n-k} \simeq \frac{1}{\sqrt{2\pi npq}} e^{-\frac{(k-np)^2}{2npq}}$ under the assumption of mutual source independence. Unfortunately, both the hypotheses of independent and identically distributed inter-arrivals and the Gaussian approximation turn out to fail in the case of multiplexing TV sources.

Figure 1.33: The asymptotic theorems.

1.10.5.4 Poisson Theorem

The *Poisson theorem* expresses the convergence of the Bernoulli process to a Poisson process when

$$n \to \infty \qquad p \to 0 \qquad np \to \lambda \qquad\qquad (1.63)$$

$$B(n,p) \xrightarrow{\mathcal{D}} P(\lambda) \qquad\qquad (1.64)$$

Indeed, considering that, at the limit $np \to \lambda$,

$$Pr[n,i] \;=\; \frac{n!}{i!(n-i)!}\, p^i\,(1-p)^{n-i} \qquad\qquad (1.65)$$

$$=\; \frac{\lambda^i}{i!}\left(1-\frac{\lambda}{n}\right)^n \frac{n!}{(n-i)!n^i(1-\frac{\lambda}{n})^i} \qquad\qquad (1.66)$$

moreover,

$$\lim_{n\to\infty} Pr[n,i] \;=\; \lim_{n\to\infty}\left\{\frac{\lambda^i}{i!}(1-\frac{\lambda}{n})^n\right\}\lim_{n\to\infty}\left\{\frac{n!}{(n-i)!\,n^i\,(1-\frac{\lambda}{n})^i}\right\} \qquad (1.67)$$

$$=\; \frac{\lambda^i}{i!}e^{-\lambda}\lim_{n\to\infty}\left\{\frac{(1-\frac{1}{n})(1-\frac{2}{n})\.....(1-\frac{i-1}{n})}{(1-\frac{\lambda}{n})^i}\right\} \qquad (1.68)$$

$$=\; \frac{\lambda^i}{i!}e^{-\lambda} \qquad\qquad (1.69)$$

This theorem is sometimes called the *law of the rare events* referring to the position of the Poisson Process. Indeed, when counting processes are considered, depending on the magnitude of the product np, the Bernoulli process may approach in the limit either the Poisson process or the Gaussian process. Small values of the limiting product np determine

the convergence to a Poisson process with an arrival rate equal to $\lambda = np$ and the quantity np, evaluated on the counting interval, can be interpreted as a window of observation. As a matter of fact, rescaling the time axis, in order to reduce the counting length and to maintain the product np as small as possible, induces rare events and, consequently, a Poisson limiting behavior. On the contrary, a stretch of time axis in the sense to increase the window length and concomitantly the product np involves the observation of a Gaussian process as demonstrated in the following paragraph. The observation of Poisson processes or of Gaussian processes is therefore dependent on the time scale of observation with respect to the occurrence rate of events. These aspects will be examined again in whole depth in Chapter 5.

1.10.5.5 Revisiting Central Limit Theorem

For large values of the product np or when $\lambda \longrightarrow \infty$, we have

$$P(\lambda) \xrightarrow{\mathcal{D}} N(0,1) \tag{1.70}$$

which states the convergence of the Poisson process to the Gaussian process. Once more, it is easily demonstrated by exploiting the characteristic functions i.e. when applied on the Poisson process

$$
\begin{aligned}
\Phi_X(\omega) &= e^{-\lambda\,(1-e^{j\omega})} \tag{1.71}\\
&= e^{-\lambda\,[j\omega - \frac{\omega^2}{2} + \mathcal{O}(\frac{\omega^2}{2})]} \tag{1.72}
\end{aligned}
$$

The normalized process

$$
\begin{aligned}
\Phi_{\frac{X-\lambda}{\sqrt{\lambda}}}(\omega) &= e^{-j\sqrt{\lambda}\omega}\,\Phi_X\!\left(\frac{t}{\sqrt{\lambda}}\right) \tag{1.73}\\
&= e^{-\frac{\omega^2}{2} + \mathcal{O}(\frac{\omega^2}{\omega})} \tag{1.74}
\end{aligned}
$$

therefore,

$$\lim_{\lambda \to \infty} \Phi_{\frac{X-\lambda}{\sqrt{\lambda}}}(\omega) = e^{-\frac{\omega^2}{2}} \tag{1.75}$$

to derive the convergence to a Gaussian process. The three asymptotic theorems are summarized in Figure 1.33.

1.10.6 Modeling the ATM Traffics

The ATM·networks are built to permit the simultaneous transportation of various services, all treated equivalently without any knowledge of the cell content i.e. without being able to discriminate certain cells against others. The only information accessible about the class of service is the priority bit. All the cell passing through a given trunk profit from the same quality of service defined at the call establishment of the transmission. Among

all those services to be carried, bulk data, voice and video sources should contribute as a major fraction of the total traffic. All the sources under study for ATM characterization are inherently variable, asynchronous, stochastic and non-stationary. The traffic models for ATM sources are consequently stochastic arrival processes aiming at accurately characterizing the cell occurrence behavior in terms of either inter-arrival or counting processes. These mathematical models are used to describe single sources as well as for merged traffics. The knowledge of individual source traffic is used to determine the bandwidth to be allocated to each particular source at call establishment and to design adequate policing algorithms to control network congestions. The analysis of merged traffics is conducted from the knowledge of all the individual traffics intervening in the aggregation. Further calculations allow designing and measuring the performances of the ATM multiplexers which have been presented as queueing systems localized at the output ports of switching fabrics. Therefore, traffic models are utmost helpful not only during the network design phase while evaluating the network performances but also at call establishment when computing the bandwidth and determining the virtual circuit (connection-oriented mode only) to be attributed to the transmission of a given service.

To start our traffic analysis, models of individual data, voice and single-scene video sources are described in this section according to the literature in the field and in consistency with measurements performed on hardware implementations of coders. The aspects relevant to TV sources (i.e. multiple-scene moving video sources) are dealt with in Chapter 3 and 5 of this textbook. According to intuition, models for data, voice and, eventually, video sources will exhibit progressive complications due to the intrinsic nature and the correlation structure of the information carried in those services. Effectively, the traffic models derived for digital image sequence video communications will turn out to result from a progressive modeling construction path initiated in this section which starts with computer data and file transmissions. To ease the comprehension of the coming models to be developed, it is worth digressing first to more general families of arrival processes, namely the renewal processes and the point processes, to which any general arrival process belongs.

1.10.7 Renewal Processes

An important class of arrival processes, generalizing the Poisson process, is obtained by a straightforward extension. Suppose that the inter-arrival times are still independently and identically distributed but no more memoryless i.e. with PDF's of any general shape instead of being a negative exponential. If the process is assumed to start from time $t = 0$, then a little care is needed with the initial conditions. If an arrival is known to have occurred at $t = 0$, then we may define an inter-arrival time process in which $\{x_1, x_2, ...\}$ are independently and identically distributed with a density f(x) and call this an *ordinary renewal process*. The *renewal processes* introduce more freedom into modeling cell traffics and turn out to be a slightly more adequate to deal with services conveying real-time-processed digital signals like voice sources which become more complicated to model than simple computer data transfers. Renewal processes generalize Poisson processes in the sense that the coefficient of variation, a parameter defined as the ratio of the standard deviation to the mean and currently equal to one for the Poisson inter-arrival PDF's, may

take any non-negative value with renewal processes. As a matter of fact, coefficients of variation inferior to unity describe inter-arrival time densities relatively less dispersed or qualitatively more regular than those of Poisson process (the coefficient of variation is equal to zero for deterministic and constant rate arrivals) whereas coefficients of variation superior to unity qualify more irregular or clustered inter-arrival processes.

An illustration of inter-arrival time distribution is the well-known *Gamma PDF* defined as

$$f(x) = \frac{\rho(\rho x)^{\alpha-1}e^{-\rho x}}{\Gamma(\alpha)} \tag{1.76}$$

where $\Gamma(x)$ is the *Gamma function* defined as $\Gamma(x) = \int_0^\infty y^{b-1}e^{-y}dy$. The PDF 1.34 is function of two parameters α and ρ. The inter-arrival process is characterized by a mean, a variance and a coefficient of variation respectively equal to $\frac{\alpha}{\rho}$, $\frac{\sqrt{\alpha}}{\rho}$, $\frac{1}{\sqrt{\alpha}}$. If $\alpha = 1$, the PDF is exponential. Provided that $\alpha > 1$ the PDF is zero at the origin and has one single maximum at $x = \frac{\alpha-1}{\rho}$. If α and $\rho \to +\infty$, assuming that $\frac{\alpha}{\rho} \to \mu$, the PDF of the normalized variable $\frac{X-\mu}{\frac{\mu}{\sqrt{\alpha}}}$ converges towards a normal $N(0,1)$. For many problems of renewal theory, a substantial advantage is gained by using integer values of α, in this case $\Gamma(\alpha) = (\alpha - 1)!$ and deriving the Erlang distribution which is still analytically tractable with Laplace transform and allows formal calculi up to the queueing analysis.

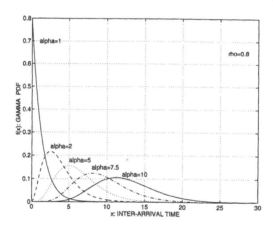

Figure 1.34: Different versions of the Gamma PDF.

1.10.8 Point Processes

While suitable choices of the density g enable the renewal processes to model a wide range of qualitative arrival behaviors, these processes remain very special due to the strong requirement that consecutive inter-arrivals be mutually independent. As a consequence, another family of arrival processes, generalizing the renewal processes, has been derived when relaxing the constraint of independent inter-arrival and allowing serial correlations. The point process removes the two restrictive assumptions inherent in the Poisson processes to consider arrival processes with general inter-arrival time distributions and serial

Chapter 1. Introduction to ATM Networks

correlations. The past research in that field has been driven mainly by physics which have identified different classes of point processes, namely the doubly stochastic Poisson processes, the compound Poisson processes, the filtered Poisson processes, the self-exciting point processes and the marked point processes. Among them, two classes will be exploited in this textbook. These are the Doubly Stochastic Poisson Process (DSPP), sometimes referred to in the literature as the non-homogeneous Poisson process, and the compound Poisson processes. The DSPP is defined as a Poisson process where the rate λ is itself a realization of a continuous-time stochastic process $\Lambda(t)$ suited for modeling a source of information. One interesting subclass of DSPP's is formed by the Markov Modulated Poisson Processes (MMPP) where the source of information is summarized in a Markov chain. A MMPP(m) is therefore a Poisson process where the rate of arrival $\lambda(t)$ varies according to a continuous-time and irreductible Markov chain defined on m states. The compound Poisson process is composed of a cascade of two arrival rates λ_1 and λ_2 in such a way that the first rate λ_1 defines the arrivals of windows or patterns (the bursts) during which the events are generated according to the second arrival rate λ_2.

The scope and the motivation to construct doubly stochastic point processes are clearly broaden. Let us consider the continuous-time and stationary Poisson process with rate $\lambda(t)$, mean m, variance σ^2 and autocorrelation function $\rho(\tau)$. The counting process $N[0, t]$, defined on the interval $[0, t]$, will be stationary with mean and variance deduced as follows

$$E\left\{N[0, t] | \lambda(u), 0 \leq u \leq t\right\} = \int_{u=0}^{t} \lambda(u) du \tag{1.77}$$

and

$$\begin{aligned} E\left\{N[0, t]\right\} &= E_{\Lambda(t)}\left\{E[N(0, t) | \lambda(u), 0 \leq u \leq t]\right\} & (1.78) \\ &= E_{\Lambda(t)}\left\{\int_{u=0}^{t} \lambda(u) du\right\} & (1.79) \\ &= mt & (1.80) \end{aligned}$$

The variance $V(t)$ is given by

$$V(t) = mt + 2\sigma^2 \int_{u=0}^{t} (t - u)\rho(u) du \tag{1.81}$$

and demonstrated in the following related to an important formula providing the index of dispersion for counting processes. This latter result will be used in Chapter 5. The index of dispersion for counts $I(t)$ is the ratio of the variance to the mean and is equal to unity for Poisson processes. That is

$$I(t) = \frac{V(t)}{M(t)} \tag{1.82}$$

The demonstration will utilize differential processes defined as $\{\Delta N(t)\}$ where $\Delta N(t)$ represents the number of arrival in the interval $(t, t + \Delta t)$. Multiple or batch arrivals are

excluded in this reasoning. The mean, the covariance and the covariance density of the differential process will be first calculated in the demonstration. Taking the expectations with respect to $\Lambda(t)$, the variance $V(t)$ and the index of dispersion $I(t)$ are thereafter deduced from the calculations.

The mean and the covariance of the differential process $\Delta N(t)$ are given respectively by

$$E[\Delta N(t)] = m\Delta t + \mathcal{O}(\Delta t) \tag{1.83}$$

and, for $\tau > 0$,

$$
\begin{aligned}
E[\Delta N(t)\Delta n(t+\tau)] &= Pr[\Delta N(t) = \Delta N(t+\tau) = 1] + \mathcal{O}(\Delta t)^2 \tag{1.84}\\
&= Pr[\Delta N(t) = 1]Pr[\Delta N(t+\tau) = 1|\delta N(t) = 1] + \mathcal{O}(\Delta t)^2
\end{aligned}
$$

The covariance density of the differential process may be defined as

$$\gamma(\tau) = \lim_{\Delta t \to 0} \frac{cov[\Delta N(t)\Delta N(t+\tau)]}{(\delta t)^2} = \lambda(t)\lambda(t+\tau) \tag{1.85}$$

Therefore, going back to the original arrival process, for a given realization $\{\lambda(t)\}$, we have that

$$\lim_{\Delta t \to 0} \frac{E[\Delta N(t)\Delta N(t+\tau)]}{(\delta t)^2} = \lambda(t)\lambda(t+\tau) \tag{1.86}$$

Taking expectation with respect to $\Lambda(t)$ and using $\rho(\tau) = \frac{cov[\lambda(t)\lambda(t+\tau)]}{V(t)}$, it follows from the definition 1.85 that

$$\gamma(\tau) = \sigma^2\rho(\tau) \tag{1.87}$$

Furthermore, let us denote $C_i(\tau)$ the covariance between the counts of two intervals of length τ and separated by $i-1$ similar intervals, then

$$
\begin{aligned}
V(k\tau) &= kV(\tau) + 2\sum_{i=1}^{k-1}\sum_{j=1}^{i}C_j(\tau) \tag{1.88}\\
&= kV(\tau) + 2\sum_{i=1}^{k-1}(k-i)C_j(\tau) \tag{1.89}
\end{aligned}
$$

if we let $k\tau$ equal to t and divide t into k identical intervals of length τ, then

$$V(t) = \frac{tV(\tau)}{\tau} + 2\sum_{i=1}^{k-1}(k-i)C_j(\tau) \tag{1.90}$$

By the definition of the integral, let us $k \to \infty$ to get

$$V(t) = mt + 2 \int_0^t (t-u)\gamma(u)du \tag{1.91}$$

It follows readily from 1.87 that

$$V(t) = mt + 2\sigma^2 \int_0^t (t-u)\rho(u)du \tag{1.92}$$

and that the index of dispersion is expressed as

$$I(t) = 1 + \frac{2\sigma^2}{mt} \int_0^t (t-u)\rho(u)du \tag{1.93}$$

Taking the limit when $t \to \infty$,

$$I(\infty) = 1 + \frac{2\sigma^2}{m} \int_0^\infty \rho(u)du \tag{1.94}$$

Therefore, the index of dispersion shows if the process exhibits over or under-dispersion relative to the ordinary Poisson process. To be convinced, let us define the time constant for the covariance integral of the arrival process as being

$$\tau_c = \int_0^\infty \rho(u)du \tag{1.95}$$

The time constant takes its complete meaning when going to an exponential covariance function approximation i.e. when

$$\rho_e(t) = e^{\frac{-t}{\tau_c}} \tag{1.96}$$

where the time constant expresses the temporal extent over which the covariance matters i.e. $\simeq 5 \times \tau_c$.

$$I(\infty) = 1 + \frac{2\sigma^2}{m} \tau_c \tag{1.97}$$

Thus for a given time constant, the asymptotic variability of the counts is directly related to the variability of the arrival rate. Moreover, at given arrival rate variability, longer time constants imply more variability of the counts.

Figure 1.35 summarizes most of the important families of stochastic processes which are potential candidates to model traffic with either counting or inter-arrival representations. The most frequent traffic models used in the ATM literature are grouped around two academic schools and can be classified as the discrete-time processes and as the continuous-time processes. Obviously, discrete-time processes are closer to the technical realm where the switching and the multiplexing procedures remain slotted and thereby discretized at the cell periods. Continuous-time process are to some extend easier to handle formally. The former discrete-time class uses, for instance, the Bernoulli process, the slotted 'on-off' Markov process, the interrupted Bernoulli process, the Markov modulated Bernoulli process (Figure 1.36). The latter continuous-time class exploits models like the Poisson process, the interrupted Poisson process, the alternating renewal process, the Markov modulated Poisson process and the N process. Both enumerations aim not at being exhaustive, more advanced details are provided in the next sections and chapters.

1.10. Traffic Models

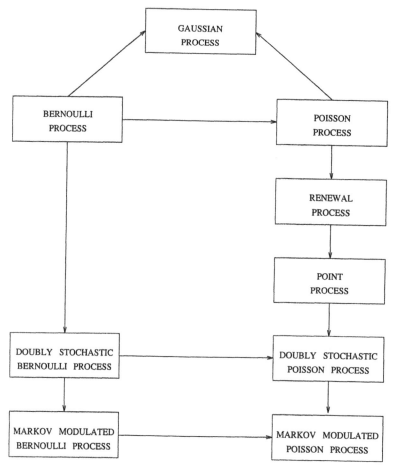

Figure 1.35: Stochastic processes for traffic models.

1.10.8.1 Traffic Models for Computer Data Sources

The generation of data from individual computer sources has been characterized in the early research stages by either Poisson processes or Bernoulli processes. Unfortunately, the arrival rate depends strongly on the application to be considered and may present various configurations which range from very short and widely spaced bursts (sporadic data transfers) to large amounts of data (bulk data transfers) diverted into the network when large computer files are transmitted.

As mentioned previously, other networks can also be connected to ATM nodes like LAN's and MAN's in local exchanges. In LAN's, packets are much larger than ATM cells and will obviously generate bursts of ATM cells when the content of LAN packets will be dumped into the ATM channel. From MAN's, the information to enter in the ATM switch is also likely to arrive by large groups of cells. These events, randomly distributed, generate bursts or multiple-cell generations. Models like ON/OFF Markov process and interrupted Poisson or Bernoulli processes can be taken into consideration to describe such

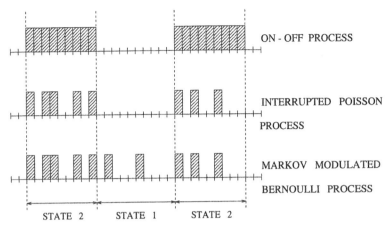

Figure 1.36: Discrete-time traffic models.

successions of bursts and silences. These models will be revisited in the next section since they are also highly representative of voice sources. Three discrete-time models reflecting the slotted nature of fixed length cells are presented in Figure 1.36 as generalizations of each other, namely the slotted ON/OFF Markov process, the Interrupted Bernoulli process and the Markov Modulated Bernoulli process.

1.10.8.2 Traffic Models for Voice Sources

The voice sources are characterized by talk spurts interrupted by silent periods. Consequently, the cell arrivals turn out to be characterized by two states, namely the ON and the OFF periods. This defines an interrupted Poisson process where

1. the ON period characterizes an active state where cells are generated according to a Poisson process with rate λ and corresponds to the talk spurts.

2. the OFF period is a silent state where no cells are generated and corresponds to the silence duration.

Let us further suppose that the transitions between ON and OFF periods occur with probability β and the transition from OFF and ON periods with probability α. This leads to a two state Markov chain with respective mean sojourn times equal to $\frac{1}{\beta}$ and to $\frac{1}{\alpha}$. Let us remark that this process is nothing else that a particular case of a two state Markov modulated Poisson process. To specify an example of voice traffic model, the period of packetization is equal to $T = 12$ ms at 32kbit/s in an ADPCM [3] coder. The cells are supposed to contain information fields of 48 data bytes. The silence periods are exponentially distributed with mean $\alpha^{-1} \simeq 650ms$ and the cell burst have mean durations of $\beta^{-1} \simeq 350ms$. The average number of ATM cells generated is $E(N) = 29$. Due to the lack of memory property involved by the geometric distribution, the cell stream associated to a single-voice source is a renewal process. The cell inter-arrival density is presented in Figure 1.37 and the distribution function is expressed as

[3] ADPCM means Adaptive Differential Pulse Modulated

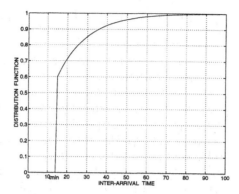

Figure 1.37: Inter-arrival distribution function of single-voice sources.

$$F(t) = [(1 - \alpha T) + \alpha T(1 - e^{\beta(t-T)})]U(t - T) \tag{1.98}$$

where $U(t)$ is the unit step function. The mean cell arrival rate is therefore equal to $\lambda = -\frac{1}{T + \frac{\alpha T}{\beta}}$. Although renewal, the process is very bursty as it is reflected by the index of dispersion equal to about 18. Merging several voice traffics together leads surprisingly and unavoidably to producing a point process (as presented in Chapter 5) i.e. a process with correlated inter-arrivals.

Let us consider N independent voice sources to be aggregated before multiplexing. If they are represented by continuous-time arrival processes, then the final cell arrival process is a birth-death process as a result of the superposition of N independent interrupted Poisson process. The birth rate is equal to $\lambda(n) = (N - n)\alpha$ and the death rate to $\mu(n) = n\beta$ for $\forall n : 0 \leq n \leq N$. The probability that n out of N sources be in the ON state $Pr[i_{ON} = n]$ is given by the binomial distribution

$$Pr[i_{ON} = n] = \binom{N}{n} P_{ON}^n P_{OFF}^{N-n} \qquad 0 \leq n \leq N \tag{1.99}$$

where $P_{ON} = \frac{\alpha}{\alpha+\beta}$ is the probability for one source to be in the ON state and $P_{OFF} = \frac{\beta}{\alpha+\beta}$ the corresponding OFF state probability. A similar study could have been also conducted by using the discrete-time versions and Bernoulli processes. In this case, the probability that n out of N sources be in the ON state would have been given by the same formula 1.99.

1.10.8.3 Traffic Models for Video Sources

The models for video traffic open new paths towards generalizations. For intricated reasons, video coders introduce not only short term correlations in between consecutive inter-arrivals but also additional statistical structures on several time scales. This latter observation is explained by the fact that video sources are structured through different time scales. When described top down, the structure is composed of variable length image sequences (due to studio edition), of images (as formatted by standards for transmissions), of groups of pixel lines (by digital encoders). Silent periods are not usually expected to occur in this type of source, but rather, large variations of instantaneous cell rates are susceptible to be generated. Therefore, the thrust towards generalization is forced in two directions

1. increasing the number of Markov states to take into account the variety of possible cell rates.

2. considering different time scales of observation since the process behaves differently according to the level of resolution under study.

The models presented in the literature for video sources have mainly dealt with single-scene video sources. In Chapter 3, this textbook will tackle the problem of modeling multiple sequence video sources. According to the literature on the field, single-sequence video source traffics are suitably modeled with either continuous-state autoregressive (AR) Markov models or discrete-state continuous-time Markov models. The first is tractable for computer simulation whereas the second fits for queueing analysis. Both model analyses are presented in the following.

Continuous-State AR Markov Models

Let $\lambda(n)$ be the average cell rate of the n^{th} image, it can be predicted by the preceding values observed during the N past frames and leads to an AR model of order N

$$\lambda(n) = \sum_{i=1}^{N} a(i)\lambda(n-i) + bw(n) \tag{1.100}$$

where w(n) is a Gaussian random process, and $\{a(i); \; i = 1, .., N; b\}$ are the AR model coefficients. It has been reported in [50] to use the order N=1 which provides a reasonable match to the experimental data and that a single exponential mode of decay in the autocovariance function suffices quite perfectly. Therefore, assuming $|a(n)| < 1$ and normalizing the Gaussian random process w(n) to a mean m and a unitary variance $N(m, 1)$, the coefficients $a(1) < 1$ and b can be expressed in terms of the expected value $E[\lambda]$ and the discrete autocovariance $C(n)$ as

$$E[\lambda] = \frac{b}{1 - a(1)}m, \quad C(n) = \frac{b^2}{1 - a^2(1)}a^n(1), \quad n \geq 0 \tag{1.101}$$

The PDF of $\lambda(n)$ is a normal $N[E(\lambda), C(0)]$. From experimental fit in [50], the expected value $E[\lambda] = 0.52$ bits/pixel and the discrete autocovariance $C(n) = 0.054(e^{-0.13})^n$ (bits/pixel)2 leading to model parameters equal to $a(1) \simeq 0.87$ and $b \simeq 0.11$.

Discrete-State, Continuous-Time Markov Process

This model approximates the actual cell rate $\lambda(t)$ with a continuous-time process $\bar{\lambda}(t)$ with discrete jumps occurring at random Poisson instants. The process is obtained from the continuous bit rate by sampling at random Poisson time instances to determine the state changes and by imposing one discrete state with rate λ_n during the inter-change period (Figure 1.39). The range of bit rate variation is discretized into $n = 1, .., N$ different states. The resolution of this model is gradually tunable at will by means of either increasing or decreasing the amount of states N and, simultaneously, increasing or decreasing the rate of the state transitions. The experiment has shown, in whole conformity with intuition

that, inside a scene, only small discontinuities can be observed. This enables one to reduce all the combinatorial state transitions of a Markov model to the limited state transitions of a birth-death process, where only transitions between neighboring states are admitted, as it is depicted in Figure 1.38. The birth-death process is described in [48] with details. In the subsequent state representation, the range of bit rates is uniformly discretized into N possible levels $\bar{\lambda}(t) = 0, A, 2A,, (N-1)A$. Let the exponential transition rates from state i to state j be denoted as $r_{i,j}$ and be expressed as

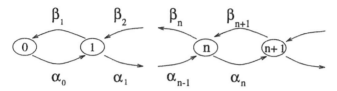

Figure 1.38: State transitions in birth-death processes.

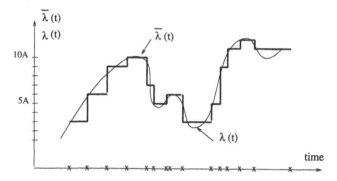

Figure 1.39: Poisson sampling and discretization of the source rate.

$$r_{i,j} = (M-i)\alpha \ \ i < M, \quad r_{i,j} = i\beta \ \ i > 0, \quad r_{i,i} = 0, \quad r_{i,j} = 0 \ \ |i-j| > 1 \quad (1.102)$$

Furthermore, the state probability $Pr[\bar{\lambda}_n(t) = kA]$ has a binomial distribution. Therefore,

$$Pr[\bar{\lambda}_n(t) = kA] = \binom{N}{k}p^k(1-p)^{N-k} \quad \text{with} \quad p = \frac{\alpha}{\alpha+\beta} \quad (1.103)$$

The expected value $E[\bar{\lambda}_n]$, the variance $\bar{C}_n(0)$ and the autocovariance $\bar{C}_n(\tau)$ are given by

$$
\begin{aligned}
E[\bar{\lambda}_n] &= NAp & (1.104) \\
\bar{C}_n(0) &= NA^2 \, p(1-p) & (1.105) \\
\bar{C}_n(\tau) &= \bar{C}_n(0) \, e^{-(\alpha+\beta)\tau} & (1.106)
\end{aligned}
$$

The birth-death process can be decomposed in turn into the superposition of N ON-OFF/burst-silence components, all identical mini-sources with each an intensity of $\bar{\lambda} = A$.

This stands as an inverse aggregation problem, also referred to as the traffic decomposition, leading to find one or several elementary sources to serve as a reference basis to describe all the ATM traffics (computer data, voice and video); this is the ON/OFF Bernoulli or Poisson process. The concept of mini-sources seems to be an attractive modeling approach, especially for the purpose of statistically multiplexing any kind of ATM traffic, the aggregated traffic can be considered as taking values of arrival rate in a set made of a number of combinations of predefined component mini-sources.

1.11 Traffic Descriptors

The traffic descriptors of any new connection are the statistical parameters which describe the source traffic. They are provided by the source requesting a connection to enable the network traffic management to determine the bandwidth to be allocated. These descriptors are essential in variable bit rate transmissions to lead to an accurate evaluation of the bandwidth to be assigned especially along a virtual path. As a consequence, the traffic descriptors are also critical data which play a major role in processing the call acceptance control and the traffic enforcement algorithms.

Most of the current literature discuss the sets of parameters to be declared by the source. They can be summarized by three main descriptors, namely the mean bit rate, the peak bit rate and the burstiness. Two fundamental problems remaining unsolved for the TV transmissions are the time scale over which to evaluate those parameters and the accurate way to define the burstiness.

The burstiness of the traffic plays a key part in the evaluation of the queueing performances since rapid degradations of the cell loss rate can be demonstrated when the cell arrival diverges from the classical Poisson process when short and long term correlations do matter. As a consequence, an important effort has been devoted in the literature to describe the burstiness characteristics of the already existing user services, namely data, voice and video-telephony traffics. Let us recapitulate the most frequently presented burstiness descriptors

1. the ratio of peak to mean bit rates.

2. the ratio of standard deviation to mean bit rate termed the peakedness.

3. the slotted 'on-off' Markov sources described with the mean sojourn times of the 'active' and 'silent' periods.

4. the Poisson process and its generalizations (interrupted Poisson process, Markov modulated Poisson process) described with a set of parameters including statistical characteristics of the cell arrivals like the variance to mean ratio measured on counting processes, the correlation and the third order moment of the arrival rate.

5. the divergence of an arrival process from the Poisson arrival process can be evaluated by two parameters, namely the index of dispersion of the counting process (the variance divided by the mean) or the squared coefficient of variation (the variance divided by the square of the mean). Those two parameters enable to discriminate among the Poisson, renewal and point processes.

The traffic burstiness in conjunction with the buffering resources is two determinant parameters which make the decision of which amount of bandwidth to allocate. In any case, a bandwidth, expressed in bit rate, has to be allocated somewhere in between the mean and the peak bit rate values. Chapter 7 will provide solutions to the problem.

1.12 ATM Network Management

The ATM network management is located in the network layer of the OSI standard. A structured management architecture will be described in form of a hierarchical organization which assigns general strategies at the summit level, distributes top down more and more specific management tasks and ends up at the bottom levels with short term policies like the traffic control algorithms. The motivation for such structures is a need to provide the network resources with a substrate of adaptive capabilities. This adaptivity thereafter allows the management to achieve optimum behaviors under the constraint to minimize well-determined cost functions and to guarantee to any potential users some required levels of performances. The control and the management algorithms will be presented in Chapter 7. As evidenced in Chapters 4 and 7, control and management systems, dealing with non-stationary parameters and environments, require adaptive systems and algorithms. These ones are most properly put into action by hierarchical structures. Under the constraint of optimizing cost functions, such layered structures lead to proper optimum adaptive algorithms. The main network management functions which deal with the traffic will be studied in this section; these are the *call acceptance control algorithms*, the *traffic enforcement* and the *congestion control*. As a matter of fact, those algorithms find a place in the layered OSI definition, they use the three lower OSI protocol layers to perform their function, for instance to communicate within the network by means of cells dedicated to signalling actions.

1.12.1 Management Architecture

The ATM management architecture aims at managing the traffic on the networks. It is composed top down of a hierarchy of three levels depicted in Figure 1.40, namely the ATM Resource Management, the ATM Traffic Management and the ATM Traffic Control.

The *ATM Resource Management* sets up different virtual networks which are each composed of groups of virtual paths. Each virtual path is mandated to provide a specified quality of service (QOS). At this level, groups of virtual paths are dynamically allocated on demand to receive any potential user services. The network system options are taken at this top level management of the network, namely the allocation of QOS, the determination of possible use of priorities and the assignment of the relative economical importance that the different user services have to be privileged with.

The *ATM Traffic Management* deals with controlling the call connection admissions. At this level, the routing algorithm determines virtual connections and allocates user bandwidths at each multiplexing node. The bandwidth is further adjusted whenever a new demand is accepted and appropriate algorithms are implemented to carry out the call acceptance control according to the strategies imposed by the ATM Resource

Management. The connection oriented or connectionless modes are managed also at this level.

The *ATM Traffic Control* is composed of two sublevels described top down, namely the *Virtual Path Control* and the *Virtual Connection Control*. The first one is in charge of guaranteeing the virtual path QOS after the connection set-up. This level of the hierarchy performs the congestion control of the Virtual Paths and ensures that the traffic volumes do not exceed the allocated thresholds. The Virtual Paths are composed of the set of virtual circuits from the individual transmitters to their respective receivers. The Virtual Circuit Control deals with policing the subscriber traffic entering the virtual circuit in relation under assignments given by the Virtual Path Control.

Figure 1.40: ATM network management architecture.

1.12.2 Call Acceptance Control

Stated as a general assignment, the call acceptance control algorithm aims at allocating a fraction of the whole bandwidth to any new VBR or CBR source. The call acceptance control algorithm has to be processed according to a request for a network connection QOS taking into account both the resulting expected volume of traffic on the virtual path and the resulting expected network *Grade of Service* (defined as the call blocking probability i.e. the probability that a call establishment be rejected). The call acceptance control implies three different actions namely the bandwidth allocation, the routing into the network, the dynamic management of the bandwidth either along the virtual circuit (connection oriented mode) or along the virtual paths (connectionless mode).

The call acceptance control algorithms can be classified in two categories according to the way of computing the requested bandwidth, these are the direct and indirect algorithms. The latter methods are further subdivided into two further families, the virtual bandwidth method and the virtual trunk method.

1.12.2.1 Direct Methods

In this category of methods, the computation of the network QOS is performed on-line. Let be k classes of different types of service, let n_k be the number of calls already accepted in the class k and $B_{W,M}$ the maximum available bandwidth. The set of states satisfying the QOS is determined by a call admissible region as presented in Figure 1.41 in such a way that

$$f^{Bw}(n_1,, n_k) \leq QOS_M \tag{1.107}$$

where QOS_M holds for the upper bound of QOS (for example, the cell loss probability) requirement and f^{Bw} for the QOS resulting from the admission of the $\sum_{i=1}^{k} n_i$ calls. An example of this method is the linear algorithm defined by the function

$$f^{Bw}(n_1, .., n_k) = \sum_{i=1}^{k} B_{W,i}\, n_i \leq \rho c \tag{1.108}$$

where $B_{W,i}$ and n_i are respectively the allocated bandwidth (expressed in this case in bit rate) and the number of calls associated to the service of type. ρ and c are respectively the load and the available capacity (in bit rate) of the transmission link. As a result of its simplicity, this method cannot take into account important additional decision criteria like the resulting blocking probability and the optimization of the bandwidth allocation algorithm. It stands therefore as a brute force method.

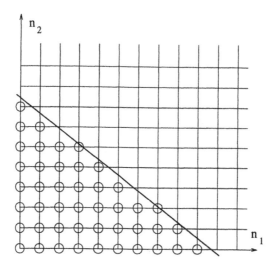

n$_1$: number of calls accepted in class 1

n$_2$: number of calls accepted in class 2

Figure 1.41: Example of call admissible region in terms of network QOS for 2 types of class.

1.12.2.2 Indirect Methods

In this family of methods, one part of the control computation is performed off-line. The values of the future potential virtual bandwidth can be computed in advance and stored with the corresponding blocking probabilities in memory. The concept by which a predefined call blocking probability is guaranteed for different types of service is related to a strategy of *bandwidth reservation*. A refinement of the bandwidth allocation can be performed after the acceptance.

Virtual Bandwidth Methods

A virtual bandwidth is granted to the user according to a general acceptance condition

$$f_V^{Bw}(n_1, ..., n_k) \leq B_{W,M} \tag{1.109}$$

where $B_{W,M}$ represents the total bandwidth available in the multiplexer and f_V^{Bw} the random variable for the total virtual bandwidth already allocated. $B_{W,M}$ and f_V^{Bw} can be expressed in bit rates, in cell loss probabilities,...

The examples of the virtual bandwidth f_V^{Bw} are numerous

1. the *sum of the peak bit rates*.

2. the *convolution approach* where the resulting bit rate density function of the superposition of several sources is computed by convolving the density functions (sum of independent random variables). Let Y be the bandwidth required by the total traffic stream and given by the sum of the random variables of the individual streams

$$Y = \sum_{i=1}^{S} N_i X_i \tag{1.110}$$

where N_i stands for the number of connections of type i and X_i for the bandwidth requirement of service of type i.

The performance parameters can be calculated by means of the distribution of Y. They are defined as follows. The congestion probability P_c is defined as

$$P_c(Y) = Pr[Y > c] \tag{1.111}$$

where c is available capacity along the link to receive the new allocation. For the total traffic stream, the rate P_{lt} of cells exceeding the link capacity is

$$P_{lt}(Y) = \frac{\sum_{L>c}(L - C)Pr[Y = L]}{E[Y]} \tag{1.112}$$

whereby $E[Y]$ denotes the mean resulting bandwidth. Assuming that the cells exceeding the capacity are randomly chosen, the cell rates P_{li} for the individual traffic streams X_i and $i = 1, ..., S$ are given by

$$P_{li}(X_i, Y) = \frac{\sum_{L>C} \sum_j \frac{\alpha_{ij}}{L}(L - C)Pr[X_i = \alpha_{ij}, Y = L]}{E[X_i]} \qquad (1.113)$$

where the distribution $Pr[X_i = \alpha_{ij}]$ defines the steady-state probability that the connection i requires the bandwidth α_{ij} while staying in state j. The P_{lt} and p_{li} provide estimators for the total link cell loss rate and for the individual source cell loss rate, respectively. The condition 1.109 can be further split into a set of performance criteria to be fulfilled to admit a call request of type i

$$E[Y + X_i] < \rho c \qquad (1.114)$$
$$P_c[Y + X_i] < \epsilon_1 \qquad (1.115)$$
$$P_{lt}[Y + X_i] < \epsilon_2 \qquad (1.116)$$
$$P_{li}[X_j, Y + X_i] < \epsilon_3 \qquad j = 1, ..., S \qquad (1.117)$$

where ϵ_i is the QOS to be guaranteed by the virtual path. A possible example of parameter values is $\rho = 0.8$, $\epsilon_1 = \epsilon_2 = \epsilon_3 = 10^{-10}$.

3. the *two-moment method* is based on the assumption of independent Gaussian distributed multiplexed source bit rates such that the acceptance condition is given by

$$f_V^{Bw}(n_1, .., n_k) = \sum_{i=1}^k m(i) + f_\epsilon \sqrt{\sum_{i=1}^k \sigma^2(i)} \le \rho c \qquad (1.118)$$

where $m(i)$ and $\sigma(i)$ stand for the mean and the standard deviation of source i, the f_ϵ is the ϵ fractile of the standard normal density function. For example, a value of f_ϵ equal to 5.6 guarantees a probability of ϵ equal to 10^{-8} of trespassing the value ρc.

Let us remark here that estimating the tail behavior of an aggregate traffic with a normal density function is quite inaccurate far from the mean. In fact, beyond a few standard deviations, the central limit theorem is highly inaccurate (weak convergence in distribution). To rigorously estimate the tail of the density function of an aggregated traffic, an accurate relationship is given by the Bienaymé-Tchebychev inequality of the probability for a random variable Y to trespass a threshold S_1

$$P(Y \ge S_1) \le \frac{E[Y]}{S_1} \qquad \text{for any } S_1 \qquad (1.119)$$

with $E[Y]$ the mean of Y. The inequality can be further applied with the bound $S_1 = e^{sS_2}$ taken with $s \ge 0$ and the random variable can be restated as $Y = e^{sW}$, W being the new random variable with known moments. The Bienaymé-Tchebychev inequality gives a new upper bound version

$$P(W \geq S_2) \leq \frac{E[e^{sW}]}{e^{sS_2}} = e^{-(sS_2 - \mu_W(s))} \tag{1.120}$$

where $\mu_W(s)$ is the logarithmic moment generating function of W. In any case, the exponent portion can be minimized by a derivative calculus with respect to s and equating to zero leading to the value s^* given by $S_2 = \mu'_W(s^*)$ and (the second derivative is supposed to be non-negative) to the inequality known in the literature as the *Chernov bound*

$$P(W \geq S_2) \leq e^{-(s^* S_2 - \mu_W(s^*))} \qquad \text{for any } s \geq 0 \tag{1.121}$$

expressing the lower bound probability for a random variable W to trespass a given threshold d_2 knowing the moments of its density function.

Virtual Trunk Method

The *virtual trunk* is defined as the allowable number of calls in progress. It is specified for each type of service. Any new source of class i is accepted if and only if the number of class i calls in progress is inferior to the virtual trunk granted to this class.

1.12.3 Traffic Enforcement

The primary goals of the *traffic enforcement* are to monitor the network traffic flow, to ensure that the actual source traffic flows comply individually to the negotiated contracts agreed at call establishment between source and network managements and, as a major point, to detect the violations in the user contracts. The excesses and contract trespassings to be tracked can originate from uncontrolled bit rate shifts or deliberate changes in the statistical flow characteristics. As a matter of fact, the traffic enforcement will play an active role in the control of network congestions. Clearly, the enforcement is to be implemented by means of *police functions* located as close as possible to the users i.e. on the subscriber lines. Several modes of action are foreseen. The repressive actions can be either immediately applied by discarding the cells in excess to contract or delayed by marking the non-contractual cells. In the latter option, the cells are allowed to enter the network but would be discarded in the switching nodes by the local priority service mechanisms in case of congestion occurrence. The policing functions may affect individual sources or groups of users; they can be *static* if it remains unchanged during the whole transmission or *dynamic* if it is updated according to the evolution of the source requirements. As no feedback actions are delivered by the network to the sources, two similar algorithms should be run, one, preventively in the coding source and, another, repressively in the network in order to avoid any conflicting situations.

A large number of policing functions have already emerged in the literature, the principles will be outlined and compared in the sequel. To picture first the most elementary police functions suggested so far in the literature, the description will furnish for each enforcement technique the algorithmic process for implementation, the model for performance evaluations and the type of traffic that the algorithm is susceptible to enforce. The presentation will thereafter proceed towards more elaborated techniques. A first group of basic policing functions is as follows

1. the *peak*

 the maximum cell rate is enforced by requiring a minimum time between consecutive cells belonging to the same source. The algorithm is as simple as to

 - set time counter to zero at any valid cell arrival.
 - discard any cell arriving before time counter reach T_{min} and keep counter running.

 This solution is available for any kind of traffic.

2. the *fixed window* or *jumping window*

 The algorithm consists on three items so as to

 - increment the counter at each cell arrival if it is below the maximum counting value N.
 - discard the cell if the counter value is N upon arrival.
 - reset the counter to zero at the beginning of each counting interval of length T. Let us notice that, in this scheme, the intervals are contiguous each to other along the time axis.

 The model of this algorithm is nothing else that the counting process version of the traffic equations evaluated on periods of length T. Solutions are available for most of the stochastic arrival process models, namely the Poisson, the Bernoulli, the Erlang-k and also the general renewal or point processes.

3. the *moving window*

 The algorithm is similar to the preceding one except that the counter is restarted when the first cell arrives and a new window of length T is activated precisely at that time. The number of cells in any possible interval is strictly limited to N. The algorithm has to

 - increment the counter at each arrival if it is below the maximum counting value N.
 - discard the cell if the counter value is N upon arrival.
 - decrement the counter by one unit after a period of T time units immediately following an accepted arrival.

 The algorithm can be modeled by G/D/N-0 queueing systems. Solutions are available for Poisson arrival.

4. the *exponential weighted moving average* (EWMA)

 The algorithm is an extension of the jumping window which takes into account the previous inter-arrival times so as to

 - define consecutive intervals of length T and set counter value to 0 at the end of each interval.

- increment the counter value for each arrival if it is below the maximum N(n).

- discard cell if the counter value is N(n) upon arrival.

- calculate the maximum number of accepted cells N(n+1) for the next interval n at the end of the current interval in terms of the policed mean cell rate and an exponentially weighted sum of accepted cells in all preceding intervals.

$$N(n+1) \ = \ \frac{S_M - aS(n)}{1-a} \quad \text{with} \quad 0 \le a < 1 \tag{1.122}$$

with the parameter $S(n)$ being updated at each time interval as

$$S(n) \ = \ (1-a)X(n) + aS(n-1) \tag{1.123}$$

where $X(n)$ is the number of cells arriving in interval n and $S(n)$ is requested to remain below a given value S_M. The case $a = 0$ represents the fixed window mechanism.

The algorithm performances can only be tested by software simulations.

5. the *leaky bucket*

The leaky bucket is one of the most cited technique in the literature. As it will turn out thereafter, leaky bucket presents serious advantages when compared to the other mechanism and, moreover, it leads to a whole family of various elaborated implementations. The basic algorithm has to

- increment the counter at each cell arrival if it is below the maximum counting value.

- discard the cell if the counting value is equal to N upon arrival.

- decrement the counter value every D time units if it is above 0.

The algorithm can be modeled as a G/D/1-(N-1) queueing system. Solutions are available for the Poisson, Bernoulli, general renewal and point processes. Let us remark that leaky bucket is also suited to the Markov modulated Poisson process traffic modeling.

Methods 2 to 4 are foreseen to monitor the mean bit rate value. The leaky bucket algorithm enable watching several parameters as the mean and the peak bit rates as well as the burstiness. The success of the leaky buckets is explained by its efficiency and its simplicity as illustrated hereafter by some comparative theoretical results. Among the different properties to put forward when analyzing a policing function, let us mention the ability of fulfilling the agreed contract, the necessity of a safety factor, the efficiency in detecting contract violations and the sensitivity to the source characteristics.

Examining the ability of fulfilling a contract, it is to be remarked that none of the policing mechanisms is able to verify exactly the contracts to the letter of the agreement. The example of policing a mean cell rate is one of the most significant. Figure 1.42 presents the cell loss probability generated by four mechanisms enforcing the mean rate

of homogeneous Poisson arrivals. The mean cell rate policed in the simulation is equal to the mean cell rate of the source. An exact policing scheme turns out directly to be untractable. Among the policing schemes, the leaky bucket performs more efficiently with less cell losses than the other mechanisms.

In deduction from the first item, safety factors need to be implemented while policing, they give the ratio of the policed mean cell rate to the mean cell rate of the source. As a matter of fact, high safety factors degrade the ability to detect contract violations but avoid erroneous cell rejection; in any case, adequate techniques should achieve the best trade-off. Figure 1.43 presents the behavior of three mechanisms with Poisson arrival at several safety factor c. Although necessary, it turns out that the introduction of a safety factor will drastically reduce the mechanism ability to detect contract violations. Here again, the leaky bucket responds better to increments of the safety factor.

The detection sensitivity to contract violation is a parameter of importance. Figure 1.44 studies a case of mean cell rate policing with safety factor. Poisson or deterministic arrival are both assumed, the mean cell loss is agreed at 10^{-11}, counter limit of 50 is identical to each mechanism, the safety factor c is 1.275 for the leaky bucket and 3.000 for the moving interval average. The deterministic cell arrival represents the worst case with respect to the number of accepted cells. The leaky bucket provides the policing action with better detection of contract violations.

The police mechanism sensitivity to source characteristics is another important parameter to be taken into account because Poisson arrival is far too optimistic and that the traffic is presumed to take diversified configurations, for instance, the Interrupted Poisson models developed for packetized computer data and voice are not realistic to characterize digital image sequence sources. It is here also an advantage of leaky bucket to be able to deal with general arrival models. Difficulties arize when trying to define the mean bit rate particularly on which interval to average the estimation. More intricated methods of traffic monitoring have been developed in the literature. Three additional structures will be proposed, namely the *adaptive leaky bucket*, the *gauge policing function* and the *delta algorithm*.

To control properly the flow traffic, the enforcement action is included in a closed loop regulation mechanism. The leaky bucket is modeled as a queue of fixed length. When the queue is filled up, overflow occurs and incoming cells are discarded. The queue service is supervised by the network flow management which provides the leaky bucket server with tokens currently generated at the mean rate. To be served and enter the network, a queued cell must get a token in a sense that, if the token pool is empty, no service will be carried out until an arrival of new tokens. This mechanism allows the network management to interact with the input flow traffic.

The *gauge policing function* lays down a more elaborated mechanism underlying credit counters. Here, the police function enforces a gauge of bit rate PDF. The Gaussian PDF envelope has already been illustrated. It operates with bit rate samples counted within consecutive periods of constant duration t. The estimated bit rate is compared to a set of credit counters. Each credit counter is associated with a bit rate range, for example a slice in the PDF to be enforced and is updated by increment or decrement according to bit rate measurement. Thresholds are assigned to each counter to impose a maximum values i.e. time restrictions upon the duration bit rate excess are allowed to

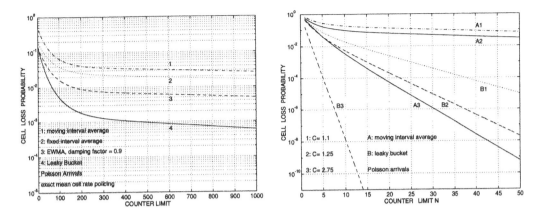

Figure 1.42: Mean cell rate policing. Figure 1.43: Mean cell rate and safety factor.

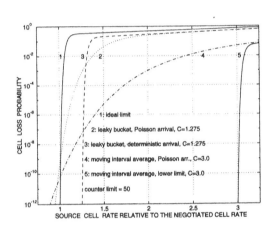

Figure 1.44: Detection of contract violations.

last. The set of credit counters mould whole bit rate PDF gauges.

The *delta method* counts the number of cells within sample periods and updates a counter each time the number of cell exceeds a predetermined value. A maximum counter value is allowed at the end of a measurement period T. This method limits the time interval that the source is allowed to transmit above a certain threshold. To put in practice that algorithm, different delta counters can be combined with each particular period and threshold. That mechanism counts number of cells in interval on demand over long time scale with savings in the hardware amount of storage. Delta is a version more general than the gauge.

To conclude on the enforcement functions, it is now generally agreed that the peak cell rate should always be policed with some safety factor. This can be easily achieved

by a leaky bucket with limited credit. Another candidate to be policed is the mean cell rate. Several studies have demonstrated that it is not possible to police the mean without defining the associated time interval. In that way, a *virtual mean* has been defined as a mean relative to specified long time intervals. To avoid the algorithms from discarding legal cells and maintaining an acceptable policing accuracy, it is important to use small safety factor and to define evaluating intervals of at least one order of magnitude smaller than the duration of the connection. In this case also, leaky buckets may play an important role. The cell burst lengths will turn out to have impact on the cell loss probability. It may therefore be judicious to include some policing on the bursts and to provide the network with a suitable burst definition. Definitions expressed in terms of a maximum number of cells within a short time interval match perfectly to the definition of moving window mechanism. Another issue in policing, especially in packetized TV will, consists in enforcing at several different time scales and load levels, this problem can only be solved by combining several policing mechanisms, for instance the Gauge, the delta, the leaky bucket and the moving window.

1.12.4 Congestion Control

In spite of having correctly declared source descriptors and performing efficient traffic enforcements, a large degree of uncertainty subsists into the traffic fluctuations which originate from the intrinsic non-stationarity and the potential correlation of the sources. When congestion occurs, the average load exploited on a network is usually within the capacity of the network, but however congestion occurs because average loads plus variations exceed temporarily the network capacity. When the congestion develops, it increases the transmission delay and the cell loss probability and, as a consequence, it degrades the QOS. The correlation between different sources is in general not taken into account by the call acceptance algorithms especially among sources that do not belong to the same connecting node. Long term correlations of small magnitude could lower the expected QOS for a long period.

The congestion control can be classified in two distinct strategies, namely the *preventive control* (open loop system) and the *feedback control* (closed loop system). Two time scales can be considered according to the duration of the congestion i.e. the *cell scale* and the *burst scale*. The cell scale means short term overloads of queue capacity generating random cell losses or short bursts of cell losses (usually no higher than 10-20 cells). The burst scale means long term overloads generating long bursts of cell losses (usually several tens of cell losses).

In a closed loop network control, a queue congestion status (for example, the mean level of the multiplexing queue occupancy) is monitored and a control can be activated to react either on the switch inputs or on the user source police functions (for example, the token generator of a leaky bucket). In this family of schemes, the control can be organized, for example, in two successive levels where all the cells in excess to the enforced thresholds are first marked by the policing algorithms and selectively discarded in case of emerging congestion. This allows achieving higher network utilizations by preserving some cells in excess. In an open loop network control, preventive actions are taken by the policing which discards the cells out of the statistical bounds.

1.13 Conclusions

In this first chapter, several topics concerning the ATM networks have been presented and outlined as an introduction to give insight to the current researches and standardization efforts performed in the field. These subjects intend to introduce and support the content of the following chapters dedicated to encoding and transmitting digital TV and HDTV signals on ATM networks. These topics constitute the basic framework allowing ATM networks to transmit TV and HDTV signals and to monitor their traffic with utmost efficiency. This chapter has evidenced that multiresoluted HDTV sources are effectively required to fulfill transmission and reception constraints to be mentioned as follows. The ATM B-ISDN is in fact intended to be connected to other networks built upon narrower bandwidths able to admit only a portion of original resolution and hence to distribute lower resoluted images. Some ATM customer decoders may also desire to pick up only one part of the total resolution without having to analyze the whole signal. This latter constraint arises from the existence of low resoluted display with electronic performances fitting video-telephony requirements. From the chapter, it turned out also that sessions requiring different levels of transmission quality should be preferably transmitted on separate virtual circuits to avoid cross-interference when congestion develops.

In Chapter 2, the way to generate a digital TV signal at constant subjective quality is investigated and lays down the foundations of designing free variable bite rate sources. The coding schemes insuring multirate transmissions for ATM B-ISDN will be investigated into details, namely the different families of operators performing the spatial and temporal signal analysis, the quantization and the entropy rate compression. The concept of priority and the potential existence of hybrid ATM-STM networks will lead to potential two-layer coding algorithms for TV and HDTV to be viewed as a particular case of multiresolution coding algorithms. The ATM-OSI layers and the coding functions will be here incorporated into a whole layered description ranging top down from the scanning of TV or HDTV images to the transmission on the ATM physical layer.

In Chapter 3, the necessity of an accurate traffic description for TV source will justify the elaboration of complete source bit-rate models. As evidenced in the section devoted to traffic description, where traffic models are built up progressively from simple computer data transfer sources, voice and single-scene video sources, the TV bit-rate modeling requires more general and intricated stochastic tools as a consequence of its temporal multiscale structure and the presence of short and long-term correlations in the signal. Measurements performed on an actual database of TV signals will further enable estimating some model parameters and show that in whole generality the conditions to apply central limit theorem are not fulfilled in all time scale of observation.

In Chapter 4, the goal of transmitting the TV signal on either CBR or VBR channels will necessitate to develop control algorithms allowing the coder to cope with both the source non-stationarities and the transmission constraints. These algorithms aim at generating an optimum TV quality which maintains the subjective image quality as constant as possible and guarantees graceful degradations whenever impossible to maintain the nominal quality with respect to the enforced transmission rate allocated on the channel. The research of the optimum algorithm is the first step towards a global coding-transmission optimum presented in Chapter 7 which aims at utilizing, with the utmost

efficiency, the bandwidth allocated to the TV transmission.

In Chapter 5, the queueing architecture of the switching nodes is investigated in conjunction with the source models to derive the statistical properties of aggregated TV traffics and compute the expected multiplexing performances. Models of merged traffics and queueing systems will be successively studied into details. As expected from the Bienaymé-Tchebychev inequality and the theorem of large numbers, a gain in statistical multiplexing will be evidenced for TV sources.

In Chapter 6, the access to the ATM multiplexing will force the coder designer to develop additional strategies to be installed in the ATM adaptation layer to cope with the drawbacks of network transmissions, namely the cell losses and random delays. Consequently, a need to upgrade the resulting end-to-end users network quality will lead to implement error correction strategies and clock recovery algorithms in the decoders.

In Chapter 7, some tasks of the ATM management will be addressed. Based on the results obtained in the previous chapters, the problem of optimum transmission on ATM channels will be tackled and subdivided into a sequence of two consecutive strategies, successively the strategy to allocate optimum TV and HDTV bandwidths along virtual paths and the strategy to use the allocated bandwidth in optimum conditions. The first issue contributes in defining call acceptance control algorithms and source traffic descriptors. The second issue gives rise to policing functions and congestion control. The ATM networks are queueing network. The principle of the queueing networks and some important theorems developed in that framework are laid down to apprehend some ways to deal with connection oriented and connectionless communications.

1.14 Bibliography

General ATM References

[1.1] J. J. Bae, T. Suda "Survey of Traffic Control Schemes and Protocols in ATM Networks", *Proceedings of IEEE, Vol. 79, No. 2, February 1991.*

[1.2] CCITT "Draft Recommendation I.113, Vocabulary of terms for Broadband Aspects of ISDN", *Study Group XVIII, Geneva, May 1990.*

[1.3] CCITT "Draft Recommendation I.150, B-ISDN ATM Functional Characteristics", *Study Group XVIII, Geneva, May 1990.*

[1.4] CCITT "Draft Recommendation I.211, B-ISDN Services Aspects", *Study Group XVIII, Geneva, May 1990.*

[1.5] CCITT "Draft Recommendation I.311, B-ISDN General Network Aspects, Traffic Control and Resource Management", *Study Group XVIII, Geneva, May 1990.*

[1.6] CCITT "Draft Recommendation I.361, B-ISDN ATM Layer Specification", *Study Group XVIII, Geneva, May 1990.*

[1.7] COST "Compendium ATM, Coding Procedures", *COST 211ter project, simulation subgroup, January 1992.*

[1.8] K. Hiraide, S. Nakajima "T. Yasui, Broadband Switching System Architecture", *IEEE Journal on Selected Areas in Communications, Vol. 5, No. 8, pp. 1346-1355, October 1987.*

[1.9] J. Y. Hui "Switching and Traffic Theory for Integrated Broadband Networks", *Kluwer Academic, 1989, 347 pages.*

[1.10] IEEE "Draft Proposed Standard Distributed Queue Dual Bus (DQDB) Metropolitan Area Network (MAN)", *Document 802.6/D11, November 1989.*

[1.11] M. de Prycker "Asynchronous Transfer Mode Solution for Broadband ISDN", *Ellis Horwood Series in Computer Communications and Networking.*

[1.12] T. D. Todd, P. A. Lopinski "A Compatible Fixed-Frame ISDN Gateway for Broadband Metropolitan Area Networks", *IEEE Journal on Selected Areas in Communications, Vol. 7, pp. 680-689, June 1989.*

[1.13] RACE "Updated Results of Traffic Simulation of the Policing Experiment", *RACE Project R1022, Technology for ATD, December 1990.*

The ATM Switching Techniques

[1.14] H. Ahmadi "Architectures and protocols for computer networks, the state of the art", *IEEE Journal on Selected Area in Communications, Vol. 7, pp. 1091-1103, 1989.*

[1.15] K.E. Batcher "Sorting networks and their applications", *Proceedings of AFIPS Conference, pp. 307-314, 1968.*

[1.16] V.E. Benes "Mathematical theory of connecting networks and telephone traffic", *Academic Press, New York, 1965.*

[1.17] V.E. Benes "Optimal rearrangeable multistage connecting networks", *Bell System technical Journal, pp. 1641-1656, July 1964.*

[1.18] F. Bernabei, A. Forcina, M. Listanti "On non-blocking properties of Parallel Delta Networks", *Proceedings of INFOCOM 1988, New Orleans, USA, paper 4A.2., March 1988.*

[1.19] F. Bernabei, M. Listanti "A hybrid switching exchange for broadband communications", *Proceedings of ICCC88, Tel Aviv, Israel, paper A.2-2, October 1988.*

[1.20] C. Clos "Study of non-blocking switching network", *Bell System Technical Journal, Vol. 32, pp. 406-424, March 1953.*

[1.21] C. Day, J. Giacopelli, J. Hickey "Applications of self routing switches to LATA fiber optic networks", *Proceedings of ISS87, Phoenix, USA, paper A7.3, March 1987.*

[1.22] D. M. Dias, M. Kumar "Packet switching in NlogN multistage networks", *Proceedings of GLOBECOM84, Atlanta, USA, paper 5.2., December 1984.*

[1.23] J. Hui "A broadband packet switch for multi-rate services", *Proceedings of ICC87, Seattle, USA, paper 22.4, June 1987.*

[1.24] J. Y. Hui "Switching Integrated Broadband Services by Sort-Banyan Networks", *Proceedings of IEEE, Vol. 79, No. 2, pp. 145-154, February 1991.*

[1.25] J. Hui and E. Arthurs "A broadband packet switch for integrated transport", *IEEE Journal of Selected Areas in Communications, Vol. SAC-5, pp. 1264-1273, October 1987.*

[1.26] Y.C. Jenq "Performance analysis of a packet switch based on a single-buffered banyan-network", *IEEE Journal on Selected areas in Communications, No. 6, pp. 1014-1021, December 1983.*

[1.27] Kirton, Ellershaw, Littlewood "Fast Packet switching for integrated network evolution", *Proceedings of ISS, Phoenix, 1987.*

[1.28] C. P. Krustal, M. Smir "The performance of multistage interconnection networks for multiprocessors", *IEEE Transactions on Computers, pp. 1091-1099, December 1983.*

[1.29] M. Kumar, J. R. Jump "Generalized delta networks", *Proceedings of International Conference on Parallel Processing, pp. 10-18, 1983.*

[1.30] T. T. Lee "The non-blocking copy networks for multicast packet switching", *IEEE Journal of Selected Areas in Communications, Vol. SAC-6, pp. 1455-1467, December 1988.*

[1.31] G. M. Masson "Binomial switching networks for concentration and distribution", *IEEE Transactions on communications, Vol. COM-25, pp. 873-883, 1977.*

[1.32] R. J. McMillen "A survey of interconnection networks", *Proceedings of GLOBE-COM, Atlanta, USA, pp. 105-113, November 1984.*

[1.33] D. S. Parker "Notes on shuffle/exchange-type switching network", *IEEE Transactions on Computers, pp. 213-222, March 1980.*

[1.34] F. A. Tobagi "Fast Packet Switch Architectures For Broadband Integrated Services Digital Networks", *Proceedings of the IEEE, Vol. 78, No. 1, January 1990, pp. 133-167.*

[1.35] J. S. Turner "Design of a broadcast packet switching network", *IEEE Transactions on Communications, Vol. 36, No. 6, pp. 734-743, June 1988.*

[1.36] J. S. Turner "New directions in communications or, which way to the Information Age¿", *Proceedings of 1986 International Zürich Seminar on Digital Communications, Zürich, Switzerland, March 1968.*

[1.37] J. S. Turner "Design of a integrated service packet network", *Journal on Selected Areas of Communications, Vol. 4, 1986.*

[1.38] C. Wu, T. Feng "On a class of multistage interconnection networks", *IEEE Transactions on Computers, pp. 694-702, August 1980.*

[1.39] Y. Yeh, M. Hluchyj, A. Acampora "The knockout switch: A simple, modular architecture for high-performance packet switching", *IEEE Journal of Selected Areas in Communications, Vol. SAC-5, pp. 1274-1283, October 1987.*

The ATM Multiplexers

[1.40] T. Y. Choi "Statistical Multiplexing of Bursty Sources in an ATM Network", *Multimedia 1989.*

[1.41] E. Çinlar "Introduction to Stochastic Processes", *Prentice-Hall, Englewood Cliffs, NJ, 1975.*

[1.42] L. Dittmann and S. B. Jacobsen "Statistical Multiplexing of Identical Bursty Sources in an ATM Network", *Proceedings of IEEE Globecom 1988, pp. 39.6.1-39.6.5.*

[1.43] E. Dutkiewicz, G. Anido "Connection Admission Control in ATM Networks", *5th ATERB FPS Workshop, Melbourne, July 1990.*

[1.44] A. E. Eckberg, Jr. D. T. Luan and D. M. Lucantoni "Meeting the Challenge: Congestion and Flow Control Strategies for Broadband Information Transport", *Proceedings of IEEE Globecom-89, pp. 49.3.1-49.3.5, 1989.*

[1.45] M. Hirano and N. Watananbe "Characteristics of a Cell Multiplexer for Bursty ATM Traffic", *Proceedings of IEEE ICC-89, pp. 13.2.1-13.2.5, 1989.*

[1.46] M. G. Hluchyj, M. J. Karol "Queueing in Space-Division Packet Switching", *Proceedings of IEEE Infocom 1988, pp. 334-343.*

[1.47] M. J. Karol, M. G. Hluchyj, S. P. Morgan "Input Versus Output Queueing on a space-Division Packet Switch", *IEEE Transactions on Communications, Vol. COM-35, No. 12, pp. 1347-1356, December 1987.*

[1.48] L. Kleinrock "Queueing Systems", *Wiley, Vol. 1, 1975.*

[1.49] H. Kröner "Comparative Performance Study of Space Priority Mechanism for ATM Networks", *Proceedings of IEEE Infocom 90, pp. 1136-1143.*

[1.50] B. Malglaris, D. Anastassiou, P. Sen, G. Karlsson and J. D. Robbins "Performance Models of Statistical Multiplexing in Packet Video Communications", *IEEE Transactions on Communications, Vol. 36, pp. 834-844, July 1988.*

[1.51] K. S. Meier-Hellstern and P. E. Wirth "Packet Switch Provisioning Accounting for Uncertainty in the Forecasting of Customer Characteristics", *Proceedings 7th International Teletraffic Congress Specialist Seminar, Adelaide, Australia, September 1989.*

[1.52] M. Nomura, T. Fujii and N. Ohta "Basic Characteristics of Variable Rate Video Coding in ATM Environment", *IEEE Journal on Selected Areas in Communications, Vol. 7, No. 5, pp. 752-760, June 1989.*

[1.53] A. Papoulis "Probability, random Variables, and Stochastic Processes", *Mc Graw Hill, 1984.*

[1.54] A. Pattavina "Multichannel bandwidth allocation in a broadband packet switch", *IEEE Journal of Selected Areas in Communications, Vol. SAC-6, pp. 1489-1499, December 1988.*

[1.55] M. Sidi, W. Z. Liu, I. Cidon and I. Gopal "Congestion Control through Input Rate Regulation", *Proceedings of IEEE Globecom-89, pp. 49.2.1-49.2.5, 1989.*

Appendix

1.A ATM Terminology

To help the reader, a small additional dictionary gathers some important vocabulary in reference to the ATM field and often used in the literature without any preliminary definition. The definitions given here stem from the literature in the field. The terminology is reported as a short lexicon.

APPLICATION LAYER: the uppermost layer which guarantees that two application processes, cooperating to carry out the desired information processing across a network, understand each other.

BLOCKING: qualifies a state in which a switching network is not able to connect an allocatable virtual circuit on the incoming link with an equivalent allocatable virtual circuit on the outgoing link. In contrast to the contention, blocking is related to the call set-up phase when the network management strives to establish a virtual connection.

A related vocabulary encompasses some more precise definitions, these are

1. STRICTLY NON-BLOCKING: qualifies the property of an ATM switching network to be always able to connect, independently of the switching network state, an allocatable Virtual Circuit on the incoming link with an allocatable Virtual Circuit on the outgoing link.

2. NON-BLOKING IN A WIDE SENSE: characterizes an ATM switching network which is able to connect an allocatable virtual circuit on the incoming link with an allocatable virtual circuit on the outgoing link, using a packing or repacking (rearranging) rule.

CIRCUIT SWITCHING: a technology that establishes a dedicated path between any pair or group of users attempting to communicate.

CONGESTION: the circumstance where increasing the input network load does not result in increasing the output due to overload situations in some network nodes. The cell transmission delays are prolonged to their maximum values and queue overflows induce large amounts of cell losses. Congestion and contention always refer to the transfer phase while blocking is related to the call set-up phase.

CONNECTION: usual connections in a telecommunication link mean a concatenation of transmission devices like channels, circuits, switches to allow services to transfer signal between two or more points in the network. In ATM transmissions, connections are established under the control of a *CONNECTION ACCEPTANCE ALGORITHM* which determines whether or not to accept the connection under request. The decision rules are based on several factors among which the following are to be mentioned: the bandwidth

requested to the service under connecting probation, the available bandwidth depending on the network state of load and the level of QOS required by the demanding service. Moreover, specifically to the ATM transmissions, two types of connection are commonly distinguished, when referring to packet-switched data communications, the *CONNEC-TION ORIENTED* and *CONNECTIONLESS* modes. The *CONNECTION ORIENTED* mode implies that a virtual circuit transmission is open during a set-up phase to establish, end-to-end through the network, a path along which all the cells will be switched immutably from transmitter to receivers. As a consequence of the connection oriented mode, the cells arrive at destination in the sequence of transmission. The connection set-up phase is a part of the work achieved by the connection acceptance algorithm. Upon admission to transmit, a second phase is started, that is termed the transfer phase. The virtual circuit shares resource with other communications being queued at intermediate point along the route between source and destination. The *CONNECTIONLESS* or *DATAGRAM* mode involved no initial connection to be set-up. The individual cells are forwarded through the network according to the instantaneous local loads and the routing is based only on the destination address. Arrival at destination in the sequence order is here not guaranteed. This mode aims at homogenizing the load repartition of the network.

CONTENTION: describes a situation where, at least two users try to access or to use simultaneously the same switching resource, for instance, launching a cell in the same output stream. The way to counter that kind of problem is currently to include a queue protecting the resource from simultaneous access.

DATA LINK LAYER: the layer that ensures correct transmission of information between adjacent nodes in a network.

FLOW CONTROL: congestion control to prevent overflow of buffers.

FRAME: unit of data of the OSI data link layer.

FULL ACCESSIBILITY: an ATM switch has full accessibility if it is possible to connect an allocatable virtual circuit on any incoming link with an allocatable virtual circuit on any outgoing link, assuming no other traffic.

GATEWAY: the interface between disparate networks that provides the necessary protocol translation.

GRADE OF SERVICE: probability that a call establishment be blocked.

LOAD: alternate terminology for the utilization factor in order to measure the mean utilization of a network node, a link and a service as the ratio of the mean cell arrival to the service rate. Literature refers sometimes to *BUSY HOUR LOAD* to characterize periods with peak demand on the network. In extension to the definition, the *LOAD CONTROL* typifies the procedure to decide whether a new connection can be accepted or not and the *OVERLOAD CONTROL* relates to a function which protects the network from overload

conditions created by unpredictable statistical cell stream behaviors.

LOCAL AREA NETWORK (LAN): a network covering small geographic areas.

NETWORK LAYER: the layer that manages routing and flow control of packet.

OVERLOAD CONTROL: a network function to avoid overload occurrences and situations due to the statistical cell stream behavior.

PRESENTATION LAYER: the layer in communication architectures responsible for ensuring the proper syntax of information being exchanged.

SESSION: connection between end users.

SESSION LAYER: the layer in the OSI reference model that manages and controls the dialogue between the users of service.

TRANSPORT LAYER: the layer that provides the appropriate service to the session layer. The layer that shields the session layer from the vagaries of underlying network mechanisms.

TRUNK: a communication channel between two switching systems.

UTILIZATION FACTOR: characterizes the ratio of the mean cell rates of all virtual channels on a link to the corresponding link rate. The maximum utilization factor determines the allowed maximum cell rate on a link, so that the required quality of service can just be guaranteed.

VIRTUAL CONNECTION/CIRCUIT: a transmission path sets up end-to-end from source to destination before transmission begins. The successive user packets are constrained to follow the fixed path and arrive at destination in sequence.

Chapter 2

TV and HDTV Coding Algorithms

2.1 Introduction

As evidenced in the first chapter of this textbook, the first and major improvement brought by the ATM networks when compared to STM networks is to enable transmissions at *either variable or adjustable constant bit rates*. The expected gain of transmitting on ATM channels will consist in taking benefit from the statistical multiplexing of numerous variable-bit-rate video sources to occupy the available bandwidth more efficiently than in the STM case. As a direct consequence of being able to support sources at variable bit rates, the transmission through ATM networks should offer the advantage of *encoding and transmitting digital TV signals at adjustable constant image quality*. In this coding mode, the output bit rate variability originates from that of the instantaneous amount of information contained in the incoming TV sources. The drawbacks to be paid in an ATM transmission is the need to cope with cell losses, with the absence of a common reference clock available from the network and with random transmission delays. The second property of the ATM networks is to support multiresolution transmissions of individual users. For instance, a HDTV service should enable any receiver of lower definition to extract, decode and display a TV or a HQVT-resoluted version of the transmitted video signal. This chapter will therefore investigate the algorithms currently used to compress the TV and HDTV video bit rate in multiresolution environments and the way to transform these compression algorithms in order to achieve variable-bit-rate applications at constant image quality.

The digital TV and HDTV formats considered in this work are those defined in EUREKA 95 presented in Table 2.1. The Rec 601 format corresponds to the digital version of the current analog standard TV. TV coders and decoders are composed of several specific operations which are explored in this chapter and outlined respectively in Figure 2.1 and in 2.2. The treatment of the digital image information begins with a *phase of analysis* which does not process the signal but is in charge of precisely describing the spatio-temporal correlation structure contained in the incoming signal. For instance, motion vectors, which characterize the local motions detected frame-to-frame within a scene, represent one of the most important information issued from this first stage of the signal description. The coding procedure starts with a *signal decomposition* process

BROADCAST HIERARCHY: EUREKA 95					
	scanning parameters	aspect ratio	sampling parameters		bit rate (Mbit/sec)
			luminance Y	color difference C	
HDP	1250/50/1:1	16:9	144MHz/O/1920	36MHz/O/960	1728
EDP	625/50/1:1	16:9	36MHz/O/960	9MHz/O/480	432
HQVT	312.5/50/1:1	16:9	9MHz/O/480	2.25MHz/O/240	108
HDI	1250/50/2	16:9	72MHz/O/1920	36MHz/O/960	1152
EDI	625/50/2	16:9	18MHz/O/960	9MHz/O/480	288
Rec 601	625/50/2	4:3	13.5MHz/O/720	6.75MHz/O/360	216

Table 2.1: TV and HDTV formats.

is thereafter applied to the video signal in order to decorrelate and to remove as far as possible the spatio-temporal redundancy included in the image sequences. The encoding algorithm proceeds with a *bit-rate compression process* composed of a *quantization* and a *variable-length coding procedure*. This compression process is adapted to the *local image content*, to the *psycho-visual characteristics of the Human Visual System* and also to a *constrained capacity* of accessing on the transmission channel. Globally, the local image content and the output buffer fillness interact concomitantly to adjust the long-term variable bit rate outcoming from the quantizer, to ensure graceful image quality degradations and to comply to different types of transmission constraints, namely the Fixed, Constant or Variable Bit Rates (FBR - CBR - VBR). To adjust suitably the quantized data rate to the channel constraints, the level of buffer occupancy is fed back to control the computation of quantization step size. To adapt or even more to match the decomposition and the quantization process to the content of the signal, statistical parameters may be estimated on the incoming signal and exploited by the coding algorithm.

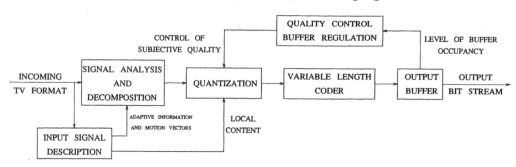

Figure 2.1: General functions of a TV coder.

Different functions to achieve VBR and CBR sequence compression will be considered in this chapter, especially, the *signal decorrelative decomposition* and the *core bit-rate compression process* composed, as mentioned herein above, of two consecutive processes, namely *a quantizer* and *a variable-length entropy coder*. The decorrelation intends to transform the incoming so as to decompose the signal into spectral components where the energy is compacted in a minimum number of coefficients to be transmitted. The quantizer is in charge of compressing the source of coefficients by an *irreversible procedure*

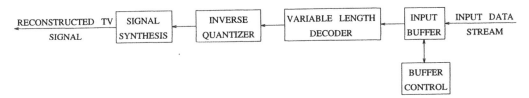

Figure 2.2: General functions of a TV decoder.

inducing degradations of the decoded and reconstructed image quality. This image degradation or distortion is made of *noise and disturbing effects*. It leads at the reconstruction on the decoder display to an impaired image quality which is measured by means of either *objective signal-to-noise ratios* to assess of an *objective quality* or *subjective notes expressed in terms of opinion scores* to assess of a *subjective quality*. As a major advantage of being able to transmit at variable bit rate, the TV signal can be transmitted at *quasi-constant quality over a whole session of communication*. An adaptive computation of the quantization-step size will be described in this chapter to monitor the quantizer with a *command of quality* such as to *control locally the subjective quality* and to be able to *produce a quasi-constant quality throughout entire programmes*. The parameter which commands the subjective quality is called the *transmission factor*. That factor is computed by the long-term constraint of output bit rate. The quantization step size is *adapted to take into account the characteristics of the Human Visual System* and *the local block content to produce constant image quality*. Let a *stripe* be defined as a slice of 8 or 16 consecutive video lines. A TV image in the CCIR 601 format is made of 72 such stripes of 8 lines. In Chapter 4, it is explained why the stripe corresponds to the fraction of the image during which the command for a constant subjective quality is maintained constant. In this textbook, the stripe will correspond to 8 or 16 consecutive video lines to fit to the block size of the decorrelation operators. The *variable-length entropy coder* compresses the quantized data rate by a *reversible procedure*, without any additional distortion of the image quality, in order to reach a resulting data rate as close as possible to the mean amount of information contained in the quantized bit stream.

The output of the coder is equipped with a *buffer* in charge of *accumulating temporarily the entropy-coded data stream to be transmitted on the channel*. The buffer is eventually emptied by a packetizer to feed the communication channel. As a result of the limited buffer capacity, a regulation process is in charge of limiting the output data rate of the quantizer and, subsequently, of preventing the buffer from overflowing. The problem of how to optimally regulate the output buffer and how to command the quantizer will be addressed in Chapter 4. The *free VBR transmission mode* is obtained with a fixed command for constant subjective quality i.e. eventually without any buffer regulation. On the contrary, *FBR, CBR and enforced VBR transmission modes* are implemented with a buffer regulation and encoded with a variable image quality.

To terminate the chapter, multi-layer coding schemes will be presented in the framework of the multi-rate and multi-resolution signal analysis theory and further adapted to comply to the transmission of TV and HDTV on ATM networks allocating two channels. A *base layer* in the coding scheme is in charge of encoding a base resolution, the TV information to be transmitted on the high-priority channel with a high and guaranteed

level of quality and an *enhanced layer* is in charge of encoding a complement of quality to be transmitted on the non-priority channel with a poorer and non-guaranteed level of quality. Multiresolution application are derived as direct generalization of this two-layer exemple.

Figures 2.3 and 2.4 overlook the outer functions to be implemented in the coder and the decoder to cope with the ATM transmission of the video information. The main procedure consists of packetizing the encoded data stream. Side information is made of error correcting codes and of time stamps. These latter aspects of how to protect the ATM transmissions against cell losses and bit errors and how to reconstruct in the decoder a clock in phase to that of the encoder will be discussed in Chapter 6.

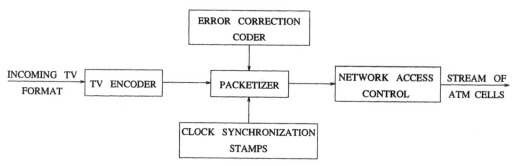

Figure 2.3: Functional overview of a TV encoder for ATM transmission.

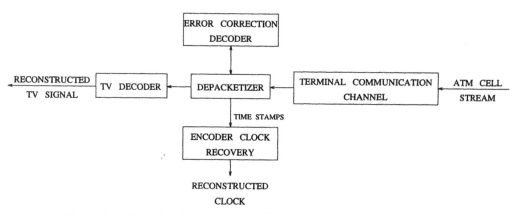

Figure 2.4: Functional overview of a TV decoder for ATM transmission.

This chapter intends to examine successively the spectral HDTV and TV signal properties, the signal decomposition and decorrelation tools, the quantization and the entropy coding. Based on that knowledge, architectures of coding will be developed starting from elementary schemes up to state-of-the-art algorithms out of the current research. Some insight will be also dedicated to the standardized coding schemes.

Chapter 2. TV and HDTV Coding Algorithms

2.2 Sampling Theorem and Spectra

Before starting to study headlong the concepts involved in coding techniques, it is worth examing into details one of the existing family of digital television signals. Focus is brought on the EUREKA 95 hierarchy. Of major importance, the sampling theorem is first restated for one- and multi-dimensional signals. The presentation proceeds with illustrating some of the sampling lattices, and, eventually some problems relevant to pre- and post-processing filters are examined. In fact, the development of efficient coding schemes and format conversion algorithms as well as the generation of TV signals at different resolution levels are highly dependent on both the sampling operations and the spectral descriptions.

2.2.1 One-dimensional Sampling Theorem and Aliasing

Let us consider the one-dimensional signal $x_a(t)$ of continuous variable t. Sampling this signal with regular T-periodicity consists of representing the continuous-time signal $x_a(t)$ by the discrete-time sequence $\{x(k) = x_a(kT)\}$ where k is an integer. This sampling process can be formulated in Dirac notations

$$x_s(t) = \sum_{k=-\infty}^{\infty} x_a(t)\delta(t - kT) = \sum_{k=-\infty}^{\infty} x_a(kT)\delta(t - kT) \tag{2.1}$$

The sampling procedure gives rise to an infinite number of spectra replicated along the frequency domain. Expressing the Fourier transform of Equation 2.1 leads to

$$X_s(f) = \frac{1}{T}\sum_{-\infty}^{+\infty} X_a(f - nF) \tag{2.2}$$

As shown in this formula, the central frequency lines of the replicas are located at integer multiples of the sampling frequency $F = \frac{1}{T}$. The parameters T and F are respectively called the sampling period and sampling rate. *When proceeding to the reconstruction of the continuous-time signal after sampling, it turns out that the original continuous signal can be recovered from an appropriate filtering if and only if it has been preventively band-limited within the range $-\frac{1}{2T} < f < \frac{1}{2T}$ before the sampling operation.* The continuous-signal reconstruction is carried out by a rectangular low-pass filter of magnitude T in the range $-\frac{1}{2T} < f < \frac{1}{2T}$. If the original signal has not been initially band-limited, aliasing problems will occurred and perfect reconstruction will not be possible.

2.2.2 Multidimensional Sampling Theorem

In this section, relationships are established between continuous signals and their periodically sampled discrete versions. The theory behind the sampling of multidimensional signals is slightly more complicated than that developed in the one-dimensional case. This arises from the variety of ways to choose the sampling geometry. The simplest scheme is termed *rectangular sampling* and refers to sample points arranged in rectangular patterns. Nevertheless, a motivation to consider generalizations stems from the fact that the

rectangular sampling is often not the most efficient way to sample a band-limited signal. Indeed, to achieve the minimum sampling density which avoids aliasing a band-limited signal with circular support, the *hexagonal sampling* pattern is the most efficient since it packs the circle bandwidths the most tightly in the frequency domain. In this optimum way to compact spectra, the replicas are located at the centers and the corners of the hexagons.

Sampling a continuous N-dimensional signal $x_a(t_1, t_2, \ldots, t_N)$ of N real variables, abbreviated here as $x_a(\mathbf{t})$, generates a discrete version $x(\mathbf{n})$ given by

$$x(\mathbf{n}) = x_a(\mathbf{Vn}) \tag{2.3}$$

In this section on multidimensional sampling, all the bold-type variables stand for vectors to remain coherent to the literature in this field like [79]. \mathbf{V} is a real $N \times N$ non-singular matrix composed of N linearly independent vectors $\{\mathbf{v}_n : n = 1, \ldots, N\}$; that is

$$\mathbf{V} = [\mathbf{v}_1 \ \mathbf{v}_1 \ \ldots \ \mathbf{v}_N] \tag{2.4}$$

The set of all the sample points is expressed as

$$\mathbf{t} = \mathbf{V} \ \mathbf{n} \tag{2.5}$$

and composed of the vectors $\sum_{k=1}^{N} n_k \mathbf{v}_k$. This set is made of all integer combinations of the column vectors $\mathbf{v}_0, \ldots, \mathbf{v}_{N-1}$ of \mathbf{V} and is called the *lattice* generated by the matrix \mathbf{V} which is named for evident reasons the *sampling matrix* and defines the basis that generates the lattice. If the vectors $\{\mathbf{v}_n : n = 1, \ldots, N\}$ represent an actual basis which generates the lattice, this sampling matrix is not uniquely defined. Indeed, in whole generality, several other bases are also admissible. The determinant of \mathbf{V} leads to a straightforward geometrical interpretation in the sampling operation as the volume of the *fundamental parallelepiped*, FPD(\mathbf{V}), generated by the vectors \mathbf{v}_n. This volume is equal to $|\det \mathbf{V}|$. Since the number of sample points per unit volume is equal to the number of FDP(\mathbf{V}) which can fit into unit volume, the volume of the fundamental parallelepiped measures a *sampling density* ρ which is defined as the number of lattice points per unit volume and therefore equal to

$$\rho = \frac{1}{|\det \mathbf{V}|} \tag{2.6}$$

Intuitively, this sampling density stands as an important concept since the achieving *minimum sampling density* is requested to optimally sample a band-limited multidimensional signal with the purpose to retain all the information and to preserve the reconstruction from aliasing effects. This is exactly the objective of the multidimensional-signal sampling theorem which is discussed in the following.

Considering a signal $x_a(\mathbf{t})$ and its Fourier transform $X_a(j\mathbf{\Omega})$, the Fourier transform $X(\omega)$ of $x(\mathbf{n})$ is given in the multidimensional realm by

$$X(\omega) = \frac{1}{|\det \mathbf{V}|} \sum_{\mathbf{k} \in I^N} X_a \left(j\mathbf{V}^{-T}(\omega - 2\pi \mathbf{Uk}) \right) \tag{2.7}$$

where $\omega = [\omega_0 \ \omega_1 \ \ldots \ \omega_{N-1}]^T$. \mathbf{I}^N is the set or the space of all the N-component integer vectors. A second matrix \mathbf{U} which will play a major role is defined as

$$\mathbf{U} = 2\pi\mathbf{V}^{-T} \tag{2.8}$$

The lattice generated by \mathbf{U} is called the *reciprocal lattice* associated with \mathbf{V} and satisfies the relationship $\mathbf{U}^T\mathbf{V} = 2\pi\mathbf{I}$ where I_N is the identity matrix of order N.

To construct $X(\omega)$ from $X_a(j\Omega)$, we define a first change of variables $\Omega = \mathbf{V}^{-T}\omega$ which leads to re-express Equation 2.7 as

$$X(\mathbf{V}^T\Omega) = \frac{1}{|\det\mathbf{V}|} \sum_{\mathbf{k}\in\mathbf{I}^N} X_a\left(j(\Omega - \mathbf{Uk})\right) \tag{2.9}$$

The matrix \mathbf{U} determines the nodes in the frequency domain around which the spectrum of the analog signal is replicated. The set of vectors of the form \mathbf{Uk} is the lattice generated by \mathbf{U}. Similarly to the one-dimensional case, a function $f(\Omega)$ is said to be periodic if $f(\Omega) = f(\Omega - \mathbf{Uk})$ for all Ω and all integer \mathbf{k}. The matrix \mathbf{U} is naturally called the *periodicity matrix*. $X(\mathbf{V}^T\Omega)$ can be interpreted as a periodic extension of $X_a(\Omega)$, with a periodicity described by the general matrix \mathbf{U}, which can be thought of as a set of N independent vectors in the frequency domain $\mathbf{U} = [u_1 \ u_2 \ \ldots \ u_N]$. The shifted versions of $X_a(j\Omega)$ are called the *alias components*. If any of the alias component has overlap with the unshifted version, it becomes impossible to recover the continuous signal $X_a(j\Omega)$ from $X(\omega)$. As observed for one-dimensional signals, if the signal X_a is preventively band-limited, aliasing can be avoided.

The Fourier transform of a N-dimensional discrete-time signal $x(\mathbf{n})$ where the time index \mathbf{n} is a column vector $\mathbf{n} = [n_0 \ n_1 \ \ldots \ n_{N-1}]^T$ is a function of the N-dimensional pulsation vector $\omega = [\omega_0 \ \omega_1 \ \ldots \ \omega_{D-1}]$ defined by

$$X(\omega) = \sum_{\mathbf{n}\in\mathbf{R}^N} x(\mathbf{n})e^{-j\omega^T\mathbf{n}} \tag{2.10}$$

The inverse Fourier transform is expressed as

$$x(\mathbf{n}) = \frac{1}{(2\pi)^D} \int_0^{2\pi} X(\omega)e^{j\omega^T\mathbf{n}}d\omega \tag{2.11}$$

Let us remark that $e^{-j\omega^T\mathbf{n}} = e^{-j\omega_0 n_0}e^{-j\omega_1 n_1}\ldots e^{-j\omega_{D-1}n_{D-1}}$ implies that $X(\omega)$ is periodic in each variable ω_i with period 2π.

To proof the relationship 2.7, let us consider

$$x(\mathbf{n}) = x_a(\mathbf{Vn}) \tag{2.12}$$

$$= \frac{1}{(2\pi)^N} \int_{\Omega=-\infty}^{\infty} X_a(j\Omega)e^{j\Omega^T\mathbf{Vn}}d\Omega \tag{2.13}$$

$$= \frac{1}{(2\pi)^N |\det\mathbf{V}|} \int_{\omega=-\infty}^{\infty} X_a(j\mathbf{V}^T\omega)e^{j\omega^T\mathbf{n}}d\omega \tag{2.14}$$

$$= \frac{1}{(2\pi)^N |\det\mathbf{V}|} \int_{\omega\in FDP(2\pi\mathbf{I})} \sum_{\mathbf{k}\in\mathbf{I}^N} X_a\left(j\mathbf{V}^{-T}(\omega - 2\pi\mathbf{k})e^{j\omega^T\mathbf{n}}d\omega\right) \tag{2.15}$$

Equation 2.14 is derived from the preceding one by a change of variables $\Omega = V^T \omega$. In Equation 2.15, we write $\omega = \omega_P - 2\pi k$ where $\omega_P \in [0, 2\pi)^N$ and k is an integer vector, the subscript P is thereafter dropped to obtain finally Equation 2.15. The relationship 2.7 is yielded by comparing Equations 2.15 and 2.11.

To illustrate this theory in the framework of digital TV formats defined in the EUREKA 95 family, examples of direct and reciprocal lattices are considered as non-uniquely possible pair of matrices. The three coordinates for matrix V are respectively the time, the vertical and the horizontal directions. The corresponding frequencies are in Hz and cycle per picture height for matrix U. The parameter H holds for the screen height. Therefore,

1. for the HDP signals

$$
V_{HDP} = \begin{bmatrix} \frac{s}{50} & 0 & 0 \\ 0 & \frac{H}{1152} & 0 \\ 0 & 0 & \frac{H}{1080} \end{bmatrix} \quad U_{HDP} = \begin{bmatrix} 50 \, Hz & 0 & 0 \\ 0 & 1152 \, \frac{c}{H} & 0 \\ 0 & 0 & 1080 \, \frac{c}{H} \end{bmatrix} \quad (2.16)
$$

2. for the EDP signals

$$
V_{HDI} = \begin{bmatrix} \frac{s}{50} & 0 & 0 \\ 0 & \frac{H}{576} & 0 \\ 0 & 0 & \frac{H}{540} \end{bmatrix} \quad U_{HDI} = \begin{bmatrix} 50 \, Hz & 0 & 0 \\ 0 & 576 \, \frac{c}{H} & 0 \\ 0 & 0 & 540 \, \frac{c}{H} \end{bmatrix} \quad (2.17)
$$

3. for the HDI signals

$$
V_{HDI} = \begin{bmatrix} \frac{s}{25} & \frac{s}{50} & 0 \\ 0 & \frac{H}{1152} & 0 \\ 0 & 0 & \frac{H}{1080} \end{bmatrix} \quad U_{HDI} = \begin{bmatrix} 25 \, Hz & 0 & 0 \\ -576 \, \frac{c}{H} & 1152 \, \frac{c}{H} & 0 \\ 0 & 0 & 1080 \, \frac{c}{H} \end{bmatrix} \quad (2.18)
$$

4. for the EDI signals

$$
V_{EDI} = \begin{bmatrix} \frac{s}{25} & \frac{s}{50} & 0 \\ 0 & \frac{H}{576} & 0 \\ 0 & 0 & \frac{H}{540} \end{bmatrix} \quad U_{EDI} = \begin{bmatrix} 25 \, Hz & 0 & 0 \\ -288 \, \frac{c}{H} & 576 \, \frac{c}{H} & 0 \\ 0 & 0 & 540 \, \frac{c}{H} \end{bmatrix} \quad (2.19)
$$

The sampling structures in the plane $y - t$ are presented in Figure 2.5 with the related reciprocal lattices in Figure 2.6.

Like any digital signal, the production of the digital TV video signals requires pre-sampling filters to prevent the spectra from aliasing in the baseband spectrum and post-sampling filters to recover the analog signal by eliminating the unwanted replicated spectra. Let us recall that digital video signals are the result of the sampling of a 3-dimensional domain according to one temporal and two spatial axes. Considering the video information as a stochastic process leads to the spectrum and auto-correlation models developed in Chapter 3.

Chapter 2. TV and HDTV Coding Algorithms

Figure 2.5: Line positions in $y - t$ domain for HDP, HDI, EDP, EDI.

Figure 2.6: Reciprocal lattices in the $f_y - f_t$ domain for HDP, HDI, EDP, EDI.

Pre-Sampling Filtering

The pre-filtering may be subdivided in a temporal, spatial vertical and horizontal filtering. The temporal filtering originates from a remanence effect in the camera tube. The choice of this parameter is not obvious since a wide range of motions has to be taken into account extending from scenes with very slow motions (0-10 samples/40ms) up to those with fast motions (more than 10 samples/40ms). The vertical spatial pre-filtering is performed by defocusing the camera optics or the electron beam therefore, by modifying the spot size since the spot plays the role of an integrator of luminance over a finite region. The CCIR Commissions have determined, for digital television production, fixed templates for horizontal pre-filters so as to minimize the limitations on the inherent capabilities of the digital parameters, to guarantee to the coder an ability of being cascaded without accumulating annoying distortions. Practically, the recommended filters resulted from a trade-off among aliasing, ringing, blur and complexity. In the compromise, the Recommendation 601 proposed to combine a sharp cut-off filter to eliminate aliasing, additional shaping to control the ringing effect and adequate rise time in order to avoid smoothed object rendition.

Post-Sampling Filtering

The repetition of spectra along the vertical frequency axis is responsible for line structure visibility. Since no actual vertical low-pass filters are used in the display, the low-pass filtering property of the human eye and the finite size of the picture tube spot are the only way to eliminate that effect. The spectra repeated at multiples of the field frequency are responsible for the *large area flicker*. As shown in Figure 2.7, the interlaced spectra labeled b interfere with the limits of visibility whereas spectra labeled a do not. The interlaced formats have indeed spectra located at quincunx points responsible for the inter-line *flickering effect* or crenelated diagonal moving edges. The line flicker becomes visible if viewers move too close to the display. This is due to the scan lines which becomes too far apart from the viewer so that the 25 Hz display rate is no longer adequate for flicker rendition. The baseband for object and motion perception is quite smaller than the limits for effect like line structure and flickering perception. Let us remark that the flickering perception may range up to 70 Hz for very contrasted display. As a matter of fact, progressive scanned sources do not suffer from this kind of effect. Television takes also advantage of the temporal post-filtering effect of the eye which is more effective for fine details than it is for flat, low detail areas.

Progressive and Interlaced TV

Since its origin, analog TV is interlaced to balance technical and perceptual limits. A frame rate of 25 Hz is sufficient for motion perception whereas a field rate of 50 Hz is required for flickering perception reasons. Progressive scanning would require twice the transmission rate but offer additional advantages which justify a long-term disappearance of the interlaced realm. The advantages of the progressive scanning are as follows

1. the easiness of format conversions is a key feature which distinguishes the progressive from the interlaced formats. Indeed, the main characteristic which discriminates a

progressive-scanned format from another is actually the *spatial resolution*. Hence, pure spatial interpolators or decimators are required to translate one progressive format to another. Moreover, those conversion filters are *dyadic filters* of the multiresolution analysis. This demonstrates the easiness of converting progressive format. On the contrary, from a theoretical point of view, a general conversion system between interlaced formats requires spatio-temporal filters. Moreover, by looking at the sampling lattices in Figure 2.5, it turns out that conversions require to proceed through an intermediate progressive format in any case. For instance, a conversion from HDI to EDI needs to convert first the y-t HDI sampling lattice into the y-t HDP lattice. Thereafter, down-sampling is permitted since the right line positions are made available. The hierarchy of progressive formats stands as *the hierarchical backbone of format conversions and compatible applications as well.*

2. interlaced TV brings flickering problems and particularly in the visibility of the spectrum b displayed in Figure 2.7. This problem imposes 2/3 vertical filtering which is avoided in progressive TV. Consequently, progressive TV allows higher vertical resolution.

3. arising from the higher vertical correlation between successive lines, progressive TV yields higher vertical decorrelation efficiency.

4. simple vertical filtering of about 2/3 is sufficient to derive an interlaced picture from its progressive version as far as visual point of view is concerned. The progressive TV is compatible with the analog interlaced TV.

This demonstrates exhaustively the advantages of processing and transmitting progressive formats.

2.3 Theoretical Introduction to Coding

At this starting point, it is worthwhile introducing some fundamental principles relevant to the theoretical analysis of video sources in terms of the information theory. Rate-distortion functions and image correlation models are discussed to lay down some foundations of the video coding.

2.3.1 Rate-Distortion Function

The rate-distortion function $R(D)$ is thus the function which gives the minimum bit rate required to encode the digital video signal so as to be able to reconstruct the signal with a distortion D. Concomitantly, *information theory* states that the rate-distortion function defines the minimum channel capacity which is required to yield that distortion D. Both rate and distortion outline the challenge of developing coding methods which consist of either minimizing the distortion at fixed rate or conversely. When video and speech are considered for compression, transmission and reconstruction, the classical objective measure of distortion, which evaluates the mean distance between original and reconstructed data, i.e. the mean squared error, turns out not to be fully adequate as arising from

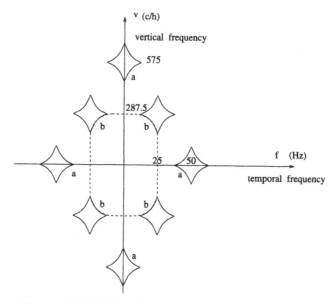

Figure 2.7: Visibility limits of the interlaced TV format.

subjective viewing effects. Hence, extensions of the concept of distortion will be proposed in this chapter when examining the quantization process.

In any case, the rate-distortion function $R(D)$ of a time-discrete continuous-amplitude source gives the bit rate necessary to transmit the source with a distortion D. In case of stationary Gaussian signals the rate-distortion function denoted R_G is analytically known and achieves the upper bound of all non-Gaussian sources [70]. This means

$$R(D) \leq R_G(D) \tag{2.20}$$

Since the video signal may not currently be modeled as either a Gaussian or a stationary process, the practical and the analytical use of the rate-distortion function $R_G(D)$ remains somewhat limited.

2.3.2 2-D Correlation and Spectrum for Image Models

It is generally agreed in the literature [33] that non-separable 2-D autocorrelation models fit real image data more adequately than separable correlation models, the generalized-isotropic correlation models have been defined for two-dimensional HDTV signal x(k,l) by means of an elliptical autocorrelation function

$$R_{xx}(k, l) = \sigma_x^2 e^{-\sqrt{\beta_h^2 k^2 + \beta_v^2 l^2}} \tag{2.21}$$

where the coefficients β_h and β_v are related to the first-order horizontal and vertical prediction or correlation coefficients ρ_h and ρ_v respectively by $\beta_h = -ln\rho_h$ and by $\beta_v = -ln\rho_v$. F. Bosveld has proposed in Reference [29] typical values fitting for natural HDTV sequences and set $\beta_v = \beta_h = 0.05$. The corresponding power spectrum is formulated as

$$S_{xx}(\omega_1, \omega_2) \;=\; \frac{2\pi\sigma_x^2}{\beta_h\beta_v} \frac{1}{\left[1 + \left(\frac{\omega_1}{\beta_h}\right)^2 + \left(\frac{\omega_2}{\beta_v}\right)^2\right]^{\frac{3}{2}}} \tag{2.22}$$

with $\sigma_x^2 = 1$ the variance of the source. The periodic power spectrum $S_{xx}(e^{j\omega_1}, e^{j\omega_2})$ of the pre-filtered time-discrete HDTV signal $x(m,n)$ is modeled by truncating $S_{xx}(\omega_1, \omega_2)$ to $\omega_1, \omega_2 \in [-\pi, \pi]$,

$$S_{xx}(e^{j\omega_1}, e^{j\omega_2}) \;=\; S_{xx}(\omega_1, \omega_2) \in [-\pi, \pi] \tag{2.23}$$

The mean-square-error rate-distortion function of a two-dimensional time-discrete stationary Gaussian source x(m,n) with power spectrum $S_{xx}(e^{j\omega_1}, e^{j\omega_2})$ leads to [83]

$$R(\theta) \;=\; \left(\frac{1}{2\pi}\right)^2 \int_{-\pi}^{\pi}\int_{-\pi}^{\pi} \max\left[0, \frac{1}{2}log_2\left(\frac{S_{xx}(e^{j\omega_1}, e^{j\omega_2})}{\theta}\right)\right] d\omega_1\, d\omega_2 \tag{2.24}$$

and

$$D(\theta) \;=\; \left(\frac{1}{2\pi}\right)^2 \int_{-\pi}^{\pi}\int_{-\pi}^{\pi} \min[\theta, S_{xx}(e^{j\omega_1}, e^{j\omega_2})] d\omega_1\, d\omega_2 \tag{2.25}$$

where $R(\theta)$ and $D(\theta)$ stand respectively for the *rate* and the *distortion* per pixel of an optimally coded signal as a function of the coding parameter θ. $R(\theta)$ represents the lower bound of the rate achievable by a coding algorithm with distortion $D(\theta)$. As presented by Bosveld in [29] and reported in Figure 2.8, the parameter θ plays the role of a threshold beyond which (area 1) all the frequency components with $S_{xx}(e^{j\omega_1}, e^{j\omega_2}) < \theta$ are coded and transmitted and beneath which (area 2) all the frequency components with $S_{xx}(e^{j\omega_1}, e^{j\omega_2}) > \theta$ are not transmitted. The resulting shaded distortion $D(\theta)$ may be split in two parts

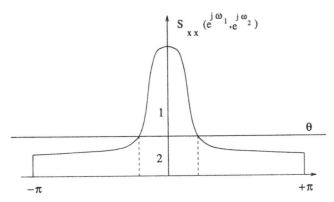

Figure 2.8: Optimum source coding.

1. the in-band noise corresponding to the quantization noise of the coded and transmitted frequencies.

2.3. Theoretical Introduction to Coding 99

2. the out-band noise corresponding to missing frequencies which are not transmitted.

As matter of fact, the error spectrum $S_{ee}(e^{j\omega_1}, e^{j\omega_2})$ takes the expression which follows

$$S_{ee}(e^{j\omega_1}, e^{j\omega_2}) = \begin{cases} \theta & \text{if } S_{xx}(e^{j\omega_1}, e^{j\omega_2}) > \theta \\ S_{xx}(e^{j\omega_1}, e^{j\omega_2}) & \text{if } S_{xx}(e^{j\omega_1}, e^{j\omega_2}) < \theta \end{cases} \qquad (2.26)$$

This stands as the error spectrum of an optimally coded Gaussian source. Therefore, when the error spectrum cannot be represented in form of Equation 2.26, it follows that the associated source is not encoded optimally.

Both the rate in Equation 2.24 and the distortion functions in Equation 2.25 are determined by the power spectrum $S_{xx}(e^{j\omega_1}, e^{j\omega_2})$. The shape of this spectrum can be compactly described by the *spectral flatness measure* γ_x^2 as the ratio

$$\gamma_x^2 = \frac{\exp\left[\left(\frac{1}{2\pi}\right)^2 \int_{-\pi}^{\pi} \int_{-\pi}^{\pi} \ln[S_{xx}(e^{j\omega_1}, e^{j\omega_2})] d\omega_1 d\omega_2\right]}{\left(\frac{1}{2\pi}\right)^2 \int_{-\pi}^{\pi} \int_{-\pi}^{\pi} [S_{xx}(e^{j\omega_1}, e^{j\omega_2})] d\omega_1 d\omega_2} \qquad (2.27)$$

which ranges in the interval $[1, 0]$. For a white noise, $\gamma_x^2 = 1$ (the source is uncorrelated, $S_{xx}(e^{j\omega_1}, e^{j\omega_2})$) and there is no coding gain to be expected. This measure decreases with the degree of correlation and hence the signal predictability. Accordingly, the expected coding gain increases and the signal can be coded with a lower rate at a given distortion compared to the previous uncorrelated case.

2.4 Techniques of Signal Decomposition

In this part of the chapter, different techniques of decomposing the digital image sequences are examined in order to derive *operators providing efficient decorrelation performances and powerful analysis capabilities*. These tools of signal processing will be exploited to transform adequately the incoming video information in such a manner to yield optimum rate-distortion compression performances from quantization and variable-length entropy coding. The *quantization process* has to be fed with information so amenable as to take into account the psycho-visual properties of the Human Visual System. The *variable-length entropy coder* aims at processing data streams structured into a minimum number of independent sources displaying each specific and significantly different statistics. The compression carried out by the quantizer is irreversible and introduces a quantization noise which should be as smooth as possible with respect to the current human visibility to introduce graceful degradations. The entropy coding is a reversible process which aims at removing up signal redundancy.

As already mentioned, the tools of signal analysis to be employed are relevant to linear transformations. Historically speaking, the research in the field has successively investigated tools which can be seen at first sight as generalizations of each other. However, strong ties exist among each other in the sense that they all express a finite signal expansion on a base in Hilbert space. The techniques to be examined in this chapter are namely, the Differential Pulse Code Modulation (DPCM), the Linear Block Transforms

(BT), the Lapped Orthogonal Transform (LOT), the Subband Filtering Technique (SBT), the Short-Time Fourier Transform (STFT), the Wavelet Transform (WT) and the Wavelet Packets (WP). All these techniques of signal analysis and decomposition share a common interconnected framework of relationships sketched in Figure 2.9. All of the operators of signal processing considered in this textbook are linear and utilized under the assumption that the input signal to be processed is a stochastic signal. The information extracted from the signal consists indeed of PDF's, correlations, spectrum contents,... Like speech and audio signals, the sequences of digital images belong to the realm of the stochastic processes when neither precise geometrical interpretation nor content recognition are actually intended to be carried out. The information extracted from the signal consists only of PDF's, correlations, spectrum contents,... Let us comment briefly this important hypothesis made on the nature of the video source. The analysis efficiency may be simply measured in terms of *decorrelation, energy compaction or DPCM-relative coding gain.* Other criteria will be added later in this chapter. To achieve decorrelation i.e. optimum compaction of pixel energy into a minimum number of transform coefficients, the source needs to be modeled in a statistical way and, especially, by the covariance structure of the signal. The analysis coding architectures developed at the end of the chapter will rely on *hybrid coding techniques* which combine linear multiresolution analysis and decomposition operators applied spatially on an image-to-image basis and temporal motion-compensated DPCM techniques. The latter tool is composed of two phases, namely a *motion estimation* and a *motion compensation* and aims at removing temporal correlations.

Figure 2.9: Overview of the tools involved in signal decomposition.

The family of linear operators examined in this chapter is referred to as the *first generation of coding.* In further extensions, the algorithms refer to the *second generation of coding* where it is intended to perform in-depth signal analysis with non-linear procedures. Let us mention, for instance, contour and texture segmentations, fractal coding, morphological analysis. In this generation, the attempt to analyze signals progresses one step ahead beyond the present techniques. Exploiting linear and non-linear tools, the latter operators may extract additional non-linear correlations and constitutive image structures. They can potentially analyze the signal more efficiently and consequently contribute to compress more drastically the information to be transmitted on the channel.

2.4.1 Principle of Predictive Coding Techniques

Historically speaking, the predictive coding technique has been the first tool employed to reduce or remove video signal redundancy or correlation. This technique assumes that the signal can be modeled as an auto-regressive process. A linear auto-regressive predictor of order N builds an estimate of the new sample to be encoded by means of a weighted sum which can be seen as the particular case of a linear filtering problem. The model is formulated as follows

$$\hat{x} = \sum_{i=1}^{N} h_i x(n - i) \tag{2.28}$$

where \hat{x} is the predicted signal which can be optimized so as to yield the minimum-mean-squared prediction error. In the stationary case, this problem leads to the Yule-Walker equations which can be solved using for instance the Levinson algorithm. In the non-stationary case, optimum adaptive filtering is the rule. Both latter and former cases correspond to solutions of the Wiener and the Kalman filters respectively. The estimated or predicted signal is not transmitted as such, but the difference between the original samples and a prediction built from the previous samples. Consequently, this technique is called *Differential Pulse Code Modulation* (DPCM). The difference signal is called the *innovations sequence* if the generation process is perfectly modeled. Under this assumption, the innovations sequence behaves as a white Gaussian noise. The DPCM coding and decoding technique is sketched in Figure 2.10. As presented in the figure, the error signal is quantized and entropy coded. The distortion stems from the quantization process applied to the prediction errors. It is easily shown in [13] that at fixed bit rate the quantization error variance is proportional to the quantized-signal variance. Hence, the coding gain G_P of a DPCM method against a pure Pulse Code Modulation is measured by the ratio $\frac{\sigma_{\hat{x}}^2}{\sigma_d^2}$ of the incoming signal variance and the prediction error variance. Furthermore, it is also shown in [13] that this ratio is upper-bounded by the inverse of the spectral flatness measure in the class of the linear predictor. Nevertheless, it will turn out in Chapter 4 that the predictors, which are optimum in the sense of the minimum-mean-square-estimate, are in essence non-linear predictors. Further comments about this important topic are treated in the local chapter conclusions.

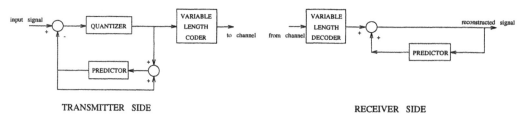

Figure 2.10: DPCM coding and decoding technique.

By means of its own construction, the DPCM technique does not provide any hierarchical or progressive representation of the incoming signal. Hence, it can not be used as such to yield those important coding properties. However, DPCM can be regarded

Chapter 2. TV and HDTV Coding Algorithms

as a particular case of block transform or subband filtering. As a specificity of image sequence processing, the DPCM technique will be enhanced with motion compensation and employed as an efficient decorrelation process along the temporal axis. To avoid any *mismatch* and any *drift* between coding and decoding operations, it is compulsory that the encoder builds its prediction by means of the information strictly available at decoder side. This constraint will turn out to be crucial in TV-HDTV *compatible applications*.

Coding Performance Measures

The coding techniques to be studied are usually compared on the basis of the reconstruction error which can be considered as an *objective measure of image quality* at the decoder display. The coding performances are measured on a common base of comparison which is taken as the PCM. PCM may be regarded as a particular case of transform coding technique wherein the transform matrix B is the identity matrix. In this special case, $Y = X$ and the mean square reconstruction error is

$$\sigma_\epsilon^2 = \frac{1}{N} E[\tilde{X}^T \tilde{X}] \tag{2.29}$$

where $\tilde{X} = X - \hat{X}$ stands as the reconstruction error expressed as the difference between the original X and the reconstructed \hat{X} signals. The transform performance measures the gain of the transform coding over PCM and compares σ_ϵ^2 for the analysis technique under consideration (block transform, subband , wavelet) to that for PCM. Hence, the *coding gain* is defined

$$G_{TC} = \frac{\sigma_\epsilon^2(PCM)}{\sigma_\epsilon^2(TC)} \tag{2.30}$$

Particular expressions of this relationship are provided in the section devoted to quantization.

2.4.2 Decorrelation Operators

In this section, the general principles of the decorrelation technique are first presented as an introduction to the first family to be studied, the block transforms. Among that family, the Karhunen Loeve Transform (KLT) and the Discrete Cosine Transform (DCT) play an important role when signal decorrelation is the major property required to the operator. In fact, no freedom is actually left to take into account further criteria. This latest argument has effectively contributed to consider alternative decomposition operators like subband or wavelet techniques to be examined next. The definition context of the decorrelation is first presented in its original version to process statistical data. Otherwise mentioned when considering adaptive filters, the incoming video signals are considered as wide-sense stationary processes.

2.4.2.1 Principle of Decorrelation Technique

The principle of any decorrelation procedure has been developed by Hotelling [1933] who stated that the optimum decorrelation of a set of experimental points in a N-dimensional

Figure 2.11: Decorrelation principle of a set of experimental points.

space is obtained *by removing as far as possible the explicable content* (i.e. the redundancy - the correlation) leaving an unexplicated fraction called the *innovative information*. This innovative information is measured by its energy. In fact, the explanatory information is contained in the *spectral modes or the eigenvectors of the covariance matrix* of the original set of points. The decorrelation operation is equivalent to a *linear transformation* of the current orthogonal coordinate axes into those of the eigenvectors to be considered as the axes of inertia of the set of points (Figure 2.11 in a three-dimensional space). The transformation behaves such that it minimizes the squared distance of the points to the eigen-axes i.e. the energy to be encoded. The properties of this operator are the following: a vector of N random variables $X[x(1), ..., x(N)]$ is transformed into a vector Y of N uncorrelated variables $Y = [y(1), ..., y(N)]$, the transformation matrix B is orthogonal and such that

1. $\sigma^2 [y(1)]$ is maximum.

2. $\sigma^2 [y(2) \mid y(2)$ is decorrelated with $y(1)]$ is maximum.

3. $\sigma^2 [y(3) \mid y(3)$ is decorrelated with $y(1)$ and $y(2)]$ is maximum.

4.

where σ^2 stands for the variance. Let us characterize the N random variables as part of a wide-sense stationary signal whose statistical properties are as follows. The mean is constant and equal to m and independent of n

$$m = E[x(n)] \tag{2.31}$$

the autocorrelation simplifies to R(n+k,n)=r(k) and is given by

$$R(k) = E[x(n)x(n+k)] \tag{2.32}$$

then, the autocovariance

$$C(k) = E\{[x(n) - m][x(n+k) - m]\} \tag{2.33}$$

The autocorrelation and autocovariance matrices of X are respectively

$$R_{XX} = E[XX^T] \tag{2.34}$$
$$\Gamma_{XX} = E[(X-m)(X-m)^T] \tag{2.35}$$

and m is the vector of components equal to the mean of the $x(i)$. The sign T holds for the matrix transposition. $\Gamma(X)$ is positive semi-definite and symmetrical. The eigenvalues are non-negative and ordered as $\gamma_1 \geq \gamma_2 \geq \gamma_3$.... In the case of a video signal processed by a linear block transform, each block may take a vector representation and constitutes a point in an Hilbert space. All the blocks of an image form a set in a space of dimension equal to the dimension of vectors. The linear transformation will refer the points to the eigen-axes. Each transform vector is a set of transform coefficients which nothing else than the coordinates along the new Hilbert basis.

For a wide-sense stationary signal, the correlation matrix is usually expressed by removing the mean (covariance) and by introducing the coefficient of correlation $\rho(k) = \frac{R(k)}{\sigma^2}$ with $\rho(0) = 1$

$$R = \sigma^2 \begin{vmatrix} 1 & \rho(1) & \cdots & \rho(n-1) \\ \rho(1) & 1 & \cdots & \rho(n-2) \\ \cdots & \cdots & \cdots & \cdots \\ \rho(N-1) & \rho(N-2) & \cdots & 1 \end{vmatrix} \tag{2.36}$$

This matrix is well-known in the field of stochastic processes under the appellation of Toeplitz matrix. $R(0) = E[|x(n)|^2] = \sigma^2$ represents the energy in the signal samples. A typical simple source model is the first order autoregressive sequence denoted AR(1) expressed as

$$X(n) = \rho X(n-1) + W(n) \tag{2.37}$$

where $W(n)$ holds for a noise process, ideally a white Gaussian noise with $E[w(n)W(n+k)] = \sigma_N^2 \delta(k)$; therefore, $\sigma_N^2 = (1-\rho^2)\sigma_X^2$ and the autocorrelation is then $R(k) = \sigma^2 \rho^{|k|}$. and, finally, the power spectral density is given by $S_{XX}(e^{j\omega}) = \frac{1-\rho^2}{1+\rho^2-2\rho\cos\omega}$. For example, $\rho = +0.85$ in speech sources and $+0.95$ in still pictures.

The orthogonal transformation is defined by a matrix B ($N \times N$) such that

$$B^T \Gamma(X) B = diag(\gamma_1\gamma_2....\gamma_N) = D_N \tag{2.38}$$

2.4. Techniques of Signal Decomposition

where *diag* stands for a diagonal matrix of order N with N diagonal elements. The transformation is unitary and orthogonal i.e.

$$B^T B = I_N \tag{2.39}$$

with I_N the unity matrix of order N. The properties of the linear transformation $X = m + BY$ are as follows. For the ease of the notation, let us assume $m = 0$

1. $\sigma^2[y(i)] = \gamma_i, \forall\, i{=}1...N$.

2. $y(1)$ is therefore of the maximum variance.

3. $\sigma^2[y(1)] \geq \sigma^2[y(2)] \geq \sigma^2[y(3)]..... \geq \sigma^2[y(N)]$.

4. $E[Y(X)^T] = D_N B^T$ implies $cov[y(i), x(k)] = \gamma_i B(i, k)$
 where *cov* stands for the covariance.

5.

$$
\begin{aligned}
cov[Y] &= E[YY^T] && (2.40) \\
&= E[BXX^T B^T] && (2.41) \\
&= BR_X B^T && (2.42)
\end{aligned}
$$

6. the unitary transform preserves the energy

$$
\begin{aligned}
E[X^T X] &= \sum_{n=1}^{N} \sigma_X^2 && (2.43) \\
&= E[X^T (B^T B)X] && (2.44) \\
&= \sum_{n=1}^{N} \sigma_Y^2 && (2.45)
\end{aligned}
$$

The percentage p_k of explanation (i.e. of variability or of inertia) furnished by the k first axes is given by

$$p_k = \frac{\sum_{i=1}^{k} \gamma_i}{\sum_{i=1}^{N} \gamma_i} \tag{2.46}$$

This theory is applied in extenso in the field of image coding where the vectors X and Y become $N \times N$ matrices, X is a square block of N by N pixels taken within the image and a linear matrix transformation is applied. This optimal decorrelation with a linear matrix transformation which satisfies the previous properties of Hotelling is referred to as the Karhunen Loeve transform [1949]. This transformation is defined by the eigenvectors of the matrix of autocovariance and, hence, concentrates the energy on a minimum number of transform coefficients of the lowest orders. The autocovariance matrix is estimated here over the whole image. To model the image pixel redundancy by a simple realistic approach, let us consider a one-dimensional signal x with a pixel-to-pixel correlation of the form $R_{XX}(u, t) = a^{|t-u|}$ ($t \in [0, T]$ where T is the line period), the kernel functions of the Karhunen-Loeve transformation (KLT) are given by the solutions of the eigenfunction equation

$$\gamma_i f_i(t) = \int_0^T a^{|t-u|} f_i(u) du \tag{2.47}$$

which is solved by using an admissible function f_i of the form of an imaginary exponential to be decomposed in a sine and a cosine function. The calculus proceeds by deriving the two following eigenfunctions

$$f_i(t) = A \cos[\pi f_0(t - \frac{T}{2})\vartheta_i] \quad \text{with} \quad i \quad \text{odd} \tag{2.48}$$

and

$$f_i(t) = A \sin[\pi f_0(t - \frac{T}{2})\vartheta_i] \quad \text{with} \quad i \quad \text{even} \tag{2.49}$$

with $f_0 = \frac{1}{2\pi} \ln \frac{1}{a}$ and with ϑ_i the solutions of

$$\tan(\pi f_0 T \vartheta_i) = \begin{cases} -\vartheta_i & \text{for } i \quad \text{even} \\ \frac{1}{\vartheta_i} & \text{for } i \quad \text{odd} \end{cases} \tag{2.50}$$

Finding eigenfunctions with the form of sine or cosine functions explains the importance of the Discrete Cosine Transform (DCT) as a sub-optimum solution of the KLT in image coding. Optimality is reached provided that the pixel sequences correspond to a Markovian model of the first order with a positive coefficient of correlation. Typically, this coefficient is of the order of +0.95 for still images and slightly smaller for moving pictures. The Discrete Sine Transform (DST) meets the same property in case of a negative coefficient of correlation which obviously does not fit for the picture content. This explains the wide spread use of the DCT which is moreover easily implemented in hardware with fast butterfly algorithms.

Unfortunately, the natural speech and video signals are intrinsically non-stationary signals which do not meet exactly the previous theory. This implies that the statistical properties of the signal are time-varying and that consequently adaptive transformation operators are necessary to maintain constant transform efficiencies. As explained later in the chapter, this justifies the motivation to develop optimum transform operators based on signal-adaptive techniques ruled by cost functions to be optimized. To characterize and compare the efficiency of energy compaction in unitary transforms, Clarke and Jain have developed performance indices

1. *Clarke's measure of efficiency* [1985]
 This measure of decorrelation efficiency compares the sum of the off-diagonal terms in matrices R_X and R_Y. They are respectively given by

$$\lambda_X = \sum_{i=1}^{N-1} \sum_{\substack{j=1 \\ i \neq j}}^{N-1} |R_{XX}(i,j)| \qquad \lambda_Y = \sum_{i=1}^{N-1} \sum_{\substack{j=1 \\ i \neq j}}^{N-1} |R_{YY}(i,j)| \tag{2.51}$$

 therefore, the decorrelation efficiency is

2.4. Techniques of Signal Decomposition

$$\eta_C = 1 - \frac{\lambda_Y}{\lambda_X} \tag{2.52}$$

Complete spectral decorrelation is achieved whenever $\eta_C = 1$.

2. *Jain's measure of efficiency* [1989]

 This parameter measures the energy compaction property of a transformation. The efficiency is defined as the fraction of the total energy in the first L components of Y where the σ_Y are indexed according to decreasing value. That is

$$\eta_J = \frac{\sum_{r=1}^{L} \gamma_r}{\sum_{r=1}^{N} \gamma_r} \tag{2.53}$$

The unitary transform which achieves $\eta_C = 1$ and minimizes η_J performs an optimum decorrelation. This is in essence the KLT.

2.4.2.2 Principle of Block Transform

Block transforms find their origin in a matrix reformulation of the orthonormal expansion theory. The matrix notation provides easy manipulations and interpretation. The idea of the signal expansion in orthogonal functions will be treated into details later in the chapter when defining the Hilbert spaces. Conceptually, the expansion projects the signal on a basis of orthogonal functions in a way which is similar to the theory of linear vector spaces. To illustrate the operation, let us consider a sequence $\{f(k)\}$ taken out of a discrete signal and defined on the interval $0 \le k \le N - 1$. The sequence $\{f(k)\}$ may be viewed as an N-dimensional vector \bar{f} and decomposed into N components verifying the properties established for Euclidean spaces. Therefore, $\bar{f} = f_0 e_0 + f_1 e_1 + \ldots + f_{N-1} e_{N-1}$ and $\{f(k)\}$ is represented as a point of coordinates (f_0, \ldots, f_{N-1}) in the N-dimensional Euclidean space spanned by the basis vectors (e_0, \ldots, e_{N-1}). If we can define a family of N linearly independent sequences on an interval $[0, N-1]$, $\{x_n(k); \ 0 \le k \le N-1 ; \ 0 \le n \le N-1\}$. This family is an *orthonormal basis* if and only if

$$\sum_{k=0}^{N-1} x_n(k) x_s^*(k) = \delta(n - s) \tag{2.54}$$

where the symbols $*$ and δ denote respectively the complex conjugation and the Kronecker function. Hence a function $f(k)$ defined on the interval $[0, N-1]$ can be uniquely represented by the orthogonal expansion as

$$f(k) = \sum_{n=0}^{N-1} \phi_n x_n(k) \qquad 0 \le k \le N - 1 \tag{2.55}$$

where ϕ_n is the coordinate or the projection of $f(k)$ on the n^{th} basis axis or function. This projection is expressed as

$$\phi_r = \sum_{k=0}^{N-1} f(k) x_r^*(k) \qquad 0 \le k \le N - 1 \tag{2.56}$$

The set of coefficients $\{\phi_n;\ 0 \le n \le N-1\}$ is called the *spectral coefficients* regardless of the sinusoidal nature of the basis functions. In fact, Equation 2.56 suggests that the spectral coefficients are derived from FIR filters.

The *block transformations* are matrix operators applied on image blocks of size $[N \times N]$. Usually, N equals 4, 8 or 16. The transformation equations are expressed as follows

1. the *direct transformation*

$$y(k,l) = \sum_{i=0}^{N-1} \sum_{j=0}^{N-1} x(i,j) H(k,l,i,j) \qquad (2.57)$$

2. the *inverse transformation*

$$x(i,j) = \sum_{k=0}^{N-1} \sum_{l=0}^{N-1} y(k,l) G(k,l,i,j) \qquad (2.58)$$

with $x(i,j)$ and $y(k,l)$ respectively the original pixel values and the *transform or the spectral coefficients*. $H(k,l,i,j)$ and $G(k,l,i,j)$ are respectively the *kernels* of the direct and inverse transformations. Evidently, in matrix notation, $Y = HX$ and $X = GY$. Obviously, the original vectors are reconstructed as linear combination of the inverse transformation matrix columns. The latter columns are referred to as being the *basis functions*. The class of *orthogonal transform* fulfills the property $H^{-1} = (H^*)^T$, asserting that the inverse of H is its conjugate transpose, defines a *unitary* transform. The Parseval relation shows readily that a unitary transform is *energy preserving*.

Among the block transforms, the Discrete Fourier Transform (DFT), the the Discrete Cosine and Sine Transform (DCT - DST), the Karhunen-Loeve Transform (KLT) and Hadamard Transform (HT) are particular cases which are worth mentioning. As earlier explained, the KLT is optimum for decorrelation and diagonalizes the covariance matrix of the incoming signal. DCT is a sub-optimum solution currently used in all the presently standardized TV coders. DCT, DST and DFT provide quite efficient localizations of energy in frequency but have poor spatial localization properties. HT has converse localization properties.

Discrete Cosine Transform

The DCT is defined as follows

$$y(i) = \frac{c(i)}{\sqrt{N}} \sum_{k=0}^{N-1} \cos\left(\frac{i\pi(2k+1)}{2N}\right) x(k) \qquad 0 \le i \le N-1 \qquad (2.59)$$

where

$$c(i) = \begin{cases} 1 & i = 0 \\ \sqrt{2} & \text{otherwise} \end{cases} \qquad (2.60)$$

The impulse responses of the analysis and synthesis filters are respectively given by

$$h_i(n) = \frac{c(i)}{\sqrt{N}}(-1)^i \cos\left(\frac{i\pi(2n+1)}{2N}\right) \tag{2.61}$$

$$g_i(n) = \frac{c(i)}{\sqrt{N}} \cos\left(\frac{i\pi(2n+1)}{2N}\right) \tag{2.62}$$

This block transform may be seen as a modulated filter bank where the cosine functions modulate a prototype filter simply defined in this case by $h_p = 1$. This remark opened the research towards a new family of filter bank called the *windowed cosine modulated filters* which is described later in this chapter.

Hadamard Transform

Hadamard transform defines matrix operators of size $N = 2^p$ through a recursive construction which starts with

$$H_1 = \frac{1}{\sqrt{2}}\begin{bmatrix} 1 & 1 \\ 1 & -1 \end{bmatrix} \tag{2.63}$$

and proceeds as

$$H_{2N} = \frac{1}{\sqrt{2}}\begin{bmatrix} H_N & H_N \\ H_N & -H_N \end{bmatrix} \tag{2.64}$$

$$= H_1 \otimes H_N \tag{2.65}$$

where \otimes indicates the Kronecker product. The z-transforms of the analysis filters are constructed according to p as

$$H_i(z) = (1 \pm z^{-1})(1 \pm z^{-2}) \cdots (1 \pm z^{-p}) \tag{2.66}$$

This implies that any Hadamard transform is always amenable by cascading successive elementary transformations of order 2. Owing to the symmetric property of the matrix, the inverse transformation is related to the direct operator as $G_i(z) = \frac{H_i(z)}{2^k}$. Hadamard transform was used in the early stage of video coding for its simplicity. In spite of its poor frequency localization, the transform offers efficient space localization properties.

2.4.3 Principle of Subband Coding

As evidenced in previous chapters, the use of block transform as a tool for signal analysis is indicated when decorrelation is only performance requiring optimization. Among them, the class of Fourier transforms (DCT) achieves good frequency localizations and enables the introduction of weighting factors in the quantization procedure to adequately take into account the frequency response of the Human Visual System. The motivation to introduce new criteria of analysis has forced the introduction of new tools of signal analysis like

the *subband coding technique*. The principle of this method consists of decomposing the input TV spectrum into several components called the subbands. The decomposition is performed by convolutional filter banks called the *analysis filters* at the encoder side. The reconstruction performed at the decoder side is achieved by another set of convolutional filters, *the synthesis filters*. This technique provides effectively the signal decomposition with additional degrees of freedom and widens the signal analysis to take into account not only the decorrelation but also other properties like the phase linearity, the regularity, the space-frequency localizations and tilings, the orthogonality or the bi-orthogonality of the analysis-synthesis bases and the perfect reconstruction of the signal on the decoder side. These properties are developed later in this chapter since any subband family leads to associated wavelets. In any case, the ultimate objective in video coding is to optimize the rate-distortion function.

This section starts with elementary concepts relative to the *multirate signal processing* theory which stands for a basis to tackle subband decomposition theory. Among the subjects to be studied, let us mention the down-rate sampling and the up-rate sampling operations in connection with the polyphase representation. They are intended to be first investigated in the following. The presentation keeps on describing the two-band and M-band filter bank decompositions. As linear expansions of signal within a Hilbert space, the subband coding technique shares strong ties with namely the block transforms, the lapped orthogonal transforms and the wavelet transforms and packets. Figure 2.12 illustrates the frequency content of a four-subband decomposition (four-tap Daubechies filters) iterated two times on the lower band performed with perfect reconstruction orthogonal filters.

2.4.3.1 Multirate Signal Processing

As an outgrowth of digital signal processing, the applications of multirate signal processing are presently numerous and cover a wide variety of engineering areas like speech or audio processing, antenna, radar and communication systems. A *multirate system* implies that the digital signal is manipulated at different clock rates along the processing procedure depending on local processes activated in the system. Accordingly, this study will treat and interpret in both time and frequency domains the basic sampling rate converters referred to as being the *decimator* and the *interpolator*. The *polyphase representation* is thereby introduced as a powerful tool for filter synthesis. This latter concept on which subband decomposition techniques are analyzed is intensively used in the literature and shares similarities with the formalism exploited in the theory of electrical circuits and alternating currents. It is worth spending some efforts to examine the topic with a sufficient depth to understand carefully the principles of multirate signal decompositions.

2.4.3.2 Down-Sampling or Decimation

The operation of *down-sampling or decimating* is defined as the linear periodically-time-varying procedure which reduces the original sampling rate f_s of the digital signal by an integer factor M to reach the frequency $\frac{f_s}{M}$. Clearly, the input-output relationship in time-domain between $y(n)$, the down-sampled signal version, and $x(n)$, the original signal, is

$$y(n) = x(Mn) \tag{2.67}$$

This process is currently depicted in coding diagrams as an encircled downward arrow flanked by the decimation factor M. As described hereafter, the down-sampling operation is in fact composed of two tightly related operations namely an anti-aliasing low-pass filter cascaded by a subsampling procedure. To obtain the relationship in the z-transform domain between $y(n)$, and $x(n)$, let $u'(n)$ be an intermediate signal defined as

$$u'(n) = \begin{cases} u(n) & \text{if } n = 0, \pm M, \pm 2M, \dots \\ 0 & \text{otherwise} \end{cases} \tag{2.68}$$

to represent $u(n)$ at the reduced sampling rate

$$y(n) = x(Mn) = u'(Mn) \tag{2.69}$$

It is zeroed otherwise. A convenient mathematical interpretation is yielded when considering $u'(n)$ as result of multiplying $W(n)$ by a train $i(n)$ of Dirac impulses periodically spaced with frequency $\frac{f_s}{M}$, that is

$$\begin{aligned} u'(n) &= i(n)u(n) \tag{2.70} \\ &= \sum_{r=-\infty}^{+\infty} \delta(n - rM)u(n) \tag{2.71} \\ &= \frac{1}{M} \sum_{k=0}^{M-1} e^{i\frac{2\pi}{M}nk}u(n) \tag{2.72} \end{aligned}$$

where the train of M-periodic Dirac pulses has been expressed in a discrete Fourier series representation [69]. Applying z-transform, $u'(n)$ becomes

$$\begin{aligned} U(z) &= \frac{1}{M} \sum_{k=0}^{M-1} Z\{x(n)[e^{j\frac{2\pi}{M}k}]^n\} \tag{2.73} \\ &= \frac{1}{M} \sum_{k=0}^{M-1} X(ze^{-j\frac{2\pi}{M}k}) \tag{2.74} \\ &= \frac{1}{M} \sum_{k=0}^{M-1} X(zW^k) \tag{2.75} \end{aligned}$$

where $W = e^{-j\frac{2\pi}{M}}$. To figure out the frequency responses, the calculation of the Fourier transform consists in evaluating the z-transform on the unit circle and, by simply letting $z = e^{j\omega}$ to deduce

$$U'(e^{j\omega}) = \frac{1}{M} \sum_{k=0}^{M-1} X(e^{j(\omega - \frac{2\pi}{M}k)}) \tag{2.76}$$

2.4. Techniques of Signal Decomposition 113

The spectral interpretation is quite straightforward since the original spectrum gets repli-cated M times according to a sum of terms whose frequency responses are regularly spaced of $\frac{2\pi}{M}$ apart. The phenomenon leads to an *aliasing effect* arising from the superposition of the replicated spectra. As a matter of fact, in order to avoid aliasing, the bandwidth of the original signal to be decimated has to be first restricted by a low-pass filter limit-ing the bandwidth down to $\frac{\pi}{M}$. This explains the necessity of implementing *anti-aliasing filters* prior to any subsampling operation.

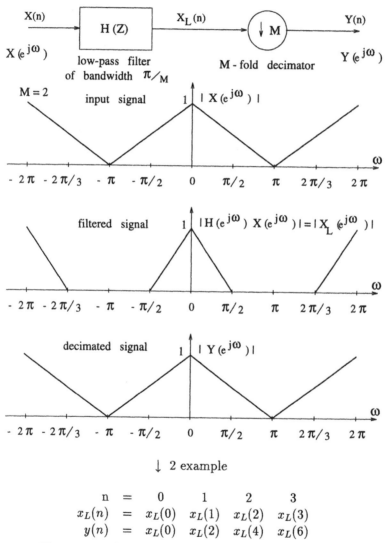

$$\begin{array}{cccccc}
\text{n} & = & 0 & 1 & 2 & 3 \\
x_L(n) & = & x_L(0) & x_L(1) & x_L(2) & x_L(3) \\
y(n) & = & x_L(0) & x_L(2) & x_L(4) & x_L(6)
\end{array}$$

Figure 2.13: Subband coding: analysis and decimation.

Going back to Equation 2.69 in the z-transform domain, the output signal is given by

$$Y(z) \;=\; \sum_{n=-\infty}^{+\infty} u'(Mn)z^{-n} \tag{2.77}$$

$$=\; \sum_{k=-\infty}^{+\infty} u'(k)[z^{\frac{1}{M}}]^{-k} \tag{2.78}$$

$$=\; U'(z^{\frac{1}{M}}) \tag{2.79}$$

$$\tag{2.80}$$

using Equation 2.75, the final input-output relationship is given by

$$Y(z) \;=\; \frac{1}{M}\sum_{k=0}^{M-1} X(z^{\frac{1}{M}}W^{k}) \tag{2.81}$$

stating the resulting equation on the unit circle, the frequency response is re-expressed as

$$Y(e^{j\omega}) \;=\; \frac{1}{M}\sum_{k=0}^{M-1} X(e^{j\frac{\omega-2\pi k}{M}}) \tag{2.82}$$

The meaning of this equation is rather immediate, the subsampling in the time-domain forced by discarding $M-1$ zeroed samples among M is accompanied in the frequency domain by a stretch of factor M such that a spectrum in the interval $(0,\frac{\pi}{M})$ is transform to occupy the interval $(0,2\pi)$. The stretch in frequency is expressed in the power $\frac{1}{M}$ contained in the exponential term. To avoid aliasing effects, the bandwidth of the original signal is reduced to $\pm\frac{\pi}{M}$ prior to down sampling. Accordingly, this anti-aliasing filter implies a loss of information which limits the maximum resolution at the Nyquist frequency.

From a stochastic point of view, the decimated signal is still stationary. In whole generality, decimating a signal x(n) with an arbitrary phase N_0 defines a resulting decimated signal in form of

$$y(n) \;=\; x(nN+N_0) \tag{2.83}$$

The auto-correlation function of y is easily calculated as

$$
\begin{aligned}
R_{YY}(k) \;&=\; E[y(n)y(n+k)] & \tag{2.84}\\
&=\; E[x(nN+N_0)y(nN+N_0)] & \tag{2.85}\\
&=\; R_{XX}(kN) & \tag{2.86}
\end{aligned}
$$

According to Wiener-Kintchine theorem, the power spectral density function of the down-sampled signal is calculated as the Fourier transform of the decimated deterministic signal expressed in 2.82.

2.4. Techniques of Signal Decomposition

2.4.3.3 Up-Sampling or Interpolation

The process of increasing the sampling rate of a digital signal $x(n)$ by an integer factor L means that $(L-1)$ new samples are interpolated in between each pair of sample values of $x(n)$. In fact, this operation to expand the sampling rate leads to cascade an up-sampler and a filter which can be low-pass or band-pass depending on the issue of the signal to recover. The up-sampler is symbolized by an encircled upward pointing arrow flanked by the corresponding up-sampling factor. The interpolated signal is defined by

$$y(n) = \begin{cases} x(\frac{n}{L}) & n = 0, \pm L, \pm 2L, \\ 0 & \text{otherwise} \end{cases} \tag{2.87}$$

This means that the clock rate increases by a factor of M. Referring to the transform domain, and expressing $Y(z)$ will illustrate the effect of the up-sampling action.

$$Y(z) = \sum_{n=-\infty}^{+\infty} y(n)z^{-n} \tag{2.88}$$

$$= \sum_{n=-\infty}^{+\infty} x(\frac{n}{M})z^{-n} \tag{2.89}$$

$$= \sum_{n=-\infty}^{+\infty} x(k)(z^M)^{-k} \tag{2.90}$$

$$= X(z^M) \tag{2.91}$$

The Fourier transform of the signal $y(n)$ is derived from the evaluation of $Y(z)$ at $z = e^{j\omega}$ as follows

$$Y(e^{j\omega}) = Y(e^{j\omega M}) \tag{2.92}$$

This shows that the spectrum of an interpolated signal contains not only the baseband frequencies of interest, that is the spectrum in interval $(-\frac{\pi}{L}, +\frac{\pi}{L})$, but also what is called the *images and the imaging effect* i.e. the baseband frequencies centered at harmonics of the original sampling frequencies at $\frac{2\pi}{L}, \frac{2\pi}{L}, ...$ As expected, stretching the time axis induces a compression in frequency. The cancellation of the unwanted images necessitates to filter the signal with a so-called *anti-imaging filter*.

From a stochastic point of view, the sampling rate expansion and the zero-padding process which is assumed to be performed with a given phase imply that, unlike decimation, up-sampling does not preserve stationarity. In order to keep the stationarity property, the up-sampling phase has to be randomized. If the input, the output signal and the filter impulse response are respectively denoted by x, z and g, it follows from up-sampling by a factor L that

$$x(n) = \sum_{m=-\infty}^{\infty} g(n - mL - L_0)x(m) \tag{2.93}$$

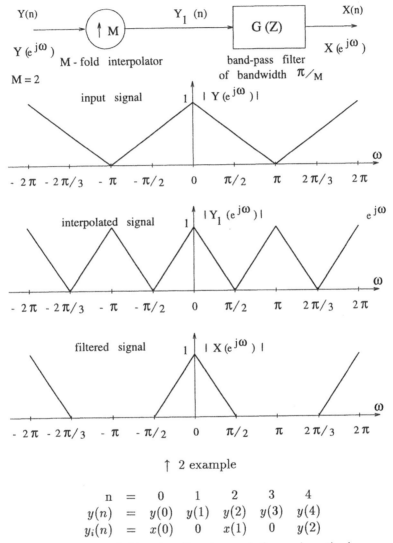

Figure 2.14: Subband coding: interpolation and synthesis.

The text below the figure:

$$
\begin{array}{cccccc}
n = & 0 & 1 & 2 & 3 & 4 \\
y(n) = & y(0) & y(1) & y(2) & y(3) & y(4) \\
y_i(n) = & x(0) & 0 & x(1) & 0 & y(2)
\end{array}
$$

↑ 2 example

where L_0 is considered as a uniform random variable over $\{0, \ldots, L-1\}$. The output of the conditional autocorrelation function assuming L_0, denoted by $R_{ZZ}(n_1, n_2 | L_0)$, is formulated as

$$\sum_{m_1=-\infty}^{\infty} \sum_{m_2=-\infty}^{\infty} g(n_1 - m_1 L - L_0) g(n_2 - m_2 L - L_0) R_{XX}(m_2 - m_1) \tag{2.94}$$

Averaging over the definition interval of L_0 yields

$$R_{ZZ}(u) = \frac{1}{L} \sum_{q=-\infty}^{\infty} \sum_{v=-\infty}^{\infty} g(q) g(q + u - vL) R_{XX}(v) \tag{2.95}$$

This conducts us to the power spectral density

$$S_{ZZ}(\omega) = \frac{1}{L} |G(\omega)|^2 S_{XX}(L\omega) \tag{2.96}$$

2.4.4 Polyphase Decomposition

The invention of polyphase representations holds as an important advance made in the field of multirate signal processing to permit not only a more general theoretical formalism but also efficient computational implementations especially for the decimation and interpolation filters. This idea originally developed by Bellanger is somewhat similar to the way of developing equations for electrical engines fed by polyphase sine-wave currents. For the shake of example, let us consider the z-transform of a filter $H(z)$ with an impulse response given by the set $\{h_0, \ h_1, \ h_2, \ldots\}$, then

$$H(z) = \sum_{k=0}^{\infty} h_k z^k \tag{2.97}$$

Expanding $H(z)$ and grouping the terms into M phases as follows

$$\begin{aligned}
H(z) = \\
(h_0 &+ h_M z^{-M} + h_{2M} z^{-2M} + h_{3M} z^{-3M} + \ldots) \\
+ (h_1 &+ h_{M+1} z^{-(M+1)} + h_{2M+1} z^{-(2M+1)} + h_{3M+1} z^{-(3M+1)} + \ldots) \\
+ (h_2 &+ h_{M+2} z^{-(M+2)} + h_{2M+2} z^{-(2M+2)} + h_{3M+2} z^{-(3M+2)} + \ldots) \\
\ldots \\
+ (h_{M-1} &+ h_{2M-1} z^{-(2M-1)} + h_{3M-1} z^{-(3M-1)} + h_{4M-1} z^{-(4M-1)} + \ldots)
\end{aligned} \tag{2.98}$$

Therefore, the idea consists of defining the polyphase components $H_k(z)$ with $0 < k < M - 1$ by

$$H_k(z) = \sum_{n=0}^{\infty} h_{k+nM} z^{-n} \tag{2.99}$$

The impulse response of the k^{th} phase filter $H_k(z)$ is given by $(h_k, \ h_{k+M}, \ h_{k+2M}, \ldots)$ and the original filter $H(z)$ may be decomposed into

$$H(z) = \sum_{k=0}^{M-1} z^{-k} H_k(z^M) \qquad (2.100)$$

Similarly, the decomposition of a signal $x(n)$ into M phases leads in the z-transform domain to expressing

$$X(z) = \sum_{n=0}^{M-1} z^n X_n(z^M) \qquad (2.101)$$

The k^{th} phase of the signal $X(z)$ follows as

$$X_k(z) = \sum_{n=0}^{\infty} x(k + nM)z^n \qquad (2.102)$$

and corresponds to the signal $X(z)$ advanced by k samples and subsampled of a factor M. Let us notice here that clockwise or counter-clockwise decompositions may be equivalently defined.

In the case of a decimator, the output $y(n)$ of the down-sampler is given in z-transform by

$$Y(z) = \sum_{j=0}^{M-1} H_j(z) X_j(z) \qquad (2.103)$$

That is, in matrix notations,

$$Y(z) = \bar{H}(z)\bar{X}^T(z) \qquad (2.104)$$

with vectors $\bar{H} = [H_0(z)\ H_1(z)\ ...\ H_{N-1}(z)]$ and $\bar{X} = [X_0(z)\ X_1(z)\ ...\ X_{N-1}(z)]$.

The polyphase representation of an interpolator may be constructed as the dual circuit of that presented for the decimator. Let us notice furthermore that the polyphase components are presented here in the reverse order

$$G(z) = \sum_{j=0}^{M-1} z^{-(M-1-j)}\ G_k(z^M) \qquad (2.105)$$

with $G_k = \sum_{-\infty}^{+\infty} g_{nN+N-1-j}z^{-n}$. If the z-transform of the input signal is $X(z)$, the interpolated output equals

$$Y(z) = \sum_{k=0}^{M-1} z^{-(M-1-k)}G_k(z^M)X(z^M) \qquad (2.106)$$

That is, in matrix equations

$$Y(z) = (z^{-M+1}\ z^{-M+2}\ ...\ Z^{-1}\ 1) \begin{bmatrix} G_0(z^M) \\ G_1(z^M) \\ \vdots \\ G_{M-1}(z^M) \end{bmatrix} X(z^M) \qquad (2.107)$$

2.4. Techniques of Signal Decomposition 119

As an application, let us consider the polyphase representation of the uniform DFT filter bank. The frequency response of the m^{th} filter is a shifted version of the low-pass prototype H_0

$$H_m(z) = H_0(z^M e^{-j2\pi\frac{m}{M}}) \tag{2.108}$$

With $W = e^{-j\frac{2\pi}{M}}$, the polyphase decomposition applied to $H_0(z)$ gives

$$H_0(z) = \sum_{k=0}^{M-1} z^{-k} G_k(z^M) \tag{2.109}$$

and

$$H_m(z) = H_0(zW^k) \tag{2.110}$$

$$= \sum_{k=0}^{M-1} (z^{-1}W^{-m})^k G_k(z^M) \tag{2.111}$$

Using $(zW^m)^M = z^M$, let us stack Equation 2.111 in a matrix notation

$$
\begin{vmatrix} H_0(z) \\ H_1(z) \\ \vdots \\ H_{M-1}(z) \end{vmatrix}
=
\begin{vmatrix} W^0 & W^0 & \cdots & W^0 \\ W^0 & W^{-1} & \cdots & W^{-(M-1)} \\ \vdots & \vdots & & \vdots \\ W^0 & W^{-(M-1)} & \cdots & W^{-(M-1)^2} \end{vmatrix}
\begin{vmatrix} G_0(z) \\ Z^{-1}G_1(z) \\ \vdots \\ Z^{-(M-1)}G_{M-1}(z) \end{vmatrix}
\tag{2.112}
$$

This matrix equation is nothing else than the DFT matrix. This leads to the conclusion that uniform filter banks can be implemented as polyphase decompositions followed by the DFT.

2.4.4.1 Two-channel Filter Bank

The basic philosophy of two-band decomposition which conducts to defining the Quadrature Mirror Filters (QMF) is treated in this subsection to provide a starting point in the study. This signal analysis tool was introduced in the mid seventies by Croisier. These filter banks implement a maximally decimated structure meaning that they work at the *critical sampling rates* and that the number of subband samples is equal to the amount of input samples. Referring to Figure 2.15, the incoming signal $x(t)$ is filtered by two filters $H_0(z)$ and $H_1(z)$ respectively a low-pass and a high-pass filter. Each output signal $x_0(n)$ and $x_1(n)$ is thereafter subsampled of a factor two, coded and transmitted. The coding process exploits separately the special properties of the individual bands by example the perceptive properties and the level of energy. At the decoder side, reverse operations take place successively to decode, up-sample and filter both signals. Finally, the signal is reconstructed. The latter signal may differ from the original version for several reasons which can be enumerated as amplitude distortion, phase distortion, aliasing and quantization noise. Clearly, the three first reasons originate usually from the filtering processes. The filter $H_0(z)$ and $H_1(z)$ are called the analysis filters, the pair forms the analysis filter

bank which operates as a bank of two antialiasing filters, splitting the spectrum into two equal subbands. According to Nyquist theorem, both filtered signals can be decimated afterwards by a factor two to yield two critically sampled subband signals V_n and $V_1(n)$. The filters $G_0(z)$ and $G_1(z)$ form a pair of synthesis filters which yields reconstruction of the signal $\hat{x}(t)$.

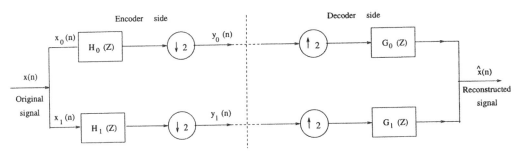

Figure 2.15: Two-channel subband coding.

Expression of the Reconstructed Signal

The most important topic in the field of multirate filter banks used in image coding deals with the search to express the conditions of perfect reconstruction for the signal $\hat{x}(n)$ in conjunction with two other closely related properties, namely the orthogonality, the phase linearity of the analysis base. Originally, it was shown by Croisier how to eliminate aliasing in a two-band channel case. Smith and Barnwell has derived in [76] the additional conditions to eliminate the filtering distortions and to yield *perfect signal reconstruction* after synthesis. Hence, tracing the signals path through Figure 2.15, the expression of perfect reconstructed signal is obtained as follows

1. the analyzed signals

$$X_k(z) = H_k(z)X(z) \qquad k = 0, 1 \tag{2.113}$$

2. the decimated signals

$$V_k(z) = \frac{1}{2}[X_k(z^{\frac{1}{2}}) + X_k(-z^{\frac{1}{2}})] \qquad k = 0, 1 \tag{2.114}$$

3. the Y_k signals

$$Y_k(z) = V_k(z^2) \tag{2.115}$$
$$= \frac{1}{2}[H_k(z)X(z) + H_k(-z)X(-z)] \qquad k = 0, 1 \tag{2.116}$$

2.4. Techniques of Signal Decomposition

4. the reconstructed signal

$$\hat{X}(z) = G_0(z)Y_0(z) + G_1(z)Y_1(z) \tag{2.117}$$

$$= \frac{1}{2}[X(z) \ X(-z)] \begin{bmatrix} H_0(z) & H_1(z) \\ H_0(-z) & H_1(-z) \end{bmatrix} \begin{bmatrix} G_0(z) \\ G_1(z) \end{bmatrix} \tag{2.118}$$

$$= \frac{1}{2}[X(z) \ X(-z)] \ H(z) \begin{bmatrix} G_0(z) \\ G_1(z) \end{bmatrix} \tag{2.119}$$

The matrix $H(z)$ is called the alias component matrix. At this stage, it is interesting to decompose $\hat{X}(z)$ in two terms and get

$$\hat{X}(z) = T(z)X(z) + S(z)X(-z) \tag{2.120}$$

the term $S(z)$ which contains $X(-z)$ originates from the decimation and takes into account of aliasing arising from decimation and imaging arising from interpolation. The second term $T(z)$ is responsible for both phase and amplitude distortions. *Perfect reconstruction* is therefore achieved if and only if

$$S(z) = \frac{1}{2}[H_0(-z)G_0(z) + H_1(-z)G_1(z)] = 0, \ \forall z \tag{2.121}$$

and

$$T(z) = \frac{1}{2}[H_0(z)G_0(z) + H_1(z)G_1(z)] = cz^{-n_0} \tag{2.122}$$

where c is a constant. Both terms are usually referred to as the *alias term or component* and the *transfer distortion function*. They are analyzed in the sequel.

Aliasing Cancellation

To cancel the aliasing effect, the selection of the filter bank has to comply to

$$G_0(z) = -H_1(-z) \tag{2.123}$$
$$G_1(z) = H_0(-z) \tag{2.124}$$

The key feature to be noticed here is that *the analysis filters allows aliasing to occur instead of avoiding it*. The task devoted to the synthesis filters is thereafter to carefully cancel the aliasing generated in the analysis. In video applications where low-pass information may be recovered alone and displayed as such on a screen of lower resoluted, a pre-filtering will be requested to suppress the residual non-cancelled aliasing effects.

Amplitude and Phase Distortion Cancellation

Cancelling aliasing is not sufficient for perfect reconstruction, the reconstructed signal may indeed suffer from a linear shift-invariant distortion arising in $T(z)$. Letting $T(e^{j\omega}) = |T(e^{j\omega})|e^{j\phi(\omega)}$, the distortion effect is then decomposed into amplitude and phase components. Therefore, the transfer function of an aliasing-free system is given by

$$T(z) = \frac{1}{2}[H_0(-z)H_1(z) - H_0(z)H_1(-z)] \tag{2.125}$$

Several choices can be made to force $T(z) = cz^{-n_0}$, for instance, the *FIR para-unitary solution* which is such that

$$H_1(z) = z^{-(N-1)}H_0(-z^{-1}) \tag{2.126}$$

where $H_0(z)$ and $H_1(z)$ are N-tap FIR filters where N is even. This condition further implies that

$$T(z) = \frac{1}{2}z^{-(N-1)}\left[H_0(z)H_0(z^{-1}) + H_0(-z)H_0(-z^{-1})\right] \tag{2.127}$$

Consequently, the condition of perfect reconstruction consists of finding an FIR filter $H_0(z)$ complying to the constraint of

$$H_0(z)H_0(z^{-1}) + H_0(-z)H_0(-z^{-1}) = c \tag{2.128}$$

This selection supposes that all four filters are causal whenever $H_0(z)$ is causal. If we let $R(z) = H_0(z)H_0(z^{-1})$, $R(z)$ turns out to be a spectral density function corresponding to the autocorrelation function $\rho(n)$ of the impulse response $h_0(n)$, which is equivalent to convolving $h_0(n)$ with $h_0(-n)$

$$\rho(n) = h_0(n) * h_0(-n) \tag{2.129}$$

Hence, if we need $\rho(n) = 0$ for n non-zero and even. Normalizing the filter coefficients, that is $\sum_{k=0}^{N-1}|h(k)|^2 = 1$, it follows that $R(z) + R(-z) = Q(z) = 1$ and

$$\rho(2n) = \sum_{k=0}^{N-1} h_0(k) * h_0(k+2n) = \delta(n) \tag{2.130}$$

To interpret in the frequency domain, we let $z = e^{j\omega}$ to derive on the unit circle that

$$R[e^{j\omega}] + R[e^{j(\omega-\pi)}] = |H_0(e^{j\omega})|^2 + |H_0(e^{j(\omega-\pi)})|^2 \tag{2.131}$$
$$= 1 \tag{2.132}$$

Considering the Equation 2.126, the previous equation is re-expressed as

$$|H_0(e^{j\omega})|^2 + |H_1(e^{j\omega})|^2 = 1 \tag{2.133}$$

Filter pairs $\{H_0(z), H_1(z)\}$ verifying condition 2.133 are asserted to be *power complementary*.

Perfect Reconstruction Quadrature Mirror Filters

Mirror image filters are pairs of FIR filters with real coefficients which satisfy the relationship

$$h_1(n) = (-1)^n h_0(n) \tag{2.134}$$

where h_0 is some low-pass filter. Equivalently stated in the transform domain

$$H_1(z) = H_0(-z) \tag{2.135}$$
$$H_1(e^{j\omega}) = H_0[e^{j(\omega-\pi)}] \tag{2.136}$$

The mirror property stems from the symmetry around $\pi/2$ and justifies the appellation of this filter bank as *Quadrature Mirror Filters* (QMF). If a QMF bank is free from aliasing, amplitude and phase distortion, it is said to have *perfect reconstruction*. This property is equivalent to the condition 2.122 and to reconstructed signals in form of

$$\hat{X}(z) = c\, z^{-n_0} X(z) \qquad \hat{x}(n) = c\, x(n - n_0) \tag{2.137}$$

which means that $\hat{x}(n)$ is merely a scaled and delayed version of $x(n)$. At this point, the constructive equations have been drawn to design multiband perfect reconstruction filter bank. However, it can be shown that these QMF filters can not simultaneously guarantee perfect reconstruction and be linear phase except in the trivial Haar filters with $H_0(z) = \frac{1}{\sqrt{2}}(1 + z^{-1})$ and $H_1(z) = \frac{1}{\sqrt{2}}(1 - z^{-1})$.

To summarize the structural design of perfect reconstruction FIR filters, the relationships which follow have to be fulfilled in a two-band analysis-synthesis design

$$G_0(z) = -H_1(-z) \qquad G_1(z) = H_0(-z) \tag{2.138}$$

$$H_1(z) = z^{N-1} H_0(-z^{-1}) \qquad H_0(z) = H(z) \tag{2.139}$$

2.4.4.2 M-channel Filter Bank

The results obtained for the two-band filter banks are here extended towards the M-band analysis operator. The M-band filter bank is presented in Figure 2.16. The maximally decimated structure is composed of M analysis filters $\{H_k, 0 \le k \le M - 1\}$ followed by decimators of factor M to achieve critical sampling. The filters can be without special restriction either FIR or IIR, separable or non-separable. This presentation will refer only to FIR filters. The IIR filter case is examined with the wavelet technique. In an M-channel maximally decimated configuration, the incoming signal $x(n)$ is split into M subband signal $x_k(n)$ by the M analysis filter bank, then decimated by a factor M and encoded. At the receiver end, the decimated signals are processed by an M-fold interpolator and recombined to produce a reconstructed signal $\hat{x}(n)$.

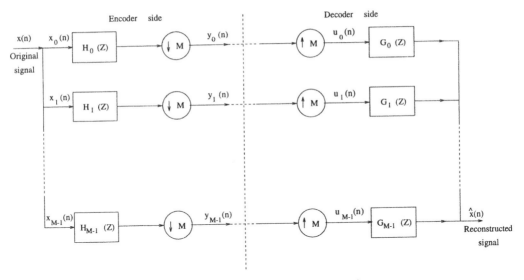

Figure 2.16: General subband coding scheme.

Expression for the Reconstructed Signal

Generalizing the reasoning pursued in the two-band case, let us trace the signal through the coding and decoding structure.

1. the subband signals $X_k(z)$ are given by

$$X_k(z) \;=\; H_k(z)\, X(z) \qquad k = 0, 1, \dots, M-1 \tag{2.140}$$

2. the decimated signals $v_k(n)$ have z-transform

$$V_k(z) \;=\; \frac{1}{M} \sum_{k=0}^{M-1} H_k(z^{\frac{1}{M}} W^l)\, X(z^{\frac{1}{M}} W^l) \qquad k = 0, 1, \dots, M-1 \tag{2.141}$$

where $W = e^{-j\frac{2\pi}{M}}$ as previously.

3. the output of the interpolators are therefore

$$U_k(z) \;=\; \frac{1}{M} \sum_{k=0}^{M-1} H_k(z W^l)\, X(z W^l) \qquad k = 0, 1, \dots, M-1 \tag{2.142}$$

4. the reconstructed signal is finally

$$\hat{X}(z) \quad = \quad \sum_{k=0}^{M-1} G_k(z)\, U_k(z) \tag{2.143}$$

$$= \quad \frac{1}{M} \left[X(z)\ X(zW)\ \dots\ X(zW^{M-1}) \right]. \tag{2.144}$$

$$\begin{bmatrix} H_0(z) & \dots & H_{M-1}(z) \\ H_0(zW) & \dots & H_{M-1}(zW) \\ \vdots & \dots & \vdots \\ H_0(zW^{M-1}) & \dots & H_{M-1}(zW^{M-1}) \end{bmatrix} \begin{bmatrix} G_0(z) \\ G_1(z) \\ \vdots \\ G_{M-1}(z) \end{bmatrix} \tag{2.145}$$

$$= \quad \frac{1}{M}\, X^T\, H_{AC}(z)\, g(z) \tag{2.146}$$

where $H_{AC}(z)$ is the *aliasing component matrix*. The reconstructed signal may be expanded in another convenient form as follows to evidence the three kinds of undesirable analysis-synthesis distortion

$$\hat{X}(z) \ = \ \left(\frac{1}{M} \sum_{l=0}^{M-1} G_l(z) H_l(z) \right) X(z) + \frac{1}{M} \sum_{\substack{u \\ v \neq 0}} \sum_{\substack{v \\ u \neq 0}} H_v(zW^u) X(zW^u) G_v(z) \tag{2.147}$$

with

$$A_l(z) \ = \ \frac{1}{M} \sum_{l=0}^{M-1} H_k(zW^l) G_k(z) \qquad 0 \le l \le M-1 \tag{2.148}$$

From Equation 2.147, it turns out clearly that the reconstructed signal $\hat{X}(z)$ is composed of a sum of shifted versions $X(zW^l)$ whose components with $l > 0$ originate from the decimation and the interpolation operation and introduce aliasing referred to be the l^{th} aliasing terms with a contributing gain given by $A_l(z)$. Therefore, the aliasing can be cancelled if and only if $A_l(z) = 0$ for $1 \le l \le M-1$ and the overall transfer function becomes

$$T(z) \ = \ A_0(z) \ = \ \frac{1}{M} \sum_{k=0}^{M-1} H_k(z) G_k(z) \tag{2.149}$$

As a matter of fact, cancelling aliasing transforms the QMF bank in an linear time invariant system. Moreover, the perfect reconstruction is yielded under both conditions that aliasing is cancelled and that pure delay is achieved between the incoming source signal at the encoding side and its reconstructed version at the decoding side. The second condition implies that $T(z) = cz^{n_0}$, $c \neq 0$ i.e. that the analysis and synthesis filter bank is free of amplitude and phase distortion and satisfies $\hat{x}(n) = cx(n - n_0)$.

In matrix notations, perfect reconstruction means

$$H_{AC}(z) g(z) \ = \ \begin{bmatrix} M A_0(z) \\ 0 \\ \vdots \\ 0 \end{bmatrix} \tag{2.150}$$

Therefore, alias cancellation is achieved whenever $g(z) = H^{-1}(z)H_{AC}(z)g(z)$ and perfect reconstruction whenever

$$
H_{AC}(z)\, g(z) \;=\; \begin{bmatrix} z^{-n_0} \\ 0 \\ \vdots \\ 0 \end{bmatrix}
\tag{2.151}
$$

Attempting to solve one of those problems requires to invert $H(z)$, an operation which is possible in principle but not easy in practice. FIR H_k filters may lead to IIR F_k filters.

Polyphase Representation

In the polyphase domain, let us recall that the polyphase representation of an analysis filter was presented as $H_k(z) = \sum_{l=0}^{N-1} z^{-l} E_{kl}(z^M)$ in Equation 2.100. Consequently, an M-band analysis filter bank yields a matrix equation

$$
\begin{bmatrix} H_0(z) \\ H_1(z) \\ \vdots \\ H_{M-1}(z) \end{bmatrix} = \begin{bmatrix} E_{0,0}(z^M) & E_{0,1}(z^M) & \cdots & E_{0,N-1}(z^M) \\ E_{1,0}(z^M) & E_{1,1}(z^M) & \cdots & E_{1,N-1}(z^M) \\ \vdots & \vdots & & \vdots \\ E_{M-1,0}(z^M) & E_{M-1,1}(z^M) & \cdots & E_{M-1,N-1}(z^M) \end{bmatrix} \begin{bmatrix} 1 \\ z^{-1} \\ \vdots \\ z^{-(M-1)} \end{bmatrix}
$$

The matrix $E(z)$ is called the *analysis polyphase matrix*. Similarly, a synthesis filter bank up-sampled by a factor leads to a corresponding polyphase representation. In z-transform, the synthesis filter can be expressed as $G_k(z) = \sum_{l=0}^{M-1} z^{-(M-1-l)} R_{lk}(z^M)$. In terms of polyphase components, the total output is given by

$$
\begin{aligned}
& [F_0(z) \ \cdots \ F_{M-1}(z)] \\
& = (z^{-(M+1)} \ z^{-(M+2)} \ \cdots \ z^{-1} \ 1) \begin{bmatrix} R_{0,0}(z^M) & R_{1,0}(z^M) & \cdots & R_{M-1,0}(z^M) \\ R_{0,1}(z^M) & R_{1,1}(z^M) & \cdots & R_{M-1,1}(z^M) \\ \vdots & \vdots & & \vdots \\ R_{0,N-1}(z^M) & R_{1,N-1}(z^M) & \cdots & R_{M-1,N-1}(z^M) \end{bmatrix} \begin{bmatrix} X_0(z^M) \\ X_1(z^M) \\ \vdots \\ X_{M-1}(z^M) \end{bmatrix}
\end{aligned}
$$

where the matrix $R(z)$ is called the *synthesis polyphase matrix*. Letting $P(z) = R(z)E(z)$, it is obvious that $P(z) = 1$ involves perfect reconstruction with an unchanged signal whether the system is FIR or IIR.

Before investigating the most general conditions of alias cancellation and perfect reconstruction for maximally decimated QMF filters, let us define a *pseudo-circulant matrix* as being an $M \times M$ Toeplitz matrix where every row is obtained using a right-shift of one position of the previous row such that the rightmost spilling over element be circulated back to become the leftmost element. To take an example,

The necessary and sufficient condition for a M-channel maximally decimated filter bank to be alias cancellation requires that the matrix $P(z)$ be pseudo-circulant.

To demonstrate the proposition, let us be back to the reconstructed signal

$$\hat{X}(z) \;=\; \sum_{s=0}^{M-1} z^{-(M-1-s)} B_s(z^M) \tag{2.152}$$

$$=\; \sum_{s=0}^{M-1} z^{-(M-1-s)} \sum_{l=0}^{M-1} P_{s,l}(z^M) C_l(z^M) \tag{2.153}$$

$$=\; \frac{1}{M} \sum_{s=0}^{M-1} z^{-(M-1-s)} \sum_{l=0}^{M-1} P_{s,l}(z^M) \sum_{k=0}^{M-1} (zW^k)^{-l} X(zW^k) \tag{2.154}$$

$$=\; \frac{1}{M} z^{-(M-1)} \sum_{k=0}^{M-1} X(zW^k) \sum_{l=0}^{M-1} W^{-kl} \sum_{s=0}^{M-1} z^{-(l-s)} P_{s,l}(z^M) \tag{2.155}$$

This expression is free from aliasing if and only if

$$\sum_{l=0}^{M-1} W^{-kl} \sum_{s=0}^{M-1} z^{-(l-s)} P_{s,l}(z^M) \;=\; 0 \qquad k \neq 0 \tag{2.156}$$

Therefore, this may be equivalently rested as if and only if the sequences $S_l(z) = \sum_{l=0}^{M-1} P_{s,l}(z^M) z^{-(l-s)}$ is constant with respect to l. Let us say $S(z)$. This is further equivalent to saying that

$$p_{s,l}(n) \;=\; s(nM + l - s) \qquad \forall n, \; 0 \le s, \; l \le M-1 \tag{2.157}$$

where $S(z) = \sum_{n=0}^{\infty} s(n) z^{-n}$ and $P_{s,l} = \sum_{n=0}^{\infty} p_{s,l}(n) z^{-n}$.
Two main properties stem from Equation 2.157

1. $P_{s,l}(z)$ depends only on $l - s$, therefore, $P(z)$ is a Toeplitz matrix given by

$$P(z) \;=\; \begin{bmatrix} P_0(z) & P_1(z) & \cdots & \cdots & P_{M-1}(z) \\ P_{-1}(z) & P_0(z) & P_1(z) & \cdots & P_{M-2}(z) \\ \vdots & & & & \vdots \\ P_{-(M-1)}(z) & P_{-(M-2)}(z) & P_{-(M-3)}(z) & \cdots & P_0(z) \end{bmatrix} \tag{2.158}$$

2. $P_{s,l}(z)$ is pseudo-circulant. Indeed, we have

$$
\begin{aligned}
p_{k,0}(n) \;&=\; s(nM - k) & \tag{2.159}\\
&=\; s[(n-1)M + M - k] & \tag{2.160}\\
&=\; p_{0,M-k}(n-1) & \tag{2.161}
\end{aligned}
$$

whence,

$$P_{k,0}(z) \;=\; z^{-1} P_{0,M-k}(z) \qquad 1 \le k \le M-1 \tag{2.162}$$

Consequently, *any QMF filter bank which is free from aliasing is such that $P(z)$ is a Toeplitz pseudo-circulant transfer matrix.* To characterize furthermore the definition of the matrix pseudo-circulant property, let us re-express each row of $P(z)$ in terms of the 0^{th} row as

$$P_{k,l}(z) = \begin{cases} P_{0,l-k}(z) & 0 \le k \le l \\ z^{-1}P_{0,l-k+M}(z) & l \le k \le M-1 \end{cases} \tag{2.163}$$

Similarly, each column can be expressed in terms of the $(M-1)^{th}$ column as

$$P_{k,l}(z) = \begin{cases} P_{M-1+k-l,M-1}(z) & 0 \le k \le l \\ z^{-1}P_{k-l-1,M-1}(z) & l < k \le M-1 \end{cases} \tag{2.164}$$

Both representations are strictly equivalent. It turns out that the $M \times M$ matrix $P(z)$ can be uniquely characterized by the 0^{th} row which is

$$[P_{0,0}(z)\ P_{0,1}(z)\ \dots\ P_{0,M-1}(z)] \tag{2.165}$$

with $P_{0,m}(z)$ the element of the 0^{th} row of $P(z)$.

To figure out the conditions for the absence of amplitude and/or phase distortion, it is first supposed that $P(z)$ is pseudo-circulant to cancel aliasing. Let us notice that the QMF system is in this case time invariant. Going back to Equations 2.155 and 2.156, the transfer function $T(z)$ takes the form of

$$
\begin{aligned}
T(z) \\
&= \frac{\hat{X}(z)}{X(z)} \\
&= \frac{1}{M}\, z^{-(M-1)} \sum_{l=0}^{M-1} \sum_{s=0}^{M-1} P_{s,l}(z^M) z^{-(l-s)} \\
&= \frac{1}{M}\, z^{-(M-1)} \sum_{l=0}^{M-1} \left[\sum_{s=0}^{l} P_{s,l}(z^M) z^{-(l-s)} + \sum_{s=l+1}^{M-1} P_{0,l-s+M}(z^M) z^{-(l-s)} \right] \\
&= \frac{1}{M}\, z^{-(M-1)} \sum_{l=0}^{M-1} \left[\sum_{s=0}^{l} P_{0,l-s}(z^M) z^{-(l-s)} + \sum_{s=l+1}^{M-1} P_{0,l-s+M}(z^M) z^{-(l-s+M)} \right] \\
&= \frac{1}{M}\, z^{-(M-1)} \sum_{l=0}^{M-1} \sum_{k=0}^{M-1} P_{0,k}(z^M) z^{-k} \\
&= z^{-(M-1)} \sum_{k=0}^{M-1} P_{0,k}(z^M) z^{-k}
\end{aligned}
$$

The fourth equation has been derived using the property 2.163 of pseudo-circulant matrices. Eventually, the transfer function $T(z)$ is formulated in terms of elements of the 0^{th} row of $T(z)$ as a scalar function which generates a reconstructed signal free from amplitude distortion if and only if $T(z)$ is all-pass.

The perfect reconstruction filter bank is an alias free system with $T(z)$ in form of a pure delay. As demonstrated here above, let us recall that $P(z)$ is pseudo-circulant and uniquely characterized by the 0^{th} row as in 2.165, that $T(z)$ is also completely determined by the elements of the 0^{th} row of $P(z)$. Therefore, $T(z)$ is a delay if and only if $P_{0,i} = 0$ for all i in the range $0 \le i \le M-1$ except for one single of the i's which must have the form cz^{-n_0}. Gathering all the properties, the alias free filter bank presents perfect reconstruction if and only if the matrix $P(z) = R(z)E(z)$ has the form

$$P(z) = cz^{-n_0} \begin{bmatrix} 0 & I_{M-r} \\ z^{-1}I_r & 0 \end{bmatrix} \tag{2.166}$$

Under this condition, $T(z)$ is reduced to

$$T(z) = cz^{-r}z^{-(M-1)}z^{-m_0 M} \tag{2.167}$$

2.4.4.3 Para-unitary property

In this section, a extension of unitary block transforms is proposed for the subband coding technique. The property which makes a jonction between unitary block transform and subband coding is usually qualified as *para-unitary*. This concept, which is fundamental to the design of cosine-modulated perfect-reconstruction filter bank and of orthonormal wavelet basis, is discussed here.

The matrix which characterizes the process of filtering and subsampling with respectively an M-length filter bank an N-order decimator is block circulant or Toeplitz as

$$\begin{bmatrix} \vdots \\ y_0(0) \\ y_1(0) \\ \vdots \\ y_{M-1}(0) \\ y_0(1) \\ y_1(1) \\ \vdots \end{bmatrix} = \begin{bmatrix} \ddots & \ddots & \ddots & \ddots & & \ddots & & \ddots \\ 0 & A_0 & A_1 & \cdots & A_{K-1} & 0 & \cdots \\ \cdots & 0 & A_0 & A_1 & \cdots & A_{K-1} & 0 \\ \cdots & \cdots & 0 & A_0 & A_1 & \cdots & A_{K-1} \\ \ddots & \ddots & \ddots & \ddots & \ddots & & \ddots \end{bmatrix} \begin{bmatrix} \vdots \\ x(0) \\ x(1) \\ x(2) \\ \vdots \end{bmatrix} \tag{2.168}$$

The sub-matrices A_i of size $M \times N$ represent FIR filters with impulse responses of length NK as $A(z) = \sum_{i=0}^{K-1} A_i z^{-i}$. To extend the unitary property of the transformations defined in Section 2.4.2.2, let us assume that the matrix in Equation 2.168 is such that, when multiplied by its transpose, it is equal to identity as follows

$$\begin{bmatrix} A_0^T & A_1^T & A_2^T & \cdots & \cdots \\ \cdots & A_0^T & A_1^T & A_2^T & \cdots \\ \cdots & \cdots & A_0^T & A_1^T & A_2^T \end{bmatrix} \begin{bmatrix} A_0 & A_1 & A_2 & \cdots & \cdots \\ \cdots & A_0 & A_1 & A_2 & \cdots \\ \cdots & \cdots & A_0 & A_1 & A_2 \end{bmatrix} = \begin{bmatrix} I & & \\ & I & \\ & & I \end{bmatrix} \tag{2.169}$$

This implies that

$$\sum_{i=0}^{K-1} A_i^T A_i = I \tag{2.170}$$

$$\sum_{i=0}^{K-1} A_{i+j}^T A_i = O \qquad j = 1, \ldots, K-1 \tag{2.171}$$

This equation may be re-written as

$$A^T(z)\, A(z) \;=\; I \tag{2.172}$$

Expressing the polyphase matrix $H_p(z)$ as a matrix polynomial i.e. $H_p(z) = \sum_{i=0}^{K-1} H_{pi} z^{-i}$. It may be demonstrated that

$$A_{K-k-1} \;=\; H_{pk}.J \qquad A(z) \;=\; z^{-K+1} H_p(z^{-1}) J \tag{2.173}$$

since convolution induces time-reversal. J is a counter identity matrix. Then it follows that

$$H_p^T(z^{-1})\, H_p(z) \;=\; I \tag{2.174}$$

The matrices which fulfills that property are called *para-unitary* as an extension of the unitary transformation defined in Section 2.4.2.2. Reference [79] develops all the relative properties of the para-unitary filter banks. In stable systems, it is worth noticing that paraunitary implies a lossless system.

2.5 Lapped Orthogonal Transforms

The motivation towards developing Lapped Orthogonal Transforms (LOT) stems from the need to overcome the *blocking effects* generated by the block transforms, for instance the DCT, at high rate compressions. Indeed, the block transforms encode and quantize neighbor blocks individually and differently. This generates discrepancies and block non-uniformity in the local subjective image quality. Consequently, visible discontinuities located along the block boundaries impair the global quality. The argument based on the block artifacts was the first attractive reason to exploit LOT's not only in image coding but also in speech coding. The LOT's perform overlapped block transformations and use pixels in the adjacent blocks to smooth out the discontinuities at the block borders. Typically, when blocks span over M samples, the LOT processes L=2M in whole similarity to a FIR filter of L taps operating on pixels. The LOT's enjoy a set of interesting properties which make them efficient for the image coding purpose and are worth mentioning as follows

1. the possibility to implement fast computational algorithms based on the butterfly family. This will provide LOT's and its extensions with efficient capabilities of hardware implementation. LOT's require moreover short filter lengths and turn out to be a first generalization of the DCT operator (L=M).

2 the coding gains reach higher values than those obtained with DCT for auto-regressive signal but also for any general spectrum derived from real-world signals.

3 the ability of adapting the analysis operation to the input signal with a properly designed prototype low-pass filter. A discussion of those parameters is presented later in the section dedicated to wavelet properties.

4 strong ties with both multirate filter-banks and wavelets makes LOT's adequate to gathering Malvar has demonstrated that LOT can be viewed as a quadrature mirror filter where the analysis and synthesis filter are FIR responses allowing perfect reconstruction. LOT's are nothing else than a step towards the modulated filter banks and wavelets.

As evidenced by those four properties, LOT's will play an important role in image coding mainly in form of Modulated Lapped Transforms (MLT) and essentially Extended Lapped Transforms (ELT) where L=2kM with k any arbitrary positive integer. After the development of this operator by Malvar, further generalizations have allowed to enlarge the toolbox of the LOT analysis operators adding new types of admissible subband filter banks (cosine modulated filter banks). Indeed, FIR filters of even length (L=2M-1) where proved to provide perfect reconstruction [64] and eventually modulated wavelets with tight frames were constructed on the class of the modulated filter banks.

2.5.1 Definition and Principle

Historically, the term LOT has been used to characterize a lapped transform whose basis functions have even or odd symmetry, and lengths equal to L=2M. M defines the size of the transform or the number of subbands whereas L holds for the number of basis functions. However, other orthogonal transforms may also be built in the case L=2M-1, such cases will be typified later in this chapter.

The lapped transform maps L input samples symmetrically taken out of blocks of M samples into M transform coefficients. By definition, $L > M$. To maintain a critical sampling rate, M new transform coefficients are computed from every M new input pixel samples. Let us consider the case of a finite length sequence X of input samples labeled $\{x_i : i = 0, .., m - 1\}$, the transform coefficients form a sequence Y labeled $\{y_i : i = 0, ..., m - 1\}$. The transform $Y_{B,i}$ of the i^{th} input signal block $X_{B,i}$ is calculated by considering over an extended signal block $X_{B,i}$ made of L consecutive samples. The operator takes M samples within block $X_{B,i}$ and the $L - M$ complementary samples overlap symmetrically over the neighbor blocks by $(\frac{L-M}{2})$ samples in block $X_{B,i-1}$ and by $(\frac{L-M}{2})$ samples in block $X_{B,i+1}$

$$Y_{B,i} = P_B X_{B,i} \tag{2.175}$$

where P_B is the direct transform operator. When considering LOT's, the input block length is twice the number of transform coefficients. That is $L = 2M$ and the matrix operator P_B has the size $L \times Ms$. Since the number M of bands equals the decimation factor, the decomposition is critically sampled. The equation governing the transformation associated with the sequence X is simply

$$Y = PX \tag{2.176}$$

where X is the input signal segmented into N blocks of size M $\{X_{B,i}; i = 1 to N\}$, and Y is the vector of transform coefficients also subdivided in N blocks, P is the global $MN \times MN$ matrix of the transformation such that

$$P = \begin{vmatrix} P_1 & & & & & 0 \\ & \ddots & & & & \\ & & P_B & & & \\ & & & P_B & & \\ & & & & P_B & \\ & & & & & \ddots \\ 0 & & & & & P_2 \end{vmatrix} \tag{2.177}$$

The reconstruction process in the decoder implies an inverse transformation in form of

$$\tilde{X} = P^T X \qquad (2.178)$$

perfect reconstruction is easily fulfilled if and only if $\tilde{X} = X$. That is to say

$$P \times P^T = I = P^T \times P \qquad (2.179)$$

showing not only that the basis functions in P must be orthogonal among themselves but also that these basis functions must be orthogonal to the overlapping portions of the basis functions corresponding to neighboring blocks. Whence, it is equivalent to state

$$P_B W P_B^T = 0 = P_B^T W P_B \qquad (2.180)$$

where W is an $L \times L$ one-block shift matrix. Hence, denoting I the identity matrix of order $(L - M) \times (L - M)$, we have

$$W = \begin{vmatrix} 0 & I \\ 0 & 0 \end{vmatrix} \qquad (2.181)$$

As a consequence, admissible LOT's must satisfy at least Equations 2.179 and 2.180. The feasible LOT's have identical analysis and synthesis operators. Since but none of the previous conditions provides insight on how to derive the conditions which optimize the coding process, several degrees of freedom remain to define the basis functions and choose them optimally according to a number of given criteria. For instance, Vaidyanathan presented the technique which minimizes the stop-band spill-over energy of the low-pass prototype filter. Other criteria may involve decorrelation conditions so as to achieve an energy compaction into a minimum number of transform coefficients and also regularity, a wavelet property.

2.5.2 Extensions of Lapped Orthogonal Transforms

The extensions of LOT has some importance in image coding. The first generalization led Malvar to defining Modulated Lapped Transform (MLT). The basis functions of the MLT are the impulse responses of the synthesis filter bank defined as

$$h_k = h(n) \cos\left[(k + \frac{1}{2})(n - \frac{L-1}{2})\frac{\pi}{M} + \phi_k\right] \qquad (2.182)$$

with $k = 1, ..., M - 1$ and $n = 1, ..., L - 1$. Under the assumption that $L = NM$, perfect reconstruction is guaranteed by an adequate choice of the phases as

$$\phi_k = (k + \frac{1}{2})(N + 1)\frac{1}{2} \qquad (2.183)$$

This allows rewriting the impulse function as

$$h_k = h(n) + \sqrt{\frac{2}{M}} \cos\left[(k + \frac{1}{2})(n - \frac{M-1}{2})\frac{\pi}{M}\right] \qquad (2.184)$$

with $\sqrt{\frac{2}{M}}$ a normalizing factor. The frequency responses of all filters are just shifted version of $H(e^{j\omega})$. As demonstrated in [72] and [81], the filter bank has perfect reconstruction provided that the low-pass filter, also called the *prototype filter* or the *window*, satisfies the following condition

$$h(L-1-n) = h(n) \tag{2.185}$$

The window is assumed to have the even symmetry, and

$$h^2(n) + h^2(n+M) = 1 \tag{2.186}$$

The MLT is superior to the DCT for several reasons, it is free of blocking effect and requires somewhat fewer memory locations and coefficients. Contrarily to the DCT, the MLT decorrelation capacities are independent of the correlation coefficient for an AR(1) source model.

The thrust that pushed Malvar to develop the Extended Lapped Transform (ELT) consisted in stretching the filter length so as to achieve $L = 2kM$ and provide the operator with still better performances. k is referred to as the *overlapping factor*. Perfect reconstruction is achieved when

$$y(n) = \sum_{l=-\infty}^{\infty} x(l) \sum_{m=-\infty}^{\infty} \sum_{k=0}^{M-1} f_k(n-mM)h_k(mM-l) \tag{2.187}$$

$$= \sum_{l=-\infty}^{\infty} x(l)\alpha(n,l) \tag{2.188}$$

For FIR filters of length L, perfect reconstruction is met if the overall delay from $x(n)$ to $y(n)$ is L-1 so as to equate $y(n) = x(n-L+1)$. As a matter of fact, perfect reconstruction is achieved if and only if $\alpha(n, l-L+1) = \delta(n-l)$ where $\delta(n)$ is the Dirac unitary impulse. Therefore,

$$\alpha(n, l-L+1) = \sum_{m=-\infty}^{\infty} h(n-mM)h(l-mM)\beta(n,l,m) \tag{2.189}$$

where

$$\beta(n,l,m) = \frac{2}{M} \sum_{k=0}^{M-1} \cos\left[\frac{\pi}{M}\left(k+\frac{1}{2}\right)\left(n-mM+\frac{M+1}{2}\right)\right]$$
$$\times \cos\left[\frac{\pi}{M}\left(k+\frac{1}{2}\right)\left(l-mM+\frac{M+1}{2}\right)\right] \tag{2.190}$$

Trigonometric laws of cosines state that

$$\frac{1}{M} \sum_{k=0}^{M-1} \cos\left[\frac{\pi}{M}\left(k+\frac{1}{2}\right)l\right] = \begin{cases} (-1)^r & l = 2rM \\ 0 & \text{otherwise} \end{cases} \tag{2.191}$$

and,

$$\beta(n,l,m) = \beta_1(n,l,m) + \beta_2(n,l,m) \tag{2.192}$$

where

$$\beta_1(n,l,m) = \begin{cases} (-1)^r & l = n - 2rM \\ 0 & \text{otherwise} \end{cases} \tag{2.193}$$

and

$$\beta_2(n,l,m) = \begin{cases} (-1)^{v+1-m} & l = (2v+1)M - n - 1 \\ 0 & \text{otherwise} \end{cases} \tag{2.194}$$

After some algebraic calculations, the perfect reconstruction condition is obtained by applying Equations 2.193 and 2.194 in Equation 2.189 to require that

$$\sum_{m=-\infty}^{\infty} h(n + mM) h(n + mM + 2rM) = \delta(r) \tag{2.195}$$

Let us consider two illustrative cases of ELT as follows

1. K=1 means that perfect reconstruction resumes to the MLT case already expressed in Equation 2.195 and corresponds precisely to the case developed earlier by Princen and Bradley. A good choice for the window $h(n)$ for the window is a sine function which ensures maximum smoothness i.e.

$$h(n) = \sin\left[\frac{\pi}{2M}\left(n + \frac{1}{2}\right)\right] \tag{2.196}$$

2. K=2, L=4M where Equation 2.195 becomes

$$h^2(n) + h^2(n+M) + h^2(n+2M) + h^2(n+3M) = 1 \tag{2.197}$$

and

$$h(n)h(n+2M) + h(n+M)h(n+3M) = 0 \tag{2.198}$$

A class of prototype filters $h(n)$ which satisfy both equations can be built on the four equations

$$\begin{array}{llll} h(M/2 - 1 - i) & = & -s_i s_{M-1-i}, & \quad h(M/2 + i) & = & -s_i c_{M-1-i} \\ h(3M/2 - 1 - i) & = & -c_i s_{M-1-i}, & \quad h(3M/2 + i) & = & -c_i c_{M-1-i} \end{array}$$

where $c_i = cos(\theta_i)$ and $s_i = sin(\theta_i)$ with $i = 0, 1, \ldots, \frac{M}{2} - 1$. Perfect Reconstruction is guaranteed for any set of angles θ_i.

2.5. *Lapped Orthogonal Transforms* 135

2.5.3 Lapped Transforms as Multirate Filter Banks

When comparing the LOT's with multirate filter banks, it may be rather clearly conjectured that LOT's can be represented as multirate filter bank decompositions where the impulse responses of the synthesis filters are the *LOT basis functions* and those of the analysis filters are the *time-reversed LOT basis functions*. In the demonstration which follows, *it is demonstrated that lapped transforms correspond to perfect reconstruction filter bank with FIR filters and a lossless polyphase component matrix. Conversely, any FIR filter banks with the perfect reconstruction property is a lapped transform.*

Let p(n,k) be the element of the n^{th} row and the k^{th} column of matrix P and

$$f_k = p(n, k) \tag{2.199}$$

with $k = 0, 1, ..., M - 1$ and $n = 0, 1, ..., NM - 1$. The synthesis filters are the lapped transform basis functions. And the analysis filters

$$h_k = f_k(NM - 1 - n) = p(NM - 1 - n, k) \tag{2.200}$$

are the time-reversed basis functions. Then, the transfer functions of the k^{th} analysis and synthesis filters are given respectively by

$$H_k(z) = \sum_{l=0}^{NM-1} h_k(l)z^{-l} = \sum_{l=0}^{NM-1} p(NM - 1 - l, k)z^{-l} \tag{2.201}$$

and

$$G_k(z) = \sum_{l=0}^{NM-1} g_k(l)z^{-l} = \sum_{l=0}^{2M-1} p_{2M-1-l,k}z^{-k} \tag{2.202}$$

Going into polyphase representation, the transfer functions become

$$H_k(z) = \sum_{l=0}^{M-1} z^{-l} E_{k,l}(z^M) \tag{2.203}$$

and

$$G_k(z) = \sum_{l=0}^{M-1} z^{-NM-1-l} \tilde{E}_{l,k}(z^M) \tag{2.204}$$

Hence, from Equations 2.201, 2.202, 2.203 and 2.204, it turns out that the l^{th} polyphase component of $H_k(z)$ is given by

$$E_{kl}(z) = \sum_{m=0}^{N-1} P(M - 1 - l, k)z^{-m} \tag{2.205}$$

and the polyphase matrix $E(z)$ is given by

$$E(z) = \sum_{r=0}^{N-1} z^{-(N-1-l)} P_l^T J \tag{2.206}$$

where J is the counter-identity matrix defined as

$$J = \begin{vmatrix} 0 & \cdots & 0 & 0 & 1 \\ 0 & \cdots & 0 & 1 & 0 \\ \vdots & \vdots & \vdots & \vdots & \vdots \\ 1 & 0 & 0 & \cdots & 0 \end{vmatrix} \tag{2.207}$$

and P_l is the l^{th} square block of P which is defined by

$$P = [P_0^T \ P_1^T \ \cdots \ P_{N-1}^T] \tag{2.208}$$

Equation 2.206 enables one to proceed writing

$$E(z)\tilde{E}(z) = \sum_{n=0}^{N-1}\sum_{m=0}^{N-1} z^{n-m} P_n^T P_m \tag{2.209}$$

The condition of orthogonality is equivalent to

$$\sum_{m=0}^{N-1-l} P_m^T P_{m+l} = \delta(l)I \tag{2.210}$$

replacing this expression into Equation 2.209, we deduce that

$$E(z)\tilde{E}(z) = I \tag{2.211}$$

This demonstrates that the condition of orthogonality expressed on lapped transform implies that the associated filter bank has a lossless polyphase component matrix. Since we may write equivalently $E(z)\tilde{E}(z) = I$ and $\tilde{E}(z)E(z) = I$, Equation2.210 can be re-written in the form of

$$\sum_{m=0}^{N-1-l} P_m P_{m+l}^T = \delta(l)I \tag{2.212}$$

which expresses a necessary and sufficient condition for perfect reconstruction. This completes the first part of the demonstration which has shown that LOT's belong to the family of the perfect reconstruction FIR filter bank. The following will demonstrate the converse, that is the fact that any perfect reconstruction FIR filter bank is a lapped transform.

To demonstrate the converse proposition, let us consider a perfect reconstruction filter bank with a lossless polyphase component matrix, i.e. $E(z)\tilde{(E)}(z) = \tilde{(E)}(z)E(z) = I$ then the corresponding aliasing cancellation matrix $H(z)$ fulfills

$$\tilde{H}(z) H(z) = H(z) \tilde{H}(z) = MI \tag{2.213}$$

which allows us to write

$$\sum_{r=0}^{M-1} H_k(z^{-1}W_M^r)H_l(zW_M^{-r}) = M\delta(k-l) \tag{2.214}$$

where $W_M = e^{\frac{-j2\pi}{M}}$. Let us define $U_{kl}(z)$ by

$$U_{kl}(z) = H_k(z) \, H_l(z^{-1}) \tag{2.215}$$

which corresponds in the time domain to

$$u_k(n) = h_k(n) \, h_l(-n) \tag{2.216}$$

In this framework, Equation 2.214 may be re-expressed as

$$\sum_{r=0}^{M-1} U_{kl}(z^{-1}W_M^r) = M\delta(k-l) \tag{2.217}$$

Hence, in the time domain,

$$u_{kl}(rM) = \delta(r) \, \delta(k-l) \tag{2.218}$$

which represents the convolution of

$$h_k(n) * h_l(-n)|_{n=rM} = \delta(r) \, \delta(k-l) \tag{2.219}$$

This result is equivalent to the orthogonality condition of the lapped transform already express in 2.180 where $P(NM-1-n,k)$ corresponds here to $h_k(n)$. This completes the proof.

2.5.4 Conclusions on Lapped Orthogonal Transforms

This part of the chapter has presented an operator which takes some importance in the field of coding speech or image sequence. Indeed, the lapped orthogonal transform and its extensions have contributed to bring additional properties to perform signal analysis. The LOT turned out to be first a generalization of the DCT allowing the encoders to suppress the blocking effects and the hardware implementation to exploit fast implementations by butterfly algorithms. According to these points of view, the DCT stands as a particular case of the LOT and the ELT. Anyway, LOT and ELT can be considered as filter banks and conversely. As such, they will be examined once again in a more general framework of the subband filtering under the peculiar appellation of *modulated filter banks*. However extension is not yet finished so far; in fact, tight frames will be further constructed to support to modulated wavelets. The LOT and ELT offer some additional degrees of freedom which permit to perform adaptive filtering or analysis and further optimize the operating performances. The criteria to be introduced are examined later in this chapter.

2.6 Wavelet Transform and Multiresolution

The wavelet transforms have recently emerged in the literature as the consequence of researches originating from interdisciplinary origins, among them, let us mention engineering with subband coding, physics with coherent states and mathematics with pseudo-differential Calderon-Zygmund operators which find applications in non-linear partial differential equations. Wavelet transform turned out rapidly to be a powerful tool in signal analysis. The motivation in signal processing was to devise a new mathematical tool which could provide the linear signal analysis operators with efficient properties of time-frequency localization to deal with non-stationary signals and analyze their multi-scale frequency content. Past developments in the field have been merely devoted to the windowed Fourier transform (usually called short-time Fourier transform) and the Wigner-Ville distribution. Though exploited by researchers for a long time, the windowed Fourier transform suffers from some major drawbacks. Among them, the limitation of performing precise time localization at different scales is the most significant disadvantage to be mentioned. Wigner-Ville distribution is another tool for time-frequency representations of energy. Although having been used and studied for many years, it reveals other disadvantages when applied to signal analysis, especially the inherent bi-linearity of the operations which makes it adequate to locate non-stationary signal energy in the time-frequency plane. As such Wigner-Ville distribution is not a tool for signal expansion in the Hilbert space as linear operators do. Hereupon, wavelet transform turned out in the mid-eighties to be an elegant alternative to the latter technique to analyze non-stationary signals and provide expansions. Wavelet transform stemmed from various research work performed by Morlet and Grossmann who introduced a first formalization effort, by Daubechies who demonstrated the important properties and described the discretization, by Meyer and Stromberg who discovered some other important classes of discrete wavelets, by Mallat who focused on the orthonormal wavelet decompositions known as the multiresolution pyramid transform appealing particularly for image analysis and by Vetterli and Burrus who derived new ways to design of wavelet filter banks. The wavelets differ basically from the previous Short-Time Fourier Transforms (STFT) by the use of time windows adapted to frequency and offering efficient time-frequency localization performances. Although the time-frequency window of analysis is limited to a lower bound according by the *principle of uncertainty*, the shape may be nevertheless adapted to frequency to meet the behavior of the natural signals whose high frequency content lasts over short periods of time and low-frequency content over long periods. This is the precise property exploited by the wavelet transform which use short-time windows at high frequencies and long time windows at low frequencies as presented in Figure 2.18. The wavelet transform turns out to be an efficient technique to localize and evidence discontinuity and particularities in a signal. Examples are numerous, let us mention the detection of changes in time series, of contours and shape in image signals, the characterization of attacks in audio signals. To describe somewhat further the audio signal, let us add that the human speech is composed of vowels which last over long periods of time and are well-localized in low frequency and consonants which are short and rich in diversified high frequencies, that music like numerous other natural signals is also composed of low frequencies spanning over short times and of high frequencies spanning over long periods of time. The wavelet transform is

adequate to analyze audio signal. Thereby, when comparing wavelet transform to short-time Fourier transform, the wavelets have a basic window, called the *mother wavelet* to be considered in signal processing as a prototype band-pass filter from which the other filters of the bank are obtained by dilatations, contractions and time translations. Upon developing the correspondence between the Laplacian pyramid structure, as studied by Burt and Adelson, for signal details at different resolution levels and the wavelet decomposition with orthonormal basis, Mallat developed the theory of the multiresolution. We will follow the steps of Mallat in this textbook.

2.6.1 Introduction to Hilbert spaces

If a set L^2 of functions of a variable x defined on some interval T contains all linear combinations of its own elements (functions), then it is a linear vector space in which the functions are called vectors. As a matter of brief introduction, this section intends to review some important notions relative to deterministic and probabilistic Hilbert spaces of measurable, square-integrable one-dimensional functions.

If $f(x)$ and $g(x) \in L^2(\mathbf{R})$, where $L^2(\mathbf{R})$ denotes the Hilbert space, the *inner product* of $f(x)$ with $g(x)$ is written

$$< g(x), f(x) > = \int_T g(x) f^*(x) dx \qquad (2.220)$$

where the symbol * denotes the complex conjugate. Both functions $g(x)$ and $f(x)$ are said to be orthogonal in the Hilbert space if the inner product is zero. For instance, $f(x) = \cos(2\pi t)$ and $g(x) = \sin(2\pi t)$ are orthogonal on $T = [0, 1]$.

The *norm* of $f(x)$ is denoted

$$||f(x)||^2 = \int_{-\infty}^{+\infty} |f^*(x)|^2 dx \qquad (2.221)$$

It can be shown that definitions 2.220 and 2.221 satisfy all *the geometrical definitions respectively established for both inner vector product and norm*. Thus, these functions of a real variable can be given geometrical interpretations.

The *convolution of two functions* $f(x)$ and $g(x)$ is given by

$$g(x) * f(x) = \int_{-\infty}^{+\infty} g(x) f(u - x) dx \qquad (2.222)$$

and is to be interpreted as a projection.

The *scaling of a factor s* is referred to be as

$$f_s(x) = \sqrt{s} f(sx) \qquad (2.223)$$

These basic properties are intended to be exploited intensively in the following sections since the transform operator can be thought of as the inner product of the given function under analysis with the kernel specific of the transform. Discrete sums could have been used instead of the continuous integrable functions. Similarly, a probabilistic Hilbert space may defined for stochastic processes and random variables on probabilistic measures. Indeed, Let X and Y be two random variables and P a probability measure on S the space where X and Y are defined. That is $X = \{f_2(s) : s \in S\}$ and $Y = f_2(s) : s \in S\}$. The *inner product* defined in 2.220 relates to the correlation of X and Y

$$E[XY] = \int_S g(s)f^*(s)dP(s) \tag{2.224}$$

The formula applies equivalently to continuous and discrete variables and can be re-expressed in terms of the joint probability distributions functions F_{XY} as

$$E[XY] = \int_S \int_S xy dF_{XY}(x,y) \tag{2.225}$$

or in terms of the joint probability density function f_{XY}

$$E[XY] = \int_S \int_S xy f_{XY}(x,y)dxdy \tag{2.226}$$

Random variables are said to be *orthogonal* if and only if their correlation is zero. Defining the norm as

$$||X||^2 = [E(X^2)] \tag{2.227}$$

leads to geometrical interpretation of random variables. The probabilistic approach will be used as such in Chapter 4 when investigating the problem of predicting the sub-image bit rate in the coder control.

2.6.2 Short-Time Fourier Transform

The classical Fourier transform of a function $f(x)$ in the Hilbert space of measurable and square-integrable one-dimensional functions, $L^2(\mathbf{R})$, is defined as the inner product of $f(x)$ with the exponential kernel function $e^{-i\omega x}$, that is

$$F(\omega) = \int_{-\infty}^{+\infty} f(x)e^{-i\omega x}dx \tag{2.228}$$

where x may represent either a time or a space variable according to the nature of the signal is under analysis and ω corresponds to the associated frequency. Since the domain of integration is extended over the whole definition interval of x, the transformation is not able to localize the transients (i.e. either edges in images or attacks in audio) in the signal under investigation. The local variations are in fact spread out all over the integration domain and the operator presents poor time-localization properties. Instead, the frequency localization properties are excellent. To counteract the former drawback, the short-time Fourier transform has been defined by windowing the inner product. The window is translated along the definition domain of variable x to cover the whole space of definition of the signal $f(x)$. Let $g(x-u)$ be that window and u its translation parameter. Clearly, to measure around point u the signal behavior (precisely the amplitude of the sinusoidal wave component at frequency ω), the following inner product was devised

$$Gf(\omega, u) = \int_{-\infty}^{+\infty} f(x)g(x-u)e^{-i\omega x}dx \tag{2.229}$$

The transform can be interpreted as the inner product of the function $f(x)$ with a constant envelope tailored by the function $g(x)$ modulated (i.e. translated around) at frequency ω. Both parameters u and ω define fixed rectangular windows in the time-frequency plane. This plane is usually referred to as the *phase-space representation*. In image coding, the space-frequency is more frequently of concern since most of the treatments are performed spatially in the pictures. The short-time Fourier transform has been originally defined by Gabor who presented $g(x)$ as a Gaussian function. The STFT can also be viewed as a filter bank analysis where the function $g(x)$ is a prototype band-pass filter with an envelope of constant length or duration modulated about frequency ω. The windowing resolution in the time-frequency space is submitted to the uncertainty principle which imposes a lower bound to time-frequency analysis. Let in fact σ_u and σ_ω be the standard deviations of the window $g(x)$ in the original and the Fourier transform respectively. These are as follows

$$\sigma_u^2 = \int_{-\infty}^{+\infty} x^2 |g(x)|^2 dx \tag{2.230}$$

and

$$\sigma_\omega^2 = \int_{-\infty}^{+\infty} \omega^2 |G(\omega)|^2 d\omega \tag{2.231}$$

The *uncertainty principle* stated by Heisenberg applies readily on function $g(x)$ to provide the achievable resolution in time and frequency with a lower bound, meaning that the resolution cannot be arbitrarily small, therefore

$$\sigma_u^2 \, \sigma_u^2 \geq \frac{\pi}{2} \tag{2.232}$$

The principle imposes a lower bound to the resolution of the analyzing window. The limit is nevertheless reached with Gaussian functions as defined in Gabor transforms. The Gabor window $g(t) = \sqrt{\frac{\sqrt{2}}{T}} e^{-\pi \left(\frac{t}{T}\right)^2}$ yields the smallest window with the highest resolution. The resolution is fixed over the entire time-frequency domain and determines the effective window of analysis. Localization of discontinuities is optimum whenever signal duration and analysis window match to each other and lead to a high value in the inner product as would have been given by correlated signals. The STFT is well-suited for the analysis of signals wherein all the patterns display approximatively the same time-frequency scale. On the contrary, windows mismatching to the time-frequency signal scale lead to small inner products and a poor *correlation* coefficient. This prohibits the use of the STFT to analyze non-stationary signals. Restated in other words, this drawback implies an intrinsic lack of multi-scale analysis capability. It has been the motivation to search towards defining new concepts of decomposition. An appealing way to overcome the limitation has motivated the design of a transform with short high frequency basis functions and long low frequency ones. An additional parameter was necessary to add to the time shift u a stretching parameter to incorporate time-frequency dilatations and contractions. This transform is referred to as the wavelet transform and examined in the subsequent section. The discrete-time Gabor expansion is used in some experimental hardware coders and expressed as

Chapter 2. TV and HDTV Coding Algorithms

$$f(k) = \sum_{m=0}^{M-1}\sum_{n=0}^{N-1} a(m,n)g(k-nM)e^{j\frac{2\pi km}{M}} \qquad (2.233)$$

where M represents the subsampling factor of the discrete phase-space in time and corresponds to the number of the different frequency channels to represent the functions $g_{mn}(k) = g(k-nM)e^{j\frac{2\pi km}{M}}$. N is the subsampling factor of the discrete phase space in frequency. The discrete coefficients of the Gabor expansion are obtained from the inner products

$$a_{mn} = \sum f(k)\gamma(k-nM)e^{-j\frac{2\pi mk}{M}} \qquad (2.234)$$

where the $\gamma(k)$ functions are bi-orthogonal functions given by

$$\gamma(t) = \frac{L_0}{\sqrt{T}}e^{\pi(\frac{t}{T})^2}\sum_{n+\frac{1}{2}\geq\frac{t}{T}}(-1)^n e^{-\pi(n+\frac{1}{2})^2} \qquad (2.235)$$

where $L_0 = 1.85471197$.

Figure 2.17: Phase diagram of the STFT.

Although frequently used in modeling the impulse response of simple cells of the human visual cortex, the approach exploiting a set of frequency windows or filter banks having the same size, for instance Gabor decomposition, is not the most likely to apply for retinal images. Instead, some experimental data tend to show that the retinal image is rather decomposed into a set of regularly spread filter banks having approximatively a constant bandwidth on a logarithmic scale. Restated in other words, the Human Visual System performs an analysis at constant relative bandwidth $\frac{\Delta f}{f} = c$. This behavior argues in favor of a per-octave image analysis as that performed by wavelet transform.

2.6. Wavelet Transform and Multiresolution 143

2.6.3 Wavelet Transform

The wavelet transform is defined by the inner product expressed as

$$Wf(\omega, u) = \int_{-\infty}^{+\infty} f(x)\psi_{u\ s}(x)dx \tag{2.236}$$

where the analyzing kernel is defined as the wavelet by

$$\psi_{u\ s}(x) = \frac{1}{\sqrt{s}}\psi(\frac{x-u}{s}) \tag{2.237}$$

where u and s are respectively *scaling* and *translating parameters* with $u\epsilon\mathbf{R}$ and $s\epsilon R_0^+$. For large u, the wavelet kernel becomes a stretched and low-frequency-located version of the prototype wavelet called the *mother wavelet* $\psi(x)$. For small u, the wavelet kernel becomes a contracted high-frequency-located basis function. As a matter of fact, the time frequency resolution of the wavelet transform involves a different trade-off to that used in STFT since at high frequencies, the wavelet basis function is sharper in time, while at low frequencies, the wavelet basis is sharper in frequency as presented in Figure 2.18. Moreover, additional conditions have to be fulfilled to construct analyzing wavelets, these are as follows

Figure 2.18: **Phase diagram of the wavelet transform.**

1. $\psi(t)$ must be *concentrated* and have *finite energy*

$$\int_T |\psi(t)|^2 dt < \infty \tag{2.238}$$

 For normalization purpose, the energy of $\psi(t)$ is re-scaled to unity.

2. the Fourier transform $\Psi(\omega)$ of $\psi(x)$ must not only be *concentrated* but also satisfy the condition of admissibility

$$C_\psi = \int_0^\infty \frac{|\hat{\psi}(\omega)|^2}{\omega} dt < \infty \qquad (2.239)$$

which implies that $\Psi(0) = \int \psi(t)dt = 0$, and that $\Psi(\omega)$ is small enough in the neighborhood of $\omega = 0$. The function $\psi(t)$ may thus be interpreted as the impulse function of a band-pass filter.

As a matter of illustration, let us cite the first two original examples of continuous-time wavelets developed in the field

1. the second derivative of the Gaussian function called the *Mexican hat*, since it looks like a cross section through a Mexican hat, that is $\psi(t) = (1 - t^2)e^{-\frac{t^2}{2}}$ with Fourier transform equal to $\Psi(\omega) = \omega^2 e^{-\frac{\omega^2}{2}}$. Figures 2.19 and 2.20 present the Mexican hat and its Fourier transform.

2. the Morlet wavelet, derived from mine prospection activities, is given by
$$\psi(t) = e^{j\omega_0 t}e^{-\frac{t^2}{2}} - \sqrt{2}e^{-\frac{\omega_0^2}{4}}e^{j\omega_0 t}e^{jt^2}$$ with Fourier transform equal to
$$\Psi(\omega) = e^{-\frac{(\omega-\omega_0)^2}{2}} - e^{-\frac{\omega_0^2}{4}}e^{-\frac{(\omega-\omega_0)^2}{4}}.$$

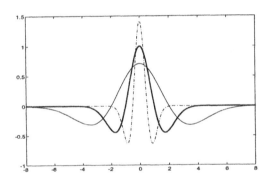

Figure 2.19: Mexican hats.

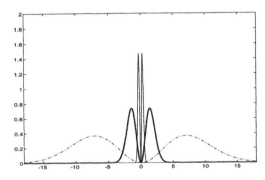

Figure 2.20: Fourier transform of Mexican hats.

2.6.4 Properties of Wavelet Transforms

Some properties determine uniquely the wavelet transformation formally represented here as $s = f(t) \rightarrow S(u, s)$, these properties are the following

1. the *linearity of the transformation* $s(t) \rightarrow S(u, s)$ which contrasts to the Wigner-Ville operator.

2. the *covariance under time translation* meaning $s(t - t_0) \rightarrow S(u - t_0, s)$

3. the *covariance under scale changes* meaning $\frac{1}{\lambda}s(\frac{t}{\lambda}) \rightarrow S(\frac{u}{\lambda}, \frac{s}{\lambda})$

4. the *conservation of energy*

$$\int_{-\infty}^{+\infty} |f(t)|^2 dt = \frac{1}{C_\psi} \int_{-\infty}^{+\infty} \int_0^{+\infty} |Wf(s,u)|^2 ds du \qquad (2.240)$$

where C_ψ has already been defined in 2.239.

2.6.5 The Discrete Wavelet Transform

To utilize the wavelet transform as a practical linear operator processing digital images, we would like to discretize the operator and, therefore, to restrict a and b to discrete values by choosing a discrete lattice $\{a_m, b_n\}$ such that $g(t) = \sum_{m,n} g_{m,n}(t) < g_{n,m}|s >$ generates stable and perfect reconstruction of the original signals. Starting from the continuous transform, the sampling lattice is easily chosen to be

$$a = a_0^m \qquad b = nb_0 a_0^m \qquad (2.241)$$

where m and n range over **Z**, where $a_0 > 1$, $b_0 > 0$ are fixed. The appropriate choices for a_0, b_0 depend, of course, on the wavelet ψ. This corresponds to

$$\psi_{mn} = a_0^{-\frac{m}{2}} \psi(a_0^{-m} t - nb_0) \qquad (2.242)$$

If, for some choice of $\psi(t)$, a and b, the set of discrete wavelets is complete in $L^2(\mathbf{R})$ and we can express any $f(t) \in L^2(\mathbf{R})$ as the superposition

$$f(t) = \sum_n \sum_m < f(t), \psi_{mn}(t) > \psi_{m,n}(t) = \sum_n \sum_m d_{m,n} \psi_{m,n}(t) \qquad (2.243)$$

The complete set of functions ψ is called a *frame*. In fact, a family of functions ψ_{mn} in a Hilbert space H is called a frame if there exist $A > 0$, $B < \infty$ so that, for all f in H,

$$A||f||^2 \le \sum_m \sum_n |< f, \psi_{m,n} >|^2 \le B||f||^2 \qquad (2.244)$$

$A > 0$ and $B < \infty$ are called the frame bounds. The left inequality is equivalent to the numerical stability required for the discrete-time wavelet reconstruction. This definition of frames is interconnected with stable reconstruction but does not represent a basis. Moreover, frames do not fulfill the Parseval theorem and the expansion using frames is not unique. To derive frames which constitute an orthonormal basis for $L^2(\mathbf{R})$, some additional constraints on the frame will be required. A frame is *tight* if $A = B = 1$. But the *tight frame* does not yet constitute an orthonormal basis, the function ψ_{mn} is not necessarily linearly independent and it remains redundancy in the frame. A frame is called *exact* if the removal of a function leaves the frame incomplete. Eventually, exact and tight frames define orthonormal basis for $L^2(\mathbf{R})$ and the associated orthonormal wavelet expansion can be thought of as the wavelet counterpart to the critically sampled subband filter bank. This allows considering the wavelet coefficients as generated by wavelet filter banks. Usually, $a_0 = 2$ and provides a per-octave decomposition, $b_0 = 1$. Thus,

$$\psi_{mn}(t) = 2^{-\frac{m}{2}}\psi(2^{-m}t - n) \tag{2.245}$$

sampling $y_m(t)$ at $n2^m$ gives

$$y_m(t) = 2^{-\frac{m}{2}}\int f(\tau)\psi(2^{-m}\tau - n)d\tau = d_{mn} \tag{2.246}$$

The dyadic sampling grid and the wavelet filter bank are illustrated in Figures 2.21 and 2.22 respectively. They point out the contrast with the sampling grid, the filter bank and the down-sampler in the STFT. Coming next, the construction of compactly supported wavelet bases is investigated to provide a multiresolution tool of signal analysis.

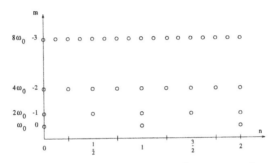

Figure 2.21: Sampling grid for discrete wavelets.

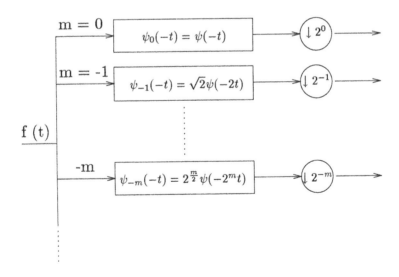

Figure 2.22: Discrete wavelet transform as a filter bank.

2.6.6 Multiresolution Signal Analysis

By definition, a multiresolution analysis consists of a sequence of successive approxima-
tions and provides the natural framework to understand and build orthonormal bases of
wavelets. The concept has been originally introduced by Meyer and Mallat who consid-
ered the multiresolution analysis as a sequence of closed subspaces $\{V_n : n \in \mathbf{Z}\}$ of $L^2(\mathbf{R})$
satisfying the properties of containment, completeness, scaling and framing.

1. the *containment* implies that

$$... \; V_2 \subset V_1 \subset V_0 \subset V_{-1} \subset V_{-2} \; ... \qquad (2.247)$$

 the subspaces V_n correspond to successive approximations or different levels of res-
 olution so as to be finer and finer with decreasing values of n.

2. the *completeness* means that

$$\overline{\bigcup_{j \in \mathbf{Z}} V_j} = L^2(\mathbf{R}) \qquad (2.248)$$

$$\bigcap_{j \in \mathbf{Z}} V_j = \{0\} \qquad (2.249)$$

3. the *scaling* property

$$f(x) \in V_m \longleftrightarrow f(2x) \in V_{m-1} \qquad (2.250)$$

 for any function $f \in L^2(\mathbf{R})$.

4. the *frame* property implies that there exists a scaling function $\phi(t) \in V_0$ such that
 $\forall m \in Z$, the set

$$\{\phi_{mn}(t) = 2^{-\frac{m}{2}}\phi(2^{-m}t-n)\} \qquad (2.251)$$

 is an orthonormal basis for V_m.

Let us comment the meaning of these properties. As already mentioned, we may in-
terpret the subspace V_j as the set of all the possible approximations at resolution 2^j in
the original signal $f(x) \in L^2(\mathbf{R})$. Let us define a linear operator P_{2^j} such that $P_{2^j}f(x)$
is the approximation of the function $f(x)$ at the resolution 2^j. As a matter of fact,
this operator is a projection operator on V_j. The *property of completeness* ensures that
$\lim_{j \to -\infty} P_{2^j}f(x) = f$ and implies that $[P_{2^j} \circ P_{2^j}]f(x) = P_{2^j}f(x)$ (\circ symbolizes the oper-
ator of composition). Among all the functions $g(x) \in V_{2^j}$ at resolution 2^j, the projection
generates the function which is the most similar to $f(x)$ and then the operator is such
that

Chapter 2. TV and HDTV Coding Algorithms

$$\|g(x) - f(x)\| \geq \|P_{2^j}f(x) - f(x)\| \tag{2.252}$$

and performs an orthogonal projection meaning that, among all functions $g(x) \in V_{2^j}$, $P_{2^j}f(x)$ is the function which is the closest to $f(x)$. Similarities can be readily mentioned with the problem of researching the optimum signal estimation or prediction by means of a Wiener or a Kalman filter. These aspects will be treated in Chapter 4 when researching the optimum prediction of the future bit rates to be observed.

The *containment property* means that if j decreases then $P_{2^j}f(x)$ leads successively to better approximations of $f(x)$. The approximation at resolution 2^{j+1} contains all the necessary information to compute the approximation at the smaller resolution 2^j. This is a causality property described by the successive inclusions.

A similar operator may be defined for all sub-space V_J. Among all the admissible ladders of subspaces, those defining the multiresolution satisfy an additional scaling requirement involving that all the spaces be scaled versions of the central space V_0. The space of approximated functions should thus be derived from one another by scaling each approximated function by the ratio of their resolution values

$$f(x) \in V_{2^J} \leftrightarrow f(2x) \in V_{2^{J+1}} \qquad \text{for any function f(x) } \in L^2(\mathbf{R}) \tag{2.253}$$

Finally, we required that there exists a unique function $\phi_{0,n} \in L^2(\mathbf{R})$, called the *scaling function*, such that the set

$$\{\phi_{0,n} = \phi(t - n) : n \in \mathbf{Z}\} \tag{2.254}$$

spans V_0 as an orthogonal basis. This is known as the basis or frame property. Moreover, $\forall j, n \in \mathbf{Z}$, $\phi_{j,n}(x) = 2^{-\frac{j}{2}}\phi(2^{-j}x - n)$ is an orthogonal basis of V_j as deduced from the scaling 2.253 and the frame 2.254 requirements. Therefore,

$$\int \phi_{j,n_1}\phi_{j,n_2} = \delta_{n_1,n_2} \tag{2.255}$$

For every $j \in \mathbf{Z}$, let us define the W_j to be the orthogonal complement of V_j in V_{j-1}. Therefore

$$V_{j-1} = V_j \oplus W_j \qquad \text{and} \quad W_j \bot W_i \qquad \forall \, i \neq j \tag{2.256}$$

It follows that

$$V_s = V_i \oplus \bigoplus_{k=0}^{s-j-1} W_{s-k} \qquad \text{for } s > j \tag{2.257}$$

Referring to 2.248 and 2.249, orthogonality and completeness of V_j implies that W_j decomposes $L^2(\mathbf{R})$ into mutually orthogonal subspaces such that

$$L^2(\mathbf{R}) = \bigoplus_{j \in \mathbf{Z}} W_j \tag{2.258}$$

2.6. Wavelet Transform and Multiresolution

Moreover, the W_j spaces fulfill the scaling property of the V_J. We can introduce an operator $Q_{2j}f(x)$ onto W_j similar to P in terms of properties. From Equation 2.256, the projection operation on V_{j-1} decomposes into a sum of projections as

$$P_{j-1}f(x) = P_j f(x) + Q_j f(x) \qquad (2.259)$$

The context interpretation of this equation is of major importance. Indeed, $P_j f(x)$ is to be considered as the low-pass part of f(x) in V_{j-1} and $Q_j f(x)$ as the high-pass part of f(x) i.e. the detail or the increment of information, to be added to $P_j f(x)$ in proceeding from V_j to V_{j-1}.

The subspaces W_j are mutually orthogonal and complementary subspaces provided with the scaling property of the subspaces V_j. Whenever bases $\phi_{j,n}$ exist and span the subspaces V_j, a basic reasonable principle of multiresolution decomposition states the existence of orthogonal bases $\{\psi_{j,k} : j, k \in \mathbf{Z}\}$ which span the space $L^2(\mathbf{R})$. Clearly, the wavelet $\psi(x) \in W_0$ is such that $\psi(x - k)$ spans W_0 and, invoking the scaling property, $\psi_{j,k}(x) = 2^{-\frac{1}{2}}\psi(2^{-j}x - k)$ spans W_j. Eventually, if the multiresolution decomposition of a signal $f(x)$ is derived whenever a set of V_J exists and satisfies Relationships 2.248 and 2.249, then the orthonormal basis of wavelets $\{\psi_{j,k} = 2^{-\frac{1}{2}}\psi(2^{-j}x - k) : j, k \in \mathbf{Z}\}$ is such that for all $f(x)$ in $L^2(\mathbf{R})$, we have

$$P_{j-1}f(x) = P_j f(x) + \sum_{k \in \mathbf{Z}} <f(x), \psi_{j,k}> \psi_{j,k} \qquad (2.260)$$

According to 2.247, 2.248 and 2.249, the whole collection of $\{\psi_{j,k} = 2^{-\frac{1}{2}}\psi(2^{-j}x-k) : j, k \in \mathbf{Z}\}$ is an orthonormal basis of $L^2(\mathbf{R})$. Restated in other words, the scaling property of the subspaces W_j guarantees that, if $\{\psi_{0,k} : k \in \mathbf{Z}\}$ is an orthonormal basis of W_0, then $\{\psi_{j,k} : k \in \mathbf{Z}\}$ is likewise an orthonormal basis for W_j $\forall j \in \mathbf{Z}$. The construction of the wavelet support is therefore limited to finding a function $\psi(x)$ in W_0 such that $\psi(x-k)$ constitutes an orthonormal basis of W_0. The function $\psi(t)$ is the wavelet function associated with the multiresolution analysis. If $\{\psi_{0,k} : k \in \mathbf{Z}\}$ is an orthogonal basis of W_0, then $\{\psi_{j,k} : k \in \mathbf{Z}\}$ is likewise to be an orthogonal basis of W_j. This reduces the task to find an orthonormal basis of W_0. The wavelet basis associated with the multiresolution analysis has thereby the property

$$\int \psi_{j_1,k_1}(x)\, \psi_{j_2,k_2}(x) dx = \delta_{j_1,j_2}\, \delta_{k_1,k_2} \qquad (2.261)$$

Examining the scaling and wavelet functions in terms of a linear combination of the orthonormal bases on subspace V_{-1}, the fundamental wavelet equation is thereafter derived. Indeed, since $\phi(x) \in V_0 \subset V_{-1}$ and that $\phi_{-1,n}$ are orthonormal basis in V_{-1}, the scaling function can be expressed as

$$\phi(x) = \sum_n h_n \phi_{-1,n} \qquad (2.262)$$

with $h_n = <\phi, \phi_{-1,n}>$ and $\sum_n |h_n|^2 = 1$. Equation 2.262 can be rewritten as

$$\phi(x) = \sqrt{2} \sum_n h_n \phi(2x - n) \qquad (2.263)$$

The coefficient set $\{h_0(n)\}$ defines the *interscale basis coefficients* which will turn out to be the coefficient of the *low-pass filter* of a two-band para-unitary filter bank. Similarly, the band-pass wavelet function can be expressed as a linear combination of the translates of $\phi(2t)$

$$\psi(x) = \sqrt{2} \sum_n g_n \phi(2x - n) \tag{2.264}$$

This is referred to as the *fundamental wavelet equation* of which the coefficients $\{g_n\}$ correspond to the high-pass unit of a two-band para-unitary filter bank. If the duration of the interscale coefficients is finite, the *scaling function is said to be compactly supported*. If there are only finitely many non-zero $\{h_n\}$, both functions ψ and ϕ are also with compact support as a finite combination of compactly supported functions. In this configuration, the subband filtering schemes to be derived will exploit only FIR filters.

2.6.7 Haar Wavelets

As a matter of introduction, let us consider the Haar wavelets. Owing to their simplicity, these functions are frequently invoked when starting to study the wavelet families and to illustrate multiresolution concepts. Haar wavelets are a particular case where the orthogonal base of analysis introduces simultaneously linear phase filters. Let V_j be a space of piecewise constant functions which satisfy

$$V_m = \{f(t) \in L^2(\mathbf{R})\} \tag{2.265}$$

$f = c$ on $[2^m n, 2^m(n + 1)] \forall n \in \mathbf{Z}$ and $\forall c \in \mathbf{R}\}$. It is quite obvious to verify that the property of containment, completeness and scaling are fulfilled. If $f(t) \in V_0$ then $f(2t) \in V_{-1}$ and conversely. The scaling function $\phi(t)$ takes the following form

$$\phi(t) = \begin{cases} 1 & \text{if } 0 \le t \le 1 \\ 0 & \text{otherwise} \end{cases} \tag{2.266}$$

and the integer translates generate an orthonormal basis for V_0 since $\int \phi(t-n)\phi(t-m)dt = \delta_{n-m}$ for $\forall m, n$. The Fourier transform of the scaling function is that follows

$$\Phi(\omega) = e^{-j\frac{\omega}{2}} \frac{\sin\left[\frac{\omega}{2}\right]}{\frac{\omega}{2}} \tag{2.267}$$

The functions $\phi(x - n)$ span the whole subpace V_0. Recalling successively that $P_{-1}f(x) = Q_0 f(x) + P_0 f(x)$ that $Q_0 f(x) \in W_0$ represents the detail information in going from resolution scale 0 to -1 and that W_0 must be spanned by the $\psi(t - n)$, the mother wavelet is therefore expressed by $\psi(t) = \phi(2t) - \phi(2t - 1)$ and therefore by

$$\psi(t) = \begin{cases} 1 & \text{if } 0 \le t \le \frac{1}{2} \\ -1 & \text{if } 0 \le t \le \frac{1}{2} \\ 0 & \text{otherwise} \end{cases} \tag{2.268}$$

The Haar functions $\psi_{mn}(t)$ are derived from translations and dilatations and form a basis function of $L^2(\mathbf{R})$. The Haar wavelet and scaling functions are presented in Figure 2.23. The Fourier transform of the mother wavelet corresponds to a band-pass filter of analysis

$$\Psi(\omega) \; = \; je^{-j\frac{\omega}{2}} \frac{\sin^2[\frac{\omega}{4}]}{\frac{\omega}{4}} \tag{2.269}$$

and it turns out that the Haar scaling and wavelet functions are much better localized in time than in frequency as a consequence of the discontinuities in the time-domain approximation. The Haar functions $\psi_{mn}(t)$ are orthonormal not only at given scales but also across the scales leading to the respective equations

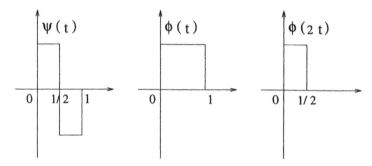

Figure 2.23: Haar wavelet and scaling functions.

$$\int \psi_{mn}(t)\psi_{mn'}(t)dt \; = \; \delta_{n-n'} \tag{2.270}$$

$$\int \psi_{mn}(t)\psi_{m'n'}(t)dt \; = \; \delta_{n-n'}\,\delta_{m-m'} \tag{2.271}$$

At scale j, the projections $Q_{j+1}f(x)$, $P_j f(x)$ and $P_{j+1}f(x)$ of f(x) on $Wj+1$, V_j and V_{j+1} are as follows

1. $P_j f(x)$ may be decomposed into odd and even indices

$$P_j f(x) \; = \; \sum_k c_{j,k}\,\phi_{j,k}(x) \tag{2.272}$$

$$= \; \sum_k c_{j,2k}\,\phi_{j,2k}(x) \; + \; \sum_k c_{j,2k+1}\,\phi_{j,2k+1}(x) \tag{2.273}$$

2. $P_{j+1}f(x)$ is given by

$$P_{j+1}f(x) \; = \; \sum_k c_{j+1,k}\,\phi_{j+1,k}(x) \tag{2.274}$$

by invoking that the coefficients at resolution $j+1$, namely $c_{j+1,k}$, may be expressed in terms of smoothing their own finer scale values such that

$$c_{j+1,j} = \; < f(x), \phi_{j+1,k} > \tag{2.275}$$

$$= \frac{1}{\sqrt{2}} < f(x), \phi_{j,2k} > + \frac{1}{\sqrt{2}} < f(x), \phi_{j,2k+1} > \tag{2.276}$$

$$= \frac{1}{\sqrt{2}} [c_{j,2k} + c_{j,2k+1}] \tag{2.277}$$

the expression of $P_{j+1}f(x)$ follows as

$$P_{j+1}f(x) = \sum_k \frac{1}{\sqrt{2}} [c_{j,2k} + c_{j,2k+1}] \frac{1}{\sqrt{2}} [\phi_{j,2k}(x) + \phi_{j,2k+1}(x)] \tag{2.278}$$

2. $Q_{j+1}f(x)$ is deduced from $P_j f(x) - P_{j+1}f(x)$ as

$$Q_{j+1}f(x) = \frac{1}{2} \sum_k [c_{j,2k} - c_{j,2k+1}][\phi_{j,2k} - \phi_{j,2k+1}] \tag{2.279}$$

$$= \sum_k d_{j+1,k}\psi_{j+1,k} \tag{2.280}$$

Consequently, the projection of $f(x)$ onto W_{j+1} may be represented in an orthonormal basis expressed by translates and dilates of the mother function $\psi(t)$,

$$\{\psi_{j+1,k} = \frac{1}{\sqrt{2}}(\phi_{j,2k} - \phi_{j,2k+1}); \; k \in \mathbf{Z}\} \tag{2.281}$$

In the Haar basis system, the filter coefficients are therefore given for the low-pass filter as

$$h_0(n) = \begin{cases} \frac{1}{\sqrt{2}} & n = 0,1 \\ 0 & \text{otherwise} \end{cases} \quad \Leftrightarrow \quad H_0(e^{-j\omega}) = \sqrt{2}e^{-\frac{j\omega}{2}} \frac{\cos[\omega]}{2} \tag{2.282}$$

and, for the high-pass filter, as

$$h_1(n) = \begin{cases} \frac{1}{\sqrt{2}} & n = 0 \\ -\frac{1}{\sqrt{2}} & n = 1 \\ 0 & \text{otherwise} \end{cases} \quad \Leftrightarrow \quad H_1(e^{-j\omega}) = j\sqrt{2}e^{-\frac{j\omega}{2}} \frac{\sin[\omega]}{2} \tag{2.283}$$

These are para-unitary filters in spite of being simple ones. From Equations 2.277 and 2.280, it turns out that the scaling coefficients $c_{j+1,k}$ and the wavelet coefficients $d_{j+1,k}$ may be computed by convolving $c_{j,k}$ with respectively $\sqrt{2}h_0(n)$ and $\sqrt{2}h_1(n)$ and down-sampling by a factor 2.

2.6. Wavelet Transform and Multiresolution

2.6.8 Ties between Subband Filters and Wavelets

In this section, the demonstration path follows first the path of the Daubechies [39] to demonstrate the tight connection between *wavelet transform* and *subband coding* and proceeds thereafter to present the particular equivalence between *para-unitary two-band FIR PR-QMF filter banks* and *compactly supported orthonormal wavelet bases*.

2.6.8.1 Links between Subband Filters and Wavelets

Let us suppose that the inner product of function $f(x) \in L^2(\mathbf{R})$ with the functions $\phi_{j,k}$ is known at some given fine scale j as $< f, \phi_{0,n} >$. Without loss of generality, we may always re-scale and suppose that j=0. Let us first compute the inner product $< f, \psi_{j,k} >$ for $j \geq 1$. Since

$$\begin{aligned} \psi &= \sum_n < \psi, \phi_{-1,n} > \phi_{-1,n} & (2.284) \\ &= \sum_n (-1)^n h_{-n+1} \, \phi_{-1,n} & (2.285) \\ &= \sum_n g_n \, \phi_{-1,n} & (2.286) \end{aligned}$$

it follows that

$$\begin{aligned} \psi_{j,k}(x) &= 2^{-\frac{j}{2}} \, \psi(2^{-j}x - k) & (2.287) \\ &= 2^{-\frac{j}{2}} \sum_n g(n) \, 2^{\frac{1}{2}} \, \phi(2^{-j+1}x - 2k - n) & (2.288) \\ &= \sum_n g(n) \, \phi_{j-1,2k+n}(x) & (2.289) \\ &= \sum_n g(n - 2k) \, \phi_{j-1,n}(x) & (2.290) \end{aligned}$$

therefore, the inner products for j=0 takes the form

$$< f, \psi_{1,k} > = \sum_n g^*_{n-2k} < f, \phi_{0,n} > \qquad (2.291)$$

At this stage, this means that the $< f, \psi_{1,k} >$ are calculated by convolving the sequence $< f, \phi_{0,n} >$ with g^*_n and retaining only the even samples. Proceeding for any j, we have successively and similarly

$$\begin{aligned} \phi_{j,k}(x) &= 2^{-\frac{j}{2}} \phi(2^{-j}x - k) & (2.292) \\ &= \sum_n h_{n-2k} \phi_{j-1,n}(x) & (2.293) \end{aligned}$$

$$< f, \psi_{j,k} > = \sum_n g^*_{n-2k} < f, \phi_{j-1,n} > \qquad (2.294)$$

are derived by convolving the sequence $< f, \phi_{j,n} >$ with (\bar{g}_n) and decimating by a factor 2.

Since $\phi \in V_0 \subset V_{-1}$ and the $\phi_{-1,n}$ are an orthonormal basis in V_{-1}, we write

$$\phi = \sum_n h_n \phi_{-1,n} \tag{2.295}$$

where $h_n = < \phi, \phi_{-1,n} >$ and $\sum_n |h_n|^2 = 1$. Whence, we have successively

$$\phi(x) = \sqrt{2} \sum_n h_n \phi(2x - n) \tag{2.296}$$

$$\phi_{j,k}(x) = 2^{-\frac{j}{2}} \phi(2^{-j}x - k) \tag{2.297}$$
$$= \sum_n h_{n-2k} \, \phi_{j-1,n}(x) \tag{2.298}$$

Hence,

$$< f, \phi_{i,k} > = \sum_n h_{n-2k}^* < f, \phi_{j-1,n} > \tag{2.299}$$

The structure of the algorithm to compute coarser approximations derives from an iterative computation at each resolution level of the inner product of $f(x)$ with the wavelet and the scaling functions ϕ as follows

1. knowing the $< f, \phi_{0,n} >$, it is possible to compute the $< f, \psi_{1,k} >$ from 2.294 and the $< f, \phi_{1,k} >$ from 2.299.

2. knowing the $< f, \phi_{1,n} >$, it is possible to compute the $< f, \psi_{2,k} >$ and the $< f, \phi_{2,k} >$.

3. ...

The procedure can be interpreted as an iterative computation or the extraction of coarser resolutions of f in conjunction with the associated details or innovations δ between consecutive levels of resolution from coarse to finer. These are the $f^0 = f^1 + \delta^1 = P_0 f(x) + Q_1 f(x)$ according to the subspace decomposition $V_0 = V_1 \oplus W_1$. In the subspaces V_j, the orthonormal basis $\{(\phi_{i,k}); \; k, j \in \mathbf{Z}\}$ leads to expanding

$$f^0 = \sum_n c_n^0 \phi_{0,n} \quad \text{and} \quad f^1 = \sum_n c_n^1 \phi_{1,n} \tag{2.300}$$

In the subpaces W_j, the orthonormal basis $\{(\psi_{i,k}); \; k, j \in \mathbf{Z}\}$ allows writing

$$\delta^1 = \sum_n d_n^1 \psi_{1,n} \tag{2.301}$$

The coefficients of the orthogonal basis transformation which applies $(\phi_{0,n})$ on $(\phi_{1,n}, \psi_{1,n})$ are deduced from Equations 2.294 and 2.299

$$c_k^1 = \sum_n \bar{h}_{n-2k} c_n^0 \qquad\qquad d_k^1 = \sum_n \bar{g}_{n-2k} c_n^0 \qquad\qquad (2.302)$$

which actually formulate a one-step-decomposition analysis filter in the subband context. Abridging the notations so as to write $c^1 = \bar{H} c^0$ and $d^1 = \bar{G} c^0$, we can iterate in the decomposition process towards further approximations in which f^1 is further split into $f^1 = f^2 + \delta^2$. This allows computing

$$f^2 = \sum_n c_n^2 \phi_{2,n} \qquad \text{and} \qquad \delta^2 = \sum_n d_n^2 \psi_{2,n} \qquad\qquad (2.303)$$

to write an up-dated version in the decomposition

$$C^2 = \bar{H} c^1 \qquad \text{and} \qquad d^2 = \bar{G} c^1 \qquad\qquad (2.304)$$

The analysis is supposed to proceed down to the resolution level j. Therefore, the information originally in $(< f, \phi_{0,n} >) = c^0$ has been decomposed into

1. $d^1 = (< f, \psi_{1,k} >), \; k \in \mathbf{Z}$,

2. $d^2 = (< f, \psi_{2,k} >), \; k \in \mathbf{Z}$,

3 ...

j. $d^j = (< f, \psi_{j,k} >), \; k \in \mathbf{Z}$,

and in a final coarse approximation $c^j = < f, \phi_{j,n} >$. The decomposition has been elaborated on a succession of orthogonal basis transformations, the inverse operation is therefore obtained by the adjoint matrices. Thus,

$$
\begin{aligned}
c_n^{j-1} &= \; < f^{j-1}, \phi_{j-1,n} > & (2.305) \\
&= \; \sum_k c_k^j < \phi_{j,k}, \phi_{j-1,n} > \; + \sum_k d_k^j < \psi_{j,k}, \phi_{j-1,n} > & (2.306) \\
&= \; \sum_k \left[h_{n-2k} \, c_k^j \; + \; g_{n-2k} \, d_k^j \right] & (2.307)
\end{aligned}
$$

Let us remark that Equation 2.306 makes use of $f^{j-1} = f^j + \delta^j = \sum_k c_k^j \phi_{j,k} + \sum_k d_k^j \psi_{j,k}$. The Equation 2.307 holds for the synthesis filter with perfect reconstruction. Coming next, the orthonormal wavelets are examined in the light of searching ties between *compact support* and *para-unitary orthonormal wavelets*.

2.6.8.2 Connections between PR-QMF Filters and Wavelets

As just announced, this section is devoted to demonstrating the important statement

Theorem 2.6.1 *the Orthonormal wavelet bases with compact support imply a para-unitary two-band FIR perfect reconstruction QMF bank and conversely*

The argumentation to be developed exploits Fourier domain to derive the equivalence between compactly supported orthonormal wavelet bases and para-unitary two-band FIR PR-QMF filters. The only constraint to yield the demonstration of this important relationship is that $H_0(z)$ has at least one zero at $z = -1$. To achieve that goal, several relationships will be successively expressed in the Fourier domain, namely the scaling function in terms of the interscale basis coefficients, the constraints on $H_0(e^{j\omega})$ and $H_1(e^{j\omega})$ so that the scaling and wavelet functions be orthonormal at any resolution scale.

Fourier Transform of the Scaling Function

In the Fourier domain, the scaling function expressed in terms of the set of interscale basis coefficients $\{h_0\}$ as shown in Equation 2.263 is given by

$$\Phi(\Omega) = \sum_n h_0 e^{-jn\frac{\Omega}{2}T_0} \; \Phi(\frac{\Omega}{2})$$ (2.308)

considering $H_0(e^{j\omega})$ as the transform of the sequence $\{h_0(n)\}$, that is

$$H_0(e^{j\omega}) = \sum_n h_0(n) \, e^{-jn\omega}$$ (2.309)

where $\omega = \Omega T_0$ is a normalized frequency. It follows that

$$\Phi(\Omega) = H_0(e^{\frac{j\omega}{2}}) \; \Phi(\frac{\Omega}{2})$$ (2.310)

Therefore, iterating infinitely many times, the Fourier transform of the scaling function $\phi(2^m t) = 2 \sum_n h_0 \phi(2^{(m+1)}t - n)$ becomes the product

$$\Phi(\Omega) = \Phi(0) \prod_{k=1}^{\infty} H_0(e^{-j\frac{\omega}{2k}})$$ (2.311)

The Fourier transform of the time scaling function is then equal to the infinite resolution product of the discrete time Fourier transform of the interscale coefficients $\{h_0\}$. Let us remark that the scaling function verifies a non-zero mean constraint

$$\Phi(0) = \int_{-\infty}^{\infty} \phi(t)dt$$ (2.312)

to be deduced from the completeness property.

Orthonormality of the Scaling Functions

As orthonormal bases of the subspaces V_m of any resolution scale m, the scaling functions $\{\phi_{mn}(t)\}$ satisfy $< \phi_{mn}(t)\phi_{ml}(t) >= \delta_{nl}$ so that any function $f(t)$ may be decomposed on the orthogonal basis of V_0 as

$$f(t) = \sum_n a(n) \; \phi(t - n)$$ (2.313)

$$= \phi(t) * \sum_n a(n) \; \delta(t - n)$$ (2.314)

re-expressed in the Fourier domain

$$F(\Omega) = \Phi(\Omega) \sum_n \alpha(n) \, e^{-j\Omega n} \tag{2.315}$$

$$= \Phi(\Omega) \, M(\Omega) \tag{2.316}$$

by letting $M(\Omega) = \sum_n \alpha(n)e^{-j\Omega n}$.

Let us search the condition that the set of scaling functions $\phi(t-n)$ be an orthonormal basis. The hint is to consider the norm $||f^2(t)||$ or the energy within $f(t)$ which may calculated either from

$$\int_{-\infty}^{\infty} |f(t)|^2 dt = \frac{1}{2\pi} \int_0^{2\pi} |M(\Omega)|^2 d\Omega \tag{2.317}$$

or from Parseval's formula in Fourier transform

$$\int_{-\infty}^{+\infty} |f(t)|^2 dt = \frac{1}{2\pi} \int_{-\infty}^{\infty} |F(\Omega)|^2 \, d\Omega \tag{2.318}$$

$$= \frac{1}{2\pi} \int_{-\infty}^{\infty} |\Phi(\Omega)|^2 \, |M(\Omega)|^2 \, d\Omega \tag{2.319}$$

$$= \frac{1}{2\pi} \int_0^{2\pi} |M(\Omega)|^2 \sum_{n=-\infty}^{\infty} |\Phi(\Omega + 2\pi n)|^2 \, d\Omega \tag{2.320}$$

Equating Equations 2.317 and 2.320, the constraint on the scaling function to be an orthonormal basis is readily given by

$$\sum_n |\Phi(\Omega + 2\pi n)|^2 = 1 \tag{2.321}$$

which can easily be transformed after some algebraic manipulations into a condition on the interscale coefficients $\{h_0(n)\}$ which is expressed as

$$|H_0(e^{j\omega})|^2 + |H_0(e^{j(\omega+\pi)})|^2 = 1 \tag{2.322}$$

This condition imposed on the interscale basis coefficients to ensure that scaling functions be orthonormal is nothing else than the requirement for a low-pass filter to act as a maximally decimated unitary PR-QMF. This demonstration holds for scaling functions on compact supports. This latter case implies that the sequence $\{h_0(n)\}$ is FIR. Equivalently restated in the z-transform domain, the previous condition becomes

$$H_0(z)H_0(z^{-1}) + H_0(-z)H_0(-z^{-1}) = 1 \tag{2.323}$$

The other requirements for orthogonality will enable deriving similar conditions as examined next.

Orthonormality of the Wavelet Functions

Since the wavelet bases span subspaces W_m and fulfill intra- and interscale orthonormalities, it follows that

$$< \psi_{mn}(t), \psi_{kl}(t) > = \delta_{m-l}\, \delta_{n-l} \tag{2.324}$$

where m and k are one pair of scaling parameters, and, n and l translation parameters. Calculations similar to those performed for the scaling functions lead to

$$\sum_n |\Psi(\Omega + 2\pi n)|^2 = 1 \tag{2.325}$$

since the set of the wavelet functions $\{\psi(t-n)\}$ constitutes an orthonormal basis which spans the subspaces w_0. Therefore, the wavelet coefficients must also satisfy

$$|H_1(e^{j\omega})|^2 + |H_1(e^{j(\omega+\pi)})|^2 = 1 \tag{2.326}$$

which, extended in z-transform, gives

$$H_1(z)H_1(z^{-1}) + H_1(-z)H_1(-z^{-1}) = 1 \tag{2.327}$$

These equations correspond to the requirement of a high-pass branch of a two-band unitary PR-QMF filter.

Orthonormality between Wavelet and Scaling Functions

Expressing orthogonality between *scaling* and *wavelet functions* to be satisfied across and within the scales leads to the time-domain condition

$$< \phi_{mn}(t), \psi_{kl}(t) > = 0 \tag{2.328}$$

once expressed in the frequency domain, the condition states

$$\sum_n \Phi(\omega - 2\pi n)\, \Psi^*(\Omega - 2\pi n) = 0 \tag{2.329}$$

and, after some calculations, it turns out that the

$$H_0(e^{j\omega})H_1(e^{-j(\omega)}) + H_0(e^{j(\omega+\pi)})^2 H_1(e^{-j(\omega+\pi)}) = 0 \tag{2.330}$$

again, in z-transform,

$$H_0(z)H_1(z^{-1}) + H_0(-z)H_1(-z^{-1}) = 0 \tag{2.331}$$

The choice of

$$H_1(z) = z^{-(N-1)}H_0(-z^{-1}) \qquad \text{N even} \tag{2.332}$$

and

2.6. *Wavelet Transform and Multiresolution* 159

$$h_1(n) = (-1)^{n+1} h_0(N - 1 - n) \tag{2.333}$$

respectively in the frequency and time domains satisfies Equation 2.330 implying cross-filtering orthogonality. Arguing that the $\phi(t)$ functions be real and orthonormal, we derive from 2.312

$$|\Phi(0)| = |H_0(e^{j\omega})|_{\omega=0} = 1 \tag{2.334}$$

$H_0(e^{j\omega})$ is a low-pass filter and referring to

$$|H_0(e^{j\omega})|^2 + |H_1(e^{j\omega})|^2 = 1 \tag{2.335}$$

then

$$\Psi(0) = \int_{-\infty}^{\infty} \psi(t)dt = |H_1(e^{j\omega})|_{\omega=0} = 0 \tag{2.336}$$

$H_1(e^{j\omega})$ is a high-pass filter. $H_0(z)$ and $H_1(z)$ have at least one zero respectively at $z = -1$ and $z = 0$. This completes the proof.

2.6.9 Multiresolution Decomposition

The multiresolution decomposition method has been originally proposed by Burt and Adelson in [31] who put forward the *Laplacian pyramid* to perform a dyadic tree-like spectral analysis. Figure 2.24 depicts the Laplacian structure of signal decomposition. The signal $x(n)$ is low-pass filtered and decimated by 2 to produce the TV sub-signal. Let us denote this sub-signal $x_D^1(n)$. Then $x_D^1(n)$ is coded and transmitted. This coded sub-signal is thereafter up-sampled by 2 and interpolated to generate a corresponding interpolated high resolution version $x_I^1(n)$ which is eventually compared to the original signal x(n) to produce a complementary signal $x_L^1(n) = x(n) - x_I^1(n)$. The interpolation errors and multiresoluted signals have respectively Laplacian and Gaussian-shaped PDF's. The major drawback of the Laplacian pyramid is critical sampling. This means that the signal is not subsampled at a minimum possible rate consistent with Nyquist's theorem. The classical over-sampled Laplacian pyramid is the noticeable exception to the common rule. A modified Laplacian pyramid coding scheme for critical sampling has been proposed in the literature [25].

The multiresolution analysis carried out by the wavelet transform as presented in the previous section decomposes a signal into successive layers at coarser resolutions. The structure of the wavelet decomposition is dyadic and similar in principle to the Laplacian pyramid, showing the innovative impulsion brought by Burt and Adelson. The major difference holds in the fact that wavelet decomposition achieves critical sampling. The dyadic wavelet transform expresses f as a sum of two functions, one lying in subspace V_1 and the other in W_1 the orthogonal complement to yield $V_0 = V_1 \oplus W_1$. Then

$$f(t) = P_1 f + Q_1 f = \sum_n c_{1,n} \phi_{1n}(t) + \sum_n d_{1,n} \psi(t) \tag{2.337}$$

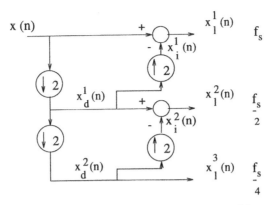

Figure 2.24: Laplacian pyramid decomposition.

the coefficients $c_{1,n}$ and $d_{1,n}$ are inner product, meaning that

$$c_{1,n} \quad = \quad <f, \phi_{1,n}> \tag{2.338}$$

$$= \quad \frac{1}{\sqrt{2}} \int f(t)\phi(\frac{t}{2} - n)dt \tag{2.339}$$

$$= \quad \sqrt{2} \int f(t) \sum_k h_0(k)\phi(t - 2n - k)dt \tag{2.340}$$

$$= \quad \sqrt{2} \sum_k h_0(k) \int f(t)\phi(t - 2n - k)dt \tag{2.341}$$

$$= \quad \sqrt{2} \sum_k h_0(k)c_{0,2n+k} \tag{2.342}$$

$$= \quad \sqrt{2} \sum_k h_0(k - 2n)c_{0,k} \tag{2.343}$$

A similar reasoning applies to $d_{1,n}$. Both yield a dyadic decomposition in form of a convolution followed by subsampling as a subband analysis with a pair of para-unitary FIR filters as depicted in Figure 2.25. The decomposition can be iterated recursively to build a whole pyramid expansion of the signal into multiresoluted versions.

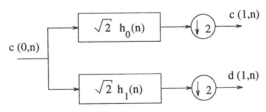

Figure 2.25: Dyadic subband decomposition of wavelets.

2.6. *Wavelet Transform and Multiresolution*

2.6.10 Properties of the Wavelet Decomposition

The design of filter banks and wavelets which guarantee perfect reconstruction is an important issue for video coding to be discussed at this stage. The wavelet transform provides a multiresolution analysis of the signal with sizeable space-frequency localization. This property is useful for compression purpose since it allows a better adaptation of the quantization. The topics to be examined in the sequel will deal successively with regularity and frequency selectivity, with space-frequency localization, with non-linear-phase orthogonal filter banks, with linear-phase bi-orthogonal filter banks, with FIR and IIR filters, with energy compaction (examined in the quantization section) and with filtering adaptive properties. These are numerous properties which have been already examined and are disseminated in the abundant literature which has emerged recently on the field. These properties allow us to design adequate filter banks to fit any specific problem of signal analysis and then to generate the corresponding wavelet operators. Fixed and adaptive wavelet packets have also contributed to bringing arbitrarily orthonormal tilings of the time-frequency plane. Time-varying or adaptive wavelet packets provide an efficient tool for the compression of non-stationary signals.

2.6.10.1 Regularity

The concept of *regularity* has been introduced by Daubechies to provide a *degree of smoothness* for wavelet and scaling functions. The regularity of the scaling function is defined as the maximum value of r such that

$$|\Phi(\Omega)| \le \frac{k}{(1 + |\Omega|)^{r+1}} \tag{2.344}$$

meaning that $\phi(t)$ is m-times continuously differentiable, and $m \ge r$. In fact, regularity implies flatness on the frequency response of $H_0(e^{j\omega})$ at $\omega = \pi$. If $H_0(z)$ has a zero of order r at $z = -1$, then the wavelet will have r consecutive vanishing moments meaning that $\int x^k \psi(x)dx = 0$ for $k = 0, 1, \ldots, r-1$. This property has potential usefullness for compression of smooth functions by wavelets leading to locate a maximum number of zero at $z = -1$.

Instead of considering the discrete version of a discrete-time filter, let us define a function $f^{(i)}(x)$ which is piecewise constant on intervals of length $\frac{1}{2^i}$ and equal to

$$f^{(i)}(x) = 2^{\frac{i}{2}} h^{(i)}(n) \qquad \frac{n}{2^i} \le x \le \frac{(n+1)}{2^i} \tag{2.345}$$

and supported on the interval $[0, L-1]$ where L is the length of impulse response of filter $H(z)$. As demonstrated by Daubechies, let us assume that $H(z)$ has a zero at the half sampling frequency, $H(e^{j\pi}) = 0$. This is reasonable since $H(z)$ has to be a half-band low-pass filter. At least one such zero is necessary for $f^{(i)}(x)$ to converge to a continuous function. Let us also define $m_0(z) = \frac{1}{\sqrt{2}} H(z)$ so as to normalize, $m_0(1) = 1$ and factor m_0 into its roots at π and a remainder polynomial $R(z)$ to yield

$$m_0 = \left[\frac{(1 + z^{-1})}{2}\right]^N R(z) \tag{2.346}$$

where $R(1) = 1$ from the definitions. Let us denote B the supremum of $|R(z)|$ on the unit circle, that is $B = \sup_{\omega \in [0,2\pi]} |R(e^{j\omega})|$. The following theorem holds

Theorem 2.6.2 (Daubechies, 1988). *If $B < 2^{N-1}$, then the piecewise constant function $f^{(i)}(x)$ defined in 2.345 converges point-wise to a continuous function $f^{\infty}(x)$.*

This stands as a sufficient condition of convergence. The reason for interest to that bound is that it has been exploited to make a design criterion to place a maximum number of zero at π to guarantee a maximum regularity. In cases where convergence is not verified, the iteration of 2.345 conduces towards fractal functions.

Introducing zeros at $\omega = \pi$ increases the flatness of the frequency response to produce a smooth low-pass filter. Evidently, the search of regularity counteracts the filtering selectivity and increases the filter spill-over and the inter-subband cross-correlation between adjacent bands. In his thesis [74], Rioul studied the frequency selectivity in terms of the regularity order within the class of orthogonal and bi-orthogonal filters. He showed how to optimally balance regularity, selectivity and filter lengths. In the orthogonal case, the choice of phase response is limited and the phase is chosen as close as possible to linearity to minimize the variation of the group delay. On the contrary, the choice of bi-orthogonal filters will consist of being as close as possible to orthogonality. In any case, regularity is considered in the image coding community as property which brings significant benefice in the rate-distortion coding balance.

2.6.10.2 Space-Frequency Localization

In video processing applications, the time-frequency localization properties of the decomposition technique remains an important consideration. In whole generality, the localization of a finite sequence $\{h(n)\}$ is defined as the RMS spread of a function in space and Fourier domains around the center of mass of the respective kernels. The time and frequency localization σ_n and σ_ω are given as the pair of variances

$$\sigma_n^2 = \frac{1}{E} \sum_n (n - \bar{n})^2 \, |h(n)|^2 \tag{2.347}$$

$$\sigma_\omega^2 = \frac{1}{E} \frac{1}{2\pi} \int_{-\pi}^{\pi} (\omega - \bar{\omega})^2 \, |H(e^{j\omega})|^2 \, d\omega \tag{2.348}$$

where E is the energy defined by Parseval's theorem as

$$E = \sum_n |h(n)|^2 = \frac{1}{2\pi} \int_{-\pi}^{\pi} |H(e^{j\omega})|^2 \, d\omega \tag{2.349}$$

where \bar{n} and $\bar{\omega}$ refer to the center of mass of the kernels in the space domain and in Fourier domain, then

$$\bar{n} = \frac{1}{E} \sum_n n |h(n)|^2 \tag{2.350}$$

$$\bar{\omega} = \frac{1}{E} \frac{1}{2\pi} \int_{-\pi}^{\pi} \omega |H(e^{j\omega})|^2 \, d\omega \tag{2.351}$$

Recalling that the uncertainty principle provides the resolution cell $\sigma_n\sigma_\omega$ with a lower bound of $\sigma_n\sigma_\omega \geq \frac{1}{9}$. The concept of space and frequency localization is also of importance in video coding. The analysis operation is required to offer high frequency localization at low and intermediate frequence to enable weighting efficiently the low and intermediate frequency. High spatial localization at intermediate and high frequencies allow to detect and to take adequately in account (masking effects) the edges in pictures and to provide desired reconstruction effects without spread or ringing. The wavelet transform turns out to be an effective tool which matches to quantization. The Human Visual System is also able to resolve the time-frequency plane such that a joint time-frequency localization should ideally be considered in a three-dimensional spatio-temporal filter design.

To compare some localization performances, Table 2.2 examines the 8×8 DCT, the 8×16 DCT-LOT as derived from Haddad and Akansu in [49]. The Daubechies six-tap wavelet filters provide $\sigma_n^2 = 0.453$ and σ_ω^2 for both the low-pass and high-pass QMF filters.

	$\bar{\omega}$	σ_ω^2	σ_n^2	$\sigma_\omega^2 \times \sigma_n^2$		$\bar{\omega}$	σ_ω^2	σ_n^2	$\sigma_\omega^2 \times \sigma_n^2$
8×8	0	0.345	5.250	1.810	8×16	0	0.092	4.654	0.427
DCT	0.74	0.302	8.405	2.539	DCT-LOT	0.59	0.055	7.615	0.418
	1.02	0.241	5.957	1.437		0.98	0.035	8.387	0.289
	1.36	0.196	5.474	1.071		1.37	0.052	8.645	0.452
	1.71	0.149	5.250	0.781		1.76	0.036	8.35	0.307
	2.08	0.120	5.026	0.606		2.16	7.50	0.061	0.459
	2.45	0.079	4.542	0.362		2.55	0.039	7.78	0.303
	π	0.139	2.096	0.290		π	0.119	5.360	0.642

Table 2.2: Time-frequency localization for DCT.

2.6.10.3 Inter-Band Aliasing and Correlation

As implied by perfect reconstruction, the synthesis filter bank is designed to cancel alias component. This is no longer verified when, in compatible or scalable application, lower-resoluted decoders will reconstruct the signal using only some lower part of the original spectrum. They break the alias cancellation conditions. Another way to deteriorate the cancellation and introduce noncancelled energy is induced when quantization is applied differently or selectively from one band to another i.e. essentially at low bit rates. Clearly, the amount of aliasing energy is link to the parameters of regularity and selectivity.

Cross-correlation between subbands is an important performance demerit to be taken into consideration, it is measured as

$$E\{Y_L(m)Y_H(m)\} = \sum_n \left[\sum_l h(l)(-1)^l h(n-l) \right] R_{XX}(n)a \quad \forall\, m \tag{2.352}$$

from the incoming signal X decomposed in two subbands Y_L and Y_H. The introduction of non-orthogonal filters and the fact that image structure information is generally spread concomitantly in several subbands inducing correlated noise components contribute to maintain some correlation between the subband signals. Vector quantization is a tool able to terminate an unfinished decorrelation procedure. Its interest is notable for low-bit-rate applications.

Chapter 2. TV and HDTV Coding Algorithms

2.6.10.4 Linear and Non-Linear Phase

It is sometimes convenient to refer to the *group delay* rather than the phase. The group delay is the negative of first derivative, with respect to ω, of the phase. The group delay expresses propagation delay. Non linear-phase synthesis filters will spread the quantization noise. Coarsely quantized edges generate noise spread over a wide frequency range. If, at reconstruction synthesis, the frequency variations of the group delay are significant (several pixels), the noise is spread around the edges and blurs the image. Non-linear phase is related to the asymmetry of the impulse response which is measured by $\sum_n [h(n) - h(2N-1-n)]^2$.

2.6.10.5 Filtering Adaptivity

As any convolutional filter, the window modulated filters (orthogonal base and non-linear phase response) and the bi-orthogonal filter banks (non-orthogonal analysis and linear phase) have both *lattice representations*. Cascading lattice structures is the way to build adaptive filters and in such way to interconnect the subband and wavelet filtering theory to that of adaptive filters [7]. Reference [25] presents and constructs lattice structures for both filter classes. Lattice structures preserve structurally the perfect reconstruction property. The latter property is preserve after quantization of the lattice parameters, the representation is robust. The resulting lattice structures are also the same for both classes 2.26 except that the interval of definition of the lattice parameters α_i differs from one class to the other.

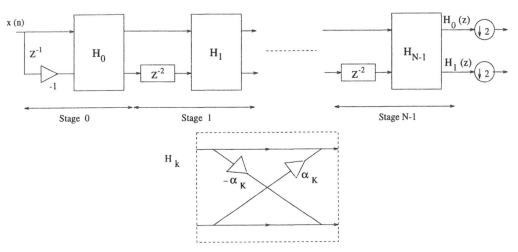

Figure 2.26: Cascade of lattice structure.

Theory of filtering adaptivity applies directly to the lattice representation and enables constructing optimum filters. A cost function taking into consideration interesting video coding properties developed in this section may be built to optimize with constraints the filter characteristics. The adaptation may be performed in-line during coding locally (changing within the image) or globally (image-per-image adaptation) or carried out off-

line when designing the coder. Numerous adaptive optimization algorithms exist in the literature. Let us only mention the most well-known *Newton* and the *stochastic gradient*.

2.6.11 Modulated Filter Banks and Wavelets

As a generalization of LOT and DCT, perfect reconstruction, FIR, unitary modulated filter banks have been constructed by several authors, let us cite [64], [65], [61], and [52]. This explains that different appellations make reference to those filters, let us mention, among all, PRMF [1], MLT, ELT, PQMF. In this section, the most general form is exhibited according to a formalism developed by Burrus and Gopinath in [46] where unitary perfect reconstruction modulated filter banks are typified and associated to wavelet tight frames of compact support. A complete parametrization of all unitary FIR modulated filter banks. All the modulated filter banks may be implemented using DCT and fast butterfly algorithms. That practical property gives a major advantage to this family of filter bank. Despite numerous advantages, the Modulated Filter Banks (MFB) have the major disadvantage that linear-phase FIR unitary MFB does not exist.

Historically, Princen and Bradley have first recognized the usefulness of those filters in applications where critically sampled analysis/synthesis is desired. Vetterli and Le Gall have developed a more advanced theoretical framework. All have shown that an M-channel modulated filter bank can be obtained with FIR analysis and synthesis filters restricting the study to the assumptions of even impulse response L=2M. H.S. Malvar extended the theory to the case L=2kM, with k any positive integer. J. Mau proceeded further and demonstrated that the restriction to L=2kM was not actually compulsory to achieve perfect reconstruction and that in fact odd length L could also provide that property. Adaptive algorithms to construct optimum time-varying modulated filter banks have been recently described as an alternative to wavelet packets in order to perform optimum tilings on the time-frequency plane in a sense of a rate-distorsion cost measure.

2.6.11.1 Modulated Filter Banks

The *modulated filter banks* are a special class of filter banks where the analysis and synthesis filters are obtained by modulation of a prototype low-pass filter. They rely on the assumption that ideally one desires the $h_i(n)$ and the $g_i(n)$ to correspond to bandpass filters occupying adjacent bands. Denoting $h(n)$ and $g(n)$ the analysis and synthesis prototypes respectively, the analysis and synthesis filters are defined by

$$h_i = h(n) \cos \left[\frac{\pi}{2M} (2i+1)n + \epsilon_i \right] \tag{2.353}$$

and

$$g_i = g(n) \cos \left[\frac{\pi}{2M} (2i+1)n + \gamma_i \right] \tag{2.354}$$

where ϵ_i and γ_i are the *phase factors*. Ideally, the filter bank splits the spectrum into M subbands of equal-width as sketched in Figure 2.27. When the MFB's verify perfect reconstruction, the phase factors assumed to be linear have necessarily the form [46], [47]

[1]PQMF: Pseudo Quadrature Mirror Filter, PRMF: Perfect Reconstruction Modulated Filter

$$\epsilon_i = -\frac{\pi}{2M}(2i+1)\frac{\alpha}{2} \tag{2.355}$$

and

$$\gamma_i = \frac{\pi}{2M}(2i+1)\frac{\alpha}{2} \tag{2.356}$$

where $\alpha \in \mathbf{Z}$ is called the *modulation phase*. Let us remark that the phase factors are independent of the filter length. The design of the filter bank is therefore confined to elaborating the low-pass filters.

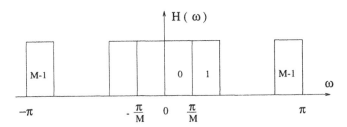

Figure 2.27: Parallel decomposition in M subbands.

Recalling that perfect reconstruction means $\hat{x}(n) = x(n)$, the condition on the filters is equivalent to

$$\sum_{l=0}^{M-1}\sum_n h_l(Mn+n_1)g_l(-Mn-n_2) = \delta(n_1-n_2) \tag{2.357}$$

The filter bank is further said to be *unitary* if $g_l(n) = h_l(-n)$.

An MFB is of *type 1* if $\alpha = M-1$ and of *type 2* if $\alpha = M-2$. Depending on M and the type of the MFB, type 1 and type 2, the α can be even or odd. Therefore, without loss of generality, the only MFB that has to be studied, are of type 1 or 2. Four classes of MFB can be defined on the *type* and the *parity of M*. Therefore, J determines the unique four classes which follow

1. $J = \frac{M}{2}$ for type 1 MFB and M even

2. $J = \frac{M-1}{2}$ for type 1 MFB and M odd

3. $J = \frac{M-2}{2}$ for type 2 MFB and M even

4. $J = \frac{M-1}{2}$ for type 2 MFB and M odd

2.6.11.2 Modulated Wavelet Tight Frames

The MFB's give rise to a class of orthonormal wavelet bases for $L^2(\mathbf{R})$. *Every unitary FIR filter bank that fulfills* $\sum_n h_0(n) = \sqrt{M}$ *is associated to a wavelet tight frame and conversely.* If the scaling $\psi_0(t)$ and the (M-1) wavelets $\psi_i(t)$ are defined as

$$\psi_i(t) = \sqrt{M} \sum_k h_i(k)\psi_0(Mt - k) \tag{2.358}$$

where $i = 0, 1, \ldots, M - 1$, then

$$\{\psi_{i,j,k}\} = \left\{ M^{\frac{1}{2}} \psi_0(Mt - k) \right\} \tag{2.359}$$

with $i = 1, \ldots, M - 1$ forms a M-multiplicity compactly supported wavelet transform in $L^2(\mathbf{R})$. The expansion of a function $f(t)$ in the Hilbert space spanned by the wavelet basis $\psi_{i,j,k}$ is given by

$$f(t) = \sum_{i=1}^{M-1} \sum_{j,k} < f, \psi_{i,j,k}(t) > \psi_{i,j,k}(t) \tag{2.360}$$

The Modulated wavelet tight frames for MFB's were originally proposed in [47] and extended to general FIR MFB's

Theorem 2.6.3 (Gopinath 1992). *An FIR MFB forms a compactly supported modulated wavelet transform frame if and only if for $l \in \{0, 1, \ldots, J-1\}$, $\Theta_l = \frac{\pi}{4} + \frac{\pi}{2M}(\frac{\alpha}{2} - l)$*

$$\Theta_l = \sum_{k=0}^{k_l-1} \theta_{l,k} \tag{2.361}$$

independent of whether the MFB is type 1 or type 2 and M is even or odd.

The theorem demonstrates that *modulated wavelet transform frames* exist for all M and any given type 1 and 2. It supplies a complete parametrization of *all compactly supported modulated wavelet transform frames of both types*. In fact, if a MFB with filters of length N is parametrized with N_p parameters, this leads to corresponding wavelet transform frames precisely parametrized by $N_p - J$ parameters since Equation 2.361 puts an additional constraint on each of the J two-channel pairs. K-regular modulated wavelet transform frames can be designed to provide smoothness to the scaling and wavelet functions.

2.6.12 Bi-orthogonal Wavelets

An alternative to the para-unitary solution has been put into evidence recently [82] as another family of FIR filters which are still perfect reconstruction and have linear phase. The construction of analysis and synthesis filter banks with arbitrary length linear phase perfect reconstruction properties has been made possible by relaxing the constraint of orthogonality to permit additional freedom.

2.6.12.1 Linear-Phase Filter Banks

In practice, the appellation perfect reconstruction implies that only the linear errors are eliminated. These are namely the aliasing, the amplitude and the phase distortions. In addition, non-linear coding errors are created by the quantization process, especially at coarse quantization (large quantization step size). This noise injected after the analysis

procedure is synthesized and affects the process of perfect reconstruction. The quantization errors are moreover typically correlated to the image content. For instance, the contours and the fine high frequency structures may be significantly impaired even though horizontal and vertical structures remain undegraded. In this case, the degradation is non-linear and correlated to some particular content structures. Some experimental works [68] have indicated that the reconstruction error caused by the coding errors are less harmful if the analysis and synthesis filters used in the QMF bank have linear phase and guarantee a group delay independent of frequency. Restated in other words, non-linear phase synthesis filters will blur the areas with high frequency information affected by quantization noise.

As an important derivation in this field, the design of real FIR linear phase QMF banks which at the same time enjoy the perfect reconstruction property must give up the power complementary property and consequently the para-unitariness of $E(z)$ as well. Real linear-phase perfect-reconstruction filter-banks exclude orthogonality. Perfect reconstruction and linear phase are however yielded simultaneously by means *bi-orthogonality*, a condition of orthogonality relating analysis filters to synthesis filters and defined here below. Bi-orthogonal filters provide a more general framework to the filter design and, for instance, an additional freedom which allows employing arbitrary-length linear-phase filters. To review some properties of linear-phase filter banks, let $H_0(z)$ and $H_1(z)$ be real filters of length N and respectively symmetric and antisymmetric, we have the impulse responses given as

$$
\begin{aligned}
h_0(n) &= h_0(N-1-n) \qquad n = 0,\ 1,\ 2, \ldots, \frac{N}{2} - 1 & (2.362)\\
h_1(n) &= -h_1(N-1-n) & (2.363)
\end{aligned}
$$

Linear-phase filters of odd length can also be designed. In this case, both filters $H_0(z)$ and $H_1(z)$ are each *symmetric filters* of length $(2N+1)$ and $(2N-1)$ respectively. Vetterli and Herley in Reference [82] have identified three classes of real linear-phase perfect-reconstruction FIR filter banks. They have proposed design results based on the most *regular low-pass*. The three classes are proposed as follows

1. both filters are symmetric and of odd lengths, differing by an odd multiple of 2.

2. one filter is symmetric and the other is antisymmetric, both lengths are even and are equal or differ by an even multiple of 2.

3. one filter is of odd length, the other is even, both have all zeros on the unit circle. Either both filters are symmetric, or one is symmetric and the other is antisymmetric.

A general discussion of bi-orthogonal filter banks and wavelets is apprehended in the two coming sections.

2.6. Wavelet Transform and Multiresolution

2.6.12.2 Bi-orthogonal Filter Banks

The calculation of the reconstructed signal in the decoder, in Section 2.4.4.1, has led to the following expressions from which perfect reconstruction conditions are rather readily extracted. Recalling that

$$\hat{X}(z) = T(z)X(z) + S(z)X(-z) \qquad (2.364)$$

$$T(z) = \frac{1}{2}[G_0(z)H_0(z) + G_1(z)H_1(z)] \qquad (2.365)$$

$$S(z) = \frac{1}{2}[G_0(z)H_0(-z) + G_1(z)H_1(-z)] \qquad (2.366)$$

Perfect reconstruction requires that $S(z) = 0$ and $T(z) = cz^{-n_0}$. As a matter of fact, referring the previous equations, namely 2.364, 2.365 and 2.366, perfect reconstruction conditions are met by imposing orthogonality across the analysis and synthesis sections so as to yield

$$< \tilde{g}_0(n-2k), h_1(n-2l) > \;=\; 0 \qquad (2.367)$$

$$< \tilde{g}_1(n-2k), h_0(n-2l) > \;=\; 0 \qquad (2.368)$$

where $\tilde{g}_i(n) = g_i(-n)$ and

$$< \tilde{g}_0(n-2k), h_0(n) > \;=\; \delta_k \qquad (2.369)$$

$$< \tilde{g}_1(n-2k), h_0(n) > \;=\; \delta_k \qquad (2.370)$$

Let us further remark that in the IIR realm, it is possible to have both orthogonality and nontrivial linear phase solutions. The FIR bi-orthogonal filter banks are also critically sampled solutions which can be used in multiresolution decomposition.

2.6.13 Bi-orthogonal Wavelets Based on the Filter Banks

To derive wavelets, it must be demonstrated that infinitely iterated bi-orthogonal perfect reconstruction filter banks converge to bi-orthogonal sets of functions and not to fractal. To yield convergence, that the filter design is supposed to have introduced the highest level of regularity in the prototype low-pass filter. The task is now to demonstrate that *regular bi-orthogonal FIR filter banks lead to bi-orthogonal bases of functions of finite length in $L^2(\mathbf{R})$ and conversely*. To prove the proposition, let us be back at resolution level i in subspaces V_i and W_i of a multiresolution decomposition and remember that the subspace W_i is orthogonal to v_i. We denote by $H_0^i(z)$ and $G_0^i(z)$ the filters which are equivalent to the cascade of i blocks of filtering and subsampling in the analysis and synthesis sections. We assume regularity to mean that the functions, defined as

$$f^{(i)}(x) = 2^{\frac{i}{2}} h_0^{(i)}(n) \qquad \frac{n}{2^i} \le x < \frac{(n+1)}{2^i} \qquad (2.371)$$

$$\check{f}^{(i)}(x) = 2^{\frac{i}{2}} \, \check{g}_0^{(i)}(n) \qquad \frac{n}{2^i} \le x < \frac{(n+1)}{2^i} \tag{2.372}$$

which are piecewise constant on intervals of length $\frac{1}{2^i}$, converge to continuous functions and not to fractals. From [34], It can be shown that the limiting functions derived from $f^{(i)}(x)$ and $\check{f}^{(i)}(x)$ are solutions of the two-scale difference equations

$$\phi(x) \quad = \quad 2^{\frac{1}{2}} \sum_{n=0}^{L-1} h_0(n)\phi(2x-n) \tag{2.373}$$

$$\check{\phi}(x) \quad = \quad 2^{\frac{1}{2}} \sum_{n=0}^{L-1} \check{g}_0(n)\check{\phi}(2x-n) \tag{2.374}$$

and define also the wavelet functions which are the associated band-pass function in form of

$$\psi(x) \quad = \quad 2^{\frac{1}{2}} \sum_{n=0}^{L-1} h_1(n)\phi(2x-n) \tag{2.375}$$

$$\check{\psi}(x) \quad = \quad 2^{\frac{1}{2}} \sum_{n=0}^{L-1} \check{g}_1(n)\check{\phi}(2x-n) \tag{2.376}$$

It turns out that $\phi(x)$ and $\check{\phi}(x)$ are orthogonal with respect to integer shifts. Clearly, we want to show that

$$< \check{\phi}(x-k)\phi(x-l) > \; = \; \delta_{kl} \tag{2.377}$$

and the proof will be conducted inductively. Orthogonality is readily deduced at level 0 since functions $\check{f}^{(0)}(x)$ and $f^{(0)}(x)$ are each equal to the indicator function on interval $[0,1)$. Then, $\check{f}^{(0)}(x)$ and $f^{(0)}(x)$ are orthogonal with respect to integer shifts and $< \check{f}^{(0)}(x-l), f^{(0)}(x-k) >= \delta_{kl}$. By induction, assuming orthogonality at the i^{th} level must imply orthogonality at the $(i+1)^{th}$ level. Indeed,

$$< \check{f}^{(0)}(x-l), f^{(0)}(x-k) >$$
$$= 2 < \sum_n \check{g}_0(n) \, \check{f}^{(i)}(2x-2k-n), \sum_m h_0(m) \, f^{(i)}(2x-2k-m) >$$

$$= \sum_n \check{g}_0(n) \, h_0(n+2l-2k)$$

$$= \delta_{kl}$$

In the limit, we obtain

$$< \check{\phi}(x-k)\phi(x-l) > \; = \; \delta_{kl} \tag{2.378}$$

Therefore,

$$< \check{\psi}(x-k)\psi(x-l) > \; = \; \delta_{kl} \tag{2.379}$$

2.6. *Wavelet Transform and Multiresolution* 171

and from Equations 2.367 and 2.368, it follows that

$$< \check{\phi}(x - l), \psi(x - k) > \quad = \quad 0 \tag{2.380}$$
$$< \check{\psi}(x - l), \phi(x - k) > \quad = \quad 0 \tag{2.381}$$

Perfect reconstruction property leads thus to functions that fulfill bi-orthogonality conditions. But these functions are not yet wavelets. To yield wavelet, we need orthogonality across the scales and completeness.

The set $\{\psi(2^i x - l), 2^{-\frac{i}{2}} \psi(2^i x - k)\}, i, j, k, l \in \mathbf{Z}$ is orthogonal set across the scales since

$$< 2^{-\frac{i}{2}} \check{\psi}(2^j x - l), 2^{-\frac{i}{2}} \psi(2^i x - k) > = \delta_{ij} \delta_{kl} \tag{2.382}$$

Completeness may be verified as in the orthogonal case [34]. This enables any function $f(t)$ defined in $L^2(\mathbf{R})$ to be expanded in the wavelet basis as

$$f(x) \ = \ \sum_j \sum_k < 2^{-\frac{i}{2}} \psi(2^j x - k, f(x) > 2^{-\frac{i}{2}} \check{\psi}(2^j x - k) \tag{2.383}$$

Analysis and synthesis wavelets are in any case interchangeable. This demonstrate that bi-orthogonal FIR filter banks allow constructing bi-orthogonal wavelets on compact supports. The converse is also true and consists of exploiting relations 2.373 to 2.376 and relations 2.378 to 2.381 to show that they correspond to bi-orthogonal filter banks. Indeed, Equation 2.378 leads to

$$
\begin{aligned}
& < \check{\phi}(x - k)\phi(x - l) > \\
&= \left\langle \textstyle\sum_n \tilde{g}_0(n)\check{\phi}(2x - 2l - n), \sum_m h_0(m)\phi(2x - 2k - m) \right\rangle \\
&= \textstyle\sum_n \sum_m \tilde{g}_0(n)h_0(m) < \check{\phi}(2x - 2l - n)\phi(2x - 2l - m) > \\
&= \textstyle\sum_n \tilde{g}_0(n)h_0(n + 2l - 2k) \\
&= \delta_{kl}
\end{aligned}
\tag{2.384}
$$

The other conditions of bi-orthogonality follows from equations 2.379 to 2.381.

2.6.13.1 IIR Wavelets

The motivation to use IIR filters arises from the fact that they lead to more general wavelets which have infinite support but exponential decay. Regularity is important for image compression purpose. Increasing the degree of wavelet regularity leads to increasing the length of the FIR filters. The IIR filters become at this stage computationally interesting since they require lower cost than a FIR filter at equal degree of regularity. Here, we follow the steps of Feauveau and all [44] who defined for image coding purpose a bi-orthogonal wavelet family based on IIR symmetric and antisymmetric subband filters.

A pair of filters $[H_0(\omega), G_0(\omega)]$ which satisfies the equations

Chapter 2. TV and HDTV Coding Algorithms

$$H_1(\omega)G_1(\omega) + H_2(\omega)G_2(\omega) = 1 \tag{2.385}$$

with $H_0(0) = G_0(0) = 0$ and $H_0(\pi) = G_0(\pi) = 1$

leads to multiresolution applications based on bi-orthogonal filters. Indeed, a family of linear-phase IIR filter pairs can be derived by exploiting the previous relations. That is

$$F_N(\omega) = \left(\frac{1 + \cos(\omega)}{2}\right)^N + \left(\frac{1 - \cos(\omega)}{2}\right)^N \tag{2.386}$$

It follows that

$$\left(\frac{1 + \cos(\omega)}{2}\right)^N \frac{1}{F_N(\omega)} + \left(\frac{1 - \cos(\omega)}{2}\right)^N \frac{1}{F_N(\omega + \pi)} = 1 \tag{2.387}$$

Letting $p + q = N$, and

$$H_1(\omega) = \left(\frac{1 + \cos(\omega)}{2}\right)^p \tag{2.388}$$

we derive

$$G_1(\omega) = \left(\frac{1 + \cos(\omega)}{2}\right)^q \frac{1}{F_N(\omega)} \tag{2.389}$$

In this case, the $H_1(\omega)$ are all symmetric without pole on the unit circle. The $H_1(\omega)$ defines a *spline of order* $2p + 1$ associated with a B-spline scaling function. Zero-phase IIR filters can easily be generated exploiting Formulae 2.388 and 2.389.

Antisymmetric filters are obtained when the term $\frac{1+\cos^2(\omega)}{2}$ is split in two parts according to $\frac{1+e^{j\omega}}{2}$ and $\frac{1+e^{-j\omega}}{2}$ dedicated to $H(\omega)$ and $G(\omega)$ respectively. The resulting filter is non-causal and can be expressed as $H(\omega) = \frac{1+e^{j\omega}}{2}\frac{N(\omega)}{D(\omega)}$ and decomposed in two terms, a causal and anti-causal part.

2.6.14 Wavelet Packets

Packet wavelets have been introduced recently by Wickerhauser as a natural generalization of the wavelet transform to perform arbitrary tilings in the phase space. In contrast with wavelet theory, where the parameters of the decomposition are the scale and the translation, wavelet packets add frequency as further degree of freedom. This brings forward possibility to build any arbitrary tiling of the time-frequency or space-frequency space. The size and shape of the analysis window in the phase space are defined by the scaling factor in similarity to the wavelet representation. In addition, the position and the frequency parameters allow centering the analysis window anywhere at will in the phase space. An example of space-frequency partitioning of wavelet packet is reported and compared with Gabor and wavelet transforms in Figure 2.28. Since wavelet packets admit an infinite set of position, scale and frequency parameters, the problem consists of building the best wavelet packet basis to expand signals. Digressing back to the binary

tree-structure subband decomposition which is nonetheless equivalent to a time-invariant packet wavelet decomposition. Any particular pruned tree version of the subband decomposition corresponds to a basis of wavelet packet analysis. The wavelet packet transform structure is based upon a binary tree whose nodes represent the application of a decimating QMF pair to a signal. Different wavelet bases can be created by selectively pruning the tree, a procedure which generates unique partioning of the original signal bandwidth into a disjoint cover of frequency subbands. Wavelet packet transform is nothing else than an arbitrary adaptive tree-structured filter bank.

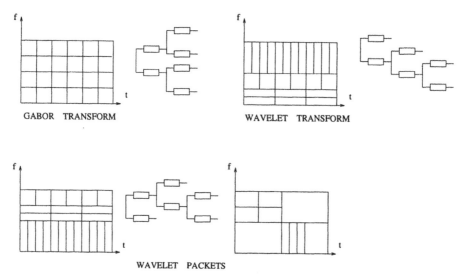

GABOR TRANSFORM

WAVELET TRANSFORM

WAVELET PACKETS

Figure 2.28: General functions of a TV coder.

An important parameter in determination of a specific wavelet packet decomposition is the criterion to keep on slicing a branch of the tree into deeper levels. This problem is typical in graph theory where a process of decomposition of data is to be carried out with the goal to optimize a cost function. These algorithms are relevant to the methodology of the *branch and bound* where a *branching process* rules the slicing, a *bounding process* evaluates a criterion to be optimized and a *backtracking process* stops the exploration and prunes the tree. In image compression, spectrum energy, entropy and rate-distortion (R-D) measures have already been exploited to find out the best wavelet packet bases. In Reference [73], a fast pruning algorithm is presented exploiting the idea that the full-depth wavelet packet is labeled with Lagrangian costs in form $D(node) + \lambda R(node)$ at each internal tree node. Then, a pruning algorithm is activated to prune the full-depth tree into the sub-tree which has minimum sum-of-leaves cost; the basic pruning criterion applied at each node is that of deciding in favor of parent or its children based on which has the lower Lagrangian cost at fixed quality factor λ.

Chapter 2. TV and HDTV Coding Algorithms

2.7 Quantization

Different topics about the scalar quantization process are successively discussed in this section. Though also extensively used in the literature, the vector quantization algorithms [15] request high complexities and do not provide any significant evidence of managing the image quality more gracefully than its scalar counterpart for high video quality and especially when processed with the DCT operator. Accordingly, we will focus only on the scalar quantization procedure and continue explaining how to adapt the quantization step-size computation in order to take into account the low-pass filtering effects of the Human Visual System, this function is currently called *weighting*, how to optimize bit allocation into a quantizer and finally how to produce a quasi-constant subjective image quality by exploiting the local image content.

The main objective assigned to a quantizer is to implement an irreversible bit-rate compression function which reduces the data rate allocated to the transform coefficients in order to take into account the constraint of a limited channel capacity and to gracefully degrade the subjective quality of the coded images. The level of subjective quality depends on both the local image content and the psycho-visual properties of the Human Visual System. To achieve the objectives, the quantization step size computation is adapted on long term by a parameter which is function of the transmission rate on the channel, on the short term by the local image specificities and on the frequency response by a low-pass filtering action based on the fact that humain eyes are less sensitive to high frequency spatial noise. Exploiting conjointly the local image content and the weighting factors, an adaptive quantization aims at producing a quasi-constant level of subjective image quality. That synergistic mechanism works according to the principle which follows. A command called the *transmission factor*, whose magnitude is computed according to the output buffer fillness, imposes the mean level of image quality involving a range of admissible and adaptive quantization step sizes. The appellation of transmission factor stems from the fact that it aims at adapting in long-term range the quantized output data rate in order to comply to the actual rate constraint enforced on the transmission channel. Specific and significant parameters computed on the local image content enable adapting the quantization step size in such manner that the resulting subjective image quality be quasi-constant when the transmission factor keeps constant value. The transmission factor becomes de facto a command to control the level of subjective quality within the images.

2.7.1 General Principle of Quantization

In order to transmit information and fit adequately the requirement of a given constant or an enforced variable channel rate gauge, the quantization is the procedure which compresses the bit rate of the decorrelated coefficients. It maps the finite set of the input magnitudes x(n) at time n into magnitudes y(n) taken within a finite set of values smaller than those of the input. The range of admissible values for the input signal x(n) is sectioned into intervals I_k as

$$I_k : \quad x_k < x(n) \leq x_{k+1}, \quad k = 1, ..., L \tag{2.390}$$

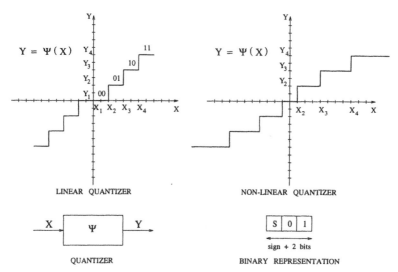

Figure 2.29: Linear and non-linear quantization characteristics.

where the x_k are termed the decision levels. Each value of x(n) which belongs to the interval I_k is transformed into a y_k called the reconstructed value. As a consequence, the set of y_k $(k = 1, ..., L)$ is related to the set of x_k by a staircase function called the *quantization characteristic* $y = \Psi(x)$ (Figure 2.29). The characteristic can be linear or non-linear. It has been shown in [13] that the optimum quantizers for minimum entropy coding are nearly linear. For a linear quantizer, the following relation holds

$$y_{k+1} - y_k = \delta_o \qquad k = 1, 2, ..., L \qquad (2.391)$$

and for the input decision intervals

$$x_{k+1} - x_k = \delta_i \qquad (2.392)$$

where δ_i is defined as the *quantization step size*.

Historically speaking, two strategies of quantization can be implemented in a video coder. The first option allocates the quantized coefficients on fixed-length words by means of a fixed-to-fixed length mapping, the second option allocates the quantized coefficients on variable-length words depending on frequency order and magnitude (fixed-to-variable length mapping). To yield variable-bit-rate applications and to dissociate the quantization and entropy coding functions, the second solution chooses to use a quantizer followed by a variable-length coder. This way of coding is described in the sequel and corresponds to the spirit in which the research activity and standardization body are presently working. Conceptually, it leads to split the core compression process into three distinct operations, namely an adaptive quantization which takes into account Human Visual properties and local image specificities, an entropy coder which is assigned to compress bit rate down to the rate of conditional information and a coder controller which is in charge to constraint and adapt the quantization step size computation in order to comply to the channel rate

Chapter 2. TV and HDTV Coding Algorithms

capacity. On the contrary, the scheme with fixed allocation of bits has been originally developed to quantize and compress the transform coefficients without any variable-length coder. In this option, the optimum quantizers are non-linear and adapted to the distributions of the input coefficients in order to maximize the signal to noise ratio with the constraint of fixed bit allocation.

The *quantization error* q, responsible of the image degradation, is given as the random variable

$$q = x - y = x - \Psi(x) \tag{2.393}$$

q is deterministic for a given x. However, in the following, x is the outcome of a random variable and q is reasonably considered as an outcome of a random variable Q and sometimes referred to as the *quantization noise*. Assuming a PDF $f_x(x)$ for the input signal, the variance of the quantization error σ_q^2 is an important quantity which qualifies the performance of a quantizer

$$\sigma_q^2 = \sum_{k=1}^{L} \int_{x_k}^{x_{k+1}} (x - y_k)^2 f_x(x) dx \tag{2.394}$$

The signal to quantization noise ratio is defined as

$$SNR = 10 \log\left[\frac{\sigma_x^2}{\sigma_q^2}\right] \tag{2.395}$$

where the variance of the input signal σ_x^2 is substituted by the squared range of the signal to defined a so-called peak-signal-to-noise ratio. Frequently, the error variance is associated to the input signal variance to define the performance factor ϵ_q^2 as the ratio $\epsilon_q^2 = \frac{\sigma_q^2}{\sigma_x^2}$. The performance factor can be further split according to rate-distortion theory as follows. Typically, it appears that

$$\sigma_q^2 = \gamma \, 2^{-2R} \, \sigma_k^2 \tag{2.396}$$

where R bits are allocated to the quantized coefficients i.e. the total number L of intervals is simply $L = 2^R$. γ depends only on the PDF for x and on the particular quantizer. Typical values for γ have been proposed in [13] as $\gamma = 1.0$, 2.7, 4.5 and 5.7 for uniform, Gaussian, Laplacian and Gamma PDF's respectively.

2.7.2 Uniform Quantizer

A uniform quantizer is characterized by decision intervals of constant length and reconstruction levels located at the mid-points of the decision intervals

$$y_{k+1} - y_k = \Delta \qquad \text{for } k = 1, \ldots, L-1 \tag{2.397}$$
$$x_{k+1} - x_k = \Delta \qquad \text{for} \quad \text{finite } x_k, x_{k+1} \tag{2.398}$$

for L intervals. Moreover, if the input signal is bounded in the interval $[-x_M, x_M]$ and that L intervals are implemented, then $\Delta = 2x_{max}/L$. The quantization error PDF may be assumed uniform on the range $[-\Delta/2, \Delta/2]$ if the quantization process is accurate enough. Then,

$$f_q(q) = \begin{cases} 1/\Delta & |q| \leq \delta/2 \\ 0 & \text{otherwise} \end{cases} \tag{2.399}$$

The error variance is equal to $\frac{\Delta^2}{12}$. If R bits are allocated to the quantized coefficient, $\Delta = 2x_M/a2^R$ and

$$\sigma_q^2 = \frac{1}{3}x_M^2 2^{-2R} \tag{2.400}$$

This error variance is reduced by a factor 4 each time L is doubled.

2.7.3 Non-uniform Quantizer

The optimum quantizer is currently designed to yield the minimum mean-squared error i.e. $\min[\sigma_q^2]$ for a given number of bits (fixed bit allocation). This optimum quantizer is referred to as the Max or the Lloyd-Max quantizer. When $L > 2$, the quantizer is non-uniform if the input PDF is itself non-uniform. Hereupon, let us consider a stochastic signal to be quantized, the sequence $\{X(n)\}$ is zero-mean with variance σ_x^2. The necessary conditions for a PDF-optimized quantizer to minimize σ_q in the general Expression 2.394 are expressed as follows

$$\frac{\partial \sigma_q^2}{\partial x_k} = 0 \quad k = 2, 3, \ldots, L \tag{2.401}$$

$$\frac{\partial \sigma_q^2}{\partial y_k} = 0 \quad k = 1, 2, \ldots, L \tag{2.402}$$

where x_k and y_k are respectively the decision and reconstruction levels, $k = 2, 3, \ldots, L$. If $f_x(x)$ is log-concave, that means a negative $\frac{\partial^2 f_x(x)}{\partial x^2}$, the conditions are also sufficient. That property holds for the Uniform, the Gaussian, the Laplacian PDF's but not for the Gamma PDF where the optimum is not global. Whenever log-concave property is verified, we are conducted to the important result which follows

$$x_{k,opt} = \begin{cases} \frac{1}{2}\left(y_{k,opt} + y_{k-1,opt}\right) & \text{for } 1 < k < L+1 \\ -\infty & \text{for } k = 1 \\ \infty & \text{for } k = L \end{cases} \tag{2.403}$$

and

$$y_{k,opt} = \frac{\int_{x_{k,opt}}^{x_{k+1,opt}} x f_x dx}{\int_{x_{k,opt}}^{x_{k+1,opt}} f_x dx} \quad k = 1, 2, \ldots, L \tag{2.404}$$

These equations give straightforward interpretations. The optimum decision levels are *half-way in between neighboring reconstruction levels*, a reconstruction level should be the *centroid* of the PDF in each appropriate interval. This means that this centroid is the mean of the input signal on the given interval. At this stage, some important results concerning the optimum quantizers can be stated. First of all, Equation 2.404 can be restated as

Chapter 2. TV and HDTV Coding Algorithms

$$y_{k,opt} = \int_{-\infty}^{\infty} x\, P[X \in I_{k,opt}]\, f_{x|X \in I_{k,opt}}\, dx \tag{2.405}$$

$$= E[X|X \in I_{k,opt}] \tag{2.406}$$

where I_k represents the intervals $[x_k < x \le x_{k+1}]$; $k = 1, 2, \ldots, L$. The previous result, which can be anticipated from estimation theory, is rearranged as

$$\int_{-\infty}^{\infty} (x - y_{k,opt})\, f_{x|X \in I_{k,opt}}\, dx = E[Q|X \in I_{k,opt}] = 0 \tag{2.407}$$

This means that the mean quantization noise in the the interval is zero if the reconstruction level is chosen as the mean of the input in that interval. This last result implies that the unconditional mean of quantization error is zero. That is $E[Q] = 0$. Multiplying 2.407 with $y_{k,opt}$ and summing over all indices k, we yield

$$E[QY] = 0 \tag{2.408}$$

meaning that *the quantization noise is orthogonal to the output of the PDF-optimized quantizer*. One step further,

$$E[QX] = E[Q(Y+Q)] \tag{2.409}$$
$$= E[Q^2] \tag{2.410}$$
$$= \min[\sigma_q^2] \tag{2.411}$$

meaning that *the input signal and the quantization error are correlated*. This result invalidates any model assuming or constructing input-independent additive noise models for the quantizer. Also, Equation 2.411 allows deducing

$$\sigma_y^2 = \sigma_x^2 - \min[\sigma_q^2] \tag{2.412}$$

meaning that *the variance of the output is less than that of the random variable at the quantizer input*. Eventually, some manipulations conduce to show that

$$E[XY] = (1 - \epsilon_q^2)\sigma_x^2 \tag{2.413}$$

$$P_k E[Q^2|X \in I_{k,opt}] = P_j E[Q^2|X \in I_{k,opt}] \tag{2.414}$$

meaning that *the error variance contributions from different intervals are identical*.

In the following section, the spatial low-pass filtering characteristics of the Human Visual System are taken into consideration to compute the quantization step size. The way to proceed is to derive weighting factors function of the frequency order of the transform coefficients and adapt the quantization step size with the weighting factors.

2.7. Quantization

2.7.4 Weighting Functions

In principle, weighting consists of quantizing the spectral transform coefficients issued from the decorrelation process more coarsely as the order or the corresponding frequency increases since the human-eye noise visibility decreases as the spatial frequencies increase. The useful concept of *weighted noise* for transform coding systems was originally introduced in Dalleur's thesis dissertation early in the eighties for Hadamard-transform-based algorithms; the extension to DCT, subband and wavelet coding techniques is quite straightforward. Let us suppose here that the different band-pass signals generated by the subband decorrelation step are not correlated (this is not actually true, especially if this condition has not be forced on the computation of the filter-bank as either a design or an on-line adaptive constraint). In fact, the input signal $x(n)$ to be filtered and decimated is supposed to be a real zero-mean wide-sense-stationary random process. All the sub-band components will share that property. Having admitted the hypothesis, we assume that the quantization noises are also wide-sense-stationary processes, white and uniformly distributed with zero-mean and variance. Considering ideally band-limited white noise entirely confined in the pass-band, the noise is not correlated and the total noise power is derived by adding up the quantization noises of the different spectral components. In a weighted noise approach, the resulting distortion is defined as a *weighted noise power* obtained as the sum of the spectral-component quantization noise weighted by factors to be computed

$$\sigma_{q,w}^2 = \sum_{i=0}^{N-1} W_i \sigma_{q,i}^2 \qquad (2.415)$$

The weighting factors have to be finally calculated to multiply the quantized coefficients during the quantization process; these latter factors will be referred to as the visibility factors. However, as shortly explained herein below, these are not fixed uniquely. Indeed and first of all, several models of the eye as a spatial filter have already been proposed and compared in [8]. One single weighting curve has to be finally selected. Moreover, the eye sensitivity depends on spatial frequencies expressed in cycles per degree (c/°), whereas the order or the frequency of the decorrelated coefficients are related to spatial frequencies expressed in cycles per picture height (c/h). The derivation of the weighting coefficients W_i from a selected filter model for the eye necessarily requires some assumption on the viewing distance expressed in picture heights. The weighting coefficients are therefore not uniquely defined.

Mannos, Sakrison, Ngan and Nill have proposed different weighting curves. The Mannos and Sakrison weighting formulae denote a band-pass response which can be reported as follows

$$H(f) = a(b + cf)e^{-(cf)^d} \qquad (2.416)$$

where f is expressed in cycles per degree. Similarly, Nill put forward the following formula

$$H(f) = (a + bf)e^{-(cf)} \qquad (2.417)$$

The approach followed in References [8], [2], [21] has consisted in deriving the visual filter model as a two-dimensional extension of the CCIR noise weighting curve (recommendation 451-2). The reasons to exploit the CCIR weighting curve are twice. First, it is widely admitted by subjective quality assessors and, secondly, it helps to smooth the coding artifacts observed when quantizing block transform coefficients. The spatial noise weighting functions W are given in function of the spatial frequencies f_x and f_y expressed in cycle per picture heights

1. for the luminance by

$$W(f_x, f_y) = 15.32 \left\{ 1 + \frac{f_x^2 + f_y^2}{[3.952 \;\; \arctan(1/2l)]^2} \right\}^{-3/2} \tag{2.418}$$

2. for the chrominance by

$$W(f_x, f_y) = 0.96 \left\{ 1 + \frac{f_x^2 + f_y^2}{[3.952 \;\; \arctan(1/2l)]^2} \right\}^{-3/2} \tag{2.419}$$

with l the distance from the screen expressed in screen height unit h. The computation of the weighting factors is presented in [21] for the DCT based coding schemes, in [8] for the subband and the pyramidal coding schemes. This approach originally due to Dalleur [2] has led to the concepts of weighted noise, weighted noise power and visibility factor. Let us denote $\sigma_{q,k}^2$ the quantization noise power in band k introduced on the signal $x_k(n)$, the power spectral density of the quantization noise after reconstruction through interpolation of factor N_k and synthesis filter $G_k(e^{j\omega})$ can be expressed as

$$\frac{1}{N_k} |G_k(e^{j\omega})|^2 \sigma_{q,k}^2 \tag{2.420}$$

The noise power density is formulated as

$$P_N = \frac{1}{N} \sum_{i=0}^{N-1} \sigma_{e,i}^2 \tag{2.421}$$

where $\sigma_{e,i}^2$ is the variance of the quantization error on the coefficient order i and N the number of subbands or the size of the DCT block. The weighted noise power density is defined by the CCIR 451-2 Recommendation as a function of the eye sensitivity

$$(P_N)_W = \int_{-f_{x,max}}^{+f_{x,max}} \int_{-f_{y,max}}^{+f_{y,max}} W(f_x, f_y)\gamma_e(f_x, f_y)df_x df_y \tag{2.422}$$

where $\gamma_e(f_x, f_y)$ is the two-dimensional noise spectral density given by

$$\gamma_e(f_x, f_y) = \frac{1}{N} |H|^2 \sigma_{e,i}^2 \tag{2.423}$$

2.7. Quantization

where H is the kernel of the decorrelation operator. A weighted noise power density can be immediately deduced as a function of the variance of the quantization error

$$(P_N)_W = \frac{1}{N} \sum_{i=0}^{N-1} W_i \sigma_{e,i}^2 \qquad (2.424)$$

and the weighting factors are related to the spatial noise weighting function by

$$W_i = \int_{-f_{x,max}}^{+f_{x,max}} \int_{-f_{y,max}}^{+f_{y,max}} W(f_x, f_y)|H|^2 df_x df_y \qquad (2.425)$$

where W_i can be considered as the weighting factor of the i^{th} subband or DCT order and $\sqrt{NW_i}$ as the visibility factors.

2.7.5 Fixed Bit Allocation

In absence of transmission noise, it is easily shown that, for a unitary transform, the mean square reconstruction error at the decoding end equals the mean square quantization error. To demonstrate the proposition, let us consider Figure 2.30 and define successively the reconstruction error and the coefficient reconstruction error as $\tilde{f} = f - \hat{f}$ and $\tilde{\theta} = x - y$. Tilded variables \tilde{f} and $\tilde{\theta}$ hold respectively for the data reconstruction errors and the coefficient quantization error. Hatted \hat{f} variable stands for the decoder-reconstructed data values. Then,

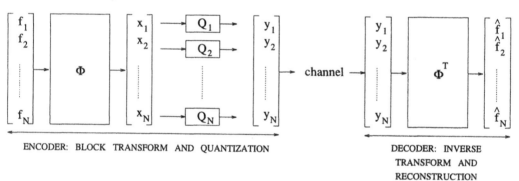

ENCODER: BLOCK TRANSFORM AND QUANTIZATION

DECODER: INVERSE TRANSFORM AND RECONSTRUCTION

Figure 2.30: Signal analysis and quantization in a coder-decoder system.

$$\underline{\tilde{f}} = \underline{f} - \underline{\hat{f}} = \Phi^T \underline{\tilde{\theta}} \qquad (2.426)$$

where underlined variables symbolize vectors made of the block coefficients in a TC operation Φ of size N. The distortion or the average mean square error is given by

$$\sigma_\epsilon^2 = \frac{1}{N} E[\underline{\tilde{f}}^T \underline{\tilde{f}}] \qquad (2.427)$$

$$= \frac{1}{N} E[\underline{\tilde{\theta}}^T \underline{\tilde{\theta}}] \qquad (2.428)$$

$$= \frac{1}{N} \sum_{n=0}^{N-1} \sigma_{qn}^2 \qquad (2.429)$$

$$(2.430)$$

where σ_{qn}^2 is the variance of the quantization error introduced on the n^{th} spectral coefficient. As a matter of fact, it is equal to $\sigma_{qn}^2 = E[|\tilde{\theta}_k|^2]$.

When only R_n bits can be allocated to the n^{th}-spectral-order quantizer, the problem is to choose the quantizer function which minimizes the variance of the quantization error under the constraint that the quantized coefficient representation is limited to R_k bits. It is known from the literature that, given the probability density function for θ_k, the optimum quantizer on point of view of the minimum mean square error is the Lloyd-Max quantizer allowing each σ_{qn}^2 to be minimized separately. Intuitively, since a mean square error is being minimized, the quantization process can be regarded as an optimum linear estimator where the error is unbiased and orthogonal to the quantization output.

In order to derive the quantization function to be applied on the different bandpass signals, the number of bits to be allocated to each spectral quantizer is chosen in the fixed allocation problem so as to minimize the global weighted noise powers. The resulting distortion is a function of the stochastic properties of the n^{th}-order spectral coefficient, namely its σ_k^2 and PDF, of the quantizer (optimum or not), and of the constrained number of allocated bits. According to the rate-distortion theory, a quantizer can be characterized by a performance factor which expresses a relationship between the spectral coefficient variance and the quantization error variance. This relationship can be expressed individually for each spectral order as

$$\sigma_{qn}^2 = f(R_n)\sigma_n^2 \tag{2.431}$$

Typically, $f(R_n) = \gamma 2^{-2R_k}$ is defined as the quantizer distortion function for an input unity variance. Moreover, Jayant and Noll have determined in [13] the values of γ corresponding to different signal PDF's. γ depends on the spectral coefficient PDF and on the type of quantizer. Applying the rate-distortion result on all the spectral coefficients, the weighted noise power can be expressed as

$$\sigma_q^2 = \frac{1}{N} \sum_{n=0}^{N-1} W_n \gamma_n 2^{-2R_n} \sigma_n^2 \tag{2.432}$$

Under the constraint R of a fixed average number of bits per coefficient,

$$\sum_{n=0}^{N-1} \frac{R_n}{N} = R \tag{2.433}$$

To minimize Equation 2.432 subject to Constraint 2.433, the Lagrange multiplier method is utilized to find the optimum choice of bit allocation. It is solved in bits per sample from

$$\frac{\partial}{\partial R_n} \left\{ \frac{1}{N} \sum_{n=0}^{N-1} W_n \gamma_n 2^{-2R_n} \sigma_n^2 - \lambda \left(R - \sum_{n=0}^{N-1} \frac{R_n}{N} \right) \right\} = 0 \tag{2.434}$$

where it is assumed that all the γ_n's are identical for each order. The final result is provided by

2.7. Quantization

$$R_n = R + \frac{1}{2} log_2 \left[\frac{N_n W_n \sigma_n^2}{\prod_{n=0}^{N-1} (N_n W_n \sigma_n^2)^{\frac{1}{N_n}}} \right] \qquad (2.435)$$

This shows that, in agreement with intuition, the number of bit to be allocated per band is proportional to the logarithm of the weighted coefficient variance.

Let us remark that Equation 2.435 may lead to negative real numbers which require to be corrected. In such circumstances, the compensation for negative number of bits is carried out by substracting bits allocated to other subbands; methods are proposed in the literature where bits are substracted one-by-one to minimize step-by-step the increasing distortion.

To obtain the coding gain, the PCM scheme has to be first referred. Reminding that, PCM is a particular block transform where $\Phi = I$, the distortion in PCM is of the type

$$\sigma_{PCM}^2 = \frac{1}{N} \sum_n \sigma_n^2 = \frac{1}{N} \sum_n \gamma_n 2^{-R_n} \sigma^2 = \gamma_n 2^{-R_n} \sigma^2 \qquad (2.436)$$

where σ is the full band variance. Assuming identical γ parameters in Equations 2.432 and 2.436, the coding gain becomes from 2.30

$$G_{TC} = \frac{\sigma^2}{\prod_{n=0}^{N-1} (N_n W_n \sigma_n^2)^{\frac{1}{N_n}}} \qquad (2.437)$$

Applying this results successively to transform coding and subband coding leads to similar expressions as follows.

Transform Coding

For unitary transforms, let us recall that $N\sigma^2 = \sum_{n=0}^{N-1} \sigma_n^2$ and the coding of TC over PCM is given by *the ratio of the arithmetic mean of the coefficient variances to the geometric mean* as

$$G_{TC} = \frac{\frac{1}{N} \sum_{n=0}^{N-1} \sigma_n^2}{(\prod_{n=0}^{n=N-1} \sigma_n^2)^{\frac{1}{N}}} \qquad (2.438)$$

This gain is maximized with the KLT since that orthogonal transform minimizes the geometric mean of the coefficient variance. Indeed, as the KLT generates a diagonal autocorrelation matrix where the diagonal TC variances are the eigenvalues of the input signal autocorrelation matrix. Hence,

$$\prod_{n=0}^{N-1} (\lambda_n)^{\frac{1}{N}} = |R_{XX}|^n = e^{\frac{1}{N} \sum_{i=0}^{N-1} \ln \lambda_n} \qquad (2.439)$$

Hence, the coding gain derived with the KLT is maximized as

$$\max G_{TC} = G_{KLT} = \frac{\sigma^2}{(\prod_{n=0}^{N-1} \lambda_n)^{\frac{1}{N}}} \qquad (2.440)$$

Chapter 2. TV and HDTV Coding Algorithms

and the limiting value of G_{KLT} when N tends to infinity achieves the upper bound on the transform coding operators. In that case

$$\lim_{N \to \infty} \frac{1}{N} e^{\frac{1}{N} \sum_{i=0}^{N-1} ln\lambda_n} = \frac{1}{2\pi} \int_{-\pi}^{\pi} ln[S_{XX}(\omega)]d\omega \qquad (2.441)$$

with $S_{XX}(\omega)$ the power spectral density of the signal. Re-expressing numerator and denominator of Equation 2.440, the coding gain turns out to be the inverse of the spectral flatness measure. Indeed, the numerator can be equivalently written as

$$\sigma^2 = \frac{1}{2\pi} \int_{-\pi}^{\pi} S_{XX}(\omega)d\omega = R_{XX}(0) \qquad (2.442)$$

and the denominator as

$$\exp\{\frac{1}{2\pi} \int_{-\pi}^{\pi} ln\left[S_f(e^{j\omega})\right] d\omega\} \qquad (2.443)$$

The resulting coding gain

$$G_{KLT}^{\infty} = \frac{\frac{1}{2\pi} \int_{-\pi}^{\pi} S_{XX}(e^{j\omega})d\omega}{\exp\{\frac{1}{2\pi} \int_{-\pi}^{\pi} ln\left[S_f(e^{j\omega})\right] d\omega\}} \qquad (2.444)$$

This important result shows that there is no gain to be expected when coding white noise since $G_{TC}^{\infty} = 1$ in that case. In fact, G_{TC}^{∞} is a measure of the signal predictability since it increases with the degree of correlation. The gain may increase as long as signal redundancy may be further removed. Consequently, the effect of the optimum coder consists of whitening the input signal.

Subband Coding

Returning to the subband coding techniques which are another variant of expanding a signal along the bases of a Hilbert space, we may readily write that

$$G_{SB} = \frac{\frac{1}{N_i N_j} \sum_{i,j} \sigma_{SB,i,j}^2}{\prod_{i,j} \left(\sigma_{SB,i,j}^2\right)^{\frac{1}{N_i N_j}}} \qquad (2.445)$$

Therefore, decorrelation is obtained by minimizing the geometric mean of the subband variances under the constraint of preserving the signal energy, that is maintaining a fixed sum of those subband variances. The optimum compaction of the energy into a minimum number of subband coefficient is a criterion to be put into the filter design or adaptation. Among all the criteria discussed in section 2.6.10, it stands as the most important since well-condensed energy decreases the local sensitivity to visual quantization degradations. In the case of a weighted quantization, the optimization is brought on Equation 2.437.

2.7.6 Entropy Coding of Quantized Signals

The question to be treated here concerns the optimal bit allocation of entropy coded quantized coefficients and the determination of the optimum quantization step sizes. Gish and Berger have shown that the optimum quantizers for coefficients to be entropy coded are nearly linear quantizers. All the admissible values of a coefficient have consequently to be quantized with the same step independently of their probabilities. It remains to determine the best quantization steps in order to derive the minimum global distortion under the constraint of a fixed entropy as it has been demonstrated in [8] and in [21] in the framework of the block transforms and of the subband signal.

The quantization step sizes to be applied on different subband coefficients have to be determined so as to minimize the weighted noise power under the constraint of a given mean entropy. The constraint is as follows

$$H = \sum_{i=0}^{N-1} \frac{H_i}{N_i} \tag{2.446}$$

Using the Lagrange method to optimize the quantization step size q_i of subband i, we have the equation

$$\frac{\partial}{\partial q_i} \left[\sum_{i=0}^{N-1} W_i \sigma_{q,i}^2 + \lambda \left(H - \sum_{i=0}^{N-1} \frac{H_i}{N_i} \right) \right] = 0 \tag{2.447}$$

The resolution leads to

$$N_i W_i \left(\frac{\partial \sigma_{q,i}^2 / \partial q_i}{\partial H_i / \partial q_i} \right) = \lambda \tag{2.448}$$

with λ constant. In the case of a negative exponential PDF (Laplacian PDF), the ratio of the partial derivative is proportional to q_i^2 and therefore,

$$N_i W_i q_i^2 = \lambda_2 \tag{2.449}$$

and then, in order to minimize the weighted noise power under the constraint of a given entropy rate, each subband i or DCT coefficient should be quantized with a step size δ_i which is inversely proportional to its corresponding visibility factor i.e.

$$\delta_i \propto \frac{1}{\sqrt{N_i W_i}} \tag{2.450}$$

As a matter of conclusions, each subband is *quantized with a quantization step size which is inversely proportional to what we have termed the visibility factor* $\sqrt{N_i W_i}$. In practical implementation of quantizers, the visibility factor is introduced in a multiplicative factor.

Chapter 2. TV and HDTV Coding Algorithms

2.7.7 Objective and Subjective Image Quality

The signal to weighted noise ratio WSNR is defined by

$$WSNR = 10 \log \frac{\varpi^2}{(P_N)_W} \tag{2.451}$$

with ϖ the range of the luminance on 8 bits. The WSNR constitutes the reference measure of the objective image quality. So far the subjective image quality expressed by mean opinion scores (Table 2.3) can be related to the WSNR using the logistic approximation proposed by the CCIR as

$$Q = \frac{5}{1 + (WSNR/37.5)^{-7}} \tag{2.452}$$

This relation provides the reader with an approximate relation between the objective and the subjective image quality. In this approach by weighting, the eye sensitivity to the spatial frequencies has only been considered to come up with a weighted noise approach.

In the real Human Visual System, other effects have to be taken into consideration: like the masking effect due to mutual interactions among neighboring stimuli, like the tuning effect due to the location, the orientation and the distance of the stimuli. In other words, this study is not sufficient enough to connect univocally the subjective image quality to the value of the quantization step size: so many parameters come into consideration that a theoretical approach is presently out of range. In the following subsection, a further adaptation of the quantization step size will be conducted by relating the block content with the local sensitivity to quality degradations.

2.7.8 In Search of Uniform Subjective Image Quality

In this section, an experimental methodology will be developed to derive a quantizer command which enables obtaining a local quasi-constant subjective image quality. Instead of presenting a theoretical development of this topic, an experimental approach is pursued in the following since that problem is extremely intricated to be tackled and a large number of parameters actually influences the subjective quality as seen at the end of the previous section. Though the Human Visual System functions are now clearly understood and well modeled, the parameters to be implemented and their sensitivity to estimate a correct subjective level of quality remain the object of an intensive long term research in the field of the digital images. Moreover, simple and easily implementable algorithms are here under consideration to utilize parameters which are directly accessible and computed locally on DCT blocks either in the original image or in the transform domain.

In any case, the visibility of the degradations due to the quantizing process depends on the Human Visual System, on the local image content (the block) and on the type of kernel used in the decorrelation operator. Let us consider some illustrative examples of resistance or sensitivity of the subjective quality to an increase of the quantization step size. For the shake of simplicity, a DCT block coding algorithm is taken as reference. However, generalization to subband techniques is quite easy.

1. blocks with dominant horizontal and/or vertical structures have an efficient compaction into a few transform DCT coefficients. They can be reconstructed quite perfectly even after a rather coarse quantization. Inversely, diagonal structures spread their original energy over numerous DCT transform coefficients of intermediate frequency. This latter type of blocks has a subjective quality highly sensitive to the quantization step size because the quantization effect is marked on many small transform coefficients which affect the contribution of the basis functions involved in the structure and impairs de facto the reconstruction.

2. local areas merging both low frequency structures and high frequency details have an intermediate resistance to the quantization. Local areas with only a high frequency content on uniformly flat background are very sensitive to the quantization.

3. the impairment visibility is function of the kernel of the operator. The DCT defects are merely block-wise and appear in check patterns. The subband defects are smoother and rather spread over large areas depending on the length of the impulse response. Intuitively speaking, the quantization noise is produced on the transform coefficients and processed by the synthesis filters in the decoder to become visible. Non-linear phase synthesis filters may spread defects of large frequency bandwidth through distortions of the group delay.

The concept of block criticality C_b has been therefore introduced to characterize the sensitivity of the coded blocks to the local subjective quality degradation Q_b when the weighted quantization step size $\delta_{b,w}$ applied on the block of transform coefficients is increased i.e.

$$C_b = -\frac{\partial Q_b}{\partial \delta_{b,w}} \qquad (2.453)$$

Let us notice that weighting is included in the quantization process. A critical block is therefore a block whose local subjective quality degrades quickly when the quantization step size increases: it becomes either noisy or spoiled by the decorrelation kernel functions.

The block criticality has not to be confused with the block activity which represents the energy of the coefficients in the transform block (considering all the coefficients except the lowest order one) and is expressed as

$$A_b = q \sum_{i,j} c(i,j)^2 \qquad (2.454)$$

where A_b is the block activity, $c(i,j)$ the coefficients of order (i,j) and q is a scaling factor. Activity has to be distinguished from criticality: a block can be active and non-critical and conversely. The activity implies rather an idea of entropy content. Linear transforms like the DCT or the KLT perform a decorrelation of the incoming signal resulting in a compaction of the energy into a small number of AC coefficients of lower order. In general, the blocks where DCT performs efficiently are non-critical blocks and conversely. Blocks can be active without being critical: for example, the image blocks having a high energy in the low frequency, in the vertical or horizontal frequencies. Blocks can be not active

Chapter 2. TV and HDTV Coding Algorithms

and be critical: for example, image blocks having their energy in high frequencies only. As a consequence, to achieve a constant subjective image quality the quantization step size has to be adapted locally according to a measure of criticality.

Let us now examine how to build an adaptive quantization. As subjective quality is mainly of concern, the results will be deduced from an experiment which will enable defining several classes of criticality and logistic curves of equal subjective quality. The experimental principle consists first of coding several sequences at different values of quantization step size and secondly of qualifying the coded blocks with subjective notes like those given in Table 2.3. The viewing conditions are those defined in the CCIR recommendation 500 i.e. of 4 to 6 times the screen height.

note	Quality	impairments
5	excellent	imperceptible
4	good	perceptible, but not annoying
3	fair	slightly annoying
2	poor	annoying
1	bad	very annoying

Table 2.3: **Grading scale of image impairments.**

At this stage, a statistical relation has to be searched to link the subjective notes qualifying the local blocks with their content (i.e. the values of the transform coefficients or some specific portions of the transform blocks). For example, the DCT transform domain can be partioned into several sub-areas (Figure 2.31)

1. horizontal and vertical frequencies located in the first column and row (area 1).

2. low and intermediate frequencies (area 2).

3. high frequencies (area 3).

This subdivision enables discriminating the relative importance of horizontal and vertical structures, the flat areas, the balance between both low frequency and high frequency detailed areas. As a matter of fact, the sensitivity of local structures to quantization step size should be rather well discriminated by such decomposition. The transform sub-areas are thereafter characterized before quantization by descriptive parameters susceptible to measure the criticality. Examples of candidate parameters to be computed on the previous sub-areas are: the energy of the transform AC coefficients, the maximum value of the AC coefficients,... A statistical analysis is thereafter applied in the multidimensional spaces gathering all the samples originating from blocks having identical subjective notes. The multidimensional space of analysis furnishes the quantization step size as a function of the block descriptive parameters at equal subjective quality. A statistical analysis should allow clustering the experimental points into significantly different areas or classes. The statistical analysis is eventually performed as follows in three steps

1. gathering the experimental points into spaces of equal subjective quality to represent the quantization step size in function of all the candidate parameters.

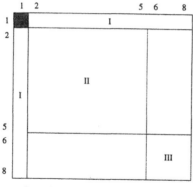

I : vertical and horizontal frequencies

II : low and intermediate frequencies

III : high frequencies

Figure 2.31: Subdivision of the DCT into sub-areas for the measure of criticality.

2. performing an analysis of the variance to separate or to cluster the set of points into different classes.

3. performing a multiple regression into each class to derive, first, the most significant explicative parameters among all the candidates and, secondly, the law into each class of the quantization step size in function of the explicative parameter furnishing the required constant subjective quality.

To conclude, the quantizer is able to produce a statistically quasi-constant quality by computing the significant parameters within each sub-area and to deduce by the experimental law the quantization step size to be applied within the block. For example, it has been shown that the maximum magnitude value computed within the sub-areas is a significant parameter to discriminate among the classes of criticality. Four classes have been considered and delimited by a set of thresholds.

2.7.9 Implementation of Quantizers

The underlying motivation to build adaptive linear and scalar quantizers is shortly explained in guise of conclusions. Originally, video coding schemes tried to exploit non-linear quantization adapted to the transform coefficient PDF's and to perform fixed bit allocation. The amount of bits allocated to each transform frequency was fixed so as to match the resulting quantized data rate to the channel capacity. The need to control more efficiently the quantization step size computation and the necessity to take into account the weighting factors and the local image content conduct the research to adjoin two new functions, namely an entropy coder and a buffer regulation. To further implement only one single quantizer concomitantly to adaptivity, the idea was to split the quantizer into a multiplier followed by a unitary step size quantizer similar to each frequency. The implementation of a quantizer is then established on the basis of a multiplier which acts as a scaling function and a linear unitary step size quantizer. The multiplier coefficients have

the form $2^{-\frac{n}{32}}$ with φ the quantizer scaling factor, a function $n(\omega, U, C_b)$ of the coefficient frequency through weighting factors, $W_{i,j}$, the class of criticality C_b or local adaptation to block content and the buffer occupancy by means of the transmission factor U for global or long-term adaptation to the channel rate. The adaptive algorithm computes a value of n for each coefficient. This technique requires to perform the inverse multiplication at the decoder side. This latter function will be referred to as the inverse quantizer.

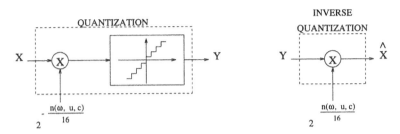

Figure 2.32: Implementation of a scalar quantizer.

2.8 Variable-Length Entropy Coding

Different Variable-Length Coders (VLC) have been presented so far in the literature. Any VLC should implement an optimum reversible mapping of the fixed length input words originating from the quantizer into variable-length output words. The VLC strives to achieve a minimum data rate. According to information theory, the fundamental principle of any VLC algorithm consists in coding the value of the input words with a binary length inversely proportional to their probability of occurrence.

Numerous variable-length coding algorithms have been presented in the literature; among them, let us first quote some of more interesting elementary techniques developed during the past thirty years: the Huffman algorithm, the universal codes of Lynch and Davisson [20], the Adaptive Truncated Run-Length codes (ATRL) [23], the Arithmetic Computed Variable Length Codes (ACVLC) [24],... As more elaborated techniques combining the previous concept for new achievements, let us notice the arithmetic codes of IBM [16], the Universal Variables Length Codes (UVLC) of UCL [21].

The foundations of information theory are now well established, let us reference the work of Gallager [17]. The concept of entropy will be first defined in this section and recent achievements of primary importance in the field of variable bit rate coding will thereafter be summarized in the following subsection.

2.8.1 General Definition of Entropy

To characterize the minimum mean amount of bit stream necessary to encode in a reversible way the quantized coefficients, the notion of measure of information or the entropy has been defined. The quantity of self-information contained in an event x_i is proportional

to the inverse of its probability of occurrence p_i. Therefore, to adopt a scale of measure ranging from 0 to $+\infty$, the self-information of the event x_i is formulated by

$$I(x_i) = \log \frac{1}{p_i} \tag{2.455}$$

When the logarithms are used in base 2 (e), the unit of entropy is the bit (nat). The self-information can be interpreted as the amount of uncertainty contained in the event x_i. Let us suppose a source, memoryless and discrete, which transmits values or letters from a countable set X of events x_i $(i = 1, .., N)$. The entropy of the source is defined in bits per source letter as a random variable being the average value of the individual self-information

$$H(X) = \sum_{i=1}^{N} p_i \log \frac{1}{p_i} \tag{2.456}$$

with the logarithm base equal to 2. It is easy to prove that $H(X) \geq 0$ and that $H(X) \leq log\ N$ with equality if and only if the probabilities P_i are equal.

The conditional self-information of an event $x_i \in X$ given the occurrence of another event $y_i \in Y$ is defined by

$$I(x_i|y_i) = \log \frac{1}{p(x_i|y_i)} \tag{2.457}$$

with $p(x_i|y_i)$ the conditional probability of the event x_i given the event y_i. The conditional entropy is a random variable over the joint ensemble X and Y defined as the average value of the individual conditional self-information

$$H(X|Y) = \sum_{i=1}^{N} p(x_i|y_i) \log \frac{1}{p(x_i|y_i)} \tag{2.458}$$

It represents the average information required to encode X when Y is known. The most important theorem to develop variable-length coders can be found in the early work of Gallager [17]. The philosophy consists in decomposing a source of coefficients into N *independent sub-sources*, each of which having an intrinsic identical statistical model. The sub-sources are thereafter more efficiently entropy coded. Let us mention for instance the decomposition of the DCT transform coefficients into sign, magnitude and position in the block.

2.8.2 Recent Achievements in Variable-Length Codes

Among all the recent developments in the field of entropy coding, two different families of variable entropy coding algorithms have emerged so far in the literature: the adaptive schemes and the universal schemes

1. the universal entropy coders use universal codes which have the properties of coding independently of the source statistics. They try to keep a high efficiency regardless of the input statistics. As the length of the piece of the source to be encoded into the same block increases, the coding efficiency has the property to converge to unity. The construction of those codes is mainly combinatoric but not predictive. As a consequence, they are perfectly suited for sources with highly non-stationary statistics.

2. the adaptive entropy coders use models to estimate and to reactualize the present probabilities of occurrence of the symbols to be encoded. The models use a prediction based on their past context to encode the coefficients as closely as possible to the past conditioned entropy. As a matter of fact, the construction of those codes is mainly predictive and efficient in the periods when the source is quasi-stationary. Let us remark that the predictive models lead towards the possibility of a time dynamic optimization according a cost function, the entropy.

Both families of entropy coding algorithms can either use memorized tabulated code books or compute the code to be output: the former codes are referred to as tabulated codes and the latter as arithmetic codes. The two following paragraphs will outline the definition and the main basic properties attached to the universal and the adaptive coding schemes.

Universal Codes for VBR Coding

The existence of the universal codes was first mentioned by Kolmogorov in 1965 who introduced the term universal to characterize the potential existence of codes fulfilling two main properties

1. the encoding depends only on the observed symbols of the source to be encoded but not on the past and not on the future symbols. This means a memoryless block-wise coding scheme.

2. some performance measures are attained arbitrarily closely as the block length goes to infinity: this introduces a notion of relativity to the universality. As a matter of fact, the potential performances to be optimized should be either the coding efficiency (to be maximized) or the per-letter coding length (to be minimized).

A universal coding method divides [20] the message in two parts: the first part tells how the encoding is to be carried out and the second part contains the effective encoding of the symbols. Let us consider M different possible encoding tables each with a uniquely decipherable code. The universal code consists successively of determining which of the M tables will minimize the coded bit stream and of encoding the symbols with the optimum table. For example, to encode N letters in that way, it requires to send a prefix to tell how to encode the following N consecutive letters and a suffix which optimally encodes those N letters. The average coded length per letter $E[l(x_N)]$ of the source X_N of N letters x_i conditioned by the knowledge θ of the best table to be used among M of them is bounded by

$$E[l(X_N|\theta)] \leq \frac{\lceil \log M + 1 \rceil}{N} + \frac{1}{N}[\sum_{i=1}^{N} p(x_i|\theta)\{\min_{\theta}(-\log p(x_i|\theta) + 1)\}] \qquad (2.459)$$

where the first term represents the prefix length or the number of bits to encode the number of the best minimum code-length book i.e. one among M of them (the signs $\lceil \ \rceil$ hold for the nearest superior integer value) and the second term represents the suffix or the coded length of the N letters x_i belonging to X_N. By applying the theorem of variable-length coding [17]

$$E[l(X_N|\theta)] \leq \frac{\lceil \log M + 1 \rceil}{N} + \frac{H(X|\theta)}{N} + \frac{2}{N} \qquad (2.460)$$

As N tends to infinity, the average length per letter tends to entropy by cancellation of all the terms except the second.

Figure 2.33 summarizes the way to encode a source with elementary universal VLC's: segmentation into N independent sub-sources and coding into prefixes and suffixes. Examples of this coding technique are UVLC, universal codes of Lynch and Davisson,.... Codes like the ACVLC's could be incorporated into a universal entropy coding scheme by designing a fast operational algorithm to determine optimum tables.

Adaptive Codes for VBR Coding

The adaptive coding algorithms use the past statistics of the source information to affect the current encoding. The source coding is based on Markovian models. Hence, the coder uses a model to dynamically estimate the present probability distributions and to track the changes due to potential non-stationarities. A simple model is the first order Markov model which uses the previous symbol as the context for the current symbol. The notions of context and of model are fundamental in the field of adaptive coding. The purpose of a context is to provide a past conditioned probability distribution or a base of statistics to encode the next symbols. The purpose of a model is to process the current set of symbols to be encoded to deduce a new set of symbols to be eventually encoded with a higher efficiency (for example, it can predict the current symbol and encode the error of prediction). Both concepts of model and context can be merged in the sense that one model can predict the events (symbols to be encoded) and the context (the symbol statistics).

The adaptive coding schemes try to reach the past conditioned entropies which are lower than the self entropies as far as the source is not too highly non-stationary (i.e. non-predictable): this constitutes the object of the present demonstration. Let be a source X of M letters to be encoded, each letter can take N different values and let $Pr'[x_i|\phi] = \{p'_1, ..., p'_N\}$ be the probabilities that a letter x_i (i=1 to M) takes the value n (n=1 to N) given the context ϕ. Let $Pr[x_i|\phi] = \{p_1, ..., p_N\}$ be the corresponding true probabilities to outcome from the realization ($\sum_{i=1}^{N} p_i = 1 = \sum_{i=1}^{N} p'_i$). The expected number of bits to code a letter x_j is given by

$$E\{\log[\frac{1}{Pr'[x_j|\phi]}]\} = \sum_{i=1}^{N} p_i[\log\frac{1}{p'_i}] \qquad (2.461)$$

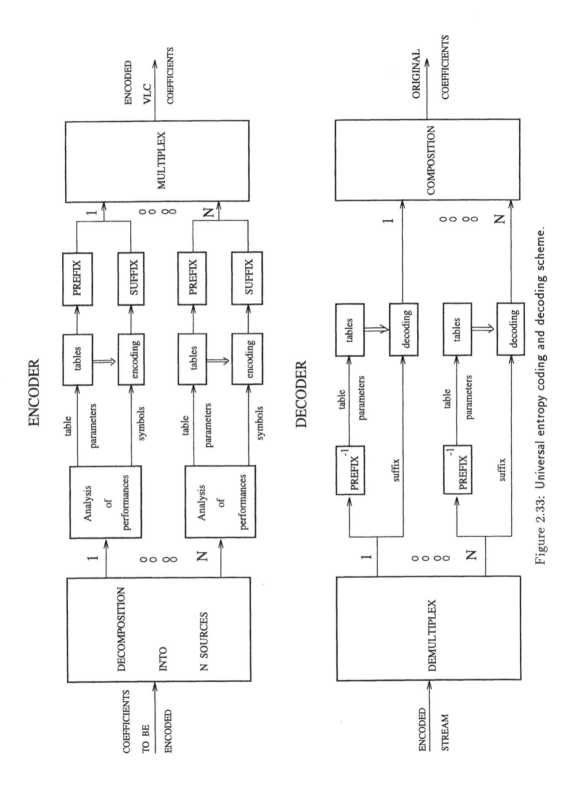

Figure 2.33: Universal entropy coding and decoding scheme.

The expected number of bits R to encode the set of M letters after the estimation of the conditional probabilities $Pr'[x_i|\phi]$ is therefore

$$R\{Pr'[X]\} = \sum_{j=1}^{M} E\{\log[\frac{1}{Pr'[x_j|\phi]}]\} \qquad (2.462)$$

by developing the expectation

$$R\{Pr'[X]\} = \sum_{j=1}^{M}\sum_{i=1}^{N} p_i[\log\frac{1}{p_i}] \qquad (2.463)$$

$$= M\sum_{j=1}^{N} p_i[\log\frac{1}{p_i} + \log\frac{p_i}{p_i'}] \qquad (2.464)$$

$$= H(X|\phi) + M\sum_{i=1}^{N} p_i[\log\frac{p_i}{p_i'}] \qquad (2.465)$$

with $H(X|\phi)$ the past context conditioned entropy. As the following inequality holds for all x in the interval $]0, +\infty[$,

$$\log(x) \leq (x-1) \qquad (2.466)$$

the following inequality is verified

$$\sum_{i=1}^{N} p_i \log[\frac{p_i'}{p_i}] \leq \sum_{i=1}^{N} p_i[\frac{p_i'}{p_i} - 1] \qquad (2.467)$$

$$\leq 0 \qquad (2.468)$$

$$R\{Pr'[X]\} \geq H(X|\phi) \qquad (2.469)$$

with equality if and only if the context conditioned probabilities are correctly predicted.

Example of adaptive coding schemes are the arithmetic codes developed by G. Langdon and J. Rissanen [16]. Other codes can be transformed into adaptive codes, for instance the UVLC's and the ACVLC's. Figure 2.34 presents the coding structure of an adaptive VLC. In the encoder, the incoming coefficients are decomposed into N independent subsources. Each of them is processed by a model to determine the context (i.e. the statistics) and the symbols to be encoded. A dedicated VLC processes the symbols according to the optimal tables for the statistics. On the decoder end, the Variable-Length Decoder (VLD) processes the coded symbols according to a context which is reconstructed by the decoder itself with the same model.

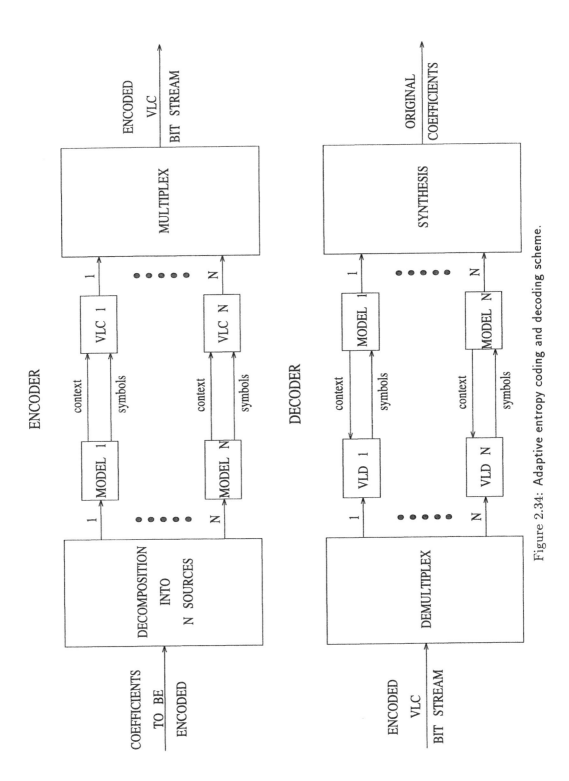

Figure 2.34: Adaptive entropy coding and decoding scheme.

2.9 Quantizer Rate-Distortion Function

The TV sources constitute one category of generator of information. As defined in the previous section, the entropy measures the minimum mean amount of information contained in the digital TV signal. When expressed in bits, the entropy represents the minimum rate necessary to transmit the information on the network in a lossless way. The goal of the coders being to compress as far as possible the entropy rate of the source, the concern of this section is the rate-distortion function, namely, the function relating the source entropy rate with the output coder entropy rate at different levels of subjective image quality. In the case of study, the transmission factor will act as an indicator of subjective quality and will be involved as such in the rate-distortion formulation.

The TV coders are composed of three successive operations: the decorrelation, the quantization and the variable-length coding of which the second is not invertible. Let us first demonstrate that reversible operations do not affect the value of the entropy. Let us moreover consider the stripe bit rate. The justification of taking the stripe as a time span reference will provided in Chapter 4 when tackling the problem of the coder regulation. Let us now compare the entropy of two random discrete variables x and y=f(x). In our case, x is the incoming TV signal considered over a stripe interval and y is the corresponding quantized signal. The resulting entropy relation is

$$H(y) \leq H(x) \tag{2.470}$$

with equality if and only if the transformation is invertible. The equality applies therefore to the decorrelation operators and to the variable-length coders which are both reversible transformations. If the transformation is one-to-one then

$$Pr[y = y_i] = Pr[x = x_i] = p_i \quad y_i = g(x_i) \quad \forall i \tag{2.471}$$

where p_i represents the probability that x takes the value x_i. Hence, $H(y)$ equals $H(x)$. If the transformation is not one-to-one as in the quantizer, then $y = y_i$ holds for more than one value of x. This implies a reduction of entropy and then $H(y)$ is lower than $H(x)$. As a consequence, the quantization procedure is within a coder the only operation which requires to model the compressed output entropy rate as a function of both input source entropy rate and value of the applied quantization step size.

Let us now introduce the rate-distortion function of a TV coder. As an intuitive guess, it is reasonable to state that the variation of the compressed output entropy rate is, in first approximation, proportional to the value of the compressed entropy rate and expressed as

$$\frac{\Delta H_q(n)}{\Delta \varphi(n)} = -\alpha H_q(n) \tag{2.472}$$

where the variation of entropy is produced by removing the least significant levels of accuracy. In this sense, $\varphi(n)$ is the normalized value of the quantizer scaling factor representing the inverse of the accuracy on a real scale ranging from 0 up to 1.

Therefore the model can be re-expressed as

$$H_q(n) = H_i(n) \exp\left[-\alpha \times (\varphi(n) - \varphi_0)\right] \tag{2.473}$$

where

- n is the sampling time, the sampling period is equal to one stripe and the sampling time corresponds to the end of the current encoded stripe.

- $\varphi(n)$ is the normalized quantizer factor when quantizing the transform coefficients, therefore, with δ being the quantization step size $\delta(n) = 2^{\varphi(n)}$, the value of $\varphi(n)$ remains constant during the whole sampling period.

- φ_0 is the normalized quantizer scaling factor at the finest quantization step size $\delta_0 = 2^{\varphi_0}$. Usually, $\varphi_0 = 0$.

- $H_q(n)$ is the compressed entropy bit rate corresponding to the quantization step size $\delta(n) = 2^{\varphi(n)}$.

- $H_i(n)$ is the source entropy bit rate corresponding to the compressed entropy bit rate at its finest quantization step size δ_0.

- α is the compression factor. First of all, α is an intrinsic characteristic of any given quantizer.

- the bit rates $H_i(n)$ and $H_q(n)$ represent bit rate accumulations over the corresponding sampling period n.

The interpretation of Relation 2.473 is rather intuitive. At high values of the coder output entropy rate, the quantization action is fine so that the number of non-zero transform coefficients with high orders is significantly high and as such contributes strongly in the output data rate. This means high variations of the compressed entropy bit rate for small changes of the quantization step size. The contrary holds at low values of the coder output entropy rate, the quantization is rather coarse so that it remains nearly no high frequency non-zero coefficients and the energy is concentrated into a few low and intermediate frequency coefficients. The sensitivity of the output rate to variations of the quantization step size is here very weak. Relation 2.473 expresses that the sensitivity of the output entropy rate is proportional to the level of the output entropy rate. The argument is valid in first approximation for compressible sequences i.e. those with a high frequency content. Consequently, this model does not hold necessarily for the sequences of video-telephony where the block content can be frequently limited in the low frequency part of the transform domain.

Let us now revisit the command for a constant subjective quality called the transmission factor U(n). It is used to compute and to adapt the quantization step size in order to take into account the long term constraints of the channel rate. To consider the example of the CMTT contribution coder at 34 Mbit/s, the DCT transform coefficients have an accuracy of 11 bits plus sign. The quantization step size is computed with respect to a variation of quantization scaling factor $\varphi(n) - \varphi_0 = \frac{U(n)}{16}$. Therefore, when $U(n) = 0$, the maximum coefficient precision is achieved at the quantizer output and, whenever the value of U(n) increases of 16, the output coefficients loose one representative bit. Owing

to the further computation of the block criticality, U(n) becomes a command for a constant subjective quality applied during the whole stripe. Therefore, taking the sampling period equal to one stripe, it follows in a first order approximation that

$$H_q(n) = H_i(n) \exp\left[-\alpha_U \times U(n)\right] \tag{2.474}$$

This transmission factor is sent on a stripe by stripe basis to the decoder.

The experimental values of the α_U factor have been estimated on several reference TV sequences and, as an important conclusion, this factor turns out to be rather constant in luminance and chrominance for a given quantizer. For instance, using a normalized quantizer scaling factor, as $\varphi(n) - \varphi_0 = \frac{U(n)}{16 \times 11}$, the BBA hardware quantizer is typically characterized by $\alpha = 5.06 - 2.97$, the RACE hardware quantizer by $\alpha = 6.60 - 5.00$ and the CMTT software quantizer by $\alpha = 4.51 - 4.18$.

2.10 Extensions of the OSI Layering

The OSI layers defined for the ATM channels can be extended to the coding algorithm by applying the same OSI rules

1. each layer depends only on the specifications of its inner layers.

2. each layer processes each piece of data independently without taking into account the data structure in its outer layers.

Top down, the layers in a coder will be composed of

1. the *scanning layer* which processes the scanning of the pictures and applies some eventual format conversions.

2. the *decorrelation layer* which removes spatial and temporal redundancy (DCT or subband operators - motion compensation). The organization of the signal in multiresolution or standalone outcomes is managed in this level.

3. the *channel rate adaptation layer* which contains quantizers, variable-length coders and bit rate regulations. It adapts the source entropy rate to comply to channel rates. It may potentially exchange some complement of quantization accuracy among different resolution levels.

4. the *ATM adaptation layer* which receives a bit stream from the encoder buffer without any semantic information. It performs the packetization and the transmission error correction.

The lower layers are of pure ATM purpose and have been described in the first chapter.

2.11 TV Encoding Architectures

The purpose of this section is to review the structures and the architectures which have led to efficient TV and HDTV coding schemes in the light of the past sections which have presented successively the major tool functions needed to compress the amount of incoming video information. These are namely the most important linear tools of digital signal analysis, the scalar quantization theory and the variable-length entropy coders. The coder structures to be examined will deal with standalone schemes, multirate or multiresolution decompositions and compatible applications. This terminology is clarified hereinbelow in conjunction with an additional nomenclature which introduces appellations like two-layer, multi-layer, hierarchical and parallel decompositions. This approach followed in the textbook starts with introducing pure intra structures and proceeds with treating hybrid schemes and, especially, those which have led to *compatible applications*.

In the classical and standardized moving video coding schemes, the spectral operators are used only to perform a two-dimensional spatial analysis. Whereas block transforms and subband filters are generally more efficient and suited for analysis and decorrelation, the current temporal signal processing is performed by predictive techniques enhanced with motion estimation and compensation. Since ATM transmissions enable carrying video information at different levels of quality along distinct virtual paths and offer to the users two levels of priority, the coding aspects relevant to two-layer and multi-layer decompositions of the video signal are first examined. These concepts have led naturally to the notion of *compatible* or *scalable* video communications and to its corollary which involves *progressive transmissions of image quality*. Exploiting multi-quality layered media of transmission corresponds to the concept of providing receivers with progressive image qualities starting with a basic guaranteed minimum quality transmitted on the channel of highest quality and adding step-by-step complements of progressive quality in a succession of approximation stages sent on a series of channels with decreasing quality.

2.11.1 Revisiting Multi-Layer Coding Schemes

The future Broad-band ISDN aims at conveying numerous moving video services at different resolution levels. The ATM transmissions are powerful and flexible enough to support multiresoluted applications. The introduction of two priority levels on an ATM transmission has immediately led to define two-layer TV-HDTV coding schemes. As a severe restriction, the broadcast of multilayered signals is limited to one or two layers by the number of priority levels available into the cell header. An ideal ATM medium of transmissions would have been such to enable the set-up of simultaneous multi-priority channels. Unfortunately, this opportunity has not been retained by the standardization bodies invoking the ease of the ATM implementation and the shortage of space available in the ATM cell header. As mentioned in Chapter 1 when discussing about how to implement the multiplexing of two-priority channels, the queueing management and the switching systems with two simultaneous quality levels turned out to be difficult tasks to be achieved in practice. The way to counter this two-layer limitation imposed on the present ATM networks consists in opening simultaneously several virtual paths at

different transmission qualities or in sectioning a single data stream into segments of progressive qualities. Quality-scalable or multi-layered HQVT-TV-HDTV transmissions may be transmitted on channels with a unique level of transmission quality. In this subsection, two-layer coding schemes are first presented and, thereafter, some concepts involved by multi-resolution applications will be developed.

2.11.2 Two-Layer Coding Schemes

In a two-layer TV coding scheme, the video information is split into two channels, namely a base layer and an enhanced layer. The *base layer* has the task to encode and transmit a reference low resoluted image quality on a channel which guarantees a high transmission quality. The *enhanced layer* encodes and transmits a complement of image quality on a channel of lower transmission quality. The decoder is in any case always able to display a minimum quasi-guaranteed base quality. The aim of such schemes is to adapt the TV coding algorithms to potential transmission media like either the hybrid STM-ATM networks or the ATM virtual paths which implement the binary priority. Both potential applications may be developed as follows

1. a mixed STM-ATM application presents a base STM layer at fixed cell rate and an enhanced ATM layer at constant or variable cell rate.

2. a pure ATM application allows a base layer with priority at constant or variable cell rate and an enhanced layer without priority also at constant or variable cell rate.

The splitting of the TV information may be performed into three independent domains, namely the coefficient accuracy, the spatial frequency and temporal domain. The corresponding implementations are summarized as follows

1. splitting in the accuracy domain consists of sending the most significant bits in the base layer and the least significant ones in the enhanced layer.

2. splitting in the spatial frequency domain consists of sending the low frequency components into the base layer and the high frequency components into the enhanced layer.

3. splitting in the temporal frequency domain consists of transmitting a signal which is temporarily filtered and sub-sampled of a factor N in the base layer and the remaining (N-1) temporal subbands in the enhanced layer.

The three different methods are not incompatible with each other but can be arranged or mixed in any combination. For example, splitting simultaneously in the accuracy and in the frequency domain (Figure 2.35) or splitting in the spatial and frequency domain with three-dimensional filters [51], [67]. The choice of decorrelation operators does not interact with the three methods of splitting. The fraction of the bit rate to be allocated on the base layer should typically vary within the range of $\frac{1}{4}$ to $\frac{1}{2}$ of the whole bit rate. The reasons which conduce to deriving schemes like that proposed in Figure 2.35 are clarified later in the chapter.

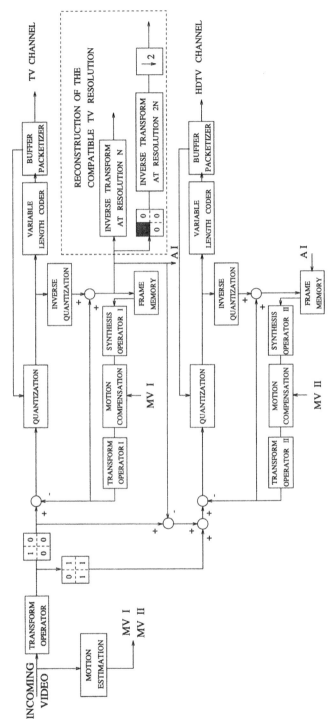

Figure 2.35: Two-layer compatible coding scheme splitting in both frequence and accuracy domains.

2.11.3 Multi-Layer Coding Schemes

In the future transmission of TV and HDTV, the problem of designing compatible and scalable coding algorithms emerges as an major problem. As a matter of fact, receivers connected on the network may be designed to exploit a lower resoluted version of the complete transmitted spectrum either to display the information on local screen or to propagate at a gateway the lower resoluted fraction through a network of narrower bandwidth. The multi-layer coding schemes can be implemented according to different variants classified as standalone, TV-HDTV-HQVT format-compatible and scalable approaches. Let us define those three different concepts

1. the *two-layer* and, more generally, the *multi-layer compatible* approach is generally referenced to a given hierarchy of HDTV formats, for instance the EUREKA 95 family. As a fundamental working principle, *compatibility* implies that the receivers associated with a lower resolution signal remain able to decode only the fraction of HDTV source corresponding to their level of resolution without any need to decode the complete HDTV signal. This refers to the *downward compatibility*. The reversed aspect of the problem consists of the *upward compatibility* and states that future decoding techniques should also allow restituting formats with lower resolution than that associated with the receiver. To illustrate that concept, let us consider an encoder which generates two levels (TV-HDTV) of standardized resolution, for example the EDI-HDI or the EDP-HDP combination. The compatible TV decoder is able to reconstruct the TV resolution by processing only the base layer (downward compatibility) and the compatible HDTV decoder can display either an HDTV quality or an interpolated TV resolution originating only from the base layer (upward compatibility). In the framework of an ATM network, the lowest level of TV resolution is transmitted on the guaranteed base layer and the complement for an HDTV resolution on the enhanced layer.

2. the *scalability* has been defined in the framework of the MPEG standardization work. This concept has been developed according to a philosophy which is similar to that of the compatibility and tries to be more general in the sense that a receiver of any resolution level should be able to pick up and decode any other resolutions independently of any referenced hierarchy of TV formats.

3. the *multi-layer standalone approach* means a non-compatible and consequently non-scalable algorithm. According to that concept, HQVT, TV and HDTV are each broadcast independently. This scheme is also referred to as a *simulcast* application.

2.11.3.1 Revisiting Signal Splitting

Conceptually, different splitting trees have been considered in the literature of signal analysis. They all consist of multirate filter banks which decompose the frequency domain. The analysis trees can be classified into parallel or hierarchical decomposition.

1. the *parallel decomposition* is implemented in whole generality by means of filters with impulse responses of arbitrary length (L) which decompose the frequency domain

into M equal bands with $L \geq M$. Particular cases are the LOT with $L = 2M$ and the block transforms like the DCT where $L = M$. The modulated filter banks and related wavelets implement parallel decomposition into M bands.

2. the *hierarchical decomposition* organizes the splitting according to a tree structure of parallel decompositions. Schematically, three different families of tree structures can be enumerated. They are namely the dyadic tree also known as pyramid decomposition, the regular tree where $M = 2^k$ and the irregular tree.

 2.1 the *dyadic or per-octave tree* splits iteratively the lower half part of the spectrum into two equal bands at any level of the tree as sketched in Figure 2.36. This coarse-to-fine signal decomposition is referred to as a *multiresolution application* in the literature. Examples of such decomposition are the *Laplacian pyramid* and the *wavelet decomposition* techniques which perform a per-octave splitting of the frequency domain as already mentioned.

 2.2 the *regular or complete binary tree* is depicted in Figure 2.37. It provides a hierarchical analysis where each level of the tree splits the preceding subband into two equal parts. The process ends at the k^{th} level with a decomposition into $M = 2^k$ equal subbands.

 2.3 the *irregular binary tree* implies an irregular termination of its tree branches. Almost all real signals concentrate significant portions of their energy in particular subregions of the spectral domain. An efficient analysis will only decompose these regions of the spectrum where energy is localized. Most of the images concentrate energy in the lower part of the spectrum. This indicates that the lower and intermediate frequencies of the overall spectrum are more significant for decorrelation. Therefore, all the subbands of the regular binary tree may not be needed when the aim is to minimize the computational burden of the filtering. Here, we recognize the spirit of the wavelet packet decomposition. An example of hierarchical subband decomposition, which is suited to generate two-layer or more generally multi-layer decomposition, is shown in Figures 2.38 and 2.39. Eventually, they lead to a three stage decomposition (HDP-EDP-HQVT).

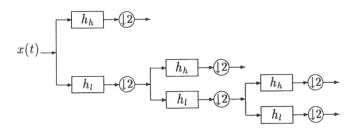

Figure 2.36: Multiresolution decomposition: the dyadic tree.

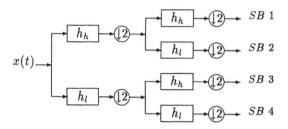

Figure 2.37: Multirate decomposition: the complete binary tree.

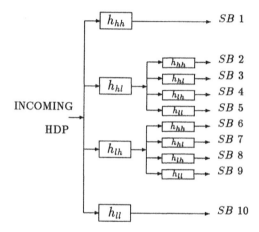

$h_{hh}, h_{hl}, h_{lh}, h_{ll}$: N TAP PRMF FILTERS.

Figure 2.38: Example of irregular subband decomposition.

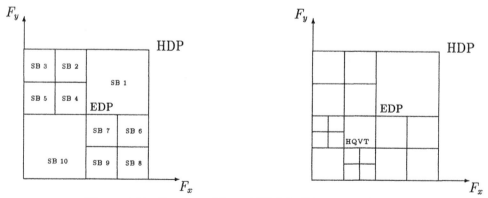

Figure 2.39: Decomposition of HDP in EDP and HQVT.

Chapter 2. TV and HDTV Coding Algorithms

2.11.3.2 TV and HDTV Format Splitting

The tools of signal analysis presented in this chapter are well suited to progressive trans-
missions. The problem is raised to determine how formats below the top definition level are
coded by a hierarchical structure. The following establishes a link between the *analysis-
synthesis methods of the video signal* and the *multiresolution coding-decoding finality*. The
top-format definition of the EUREKA 95 format hierarchy is considered to be that of the
HDP format. Let us consider that the HDP is encoded by means of an operator of size
$N \times N$, the bit stream which is picked up at lower resolution levels is referenced as 2^j with
j=-1 and j=-2 for the EDP and the HQVT format respectively. Both are expected to be
processed using an operator sized at their own lower resolution of concern. This means a
size of $N2^j \times N2^j$ with $j = -1$ and -2 respectively. The decoding operator involves the
following features

1. if coding uses block transforms, the inverse transformation has a reduced size.

2. if coding uses hierarchical subband filters, a synthesis process can work with some
 low-resolution reconstruction steps of the HDP synthesis filter bank.

3. if coding uses parallel subband filters, a synthesis process with a reduced number of
 filters can work at reduced speed.

The *first actual problem* arises when coding lower-level formats. The operator size can
either be matched to the format level or be left similar for all formats. The latter concept
is referred to be the *Format Independent Splitting* (FIS) and the former to be the *Format
Dependent Splitting* (FDS). Restated in other words, FDS considers lower levels as deci-
mated versions of the top format and FIS as a part of the top format. A second question
concerns the way or the mode to display at the decoder side. This problem has to be put
forward in relation to the preceding concepts. Indeed, the decoder may always display
the maximum resolution allowed by the decoder capacity. This mode is referred to as
the *full-screen mode*. On the other hand, the received format can be displayed with its
actual dimensions. In this latter case, called the *window mode*, the sub-formats are seen
as windows taken out of the top level format. Hereupon, reference is made to the work
presented by Vandendorpe in his thesis and issued from the RACE-HIVITS project. The
main results are reported here and the writing of the following paragraphs stays rather
closely to the spirit of the thesis dissertation.

Format Dependent Splitting

In the FDS procedure, the operator size is matched to the format. Any sub-format is
considered as a down-sampled version of the top format signal. Therefore, the operator
size is down-scaled of the same factor. For instance, if the HDP signal is encoded by
means of an operator of transform coding (DCT) or a subband filter bank, both of size
N, then a j-level-below format will be encoded by means of an operator of size $N2^{-j}$.
Supposing that the decoded picture is displayed in the receiver full-screen mode, the
decoder needs an operator of size identical to that of the coder, independently of the
transmitted format. By contrast, the window mode requires that the size of the decoding

operator matches to the transmitted format. Parallel and hierarchical decompositions behave differently from each other when examining both modes. Hence, we derive four combinatoric configurations. Let us evidence their salient characteristics as follows

1. the *full-screen mode and the parallel operator* case is outlined in terms of the operator sizes in Table 2.4. The table applies also for parallel subband coding schemes. The operator size at the decoding side is independent of the transmitted format. The size is therefore constant for a receiver of a given resolution and equal to the size of an analysis operator in the coder associated with the same resolution. For instance, if an EDP transmission is taken into consideration, the encoding operator has a size of $N_h = 8$, the synthesis operators in the HDP decoders will use $N_h = 16$ in both horizontal and vertical directions since they display the information on a four-times-larger screen. The synthesis operator in the HQVT requires four similar reasons a size of $\frac{N}{2}$ to display on a screen which is the fourth part of the EDP screen. One advantage of the FDS approach exploited in conjunction with the full-screen mode is to provide display sizes matching to the decoder resolution.

ENCODER	DECODER		
	HDP	EDP	HQVT
HDP $[16 \times 16]$	$[16 \times 16]$	$[8 \times 8]$	$[4 \times 4]$
EDP $[8 \times 8]$	$[16 \times 16]$	$[8 \times 8]$	$[4 \times 4]$
HQVT $[4 \times 4]$	$[16 \times 16]$	$[8 \times 8]$	$[4 \times 4]$

Table 2.4: FDS parallel coding and full-screen decoding.

2. the *window mode and parallel coding* adapt the display size to that of the transmitted information leading to Table 2.5. If EDP is transmitted, the HDP receiver will display it as EDP and this EDP picture will constitute a window of an HDP display. An HQVT receiver will only be able to display the fourth part of the EDP input format. The decoder operator size has to be matched to the transmitted image format otherwise a less-resoluted receiver will be limited to display a fraction of the transmitted sequence. Strictly speaking, the window display mode does not meet in the FDS approach the compatibility condition as stated earlier.

ENCODER	DECODER		
	HDP	EDP	HQVT
HDP $[16 \times 16]$	$[16 \times 16]$	$[16 \times 16]$	$[16 \times 16]$
EDP $[8 \times 8]$	$[8 \times 8]$	$[8 \times 8]$	$[8 \times 8]$
HQVT $[4 \times 4]$	$[4 \times 4]$	$[4 \times 4]$	$[4 \times 4]$

Table 2.5: FDS parallel coding and window mode display.

3. the *full-screen mode coupled with hierarchical operators* implies that, at the decoding side, the number of stages is matched to the decoder resolution. The number of stage required to implement the hierarchical operator is derived from the logarithm in base 2 of the parallel operator size. Table 2.6 summarizes different encoding-decoding configurations. The synthesis operator size is matched to the decoder

resolution. At the decoding end, the number of stages has to be adapted to the input format. An example of a HDP signal in a hierarchical subband analysis is depicted in Figure 2.40; if the decoder work on a EDP.

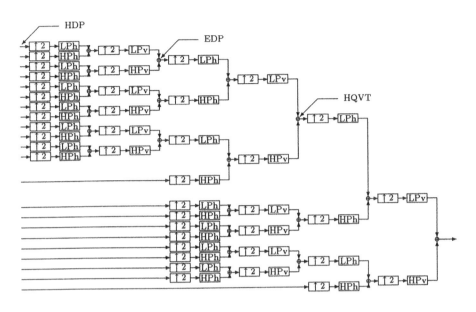

Figure 2.40: Hierarchical subband analysis as function of the input format in a FDS system.

ENCODER	DECODER		
	HDP	EDP	HQVT
HDP [3 × 3]	[3 × 3]	[2 × 2]	[1 × 1]
EDP [2 × 2]	[3 × 3]	[2 × 2]	[1 × 1]
HQVT [1 × 1]	[3 × 2]	[2 × 2]	[1 × 1]

Table 2.6: FDS hierarchical coding and full-screen decoding.

4. in the *window mode and hierarchical analysis configuration*, the number of stages at the decoder end is imposed by the transmitted signal and Table 2.7 is easily established from adapting the corresponding table presented for the parallel operator. Similarly to the parallel approach, the number of decoder stages is a function of the transmitted format meaning that a given decoder has to use different numbers of stages depending on the transmitted format. Arising from the hierarchical structure of the synthesis operator, the conditions of decoding are less critical here than for the parallel case since, in a hierarchical system, only one general synthesis stage can be used in decoder whereas, in a parallel system, operators of different sizes are required in each decoder.

ENCODER	DECODER		
	HDP	EDP	HQVT
HDP $[3 \times 3]$	$[3 \times 3]$	$[3 \times 3]$	$[3 \times 3]$
EDP $[2 \times 2]$	$[2 \times 2]$	$[2 \times 2]$	$[2 \times 2]$
HQVT $[1 \times 1]$	$[1 \times 1]$	$[1 \times 1]$	$[1 \times 1]$

Table 2.7: FDS hierarchical coding and window mode display.

Format Independent Splitting

In the FIS system, the sub-formats can no longer be considered as decimated version but rather as a part of the top format. In this approach, all the coders exploit a similar operator which runs at the speed of the input format. Four new configurations may be considered as follows when combining parallel and hierarchical operators with full-screen and window modes.

1. in the *full-screen mode and parallel decomposition*, the decoder behavior is adapted in terms of the format of the transmitted video signal. Table 2.8 illustrates the present case of study. A HDP signal encoded by means of an 8×8 DCT requires a compatible decoded EDP supplied by a 4 inverse DCT and a compatible HQVT supplied by a 2×2 inverse DCT. A HQVT signal encoded in the FIS approach requires also an 8×8 DCT; the compatible HDP and EDP decoders need respectively 32×32 and 16×16 DCT operators.

ENCODER	DECODER		
	HDP	EDP	HQVT
HDP $[8 \times 8]$	$[8 \times 8]$	$[4 \times 4]$	$[2 \times 2]$
EDP $[8 \times 8]$	$[16 \times 16]$	$[8 \times 8]$	$[4 \times 4]$
HQVT $[8 \times 8]$	$[32 \times 32]$	$[16 \times 16]$	$[8 \times 8]$

Table 2.8: FIS parallel coding and full-screen decoding.

2. in the *window mode and parallel analysis*, all the coders use the same operator size. Since display size is matched to transmitted format, all the coders and decoders require an identical operator size, this leads to a trivial Table 2.9.

ENCODER	DECODER		
	HDP	EDP	HQVT
HDP $[8 \times 8]$	$[8 \times 8]$	$[8 \times 8]$	$[8 \times 8]$
EDP $[8 \times 8]$	$[8 \times 8]$	$[8 \times 8]$	$[8 \times 8]$
HQVT $[8 \times 8]$	$[8 \times 8]$	$[8 \times 8]$	$[8 \times 8]$

Table 2.9: FIS parallel coding and window mode display.

3. in *full-screen mode and hierarchical*, the table which has been put forward for the parallel case can be readily adapted to the present problem as drawn in Table 2.10. In this case, the number of stages in the decoder depends on both the input format

and the decoder resolution. Any decoder which has the complete number of required stage is able to operate the other cases. For example, an 3-stage HQVT decoder as drawn in Figure 2.41 may decode any of the input formats. The signal is fed into the decoder at different locations depending on the input formats. In case HDP is transmitted, the compatible HQVT decoder needs only the lowest order subbands; those are fed into the HQVT decoder at point denoted HDP. In case EDP is transmitted, it has to be fed in point denoted EDP. In Figure 5.4, LP and HP stand for low-pass and high-pass filters respectively, v and h for the vertical and horizontal processing.

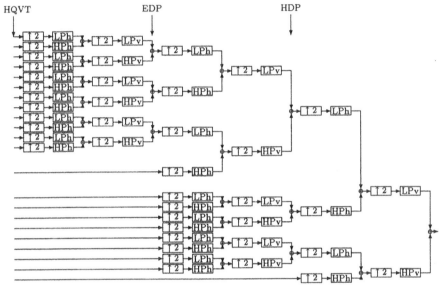

Figure 2.41: Synthesis of a HQVT decoder in FIS and full-screen mode.

ENCODER	DECODER		
	HDP	EDP	HQVT
HDP [3 × 3]	[3 × 3]	[2 × 2]	[1 × 1]
EDP [3 × 3]	[4 × 4]	[3 × 3]	[2 × 2]
HQVT [3 × 3]	[5 × 5]	[4 × 4]	[3 × 3]

Table 2.10: FIS hierarchical coding and full-screen decoding.

4. in the *window mode and hierarchical analysis*, all the formats are encoded and decoded by means of the same number of stages. Obviously, the decoder runs at the speed corresponding to that decoder size. This coding-decoding configuration is considered in Table 2.11.

2.11. TV Encoding Architectures 211

ENCODER	DECODER		
	HDP	EDP	HQVT
HDP [3 × 3]	[3 × 3]	[3 × 3]	[3 × 3]
EDP [3 × 3]	[3 × 3]	[3 × 3]	[3 × 3]
HQVT [3 × 3]	[3 × 3]	[3 × 3]	[3 × 3]

Table 2.11: FIS hierarchical coding and window mode display.

Conclusions on Format Splitting

The full-screen mode is the only mode providing actual compatibility. Let us consider the FDS approach and suppose that a DCT operator is used at the HDP resolution level. The DCT operating size at the EDP level is 8. The weighting included in the quantization process involves here to state an important remark. In fact, the low resoluted compatible channel constructed by simply sending the lowest order of the HDP coefficients in the EDP channel conducts to a compatible channel with higher bit rate than the minimum required by the compatible decoder. Indeed, a transform coefficient of order in a block of size 8 is representative of the spectral content localized around $\frac{i\pi}{8}$. Moreover, we know that the DCT operator provides efficient frequency localizations. Obviously $\frac{i\pi}{8} \geq \frac{i\pi}{16}$s and the i^{th} transform coefficient in a block of size 8 will have a smaller sensitivity factor than the coefficient i in a block of size 16. This is true since the weighting curve is low-pass-shaped. This implies that *the HDP signal requires more accuracy in the low order coefficient range than EDP does* since the transform coefficients used for the compatible sequence production in the HDP information are less weighted than the corresponding coefficients of a real EDP signal. This important remark explains why *the transmission of a HDP signal in two compatible and separate channels EDP-HDP requires to split the incoming signal in frequency as well as in precision or quantization accuracy.* Figure 2.35 exploits the double splitting as a direct application of this important conclusion. Similar reasonings apply for FIS configurations.

2.11.4 The Coding Architectures

At this advanced stage of the chapter, different coding architectures have to presented and discussed in the framework of transmitting standalone or compatible applications. Starting with pure-intra coding schemes which deploy analysis and decorrelative action only in the spatial domain without performing any temporal signal correlation, the study proceeds to hybrid schemes which combine temporal predictive coding with spatial linear decorrelation operations i.e. DCT, subband or wavelet decompositions. The decorrelative prediction takes advantage of the temporal redundancy which exists between successive pixels. Further improvements lead to introducing motion-compensated predictive tools refined with motion searches and estimations computed at half and sometimes quarter-pixel accuracy. Such hybrid coding schemes have opened the path towards the present standardization activities. In derivation to that work, additional coding modes have been developed, namely interpolative modes to interpolate one or more images in between two consecutive intra modes and predictive modes to predict one or more image ahead from the current image. Finally, bidirectional motion compensation processes generating for-

ward and backward motion vectors have also been taken into account. Some pioneering works have recently introduced three-dimensional spatio-temporal analysis combined to appropriate motion compensations in low-frequency spatio-temporal subbands. Motion-compensated temporal filtering has already been considered for the time-varying TV images. Three-dimensional subband coding results in a multiresolution decomposition in both temporal and spatial domains. It transforms an original sequence into subsampled sequences to accomplish generalized decompositions and straightforward format conversions.

2.11.4.1 Pure Intra Coding Schemes

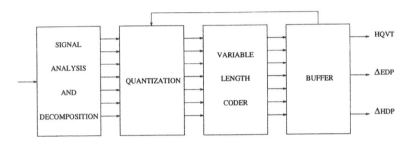

Figure 2.42: Compatible intra coder.

The concept of coding in the *hierarchical pure-intra mode* has emerged when attention has been focused on progressive image transmissions. In *progressive image communications*, a low quality image is first transmitted with as few data stream as possible over a low-bandwidth channel. This carries the most important information to recover a rough image. Upon request of the receiver, a low-resoluted image is first reconstructed and can progressively be improved with further transmissions. A variety of approaches has been proposed since 1980. Let us remind the Laplacian decomposition developed in Section 2.6.9 as a foundation of the multiresolution. The image is here organized in a pyramidal structure in which the levels correspond to successive approximations to the original image. By transmitting the pyramidal data structure from top to bottom, the approximations can be reconstructed with successive refinement. Burt and Adelson defined a Laplacian-like pyramid as a set of quasi-bandpass filtered versions of the image. The lower pyramid levels correspond to high-pass filtered versions of the image and the higher levels to low-pass filtered versions. A low-pass filtered signal out of the image is first substracted from the original image, giving a decorrelated difference image as the bottom level of the Laplacian pyramid structure. The same process is then applied to the low-pass filtered version of the image. Repeating iteratively the procedure yields a sequence of difference images which can be considered as a set of band-pass filtered versions of the image or as a set of successive approximations in a progressive transmission.

A pure intra block transform coding may also perform progressive transmission by transmitting planes of transform and quantized coefficients of the same order. The progressive intra coder starts with the lower transform order and proceeds plane-by-plane in the sequence of increasing orders. Whatever the analysis tool could be, the intra coding algorithm principles are similar as depicted in Figure 2.42. In principle,

that coding scheme is compatible in conformance with the definition stated earlier. The scheme involves an analysis operation, a set of scalar quantizers, variable-length coders and buffers to accumulate the temporary bit stream in excess to the allowed transmission rate.

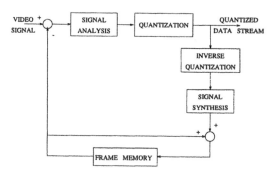

Figure 2.43: Hybrid coder in model 1.

2.11.4.2 Hybrid Coding Schemes

Intra coding mode takes only in account the spatial picture correlation. In order to improve the global coding efficiency, simple means require to decorrelate the temporal redundancy which exists between successive pictures. The temporal picture decorrelation may be readily obtained by quantizing the difference between the current picture and a prediction simply built by means of the previous decoded picture. This predictive procedure achieves maximum efficiency when non-moving images are to be encoded and is unsuited to decorrelate most of the moving parts of the sequences. Nevertheless, it is worth considering since it offers an easy substratum to understand some differences leading to compatible and non-compatible systems. Let us then examine two different hybrid coding systems referred to as *model 1* and *model 2*. In model 1, the prediction is provided by the previous decoded picture. The difference between the incoming original picture and the prediction is thereafter decorrelated spatially with a linear analysis operator and quantized in the coding loop as sketched in Figure 2.43. In model 2, the difference is computed in the transform domain rather than in the original pixel domain as drawn in Figure 2.44. In fact, model 2 turns out to be a compatible system whereas model 1 is not. Indeed, in reference to the definition of compatibility, the coder is not allowed to use information which is not available at a low-resoluted decoder end. This is precisely the fact which occurs in model 1 if considering the example of a HDP-EDP system, the predicted HDP is split into an EDP and a complementary signal by the analysis tool located within the encoding loop. A HDP decoder is always able to sum both signals and reconstruct the decoded picture but the compatible EDP decoder can not access the entire information having been used by the analysis operator. A *drift effect* will progressively appear and blur the reconstructed sequence. *To avoid any mismatch between encoder and lower-resoluted compatible decoder, it is compulsory that the prediction built for any lower level exploits the information strictly available to the decoders working at that level.* Hence, if the difference is computed in the transform domain after frequency decomposition, the problem of compatibility is solved.

For instance, in a subband or a wavelet decomposition, the signal to be transmitted is made of the different transform coefficients. If the prediction is performed within the subbands independently of each other, the sequences of prediction subband coefficients available at any lower-resoluted decoder lead to the correct reconstruction of the coded coefficient by means of the appropriate local frame memory within the subband.

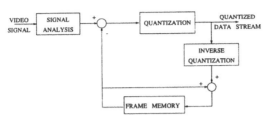

Figure 2.44: Hybrid coder in model 2.

Let us now consider the *progressive transmission* of one single image through a system composed of an orthogonal decomposition with hybrid-loop, quantization, and noise-free transmission. The residual coding errors arising from quantization are iteratively fed back, requantized and transmitted. At the receiver end, the successive approximations of the original signal are reconstructed progressively forming $\sum_{m=0}^{k} \hat{Q}_m$ which sums in a frame memory the received information up to stage k and then performing the inverse transform to recover the reconstructed version. Let us assume that the image is stationary, meaning that it remains fixed during the period of observation. If an optimum bit allocation is performed, it can be demonstrated that the average reconstruction error variance converges to zero as the number of stages in the progressive transmission and iterative reconstruction approaches infinity. Let us declare that the reconstruction is stable in this case. Clearly, stability implies that

$$\lim_{k \to \infty} \min[\sigma_{r,k+1}^2] = 0 \tag{2.475}$$

the average reconstruction error variance up to stage k progressively approaches zero. Following the notation used in Section 2.7 devoted to quantization, the variance of the average quantization error at iteration k=0 can be formulated as follows

$$\min(\sigma_{q,1}^2) = \frac{1}{N \times N} \sum_{i,j=0}^{N-1} \sigma_{q,1,i,j}^2 \tag{2.476}$$

$$= \epsilon_0^2 \, 2^{-2B_0} \left(\prod_{i,j=0}^{N-1} \sigma_{0,i,j}^2 \right)^{\frac{1}{N \times N}} \tag{2.477}$$

$$= \epsilon_0^2 2^{-2B_0} \frac{\left(\prod_{i,j=0}^{N-1} \sigma_{0,i,j}^2 \right)^{\frac{1}{N \times N}}}{\frac{1}{N \times N} \sum_{i,j=0}^{N-1} \sigma_{0,i,j}^2} \sigma_x^2 \tag{2.478}$$

where

1. $\sigma_{i,j}^2 = E[Q_{i,j}^2]$ is the variance of the $(i,j)^{th}$ transform coefficient.

2. $\sigma_{q,k+1,i,j}^2 = E[(X_{k,i,j} - X_{k,i,j})^2]$ holds for the quantization error variance of the $(i,j)^{th}$ coefficient in the transform domain at stage k.

3. $\sigma_x^2 = \frac{1}{N \times N} \sum_{i,j=0}^{N-1} \sigma_{i,j}^{N-1} = \frac{1}{N \times N} \sum_{i,j=0}^{N-1} \sigma_{0,i,j}^2$ represents the average image energy.

Proceeding to the k^{th} reconstruction iteration, the average quantization error can be restated as

$$\min(\sigma_{q,k+1}^2) = \frac{1}{N \times N} \sum_{i,j=0}^{N-1} \sigma_{q,k+1,i,j}^2 \tag{2.479}$$

$$= \epsilon_k^2 \, 2^{-2B_k} \left(\prod_{i,j=0}^{N-1} \sigma_{q,k,i,j}^2 \right) \tag{2.480}$$

$$= \epsilon_k^2 \, 2^{-2B_k} \frac{\left(\prod_{i,j=0}^{N-1} \sigma_{q,k,i,j}^2 \right)^{\frac{1}{N \times N}}}{\min(\sigma_{q,k}^2)} \, \min(\sigma_{q,k}^2) \tag{2.481}$$

$$= \left(\prod_{m=0}^{k} \epsilon_m^2 \, 2^{-2B_m} \frac{\left(\prod_{i,j=0}^{N-1} \sigma_{q,m,i,j}^2 \right)^{\frac{1}{N \times N}}}{\frac{1}{N \times N} \sum_{i,j=0}^{N-1} \sigma_{q,k}^2} \right) \sigma_x^2 \tag{2.482}$$

A coding factor c_m for the m^{th} stage may be defined as the ratio of the average energy of the $(m+1)^{th}$ error array to that of the m^{th} error array. As a matter of fact, the coding factor will approach zero when the iterations progress. Then,

$$c_m = \frac{\sigma_{q,m+1}^2}{\sigma_{q,m}^2} \tag{2.483}$$

$$= \epsilon_m^2 \, 2^{-2B_m} \frac{\left(\prod_{i,j=0}^{N-1} \sigma_{q,m+1,i,j}^2 \right)^{\frac{1}{N \times N}}}{\sigma_{q,m}^2} \tag{2.484}$$

with $m = 0, 1, \ldots, k$, and,

$$\epsilon_m^2 \, 2^{-2B_m} = \left[\prod_{i,j=0}^{N-1} (\epsilon_{m,i,j}^2 \, 2^{-2B_{m,i,j}}) \right]^{\frac{1}{N \times N}} \tag{2.485}$$

The ratio in Equation 2.484 leads to the following inequality

$$\frac{\left(\prod_{i,j=0}^{N-1} \sigma_{q,m+1,i,j}^2 \right)^{\frac{1}{N \times N}}}{\sigma_{q,m}^2} \leq 1 \tag{2.486}$$

wherein equality is met if and only if all the quantization error variances at stage m are equal. If the quantizers at stage $m = 0, 1, \ldots, k$ are correctly designed in such manner that

$$\epsilon^2_{m,i,j}\, 2^{-2B_{m,i,j}} \;<\; c \;<\; 1 \qquad i,j = 0,1,\ldots,N-1 \tag{2.487}$$

the coding factor satisfies the inequalities $c_m < c < 1$ for $m = 0,1,\ldots,k$. From Equations 2.482 and 2.487, the convergence of the average reconstruction error variance can be evidenced when the number of approximation stages k tends to infinity

$$
\begin{aligned}
\lim_{k\to\infty} \min(\sigma^2_{r,k+1}) \;&=\; \lim_{k\to\infty} \min(\sigma^2_{q,k+1}) \tag{2.488}\\[2mm]
&=\; \lim_{k\to\infty} \left[\prod_{m=0}^{k} \frac{\min(\sigma^2_{q,k+1})}{\min(\sigma^2_{q,m})} \right] \sigma^2_x \tag{2.489}\\[2mm]
&=\; \lim_{k\to\infty} \left(\prod_{m=0}^{k} c_m \right) \sigma^2_x \tag{2.490}\\[2mm]
&<\; \sigma^2_x \lim_{k\to\infty} \left(\prod_{m=0}^{k} c \right) \;=\; \sigma^2_x \lim_{k\to\infty} c^{k+1} \;=\; 0
\end{aligned}
$$

This *convergence ascertains that lossless transmission* can be achieved in a hybrid scheme. Theoretically, this demonstration suffers from some simplifications which are worth being pointed out. However, it can be demonstrated that practical quantizers still preserve the convergence property. In fact, for each stage except k=0, the procedure of optimizing the bit allocation turns out not to be meaningful since the variance of the errors should be identical. This is evidently not verified and it is necessary that a practical system optimize the bit allocation at each stage in order to encode the coefficient errors with optimum efficiency.

2.11.4.3 Motion-Compensated Hybrid Coding Schemes

In both interframe and interfield predictive coding modes, the temporal redundancy can be removed more efficiently if the displacements of moving objects, pannings and zoomings can be taken into consideration. Two distinct approaches for motion compensated prediction have been investigated in the literature, namely the pixel recursive and the block-matching motion estimation. The *pixel-recursive motion estimation* algorithms estimate the motion parameters recursively to minimize the motion-compensated error signal on each pixel. This technique of estimation has easily been extended to incorporate the rotational and translational motions which are key features in any real or artificial scene. The *block-matching motion estimation methods* have been considered for most of the coding schemes developed so far for standardization issues and for block-coding transform applications. The fundamental idea of this technique consists in partitioning the coding frame into non-overlapping blocks in which all the pixels are constrained to have the same motion or displacement vector. The algorithm proceeds with encoding the difference between the blocks of an incoming image and their respective best prediction found by searching exhaustively through a given area called the *search window* and located in the previous decoded picture. As the decoder has also to know which block is the best prediction for each block to be decoded, the motion vectors need to be transmitted as complementary information. This encoding procedure is referred to as the *block-matching*

motion estimation (prediction phase) and compensation (coding phase). The search to pick up the best predictor in the previous frame is supported by a matching criterion which minimizes a cost objective in form of mean distortion function. Jain and Jain have proposed the following criterion

$$S(k,l) = \frac{1}{n\,m} \sum_{i=1}^{n} \sum_{j=1}^{m} g[P_f(i,j) - P_{f-1}(i+k,j+l)] \qquad (2.491)$$

where $P_f(i,j)$ is the intensity of the pixel located at coordinates (i,j) in frame f, n and m are the size of the motion blocks. For any given non-negative distortion function $g(x)$, the best match corresponds to a block animated by a spatial displacement vector with horizontal and vertical components $(d_h = k_{opt}, d_v = l_{opt})$ which minimize the criterion S within the search window (k_M, l_M). Currently, though the most efficient criterion is actually and experimentally the resulting energy i.e. the mean square difference $g(x) = x^2$, the implemented hardware criterion in video applications has often been the mean absolute difference $g(x) = |x|$ on account of its easy feasibility.

To give some practical insight on what is commonly implemented in the standardized algorithms, let us take the MPEG coder as reference. The search algorithm works on luminance with block windows of 16×16 pixels and implements a two-step search in which a first exhaustive search is applied on the previous picture at pixel accuracy within the search area and a second search at half-pixel accuracy is carried out around the optimum using a local half-pixel-interpolated picture support. In this coder, motions are moreover estimated and compensated in both temporal directions i.e. forwards and backwards. Motion prediction vectors are also estimated on fields and frames, obtained by merging both image fields, to provide the encoder with the choice to make the decision of the most *efficient predictive mode*. Arising from the larger amount of information and details contained in the luminance component as compared to the chrominances, the motion vectors are usually estimated in luminance and exploited to compensate luminance and both chrominances. These considerations have led to defining three types of pictures according the coding modes: the I-pictures for *pure intra coded pictures*, the P-pictures for *forward motion-compensated prediction pictures* and the B-pictures for *forward and backward motion-compensated interpolation pictures*. In the MPEG coder, each N^{th} frame within a transmission starting with a first frame coded in intra mode is further encoded as pure-intra frame (for instance, N=12). Predicted frames are encoded relatively to either a previous predicted or a previous pure-intra frame, they follow each other every M^{th} frame (for instance, M=3). Interpolated frames are coded with reference to both closest previous and next predicted or pure-intra frames. Figure 2.45 summarizes all the MPEG coding modes.

Considering again compatible transmission systems, the study carried out in the previous paragraph still applies when motion compensation is introduced in the predictor. No mismatch between encoder and decoder can be tolerated on penalty of creating a drift effect which blurs and progressively degrades the quality of the reconstructed images on decoder display. Two coding schemes are analyzed in the following which guarantee compatibility within a hierarchy of resolutions and where the prediction process is consequently performed by means of the only information actually available at each level of

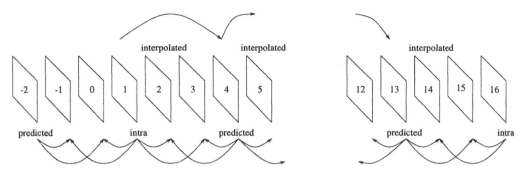

Figure 2.45: Inter-relation of the MPEG coding modes.

resolution on the decoder ends. The first scheme refers to an *in-band prediction model* and the second to a *per-format prediction model*.

The in-band prediction model is a straightforward extension of the hybrid version where each subband is predicted only from exploiting the information contained in the corresponding subband of the preceding decoded images.

In-band Prediction Technique

The in-band prediction technique matches to the concept of scalability. To perform prediction, each individual subband exploits the information available in its own subband in the previous decoded picture. This scheme is similar for each band to what has been done in the hybrid loop without motion compensation meaning that a band of a new picture is predicted by the same band in the previous picture. The introduction of motion compensation raises a new problem related to the sampling density at the subband level and arising from the decimation carried out in the analysis stage. The sampling density is smaller in the subbands and the motion estimation has to be performed with as much accuracy as possible. To yield accuracy, the estimation is carried out in the incoming original domain as in 2.35 for a per-format scheme or, even more, at half-pixel accuracy in the original domain. Hence, the resolution of the motion vector is at least that of the interval between neighboring pixel or the half. Interpolating the subbands becomes necessary to carry out motion compensation.

Each subband can only interpolate the sequence $x_i(nN)$ of sample available at the entry of its own synthesis filter on the decoder side regardless of the other subbands. Ignoring the subband quantization, if perfect reconstruction is fulfilled, $x_{in}(n) = x_{out}(n)$ for the whole signal, that is

$$X_{in}(e^{j\omega}) = X_{out}(e^{j\omega}) \tag{2.492}$$

Hence,

$$
\begin{aligned}
X_i(e^{j\omega}) &= H_i(e^{j\omega}) \, X_{in}(e^{j\omega}) & \tag{2.493} \\
&= H_i(e^{j\omega}) \, X_{out}(e^{j\omega}) & \tag{2.494}
\end{aligned}
$$

$$= H_i(e^{j\omega}) \sum_{j=0}^{N-1} G_j(e^{j\omega} Y_j(e^{j\omega}) \tag{2.495}$$

where $y_i(n)$ is the subband signal j after sampling expansion at the entrance of the synthesis filter g_i. The reconstruction of each subband requires the knowledge of all the other ones to be perfect. The subband samples before decimating are derived from interpolating all the subbands by means of filters with transmittance $H_i(e^{j\omega} G_i(e^{j\omega})$ to embody all the subband contributions.

In an in-band predictive scheme, where the subbands are encoded individually and independently of each other, interpolation is not perfect and the aliasing generated by the analysis stage will not be removed since only one term of the summation 2.495 is considered. Having subband i interpolated as

$$\hat{X}_{in}(e^{j\omega}) = H_i(e^{j\omega})G_i(e^{j\omega}) Y_i(e^{j\omega}) \tag{2.496}$$

where the hatted variable stands for the estimate. The interpolation error is readily derived as

$$X_i(e^{j\omega}) - \hat{X}_{in}(e^{j\omega}) = \sum_{\substack{j=0 \\ j \neq i}}^{N-1} - H_j(e^{j\omega}) G_j(e^{j\omega}) Y_j(e^{j\omega}) \tag{2.497}$$

Ideal filters avoiding aliasing should be of the form

$$H_i = \frac{G_i}{N} = \begin{cases} 1 & \omega \in [i\pi/N , (i+1)\pi/N] \\ 0 & \text{elsewhere} \end{cases} \tag{2.498}$$

If these filter were employed in the analysis and synthesis stages, similar filters could be used in the interpolation problem. Nevertheless, aliasing will never be perfectly cancelled in practical cases.

Per-format Prediction Technique

The per-format prediction technique matches to the concept of compatibility. The information is cumulated up to the levels defined in the format hierarchy. Let us again consider the EDP and HDP formats. All the subbands available at the EDP decoder side are exploited to perform a global prediction at the EDP level in the encoder. Since all the available subbands are employed and cumulated in the per-format approach, the EDP subbands are deduced as

$$X_i^{EDP} = H_i(\omega) \sum_{i=0}^{N_{EDP}} G_i(\omega)Y_i(\omega) \tag{2.499}$$

where N_{EDP} is the number of bands available at EDP level. The subbands required only for the HDP decoder can use all subbands for their prediction. For such band indexed k, we get

$$X_k^{HDP} = H_k(\omega) \sum_{i=0}^{N_{HDP}} G_i(\omega)Y_i(\omega) \tag{2.500}$$

This shows that the prediction of each subband requires the maximum information to yield simultaneously the best aliasing cancellation and the best subband estimation.

2.11.4.4 Three-Dimensional Coding Schemes

Three-dimensional subband coding involves a generalized multiresolution approach which decomposes the signal in both spatial and temporal domains. This offers simple solutions to format conversion between HDP, EDP and respectively HDI and EDI. As a result of the temporal decomposition, the incoming sequence is converted into several subsampled sequences containing information at different temporal frequencies. The extension of two-dimensional coding to include the temporal direction is a natural progression. Some of the first works performed in three-dimensional subband coding are reported in [51] and in [54]. To reduce temporal correlations in the low spatio-temporal bands, the authors in [51] and [71] have proposed to use temporal DPCM, employing three-dimensional linear predictors. The implementation in [71] differs in that it was adaptive. The linear predictor switched between a three-dimensional spatio-temporal model and a two-dimensional spatial model depending on the temporal correlation. Motion estimation has also been used in [54] and [67] to perform motion-compensated filtering. This differs from motion-compensated prediction where a prediction is made and the corresponding residual error is thereafter encoded. Instead, the motion estimate is used to filter the pixel values along their motion trajectory. Theoretically, a greater degree of energy compaction would be obtained since the pixel values are expected to slightly vary along their own trajectory of motion. According to Woods in [85], three-dimensional subband coding achieves high quality results at modest bit rate. When comparing subjective quality image at equal bit rate, the three-dimensional coder gives by far more pleasant results than a two-dimensional coding scheme. The application of the subband decomposition along the temporal axis is advantageous over predictive schemes since the structure can be non-recursive, which avoids infinite propagation of transmission errors.

Three-dimensional multiresolution decompositions usually start with a *temporal subband decomposition*. As a result of that decomposition, the original sequence is transformed into several subsampled sequences, each of which contains information on its own specific band representing in some sense the *velocity of the temporal change*. If the amount of motion is low, the amount of energy in the higher frequency component will be low and the energy compaction will be good even without motion adaptation. This feature is no longer fulfilled in case of complex scenes with a high and various amount of motion. In this case, Ohm showed in [67] that a three-dimensional subband coding without motion compensation performs worse than motion-compensated versions. The reason beyond that observation is understood when regarding three-dimensional spectra. Indeed, the temporal frequency axis may contain aliasing components if the amount of motion shift between adjacent frames is more than one pixel. The motion compensation operation performs a shift of the three-dimensional spectra towards lower temporal frequency as demonstrated in [41] and reduces temporal aliasing effects. Hence, to encode and yield high energy compaction, an adequate combination of motion compensation and subband coding is desirable. Figure 2.46 depicts the solution proposed by Ohm in [67].

As mentioned here above, motion-compensated filtering refers to temporal filtering of a time-varying image along estimated motion trajectories and turns out to be an adequate solution to supply the temporal filtering component of a three-dimensional video sequence filtering. The underlying assumption is that the signal is slowly varying along

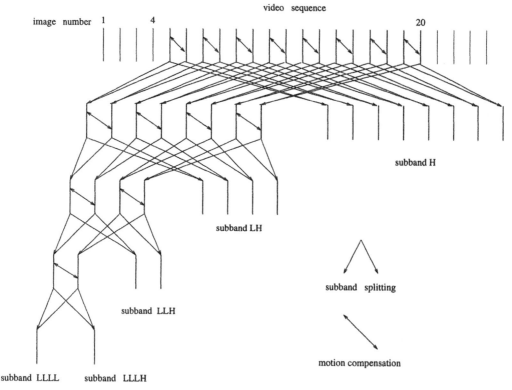

Figure 2.46: Example of three-dimensional motion-compensated analysis.

the trajectories so that prediction or decorrelation can be particularly efficient. The motion-compensated filtering may be written as $y(\underline{x}, t) = f[s(\underline{x}, t)]$ where $s(\underline{x}, t)$ is the one-dimensional signal made of the input image along the motion trajectory intercepting the point (\underline{x}, t), F the filtering operator and $\underline{x} = (x_1, x_2)$ the spatial position. The resulting motion-compensated filter is neither linear nor invariant, unless F is linear and all the motion trajectories are parallel. In the latter specific case, the filter is linear with impulse response of the form $h(\underline{x}, t) = h_1(t)\delta(\underline{x} - \underline{v}t)$ where $h_1(t)$ represents the impulse response along the motion trajectory. We derive thereafter

$$y(\underline{x}, t) \;=\; \int\!\!\int\!\!\int h_1(\tau)\delta(\underline{s} - \underline{v}\tau)u(\underline{x} - \underline{s}, t - \tau)\; d\underline{s}d\tau \tag{2.501}$$

$$=\; \int h_1(\tau)s(t - \tau, \underline{x}, t)d\tau \tag{2.502}$$

Then the three-dimensional filter response is given by

$$H(\underline{f}_{\underline{x}}, f_t) \;=\; \int\!\!\int\!\!\int h_1(t)\; \delta(\underline{x} - \underline{v}t)e^{-j2\pi(f_{\underline{x}}\underline{x} + f_t t)}d\underline{x}dt \tag{2.503}$$

$$=\; H_1\left(\underline{f}_{\underline{x}}^T\underline{v} + f_t\right) \tag{2.504}$$

Consequently, the filter response is constant on planes $\underline{f}_x^T \underline{v} + f_t = c$. H_1 is a low-pass filter which attenuates all the components off the plane $\underline{f}_x^T \underline{v} + f_t = 0$.

Let us remark here that, *invoking group theory*, the derivation of three-dimensional spatio-temporal wavelets is almost automatically perceived with a possibility to extend to n-dimensional spaces. As usual, the spatio-temporal wavelet transform expands the signal as a sum of spatio-temporal basis functions obtained from three-dimensional filtering. The wavelets under consideration here takes the form [27] of $\psi(a, \underline{b}, \theta)$ where a is the scale, \underline{b} the vector of spatial positions, and θ the directions of motions.

2.11.5 CBR - VBR Options

The problem addressed here concerns which option between a CBR or a VBR coding scheme to adopt in each layer. As a matter of fact, guaranteeing a base layer implies that a fixed priority bandwidth has been allocated into the network. As a consequence, the maximum utilization of this bandwidth at 100 % of its capacity is the optimum solution. It rather implies a CBR coding scheme into the base layer or a VBR policed or forced to occupy its full bandwidth. In this latter case, the quality is no more kept constant in the base layer.

2.12 Conclusions

In this chapter, different aspects of image coding for ATM transmissions have been presented and discussed. These were namely the image formats as defined by the standardization bodies, the spectra, the analysis and decorrelation process, the quantization procedure and the variable-length entropy coding. Multirate and multiresolution architectures have been presented in relation with compatible and scalable applications. A layered coding architecture similar to that of the OSI-layers has also been deduced as a direct outgrowth of the definitions.

Important achievements have been obtained in the field of coding for ATM transmissions and of modeling the whole transmission chain.

1. for the coding purpose, the goal to generate a constant subjective quality has been successfully reached and the hardware implementation of the adaptive quantization algorithm testifies of the correct foundations of the methodology. Arising from the variable and non-stationary nature of TV information, the source of entropy at constant quality turns out to be stochastic variable rate generators. Such a data stream will be referred to in this textbook as a *free VBR sources*.

2. for what concerns the modeling issue of this work, a first stepping-stone has been laid with the derivation of a rate-distortion function well befitting to reality at least in first approximation.

These achievements initiate the search performed in the coming chapters which will answer these fundamental questions

1. how to characterize statistically free VBR sources?

2. what should be a realistic source model?

3. how to control a non-stationary VBR source to generate a CBR stream at the expense of lowering gracefully the image quality?

4. how to obtain the optimum image quality when the transmission channel does not admit free variable rate sources?

As described in this chapter in connection with the opportunity offered by the ATM management to transmit with two levels of priority, most of TV or HDTV coding schemes can be transformed into a two-layer algorithm. The concept of multiresolution brings a straightforward generalization of the communications to yield scalable multilayer transmissions. So far, the analysis of the parameters influencing subjective image quality still constitutes a topic for further long term research.

2.13 Bibliography

The Digital TV and HDTV Coding Schemes

[2.1] J. Biemond, F. Bosveld and R. Lagendijk "Hierarchical subband coding of HDTV in ISDN", *ICASSP-90, Albuquerque, NM, pp. 2113-2116, 4-7 April 1990.*

[2.2] P. Dalleur "Analyse théorique et réalisation d'un système de réduction du débit binaire en vue d'une transmission numérique du signal de télévision en couleur", *Ph.D. Thesis, UCL, 1984.*

[2.3] A. K. Jain "Fundamentals of Digital Image Processing", *Prentice Hall, 1989.*

[2.4] D. J. Le Gall, H. Gaggioni, C. T. Chen "Transmission of HDTV signals under 140 Mbit/s using a subband decomposition and discrete cosine transform coding", *Signal Processing of HDTV, Elsevier Science Publishers, 1988.*

[2.5] H. G. Musmann, P. Pirsh and H.-J. Grallert "Advances in Picture Coding", *Proceedings of IEEE, Vol. 73, No. 4, pp. 523-548, April 1985.*

[2.6] A. N. Netravali and B. G. Haskell "Digital Pictures, Representation and Compression", *Plenum Press, 1988.*

[2.7] R. C. Reininger, J. D. Gibson "Distribution of the Two-Dimensional DCT Coefficients for Images", *IEEE Transactions on Communications, Vol. Com. 31, No. 6, pp. 835-839, June 1883.*

[2.8] L. Vandendorpe "Hierarchical Coding of Digital Moving Picture", *Ph.D. Thesis, UCL, October 1991.*

The Quantization

[2.9] T. Berger "Optimum Quantizers and Permutation Codes", *IEEE Transactions on Information Theory, Vol. IT 18, No. 6, pp. 759-764, November 1972.*

[2.10] T. Berger "Rate Distortion Theory", *Prentice Hall, 1971.*

[2.11] T. Berger "Minimum Entropy Quantizer and Permutation Codes", *IEEE Transactions on Information Theory, Vol. IT 28, No. 2, pp. 149-157, March 1982.*

[2.12] A. Gersho and R. M. Gray "Vector Quantization and Signal Compression", *Norwell, MA, Kluwer Academic, 1992.*

[2.13] N. S. Jayant and P. Noll "Digital Coding of Waveforms: Principles and Applications to Speech and Video", *Prentice-hall Inc., Englewood Cliffs, 1984.*

[2.14] A. J. Kurtenbach, P. A. Wintz, "Quantization for Noisy Channels", *IEEE Transactions on Communications, Vol. COM-17, No. 2, pp. 291-302, April 1969.*

[2.15] J. Max "Quantizing for Minimum Distortion", *IRE Transactions on Information Theory, pp. 7-12, March 1960.*

The Variable-Length Coders

[2.16] R. Arps, G. Langdon, J. Mitchell, W. Pannebaker and R. Pasco "Q-Coder Adaptive Binary Arithmetic Coder", *IBM Journal of Research and Development, Vol. 32, pp. 719-795, IBM, November 1988.*

[2.17] R. G. Gallager "Information Theory and Reliable Communications", *John Wiley & Sons inc. 1968.*

[2.18] A. N. Kolmogorov "Three Approaches to the Quantitative Definition of Information", *Probability and Information Transmission, Vol. 1, No. 1, (English Translation), pp. 1-7, 1965.*

[2.19] G. G. Langdon "An Introduction to Arithmetic Coding", *IBM Journal of Research and Development, Vol. 28, No. 2, pp. 135-149, March 1984.*

[2.20] J. C. Lawrence "A New Universal Coding Scheme for the Binary Memoryless Sources", *IEEE Transactions on Information Theory, Vol. IT-23, No. 4, pp. 466-472, July 1977.*

[2.21] B. Macq "Perceptual Transforms and Universal Entropy Coding for an Integrated Approach to Picture Coding",*Ph.D. Thesis, UCL, pp. 101-110, September 1989.*

[2.22] J. P. M. Schalkwijk "An Algorithm for Source Coding", *IEEE Transactions on Information Theory, Vol. IT-18, No. 3, pp. 395-399, May 1972.*

[2.23] H. Tanaka - A Leon-Garcia "Efficient Run-Length Encodings", *IEEE Transactions on Information Theory, Vol. IT-28, No. 6, pp. 880-889, November 1982.*

[2.24] P. Tourtier, C. Perron "Arithmetically Computed Variable-Length Codes", *Proceedings of the Picture Coding Symposium, CSELT, Torino Italy, pp. 5.6.1-5.6.2, 12-14 September 1988.*

Multi-Rate and Multi-Resolution Signal Decomposition

[2.25] A. N. Akansu, R. A. Haddad "Multiresolution Signal Decomposition", *Academic Press, Inc., 1992.*

[2.26] R. Ansari, Didier Le Gall "Advanced Television Coding Using Exact Reconstruction Filter Banks", *in Subband Image Coding, Chapter 6, edited by J. W. Woods, Kluwer Academic Publishers, 1991.*

[2.27] J. P. Antoine, R. Murenzi "Directional Wavelets in Higher Dimensions", *Technical Report P3-94, Center for Theoretical Studies of Physical Systems, Clark Atlanta University, 1994.*

[2.28] M. Antonini, M. Barlaud, P. Mathieu, I. Daubechies "Image Coding Using Wavelet Transform", *IEEE Transactions on Image Processing, pp. 205-220, Vol. 40, No. 2, September 1992.*

[2.29] F. Bosveld, R. L. Lagendijk and J. Biemond "Hierarchical coding of HDTV", *Signal Processing: Image Communications, Vol. 4, 1992, pp. 195-225.*

[2.30] F. Bosveld, R. L. Lagendijk and J. Biemond "Compatible spatio-temporal subband encoding of HDTV", *Signal Processing, Vol. 28, pp. 271-289, 1992.*

[2.31] P. J. Burt and E. D. Adelson "The Laplacian Pyramid as Compact Image Code", *IEEE Transactions on Communications, pp. 532-540, April 1983.*

[2.32] P. M. Cassereau, D. H. Staelin and G. de Jager "Encoding of Images Based on the Lapped Orthogonal Transform", *IEEE Transactions on Communications, Vol. 37, pp. 189-193, February 1989.*

[2.33] R. J. Clarke "Transform Coding of Images", *Academic Press, Inc., 1985.*

[2.34] A. Cohen, I. Daubechies, J. C. Feauveau "Biorthogonal bases of compactly supported wavelets", *Communications in Pure and Applied Mathematics, No. 45, pp. 485-500, 1992.*

[2.35] R. R. Coifman and M. V. Wickerhauser "Entropy-Based Algorithm for Best Basis Selection", *IEEE. 713-718, March 1992.*

[2.36] R. R. Coifman, Y. Meyer, V. Wickerhauser "Wavelet Analysis and Signal Processing", *in Wavelets and Their Applications, edited by M. B. Ruskai, Jones and Bartlett Publishers, 1992.*

[2.37] R. E. Crochiere and L. R. Rabiner "Multirate Digital Signal Processing", *Prentice Hall Signal Processing Series, Prentice Hall, Englewood Cliffs, New Jersey, 1983.*

[2.38] I. Daubechies "The Wavelet Transform, Time-Frequency, Localization and Signal Analysis", *IEEE Transactions on Information Theory, Vol. 36, pp. 961-1005, September 1990.*

[2.39] I. Daubechies "Ten Lectures on Wavelets", *CBMS-NSF, Regional Conference Series in Applied Mathematics, SIAM, Philadelphia, 1992.*

[2.40] I. Daubechies "Orthonormal bases of compactly supported wavelets", *Communications on Pure and Applied Mathematics, Vol. XLI, pp. 909-996, November 1988.*

[2.41] E. Dubois "Motion-compensated Filtering of Time-Varying Images", *Multidimensional Systems and Signal Processing, Vol. 3, pp. 211-239, 1992.*

[2.42] D. E. Dudgeon, R. M. Mersereau "Multidimensional Digital Signal Processing", *Prentice Hall Signal Processing Series, Prentice Hall, Englewood Cliffs, New Jersey, 1993.*

2.13. Bibliography

[2.43] T. Ebrahimi "Perceptually Derived Localized Linear Operators: Application to Image Sequence Compression", *Ph.D. Thesis, Swiss Federal Institute of Technology, 1992.*

[2.44] J. C. Feauveau, P. Mathieu, M. Barlaud, M. Antonini "Recursive Biorthogonal Wavelet Transform for Image Coding", *IEEE ICASSP, Toronto, Canada, pp. 2649-2652, May 1991.*

[2.45] H. Gharavi "Subband Coding of Video Signals", *in Subband Image Coding, Chapter 6, edited by J. W. Woods, Kluwer Academic Publishers, 1991.*

[2.46] R. A. Gopinath "Wavelet and Filter Banks - New Results and Applications", *Ph.D. Thesis, Rice University, Houston, August 1992.*

[2.47] R. A. Gopinath, C. S. Burrus "On Cosine-Modulated orthonormal wavelet bases", *Technical Report CML TR92-06, Rice University, Houston, March 1992.*

[2.48] R. A. Gopinath, C. S. Burrus "Theory of Modulated Filter Banks and Modulated Wavelet Tight Frames", *Technical Report CML TR92-18, Rice University, Houston, August 1992.*

[2.49] R. Haddad, A. N. Akansu, A. Benyassine "Time-Frequency Localization in Transforms, Subbands, and Wavelets: a Critical Review", *Optical Engineering, Vol. 32, No. 7, pp. 1411-1429, July 1993.*

[2.50] B. Haskell, K-H Tzou and T.R. Hsing "A Lapped Orthogonal Transform Based Variable Bit-Rate Video Coder for Packet Networks", *IEEE Proceedings of ICASSP, pp. 1905-1908, 1989.*

[2.51] G. D. Karlsson"Subband Coding for Packet Video", *Ph.D. Thesis, Columbia University, New-York, 1990.*

[2.52] R. D. Koipillai and P. R. Vaidyanathan "Cosine-modulated FIR Filter Banks Satisfying Perfect Reconstruction", *IEEE Transactions in Speech Processing, pp. 770-783, April 1992.*

[2.53] J. Kovacevic "Filter Banks and Wavelets: Extension and Applications", *Ph.D. Thesis, Columbia University, 1991.*

[2.54] T. Kronander "Some aspects of Perceptual Based Image Coding", *Ph.D. Thesis, Linkoping University, Sweden, 1989.*

[2.55] M. Kunt, T. Ebrahimi, T. R. Reed "Video Coding Using a Pyramidal Gabor Expansion", *Proceedings of the Visual Communications and Image Processing, Vol. I-1360, Lausanne, 1990, pp. 489-502.*

[2.56] B. Loret, G. Eude and J. Guichard "Comparison of Several Two-Layer Schemes Based on H261", *Third International Workshop on Packet Video, Session C13, March 22-23 1990, Morristown, NJ, USA.*

[2.57] S. G. Mallat "A Theory for Multiresolution Signal Decomposition: the Wavelet Representation", *IEEE Transactions on Pattern Analysis and Machine Intelligence, Vol. 11, No. 7, pp. 674-693, July 1988.*

[2.58] S. G. Mallat "Multifrequency Channel Decompositions of Images and Wavelet Models", *IEEE Transactions on Acoustics, Speech, ans Signal Processing, Vol. 37, No. 12, pp. 2091-2110, December 1989.*

[2.59] S. G. Mallat "Multiresolution Approximations and Wavelet Orthonormal Bases of L^2", *Transactions on American Mathematical Society, Vol. 315, No. 1, pp. 69-87, September 1989.*

[2.60] H. S. Malvar "Lapped Transform for Efficient Transform/Subband Coding", *IEEE Transactions on Acoustics, Speech and Signal Processing, Vol. 38, No. 6, pp. 969-978, June 1990.*

[2.61] H. S. Malvar "Modulated QMF Filter Banks with Perfect Reconstruction", *Electronics Letters, 26, pp. 906-907, June 1990.*

[2.62] H. S. Malvar "Signal Processing with Lapped Transform", *Artech House, Inc, Norwood, MA 02062, 1992.*

[2.63] H.S. Malvar and D.H.Staelin "Reduction of Blocking Effects in Image Coding with a Lapped Orthogonal Transform", *IEEE Proceedings of ICASSP, pp. 781-784, 1988.*

[2.64] J. Mau "Perfect Reconstruction Modulated Filter Banks", *Proceedings of ICASSP 92, San Francisco, Vol. 4, pp. IV-273, 1992.*

[2.65] T. Q. Nguyen "A Class of Generalized Cosine-modulated Filter Banks", *Proceedings of IEEE-ISCAS, San Diego, pp. 943-946, 1992.*

[2.66] T. Q. Nguyen, P. P. Vaidyanathan "Structures for M-Channel Perfect Reconstruction FIR QMF Banks which Linear Phase Analysis Filters", *IEEE Transactions on Acoustics, Speech and Signal Processing, Vol. 38, No. 3, pp. 433-446, March 1990.*

[2.67] J. R. Ohm "Temporal Domain Subband Video Coding with Motion Compensation", *Proceedings of ICASSP-92, Vol. 3, pp. III-229-232, March 1992.*

[2.68] P. Onno and C. Guillemot "Tradeoffs in the Design of Wavelet Filters for Image Compression", *Proceedings of the Visual Communications and Image Processing, Vol. II-2094, Boston, pp. 1536-1547, 1993.*

[2.69] A. V. Oppenheim and R. W. Schafer "Digital Signal Processing", *Prentice-Hall, 1975.*

[2.70] W. A. Pearlman "Performance Bounds of Subband Coding", *in J. W. Woods, Editor, Subband Image Coding, Kluwer Academic Publishers, 1991, Chapter 1, pp. 1-41.*

[2.71] C. I. Podilchuk and N. Favardin "Perceptually Based Low Bit rate Video Coding", *Proceedings of ICASSP, pp. 2837-2840, 1991.*

2.13. Bibliography

[2.72] J. P. Princen and A. B. Bradley "Analysis/synthesis filter bank design based on time domain aliasing cancellation", *IEEE Transactions ASSP, Vol. 34, No. 5, pp. 1153-1161.*

[2.73] K. Ramchandran and M. Vetterli "Best Wavelet Packet Bases in a Rate-Distortion Sense", *IEEE Transactions on Image Processing, Vol. 2, No. 2, pp. 160-175, April 1993.*

[2.74] O. Rioul "Ondelettes régulières: Application à la compression d'images fixes", *Ph.D. Thesis, CNET, Paris, March 1993.*

[2.75] O. Rioul and M. Vetterli "Wavelets and Signal Processing", *IEEE Signal Processing Magazine, pp. 14-38, October 1991.*

[2.76] J. T. Smith and T. P. Barnwell "Exact reconstruction techniques for tree-structured subband coders", *IEEE Transactions ASSP, Vol. 34, No. 3, pp. 434-441, June 1986.*

[2.77] P. P. Vaidyanathan "Quadrature Mirror Filter Banks, M-Band Extensions and Perfect-Reconstruction Techniques", *IEEE ASSP Magazine, pp. 4-19, July 1987.*

[2.78] P. P. Vaidyanathan, Phuong-Quang Hoang "Lattice Structure for Optimal Design and Robust Implementation of Two-Channel Perfect-Reconstruction QMF Banks", *IEEE Transactions on ASSP, Vol. 36, No. 1, January 1988.*

[2.79] P. P. Vaidyanathan "Multirate Systems and Filter Banks", *Prentice Hall Signal Processing Series, Prentice Hall, Englewood Cliffs, New Jersey, 1993.*

[2.80] P. P. Vaidyanathan "Multirate Digital Filters, Filter Banks, Polyphase Networks and Applications: a Tutorial", *Proceedings of IEEE, Vol. 78, No. 1, pp. 56-93, January 1990.*

[2.81] M. Vetterli and D. Le Gall "Perfect reconstruction filter banks: some properties and factorizations", *IEEE Transactions on Acoustics, Speech and Signal Processing, Vol. 37, No. 7, pp. 1057-1071, July 1989.*

[2.82] M. Vetterli and C. Herley "Wavelets and Filter Banks: Theory and Design", *IEEE Transactions on Acoustics, Speech and Signal Processing, Vol. 40, No. 9, pp. 2207-2232, September 1992.*

[2.83] L. Wang and M. Goldberg "Progressive Image Transmission by transform Coefficient Residual Error quantization", *IEEE Transactions on Communications, Vol. 36, No. 1, January 1988.*

[2.84] P. H. Westerlink, J. Biemond, and, D. E. Boekee "Subband Coding of images", *in Subband Image Coding, Chapter 5, edited by J. W. Woods, Kluwer Academic Publishers, 1991.*

[2.85] J. W. Woods and Gary Lilienfield "Experiments in Motion compensated three-Dimensional Subband Coding", *Private Communication, Center for Image Processing Research, Rensselear Polytechnic Institute, March 1993.*

Chapter 3

Bit Rate Models

3.1 Introduction

The purpose of this chapter is to present bit rate models for digital TV and HDTV coders in Variable Bit Rate (VBR) applications in order to transmit for instance on ATM networks. As mentioned in Chapter 1, modeling multi-scene video sources is more intricated than modeling computer data and voice sources. However, a logical construction path which leads to more and more complicated traffic models has already been presented to cover computer data, voice and single-scene video sources. Indeed, two additional axes of generalization need to be examined in the present case of multi-scene video traffics; these are namely the multiplicity of potential cell rates to be output, for instance those at the image level, and the temporal multiresolution analysis to embody source behaviors ranging on more than nine temporal decades. The reasons to exploit a manifold variety of Markov states can be explained simply as follows. The TV signal is made of a succession of scenes having each a specific density of information; therefore, the amount of Markov states in a chain modeling video cell rates (Chapter 1) has to be increased significantly to take into account the diversity of scenes to be processed. Several factors interact on the generation of the TV video sources, they play a role on a wide temporal scale ranging from the cell generation at the order of the microsecond $[10^{-6}s]$ up to programmes at the order of hours i.e. $[10^{+3}s]$. These factors are namely the scene edition, the digital sampling in formatted image structures, the coding algorithms and the packetization for network transmissions. Consequently, the encoded TV source traffics have to be studied at different levels of temporal resolution in order to extract the specific behavior at each level in connection with the cause which it originates from. Depending on each specific application exploiting the source modeling, only some specific levels extracted from the present representation may actually be utilized, the remaining non-activated resolution levels may nevertheless play an adaptive action on the levels currently involved in the modeling issue. Moreover, the TV sources and traffics are, by essence, non-stationary and stochastic processes. The analysis of any non-stationary signals is more efficiently performed in a multi-scale basis which allows seeing successively continents, countries, woods, trees and eventually leaves. The non-stationarity in signals is not necessarily present at all the scales of the analysis. Indeed, as a matter of intuitive facts, a long-term source analysis should roughly look stationary contrary to short-term modeling counterparts.

The stochastic nature of the source stems from the fact that the semantic and syntactic contents of the picture information to be carried are deliberately lost at the transmission stages: the ATM networks handle cell independently of the content, only the destination and quality of service matter effectively in the transmission process. Another important feature to be again mentioned is the difference in processing scales between the image coding algorithms on one side and the ATM routing and multiplexing procedures on the other side. The first world deals with macroscopic involvements ranging from seconds to hours and the second with microscopic scales of tens of microseconds.

To prolong the above discussion on the multiscale modeling approach of video sources and the multiscale time data processing, it is worth mentioning the existence of two different schools of modeling variable bit rate video sources

1. for the configurations considered by video coders, the data rates are of the order of megabits per second segmented in cells of a few tens of bytes. The discrete nature of the cell nature is often completely ignored and the data flow is treated as a continuous bit stream pictured as a fluid flow. As a consequence, the sources are modeled as producing continuous bit streams evolving through different states with given probabilistic transitions between the admissible rates. This approach of traffic modeling, known as the fluid flow approximation, is a powerful tool which allows the use of simple analytic models, taking into account the source correlations. Though very attractive for coding and decoding purpose, these models constitute only a rough approximation of the ATM traffic reality and cannot take into account fine analyzes of queueing behaviors like those required to derive precise transmission quality of service. In fact, these are valid for heavy loaded multiplexers i.e. at $\rho > 0.8$ and can evidently derive only macroscopic results at the time of its analysis.

2. for the configurations considered by the ATM designers, the data rates were initially of the orders of a few hundreds of kilobits for computer data and voice sources and ATM multiplexers which are queues with length of tens of cells. The predominant care at this level consists of deriving realistic queueing models reflecting as closely as possible the discrete and correlative nature of the cell arrival processes, while still being analytically tractable.

The multi-scale modeling approach tries to link both families in a structured approach in order to achieve more precise characterizations. Depending on the application of interest, one or several time scales have to be considered to achieve an optimum solution to the problems laid down by the TV transmissions on ATM networks.

As a necessary and unavoidable initial step to investigate any new family of coding algorithms, the introductive approach to modeling bit or cell rates consists of building a data base of thorough statistics performed on bit rate measurements collected on built-up hardware coders processing actual sources of TV pictures. The goals of building models and of collecting actual bit rates for VBR TV and HDTV sources are evidently manifold. As enumerated hereafter, these models will enable the network designer

1. to statistically characterize TV and HDTV entropy sources considered as non-stationary discrete stochastic processes.

2. to design efficient predictors to implement in both VBR and CBR environments an optimum control of the coder output bit rates in conjunction with graceful variations of image quality (Chapter 4).

3. to derive corresponding models of multiplexed sources and, especially, to estimate the performances resulting from multiplexing TV sources (Chapter 5).

4. to determine the most efficient and realistic TV and HDTV source traffic descriptors to be declared to the network for an optimum allocation of network bandwidths (Chapter 7).

5. to determine source parameters to be policed by the network in order to ensure efficient network congestion controls (Chapter 7).

The models should be so general as to encompass different coding techniques and different levels of signal resolution. The decorrelative coding techniques considered in this study are based on spatial linear operators (DCT and subband coding schemes) and on motion-compensated temporal predictors as developed in Chapter 2. The levels of resolution to be taken into consideration range from video-conference to standard television and high-definition television. As no restrictions may be definitively stated so far in the analysis and as a whole general approach is first intended to be put forward and experimented, the coders are supposed to transmit in a free VBR mode i.e. at constant subjective image quality without any buffer control acting on the quantization procedure.

Two dual stochastic processes are susceptible to be modeled depending on the scale of observation

1. at the finest level of observation, cell inter-arrival times processes model the time intervals between consecutive cells.

2. at coarser or higher scales, averaged bit rates or cell rates are evaluated on fixed time spans. They lead to counting processes measuring the amount of bits or cells generated by the sources within fixed time intervals.

This chapter will start with describing an experiment to characterize the digital TV sources in VBR applications. The experiment consists of processing the real-time digital TV signal currently produced by a broadcaster [1] with a hardware coder in order to collect both bit rates and cell inter-arrival times. The chapter will proceed with the development of a complete source model for TV entropy bit rates. This model is composed of a hierarchy of layers described bottom up. Beginning with the cell arrival layer at the time scale of microseconds, the modeling will continue with counting processes successively at the stripe layer [2] and the image layer to end up with the characterization of scenes and programmes at a time scale of hours. Each layer brings by its own characterization some partial or complete solutions to any of the five problems enumerated here above in the introduction. The chapter will thereafter analyze each layer by specific sub-models: Markov modulated

[1] the French Belgian TV and Radio Broadcaster: the RTBF.
[2] a fraction of the image equal to eight consecutive video lines, previously defined in Chapter 2.

3.1. Introduction

Poisson processes at cell arrival layer, periodic processes at stripe cell rate layer, non-stationary auto-regressive processes at image layer and semi-Markov processes at scene layer. These sub-models will be tested for reliance with statistics performed on actual data. To provide the analysis with an in-depth study of the source behavior, a simple coder implementing intra and inter modes without motion compensation is first thoroughly examined. Thereafter, the modeling trends are proposed for a motion compensated video coder and for the standardized MPEG-II coder. The analysis of these different coders will lead to circumscribe the problem of modeling one layer TV sources as variable bit rate services. To ease the reading, this chapter reports the experimental results and presents the models. The underlying theoretical support is provided in dedicated appendixes.

3.2 Experiment with Actual Time Digital TV

This section will be dedicated to the presentation of experimental measurements carried out on hardware coders processing actual TV pictures. The original TV signal was produced in high quality contribution PAL by the broadcaster meaning that nevertheless some high frequency components have been filtered in the picked-up digital signal. The PAL-to-CCIR transcoding process has been produced in situ without suffering from additional degradations. This reflects a typical situation where digital coders will be used in the next future i.e. the production is made in an analog manner and the coding and transmission in a digital way. The statistical analysis performed on the collected data rates will enable us to validate and to refine the models.

3.2.1 Bit Rate Measurements

About 25 hours of real time broadcast TV have been transcoded from high quality PAL format into CCIR 601 format and recorded on digital D1 support at the broadcasting center. Those records contain TV programmes of all categories: debates, cartoons, movies, theater, video clips, classical music, news, advertisements, cultural productions, entertainments, TV movies, shows, synthetic movies, sports (football, tennis),... The format of the picture material is recorded according to the CCIR Rec. 601 at 25 Hz/625 lines. The active part of the picture contains 72 stripes of 8 lines. The video-framing however is organized here in 76 stripes made of those 72 active stripes and of 4 additional stripes containing field synchronization information. Different reference frequencies will be used in the sequel, namely the frame frequency $f_f = 25\ Hz$ and the stripe frequency $f_s = 1.9\ kHz$.

The recorded source has been processed by a hardware coder (as presented in Figure 3.3): this coder implements an hybrid decorrelative scheme based on spatial DCT for 8×8 blocks and on a temporal differential decorrelative loop without motion compensation. The coder implements a quantizer (linear law adapted locally, with the criticality, in frequency, with weighting factors and globally with the channel capacity), an entropy coder (UVLC) and a buffer regulation (Chapter 4), a packetizer and an ATM adaptation layer (Chapter 6). The bit stream at the output of the VLC with the video framing feeds a packetizer which fills up the cells according to the CCITT recommendations. In the experiment which was carried out in laboratory, once the VLC process has delivered

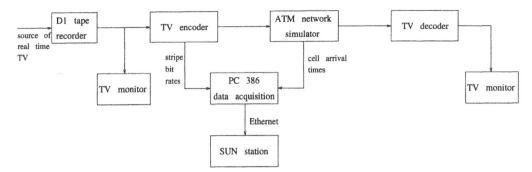

Figure 3.1: Experimental set-up for the bit rate acquisition.

enough bits to fill a cell, this cell is launched on the network in the next coming time slot.

The variable output bit rates have been measured and collected on a stripe-by-stripe basis at different fixed values of the transmission factor[3]. The stripe period was the lowest time interval available for the bit rate acquisitions (Figure 3.1). Seven levels of quality (i.e of the transmission factor values) have been processed during the experiment. To give an idea of the image quality expressed on a subjective scale ranging in the interval [0-5], the transmission factors ranging from 0 to 10 give a subjective quality of 4.5 to 5 corresponding to contribution applications; the transmission factors ranging from 10 to 30 give a subjective quality from 3.5 to 4.5 corresponding to distribution applications; for transmission factors higher than 30, some block effects are visible.

The real time acquisition of the bit rates has been performed by means of a Personal Computer, thereafter transferred on computer hard disks and finally stored on magnetic tapes (to give orders of magnitude, the required capacity to store the values of the stripe bit rates has a magnitude of 12.96 Mbytes per hour). The cell inter-arrival times have also been measured at constant values of the transmission factor as the number of empty slots between consecutive cells. To carry out the measurement an ATM network simulator has been emulated as an ATM connection of 150 Mbit/s. This means that the bit rate along the ATM links is clocked in time slot at the cell rate or *cell frequency* equal to $f_c = 0.354$ MHz. The ATM cells contain 53 bytes with 5 bytes devoted to the header and 3 bytes to the error correction purpose. Launching at the next time slot means that, when a cell is ready, it is inserted in the following time slot. Thus, the buffering mechanism used in the packetizer is kept to the strict minimum imposed by the need to wait to reach enough bits to fill a cell and by the timing of the ATM links. The term *bufferless packetizing* would probably be more adequate to describe this situation where the encoder buffer located at the output of the VLC is virtually unexistent.

3.3 Complete Model Description

Let us now examine the content of the entropy source. The decorrelative operators are applied locally within the image. This implies that some correlation on larger scales

[3]The transmission factor has been defined in Chapter 2 as the parameter computed by the buffer control algorithm to adapt the quantization step size in order to comply to the channel capacity.

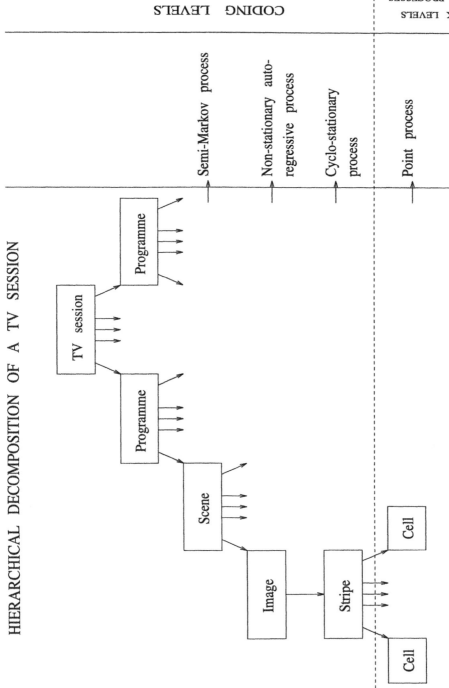

Figure 3.2: Hierarchical modeling of the whole TV signal.

remains. This correlation depends on several factors, namely the structure of editing the TV programmes [4], the way of scanning images, the format used to represent the image and the algorithms encoding the digital TV signals. The way TV is edited leads to subdividing a TV session into programmes, scenes and images. The scanning of the images is a periodic process performed by a camera which can additionally split the image into fields. The encoding algorithms go on by further subdividing the image into stripes. At the sub-stripe transmission level where the data are handled by the packetizers and the ATM channel, the cell inter-arrival time will be considered.

The definition of the image format (Chapter 2) and that of the cell format (Chapter 1) have been frozen by the standardization bodies. The notion of stripe stems from an algorithmic coding purpose (Chapters 2 and 4). *Scenes* and *programmes* have definitions relevant to their specific issue of concern. In one sense, the visual scene specifies time intervals where the signal is characterized by a fixed background with possible panning and zooming and by a variable foreground with humans or objects in motion. A visual programme is a set of scenes defining a whole entity corresponding to definite subjects like a movie, a debate, a cartoon,.... In the bit rate modeling approach, the definition of the scenes and the programmes will be restated in terms of their statistical properties. These aim at characterizing the process at a level slightly different from that of the visibility. Indeed, the *statistical scenes* are characterized by time intervals over which bit rate statistics (like image bit rate) can rather be considered quasi-stationary. In that sense, the statistical scenes can be longer or smaller than its associated visible scenes depending on the changes in the prevailing stationary regime. A change of background can imply a drastic change of image bit rate and, therefore, a discontinuity within stationarity. These singularity points within image and stripe bit rates are referred to as scene changes. These scene changes delimit the span of each scene. A scene change can take any shape between abrupt and smoothed transitions. The statistical scenes can be characterized by statistics on their lengths and bit rates. A *statistical programme* is defined as the segment of time during which the scene statistics are quasi-stationary. The final hierarchical model of bit rates is presented in Figure 3.2.

Any non-stationary stochastic process can be usually modeled according to the spectrum estimation theory by either parametric or non-parametric models. The non-parametric models lead to the estimation of time-frequency representations like the short-time Fourier transform, the Wigner-Ville distribution and the wavelets. The parametric models lead to the parametric estimations like the Auto-Regressive Moving Average (ARMA) representations. Although both of them are complementary, parametric models will turn out to be more attractive here to build predictors on bit rate signals.

3.4 Statistical Modeling Approach

The following subsections will deal with the different layers of the model, namely the cell inter-arrival times, the stripe cell rates, the image bit rates, the statistical scenes and

[4]The video editing process consists of assembling sequences into one programme and plans into one sequence. The plan is commonly defined as the basic unit of shooting video. In this textbook, the plan will be termed a scene.

programmes. Each of them will be discussed according to a common framework

1. by descriptive statistics obtained on real time TV records with a coder (Figure 3.3) exploiting an 8 × 8 block DCT operator and temporal prediction without motion compensation. The scheme implements an UVLC algorithm as variable length entropy coder. This coder will be referred to as test coder-model 1.

2. by a modeling treatment with corresponding parameter estimations.

3. by an eventual test of model reliability.

An additional section will thereafter present statistics performed on other coders referred to be namely the test coder-model 2 and 3. The third example is nothing else than the MPEG-II coder. The test coder-model 2 implements a predictive loop with motion compensation at half-pixel accuracy and an ACVLC as variable length coder; the third one introduces additional coding modes (image and field motion compensation capabilities and interpolated coding mode).

3.4.1 Modeling at the Cell Inter-Arrival Layer

Modeling the cell inter-arrivals is of importance in the case where no control is applied to the cell generation. In this particular case, the coder behaves as a free VBR source. The description of cell inter-arrival process is of interest when multiplexing sources and estimating global performances (for instance, the cell loss probability). The statistics will show how inter-arrival times can be closely related to the processing characteristics of the variable-length coders and constitute, in some aspects, a real signature of how variable length coders actually process the quantized coefficients. The most significant parameters characterizing the cell inter-arrival processes in the case of a free VBR coder have to be used to describe the source traffic (traffic descriptors) at the transmission call set-up and be included in the calculation of the multiplexed traffic to deduce multiplexing performances (Chapter 5). As a complementary illustrative description, the instantaneous cell rates are also provided in the analysis.

A model of cell occurrence will be proposed for TV sources. It is based on the Markov modulated Poisson processes of order m [MMPP(m)] showing that the order m=2 suffices to approximate the cell generation process quite well. That latter process requires four parameters to be taken among those characterizing at best the arrival procedure. They are considered as realistic tools to represent arrival processes in the family of the point processes (Chapter 1, Reference [15]). These models of cell occurrences are referred to as *source traffic equations* in the field of ATM networks and they are of prime importance for the network designers.

3.4.1.1 Statistics of Inter-Arrival Times

The *inter-arrival times* $I(n)$ are defined as the time elapsed between the generation of two consecutive cells. In this section, the inter-arrival times are discretized as the number of slots embedded in between two consecutive cells. The reference for computation is the beginning of the time slot. To visualize this phenomenon, two diagrams show bars with

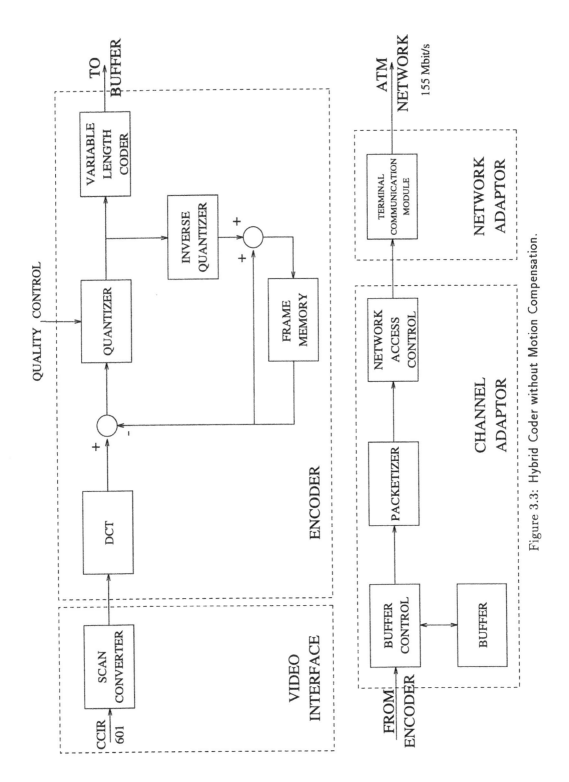

Figure 3.3: Hybrid Coder without Motion Compensation.

amplitudes equal to the inter-arrival times. Consecutive inter-arrival times are presented from left to right. For example, Figure 3.4 is drawn at a transmission factor of 5 and displays 150 consecutive inter-arrivals spanning about five stripes. The cell generation can be thought of as a repetitive process with stripe periodicity. Figure 3.4 shows groups of small inter-arrival times followed by longer inter-arrival times (30-40 time slots); an identical pattern of about twenty-five cells is replicated five times. That stripe pattern is triangle-pair-shaped testifying of the algorithmic procedure which encodes first all the luminance coefficients and, secondly, all the chrominance coefficients. This behavior arising from the VLC is mostly visible at low values of the transmission factor. The VLC first gathers all the coefficients to be encoded within the stripe in stacks of different DCT orders. The VLC processes the complete set of quantized coefficients on a stack-by-stack basis beginning with the lowest order of luminance up to terminating the treatment of all the luminance orders and restarting the same procedure on the chrominance coefficients up to completing all the stacks. The process is replicated at the beginning of each stripe when a complete set of coefficients is ready to be encoded. When the value of the transmission factor increases, the number of cells to be launched per stripe in the network decreases, the inter-arrival times increase and loose their previous shape as shown in Figure 3.5. The whole inter-arrival time statistics depend on the content of the encoded sequence and on the transmission factor.

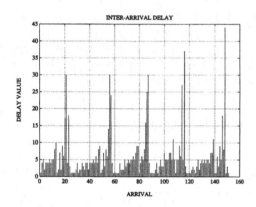 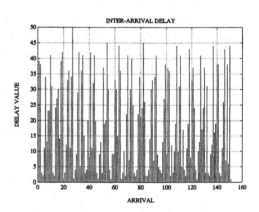

Figure 3.4: Inter-arrival delays I(n) at U=5. Figure 3.5: Inter-arrival delays I(n) at U=40.

The values of the first two moments of the inter-arrival times $I(n)$ (the mean m_I and the standard deviation σ_I expressed in time-slot unit) are gathered in Table 3.1 as a function of the transmission factor value U.

The PDF of the inter-arrival times $I(n)$ are sketched in Figures 3.6, 3.7, 3.8 and 3.9 at four different values of the transmission factor (the density functions of the inter-arrival time versus the discretized inter-arrival time value). It turns out directly that they are all limited at a value around 50 time slots and that a small mass of probability is visible nearby a length of 175 time slots in all the diagrams. That mass corresponds to the blanking stripes (two of them in each image) where no cell is transmitted except a

U	m_I	σ_I
5	6.7	11.5
10	9.9	14.8
15	11.6	15.9
20	13.4	17.0
30	16.9	18.7
40	19.6	19.8

Table 3.1: Mean and standard deviation of the inter-arrival time $I(n)$.

synchronization cell. The limit at 50 time slots corresponds to the slowest packetization process reached when all the coefficients to be encoded are equal to zero. The probability density functions of the inter-arrival times are quasi-exponential at high bit rates (low values of the transmission factor). When the bit rate decreases, the masses of probability spread over the whole range of admissible time slots [0-50]. Two peaks appear at low bit rates, they are located around the minimum zero, one peak corresponds to the coding of the non-zero DCT coefficients and, around the maximum value of the inter-arrival times, another peak corresponds to the encoding of the zero DCT coefficients.

The autocorrelation function of the inter-arrival time process is presented in Figures 3.10 and 3.11 (correlation versus time lag expressed in slots). The existence of correlation between consecutive cell inter-arrival times prohibit us from modeling the arrivals as simple Poisson process even if the PDF approximates in some cases a negative exponential curve. In agreement with the randomization effect of noisy images on the inter-arrival time patterns, the autocorrelation functions should decrease slightly more quickly when the transmission factor increases.

3.4.2 Instantaneous Unbuffered Cell Rates

In this section, the cell rates under investigation are the *instantaneous cell rates* $R_U(n)$ of the coder in a bufferless packetizing scheme. Let us begin with defining the instantaneous cell rate. The instantaneous cell rate is inversely proportional to the values of the inter-arrival process. The maximum cell rate value or the peak instantaneous cell rate is reached when one cell is delivered per time slot i.e. at the cell frequency f_c. Let us normalize that maximum frequency to unity, all other cell rates are de facto fractions of the cell frequency. According to that definition, if n time slots separate the beginning of two consecutive cells, then the n samples of the instantaneous cell rate on this interval are assigned to the value of $\frac{1}{n}$. The peak cell rate observed at the different values of the transmission factor is the maximum cell rate of one cell per time slot. The mean and the standard deviation m_{R_U} and σ_{R_U} are gathered into Table 3.2 with respect to different values of the transmission factor U.

To analyze somewhat further the instantaneous bit rate, the power spectral density is considered; Figure 3.12 presents the spectrum of the instantaneous cell rates at different values of the transmission factor. The diagram sketches the power spectrum expressed in $(\frac{cell}{cell\ period})^2$ versus the frequency normalized by the sampling frequency equal to the cell frequency f_c. Components at multiples of the stripe frequency show up in the spectrum.

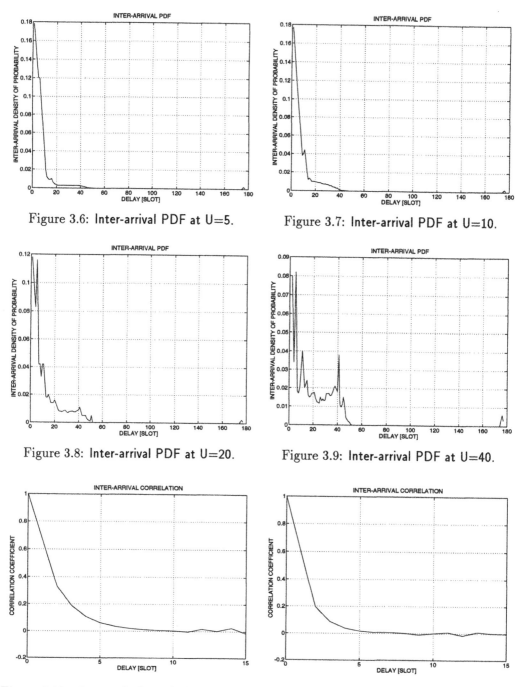

Figure 3.6: Inter-arrival PDF at U=5.

Figure 3.7: Inter-arrival PDF at U=10.

Figure 3.8: Inter-arrival PDF at U=20.

Figure 3.9: Inter-arrival PDF at U=40.

Figure 3.10: Inter-arrival correlation at U=5.

Figure 3.11: Inter-arrival correlation at U=40.

U	m_{R_U}	σ_{R_U}
5	0.14	0.177
10	0.101	0.156
15	0.087	0.135
20	0.076	0.122
30	0.060	0.096
40	0.052	0.082

Table 3.2: Mean and standard deviation of the instantaneous cell rates $R_U(n)$.

To illustrate the existence of embedded but not visible components at multiples of the image frequency (25 Hz), the sequence of instantaneous cell rates at U=40 has been filtered by a simple mean averaging filter (mean performed over 700 samples) and subsampled of a factor 300 to display peaks at the multiples of the 25 Hz frequency (Figure 3.13). The subsampled reference frequency f_{C_2} is here equal to 1.117 kHz.

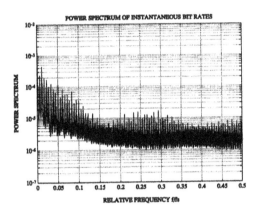

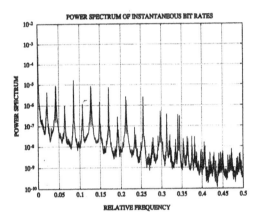

Figure 3.12: Power spectrum of the instantaneous cell rate at U=5.

Figure 3.13: Power spectrum of the instantaneous cell rate after subsampling of 300 at U=40.

3.4.3 Models at the Cell Inter-Arrival Layer

The characterization of the cell inter-arrival time processes contributes to describing the sub-stripe cell rates. The arrival process depends not only on the source and the required image quality but also on the coder and its algorithm. Indeed, the level of image quality to be transmitted determines the mean cell inter-arrival time, the local density of image information modulates the amount of data to transmit. Finally, the coding algorithm and, especially, the algorithmic hardware implemented at the level of both the variable-length entropy coder and the packetizer, modulate also strongly the resulting cell generation.

First of all, we can assert that, in any case, the PDF of the cell inter-arrival times will be limited within two bounds

1. the lower bound is mainly determined by physical constraints originating from either the coder or from the network. On the coder side, the lower limit is given by the minimum time to generate a cell, for instance to illustrate with a reference TV clock at 27 MHz and a bus of one byte connecting the VLC to the packetizer, the shortest time to packetize is 1.9 μs. On the network side, the lower limit is the minimum time to launch a cell which corresponds to the slot time, and to illustrate with a 150 Mbit link, the slot time is equal to 2.8 μs.

2. the upper bound is fixed by either the synchronization mechanism or by the compression efficiency of the VLC. Caused by the existence of a synchronization mechanism, the maximum inter-arrival time can correspond either to one stripe duration, for instance during the blanking period, or to the interval between two consecutive time-stamp cells launched even if no data are to be transmitted. In the coding algorithm, the lowest speed to generate a cell is achieved when long strings of zeroed-coefficients have to be entropy coded by the VLC i.e. when the variable length compression achieves its maximum.

As a matter of fact, the potential PDF could have different aspects, namely a negative exponential shape with an eventual additional mass of probability located at the origin, a Gamma PDF, a uniform PDF. Two potential peaky masses can be moreover expected within the PDF as follows. A first one is located around the weak values of the inter-arrival times corresponding to the VLC encoding strings of non-zero coefficients where the entropy compression is low and another around the high values of the inter-arrival time corresponding to the VLC encoding strings of zero coefficients where the entropy compression is strong.

The existence of a potential correlation between consecutive inter-arrivals leads to modeling with doubly stochastic Poisson processes and, more particularly, Markov modulated Poisson processes (MMPP). The MMPP is a particular case of a more general point process, the N process, where the capability of observing batch arrivals has been removed. This applies to video source since, for obvious reasons, the packetizers are able to launch one single cell at a time on the network. Let us define briefly the MMPP(m) as a non-homogeneous Poisson process where the arrival rate varies according to an irreducible m-state continuous time Markov chain. When the chain is in state i, the MMPP is said to be in phase i and the cell arrival rate is λ_i with i=0,...,m. The MMPP(m) is characterized by matrices Q and Λ and by an initial probability vector of the states referred to as γ. The $[m \times m]$ matrices Q and Λ are respectively the generator matrix of the Markov chain and the diagonal matrix with the λ_i as diagonal elements. A description of MMPP(m) is provided in Appendix 3.A where the moments of the inter-arrival time and counting processes and the connection with other arrival processes are presented. It has been shown [15] that a MMPP with two Markov states is sufficient to model an extremely large variety of interval configurations. In this chapter, the two-state Markov chain is considered as an approximation and characterized by two mean sojourn times in states 1 and 2 respectively r_1^{-1} and r_2^{-1} and by two arrival rates λ_1 in state 1 and λ_2 in state 2. In whole evidence, using MMPP(m) should lead to a more precise modeling approach which turns out not to be necessary in all the cases.

3.4.4 Estimation of MMPP(2) Parameters

The four parameters of the Markov chain have been estimated by a statistical method based on an iterative procedure and a backward dynamic programming algorithm [15]. The scheme is iterative in the sense that successive estimations of the sequence of Markov states J_i termed the phase sequences $\{J_i\}_{i=0}^m$ are computed from matrices Q and Λ derived at the previous iteration. The scheme uses at each iteration a backward dynamic programming algorithm to yield an updated version of the phase sequence $\{J_i\}_{i=0}^m$. The scheme calculates a first initial estimate of the phase sequence $\{J_i\}_{i=0}^m$ from the observed inter-arrival sequence $\{x_i\}_{i=0}^n$. This first estimation of the phase sequence enables the algorithm to derive a first estimate of the matrices Q and Λ. Using further the property of the MMPP to be a Markov renewal process, the likelihood function for Q and Λ given the observed inter-arrival sequence $L(Q, \Lambda | x_1, \ldots x_n)$ is maximized by a backward dynamic programming algorithm to derive the maximum likelihood estimate of a new estimated version of the phase sequence. A second estimate of Q and Λ is deduced to restart the same computation. The procedure is iterated up to stabilization of the estimates. Table 3.3 gathers the parameter values for five different values of the transmission factor covering the whole range of admissible image qualities. The unit for the λ_i is the $\left[\frac{cell}{time \ slot}\right]$ and the unit for the r_i is the $\left[\frac{1}{time \ slot}\right]$. The estimation algorithm was run on sequences of 500 consecutive arrivals and an average was carried out over 100 different sequences.

U	10	15	20	30	40
λ_1	0.35	0.33	0.21	0.11	0.078
λ_2	0.036	0.039	0.0076	0.0067	0.0066
r_1	0.066	0.059	0.00031	0.00042	0.00036
r_2	0.029	0.023	0.0022	0.00015	0.0022

Table 3.3: MMPP(2) parameters at different values of U.

To find out the reliance of this modeling approach, the test of Kolmogorov-Smirnov has been applied to measure the overall absolute difference D between two cumulative distribution functions: the distribution of the actual inter-arrival times of the database and their related modeling with MMPP(2). Moreover, a level of significance $Q = Pr\{D > observed\}$ is associated with the test [14]. Strong significance levels are reached in practice when $Q > 0.01$. Table 3.4 presents the Kolmogorov-Smirnov statistic D with its level of significance on sets of 100 actual observations for different transmission factors. The test demonstrates the relative adequation of the models, especially when U increases.

U	10	15	20	30	40
D	0.139	0.125	0.097	0.082	0.076
Q	0.0024	0.048	0.13	0.27	0.59

Table 3.4: Kolmogorov-Smirnov statistic D and level of significance Q for MMPP(2).

Some additional incitement to reliability especially dealing with the cumulative correlation will be provided in Chapter 5 when comparing experimental values of the limiting indexes of dispersion for counting processes with those generated by MMPP arrivals.

To conclude on inter-arrival process models, the MMPP(m) is an accurate model to characterize the single-TV-source traffic. Batch arrivals are not allowed since the source packetizer can only send one cell at a time on the channel contrary to the ATM multiplexer inputs where batches are observable and, therefore, the use of versatile N processes is necessary to take into account those events. The MMPP(2) turns out to be a good approximation for some coding sources able to take into account four essential parameters describing the cell arrival process; these are, for instance, the mean, the variance, the skewness and the correlation. As the arrival process is highly dependent on the entropy coding and packetizing schemes, these deductions cannot be extended to other coders.

3.4.5 Bit Rate Models at the Stripe Layer

In this section, the stripe entropy bit rate will be statistically analyzed and demonstrated as being a discrete periodic process driven by a non-stationary source of information. Let this discrete stochastic process be denoted a *Discrete Non-Stationary Periodic Process* (DNSPP). To ease the coming exposition, the source of information will be assumed to be quasi-stationary within a scene as it is usually verified.

3.4.5.1 Statistics of Buffered Stripe Cell Rate

In this subsection, the cell rate is estimated as a counting process evaluated on fixed time intervals of one-stripe span. Restated in other words, the cell rates are those which would be obtained if the cells were accumulated into a buffer over periods equal to one stripe and sent at once on the network. The stripe cell rates $R_S(n)$ are given in Table 3.5. The table gathers the mean m_{R_S} and the standard deviation σ_{R_S} both expressed in $\frac{cell}{stripe}$. Additionally, the skewness S and the kurtosis K are supplied.

The *skewness* characterizes the degree of asymmetry of a PDF around its mean. The skewness is conventionally defined in such a way to make it non-dimensional. It is the third moment expressed as

$$S = \frac{1}{N} \sum_{j=1}^{N} [\frac{x_j - \bar{x}}{\sigma}]^3 \tag{3.1}$$

where \bar{x} and σ are respectively the mean and the standard deviation of the discrete-time random process. A positive value of the skewness signifies a PDF with an asymmetric tail extending out towards more positive x, a negative value signifies a PDF whose tail extends out towards more negative x.

The *kurtosis* is another a non-dimensional quantity. It measures the relative degree of sharpness or flatness of a PDF relatively to the normal PDF. A positive value is termed leptokurtic (the shape of the Matterhorn), a negative value is termed platykurtic (flatness i.e. having less kurtosis than the Normal PDF). The kurtosis represents the fourth moment

$$K = \{\frac{1}{N} \sum_{j=1}^{N} [\frac{x_j - \bar{x}}{\sigma}]^4\} - 3 \tag{3.2}$$

U	m_{R_S}	σ_{R_S}	S_{R_S}	K_{R_S}
0	65.7	18.4	-1.48	3.79
5	25.7	10.9	0.45	3.21
10	18.1	7.2	0.70	5.06
20	13.6	5.4	0.88	7.45
30	10.7	4.5	1.06	9.90
40	9.2	3.6	1.06	11.07

Table 3.5: Statistics of the stripe cell rate $R_S(n)$.

The kurtosis is equal to zero in the case of Gaussian PDF's.

Figure 3.14 shows the stripe cell rates evolution (depicted in cells per stripe) in terms of the consecutive stripe intervals at different values of the transmission factor. For synchronization purpose, each field begins with two zero-rate stripes. The periodic property of the stripe cell rate shows up immediately with a periodicity of 76 stripes (periodic processes).

Figures 3.15 to 3.18 present PDF's of stripe cell rates. The PDF's are never really Gaussian but merely testify of the different coding modes implemented in the scheme (spatial intra mode, temporal predictive mode). Here, the two emerging peaky masses can be interpreted as corresponding to the inter mode (the lower one) and to the intra mode (the higher one). The autocorrelation function among the stripe cell rates is displayed in Figures 3.19 and 3.20. The periodicity of the stripe cell rate process is illustrated in the correlation diagrams drawn as a function of the time lag expressed in stripe. They display the expected periodicity of 76 stripes. The spectral power density (Figure 3.21) displays also the image frequency (the reference frequency is the stripe frequency f_s of 1.9 kHz, the spectrum is referred to the normalized frequency. A division unit equals 0.95 Hz).

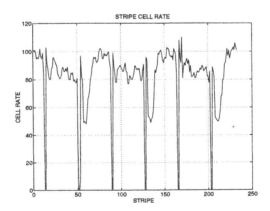

Figure 3.14: Stripe cell rate at U=5.

3.4.5.2 Modeling at the Stripe Layer

Cyclo-stationary and periodic processes will be defined in the next section and revisited in Appendix 3.B with refinements of the definitions. Periodic processes are generated at the

output of a camera which performs a periodic scanning of a wide sense stationary process. Preservation properties of a periodic process can be easily demonstrated after different transformations, namely the linear stationary transformation, the memoryless non-linear transformation, the time averaging over lengths smaller than the cyclo-stationary period, the addition of either white noise processes or other periodic processes with the identical periodicity,... These properties mean that cyclo-stationary and periodic characteristics propagate along a TV coder (decorrelation, quantization and VLC) up to output to generate the resulting output stripe cell rate to be transmitted. As an additional feature of importance, the class of cyclo-stationary processes generated by a periodic transformation is a subclass with the property of constant mean and variance.

As a generalization of the periodic processes, the DNSPP can be defined in a pure non-stationary context. Under those general assumptions, an equivalent generation theorem and equivalent preservation properties can be demonstrated following a demonstrative path similar to that one followed with the periodic processes. Hence, as a final consequence, the entropy bit rate averaged over 8 video lines is a DNSPP approximated by cyclo-stationary processes or periodic processes within quasi-stationary scenes.

Definition of Cyclo-Stationary Processes

The *wide sense cyclo-stationary processes* are a subclass of non-stationary stochastic processes for which the two first moments exhibit a T-periodicity. As a consequence, the two first moments comply to the relations

$$M_x(n + T) = M_x(n) \tag{3.3}$$

$$R_{xx}(n + T, s + T) = R_{xx}(n, s) \tag{3.4}$$

Defining two independent variables successively called the *epoch* $t_m = \frac{n+s}{2}$ and the *delay* $\tau = n - s$, the process is wide sense cyclo-stationary with period T if it is periodic in t_m with a period T but not periodic in τ leading to the following expression

$$R_{xx}(t_m + T, \tau) = R_{xx}(t_m, \tau) \tag{3.5}$$

Definition of Periodic Processes

A more restrictive subclass of stochastic processes is the *periodic process* where

$$R_{xx}(n + T, s) = R_{xx}(n, s) = R_{xx}(n, s + T) \tag{3.6}$$

This means that the process is T-periodic in the delay τ and in the epoch t_m. Therefore,

$$R_{xx}(t_m + T, \tau + T) = R_{xx}(t_m, \tau) \tag{3.7}$$

to signify that all the realizations of $x(t)$ are T-periodic.

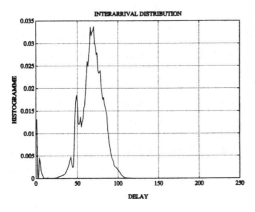

Figure 3.15: Stripe cell rate PDF at U=0.

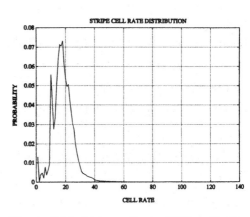

Figure 3.16: Stripe cell rate PDF at U=10.

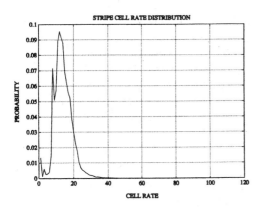

Figure 3.17: Stripe cell rate PDF at U=20.

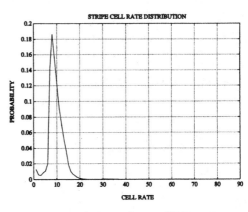

Figure 3.18: Stripe cell rate PDF at U=40.

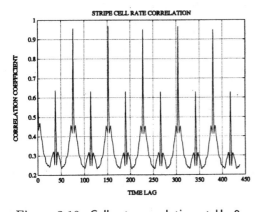

Figure 3.19: Cell rate correlation at U=0.

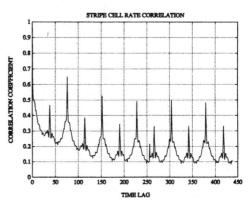

Figure 3.20: Cell rate correlation at U=40.

3.4. Statistical Analysis and Modeling Approach *249*

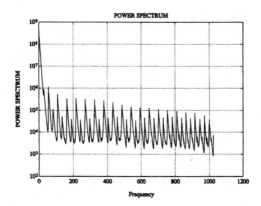

Figure 3.21: Power spectrum of the stripe cell rate ($\frac{f_s}{2} = 1024$).

A Subclass of Periodic Processes

The periodic process generated as the output of a periodic time scale transformation (camera) has a constant mean and a constant variance. This property defines a subclass of periodic processes in which only the autocorrelation function displays a periodic behavior.

Let $F(n) = c + p(n)$ be a time scale transformation with c being a known positive constant, $p(n)$ a T-periodic function and x a stationary process to be applied to the transformation: the calculation of the mean, of the auto-correlation function and of the variance of the output process $y = x[F(n)]$ demonstrates the proposition

1. for the mean

$$
\begin{align}
M_y(n+T) &= E\{x[c(n+T) + p(n+T)]\} \tag{3.8} \\
&= M_x(n) \qquad \forall n \tag{3.9} \\
&= M_y(n) \qquad \forall n \tag{3.10}
\end{align}
$$

2. for the autocorrelation function

$$
\begin{align}
R_{yy}(n+T, \tau+T) &= E\{x[c(n+T) + p(n+T)]x[c(\tau+T) + p(\tau+T)]\} \\
&= R_{yy}(t, \tau) \qquad \forall n, \quad \forall \tau \tag{3.11}
\end{align}
$$

3. for the variance

$$
\begin{align}
\sigma_y^2 &= R_{yy}(n, n) - M_y^2(n) \tag{3.12} \\
&= R_{xx}(0) - M_x^2 \tag{3.13}
\end{align}
$$

As a matter of conclusions, the stripe bit rate statistics are characterized during stationary scenes by a constant ratio $\frac{\sigma}{mean}$.

3.4.6 Modeling at the Image Layer

This section presents the statistics and the modeling at the image layer with moving average autoregressive (ARMA) processes. The statistics performed at this level will enable obtaining general characteristics of image bit rates, especially the probability density functions and the autocorrelation function. In Chapter 7, the image bit rates will allow estimating the gain in statistically multiplexing TV sources on the basis of optimum bandwidth allocation. The use of the image model results to be manifold, for instance, detecting scene changes and controlling coder output bit rates.

3.4.6.1 Statistics of Buffered Image Bit Rates

In this section, the bit rate is estimated on fixed time intervals of one image. In other words, the bit rates are equivalent to those obtained by accumulating the bit stream into a buffer over periods equal to one image and by launching the whole quantity on the network according to a predefined strategy. The image bit rates $R_I(n)$ given in Table 3.6 have been estimated at six different values of the transmission factor U=0 to 40. Table 3.6 gathers the mean m_{R_I} and the standard deviation σ_{R_I} both expressed in $\frac{bits}{image}$. Skewness and kurtosis are also tabulated. As a consequence of the significantly high kurtosis values, it has to be noticed that the shape of the bit rate PDF is relatively tightly shrunk around the mean. This implies a survivor function shaped as a narrow sigmoid function with a high sensitivity to errors when locating the survival at 10^{-n} (n=5 to 9) and, by consequence, when computing the bandwidth.

U	m_{R_I}	σ_{R_I}	S_{R_I}	K_{R_I}
0	1807686	388156	-2.72	8.63
5	729661	216449	-0.81	2.21
10	564822	115865	0.44	2.47
20	433622	92104	0.61	3.16
30	336443	80206	0.051	3.90
40	280943	64428	-0.22	3.16

Table 3.6: Statistics of the image bit rates $R_I(n)$.

What is significant in this table is the relatively constant value of the standard-deviation-to-mean ratio which stays around 0.21. That ratio turns out to be of some significance, it was already deduced from the early statistics carried out on the TV test sequences of reference (MOBILE AND CALENDAR,..). This ratio depends not only on the source signal characteristics but also on the particular coding algorithm used in the experimentation which prevents us from any excessive generalization.

Figure 3.22 displays at U=5, as an example, the image bit rates in function of 200 consecutive images to overview some scenes changes. Figures 3.23 to 3.26 present the image bit rate density functions. They are not really Gaussian laws. Figures 3.27 and 3.28 sketch correlation diagrams (time lag in image): they show the strong correlation existing within the image bit rates. Figure 3.29 analyzes the spectrum of the image bit rates (the reference frequency being the image frequency).

3.4.7 Bit Rate Models at the Image Layer

The bit rate models at the image layer are obtained by averaging the non-stationary periodic process over time spans equal or longer than the period. As a consequence, image bit rates loose any periodicity and are therefore modeled by non-stationary autoregressive moving average processes

$$x(t) = -\sum_{i=1}^{p} a(t,i)x(t-i) + \sum_{j=0}^{q} b(t,j)\epsilon(t-j) \tag{3.14}$$

with $x(t)$ being here the image bit rate, $[a(t,i); i = 1\ to\ p]$ the AR time-varying coefficients, $[b(t,j); j = 1\ to\ q]$ the MA time-varying coefficients and $\epsilon(t)$ a white Gaussian noise.

The model has been numerically estimated using the method of the least-square modified Yule-Walker equations which are known to be a method yielding accurate estimates of AR coefficients [Chapter 10 in [11]]. That algorithm uses more equations than unknowns and results in a least-square estimation of the AR parameters. A good rule of thumb is here to take $N \cong 3p$. The AR coefficients are therefore first estimated using Levinson recursions conjugated with a least-square estimation. Once the AR parameter estimates have been obtained, the data are filtered with the $A(z) = \sum_{i=1}^{p} a(k)z^{-k}$ to extract the MA part of the model on which Durbin's method is applied to derive the MA parameter estimates.

The adequate model orders, in the sense of minimizing the variance of the driving white noise, were found to be respectively 3 and 2 for the AR part and the MA part: the number of equations in the method was taken as three times the order of the AR part. Table 3.7 presents the model parameter obtained in one scene taken as example: mean value, a(i), b(i), σ variance of the driving noise.

U	0	10	20	30	40
mean (bit)	1573380	566368	425692	335739	283306
$a(1)$	0.88	0.88	0.93	0.94	0.95
$a(2)$	-0.45	-0.41	-0.46	-0.41	-0.45
$a(3)$	0.25	0.40	0.17	0.31	0.32
$b(1)$	-0.26	-0.10	-0.83	-0.28	-0.11
$b(2)$	0.11	0.26	-0.13	-0.27	-0.56
σ (bit)	211385	95448	53344	48351	35716

Table 3.7: Model parameters for image bit rates.

3.4.8 Modeling at the Scene Layer

The scene is an important period of time within the bit-rate time series: the bivariate sequence composed of scene-change instants and mean image bit rates (function of the specific density of information held in the scene) represents the most important part of the non-stationarity contained in the TV sources. Nevertheless, as a consequence of the editing video techniques, this non-stationarity is still amenable to modeling, the video bit

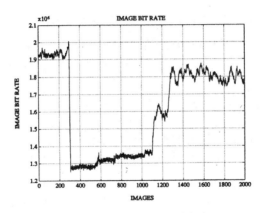

Figure 3.22: Image bit rate at U=5.

rate is decomposable into a succession of quasi-stationary segments and the scenes are precisely those quasi-stationary periods.

The statistical analysis of the scenes leads to characterize the probability density functions of both the scene duration and the mean image bit rate per scene. The algorithm to localize scene changes will be described below in Appendix 3.D by a statistical method. It is rather evident that, at this stage of the data rate analysis, the visual information of scene changes is not accessible and that only statistical methods can discriminate between an effective occurrence of a scene change and a small fluctuation within a scene. The detection of a scene change has to be taken according to some given threshold based criteria. As a statistical characterization of the image bit rates is of concern, a mathematical method of processing the data rate is more adequate than one consisting in counting de visu scene changes: what is important here is the significant changes in the data rates. Four different approaches can be carried out to locate the scene changes

1. detection of changes within the correlation structure of a model.

2. detection of changes in the mean value of the process.

3. detection of changes in the variance of model prediction errors. As a variant, the detection of the moments when the sequence of innovations deviates significantly from white noise.

4. detection of changes in the spectral properties.

According to Reference [1], the methods 1 and 2 should furnish more precise results. Method 2 provides the users with a real time implementable method. As the analysis is performed off-line on a computer, a combination of methods 1 and 2 [3.8], in principle more sophisticated, purely stochastic and but potentially more accurate, is developed in Appendix 3.D and has been used to the statistical description of the scenes. This numerical algorithm leads eventually to a simple testing procedure.

The modeling issue at the scene layer is thereafter presented with semi-Markov processes taking into consideration the double stochastic aspect of the scene inter-arrival

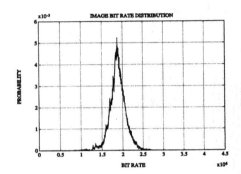

Figure 3.23: Image bit rate PDF at U=0.

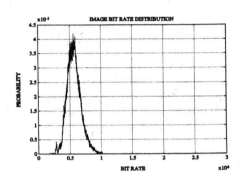

Figure 3.24: Image bit rate PDF at U=10.

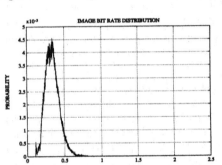

Figure 3.25: Image bit rate PDF at U=20.

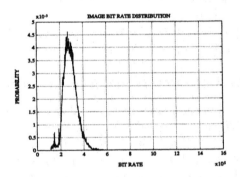

Figure 3.26: Image bit rate PDF at U=40.

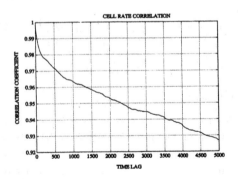

Figure 3.27: Image correlation at U=0.

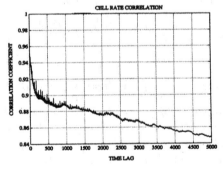

Figure 3.28: Image correlation at U=40.

Chapter 3. Bit Rate Models

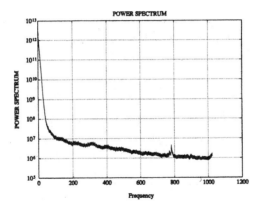

Figure 3.29: Power spectrum of the image bit rate at U=0 $\frac{f_i}{2} = 1024$.

durations and the mean image bit rates per scene. The instants of scene changes determine embedded points in between which the mean image bit rates are to be considered as the states of an embedded Markov chain. The state transition probability matrix is programme dependent. A further study at the scene layer will demonstrate to which extent programmes behave in a way significantly different from each other.

3.4.9 Statistics at the Scene Layer

The method of detecting scene changes presented in Appendix 3.D has been applied to the bit rate database and has furnished the general PDF of the scene inter-arrival process presented in Figure 3.30. The threshold of probability for the χ^2 test was put at 0.5, involving the detection of steps higher than 2.1 Mbit/s on the bit rate database at U=0. The presence of two lobes/modes in the PDF of the scene change inter-arrival times can be probably explained by two existing fashions of producing TV programmes: short scenes of the movies and long scenes taken in studio.

The mean image bit rate per scene has been gathered into a histogram with twenty points at U=0 and is presented in Figure 3.31. They are distributed as quasi-perfect Gaussian laws.

3.4.9.1 Bit Rate Models at the Scene Layer

The evolution of the image bit rate at the scene layer is mainly dependent on the type of encoding algorithm: pure intra coding i.e. without temporal prediction, intra-inter coding with temporal prediction using or not a motion compensation. The image bit rate obtained with a pure intra coder will stay quasi-stationary during the scenes giving an image bit rate in the form of a succession of staircases. Each stair corresponds to a particular scene and the discontinuities at scene changes are located at random point occurrences t_i. In the case of coders implementing intra-inter coding schemes, the first image of each scene is coded in the intra mode and is followed by intra-inter coded images. As a consequence, in this case, the first image of each scene will be characterized by a bit rate higher than the following ones within the scene.

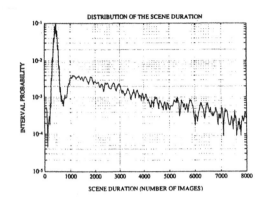

Figure 3.30: Statistics of the scene durations.

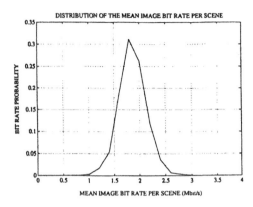

Figure 3.31: Histogram of the mean image bit rates per scene at U=0.

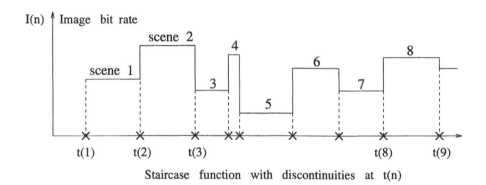

Staircase function with discontinuities at t(n)

Markov chain embedded in I(n)

Figure 3.32: Image bit rates at scene level.

In the case of a pure intra coding scheme, the image bit rates describe a continuous-time Markov chain which is a Markov process consisting of a family of staircase functions (discrete states) with discontinuities at random points. As presented in Figure 3.32, let $t(n)$ be the instant (discrete variable) of the n^{th} scene change, $R_I(t)$ the image bit rate (continuous variable) and $q(n)$ the value of $R_I(t)$ at $t(n)$

$$q(n) = R_I[t(n)] \qquad (3.15)$$

The values $q(n)$ of R_I taken at $t(n)$ generate a discrete-Markov sequence called the Markov chain embedded in the process $R_I(t)$. A discrete-state stochastic process is called semi-Markov if it is not Markov but the embedded sequence $q(n)$ generates a Markov chain. The semi-Markov process is specified by two processes as

1. the embedded Markov chain.

2. the underlying point process.

In the case of an intra-inter hybrid coder, the process remains a semi-Markov process under the condition to consider the Markov states as the mean image bit rate computed over the scene. Let us now describe those two processes.

Embedded Markov Chain

The embedded Markov chain is characterized, first, by the state probabilities i.e. the probabilities of having an image bit rate R_I within the scene located in a given range $p_i(t) = Pr[L_{i-1} \leq R_I(t) < L_i]$ where the L_i stands for the states thresholds and, secondly, by the state transition probabilities $\pi_{i,j}(t_1, t_2) = Pr[L_{j-1} \leq R_I(t_2) < L_j \mid L_{i-1} \leq R_I(t_1) < L_i]$. According to the accuracy to be obtained with the description, the whole range of admissible values of the mean image bit rate has to be sliced into an increasing number of states: 15 to 20 states seem to be sufficient for a fine description.

An example of state transition probability ($Pr[i, j]$ is the probability that, being in state i, the system changes to state j at scene change) is given in Table 3.8 with ten different states. Evidently,

$$\sum_j Pr[i, j] = 1 \quad \text{and} \quad p_i(t_2) = \sum_j Pr[i, j]P_j(t_1) \qquad (3.16)$$

The locations of scene change have been estimated here on one particular programme (movies, programme 4 in Section 5) at U=0. The whole scale of image bit rate has been subdivided into 20 equidistant segments of which the ten most significative are displayed on Table 3.8. The state i=j=1 represents the interval of image bit rates [35.0-37.5], each segment magnitude equals 2.5 Mbit/s. Let us remark that the transition matrix testifies of the existence of a well standing embedded Markov chain in the mean image bit rate per scene. Moreover, the transition matrices appear to be characteristic of the type of programme (movie, debate,...).

3.4. Statistical Modeling Approach　　　　　　　　　　　　　　　　　　　　257

$Pr[i,j]$	j=1	j=2	j=3	j=4	j=5	j=6	j=7	j=8	j=9	j=10
i=1	0	0.353	0.470	0.117	0.058	0	0	0	0	0
i=2	0.013	0	0.427	0.386	0.093	0.066	0.013	0	0	0
i=3	0.009	0.028	0	0.420	0.411	0.065	0.047	0.018	0	0
i=4	0	0.015	0.097	0	0.466	0.256	0.120	0.045	0	0
i=5	0	0	0.010	0.151	0	0.495	0.222	0.111	0.010	0
i=6	0	0	0.020	0.040	0.240	0	0.340	0.320	0.040	0
i=7	0	0	0	0.026	0.184	0.394	0	0.263	0.026	0.105
i=8	0	0	0	0	0	0	0.50	0	0.250	0.250
i=9	0	0	0	0	0	0	0.25	0.50	0	0.25
i=10	0	0	0	0.5	0	0	0.5	0	0	0

Table 3.8: Matrix of transition $Pr[i,j]$ of the embedded Markov chain $q(n)$.

The Underlying Point Process.

The occurrence of scene changes can be represented in whole generality by any process modeling random arrivals: Poisson, renewal and point processes. As presented in the statistical description, the probability density function of the duration displays a general shape. Point processes should the most general way to describe the scene change inter-arrival process. Nevertheless, due to the particular low level of correlation in between consecutive scenes $[R_{xx}(0) = 1.0, 0.1 < R_{xx}(1) < 0.2]$, a realistic representation consists of considering the inter-arrivals as elements of a renewal process. A simplification can be easily proposed by fitting a Gamma probability density function (Figure 3.30), namely $f(r) = \frac{\rho(\rho r)^{(\beta-1)}\exp[-\rho r]}{\Gamma(\beta)}$ with r the scene change inter-arrival time, ρ the mean rate of change arrivals, Γ the Gamma function of a real parameter β. In the present case, $0 < \beta < 10$ and, especially if β is taken as an integer, the density is Erlang which allows one to handle the process analytically and to exploit formal expressions with that model. The discrimination among log-normal, Weibull and Erlang is usually performed by considering first the asymptotic behavior as the scene length tends to infinity (exponential in our case i.e. in favor of the Gamma family) and secondly the skewness on which similar conclusions may be drawn in favor of the Gamma PDF. In any case, very accurate models should consider a superposition of at least two Gamma one for TV-studio recordings (long and often simple scenes) and another for fast-motion-content recordings (short and information-dense scenes).

Contribution of the Study at the Scene Layer

The main contribution is here to derive an embedded Markov process and, even more typically, a semi-Markov process to characterize the image bit rates at the scene layer. To summarize the constructive way to define a semi-Markov process, we consider a stochastic matrix to take into account transition in a process which evolves as follows. The transitions occur from state to state according to a Markov chain and whenever the process sojourns in state i, the next state to be visited is j with probability p_{ij}. When the successive states are i and j, the density of the sojourn time is in whole generality a function of the states i and j. The process which records the state at each time is the semi-Markov

process. A common version of semi-Markov process is the embedded Markov chain within a renewal independent and identically distributed (i.i.d. or GI in Kendall notations) arrival process. Our scene-bit-rate model combines those two features a renewal process (the occurrence of scene changes is an i.i.d. arrival process) and a Markov process (the value of the mean image bit rates per scene) and can be modeled as semi-Markov process. The theory relative to that process is developed by Sobel and Heyman in Reference [10].

3.5 Statistics at the Programme Layer

One programme is to be considered as a whole entity characterized by specific stationary statistics. The database of actual TV signal can be split into 15 different programmes. Table 3.9 presents the values of the mean image bit rates for those fifteen different real time TV programmes of 1.5 hour each. The bit rate is freely variable and the transmission factor is maintained constant. The mean image bit rate at equal subjective quality is one of the most significant criteria to negotiate a change (renegotiation) in the bandwidth allocated by the network.

Programme	U=0	U=2	U=5	U=10	U=20	U=30	U=40
PG(1)	41.6	25.3	15.2	12.2	9.2	6.1	6.3
PG(2)	36.4	16.6	10.6	9.6	8.1	6.8	5.1
PG(3)	46.8	27.0	16.7	14.1	10.8	8.6	7.2
PG(4)	45.4	26.7	18.2	13.2	10.1	8.2	6.9
PG(5)	47.5	28.7	19.4	14.1	10.7	7.0	6.5
PG(6)	66.8	30.7	21.9	15.8	12.4	8.9	8.1
PG(7)	45.6	26.4	17.3	12.0	8.3	6.8	6.4
PG(8)	43.6	21.2	16.3	12.1	9.3	6.9	6.4
PG(9)	44.4	25.6	17.5	12.9	10.0	7.9	6.7
PG(10)	47.3	27.1	19.5	13.9	10.6	8.4	6.8
PG(11)	44.2	25.9	17.4	12.5	9.2	7.6	6.4
PG(12)	37.5	29.1	17.3	14.0	10.7	8.4	6.7
PG(13)	35.9	22.6	15.1	9.9	8.6	6.6	6.0
PG(14)	45.8	27.5	16.1	13.3	10.2	8.2	7.0
PG(15)	46.1	27.7	18.9	13.5	10.6	8.3	7.2

Table 3.9: Characteristics of 15 different programmes: mean image bit rates [Mbit/s] at different values of the transmission factor U.

The variability of the mean is more significative for low transmission factors. At high transmission factors, $U \geq 20$, all intermediate and high frequency transform coefficients are quantized to zero and, therefore, all mean image bit rates are rather close each to the other. At low transmission factors and, especially, when no motion compensation is applied, variability is higher. For $U \leq 10$, the range becomes higher than the half of the global mean rate value. For example, at $U = 10$, the mean equals 12.8 Mbit/s with a range equal to [15.8 − 9.6 =] 6.2 Mbit/s. At $U = 5$, the mean and the range values are respectively equal to 17.16 Mbit/s and [21.9 − 10.6 =] 11.3 Mbit/s. The main

conclusion so far is that a negotiation of bandwidth at the horizon of programmes is not to be disregarded, especially in cases where $U \leq 10$.

Programme	U=10	U=20	U=30	U=40	U=50
PG(1)	23.7	20.4	11.2	6.2	4.7
PG(2)	19.3	16.5	8.5	5.0	4.3
PG(3)	25.0	21.6	12.1	6.9	5.2
PG(4)	24.7	21.3	11.9	6.5	4.9
PG(5)	25.4	21.8	12.0	6.5	4.8
PG(6)	25.2	22.7	14.2	8.3	5.8
PG(7)	25.5	20.1	10.9	6.2	4.6
PG(8)	23.1	20.1	10.8	5.8	4.4
PG(9)	22.2	19.3	11.8	6.3	4.4
PG(10)	24.9	21.9	12.4	6.6	4.8
PG(11)	23.5	20.6	11.0	5.8	4.7
PG(12)	27.6	23.8	13.4	6.6	4.6
PG(13)	21.3	17.9	9.4	5.4	4.4
PG(14)	25.9	22.4	12.7	6.4	4.9
PG(15)	24.3	21.0	12.1	7.0	5.4

Table 3.10: Characteristics of 15 different programmes: mean image bit rates [Mbit/s] at different values of the transmission factor U (case with motion compensation: coder-model 2).

SOURCE	mean	standard deviation	skew	kurtosis	min	max
1	485387	107824	1.28	4.10	152672	2136320
2	445602	101587	1.39	4.40	152640	2215680
3	567590	112838	0.48	1.06	153664	1740576
4	534601	87795	0.82	1.77	157568	1135872
5	565470	112095	0.81	1.42	151040	1995904
6	637316	280220	1.15	1.24	141690	2119616
7	478492	121705	0.55	0.55	151136	1193088
8	484595	122576	1.74	6.91	139680	2665376
9	518635	124566	1.09	2.73	155968	1247008
10	558996	137127	0.51	1.41	150944	2341792
11	534091	77678	1.09	5.92	158304	1361664
12	569346	84629	0.65	1.20	208864	1214592
13	447092	70094	0.58	2.08	155520	1205312
14	533877	87839	0.58	4.43	157632	2084512
15	538005	151196	0.53	1.52	138112	2801792

Table 3.11: Characteristics of 15 different sources, U=10, coder-model 2 (unit: bit/image).

3.6 Statistics on other Coders

Some interesting features can be noticed from statistics performed on other coders. Two coders are intended to be examine investigated to extract other potential source behaviors and better understand the influences of coding characteristics on the statistical outcome. Readily, the trend has been to start with a simple algorithm using merely intra mode with poor temporal prediction capabilities, as there is no motion compensation, and to continue with coder exploiting more efficiently the temporal prediction with motion compensation at a fraction of pixel accuracy and forward and backward estimations. These two new algorithms are respectively the coder-model 2 and the MPEG-II coders.

3.6.0.2 The Coder-Model 2

This coder performs a prediction with motion compensation at pel-accuracy (Figure 3.33). Let us notice that the DCT operator is here located within the predictive loop, that the precision on transform coefficients requires one bit more than coder-model 1 and that the entropy coder uses the ACVLC's with zig-zag scanning within the transform DCT blocks. Algorithmically, this coder carries out the algorithm developed in the CCIR Recommendation 723 for digital TV contribution FBR applications at 34-45 Mbit/s in 50-60 Hz countries. The only noticeable difference in coder-model 2 for this statistical study is the use of ACVLC entropy coders instead of B1 codes.

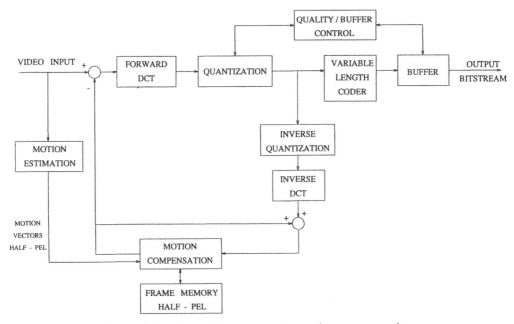

Figure 3.33: Hybrid TV coder with motion compensation.

Noticeable differences with the first coder can be summarized at each level of the model as follows

1. about cell inter-arrival times, the PDF's are mainly dependent on the VLC's. An intra-block zig-zag scanning of the DCT coefficients compared with an order by order scanning (UVLC) tends to shape the inter-arrival time density functions towards more uniformity. The VLC in this second case encodes the blocks by groups of quad-blocks. A quad-block is made of two neighbor luminance blocks with the two corresponding chrominance blocks. At a mean bit rate of 15 Mbit/s, the capacity of the ATM cell corresponds to about two coding quad-blocks [5].

2. about stripe bit rates, the proportions of intra-inter coded cell rates are related to the capacity of the temporal decorrelative process. Figure 3.34 shows how the proportions differ in a motion compensated coder in comparison with the first coder (Figure 3.6). The correlation function is periodical according to the way of processing i.e. frame by frame or field by field (Figure 3.35).

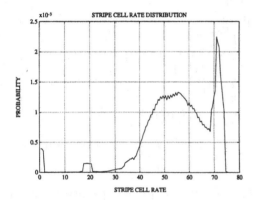

Figure 3.34: Stripe cell rate PDF at U=0.

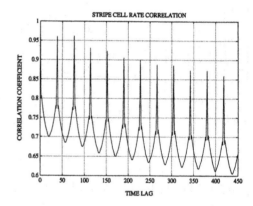

Figure 3.35: Stripe cell rate correlation at U=0.

3. about image bit rates, correlations between consecutive image bit rates are expected to decrease when the temporal decorrelative capabilities increase (the autocorrelation function versus image lag is presented in Figure 3.36 which has to be compared with Figure 3.27). The image bit rate PDF's are thereafter presented in Figure 3.37.

4. about scene statistics, the location of scene changes remains unchanged from one coder to another. The image bit rates decrease during the few first frames following the scene changes according to intuition.

5. about programme characteristics, Table 3.10 with the different mean image bit rates presents smaller differences when estimated on a coder with motion compensation. For example, at $U = 10$, the global mean and range stay at 24.1 Mbit/s and $[27.6 - 19.3 =]$ 8.3 Mbit/s and, at $U = 20$, the parameters equal 20.7 Mbit/s and

[5] a quad-block is made of two luminance and two chrominance (8 × 8) blocks, these four blocks are adjacent in the image

Chapter 3. Bit Rate Models

[23.8−16.5 =] 7.3 Mbit/s. In any case, the range remains lower than the third of the mean. Higher differences in between programmes are to be pointed out with other moment orders referred in Table 3.11. That table summarizes of the characteristics for 15 different sources (coder-model 2) which aim at being multiplexed. It is given to present the variability of TV sources beyond the first moment. Each individual source represents a different programme corresponding to Table 3.11 at a transmission factor U equal to 10. The table furnishes mean images bit rate (bit/image), standard deviation (bit/image), skewness, kurtosis, minimum value (bit/image) and maximum value (bit/image).

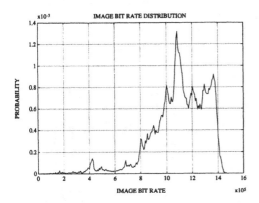

Figure 3.36: Image bit rate PDF at U=0.

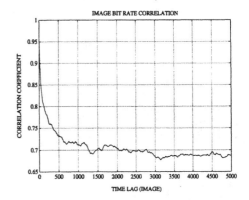

Figure 3.37: Image bit rate correlation at U=0.

3.6.0.3 The MPEG-II Coder

The MPEG-II coder presented schematically in Figure 3.38 and described in [14] introduces new coding modes or picture types referred to as the I-pictures, for intra coded pictures, the P-pictures, for forward motion-compensated prediction pictures and B-pictures, for motion-compensated interpolation pictures. Every N frame, a picture is coded in intra mode. (1, N+1, 2N+1, ...). M (< N) frames define a group of pictures and every M frame, a picture is coded in the predicted mode P. The interpolated frame in the group of M pictures is coded with reference to the two closest previous and next predicted or intra frame. No particular entropy coders are specified so far for MPEG-II coders.

The pictures are commonly subdivided into slices and macro-blocks. A macro-block is made of 4 blocks (8 × 8) of luminance and 4 blocks (8 × 8) of chrominance. The slice is composed of 16 consecutive video lines. Two types of motion vectors are estimated for each macro-block of P and B-frames; these are frame motion vectors and field motion vectors. One motion vector is generated per macro-block and per direction, forward and backward.

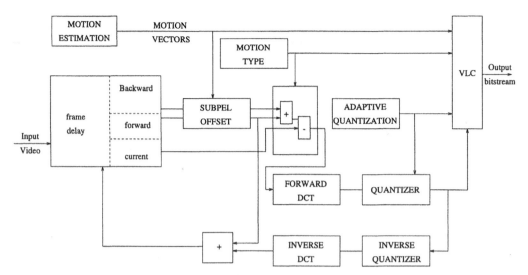

Figure 3.38: Schematic overview of the MPEG-II coder.

Figures 3.39, 3.41 and 3.43 present the bit rate distributions for I, P and B-frame macro-blocks. As a matter of fact, the PDF's are the most spread for I-frame macro-blocks, where the diversity in informative content is the highest, and more and more concentrated for P and B-frame macro-blocks, where noise prediction is more and more involved.

Figures 3.40, 3.42 and 3.44 report the bit rate PDF's for I, P and B-frame slices. Similar phenomena are observed among I, P and B PDF's. The intra mode displays wide-spread PDF's. Prediction mode displaces and concentrates the probability densities to lower bit rates leaving caudal densities extending towards higher bit rate values.

Figure 3.45 shows the temporal evolution of the picture bit rate. The observation of that diagram leads immediately to the conclusions that follow. The image or picture bit rate of any TV source can be expected to be in between two extreme cases, namely that of a simple intra mode coder and that of an optimally efficient intra/inter mode coder. The former extreme case will display image bit rates in form of a succession of steps with random heights and time lengths. The latter extreme case will display impulses of intra coded pictures with random heights emerging from a rather flat base line of pictures which are optimally coded in a predicted or interpolated mode. The intra-coded pictures are either randomly localized, as the first picture of a new scene to be coded, or deterministically positioned, as an imposed refresh picture. The inter-coded pictures bit rate are mostly made of prediction noise arising as innovative information .

3.7 Conclusions

In this chapter, a multiscale model of TV source bit rates has been presented. The model considers the input signal as a non-stationary source of entropy. Owing to the structure of editing the video information and encoding algorithms, the input signal can

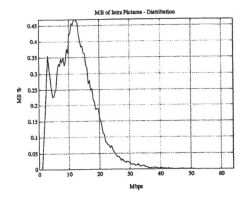

Figure 3.39: MB bit-rate PDF for I pictures.

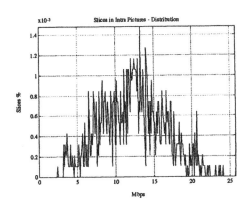

Figure 3.40: Bit-rate PDF for I pictures.

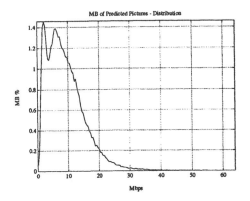

Figure 3.41: MB bit-rate PDF for P pictures.

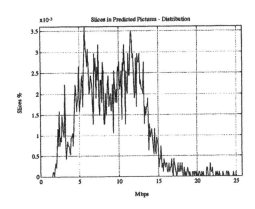

Figure 3.42: Bit-rate PDF for P pictures.

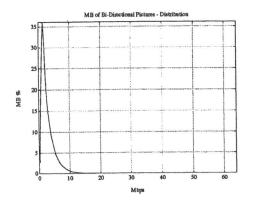

Figure 3.43: MB bit-rate PDF for B pictures.

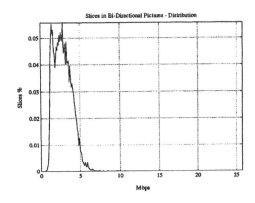

Figure 3.44: Bit-rate PDF for B pictures.

3.7. Conclusions

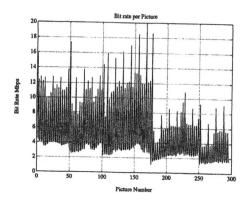

Figure 3.45: Picture-bit-rate process.

still be structured into a hierarchical description. First of all, a TV session is composed of programmes which have been successively divided into scenes, images, stripes and cells. All those levels have been represented with adequate models. Among the most important achievements leading to characterize the source multiplexing in Chapter 5, two models have to be mentioned: the Markov modulated Poisson processes to represent cell inter-arrival processes, especially for high transmission factors, and Markov renewal processes to represent the evolution of image bit rates at scene layer. Chapter 4 will go on modeling whole coders and terminating the encoding side of the transmission chain.

From the statistical study, it turns out clearly that

1. the statistics of cell inter-arrival time processes are essentially determined by the VLC and the packetizer procedures implemented in the coder under consideration.

2. the statistics of sub-image bit rates and, especially at the stripe level, are periodic processes characterized by constant means and variances and by periodic auto-correlation functions. This periodic property originates from the image scanning process of the image performed by the camera on the natural scenes (the observed periodicity depends on the desired image formats). The probability density functions are expected to display a multi-modal shape testifying of the different coding modes, for instance, the *pure intra* and the *inter-frame* modes implemented within the coding algorithm. There should be as much modes to be observed in the resulting PDF as coding modes in the algorithm. Each of those coding modes contributes individually in the resulting PDF with an intensity proportional to the frequency by which it is solicited.

3. the statistics of image bit rates turn out to be rather more peaky than a Gaussian shape. Consequently, the PDF description will be more difficult since it involves more parameters to be accurately shaped and more sensitive to parameter errors particularly when computing the bandwidth.

4. the scenes statistics depend on the sources and typically on how the video pro-grammes are edited in studio. The scenes contribute significantly to the non-

Chapter 3. Bit Rate Models

stationarity in the TV signal by the occurrence of scene changes and by the related mean image bit rate within the scenes. All the statistics can be roughly considered as quasi-stationary within the scenes.

5. the changes in TV programmes are foreseeable and normally planned by the broadcasting center. The programme bit rate statistics should be known in advance and, therefore, require a possible preventive negotiation with the network management to readjust the available bandwidth.

From this study, it can be readily inferred that two different possibilities of transmitting cells on the network can be taken into consideration

1. the source is free to launch cells at this own rhythm of packetization (a free VBR source without any gauge policing the output variable bit rate). In the free VBR case, the arrival process is a characteristic of the VLC and of the packetizer, the model chosen to characterize the cell generation (traffic equation) is a point process and in whole generality a MMPP(m). Referring to the actual way of launching cells on an ATM channel, there is no need to develop generation processes with batch events since it is not possible to transmit several cells simultaneously, one cell at a time is the rule imposed by the nature of the channel. Bursty events (consecutive slots dwelled by the same source is highly likely to occur) are to be taken into considerations, this possibility may be included in an MMPP(m). In first approximation, the MMPP(2) which allows to take into account a set of four statistical parameters to characterize the cell generation suits the source modeling with an acceptable compromise between the number of descriptive parameters to be utilized and the model accuracy. The results obtained in the experiment are not the only determinants in the problem, those four parameters will be in fact precisely defined in Chapter 5 where inter-arrival time processes will be studied into more details, especially in connection with the source superposition and the queueing issue. In any case, these four parameters should incorporate mean and variance values and additional items like the correlation between inter-arrivals and the skewness of PDF's.

2. the coder accumulates in the output buffer the data stream to be transmitted during a given time span and transmits this buffered amount of data spread within the following time span. It remains at this stage to determine optimum time span to accumulate the output bit stream and how to spread cells over the next period. In this second method, the model to characterize sources is given, first, by the probability density function of cell rates estimated over optimum time span and, secondly, by the cell inter-arrival time characteristics. Chapter 7 will answer both questions.

Those two options will be revisited successively in Chapters 5 and 7 in order to search the optimum way of transmitting the TV information on ATM networks. At the end of the present chapter, only the first part of the work has been performed in the search to deduce traffic descriptors and source parameters likely to be enforced. The next

steps in this textbook consist, first, of investigating source multiplexing characteristics (Chapter 5) and, secondly, of providing the additional stepping-stone of the optimum transmission on the ATM networks (Chapter 7).

3.8 Bibliography

[3.1] M. Basseville "Detecting Changes in Signals and Systems: A Survey", *Automatica, Vol. 24, No. 3, pp. 309-326, 1988.*

[3.2] M. Basseville, I. V. Nikiforov "Detection of Abrupt changes: Theory and Applications", *Prentice Hall, Englewood Cliffs, NJ, 1993.*

[3.3] E. Çinlar "Introduction to Stochastic Processes", *Prentice-Hall, Englewood Cliffs, NJ, 1975.*

[3.4] D. R. Cox "Some Statistical Models Connected with Series of Events", *J. R. S. S. B-17, pp. 129-164, 1955.*

[3.5] L. E. Franks "A Model for the Random Video Process", *Bell System Technical Journal, pp. 609-630, April 1966.*

[3.6] W. A. Gardner "The Spectral Correlation Theory of Cyclo-Stationary Time-Series", *Signal Processing, 11, pp. 13-36, 1986.*

[3.7] W. A. Gardner "Introduction to random Processes with Applications to Signals and Systems", *Mc Graw Hill, New-York, 1984.*

[3.8] J. Grandell "Doubly Stochastic Poisson Process", *Springer-Verlag, Berlin, 1976.*

[3.9] Y. Grenier "Identification des modèles ARMA non stationnaires", *Proceedings Séminaire Algorithmes Rapides pour le traitement des Systèmes Linéaires, Aussois, France, RCP CNRS 567, pp. 10.1-10.19, 1981.*

[3.10] D. P. Heyman and M. J. Sobel "Stochastic Models in Operations Research", *McGraw-Hill Book Company, Volume I.*

[3.11] S. M. Kay "Modern Spectral Estimation: Theory and Application", *Prentice-Hall, Signal Processing Series, Englewood Cliffs, NJ, 1988.*

[3.12] J. F. Kingman "On Doubly Stochastic Poisson Process", *Royal Cambridge Philosophic Society, 60, pp.923-960, 1964.*

[3.13] J.-P. Leduc, S. D'Agostino "Universal VBR Videocodecs for ATM networks in the Belgian Broadband experiment", *Signal Processing: Image Communication, Vol. 3, pp. 157-165, June 1991.*

[3.14] D. J. Le Gall "The MPEG video compression algorithm", *Signal Processing: Image Communication 4, pp. 129-140, 1992.*

[3.15] K. S. Meier "A Statistical Procedure for Fitting Markov-Modulated Poisson Processes", *Ph.D. Thesis, University of Delaware, USA, 1984.*

[3.16] G. V. Moustakides, A. Benveniste "Detecting Changes in the AR Parameters of a Nonstationary ARMA Process", *Stochastics, Vol. 16, pp. 137-155, 1986.*

[3.17] A. Papoulis "Probability, Random Variables, and Stochastic Processes", *Mc Graw Hill, New York, 1984.*

[3.18] A. Papoulis "Predictable Processes and Wold's Decomposition: a Review", *IEEE Transactions on ASSP, Vol. 33, No. 4, pp. 933-938, August 1985.*

[3.19] R. Pyke "Markov Renewal Process: definitions and preliminary properties", *Annales Mathematical Statistics, 32, pp. 1231-1242, 1961.*

Appendix

3.A Markov Modulated Poisson Processes

The Markov modulated Poisson processes have emerged as one of the notable way of modeling traffic equations i.e. cell arrival processes originating from individual sources connected on the network. The MMPP's belong to the family of the doubly stochastic processes. As such, they hold as a specific family of point processes. Furthermore, the MMPP is also a particular case of the versatile Markovian point process originally introduced by Neuts [27] on which further important research efforts have been devoted in order to yield tractable numerical algorithms dealing with queueing systems fed by this general process. These modeling aspects are tackled in Chapter 5 where the concern is focused on ATM multiplexers.

3.A.1 Definition of the MMPP

A MMPP is a doubly stochastic process i.e. a Poisson process whose rate varies according to a continuous time function, and especially in this case, to an irreductible m-state continuous time Markov chain. When the underlying Markov chain is in state i, $0 \leq i \leq m$, the MMPP is said to be in phase i and the arrival rate of points is λ_i during the sojourn in that phase. To avoid triviality, the λ_i are assumed to be positive. The notation MMPP(m) is utilized to denote that the underlying Markov chain has m states. An MMPP(m) process is completely specified by three elements

1. the infinitesimal generator Q of the underlying Markov chain defined as

$$
Q \; = \;
\begin{vmatrix}
-\sigma_1 & \sigma_{12} & \cdots & \sigma_{1m} \\
\sigma_{21} & -\sigma_2 & \cdots & \sigma_{2m} \\
\cdot & \cdot & \cdots & \cdot \\
\cdot & \cdot & \cdots & \cdot \\
\cdot & \cdot & \cdots & \cdot \\
\vdots & \vdots & \cdots & \vdots \\
\sigma_{m1} & \sigma_{m2} & \cdots & -\sigma_m
\end{vmatrix}
\tag{3.17}
$$

 where the parameters σ_i stand for the mean sojourn times in state i. The related theory to this way of representing Markov chains is presented in [3].

2. the diagonal matrix Λ where the i^{th} diagonal element represents the arrival rate $\lambda_i \geq 0$ of the Poisson process activated in phase i, that is

$$
\Lambda \; = \; diag[\lambda_1, ..., \lambda_m]
\tag{3.18}
$$

3. the initial probability vector γ that the state or the phase of the Markov chain having the generator Q at time t=0 be in J=1, ..., m

$$\underline{\gamma}(i) \;=\; Pr[J(0) = i] \qquad \sum_{i=1}^{m} \underline{\gamma}(i) \;=\; 1 \qquad\qquad (3.19)$$

The stationary version of the process is obtained by choosing the initial state probability vector equal to the stationary vector $\underline{\pi}$ of matrix Q. For the shake of brevity, the stationary MMPP(m) with specific γ, Q and Λ parameters is referred to as a $(Q, \Lambda) - source$ in the literature.

3.A.2 Characterizing the MMPP(m)

Neuts has pointed out that the MMPP is a special case of a more general process defined in Chapter 5 and called the versatile Markovian point process or N process. The MMPP is a particular case of doubly stochastic Poisson process as explained in [4] and [8]. More informally, the doubly stochastic Poisson processes were first introduced by Cox, as a non-homogeneous Poisson process whose rate varies according to a non-negative stationary stochastic process. The MMPP corresponds to the special case where the non-negative stationary stochastic process is a continuous-time Markov chain. To further outline the contribution brought by Kingman [12], let $\Gamma(t)$ be a non-negative stationary stochastic process, measurable in the sense of Doob and suppose that $\Gamma_*(x) = \int_0^t \Gamma(t)dt$ is finite for all finite x, but not identically zero. Then the right-continuous inverse function $\Gamma^{-1}(x)$ of $\Gamma_*(x)$ exists. If π is a Poisson process of rate one and independent of Γ, then conditional on Γ, the process $\Gamma^*(\pi)$ is an inhomogeneous Poisson process with rate $\Gamma(t)$ and the process $\Gamma^*(\pi)$ is a representation of the doubly stochastic Poisson generated by Γ.

The MMPP may also be considered as a Markov renewal process as shown hereafter to ease the analytical derivations. The bivariate sequence of random variables $\{(J_n, X_n) : n \geq 0\}$ is defined as follows. Let J_0 denote the phase of the Markov process having generator Q at t=0, and let $X_0 = 0$. The n^{th} event of the MMPP is associated with the corresponding state J_n of the underlying Markov process as well as the time X_n, $n \geq 1$, between the $(n-1)^{th}$ and the $(n)^{th}$ arrival. Hence obviously the bivariate sequence $\{(J_n, X_n) : n \geq 0\}$ defines a Markov renewal sequence. It can be also easily shown that the transition probability distribution matrix $F(.)$ is given by

$$F(x) \;=\; \int_0^t e^{(Q-\Lambda)t}\Lambda dt \qquad x > 0 \qquad\qquad (3.20)$$

of which the elements $F_{ij}(x)$ are the conditional probabilities $Pr[J_n = j, X_n < x | J_{n-1} = j]$, for $n \geq 2$. When the origin of time does not correspond to an arrival instant, the probabilities $Pr[J_n = j, X_n < x | J_0 = j]$ have to be defined separately.

Let $X_1, X_2,, X_n$ be the first n sojourn intervals in the Markov renewal process. The Laplace-stieltjes transform $f^*(s)$ of the transition probability matrix $F(.)$ is given by

$$f^*(s) \;=\; E\{e^{-sX}\} \;=\; (sI - Q + \lambda)^{-1}\Lambda \qquad\qquad (3.21)$$

Similarly, the joint Laplace-Stieltjes transform matrix $f^*(s_1,, s_n)$ of $X_1, ..., X_n$, $n \geq 1$, is given by

$$f^*(s_1, ..., s_n) = E\{e^{-\sum_{k=1}^{n} s_k X_k}\} \tag{3.22}$$

$$= \prod_{k=1}^{n} [(sI - Q + \lambda)^{-1}\Lambda] \tag{3.23}$$

The factor corresponding to the first sojourn interval may have to be modified in cases where the time origin is not an arrival instant. The time-stationary version is obtained by choosing J_0 to be the stationary vector $\underline{\pi}$ of Q, that is, the unique vector satisfying

$$\underline{\pi}Q = \underline{0} \quad \text{with} \quad \underline{\pi}e = 1 \tag{3.24}$$

and by defining the conditional probabilities $Pr[J_1 = j, X_1 \le x | J_0 = j]$ as before. This is the particular version for the MMPP construction described for the general Markov renewal process in Pyke [19].

3.A.3 Moments of the MMPP(m) Process

In this section, different moment formulae of the MMPP(m) are presented and calculated for both companion versions, namely the inter-arrival time processes and the counting processes.

3.A.3.1 Inter-arrival Times

Non-central and product moment matrices of the inter-arrival time processes are evaluated from the Laplace-Stieltjes transform $f^*(s)$ by exploiting the general properties of the moment generating functions.

1. the non-central moment matrices $\mu'_{i,n} = E[x_i^n], \quad i \ge 1$ can be evaluated by calculating the partial derivatives of the matrix Laplace-Stieltjes transform $f^*(s_1, s_2, ..., s_{n+1})$

$$(-1)^n \frac{\partial^n f^*(s_1, ..., s_i)}{\partial s_i^n}\Big|_{s_1=s_2=....=s_i=0} \tag{3.25}$$

which allows deducing, after some calculations,

$$\mu'_{i,n} = [(\Lambda - Q)^{-1}\Lambda]^{i-1}(\Lambda - Q)^{-n-1}\Lambda \tag{3.26}$$

2. the product moment matrices $\mu_{1,n+1} = E[X_1 X_{n+1}], i \ge 1$, are found by calculating the partial derivatives

$$\frac{\partial^2 f^*(s_1, ..., s_{n+1})}{\partial s_1 \partial s_{n+1}}\Big|_{s_1=s_2=....=s_{n+1}=0} \tag{3.27}$$

leading eventually to

$$\mu_{1,n+1} = (\Lambda - Q)^{-2}\Lambda[(\Lambda - Q)^{-1}\Lambda]^{-n-1}\Lambda(\Lambda - Q)^{-2}\Lambda \qquad (3.28)$$

3. the n-step correlation matrix $E\{[X_1 - E(X_1)][X_{n+1} - E(X_{n+1})]\}$, $n \geq 1$, is derived after some calculations from

$$\{\frac{\partial^2 f^*(s_1, ..., s_{n+1})}{\partial s_1 \partial s_{n+1}} - \frac{\partial f^*(s_1, ..., s_{n+1})}{\partial s_1} - \frac{\partial f^*(s_1, ..., s_{n+1})}{\partial s_{n+1}}\}|_{s_1=s_2=....=s_{n+1}=0} (3.29)$$

as

$$E\{[X_1 - E(X_1)][X_{n+1} - E(X_{n+1})]\}$$
$$= (\Lambda - Q)^{-2}\Lambda \{ [(\Lambda - Q)^{-1}\Lambda]^{-n-1} - [(\Lambda - Q)^{-1}\Lambda]^{2n} \} (\Lambda - Q)^{-2}\Lambda \qquad (3.30)$$

Let us now investigate the rate at which the n-step correlation matrix converges to zero as $n \to \infty$ in case of having a diagonalizable the stochastic matrix $(\lambda - Q)^{-1}\Lambda$. The eigenvalues of $(\lambda - Q)^{-1}\Lambda$ are denoted $1, \gamma_2, ... , \gamma_m$ and sorted as $1 \geq |\gamma_2| \geq ...|\gamma_m|$. Denoting the right and left eigenvectors \underline{v}_j and \underline{u}_j as those corresponding to the eigenvalues γ_j, with $2 \leq j \leq m$. It may be demonstrated that, as $n \to \infty$, the n-step correlation matrix, $E\{[X_1 - E(X_1)][X_{n+1} - E(X_{N+1})]\}$ tends to zero geometrically with the rate γ_2 as follows

$$E\{[X_1 - E(X_1)][X_{n+1} - E(X_{n+1})]\}$$
$$= (\gamma_2^n - \gamma_2^{2n+1})(\Lambda - Q)^{-1}\underline{v}_2\underline{u}_2(\Lambda - Q)^{-2}\Lambda \qquad (3.31)$$
$$+ \sum_{k=3}^{m}(\gamma_k^n - \gamma_k^{2n+1})(\Lambda - Q)^{-1}\underline{v}_k\underline{u}_k(\Lambda - Q)^{-2}\Lambda$$

To prove this proposition, the trick consists of exploiting the fact that $(\Lambda - Q)^{-1}\Lambda$ is diagonalizable in order to write the n^{th} power of the matrix in form of $[(\Lambda - Q)^{-1}\Lambda]^n = \underline{e}\underline{p} + \sum_{k=2}^{m} \gamma_k^m \underline{v}_k\underline{u}_k$, where \underline{p} is the stationary vector of $(\Lambda - Q)^{-1}\Lambda$. Then, by substituting into 3.30 and using the fact that \underline{v}_k is a right eigenvector of $(\Lambda - Q)^{-1}\Lambda$, the result 3.31 is deduced.

3.A.3.2 Counting Processes

The number of arrival in the interval $(0, t]$ is denoted by $N(0, t)$ and the phase of the process $J(t)$ at time t. The moment matrix-generating function allows deriving the moments which follow.

Mean Value Matrix

The matrix $M(t) = \{E[N(0, t), J(t) = j|N(0) = 0, J(0) = i]\}$ of the mean number of arrivals in the interval $(0, t]$ is given by

$$M(t) = \sum_{n=1}^{\infty} \frac{t^n}{n!} \sum_{\nu}^{n-1} Q^{\nu}\Lambda Q^{n-1-\nu} \qquad (3.32)$$

Moment Vectors

The vector $\underline{\mu}(t) - M(t)\underline{e} = \{E[N(0,t)|N(0,0) = 0, J(0) = i]\}$ is given by

$$
\begin{aligned}
\underline{\mu}(t) \;=\;& \underline{\pi}\,\underline{\Lambda}\,t\,\underline{e} + (I - \underline{e}\,\underline{\pi})(\underline{e}\,\underline{\pi} - Q)^{-1}\Lambda\,\underline{e} \\
& + (\underline{e}\,\underline{\pi} - e^{Qt})(\underline{e}\,\underline{\pi} - Q)^{-1}\Lambda\,\underline{e}
\end{aligned}
\tag{3.33}
$$

The second factorial moment vector $\underline{\mu}_2(t) - M(t)\underline{e} = \{E[N^2(0,t)|N(0,0) = 0, J(0) = i]\}$ of the number of arrivals in $(0, t]$ is given by

$$
\begin{aligned}
\underline{\mu}_2(t) \;=\;& -2M(t)(\underline{e}\,\underline{\pi} - Q)^{-1}\Lambda\,\underline{e}\,t \\
& + (\underline{\pi}\,\underline{\Lambda})^2 t^2 \underline{e} + 2t\,(\underline{\pi}\,\underline{\Lambda})\,(I - \underline{e}\,\underline{\pi})\,(\underline{e}\,\underline{\pi} - Q)^{-1}\Lambda\,\underline{e} \\
& + 2t\,(\underline{e}\,\underline{\pi})\,\Lambda\,(\underline{e}\,\underline{\pi} - Q)^{-1}\Lambda\,\underline{e} \\
& - 2(\underline{\pi}\,\underline{\Lambda})\,(I - e^{Qt})\,(\underline{e}\,\underline{\pi} - Q)^{-2}\Lambda\,\underline{e} \\
& + 2(\underline{e}\,\underline{\pi} - Q)^{-1}\,\Lambda\,(\underline{e}\,\underline{\pi} - Q)^{-1}\Lambda\,\underline{e}
\end{aligned}
\tag{3.34}
$$

The proof of these formulae can be achieved by following the derivations given in Neuts [27] for the more general class of versatile Markovian point process. The moments are deduced from the matrix-generating function

$$
\tilde{P}(z, t) \;=\; \sum_{\nu=0}^{\infty} P(\nu, t) z^{\nu} \qquad |z| \le 1
\tag{3.35}
$$

and given by

$$
\tilde{P}(z, t) \;=\; e^{[(Q - (1-z)\Lambda]t}
\tag{3.36}
$$

where $P(\nu, t)$ is the $m \times m$ matrix with elements $P_{ij}(\nu, t) = Pr[N(0,t) = \nu, J(t) = j|N(0,0) = 0, J(0) = i]$ for $\nu \ge 0$.

Let us remark that the matrix $\underline{e}\,\underline{\pi} - Q$ is non-singular. In fact, let \underline{v} denote a non-zero vector such that $\underline{v}\,(\underline{e}\,\underline{\pi} - Q) = 0$, or, $(\underline{v}\,\underline{e})\,\underline{\pi} = \underline{v}Q$. Multiplying by \underline{e}, $\underline{v}\,\underline{e} = 0$, since $Q\underline{e} = 0$ and $\underline{\pi}\,\underline{e} = 1$. It follows that $\underline{v}Q = \underline{0}$, so that $\underline{v} = k\underline{\pi}$, but since $\underline{v}\,\underline{e} = 0$, it follows that $k = 0$. The matrix $\underline{e}\,\underline{\pi} - Q$ is therefore non-singular.

3.B Video Signal Models

The cyclo-stationary process observed in the stripe-bit-rate series originates from quasi-stationary processes (the incoming signal is temporary considered as stationary to ease the presentation under the assumption of slow motions) which have been subject to periodic transformation, the scanning. Other kinds of periodic transformations generate cyclo-stationary and periodic processes; they are, namely the linear and the circular sampling, the time-scale multiplexing or modulation. The theory of the cyclo-stationary process has been originally unified by W. A. Gardner in his Ph.D. thesis and the video models of random signal by Franks in [5].

The video signal which results from conventional line-scanning of a rectangular visual-field. Using the Markov model derived by Franks [5] for the video line segments, the autocorrelation function between lines k and l is expressed as

$$R_{kl}(n-s) = \rho^{|k-l|} e^{-2\pi f_0 |n-s| \bmod T} \tag{3.37}$$

which is periodic in $(n-s)$.

To introduce the study of this video modeling, some additional material provide the reader with fine definitions of stochastic processes and their interconnections to support a theorem relating the generation of cyclo-stationary and periodic processes.

3.B.1 Stationary Process

Two types of stationarity can be defined, namely the stationary-of-order-two [S(2)] and the stationary-in-the-wide-sense (WSS). The definitions are as follows.

3.B.1.1 Stationary-of-Order-Two Process

A random process $\{x(t); t \in J\}$ is *stationary-of-order-two* if and only if

1. the PDF's for the random variable variables $\{x(t)\}$ are identical for all $t \in J$:

$$p_{x(t)}(.) = p_{x(0)}(.) \qquad \forall t \in J \tag{3.38}$$

2. for every $t, s \in J$ the joint PDF for the random variables $x(t)$ and $x(s)$ depends only on the difference of indices t-s

$$p_{x(t)}(.,.) = p_{x(0)}(.) \qquad \forall t, s \in J \tag{3.39}$$

If x is a continuous-time random process of the variable t, then the index set J is the set of real numbers \mathbf{R}, and if x is a discrete-time random sequence of the variable n then J is the set of integers \mathbf{I}, that is $t \in \mathbf{R}$ or $n \in \mathbf{I}$. A similar remark applies to the following definitions.

3.B.1.2 Stationary-in-the-Wide-Sense Process

A random process $\{x(t); t \in J\}$ is *stationary-in-the-wide-sense* if and only if

1. the mean function for the random process x is independent of the index t for every $t \in J$

$$
\begin{aligned}
m_x(t) &= E[x(t)] & (3.40) \\
&= \int_{-\infty}^{+\infty} y p_{x(t)}(y) dy & (3.41) \\
&= m_x(0) \quad \forall t \in J & (3.42)
\end{aligned}
$$

2. for every $t, s \in J$, the autocorrelation function for the random process x depends only on the difference of indices $t - s$

$$
\begin{aligned}
R_{xx}(t, s) &= E[x(t) x^*(s)] & (3.43) \\
&= \int_{-\infty}^{+\infty} y\gamma^* p_{x(t)x(s)}(y, \gamma) dy d\gamma & (3.44) \\
&= R_{xx}(t - s, 0) \quad \forall t, s \in J & (3.45)
\end{aligned}
$$

The sign * denotes the complex conjugation.

Let us notice that the stationary-of-order-two process delimits a subclass of the class of processes which are wide-sense stationary and both of these classes are characterized by the invariance of certain statistical parameters to arbitrary shifts of the indexing variable. Let us now define two additional superclasses which are characterized by the invariance of certain statistical parameters to shifts of the indexing variable by multiples of a basic period. To emphasize the cyclic character of these processes, the term cyclo-stationarity is used.

3.B.2 Cyclo-stationary Process

In this section, three processes are defined, namely the cyclo-stationary-of-order-two [CS(2)], the cyclo-stationary-in-the-wide-sense (WSCS) and the periodic-in-the-wide-sense (WSP).

3.B.2.1 Cyclo-Stationary-of-Order-Two Process

A random process $\{x(t); t \in J\}$ is *cyclo-stationary-of-order-two with period T* if and only if

1. the PDF for the random variable $x(t)$ is identical to that for the random variable $x(t + T)$ for every $t \in J$

$$
p_{x(t)}(.) = p_{x(t+T)}(.) \quad \forall t \in J \tag{3.46}
$$

2. for every $t, s \in J$, the joint PDF for the random variables $x(t)$ and $x(s)$ is identical to that for the random variable $x(t + T)$ and $x(s + T)$

$$p_{x(t)x(s)}(\cdot, \cdot) = p_{x(t+T)x(s+T)}(\cdot, \cdot) \qquad \forall t, s \in J \tag{3.47}$$

3.B.2.2 Cyclo-Stationary-in-the-Wide-Sense Process

A random process $\{x(t); t \in J\}$ is *cyclo-stationary-in-the-wide-sense* with period T if and only if

1. the mean function for the random process x is T-periodic

$$
\begin{aligned}
m_x(t + T) &= E[x(t + T)] \tag{3.48} \\
&= m_x(t) \quad \forall t \in J \tag{3.49}
\end{aligned}
$$

2. for every $t, s \in J$, the autocorrelation function for the random process x is jointly T-periodic in t and s

$$
\begin{aligned}
R_{xx}(t + T, s + T) &= E[x(t + T)x(s + T)] \tag{3.50} \\
&= R_{xx}(t, s) \quad \forall t, s \in J \tag{3.51}
\end{aligned}
$$

It is possible that WSCS processes have constant mean and variance like WSS processes and yet have autocorrelation functions which display periodic fluctuations.

3.B.2.3 Periodic-in-the-Wide-Sense Process

A random process $\{x(t); t \in J\}$ is *periodic-in-the-wide-sense* if, in the WSCS, one substitutes the second condition by

$$
\begin{aligned}
R_{xx}(t + T, s) &= R_{xx}(t, s + T) \tag{3.52} \\
&= R_{xx}(t, s) \quad \forall t, s \in J \tag{3.53}
\end{aligned}
$$

meaning that $R_{xx}(\cdot, \cdot)$ is jointly T-periodic in its two variable. It is less restrictive than the condition that R_{xx} be individually T-periodic in each of its variables.

All processes which are stationary-of-order-two are cyclo-stationary-of-order-two with any choice of T, and all wide-sense stationary processes are wide-sense cyclo-stationary with any choice of period T. All wide-sense periodic processes are wide-sense cyclo-stationary and are not wide-sense stationary. To summary, the various classes of processes are related as shown in the Venn diagram of Figure 3.46.

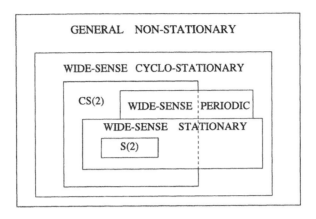

Figure 3.46: Venn diagram for the family of cyclo-stationary processes.

3.B.3 Scanning the Video Signal

In this section, the multi-dimensional linear transformation like that performed by the camera scanning is examined in terms of the effects produced on the properties of incoming stochastic video process. The discussion deals with the transformation of multi-dimensional quasi-stationary processes into one-dimensional cyclo-stationary processes. The concept of generating wide-sense cyclo-stationary processes from the scanning operation is also addressed.

3.B.3.1 Multi-Dimensional Linear Transformations

A three-dimensional process y is a random function of three independent variables: $y(t, u, v)$, $t \in \mathbf{R}$, $u \in D_1$, $v \in D_2$. In this application, t represents the time coordinate and u and v the two spatial coordinates. The domains D_1 and D_2 are finite intervals in \mathbf{R}. The process considered is quasi-wide-sense stationary if and only if each of the one-dimensional processes $y(., u, v)$ is WSS for each value of $u \in D_1$ and $v \in D_2$. If y is the input to a transformation G, and x is the output, then the realizations of x are related to the corresponding realizations of y as follows

$$x(t) = \int_{D_1} \int_{D_2} \int_{\mathbf{R}} G(t, \tau, u, v) y(\tau, u, v) d\tau dv du \qquad (3.54)$$

where $G(t, \tau, u, v)$ is the three-dimensional impulse response. Furthermore, let G be a quasi-periodic transformation with period T if and only if

$$G(t + T, \tau + T, u, v) = G(t, \tau, u, v) \qquad \forall t, \tau \in \mathbf{R}, \ u \in D_1, \ v \in D_2 \qquad (3.55)$$

Using these definitions, the theorem for the generation of T-periodic cyclo-stationary is stated as follows.

If the input y to a three-dimensional quasi-periodic transformation with period T is a three-dimensional quasi-WSS process, then the one-dimensional output x is a T-CS process.

The proof is rather straightforward.

3.B.3.2 Line-Scanning a Rectangular Video Field

The process of scanning a finite rectangular field, performed by a camera, can be modeled with a three-dimensional linear transformation. Then the scanner is fully characterized by the impulse response $G(t, \tau, u, v)$ which is sometimes referred to as a window function. With reference to Figure 3.47 and to Equation 3.54, $D_1 = (0, W_1)$ and $D_2 = (0, W_2)$ are the domains for u and v, and $y(t_0, u_0, v_0)$ is a realization of the three-dimensional process y evaluated at time t_0, horizontal distance u_0, and vertical distance v_0. The video signal is the scanner output process x and is obtained from y as in Equation 3.54.

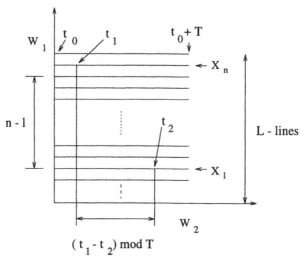

Figure 3.47: Line-scanning diagram.

The conventional video camera employs a constant velocity line-scanner whose impulse response can be modeled as (with some abuse of notation):

$$G(t, \tau, u, v) = G[u_1(t) - u, v_1(t) - v]\delta(t - \tau) \tag{3.56}$$

where the functions u_1 and v_1 are as shown in Figure 3.48, and each is LT-periodic where T is the time required to scan a single line and L is the number of lines per frame. Therefore, the scanner G is a quasi-periodic transformation with period LT, so that if y is quasi-WSS then the video process x is CS (period LT), according to the previous theorem of generation.

If the above window function $G(.,.)$ is ideal, a two-dimensional impulse function, then

$$x(t) = y[t, u_1(t), v_1(t)] \tag{3.57}$$

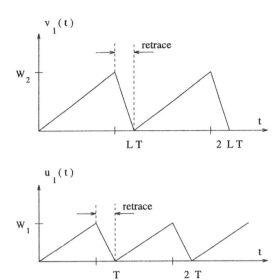

Figure 3.48: Vertical and horizontal line-scanning functions.

Using this ideal model for the scanner along with the assumption of zero-retrace time and the model for y proposed by Franks [5], results in an autocorrelation function for x which is composed of three periodic factors. The first factor characterizes the correlation within any given line, the second characterizes line-to-line correlation, and the third characterizes frame-to-frame correlation as follows

$$R_{xx}(t, s) = k_1(t - s)k_2(t, s)k_3(t, s) \tag{3.58}$$

where

1. the correlation within a line

$$k_1(t - s) = \rho_1^{(t-s)mod\ T} \tag{3.59}$$

 is T-periodic in $(t - s)$.

2. the line-to-line correlation

$$k_2(t, s) = \rho_2^{\frac{1}{T}|(t-t\,mod\ T)mod\ LT-(s-s\,mod\ T)mod\ LT|} \tag{3.60}$$

 is jointly T-periodic in t and s.

3. the frame-to-frame correlation

$$k_3(t, s) = \rho_3^{\frac{1}{T}|(t-t\,mod\ LT)-(s-s\,mod\ LT)|} \tag{3.61}$$

 is jointly LT-periodic in t and s.

Figure 3.49 shows the periodic factor in the autocorrelation function for video signal.

3.B. Video Signal Models

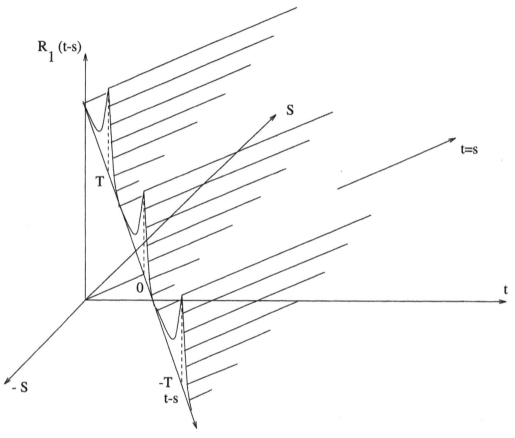

Figure 3.49: Autocorrelation function for video signal.

3.B.4 Video Signal Modeling

Let us consider a zero-mean video signal $v(t)$ picked up at the output of a camera scanning at constant velocity the picture field. Table 3.12 recapitulates the definitions of the variables used in this appendix. The stochastic video signal is assumed to be either a still picture or a slowly-moving scene and consequently represented as a stationary stochastic process $d(x, y)$ described by a two-dimensional autocovariance function

$$R(\alpha, \beta) \;=\; E\{d(x_1, y_1)d(x_2, y_2)\} \tag{3.62}$$

where $\alpha = x_2 - x_1$ holds for the horizontal displacement and $\beta = y_2 - y_1$ the vertical displacement. The accessible video signal $v(t)$ is a stationary process with autocorrelation function given by

$$\begin{aligned}
R_1(\tau) \;&=\; E\{v(t)v(t+\tau)\} & (3.63)\\
&=\; R(\tau, 0) & (3.64)
\end{aligned}$$

assuming that the scanner moves with unit velocity and that $E\{v(t)\} = 0$. Actually, the scanning operation is usually a non-linear function of luminance but however the model derived in this section has the property that its autocovariance function is changed only by a multiplicative constant when subjected to a zero-memory, non-linear transformation. Hence, the model maintains its validity whatsoever the scanner characteristics and the companding operations applied to the video signal.

To take into account the line-to-line correlation, the sequential scanning is now considered as sweeping an horizontal line over intervals of length T_e seconds and all the successive lines in the vertical direction in intervals of T seconds. The abrupt change in scanner position when it reaches the edge of the strip causes the video signal to become a non-stationary process. The autocorrelation function for that process is T-periodic in t, meaning $\psi(t, \tau) = E\{v(t)v(t+\tau)\}$. This is related to a stationary process in the usual manner by considering t as a random variable uniformly distributed on the interval $(0, T]$. It follows that

$$\begin{aligned}
R_2(\tau) \;&=\; E\{\psi(t, \tau)\} & (3.65)\\
&=\; \sum_{k=-\infty}^{\infty} \phi(\tau - kT, kT_e)P(k, \tau) & (3.66)
\end{aligned}$$

The probability $P(k, \tau)$ that the points t and $(t + \tau)$ fall in lines k apart is given by the translates of the triangular function $q_T(\tau)$. $q_T(\tau)$ is defined as

$$q_T(\tau) \;=\; \begin{cases} 1 - \frac{|\tau|}{T} & \text{for} \quad |\tau| \le T \\ 0 & \text{otherwise} \end{cases} \tag{3.67}$$

i.e. as the triangular function, we get

$$P(k, \tau) \;=\; q_T(\tau - kT) \tag{3.68}$$

Inserting Equation 3.68 in Equation 3.66, the autocorrelation function of the video signal with line-to-line correlation becomes

$$R_2(\tau) = \sum_{k=-\infty}^{\infty} R(\tau - kT, kT_e)\, q_T(\tau - kT) \tag{3.69}$$

When dealing with video data, $R(\frac{T}{2}, \beta) \simeq 0$, this implies that the autocorrelation function $R_2(\tau)$ is a sequence of isolated pulse shapes given by $q_T(\tau)R(\tau, 0)$ located on integer multiples of T. Figure 3.50 sketches the line-to-line correlation configuration. The power spectral density of the process is given by

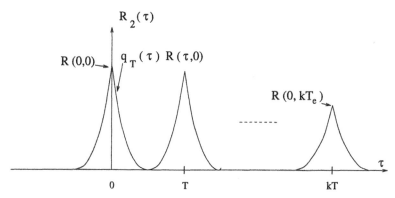

Figure 3.50: Line-to-line correlation.

$$\Phi_2(f) = \int_{-\infty}^{\infty} R_2(\tau)e^{-2j\pi f\tau}d\tau \tag{3.70}$$

$$= \sum_{k=-\infty}^{\infty} F(f, kT_e)e^{-2\pi kTf} \tag{3.71}$$

where

$$F(f, kT_e) = \int_{-\infty}^{\infty} q_T(\tau)R(\tau, kT_e)e^{-j2\pi f\tau}d\tau \tag{3.72}$$

If we let

$$H(f, \nu) = \int_{-\infty}^{\infty} F(f, \sigma)e^{-j2\pi\nu\sigma}d\sigma \tag{3.73}$$

then

$$F(f, kT_e) = \int_{-\infty}^{\infty} H(f, \nu)e^{j2\pi kT_e\nu}d\nu \tag{3.74}$$

If Equation 3.74 is introduced in Equation 3.71 and if the Poisson identity

$$\sum_{k=-\infty}^{\infty} e^{-j2\pi kx} = \sum_{m=-\infty}^{\infty} \delta(x-m) \tag{3.75}$$

is exploited, we derive eventually

$$\Phi_2(f) = \frac{1}{T_e} \sum_{m=-\infty}^{\infty} H\left(f, \frac{T}{T_e}\left(f - \frac{m}{T}\right)\right) \tag{3.76}$$

In typical picture information, $R(\tau, 0)$ is so narrow compared to $q_T(\tau)$ as to approximate $R(\tau, 0) = q_T(\tau)\, R(\tau, 0)$. In this case, $H(f, \nu)$ is the double Fourier transform of the picture autocovariance function

$$H(f, \nu) \simeq \int\int_{-\infty}^{\infty} R(\tau, \sigma)e^{-j2\pi(f\tau + \nu\sigma)}d\tau\, d\sigma \tag{3.77}$$

Moreover, the power spectral density Φ_2 can be approximated by the product of a T-periodic function and an envelope with relatively small variation over the T-wide intervals. Let us remark that $H(0, \frac{t}{T_e})$ is very narrow compared to $H(f, 0)$ since $H(f, 0)$ and $H(0, f)$ have approximatively the same width and since $\frac{T}{T_e} \gg 1$. Furthermore, $H(f, 0)$ has relatively small variation over intervals of width $\frac{1}{T}$ and can be approximated as follows

$$\Phi_2(f) \simeq \frac{1}{T_e} \sum_{m=-\infty}^{\infty} H\left(\frac{m}{T}, \frac{T}{T_e}\left(f - \frac{m}{T}\right)\right) \tag{3.78}$$

$$\simeq \frac{1}{T_e} H(f, 0) \sum_{m=-\infty}^{\infty} H\left(0, \frac{T}{T_e}\left(f - \frac{m}{T}\right)\right) \tag{3.79}$$

$$\tag{3.80}$$

Such a formulation of the spectral density corresponds to the property of separability of $R(\tau, \sigma)$; that is $\lambda R(\tau, \sigma) = d^2 R_h(\tau) R_v(\sigma)$ where $R_h(\tau)$, $R_v(\tau)$ and d^2 represent respectively the normalized autocorrelation functions for scanning along horizontal and vertical lines and $d^2 = R(0, 0)$. Neglecting the edge effects, we derive

$$H(f, \nu) = d^2\, \Phi_v(\nu)\Phi_h(f) \tag{3.81}$$

the power spectral density $\Phi_2(f)$ becomes

$$\Phi_2(f) = \frac{d^2}{T_e} \Phi_h(f) \sum_{m=-\infty}^{\infty} \Phi_v\left(\frac{T}{T_e}\left(f - \frac{m}{T}\right)\right) \tag{3.82}$$

The third correlation is the frame-by-frame correlation generated by the repeated scanning of a finite portion of a camera field. Assuming slow motions and variations compared to the frame repetition rate, $\frac{1}{NT}$,

$$R_3(\tau) = \sum_{k=-\infty}^{\infty} R_t(kNT)R_2(\tau - kNT) \tag{3.83}$$

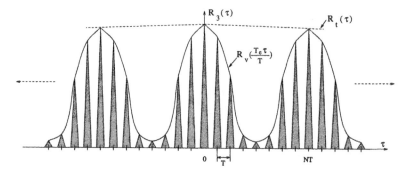

Figure 3.51: Frame-to-frame correlation.

Owing to the hypothesis of slow motions and variations, the frame-to-frame correlation is high and $R_3(\tau)$ is essentially the product of $R_t(f)$ and $R_2(\tau)$. Figure 3.51 presents the frame-to-frame correlation configuration. The power spectral density is further given by

$$\Phi_3(f) \quad = \quad \Phi_2(f) \sum_{k=-\infty}^{\infty} \phi_t(kNT)e^{-jkNT2\pi f} \tag{3.84}$$

$$= \quad \frac{1}{NT} \Phi_2(f) \sum_{l=-\infty}^{\infty} \Phi_t\left(f - \frac{l}{NT}\right) \tag{3.85}$$

Assembling Equations 3.82 and 3.85, the final expression for the frame-to-frame correlation $\Phi_3(f)$ is derived as the product of three functions

1. an envelope $F_h(f)$ representing the horizontal picture correlation.

2. a function $F_v(f)$, T-periodic, representing the vertical picture correlation.

3. a function $F_t(f)$, NT-periodic, representing the frame-to-frame correlation.

Finally,

$$\Phi_3(f) \quad = \quad \left[d^2\Phi_h(f)\right] \left[\frac{1}{T_e} \sum_{m=-\infty}^{\infty} \Phi_v\left(\frac{T}{T_e}\left(f - \frac{m}{T}\right)\right)\right] \left[\frac{1}{NT} \sum_{l=-\infty}^{\infty} \Phi_t\left(f - \frac{l}{NT}\right)\right]$$

$$= \quad F_h(f)\, F_v(f)\, F_t(f) \tag{3.86}$$

This final equation evidences three structures contained in the spectrum: the finest $F_t(f)$ with $\frac{1}{NT}$-periodicity modulated by a first envelope $F_v(f)$ with $\frac{1}{T}$-periodicity which is in turn modulated by a second envelope $F_h(f)$. The reasoning to derive Equation 3.86 has been made under the assumption of progressive scannings. The derivations for scanning operations involving line interlacing are rather simple in Equation 3.86. Since consecutive lines are twice apart, the factor $F_v(f)$ is modified by replacing T_e with $2T_e$. This modification results in the individual peaks in $F_v(f)$ centered at multiples of $\frac{1}{T}$ being broadened to twice their original width. Since the picture is scanned vertically every $\frac{NT}{2}$ seconds, the $F_t(f)$ factor is modified by replacing N by $\frac{N}{2}$.

$R(\alpha, \beta)$	autocorrelation function of picture luminance.
$R_1(\tau)$	autocorrelation function of video signal obtained from linear. horizontal scanning of infinite picture.
$R_2(\tau)$	autocorrelation function of video signal obtained from sequential horizontal scanning of infinite picture.
$R_3(\tau)$	autocorrelation function of video signal obtained from repeated scanning of rectangular portion of picture.
$R_h(\tau)$	normalized version of $R(\tau, 0)$.
$R_v(\tau)$	normalized version of $R(0, \tau)$.
$R_t(\tau)$	normalized correlation at a point as a function of time
$F_h(f)$	factor of power spectral density for point-to-point correlation.
$F_v(f)$	factor of power spectral density for line-to-line correlation.
$F_t(f)$	factor of power spectral density for frame-to-frame correlation.
T	line scan interval in second.
T_e	time interval equivalent to distance between adjacent lines at scanner velocity.
N	number of lines per frame.

Table 3.12: Local symbol glossary.

3.C Auto-regressive estimation of DNSPP

This appendix addresses the problem of how to estimate a DNSPP. The existence of stationary Auto-Regressive (AR) processes is a consequence of Wold's theorem of decomposition as presented in [3.2]. The auto-regressive model can be considered as a stationary stochastic process obtained at the output of a causal Finite Impulse Response (FIR) filter driven by a Gaussian noise. This FIR filter can be interpreted as the correlative structure contained within the model i.e. the fraction of the information which can be effectively explained and the Gaussian noise interpreted as the innovative information. It is demonstrated in [3.6] that Wold's decomposition still applies to non-stationary processes and leads to a non-stationary AR model given for the zero-mean variable $x(t)$ as

$$x(t) = -\sum_{i=1}^{p} a(i, t-i)x(t-i) + \epsilon(t) \tag{3.87}$$

with

$$E\{\epsilon(t)\} = 0 \quad E\{\epsilon(t)x(t-i)\} = 0 \quad \forall i \tag{3.88}$$

The auto-regressive models will be used to predict the time series composed of the successive samples of the stripe bit rate.

For a stochastic process with a T-periodic structure, the non-stationary auto-regressive coefficients of the FIR filter vary in a periodic manner and a finite auto-regression can be written as

$$x(t) = -\sum_{i=1}^{p} a(i, t-i)x(t-i) + \epsilon(t) \tag{3.89}$$

with

$$a_i(t) = a_i(t + kT) \qquad E\{\epsilon(t)\} = 0 \qquad E\{\epsilon(t)x(t-i)\} = 0 \quad \forall i \quad \forall k \tag{3.90}$$

In the sequel, the AR time-dependent coefficients will be developed into a Fourier basis corresponding to the hypothesis that the $a_i(t)$ are periodic. The development will be restricted to the first Fourier coefficients of the series to generate a new AR model with time-invariant coefficients. The resulting AR model is thereafter replaced by a vector process. This latter process can be easier exploited to estimate the new set of model coefficients. As the auto-regressive coefficients are T-periodic, they can be expanded into the Fourier series

$$a(i, t-i) = \sum_{n=0}^{\infty}\{A(i,n)\cos(2\pi n \frac{(t-i)}{T}) + B(i,n)\sin(2\pi n \frac{(t-i)}{T})\} \tag{3.91}$$

If the process is not too highly time-varying, the auto-regressive coefficients can be approximated by expanding over only a few terms (m terms) and Equation 3.89 becomes

$$x(t) = -\sum_{i=1}^{p}[\sum_{n=0}^{m}\{A(i,n)\cos(2\pi n \frac{(t-i)}{T}) + B(i,n)\sin(2\pi n \frac{(t-i)}{T})\}]x(t-i) \\ +\epsilon(t) \tag{3.92}$$

and can be restated as

$$
\begin{aligned}
x(t) = {} & -\sum_{i=1}^{p} A(i,0)x(t-i) \qquad \text{[term 1]} \\
& -\sum_{i=1}^{p}\sum_{n=1}^{m} A(i,n)x(t-i)\cos[2\pi n \frac{(t-i)}{T}] \qquad \text{[term 2]} \\
& -\sum_{i=1}^{p}\sum_{n=1}^{m} B(i,n)x(t-i)\sin[2\pi n \frac{(t-i)}{T}] \qquad \text{[term 3]} \\
& +\epsilon(t)
\end{aligned}
\tag{3.93}
$$

This equation presents the linear prediction of a T-periodic time series which is obtained by regressing the present time with successively the past time series values [term 1] and the past time series modulated by cosines [term 2] and sines [term 3] of fundamental and harmonic frequencies. At this stage, it seems appropriate to break the one-dimensional time series time-varying coefficients into their basis function representation and to transform this basis representation into components of a multivariable time-invariant process. The non-stationary auto-regressive coefficients are therefore decomposed within a set of basis functions

$$a(i, t-i)x(t-i) = \sum_{j=1}^{2m+1} d(i,j)[f_j(t-i)x(t-i)] \tag{3.94}$$

Now a vector $U(t)$ can be defined as

$$U(t) = [f_0(t)x(t),, f_s(t)x(t)]^T \qquad (3.95)$$

with s=2m+1, $f_0(t) = 1$, $f_1(t) = \cos[2\pi \frac{t}{T}]$,, $f_{2+m}(t) = \sin[2\pi \frac{t}{T}]$, The symbol T stands for the transpose of the vector. Each term of Equation 3.94 becomes

$$a(i, t - i)x(t - i) = [d(i, 0),, d(i, s)]U(t - i) = \alpha_i U(t - i) \qquad (3.96)$$

and the multivariable auto-regressive process is reexpressed as

$$x(t) = -\sum_{i=1}^{p} \alpha_i U(t - i) + \epsilon(t) \qquad (3.97)$$

Gathering into the vector θ all the parameters to be estimated (s × p)

$$x(t) = -[U(t - 1), U(t - 2), ..., U(t - p)]\theta + \epsilon(t) \qquad (3.98)$$

with $\theta = [d(1, 0), d(1, 1), .., d(1, s), d(2, 0), ..., d(p, s)]$.

The remaining problem consists of estimating θ. To achieve this goal, the best predictor has to be defined as that one which achieves the best decorrelation and therefore minimizes the variance of prediction errors (the innovative information). In other words, the optimum predictor is such that prediction error $\epsilon(t)$ is not correlated with the other explicative terms $U(t - i)$ with $i = 1$ to p. The prediction error is given by

$$\epsilon(t) = x(t) + [U(t - 1), U(t - 2), ..., U(t - p)]\theta \qquad (3.99)$$

The best estimation is that one which minimizes the prediction error given the past time series values

$$\epsilon(t) = x(t) - \hat{x}(t) \qquad (3.100)$$

where \hat{x} stands for the best predictor of $x(t)$. It can be demonstrated [3.5] that the best predictor is the conditional expectation of $x(t)$ given its past values $(x(t - 1), ..., x(t - p))$

$$\hat{x}(t) = E[x(t)|x(t - 1),, x(t - p)] = -[U(t - 1), U(t - 2),, U(t - p)]\theta(3.101)$$

To express orthogonality of the prediction error with the past samples, it is worth observing that the gradient of the innovation $\epsilon(t)$ is

$$\frac{\partial \epsilon}{\partial \theta} = [U(t - 1), .., U(t - p)]^T \qquad (3.102)$$

the orthogonality between the gradient of the error and the error itself gives the condition

$$E\{\frac{\partial \epsilon(t)}{\partial \theta} \epsilon(t)\} = 0 \qquad (3.103)$$

Replacing the gradient and the prediction error by their respective expressions in Equation 3.103 leads to an equation of a type referred to in the literature as the Yule-Walker equation for the AR parameter estimation

3.C. Auto-regressive estimation of DNSPP 289

$$E\left\{ \begin{Vmatrix} U(t-1) \\ \cdots \\ \cdots \\ U(t-p) \end{Vmatrix} [U^T(t-1) \ \cdots \ U^T(t-p)] \right\} \theta \ = \ -E\left\{ \begin{Vmatrix} U(t-1) \\ \cdots \\ \cdots \\ U(t-p) \end{Vmatrix} x(t) \right\} \qquad (3.104)$$

This result enables computing an estimate of θ. The modeling by a non-stationary AR process has lead to introduce a vector process which is the projection of the original scalar AR process on a set of basis functions. In our particular case, the non-stationary AR process has been transformed into a set of stationary scalar processes for which the general theory of the AR parameter estimation can still be applied.

3.D Detection of Scene Changes

Let us assume that we are coding TV video sequences with a pure intra mode algorithm. When the bit rate of the coded video information is averaged over intervals of one single image to smooth out all the internal image fluctuations, the samples of the image-bit-rate time series are rather constant during each scene as a consequence of the assumption of quasi-stationarity. Indeed, changes and abrupt shifts are not usually observed within a scene but may however not be totally excluded. At visible scene-change occurrence, the resulting shift in the image bit rate may take any shape ranging from no perceptible variation to sudden or abrupt variations depending on whether the change in the information density is significant or not. In between those two extreme configurations, any smooth or slow variation is also possible. The fact that not all visible scene changes induce actual changes in the image bit rate has forced us to define the concept of *statistical scene changes* instead of *visible ones*. The goal is clearly to derive the effective changes of bit rate and their statistics with the scope of describing source traffic equations totally dissociated from the visual image content.

Solving the problem of detecting changes in the mean-bit-rate time series consists in segmenting the discrete-time signal into statistical scenes and gathering statistics of both their length and their mean-image-bit-rate value per scene. A survey paper [1] from which this appendix is inspired, provides 79 references on the topic of detecting changes in non-stationary signal and systems. Among all those methods, let us quote the following of change detection: the jumps in the mean value, the changes in the observed noise of a Kalman filter state space representation, changes in the spectral properties or eigen-structure of an AR or ARMA model. Those methods can be further subdivided in on-line and off-line algorithms. The first family exploits statistical decision rules so simple as to be easily implemented on real time computations, for instance the detection of change in the mean value. By contrast, the second family presents more intricated procedures, for instance the method to detect changes in eigen-structure of an ARMA filter. Both examples are successively addressed in this appendix.

3.D.1 Detection of Changes of Unknown Magnitude

Let μ_0 and μ_1 be the mean values of the time series prior and posterior to a jump to be detected and located. Usually, the mean μ_0 is known since having been evaluated on-line but the new-come mean μ_1 is however unknown. Therefore, if $\epsilon(n)$ represents a white Gaussian noise sequence $N(0, \sigma)$, $y(n)$ the sequence of observations and r the change instant to be detected or estimated, the sequence can be expressed as

$$y(n) \;=\; \mu_m + \epsilon(n) \qquad 0 \le m \le \infty \tag{3.105}$$

where

$$\mu_m \;=\; \mu_0 \quad \text{if } m \le r - 1 \tag{3.106}$$
$$\;=\; \mu_1 \quad \text{if } m \ge r \tag{3.107}$$

The minimum jump magnitude to be detected may be decided a priori for both increase or decrease as ν. The Page-Hinkley detecting rules are computed by evaluating four new quantities T, U, M and m as follows

1. for a decrease,

$$T(0) \quad = \quad 0 \tag{3.108}$$

$$T(n) \quad = \quad \sum_{k=1}^{n} (y(k) - \mu_0 + \frac{\nu}{2}) \tag{3.109}$$

$$M(n) \quad = \quad \max_{0 \leq k \leq n} T(k) \tag{3.110}$$

detection is performed when $M(n) - T(n) > \lambda$ where λ is the decision threshold.

2. for an increase,

$$U(0) \quad = \quad 0 \tag{3.111}$$

$$U(n) \quad = \quad \sum_{k=1}^{n} (y(k) - \mu_0 - \frac{\nu}{2}) \tag{3.112}$$

$$m(n) \quad = \quad \min_{0 \leq k \leq n} U(k) \tag{3.113}$$

detection is performed when $U(n) - m(n) > \lambda$

The rule to estimate the location of the instant \hat{r} corresponding to the jump is to take the last maximum or minimum observed before the detection.

A finer approach consists of proceeding to the maximum likelihood estimation approach in testing two hypotheses

1. no change

$$\mathcal{H}_0 \; : \; r > n \tag{3.114}$$

2. effective change

$$\mathcal{H}_1 \; : \; r \leq n \tag{3.115}$$

The likelihood ratio between these hypotheses is given by

$$\prod_{k=r}^{n} \frac{p_1(y_k)}{p_0(y_k)} \tag{3.116}$$

where the $\{p_i : i = 1, 2\}$ are the Gaussian PDF's of the process y(n) with mean μ_0 and μ_1 respectively. Taking the logarithms leads to the likelihood function

$$\Lambda_n(r) \quad = \quad \frac{\mu_1 - \mu_0}{\sigma^2} \sum_{k=r}^{n} (y_k - \frac{\mu_0 + \mu_1}{2}) \tag{3.117}$$

$$= \quad \frac{1}{\sigma^2} S_r^n(\mu_0, \nu) \tag{3.118}$$

with $\nu = \mu_1 - \mu_0$ the magnitude of the jump and

$$S_i^j(\mu, \nu) = \nu \sum_{k=i}^{j} (y_k - \mu - \frac{\nu}{2}) \tag{3.119}$$

The likelihood ratio test, to decide whether hypothesis \mathcal{H}_0 or \mathcal{H}_1 is the most likely to be true, is given by

$$\max_{1 \leq r \leq n} \max_{\nu} S_r^n(\mu_0, \nu) \underset{\mathcal{H}_0}{\overset{\mathcal{H}_1}{\gtrless}} \lambda \tag{3.120}$$

Restated in other words, the rule is to decide \mathcal{H}_1 whenever the likelihood ratio exceeds λ, and \mathcal{H}_0 otherwise. Using Equation 3.119, the double maximization can be further transformed in a single one by exploiting

$$\hat{\nu}_n(r) = \arg\max_{\nu} S_r^n(\mu_0, \nu) \tag{3.121}$$

$$= \frac{1}{n - r + 1} \sum_{k=r}^{n} (y_k - \mu_0) \tag{3.122}$$

This achieves an experimentally robust decision-making procedure carried out at a relatively low computational burden.

3.D.2 Detection of Changes in AR Eigen-Structures

In this second part, an off-line algorithm for the detection of scene changes based on the image bit rate values is presented. The image bit rate is considered as a time series modeled by an auto-regressive-moving-average (ARMA) model. The idea to detect changes in AR coefficients of a non-stationary ARMA process consists in detecting changes in the correlative structure of the model. The MA coefficients are considered as unknown parameters not necessary for the detection. The best way to proceed is to test changes into the eigen-structure of the model i.e. a change in the location of poles. The AR model part of the image bit rates previously presented by

$$x(t) = \sum_{i=1}^{p} a(t, i)x(t - i) + \sum_{j=0}^{q} b(t, j)\epsilon(t - j) \tag{3.123}$$

will be the object of the study to determine the location of the changes. The AR coefficients are considered as stationary in between two consecutive changes. The MA coefficients are non-stationary and unknown parameters.

Identification of AR Coefficients

Assuming that a record of s consecutive values of the time series $[x(0), ..., x(s)]$ is available for the process x(t), the modified Yule-Walker method leads to the least-square estimation of the parameters

$$\theta = [a_1, ..., a_p]^T \tag{3.124}$$

are furnished by solving the set of equations in form of

$$[-a_p \ -a_{p-1} \ \ -a_1 \ 1] \, \mathcal{H}_{p,N-1}(s) = 0 \tag{3.125}$$

where \mathcal{H} is a $(p+1) \times N$ empirical matrix termed the Hankel matrix of the observed process; the matrix \mathcal{H} is determined as follows

$$\mathcal{H}_{p,N-1}(s) = \begin{vmatrix} R_{q-p+1}(s) & R_{q-p+2}(s) & R_{q+1}(s) & R_{q+2}(s) & \cdots & R_{q-p+N}(s) \\ R_{q-p+2}(s) & R_{q-p+3}(s) & \cdots & & & \cdots \\ \vdots & \vdots & & & & \vdots \\ R_{q+1}(s) & R_{q+2}(s) & & & \cdots & R_{N+q}(s) \end{vmatrix} \tag{3.126}$$

where the $R_k(s)$ are autocorrelation functions defined by

$$R_k(s) = \sum_{t=0}^{s-k} x(t+k)x(t) \qquad t \geq 0 \tag{3.127}$$

The number of instruments N has to satisfy $N \geq p$, practically, $N \simeq 3p$. This algorithm leads to the least-square modified Yule-Walker equations. Numerical considerations to implement the computation are presented in Reference [11]. The estimate obtained by this method has been proved [16] to be a consistent estimate of the true vector parameter θ for the AR process in either stationary and non-stationary conditions. The method is also robust with respect to the unknown MA part.

Detection of Changes

The problem addressed now is clearly to detect by a statistical test a change in the vector θ assuming that the sequence $x(n)$ is observable and known on a past of more than s samples. The aim is to decide between two hypotheses: $H_0 : \theta = \theta_0$ and $H_1 : \theta \neq \theta_0$. The test is supposed to detect small changes in θ_0 of the form of $\theta_0 + \delta\theta$. $\delta\theta$ is the variation of unknown direction and magnitude in the vector θ_0 to be detected by the test. The goal is now to deduce a simple test tractable by a numerical off-line approach. The idea here is to transform the test of detecting the scene changes into a simpler one already available in the current literature. This test to be performed will be demonstrated as being a χ^2 test to detect a change in the mean value of a Gaussian distributed scalar random variable. To achieve this goal, let $U_N(s)$ be a vector defined as

$$U_N(s) = H_{p,N-1}^T(s)\theta_0 \tag{3.128}$$

To achieve a numerically efficient way to describe $U_N(s)$, let us define $w(t)$ and $Z(t)$ as

$$w(t) = x(t) - \sum_{i=1}^{p} a_i x(t-i) \tag{3.129}$$

which represents the source of noise or the MA part of the model and

$$Z(t) = [x(t-q-1), x(t-q-2),, x(t-q-N)]^T \tag{3.130}$$

which is orthogonal to $w(t)$ under the hypothesis H_0 of no change in θ_0 i.e. θ_0 represents the AR part of the actual process.

$U_N(s)$ can be rewritten as

$$U_N(s) = \sum_{n=q+N}^{s} w(n)Z(n) \tag{3.131}$$

While the vector θ does not change and $\theta = \theta_0$, $U_N(s) = 0$ as imposed by Equations 3.129 and 3.130 meaning that the prediction error $w(t)$ remains orthogonal to the past time series samples given by $Z(t)$.

The covariance matrix of $U_N(s)$ is given by

$$\Sigma_N(s) = \sum_{U=q+N}^{s-q} \sum_{i=-q}^{q} E\{w(t)w(t-i)Z(t)Z^T(t-i)\} \tag{3.132}$$

The estimate of the covariance matrix is given by

$$\hat{\Sigma}_N(s) = \sum_{U=q+N}^{s-q} \sum_{i=-q}^{q} w(t)w(t-i)Z(t)Z^T(t-i) \tag{3.133}$$

The trick is here to use two theorems demonstrated for non-stationary processes issued from the martingale theory. They will allow to transform the problem of detecting changes in the parameters θ_0 into a simple problem of detecting a change in the mean of a Gaussian scalar process by a maximum likelihood detection based on a χ^2 test. These theorems are the extensions of, first, the law of large numbers and, secondly, the central limit theorem to non-stationary processes. They have been demonstrated by Benveniste and Moustakides [16] as follows

1. the law of Large Numbers states that

$$\Sigma_N^{-1}(s)\hat{\Sigma}_N^{-1}(s) \quad \longrightarrow \quad I_N \tag{3.134}$$
$$s \to \infty \tag{3.135}$$

where I_N is the identity matrix of order $(N \times N)$. The interpretation of this equation is simply that the estimate of the covariance matrix $\hat{\Sigma}_N$ as defined in Equation 3.133 is a consistent estimate for the true covariance matrix Σ_N since the estimate converges to the true matrix.

2. the central limit theorem states the following convergence

$$\Sigma_n^{-1/2}(s)U_N(s) \quad \longrightarrow \quad N(0, I_N) \tag{3.136}$$
$$s \to \infty \tag{3.137}$$

and under a small change in θ_0

$$\Sigma_n^{-1/2}(s)[U_N(s) - \mathcal{H}_{p-1,N-1}^T \frac{\delta\theta}{\sqrt{s}}] \longrightarrow N(0, I_N) \tag{3.138}$$

$$s \to \infty \tag{3.139}$$

where $N(0, I_N)$ is a Normal law of dimension N.

Both theorems state convergence in distribution which has been defined in Chapter 1. The importance of those theorems is to reduce the initial problem into the detection of a change in the mean value of a Gaussian process. Assuming first a Gaussian PDF for U_N, the statistical test of a change into the vector θ_0 becomes a test on the mean μ. The test consists now in comparing the hypothesis H_0 meaning $\mu_0 = 0$ of U distributed as a Normal $N(0, \Sigma)$ against the hypothesis H_1 meaning $\mu \neq 0$ of U distributed as a Normal $N(\mu, \Sigma)$. The test is performed by comparing the quantity $U_N^T \Sigma^{-1} U_N$ with a given threshold.

The next step considers the central limit theorem under a small change of θ to obtain a linear model of the form

$$x = U_N + \mathcal{H}^T \delta\theta \tag{3.140}$$

and to deduce the maximum likelihood estimate of $\delta\theta$ defined as the unknown variation of θ_0 [16]. Hence, for small changes of θ, the procedure consists in an optimum χ^2 test with p degrees of freedom given by

$$t_0 = U_N^T \Sigma^{-1} \mathcal{H}_{p,N-1}^T (\mathcal{H}_{p,N-1} \Sigma^{-1} \mathcal{H}_{p,N-1}^T)^{-1} \mathcal{H}_{p,N-1} \Sigma^{-1} U_N \tag{3.141}$$

This method yields a diagnosis to locate scene changes.

Chapter 4

Coding Control Algorithms

4.1 Introduction

This chapter intends to develop different regulation schemes to monitor the output bit stream within TV and HDTV coding systems. Two main goals are expected to be achieved by the regulation. The primary purpose concerns the control of the image quality and the secondary one concerns the control of the encoder buffer fillness. The objectives may be outlined as follows

1. *realizing a graceful control of the image quality* i.e. ensuring the best quality with a maximum uniformity of subjective image quality.

2. *achieving the optimum use of the buffer capacity* to maximize the image quality and to prevent the buffer from either overflowing or underflowing. As explained later in Chapter 6, avoiding underflows in encoder buffers prevents the decoder buffer from overflowing and conversely.

The buffer regulation has therefore the task to balance those two closely related actions. A uniform quality can be achieved locally within the images with the use of an adaptive quantization scheme based on the computation of a local block criticality as already described in Chapter 2. Exploiting that adaptive mechanism, a parameter called the transmission factor has been introduced to control the computation of the quantization step size over long term periods and to produce locally a quasi-constant subjective image quality while it is maintained constant. Hence, to ensure a maximum uniformity in the subjective image quality, the transmission factor should be maintained as constant as possible or be a very slowly time-varying parameter. As a matter of fact, the transmission factor turns out to be a real-time command of subjective quality.

The TV encoders are designed with an output buffer in charge of collecting the variable data stream at the output of the VLC's (Chapter 2). As a result of functional limitations aiming at limiting the total transmission delay and ensuring a fixed synchronism between decoder and encoder, the output buffer (Chapter 6) has a limited size of the order of one to two coded images (i.e. one to a few Mbit in TV). The buffer regulation computes the transmission factor in order to adjust entropy rates at the quantizer

output and to comply to channel transmission rates without underflowing or overflowing the buffer.

Several schemes of regulating and controlling coders will be successively presented in this chapter providing the analysis with gradual levels of complexity in order to reach both objectives. The algorithms to be investigated will be successively

1. a *regulation with a simple linear feedback* of the level of buffer occupancy to compute the transmission factor.

2. a *regulation with a digital transfer function*, called a *regulator* or a *corrector*, inserted within the reaction loop. A particular case of such a transfer function is the Proportional-Integrator-Differentiator (PID) regulator.

3. a *regulation with an optimum controller*. A controller is a device more general than a simple transfer function in the sense that it implements a complete algorithm designed to observe the output bit stream which feeds the coder buffer and to generate control sequences in order to optimally balance the command of the subjective image quality with the evolution of the buffer occupancy level.

The regulation with a simple linear feedback response is designed without any effective assumption or model about the characteristics of the input signal. This scheme will nevertheless be described to lay down the foundations to treat to the following schemes. Due to its simplicity, it suffers from some inherent drawbacks like potential occurrence of overflows and underflows, oscillations of subjective quality within images and inherent lack of adaptation to cope with the non-stationarities of TV input sources.

The adjunction of a PID regulator into the feedback loop takes into account simplified source models of image bit rates in form of an infinite sequence of consecutive staircases where the steps are located at the scene changes. Consequently, the modeled image bit rate is here a succession of impulses and steps with random heights and durations. The PID regulator provides the coding algorithm with adequate additional capabilities since it avoids any overflow and monitors the transient and steady-state coder responses to scene changes.

The third regulation scheme is adapted to the non-stationary model of TV signals developed in Chapter 3 at the stripe, image and scene levels. The purpose is to proceed one step ahead and derive an optimum control scheme which uses the level of buffer occupancy as an *observation* parameter and constructs a *control strategy* defined here as the sequences of consecutive transmission factor to be applied to the quantization step size computation. The strategy has the task of minimizing a *cost function* which balances the requirement for a uniform quality with that of a level of buffer occupancy varying without neither underflowing nor overflowing. Several concepts are derived from such general control; among them, let us cite the *adaptivity* and the *dual control*. Recently, the theory of neural networks has demonstrated its capability to perform optimum control tasks similar to those described in this application. As a consequence, the principles and the properties of neural networks are outlined in a dedicated section to show relevance of that method.

Both Constant Bit Rate (CBR) and Variable Bit Rate (VBR) transmission modes require a control of output bit rates. In CBR applications, the bit rates of TV entropy

sources which are inherently non-stationary as demonstrated in Chapter 3 need to be controlled and be compressed to reach the constrained constant bit rate imposed on the transmission channel. In VBR applications, the coder is not allowed to transmit at will with any bit rate variability but has to refrain trespassing a statistical gauge enforced by the network management. The coder has therefore to comply to a traffic contract negotiated with the network at the transmission set-up. In this contract, the source specifies its traffic descriptors i.e. its statistics to the network management and the network furnishes statistical parameters to limit the source variability to be enforced in terms of bit rate PDF's and cell inter-arrival times. A control is therefore necessary to avoid infringing the variability limitations and to gracefully adapt the quantization step size to compress more strongly any temporary excess of entropy rate entering the coder.

4.2 Loop with Linear Feedback Response

A sound initial approach to a regulation scheme consists of designing a linear feedback response as a basic solution to be further refined and generalized. A diagram (Figure 4.1) sketches the functional parts of the coder that have already been developed in Chapter 2. Three functions interact here in the regulation. These are typically the entropy bit-rate compression performed conjointly by the quantizer and the VLC, the temporary bit-stream accumulation in an output buffer, the feedback loop using the level of buffer occupancy to monitor the compression of entropy bit rates. These three functions are intended to be thoroughly modeled in terms of discrete equations on entropy bit rates and used into different control schemes as described later in the chapter.

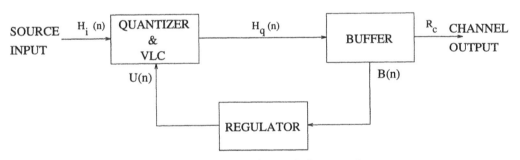

Figure 4.1: Schematic regulation overview.

4.2.1 Compression of Entropy Rates

As presented in Chapter 2, the quantizer step size is computed for each transform coefficient as a function of three parameters, namely the order or the spatial frequency, the local image criticality and the transmission factor which imposes the level of subjective quality. A quantizer model has been developed in form of a rate-distortion function relating the output entropy bit rate $H_q(n)$ with its input value $H_i(n)$ in terms of the transmission factor $U(n)$. n stands for the sampling instants to be defined later in this chapter. Let

us recall that the transmission factor enables compressing the input entropy rate at constant subjective quality. When the transmission factor increases, the quantizer step size increases, the transform coefficients are more and more coarsely quantized and the output entropy bit rate decreases. On one hand, the transmission factor enables adjusting the quantized output data rate; on the other hand, the level of buffer occupancy $B(n)$ is a cumulated measure of the data rate in excess of the constraint transmission rate imposed on the channel. Hence, when the level of buffer occupancy tends to increase, the transmission factor has to be increased to comply to the specified channel rate of transmission and conversely. Therefore, the level of buffer occupancy may be fed back to the quantizer to adjust the output bit rate. The simplest feedback reaction to be implemented is therefore a linear response with a positive slope relating the transmission factor to the level of buffer occupancy.

4.2.2 Buffer Functionality

In this section, the functionality of the encoder buffer will be defined and related with transmission and coding constraints. Especially, the capacity of the buffer will be limited to a size approximatively equivalent to the mean bit stream generated by one up to a few coded images. That constraint will impose the rate of updating the transmission factor.

The output buffer of the encoder is a FIFO memory in which the data stream leaving the VLC is collected and temporarily stored. The content of this buffer is emptied by the packetizer. The buffer accumulates the fraction of stripe bit stream in excess with respect to either the constant bit rate constrained by the channel in CBR applications or to the variable bit rate enforced by the network contract (the police functions of ATM network) in VBR applications.

Ideally, the size of the encoder buffer should be as large as possible (i.e. *infinite*). Nevertheless, besides some constraints of hardware limitations, functional transmission arguments tend to limit the time elapsed in between the scanning of the images and their displaying on the decoder screen once reconstructed. In practice, maximum tolerable transmission delays of a few images (about 10-15 images maximum) are allowed in real time TV and interactive video-conferencing. That constraint limits the transmission delay and, therefore, the maximum buffer capacity. To explain that aspect, let us define the transmission delay of a piece of data as the time elapsed between the instant of their entry into the encoding output buffer and the instant of their exit out of the decoding input buffer. In Chapter 6, it is shown that the mean transmission delay has to be maintained constant in order to synchronize the decoder timing with that of the encoder work. To outline the argumentation developed so far

1. the transmission delay has to be limited. This implies a buffer of limited capacity and a need to regulate the evolution of the level of buffer occupancy without neither overflowing neither underflowing.

2. the transmission delay has to be maintained as constant as possible to maintain a *synchronism* in between the encoder and the decoder. Both encoder and decoder have a buffer to be controlled in terms of level of occupancy. It will be shown in Chapter 6 that, to achieve a synchronization between both buffers, a *relationship*

 Chapter 4. Coding Control Algorithms

of conservation has to be permanently fulfilled. This involves de facto that the regulation of the decoder input buffer is enslaved to the regulation of the encoder output buffer. That additional coupling effect between the levels of buffer occupancy in the encoders and the encoders emphasizes the master function of the encoder buffer regulation.

These two key transmission features justify the research effort towards an adequate regulation scheme of the level of the encoder buffer.

The regulation scheme has to be moreover as fine as possible to take into account the prime goal of achieving a subjective image quality as uniform as possible. The choice of the time interval during which the transmission factor is maintained constant is a compromise between the maximum buffer capacity and the need to maintain the subjective image quality as constant as possible. To avoid buffer overflow and to achieve a good system controllability, the feedback loop has to update the value of the transmission factor at time intervals as small as possible and, in any case, inferior to the period of one image. In the opposite way, the intervals between consecutive updates should be stretched as long as possible to ensure a uniformity in the image quality. A period of one or a few stripe durations turns out to be a compromise for the best interval in between consecutive updates of the transmission factor. In the rest of this chapter, the stripe period will be taken as time interval over which the transmission factor is forced to be constant and, consequently, it will become naturally the sampling period n to be considered in the discrete system equations.

4.2.3 Feedback Loop

The purpose of this section is to present the feedback loop or the relation linking the level of buffer occupancy with the transmission factor. The linear response is here first considered. The slope can be configured differently according to the mode of transmission to be here either CBR or VBR (Figures 4.2 and 4.3 respectively).

In a CBR application, the reaction chain implements a linear response with positive slope between the level of the buffer occupancy and the transmission factor. Assuming image information with one constant entropy bit rate, a stable equilibrium is reached between the level of buffer occupancy and the transmission factor. To show the stable system behavior, let us force slight impulse variations around the equilibrium point, this means either incrementing or decrementing the transmission factor. An increment tends to decrease the quantized data rate, to lower the level of buffer occupancy and, eventually, to force a return towards equilibrium. The decrement leads to a converse effect with a final return to equilibrium. When the incoming entropy rate increases as result of a scene change, the point of equilibrium is shifted to higher coordinates implying higher values for both the transmission factor and the level of buffer occupancy and conversely when the incoming entropy rate decreases. In the case of an incoming entropy bit rate lower than the rate of the transmission channel, the equilibrium point decreases down to impose a transmission factor equal to zero, this event eventually induces an underflow. At this stage, the buffer empties such that it is no longer possible to comply to the transmission rate without stuffing with an additional stream of bits. On the contrary, if the incoming entropy bit rate jumps to a such high value that the variations of transmission factor

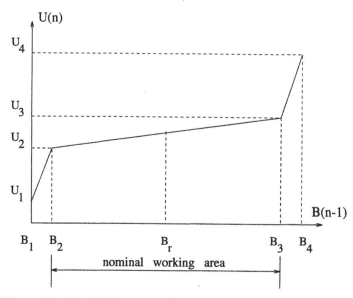

Figure 4.2: Feedback response for constant-bit-rate channel.

during the following stripes are not enough to compensate the step, the buffer overflows momentarily and data are lost in the encoder. Two additional extreme fall-back zones have been added to provide the reaction chain with an increased slope one at high levels of the buffer occupancy to prevent the buffer from overflowing, another at low levels of the buffer occupancy to avoid the buffer from underflowing when it tends to empty. As an extreme case, a stuffing is performed by the coder police function to maintain the constant output bit rate and the equilibrium point within admissible values (Figure 4.2).

When dealing with a free VBR application, the transmission factor is ideally maintained constant for any image bit rate and the output cell rate is free to fluctuate at the rhythm of the incoming non-stationary TV source. In practice, a police function imposed at call set-up is in charge to limit the variability of the output rate within a PDF gauge specified at least by a mean and a peak image bit rate. In the enforced VBR case, the buffer is used only to accumulate the bit stream exceeding the statistical gauge negotiated at call set-up. No feedback regulation scheme is therefore usually required during this mode and a perfect uniform quality is provided by simply maintaining a constant transmission factor. Due to the occurrence of sequences with an information density so high as to induce an output bit rate exceeding the traffic rate negotiated at call set-up, the buffer occupancy rises and reaches a threshold level beyond which it is necessary to switch on a fall-back regulating mode to prevent the buffer from overflowing. A feedback regulation is switched on to increase momentarily the transmission factor and ensure a return to an admissible output bit rate. As a consequence, the image quality is no longer kept constant but is slightly degraded by a more coarse quantization step size until the decrease of input information density. The diagram of the control loop for VBR channel is drawn in Figure 4.3.

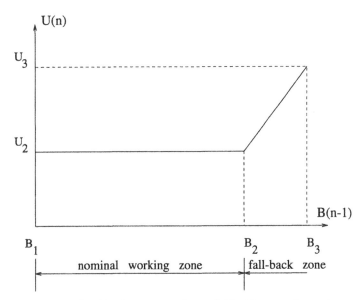

Figure 4.3: Feedback response for variable-bit-rate channel.

4.2.4 Descriptive Equations of the Loop

To draw the discrete system equations, the sampling period n is taken equal to the stripe period and the bit rates to be considered are those accumulated up to the end of the stripe and, consequently, sampling instants correspond to these particular times. Descriptive equations of the loop behavior (Figure 4.4) are expressed by a set of relations referred to as

$$H_q(n) = H_i(n) \times \exp[-\alpha \times U(n)] \tag{4.1}$$

the rate-distortion function of the quantizer and the VLC,

$$F(n) = H_q(n-1) - R_c \tag{4.2}$$

the excess of quantized stripe bit rate with respect to the channel constraint,

$$B(n) = max[B(n-1) + \frac{1}{B_M} \times F(n), 0] \tag{4.3}$$

the evolution of the level of buffer occupancy,

$$U(n) = U_0 + q_p \times [B(n-1) - B_0] \tag{4.4}$$

the reaction response. In these equations, H_i, H_q, R_c stand respectively for the stripe entropy bit rates corresponding respectively to the quantizer input and output and to the transmission channel, B is the level of buffer occupancy with a maximum capacity equal to B_M, U is the transmission factor and F is the excess of the stripe bit rate at the output

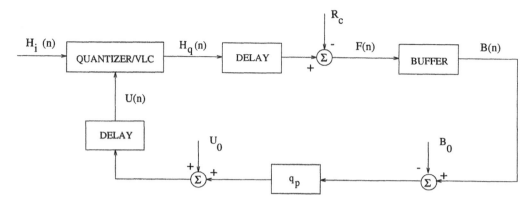

Figure 4.4: Loop model with linear feedback response.

of the VLC inducing a charge or a discharge of the buffer. The parameters q_p, U_0 and B_0 are respectively the slope and the origin coordinates of the linear reaction curve.

Two delays equal to one sampling period emerge from the equations. The first, in the equation of the channel constraint, is due to the use of the UVLC which gathers transform coefficients of one stripe and encodes them during the next period; consequently, the data rate corresponding to the quantized coefficients is therefore available during the next stripe period. The second delay is present in the reaction loop where the transmission factor is computed at the end of each stripe period and applied during the next one.

4.2.5 Drawbacks of Linear Feedback

The linear reaction response presents some drawbacks prohibiting its use with real time TV. These drawbacks to be corrected can be enumerated as follows

1. the transient responses towards the equilibrium point can deviate outside bounds of buffer capacity inducing an overflow. The reaction loop with a simple linear reaction response can never really guarantee and absolutely protect the buffer from overflowing.

2. the slope of the reaction curve can never be adequately fixed. Indeed, if the slope is small, it induces a nearly constant value of both transmission factor and subjective image quality but at increasing risks of overflow. If the slope is high, it lowers the probability of overflow but, as a counterpart, it produces highly variable transmission factors.

These few sentences state the core problem of balancing, in one side, the need of a uniform quality with, on the other side, a buffer control without overflow. Those major drawbacks justify to adapt the reaction loop to correct this regulation scheme and get more efficient responses from the coder. The two following sections are devoted to that improvement, the first uses a digital regulator and the second considers the optimum controller.

4.3 Regulators in the Feedback Chain

A digital corrector is an additional transfer function (with poles and zeros) inserted into a regulation loop system to monitor the transient behavior and the steady state error of the output responses of the closed loop system. A PID regulator is a particular transfer function in the family of the correctors which is composed of a set of three parameters (q_p, q_i, q_d). In a TV coder, the only available location where to insert a regulator is the reaction chain. The three parameters are assigned as follows. q_p is the slope of the reaction response, q_i the coefficient of integration i.e. the coefficient which multiplies the cumulated sum of relative buffer occupancies and q_d the coefficient of differentiation i.e. the coefficient which multiplies the difference between consecutive levels of buffer occupancy.

4.3.1 Integrator and Differentiator

Adding an integrator allows the system response to translate or to displace the linear curve of reaction vertically along the U-axis of the transmission factors. By its contribution, the integrator enables imposing a *reference level* of buffer occupancy where to converge in steady-state. Computations are carried out by integrating the difference between the current level of buffer occupancy at the end of each stripe and the reference level. Let us suppose a positive coefficient of integration q_i. If the buffer level is below the reference, the contribution of the integrator in the computation of the transmission factor is negative, it tends to lower the value of the transmission factor and to force the system to join the equilibrium state corresponding to the buffer reference level. Conversely, if the buffer level is above the reference, the contribution of the integrator is positive and slows down the divergence from the equilibrium point. Depending on the magnitude of the coefficient of integration, the convergence is more or less speeded up and oscillations can be potentially induced. This requires to study the stability of the system.

The advantage of implementing an integrator is significant since it enables forcing the level of buffer occupancy towards converge to a reference level, for example, in a range of 20 % to 50 % of the available capacity. The reference level imposes a reserve of bit rate available in prevision of the occurrence of the next scene change which will require a first image entirely coded in the intra mode and, as a consequence, a temporary higher data rate to maintain as far as possible a high and uniform image quality. Upgrading the quality of the first image in a scene ensures a basis to carry out fine predictions in the following images at the expense of a minimum bit rate. Restated in other words, degrading the quality of the first image by applying a coarse quantization step size will degrade the efficiency of the temporal prediction and require to encode the first images of the scene a global amount of bits larger than that yielded when guaranteeing a first image of high quality. The notion of *reserve of bit rate* is a particular case of a more general behavior called the *caution* which consists in increasing the transmission factor to take care of the potential occurrence of not foreseeable difficult images with an high entropy rate. The notion of *caution* is important to cope with non-stationary and unpredictable systems, this notion will appear more evidently when dealing with the optimum control scheme.

Set in opposition to the long term action of the integrator, the action of the differentiator plays on the short term spans. Let us consider a positive differentiation coefficient q_d, the differentiation computes the difference between two consecutive relative levels of buffer occupancy (i.e. values referred to the reference buffer level). When the level of buffer occupancy tends to diverge from equilibrium, the differentiator adds a contribution to slow down the trend (negative below and positive above the reference level). The effect is similar when the level tends to converge to the reference level in the sense that the contribution slows down the convergence. With a negative coefficient, the contribution of the differentiator can generate unstability. The *differentiation action* is a particular case of an action called *the prediction* which anticipates the buffer behavior to control the system more efficiently. With a positive differentiation coefficient, the differentiator counteracts the buffer evolution to slow down the evolution; on the contrary, with a negative value, the differentiator speeds up the buffer evolution.

4.3.2 Characteristics of PID Regulation

The PID regulation algorithm refers to a simplified model of TV source where the mean amount of innovative information per image is constant inside each scene. Hence, the input density of information per image could be modeled by a succession of steps (or slopes) with both random height (equal to the mean amount of information in the image) and duration (equal to the time interval between two consecutive scene cuts referred in Figure 3.30). The stripe bit rates can be modeled as a superposition of two signals, namely a mean amount which corresponds to the mean long-term rate per scene and a stochastic periodic process which is generated by the periodic sampling process of consecutive quasi-stationary images. Those considerations lead to discriminating a short term from a long term regulation. The short term regulation consists of smoothing out the periodic fluctuations by the low-pass filtering effect of the loop which is performed by a large coder buffer. The long term regulation copes with the succession of steps in the image bit rates. The main problem is therefore to define the way to proceed with the long term regulation. The present algorithm has to deal with impulse, step, and exceptional slope responses. The goal of adding a PID regulator is definitely to provide the loop with additional capabilities when dealing at scene cuts with abrupt changes in the mean value of the image bit rate i.e.

1. to impose the steady-state responses to specified signals (impulse, step, slope) with an error equal to zero i.e. to guarantee a return to the reference level of buffer occupancy.

2. to impose transient responses with a specified time constant (set-up time).

3. to provide the system with a response such to avoid any buffer overflow taking into account the worst changes of scene.

In the following, the paragraph will present successively the coder model for CBR and for VBR channels, and will further proceed by analyzing the stability of the system, first, in its linear approximation and, secondly, in a precise non-linear approach.

4.3.3 Model for CBR Channels

Inserting one cell of PID regulator inside the reaction loop leads to the model presented in Figure 4.5 where the level of buffer occupancy $[B(n)]$ is compared to a reference level (B_r: for example 50% of occupancy), the difference between the level of buffer occupancy and the reference buffer level is scaled, integrated $[I(n)]$ and differentiated $[D(n)]$ at the end of each stripe to contribute to the computation of the transmission factor $[U(n)]$. Descriptive equations of the system (1 to 4) are given as follows in the case of one PID cell

$$H_q(n) = H_i(n) \times \exp[-\alpha \times U(n)] \quad \text{quantizer \& VLC} \tag{4.5}$$

$$F(n) = H_q(n-1) - R_c \quad \text{channel constraint} \tag{4.6}$$

$$B(n) = max[B(n-1) + \frac{1}{B_M} \times F(n), 0] \quad \text{buffer accumulation} \tag{4.7}$$

$$I(n) = I(n-1) + [B(n) - B_r] \quad \text{integrator (PID)} \tag{4.8}$$

$$D(n) = B(n) - B(n-1) \quad \text{differentiator (PID)} \tag{4.9}$$

$$U(n) = U_0 + q_p \times [B(n-1) - B_0] + q_i \times I(n-1) + q_d \times D(n-1) \quad \text{reaction loop (PID)} \tag{4.10}$$

where the coefficients q_p, q_i, and q_d are the PID-regulator parameters respectively for the slope, the integration and the differentiation. R_c is the fixed channel bit rate and B_M is the maximum buffer capacity. The point of coordinates U_0 and B_0 corresponds to the origin of the linear curve within the reaction.

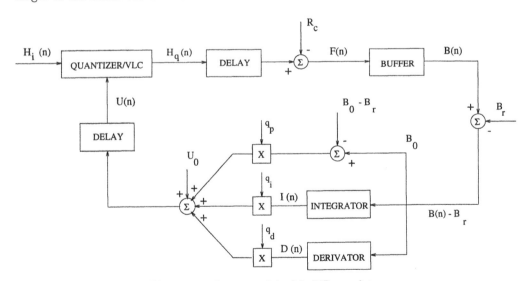

Figure 4.5: Loop model with PID regulator.

The behavior of the system is in first approximation a superposition of two working modes, namely the steady-state equilibrium point and the transient responses, as described in the two following sections

1. the *bias or equilibrium point* corresponds to the mean behavior to be attained if the input source were generating a constant image bit rate equal to its current mean entropy rate. In this mode, the level of buffer occupancy has reached its reference and the transmission factor is stabilized around its mean value.

2. the *transient responses* before reaching equilibrium occur at the scene changes where the input source generates a step in the image bit rate and forces the system to a transient excursion towards a new equilibrium state. Restated in other words, the response is that one which would be obtained if the system were instantaneously put away from equilibrium and had to tend to a new equilibrium state. This has to be a stable point of equilibrium.

In this description, the periodic stripe bit rates are supposed to be low-pass filtered by the buffer and the scene length so long as to enable the system to reach equilibrium before the occurrence of the next scene change. Indeed, the transient time constants are usually lower than 10 images and the scene lengths are not shorter than 25 images. This constitutes the approximation of this model and allows treating the system with deterministic equations without taking into account the non-stationary stochastic behavior of the input source of entropy.

4.3.3.1 Equilibrium State

The bias working state is described by these relations

$$H_{q,eq} = H_{i,eq} \times \exp\left[-\alpha \times U_{eq}\right] \tag{4.11}$$

$$H_{q,eq} = R_c \tag{4.12}$$

$$B(n) = B_r \; ; \; I(n) = I_{eq} \; ; \; D(n) = 0 \tag{4.13}$$

$$U_{eq} = U_0 + q_p \times [B_r - B_0] + q_i \times I_{eq} \tag{4.14}$$

where I_{eq} is the integrator value accumulated at the current equilibrium state, $H_{q,eq}$ and $H_{i,eq}$ are mean stripe entropy bit rates at equilibrium. In a stabilized equilibrium mode, the value of U_{eq} is adjusted by the integrator to apply the correct quantization step size on $H_{i,eq}$ to reach $H_{q,eq}$.

The equilibrium state corresponds to the point where the transmission factor is such that the output quantized data rate equals, in mean, the channel rate. The positive slope of regulation loop induces a stable equilibrium because

1. any increase of transmission factor implies a decrease of successively the mean quantized data rate and the level of the buffer occupancy. By the feedback reaction, a resulting decrease of transmission factor is induced.

2. any decrease of transmission factor implies the converse mechanism.

This shows that an equilibrium state can be reached. This behavior is necessary but not sufficient meaning that a stability area has to be delimited.

4.3.3.2 Transient Responses

Descriptive equations of the system are given as follows by a set of discrete relations, the equilibrium state is here relocated at the origin and calligraphic variables represent variations around their final equilibrium value $[\mathcal{U}(n) = U(n) - U_{eq},\ \mathcal{B}(n) = B(n) - B_r,\ \mathcal{H}_q(n) = H_q(n) - R_c]$

$$\mathcal{H}_q(n) = H_{i,eq} \times \exp[-\alpha \times U_{eq}] \times \exp[-\alpha \times \mathcal{U}(n)] = R_c \times \exp[-\alpha \times \mathcal{U}(n)] \quad (4.15)$$

$$\mathcal{H}_q(n-1) = H_q(n-1) - R_c \quad (4.16)$$

$$\mathcal{B}(n) = max[B(n-1) + \frac{1}{B_M} \times \mathcal{H}_q(n-1), 0] \quad (4.17)$$

$$\mathcal{B}(n) = B(n) - B_r \quad (4.18)$$

$$I(n) = I(n-1) + \mathcal{B}(n) \quad (4.19)$$

$$D(n) = \mathcal{B}(n) - \mathcal{B}(n-1) \quad (4.20)$$

$$\mathcal{U}(n) = q_p \times [\mathcal{B}(n-1)] + q_i \times I(n-1) + q_d \times D(n-1) \quad (4.21)$$

The resolution of this set of equations leads to two non-linear difference equations one for $\mathcal{U}(n)$ and another for $\mathcal{B}(n)$. The resolution is presented in two steps, a non-linear recurrence equation is first deduced and further expressed in a n-dimensional space.

Non-Linear Recurrence Equations

1. for \mathcal{U} (n)

$$\mathcal{U}(n+4) - 2 \times \mathcal{U}(n+3) + \nu \times \mathcal{U}(n+2) + \xi \times \mathcal{U}(n+1) + \eta \times \mathcal{U}(n) + f_1 = 0 (4.22)$$

with

$$\nu = 1 + \alpha \times \frac{R_c}{B_M} \times (q_p + q_i + q_d) \quad (4.23)$$

$$\xi = -\alpha \times \frac{R_c}{B_M} \times (q_p + 2q_d) \quad (4.24)$$

$$\eta = \alpha \times \frac{R_c}{B_M} \times q_d \quad (4.25)$$

The function f_1 contains the non-linearities.

4.3. Regulators in the Feedback Chain

2. for \mathcal{B} (n)

$$B(n+4) - 2 \times B(n+3) + \nu \times B(n+2) + \xi \times B(n+1) + \eta \times B(n) + f_2 = 0 \quad (4.26)$$

Again, f_2 contains the non-linear part of the equation.

The way to proceed further consists in expressing the equations in a four-dimensional state space.

State-Space Equations

1. for \mathcal{U} (n)

let

$$
\begin{array}{rcll}
x_1(n) & = & \mathcal{U}(n) & \quad (4.27) \\
x_2(n) & = & x_1(n+1) & \quad (4.28) \\
x_3(n) & = & x_2(n+1) & \quad (4.29) \\
x_4(n) & = & x_3(n+1) & \quad (4.30)
\end{array}
$$

the following matrix equation is deduced

$$X(n+1) \;=\; A \times X(n) \;-\; B \times f_1[x_1, x_2, x_3, x_4] \quad (4.31)$$

with

$$
X = \begin{vmatrix} x_1 \\ x_2 \\ x_3 \\ x_4 \end{vmatrix}
\quad
A = \begin{vmatrix} 0 & 1 & 0 & 0 \\ 0 & 0 & 1 & 0 \\ 0 & 0 & 0 & 1 \\ -\eta & -\xi & -\nu & 2 \end{vmatrix}
\quad and \;\; B = \begin{vmatrix} 0 \\ 0 \\ 0 \\ 1 \end{vmatrix}
$$

2. for \mathcal{B} (n)

The same reasoning applies by letting

$$
\begin{array}{rcll}
x_1(n) & = & \mathcal{B}(n) & \quad (4.32) \\
x_2(n) & = & x_1(n+1) & \quad (4.33) \\
x_3(n) & = & x_2(n+1) & \quad (4.34) \\
x_4(n) & = & x_3(n+1) & \quad (4.35)
\end{array}
$$

the following matrix equation is deduced

Chapter 4. Coding Control Algorithms

$$X(n+1) = A \times X(n) - B \times f_2[x_1, x_2, x_3, x_4] \tag{4.36}$$

in this case, matrix A has a similar form to that one found for $\mathcal{U}(n)$, the same properties apply for both.

4.3.4 Model for VBR Channels

As earlier described, in case of exploiting on VBR channels, the transmission factor is usually maintained constant (the nominal mode) [1] except in a fall-back mode i.e. in scenes where the mean image bit rate exceeds the specified policed values. In this case, the transmission factor has to be adjusted to force the buffer occupancy to join a reference level and to comply to the traffic contract with the network. The reaction curve is segmented in two parts, an horizontal area for the nominal mode and an inclined area for the fall-back mode. The reference level of buffer occupancy is that located at the connection of those two parts.

In VBR applications, the coding system implements a backward propagation mechanism working passively as follows. The internal coder police function prevents the packetizer from transmitting with a cell rate beyond the bit rate gauge specified by the network at the transmission call set-up. In the case of an entropy bit rate higher than the policed channel rate, the packetization is slowed down, the exceeding bit rate fills momentarily the coder output buffer; beyond a threshold of buffer occupancy, a feedback chain is switched on and reacts on the quantizer to increase the quantization step size and therefore lower the output quantized data rate.

Let us now examine the relevant equations related to both modes

1. during the *nominal mode* the buffer occupancy lies at a level lower than the reference and the buffer is emptied as quickly as possible. The regulation is always disabled, except when leaving the fall-back mode and recovering the nominal mode, the integrator is progressively released during the transition to ensure a monotone evolution of the transmission factor.

$$H_q(n) = H_i(n) \times exp[-\alpha \times U(n)] \tag{4.37}$$

$$\begin{aligned} R_c(n) &= R_{c,M} \quad \text{if} \quad H_q(n) \geq R_{c,M} & (4.38)\\ &= K(n) \quad \text{if} \quad H_q(n) < R_{c,M} & (4.39) \end{aligned}$$

where K(n) is such that

$$\begin{aligned} K(n) &= H_q(n) & \text{if} \quad & B(n-1) = 0\\ &= H_q(n) + B(n-1) \times B_M & \text{if} \quad & B(n-1) \times B_M < R_{c,M} - H_q(n)\\ &= R_{c,M} & \text{if} \quad & B(n-1) \times B_M \geq R_{c,M} - H_q(n) \end{aligned}$$

[1]the nominal mode means the mode in which the system should spend the most frequent part of time i.e. preferably more than 90%

$$B(n) = max[B(n-1) + \frac{H_q(n) - R_c(n)}{B_M}, 0] \qquad (4.40)$$

$$S(n) = B(n) - B_r \qquad (4.41)$$

$$I(n) = \begin{cases} 0 & \text{if} \quad I(n-1) \le 0 \\ I(n-1) + S(n) & \text{if} \quad I(n-1) > 0 \end{cases} \qquad (4.42)$$

The integrator is released with continuity after an excursion in the fall-back mode when recovering the nominal mode; otherwise, I(n)=0.

$$D(n) = 0 \qquad (4.43)$$

2. during the *fall-back mode*, initiated when the buffer occupancy stays beyond its reference level, the regulator is switched on to pull down the output quantized bit stream with a specified transient time and to maintain the buffer occupancy at its reference value. All Equations (4.5 to 4.10) developed in the previous paragraph hold to describe the configuration of this mode.

4.3.5 Study of Stability

The following two subsections are devoted to monitoring both system stability and response in image quality. The linear behavior of the system is first addressed in this study and will be followed by the non-linear aspects.

The system behaves as a linear system if developing the non-linearity into series

$$\exp[-\alpha \times \mathcal{U}(n)] = 1 - \mathcal{U}(n)[\alpha + \sum_{i=2}^{\infty} \frac{(-1)^{i-1} \alpha^i \mathcal{U}^{i-1}(n)}{i!}] \qquad (4.44)$$

$$= 1 - \mathcal{U}(n) \alpha' \qquad (4.45)$$

the condition

$$\alpha \gg \sum_{i=2}^{\infty} \frac{(-1)^{i-1} \alpha^i \mathcal{U}^{i-1}}{i!} \qquad (4.46)$$

is satisfied. Otherwise, the effect of the non-linearities will prevail over the system. Depending on the magnitude of the variation in mean image bit rates at scene changes, the responses of the closed loop system are perturbated by the non-linearities. The effects are gradually marked when the magnitudes of the steps in mean image bit rate increase. Let us take an example with $\mathcal{U} = 10$ due to a change of H_i from 29000 bit/stripe to 80000 bit/stripe which are frequent conditions in real time TV occurring when changing from a simple scene poor in information (for example, the test sequences *Claire* or *Miss America*) towards a complex scene dense in information (for example, the test sequences *Mobile and Calendar* or *Football*). In that case, $\alpha = 0.1$ and $\alpha' = 0.062$. The variation in α implies a temporary displacement of the pole location and leads to calculating a sensitivity of pole location to a change in α which is expressed by a partial difference equation given by

$$\frac{\partial a}{\partial \alpha} = \frac{R_c}{B_M}(q_p + 2q_d)\frac{1}{a-b} \tag{4.47}$$

in the case of two double poles a and b. If a=0.94 and b=0.06, $a + \Delta a = 0.978$ and the time constant [2] is stretched from 74 stripes to 207 stripes i.e. multiplied by a factor 3 of change. The system is closer to unstability. The response is no longer short enough to prevent the buffer from overflowing since the response of U(n) is longer and longer and the buffer fluctuates faster. This induces oscillations and can generate overflows. The study of non-linearities is therefore an important issue when designing a PID for real time coders.

The complete non-linear model can still be treated analytically, for instance, with Ljapounov's theory. Moreover, additional methods could have been presented. Let us cite Banach's contraction theorem and the numerical methods based on sketching phase portraits widely exploited on computer by means of formal mathematical tools.

4.3.5.1 Linear Approximation for the Coder Model

The linear model can be studied through various classical approaches, among them, let us mention

1. the *linear approximation* of the discrete system equations leading to a discussion about root locations of the characteristic equation.

2. the *z-transformation* leading to the same discussion with, additionally, an analytical calculation of the response to input signals like impulses, steps and slopes, the application of Nyquist's theorem of stability and the computation of stability margins.

3. the *algebraic criteria* of stability like Routh-Hurwitz and Schur-Cohn theorems to be applied as necessary and sufficient stability conditions.

as the most currently employed techniques.

Linear Model with State-Space Equations

The linear approximation of discrete Equations 4.22 and 4.26 leads to a *characteristic equation* with real coefficients ν, ξ, η. It is obtained by introducing the variable r and by cancelling the non-linear component f_1 so as to obtain

$$r^4 - 2 \times r^3 + \nu \times r^2 + \xi \times r + \eta = 0 \tag{4.48}$$

The discrete difference equation is stable if and only if the roots of the characteristic equation are in module inferior to the unity. In the case of stability, some other requirements are to be fulfilled to generate an acceptable image quality. Preference is stressed on monotone decreasing responses which prohibit any stripe-by-stripe oscillatory evolution of the transmission factor (and therefore of the local image quality). Complex solutions

[2]the time constant is here defined as the transient time necessary to reach 99% of the final steady-state value.

in conjugated pairs have also to be avoided since they lead to lightly damped convergent waveforms typified by an oscillatory exponential decay. For similar reasons, real negative roots have also to be excluded from the set of solutions. Admissible solutions are either any critically damped responses provided by two pairs of equal real and positive roots inferior to the unity or any heavier supercritically damped solutions leading to responses with longer time constants.

Linear Model with z-Transformation

The z-transform version of linear approximation of Equations 4.5 to 4.10 is stated as follows in one-by-one correspondence with $H_q(z) = \mathcal{H}_q(z) + R_c$, $U(z) = \mathcal{U}(z) + U_{eq}$, $H_i(z) = \mathcal{H}_i(z) + R_c \exp[\alpha \times U_{eq}]$

$$\mathcal{H}_q(Z) = -\alpha R_c \times \mathcal{U}(z) + \mathcal{H}_i(z) \exp[-\alpha \times U_{eq}] \tag{4.49}$$

as the linear version of Equation 4.15 in z-transform

$$F(z) = z^{-1} \times \mathcal{H}_q(z) \tag{4.50}$$

$$B(z) = \frac{1}{B_M} \times \frac{F(z)}{1 - z^{-1}} \tag{4.51}$$

$$I(z) = \frac{B(z)}{1 - z^{-1}} \tag{4.52}$$

$$D(z) = (1 - z^{-1}) \times B(z) \tag{4.53}$$

$$\mathcal{U}(z) = z^{-1} \times [q_p \times B(z) + q_i \times I(z) + q_d \times D(z)] \tag{4.54}$$

The corresponding schematic model is presented in Figure 4.6.

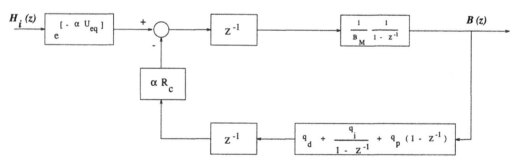

Figure 4.6: Modeling of the control loop in the linear first-order approximation.

The impulse, step and slope responses can be easily calculated, they lead to a discussion of pole locations in the z-plane similar to that carried out in the previous paragraph. The steady state error $\epsilon(n)$ to input command is determined by the theorem of the final value applied to z-transformation which states

Chapter 4. Coding Control Algorithms

$$\epsilon(\infty) = 0 \quad or \quad \lim_{z \to 1}[(1 - z^{-1}) \times E(z) \times W(z)] = 0 \qquad (4.55)$$

where $E(z)$ is the input command and $W(z)$ is the closed loop transfer function expressed as

$$W(z) = \frac{1}{1 + H(z) \times G(z)} \qquad (4.56)$$

with $H(z)$ and $G(z)$ being the z-transfer function of respectively the direct and the reaction chain. In the case where one single cell of PID is implemented, impulse, step $[E(z) = \frac{1}{1-z^{-1}}]$ and slope responses $[E(z) = \frac{Tz^{-1}}{(1-z^{-1})^2}]$ induce a steady-state error without any bias. As a salient point in the linear approximation, the loop behavior (transient and steady-state) can be specified analytically with the loop parameters B_M, α, q_p, q_i, q_d and R_c.

According to Nyquist's theorem, we let $z = e^{j\phi}$ in the transfer function of the direct and the reaction chain

$$H(z = e^{j\phi}) = e^{-j\phi} \times \frac{1}{B_M} \times \frac{1}{1 - e^{-j\phi}} \qquad (4.57)$$

$$G(z = e^{j\phi}) = \alpha R_c \times e^{-j\phi} \times [q_p + \frac{q_i}{1 - e^{-j\phi}} + q_d(1 - e^{-j\phi})] \qquad (4.58)$$

a discrete linear system is demonstrated to be stable if and only if the curve of $H(e^{j\phi})G(e^{j\phi})$ of the open loop transmittance sketched in the complex plane shows a path such that, when circulating on the curve from $\phi = 0$ to $\phi = 2\pi$, the point $(-1, j0)$ is continuously located on the left of that curve. In Figures 4.7 and 4.8, the Nyquist curve is sketched in two different working configurations, the gain margin is in any case greater than 10 dB ($B_M = 10^6$ bits, $\alpha = 0.41$, $q_p = 19.8$, $q_i = q_d = 0.49$). Two features have to be considered, namely the symmetry of the curve about real axis and the loop encircling origin due to the presence of two sampling delays.

4.3.5.2 Numerical Examples of PID

Table 4.1 presents a set of parameters for a reaction response in CBR applications at 15 Mbit/s. The curve is subdivided in three segments $i = 1$ to 3. The segments 1 and 3 characterize fall-back behaviors. PID parameters and origin coordinates of the three segments are given in Table 4.1.

segment i=	1	2	3
q_p	500	100	450
q_i	5	0.6	5
q_d	200	150	200
B_i	0	0.1	0.9
U_i	0	50	130

Table 4.1: Example of PID parameters.

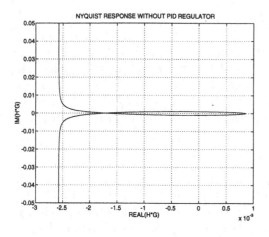

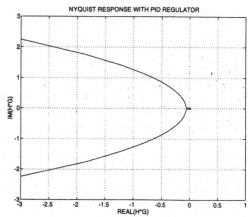

Figure 4.7: Nyquist response without PID regulator.

Figure 4.8: Nyquist response with PID regulator.

The scale of the transmission factor value is $\{[U(n) \in [0, 176]\}$ to control a quantization step size in the form of $\delta(n) = f(2^{-\frac{U(n)}{16}})$ (Chapter 2) which can quantize in their full range the transform coefficients expressed with 11 bits. The level of buffer occupancy is expressed as a fraction of the maximum capacity $\{[B(n) : 0 \text{ to } 1]\}$. The reference level of buffer occupancy is 0.5. In that case, the poles are double and located at a=0.958 and b=0.042. The experimental conditions are those which follows $\alpha = \frac{4.51}{16 \times 11}$, $R_c = 8333.0$ bit/stripe or 15 Mbit/s and $B_M = 1$ Mbit.

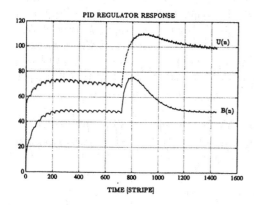

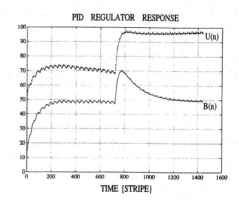

Figure 4.9: Regulator with non-linear system.

Figure 4.10: Regulator with linear system.

Figures 4.9 to 4.10 present the responses to scene changes obtained with simulated TV source and coder in terms of buffer occupancy $B(n) \in [0\%, 100\%]$ and transmission factor $T(n) \in [0, 176]$ versus time expressed in stripe unit. $B(n)$ is therefore represented in

Chapter 4. Coding Control Algorithms

per cent of buffer occupancy and T(n) in a non-normalized range, the start is non-linear in both cases to force at stripe 700 identical initial conditions. To evidence the non-negligible effects of the non-linearities, two cases have been drawn, one with a linear response of compression and another with a negative exponential testifying of the real response. In the non-linear case, the shift of poles has extended the duration of control response. This induces a higher excursion of the level of buffer occupancy and consequently of the transmission factor. This tendency towards overflow and instability justifies a study of the non-linear behavior.

4.3.5.3 Non-Linear Model

The study of non-linear discrete systems involves numerous definitions of stability. An equilibrium state is termed stable if every nearby solution stays nearby for all future times. This chapter intends to treat one type of stability presenting an actual interest. That is the determination of the four-dimensional hypervolume L of asymptotical stability. If L is the domain where all the solutions tend to equilibrium as time tends to infinity, then the equilibrium state is said to be asymptotically stable on L (i.e. the area where $\lim_{n\to\infty} x(n) = 0$). Conversely, if it is possible to find perturbations that move the system away from rest, the equilibrium is called unstable.

Several features will characterize the differences between linear and non-linear systems. Contrary to linear systems, the conditions for system stability and unstability are stated as sufficient but not necessary conditions. As a matter of fact, any four-dimensional hyper-volume of asymptotical stability or unstability delimited with the theory could not be defined univocally. This means that an undeterminated hyper-volume could subsist where neither system stability nor unstability can be really deduced from theory. Moreover, the stability of the non-linear system is sensitive to initial conditions meaning that a specific hyper-volume of stability has to be delimited with respect to initial conditions. In fact, for some variable values belonging to the hyper-volume L of asymptotical stability, the initial conditions can induce transient sequences which leave the predefined stability domain and, therefore, generate system unstability. This defines a second hyper-volume L' of stability contained in L and constitutes the second difference with linear systems since the stability of a non-linear system depends on the initial conditions.

For non-linear discrete difference equations, the domain of asymptotical stability or unstability surrounding an equilibrium point can be approached by at least three methods, namely Ljapounov's theory, phase portrait and Banach's theory which is explained in Appendix 4.A.

Second Theorem of Ljapounov

To express Ljapounov's second theorem, let a discrete difference equation of order m with an equilibrium state located at the origin be noted as

$$F(x_n, x_{n+1}, ..., x_{n+m}) = 0 \qquad (4.59)$$

The method states different principles which define first a hypervolume of asymptotical stability for variable values. The exposition of the theorem will be followed by a further

way to proceed to find the hypervolume of stability with respect to the initial conditions. The system is stable if it is possible to define a function V_π positive definite such that

1. everywhere, except at the origin where it could be zero, V is expressed as

$$V_\pi = X^T(n)CX(n) \geq 0 \qquad with\ det(C) > 0 \qquad (4.60)$$

where $X(n)$ is a vector of the m-dimensional space fulfilling the relation given by $F[X(n)] = 0$ and C is any square symmetric positive definite matrix.

2. the hyper-volume where $\Delta V_\pi < 0$ (except at the origin where it could be zero) is declared to be a sufficient domain of asymptotical stability with respect to the variable values

$$\Delta V_\pi = X^T(n+1)CX(n+1) - X^T(n)CX(n) \qquad (4.61)$$

therefore in the case of the state-space Equation 4.48

$$\Delta V_\pi = X^T[A^TCA - C]X - 2f_1B^TCAX + B^TCBf_1^2 < 0 \qquad (4.62)$$

The stability obtained here with the theorem of Ljapounov is a stability with respect to the variable values. To proceed further and define the domain of stability to the initial conditions, let us define a Ljapounov equipotential closed hyper-surface as having the following property

$$P_1 < P_2 \qquad \Longrightarrow \qquad E_{P_1} \subset E_{P_2} \qquad (4.63)$$

where P_i and E_{P_i} correspond respectively to the potential and the interior hyper-space of the hyper-surface defined by Ljapounov's function $V_\pi = P_i$. When V_π fulfills Ljapounov's condition, the matrix C is positive definite. Let the γ_i (i=1,..,4) denote the eigenvalues of the matrix C as real positive values. By an orthogonal transformation Y=BX, the function V can be written in the canonical form

$$V_\pi = \gamma_1 y_1^2 + \gamma_2 y_2^2 + \gamma_3 y_3^2 + \gamma_4 y_4^2 \qquad (4.64)$$

the hyper-surfaces defined by this expression $V_{pi} = X^TCX$ are ellipsoids of four dimensions given by

$$\frac{X_1^2}{\frac{P}{\gamma_1}} + \frac{X_2^2}{\frac{P}{\gamma_2}} + \frac{X_3^2}{\frac{P}{\gamma_3}} + \frac{X_4^2}{\frac{P}{\gamma_4}} = 1 \qquad (4.65)$$

where the semi-axes are given by

$$r_i = \sqrt{\frac{P}{\gamma_i}} \qquad i = 1, 2, 3, 4 \qquad (4.66)$$

Hence, the functions V_π determine Ljapounov's equipotential surfaces. P stands for the value of the potential.

The domain of total stability (to both variable values and initial conditions) is obtained as the equipotential hyper-surface which has the highest potential P_M and which is contained in the hypervolume L of stability with respect to the variable values

$$X_0^T C X_0 \leq P_M \tag{4.67}$$

The interpretation to be given to this surface is that any initial point located within this surface is attracted by the decreasing potentials to finally converge towards the equilibrium point.

Phase Portraits

The phase trajectories are deduced from computer simulations, they sketch the evolution of $[X(n+1) - X(n)]$ as a function of $X(n)$, they enable to show the non-linear behavior in either stable or unstable domains.

The study of non-linear behavior of regulation loop has been carried out by three methods. Figures 4.11 to 4.16 sketch the stability domain with respect to variable values in the subspace $X_1 = 5.0$, in the case of a TV coder at 20 Mbit/s and a buffer of 10^6 bits. The loop parameters (PID) computed by linear approximation are valid around the equilibrium point for small input perturbations. This covers small changes occurring at scene cuts but not those involving consecutive scenes with an important difference between mean image bit rates. The study of non-linearities has therefore allowed to delimit, around equilibrium, the hyper-volume beyond which effects of non-linearities induce oscillations in the response due to an initial position being outside this delimited area. Moreover, a further outer hyper-volume has been delimited beyond which instability is observed (i.e. buffer overflow). Each of the four methodologies has presented slightly different areas as a consequence of the fact that each area realizes only sufficient condition of asymptotical stability.

Let us remark here the effect of the non-linearities arising from the quantization model. They introduce chaotic modes when the system is pushed into the hyper-volume of unstability. As a matter of fact, the second order system approximation leads to an equation of the form

$$H_q(n+1) = H_q(n) + \alpha H_q^2(n) \tag{4.68}$$

which belongs to the family of the mathematical epidemic models. They have been demonstrated as generating, with respect to the value of α, disorder figures with bifurcations and strange attractors.

Contribution of Non-Linear Behaviors

The non-linear part of the model brings important contributions to design a regulation preventing buffer from overflowing. Practically, the limiting surface of stability has led to compute admissible excursion bounds for the integration to avoid, first of all, overflows

but also oscillations in quality response. For the PID parameters tabulated in 4.1, the integration excursions have been limited within [-20,+25]. This means that, for sequences with small source entropy rate, the integration will be limited in its downward shift along the reaction curve, the equilibrium will be achieved at a level of buffer occupancy lower than that of the reference. Intuitively, that limitation prevents the reaction response from being too weak to cope with any potential difficult coming scene. Moreover, stabilizing at a lower level of occupancy, the buffer provides the system with a higher reserve of bit rate.

4.4 Optimum Control Algorithm

In this third scheme, a generalization of the concept of regulation is addressed. The regulator is no longer a transfer function in a classical sense but, rather, an algorithm called a controller. It enables taking into account the intrinsic stochastic nature of input sources and implementing generalized and optimized transfer functions. The optimum control is based on three features which are

1. a *cost function* to be optimized.

2. a *predictor* to project into the future source bit rates to be expected with respect to the correlation learnt from the past i.e. to build an expected horizon of incoming entropy rate. The predictor has to be optimum and adapted to both the non-stationarity of the input source rate and to the non-linearity of the coding function. A Kalman filter fulfills all these requirements and is exploited to model optimally the input information rate in conjunction with the coding system and provide the controller with a substratum of expected forthcoming bit rates.

3. an *optimum search* through the predicted bit rates covering the future up to the horizon (the horizon is defined as the maximum extend of future to which the previsions are estimated).

The scheme exploits the model of a non-stationary TV signal subdivided into a multiresoluted time scale structure of programmes, scenes, images and stripes, as already developed in Chapter 3. The algorithm is adaptive and enough general to deal simultaneously with both non-linear systems and non-stationary sources. The optimum control is implemented at the lower bit rate level, that of the stripe bit rate. The adaptation is carried out when forcing each level of the multiresoluted bit rate structure to adjust the control parameters managed by the lower level so as to cope with input signal non-stationarity. The different control functions will be explained and the properties detailed to yield an adaptive optimum strategy. Kalman and Bellman theory are shortly reviewed to support the theoretical comprehension.

4.4.1 Cost Function

The optimum strategy consists in allowing, on a stripe-by-stripe basis, the smallest changes in the subjective image quality (these changes are defined by

Figure 4.11: Ljapounov stability: lower limit.

Figure 4.12: Ljapounov stability: upper limit.

Figure 4.13: Banach stability: lower limit.

Figure 4.14: Banach stability: upper limit.

Figure 4.15: Phase-portrait-based stability: lower limit.

Figure 4.16: Phase-portrait-based stability: upper limit.

4.4. Optimum Control Algorithm

$\Delta U(n) = U(n+1) - U(n))$ i.e. in controlling the coder as smoothly as possible, especially at scene changes. For the reasons explained in Section 3, the control should also force the buffer level to converge to a consigned reference level B_r before the occurrence of the next scene change. As a consequence, the best long term balance between a regulation of quality and of buffer is performed by minimizing a cost function of the type

$$V(i) = \sum_{n=i}^{i+N} E\{[\Delta U(n+1)]^2 + \vartheta[B(n+1) - B_r]^2\} \tag{4.69}$$

where i is the current instant of decision and N, the horizon. The parameters ϑ and B_r can further be adapted according to constraints originating from lower resolutions in the time scale to take into account for instance statistics of scenes and image bit rates at the horizon of each TV programme.

Some additional constraints can eventually be added to the control like a practical limitation into the maximum level of buffer occupancy to cover its actual capacity $0 \leq B(n) \leq 100\%$.

4.4.2 Optimum Source Bit-Rate Predictors

The optimum predictive bit-rate models [3] for TV sources are directly derived from the source models developed in Chapter 3 at either the stripe or the image level. The optimum predictive filter according to the performance criterion of the Minimum-Mean-Squared-Error (MMSE) estimation in case of stationary stochastic signals is the Wiener filter. Therefore, in this section, the foundations of the MMSE estimation are first laid down and the principle of Wiener filter is thereafter discussed in terms of orthogonal projections. State-space equations are introduced to derive a Kalman filter and explain its properties as an optimum MMSE estimator for non-stationary discrete signals. Moreover, after having extended the predictive operation to incorporate both the input bit rate and the coder model, a computational implementable Kalman filter is treated in a context so general as to deal with both non-linear and non-stationary systems.

4.4.2.1 Concept of MMSE Estimation

A Hilbert space L for random variables is conveniently defined with a similarity to the Euclidean space (Chapter 2) where the inner-product has already been defined. Let S be the sample space on which two random variables X and Y are defined, P be the probability measure on S. By reminiscence to the inner-product formulae, a geometrical interpretation is researched and leads to defining the following notations

$$(X, Y) = E\{XY\} \qquad ||X|| = [E\{X^2\}]^{\frac{1}{2}} \tag{4.70}$$

It can readily be verified that these definitions characterize legitimate inner-product (X, Y) and norm $||X||$. Indeed, in the Hilbert space L, the expected value of the product of two random variables X and Y is given by the Stieltjes integral

[3]Tilded variables, barred variables and hatted variables stand respectively for optimum values, mean values and predicted values.

$$E\{XY\} = \int_{s \in S} \alpha(s)\beta(s)dP(s) \qquad (4.71)$$

where X and Y are functions of event points $s \in S$, as $X = \{\alpha(s) : s \in S\}$ and $Y = \{\beta(s) : s \in S\}$. This corresponds exactly to the common definition of the inner-product as already mentioned in Chapter 2 where it has been demonstrated how the expected value, i e. the correlation, can be further re-formulated in terms of the joint probability density function f_{XY} as

$$E\{XY\} = \int \int XY f_{XY}(X,Y)dXdY \qquad (4.72)$$

In space L, the variables X and Y are termed vectors. This provides the random variables with a geometrical representation which can be extended to all known concepts, for instance, the orthogonality between two random variables X and Y given by $E\{XY\} = 0$, the distance between two vectors X and Y is given by the norm of their difference and the cosine of angles given by $\cos\theta = \dfrac{E\{XY\}}{\sqrt{E\{X^2\}E\{Y^2\}}}$. Furthermore, Pythagor's theorem finds here a direct application. The squared norm of the sum of two orthogonal vectors X and Y is equal to the sum of their squared norms, then

$$(X,Y) = 0 \qquad \leftrightarrow \qquad ||X \pm Y||^2 = ||X||^2 + ||Y||^2 \qquad (4.73)$$

The law of cosines on the sides of a triangle states that the square of the side opposite to one angle, θ, is equal to the sum of the squares of the other two sides minus twice their product times $\cos\theta$, then

$$||X - Y|| = ||X||^2 + ||Y||^2 - 2(X,Y) \qquad (4.74)$$

Let us also observe that Cauchy-Schwarz inequality which holds for every pair of vectors (X,Y) as $|(X,Y)| \le ||X|| \, ||Y||$ is a direct consequence of the trigonometric inequality $|\cos\theta| \le 1$ for any angles θ. These results for the Euclidean space are identically valid in any arbitrary m-dimensional Hilbert spaces. For example, let us consider a m-dimensional space as a subspace M of a l-dimensional Hilbert space L, clearly $l > m$. The closest vector \hat{X}_0 in M to an unknown vector X in the unobservable space L is given by the unique solution expressing the orthogonal projection of X onto M. Hence, the difference between X and the closest vector \hat{X}_0 is orthogonal to every vector \hat{X} in M and $(X - \hat{X}_0, \hat{X}) = 0$ $\forall \hat{X} \in M$. This *condition of orthogonality* can be expressed in terms of any set of basis vectors of subspace M as follows (Figure 4.17). Specifically for \hat{X}, we get

$$\hat{X} = \sum_{i=1}^{m} h_i Y_i \qquad (4.75)$$

where the vectors $\{Y_i : i = 1, ..., m\}$ are a basis of subspace M and the scalars $\{h_i : i = 1, ..., m\}$ the projections of \hat{X} on the basis vectors Y_i. Within the basis functions, we are looking for the scalars h_i^0 which satisfy the condition of orthogonality, that is

$$(X - \hat{X}_0, Y_i) = 0 \qquad i = 1, 2, ..., m \qquad (4.76)$$

4.4. Optimum Control Algorithm

The $\hat{X}_0 = \sum_{j=1}^{m} h_j^0 Y_j$ which fulfills the condition has also to satisfy the condition formulated on the scalars h_i^0 as follows

$$\sum_{j=1}^{m} h_j^0 (Y_j, Y_i) = (X, Y_i) \qquad i = 1, 2, \ldots, m \qquad (4.77)$$

or in a matrix formulation,

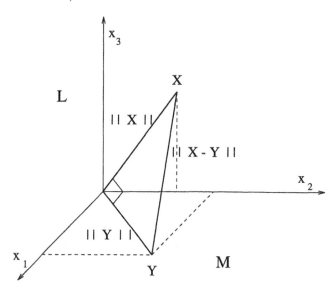

Figure 4.17: Principle of orthogonality in Hilbert and Euclidean spaces.

$$R_{YY} H_0 = R_{XY} \qquad (4.78)$$

where the elements (i, j) of the $m \times m$ matrix R_{YY} are the inner products (Y_i, Y_j), the i^{th} component of vector R_{XY} the inner product (X, Y_i) and H_0 the vector of the scalars h_i^0. The problem of estimating l values of the time series $X = [x_1, \ldots, x_l]^T$ by filtering an observable time series Y with a sequence of m weights or coefficients $H = [h_0, \ldots, h_{m-1}]^T$ is a direct application of expressing an orthogonal projection. The problem leads to a least-squared estimation which minimizes a measure of the estimation error $\min_H ||X - \hat{X}||$. The estimate \hat{x}_n of the n^{th} component of \hat{X} has the form $\hat{x}_n = \sum_{i=0}^{m-1} h_i y_{n-i}$ with $n = 1, \ldots, l$. Restated in vector notations as

$$\hat{X} = \sum_{i=0}^{m-1} h_i Y_i \qquad (4.79)$$

and the filter vector H_0 which minimizes the estimation error is given by Equation 4.78. In terms of random variables in Hilbert space, the optimum filter H_0 is specified by

$$R_{XY}(i) = \sum_{n=1}^{l} x_n y_{n-i} \qquad (4.80)$$

which is the cross-correlation of time series X and Y and by

$$R_{YY}(i,j) = \sum_{n=1}^{l} y_{n-j} y_{n-i} \tag{4.81}$$

which is the auto-correlation of time series Y. This completes the study of the geometrical interpretation of our search towards the unique solution which achieves the minimum-norm-error approximation problem.

4.4.2.2 The MMSE as Conditioned Expectation

To proceed one step further in the study of the MMSE estimation, let M denote a subspace of L containing all the finite-mean-squared functions $g(Y)$ of a random variable Y for which $E\{g^2(Y)\} < \infty$. The minimum-mean-squared-error estimation filter achieves

$$\min_{\hat{X}=g(Y)} [E\{(X - \hat{X})^2\}] \tag{4.82}$$

where the random variable $\hat{X} = g(Y)$ is an estimator of the variable $Y(n)$. Let \tilde{X} be the optimum value of \hat{X}. The problem can be restated as

$$\min_{\hat{X} \in M} [\|X - \hat{X}\|] \quad X \in L \tag{4.83}$$

The geometric interpretation shows that this optimum estimator \hat{X}_0 is the orthogonal projection of X on M. This optimum estimator is referred to be *of the minimum variance* for obvious reasons and provides also estimation with a unique solution expressed by the orthogonality condition as

$$E\{(X - \hat{X}_0)\hat{X}\} = 0 \quad \forall \hat{X} \in M \tag{4.84}$$

$$E\{[X - g_0(Y)]g(Y)\} = 0 \quad \forall g(Y) \tag{4.85}$$

where $g_0(Y)$ is the optimum estimation function being sought, and $g(Y)$ is any admissible estimation function. The orthogonality turns out to be a necessary and sufficient condition of optimality. The next statement to be demonstrated consists on equaling the optimum solution to the conditioned expectation. That is to write

$$\hat{X}_0 = g_0(Y) = E\{X|Y\} \tag{4.86}$$

To verify this statement, the right equality is introduced in Equation 4.85 to yield

$$E\{Xg(Y)\} = E\{E\{X|Y\}g(Y)\} \tag{4.87}$$
$$= E\{E\{Xg(Y)|Y\}\} \tag{4.88}$$

This simply expresses that the expected value of the conditional mean is the unconditional mean. To derive another way to evidence this interesting property of the conditional mean, it is simple to develop the expression 4.83 to minimize such that

$$E\{\|g(Y) - X\|\} \quad = \quad E\{ \; E[\|g(Y) - X\| \; |Y] \; \} \tag{4.89}$$
$$= \quad E\{ \; E[\|g(Y) - E[X|Y] + E[X|Y] - X\| \; |Y] \; \} \tag{4.90}$$
$$= \quad E\{ \; E[\|g(Y) - E[X|Y]\|] + E[\|E[X|Y] - X\| \; |Y] \; \} \tag{4.91}$$

which is clearly minimized when $g(Y) = E\{X|Y\}$.

Consequently, the *MMSE estimator for X in terms of Y is not only an orthogonal projection but also a random variable expressed by a conditioned expectation $E\{X|Y\}$ which represents what one expects X to be having observed Y.* In whole generality, the conditional expectation $E\{X|Y\}$ is not a linear function of Y and this MMSE estimator of the minimum variance is non-linear. The Gaussian process excepts the general rule since the expected mean can be written in form of a linear function as $E\{X|Y\} = c_1 Y + c_2$. The Gaussian process is in fact the single process for which minimum-variance estimation corresponds to linear minimum variance estimation.

4.4.2.3 The Wiener Filter

By definition, the random variable \hat{X} is called an *estimator* and $g(Y)$ the *estimation function*. The optimum estimation can be implemented with a causal, stable and invertible filter called the *innovations representation of Y(n)*. The term *innovations* defines an entirely new information generated at each predictive instant as the error of prediction which may be represented as a random variable in form of a white Gaussian noise. In case of the estimate \hat{X}_0 can be obtained by passing the observation $Y(t)$ through a linear time-invariant filter with impulse-response function h_0, the optimum filter derived from the time-invariant transfer function is called the *Wiener filter* and explained herein below. The motivation to proceed towards implementable non-stationary filters and predictors will lead us to describing an alternative formulation of the MMSE estimation problem to be developed with state-space equations restricting the class of estimation problem to those involving signal in additive noise and restricting the signal to those exhibiting a specific dynamical structure. The non-stationary predictor is in fact the Kalman filter to be studied latter.

Trying to estimate the value of a random process $X(t)$ in function of time in some interval $[0, T]$. Since the optimum estimation may take different values for different values of time t, the set $\{h_0(t, u) : t \in [0, T]\}$ is researched so as to minimize the set of MSE's

$$\min_{h(t,u)} E\left\{ \left[X(t) - \hat{X}(t) \right] \right\}^2 \qquad \forall t \in [0, T] \tag{4.92}$$

The linear estimation rule is used. Given a sample process $\{y(t) : t \in V\}$, it is desired to estimate the value of the random process $X(t)$, that is

$$\hat{X}(t) \quad = \quad \int_V h(t, u) Y(u) du \qquad \forall t \in [0, T] \tag{4.93}$$

Different classes of estimation problem may be derived by determining specific set V and T. For instance, if $V = \{u : U \leq t + \alpha\}$, the estimate is formulated as

Chapter 4. Coding Control Algorithms

$$\hat{X}(t) = \int_{-\infty}^{t+\alpha} h(t, u)Y(u)du \qquad (4.94)$$

If $\alpha = 0$, $\hat{X}(t)$ is a *causal estimate*, if $\alpha < 0$, $\hat{X}(t)$ is a *causal predicted estimate* and if $\alpha > 0$, $\hat{X}(t)$ is a *non-causal interpolated estimate*. The design equation is

$$\int_V H(t, u)E\{Y(v)Y(u)\}\,du = E\{X(t)Y(v)\} \qquad \forall v \in V,\ t \in T \qquad (4.95)$$

In case $X(t)$ an $Y(t)$ are jointly wide-sense-stationary processes, meaning that $R_Y(v, u) = R_Y(v-u)$, $R_{XY}(t, v) = R_{XY}(t-v)$ and $V = T = [-\infty, +\infty]$, the design equation becomes time-invariant and the estimate $\hat{X}_0(t)$ the result of a convolution

$$h_0(t, u) = h_0(t - u) \qquad (4.96)$$

and

$$\hat{X}_0(t) = \int_{-\infty}^{\infty} h_0(t - u)Y(u)du = h_0(t) * Y(t) \qquad (4.97)$$

It easily verified that

$$\int_{-\infty}^{\infty} h_0(w)R_Y(\tau - w)dw = h_0(\tau) * R_Y(\tau) = R_{XY}(\tau) \qquad (4.98)$$

Consequently, the optimum non-causal Wiener filter is yielded by the solution of the Fourier transform equation

$$H_0(\Omega) = \frac{S_{XY}(\Omega)}{S_Y(\Omega)} \qquad (4.99)$$

The causal Wiener filter is derived when $V = [U : U \leq t]$ and $T = [-\infty, +\infty]$. It leads to the Wiener-Hopf equation

$$\int_0^{\infty} h_0(w)R_Y(\tau - w)dw = R_{XY}(\tau) \qquad (4.100)$$

As explained in the following section, the causal Wiener filter is classically solved by decomposing the transfer function into a cascade of a whitening filter and an optimum filter for white noise observations.

4.4.2.4 The Wiener Filter as a Linear Predictor

Wold's decomposition theorem states that any arbitrary zero-mean, finite-mean-square, wide-sense-stationary stochastic process $x(n)$ can be decomposed into a sum of two orthogonal processes x_r and x_p where $x_r(n)$ is a regular process and $x_p(n)$ a predictable process so as

$$x(n) = x_r(n) + x_p(n) \qquad (4.101)$$

Wold's theorem applies to non-stationary processes as well and can be generalized in a strict-sense stationarity, a case referred to as Doob's decomposition theorem. Both regular and predictable processes may be further successively defined in terms of their spectral properties and as well as of their prediction characteristics. This is the purpose of the following paragraphs to define regular and predictable processes.

A stochastic process $x(n)$ is said to be *regular* if its power spectrum $S(e^{j\omega}) = |L(e^{j\omega})|^2$ satisfies a necessary and sufficient condition stated as follows. $L(z)$ is a function which is analytic for $|z| > 1$ and expanded as

$$L(z) = \sum_{n=0}^{\infty} l_n z^{-n} \qquad |z| > 1 \tag{4.102}$$

The necessary and sufficient condition for a process to be regular is to fulfill the Paley-Wiener condition which is given as

$$\int_{-\pi}^{\pi} |lnS(e^{j\omega})|d\omega < \infty \tag{4.103}$$

and means that a regular process cannot be band-limited. The Paley-Wiener condition states in fact that $S(e^{j\omega})$ must decay quite slowly towards zero when $\omega \to \infty$.

A linear predictor $\hat{X}(n)$ of a stochastic process $x(n)$ is expressed as a sum

$$\hat{X}(n) = \sum_{k=1}^{\infty} a(k)x(n-k) \tag{4.104}$$

where the prediction coefficients $a(k)$ are unknowns to be determined. The MMSE solution of the prediction is given by

$$P = \min_{a_k} E\{|x(n) - \sum_{k=1}^{\infty} a(k)x(n-k)|^2\} \tag{4.105}$$

to determine the optimum prediction coefficients. The projection theorem is used to minimize the mean-squared error and therefore the quantity

$$\epsilon(n) = x(n) - \hat{x}(n) \tag{4.106}$$

A stochastic process $x(n)$ is currently called *predictable* if $P = 0 = E\{\epsilon^2(n)\}$, and therefore if $x(n) = \hat{x}(n)$. A necessary and sufficient condition for a process to be predictable is to have a spectrum consisting of lines

$$S(e^{j\omega}) = \sum_i \alpha_i \delta(\omega - \omega_i) \tag{4.107}$$

A *predictable process* is also known as a *singular* process since it represents an AR model with a zero-driving noise i.e. without innovations and hence perfectly predictable. Restated in other words, the predictable process is a marginally unstable system which generates a response in form of sine waves without any excitation.

This decomposition of process $x(n)$ and of its spectral densities $S_X(f)$ in two component processes is supported by Doob's theorem and yields a general expression valid for any stochastic processes. Interestingly, Paley-Wiener condition guarantees the decomposition. Indeed, the process with a spectral density satisfying the Paley-Wiener condition is the *regular component* $x_r(n)$ and the remainder component x_s is the *predictable* or the *singular* part of process $x(n)$. As a direct application in the sequel, the regular processes will represent the innovations and the singular process the explicable part of the predictor. The optimum filter which will be derived from $x(n)$ as singular process is called the *Wiener filter* to honor the pioneering work of Norbert Wiener in the field.

As mentioned earlier, a predictor can be considered as the projection of its present value on the space spanned by the past observed samples. The optimum predictor has prediction errors which are orthogonal to the past-observed-data series and is therefore expressed as

$$E\{[x(n) - \sum_{k=1}^{\infty} a(k)x(n-k)]x(n-m)\} = 0 \quad m \geq 1 \tag{4.108}$$

restated in other words, it follows that in terms of auto-correlation functions

$$R[m] = \sum_{k=0}^{\infty} a(k)R[m-k] \quad m \geq 1 \tag{4.109}$$

referred to be a discrete-time version of the Wiener-Hopf equation. This equation set must be solved to determine the unknown coefficients a(k). The prediction error is the output of the signal $x(n)$ applied to an error filter given by

$$E(z) = 1 - \sum_{k=1}^{\infty} a_k z^{-k} \tag{4.110}$$

An elegant method to determine the coefficients $a(k)$ when $x(n)$ is a regular process consists of having recourse to the *innovations representation* to be interpretated as an extension of the Gram-Schmidt orthonormalization to the space spanned by $x(n)$ and its past $\{x(n-i) : i = 1, ...\infty\}$. The concept of innovations plays a key role in deriving causal optimum filters. As previously mentioned, a process $x(n)$ is regular if its spectrum can be factored as $S(e^{j\omega}) = |L(e^{j\omega})|^2$ where $L(z)$ is a function analytic for $|z| > 1$. Therefore $L(z)$ can be expanded into power series $L(z) = \sum_{n=0}^{\infty} l_n z^{-n}$. Without loss of generality, we can assume also that $L(z)$ is minimum phase, meaning that the inverse $\Gamma(z) = \frac{1}{L(z)}$ is analytic for $|z| > 1$ and is further expandable into power series as $\Gamma(z) = \sum_{n=0}^{\infty} \gamma_n z^{-n}$ convergent for $|z| > 1$. Both $L(z)$ and $\Gamma(z)$ specify two linear causal filters with respective impulse responses l_n and γ_n. These filters are called respectively the innovations and the whitening filters. Using the process $x(n)$ as input to the system $\Gamma(z)$, the innovations of $x(n)$ are derived as

$$i(n) = \sum_{k=0}^{\infty} \gamma_k x(n-k) \tag{4.111}$$

4.4. Optimum Control Algorithm

To further demonstrate the meaning of the innovations as a unit-power white noise, let us exploit the regular property implies that

$$S(z) = L(z)L(z^{-1}) \tag{4.112}$$

and, hence, when applied to the $\gamma(z)$ system, it follows that

$$S_{ii}(z) = S(z)\Gamma(z)\Gamma(z^{-1}) = 1 \tag{4.113}$$

to complete the proposition.

Moreover, if $i(n)$ is the input to the innovations filter $L(z)$, then the response equals $x(n)$ as

$$x(n) = \sum_{k=0}^{\infty} l_k i(n-k) \tag{4.114}$$

from Equations 4.111 and 4.114, it turns out that the processes $x(n)$ and $i(n)$ are linearly equivalent in the sense that each is linearly dependent on the other and its past. This shows that the predictor $\hat{x}(n)$ of $x(n)$ can be expressed in terms of the past of $i(n)$. The predictor of $x(n)$ can be expressed by

$$\hat{x}(n) = \sum_{k=1}^{\infty} l_k i(n-k) \tag{4.115}$$

As a matter of fact, the prediction error is given by

$$\epsilon(n) = x(n) - \hat{x}(n) = l_0 i(n) \tag{4.116}$$

This error is orthogonal to $i(n-k)$ for $k \geq 1$ since $i(n)$ is a white noise. Arising from the orthogonality principle, $\hat{x}(n)$ is simultaneously the predictor of $x(n)$ and the output of the system transfer function

$$H_i(z) = L(z) - l_0 \tag{4.117}$$

with input $i(n)$. The resulting system is known as the Wiener predictor of $x(n)$

$$H(z) = \Gamma[L(z) - l_0] = 1 - \frac{l_0}{L(z)} \tag{4.118}$$

Wiener predictor is the second step towards understanding the construction of the optimum predictors which still requires generalizations to cope with non-stationary processes and an alternative equivalent approach of MMSE estimation with state-space models to ease the solution. In fact, the non-stationary discrete stochastic signals as those represented by the stripe or the image TV bit-rate time series can be represented by two companion versions leading to equivalent innovations representation approaches. Those two modeling approaches which represent identical predictive versions are referred to be namely the state-space version and the input-output version. Both are still amenable to computational efficient numerical implementations. These are respectively named a Kalman filter and a non-stationary autoregressive process and will be conjugated with each other in the implementation of the prediction algorithm to be derived subsequently. In a first step, the stripe entropy rates are estimated on the horizon of a coming image according to a Kalman filter with a number of states equal to the number of stripe contained in one image. As a further progress, the coder model is introduced in the entropy predictor to embody both entropy source and coder model in a whole system representation.

4.4.2.5 Stochastic State-Space Models

The *stochastic state-space equations* of the Kalman filter are defined as follows where n denotes the instant of observation

$$X(n+1) \;=\; A(n)X(n) + B(n)U(n) + w(n) \tag{4.119}$$

$$Y(n) \;=\; C(n)X(n) + v(t) \tag{4.120}$$

where stochastic model components, $w(n)$ and $v(t)$, symbolize white noise processes i.e. the *process noise* and the *observation noise* respectively. The state-space vector $X(n+1)$ at the time $n+1$ is predicted from the state-space vector at time n and the control-acting vector $U(n)$ (Figure 4.18). $Y(n)$ stands as the observed system vector (the observations). The matrices $C(n)$, $A(n)$, $B(n)$ are the transformation matrices.

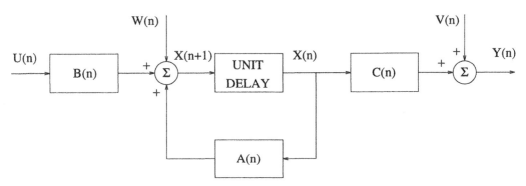

Figure 4.18: Information flow diagram in a Kalman Filter.

The state of a system is defined as the minimum amount of information about the past system history which is necessary to predict the future response. If the process noise is a Gaussian process, the state-space representation is optimum when it provides the minimum variance estimate of the state. This means, in accordance with the previous statements, that the model estimates the conditional expectations of $X(t)$ given the past observed data $Y(n-1)$, $Y(n-2)$, The state-space model can be further interpreted as a version of a first order Markov model since the evolution of the PDF of $X(n)$ conditioned on its past values comes down to be expressed as

$$Pr[x(n)|x(t-1), x(t-2), ..., x(t-n)] \;=\; Pr[x(n)|x(t-1)] \tag{4.121}$$

As a matter of example, let us digress momentarily to video bit rate predictors. According to the present equations, the state-space model applies for either stripe or image bit rate predictions. As a matter of fact, the model can produce not only one-step-ahead predictors for image bit rates in form of first order autoregressive processes but also N-step-ahead predictors of stripe bit rates in form of state-space models. The former predictive model has already be mentioned in Chapter 1 Section 1.10.8.3 while studying the first video traffic models. The latter leads to a matrix treatment at a higher resolution level. Since the natural horizon N is that of one image and that N equals 72 stripes in one

TV image, $X(n)$ is a state vector which may be refined up to considering 72 dimensions (N corresponds also to the periodicity of the process modeling the stripe bit rates).

To derive the state PDF in a recursive formulation, some further assumptions are first stated for the shake of simplicity. The signals are Gaussian and the processes $w(n)$ and $v(n)$ are zero-mean stationary Gaussian white noise processes with a covariance expressed as

$$E\left\{\left|\begin{array}{c} w(n) \\ v(n) \end{array}\right|\left|w^T(n)\ v^T(n)\right|\right\} = \left|\begin{array}{cc} Q & S \\ S^T & R \end{array}\right|\delta(n-s) \tag{4.122}$$

Let also the initial state x_0 be a random variable of mean \bar{x}_0 and covariance P_0. Therefore, considering expected values, the expected state value $\bar{X}(n) = E[X(n)]$ leads to a state equation in form of

$$\bar{X}(n+1) = A(n)\bar{X}(n) + B(n)u(n) \qquad \bar{X}(t_0) = \bar{x}_0 \tag{4.123}$$

and, the state covariance $P(n)$, given by

$$P(n+1) = E\{[X(n) - \bar{X}(n)][X(n) - \bar{X}(n)]^T\} \tag{4.124}$$

to an observation equation in form of

$$P(n+1) = A(n)P(n)A^T(n) + Q \qquad P(n_0) = P_0 \tag{4.125}$$

In case of Gaussian processes, the first two moments uniquely describe the process PDF and the corresponding moments of output signal are deduced as follows

$$E\{y(n)\} = \bar{y}(n) = C\bar{x}(n) \tag{4.126}$$

and

$$E\{[y(n) - \bar{y}(n)][y(s) - \bar{y}(s)]^T\} \tag{4.127}$$

$$= CA^{n-s}P(s)C^T + R\delta(t-s) + A^{t-s-1}S[\delta(n-s)-1] \qquad n \geq s \geq n_0 \tag{4.128}$$

for the mean and the covariance respectively.

As already mentioned several times, the innovations model for non-stationary processes is expressed in a state-space recursive modeling way by the Kalman filter [10] and exploits the conditioned mean of $x(n+1)$ given the observations of $y(i); i = 0, .., n$ in the following recursion

$$\bar{X}(n+1) = A(n)\bar{X}(n) + K(n)[Y(n) - C(n)\bar{X}(n)] \quad ; \quad \bar{X}(n_0) = \bar{X}_0 \tag{4.129}$$

where $K(n)$ is the filter gain defined in terms of the conditional state error covariance matrix $\Xi(n)$ as

$$K(n) = [A(n)\Xi(n)C(n)^T + S][C(n)\Xi(n)C(n)^T + R]^{-1} \tag{4.130}$$

where $\Xi(n)$ is defined by

$$\Xi(n) = E\{[\bar{X}(n) - X(n)][\bar{X}(n) - X(n)]^T | X(n-1), .., X(n_0)\} \tag{4.131}$$

and n_0 is the time origin. The gain K(n) satisfies the Matrix Riccati Difference Equation

$$\Xi(n+1) = A(n)\Xi(n)A^T(n) + Q + K(n)[C(n)\Xi(n)C^T(n)]K(n) \quad ; \quad \Xi(n_0) = \Xi_0 \tag{4.132}$$

Without loss of generality, let S be equal to zero. The Kalman filter can be restated as

$$\bar{X}(n+1) = A_t(n)\bar{X}(n) + K(n)Y(n) + B(n)y(n)] \tag{4.133}$$

where the filter state transition matrix $A_t(n)$ and the filter gain matrix $K(n)$, respectively, are as follows

$$A_t(n) = A(n) - K(n)C(n) \tag{4.134}$$

$$K(n) = A(n)\Xi(n)C(n)^T[C(n)\Xi(n)C(n)^T + R]^{-1} \tag{4.135}$$

and

$$\Xi(n+1) = \begin{aligned} & A(n)\Xi(n)A^T(n) \\ & + A(n)\Xi(n)C^T(n)[C(n)\Xi(n)C^T(n) + R]^{-1}C(n)\Xi(n)A^T(n) \\ & + Q \quad ; \quad \Xi(n_0) = \Xi_0 \end{aligned} \tag{4.136}$$

In general, the Kalman gain $K(n)$ converges to a steady-state behavior as $n \to \infty$ and the asymptotic solution Ξ satisfies the algebraic Riccati Equation deduced from equating $\Xi(n+1) = \Xi(n)$; that is

$$\Xi - A\Xi A^T + A\Xi C^T[C\Xi C^T + R]^{-1}C\Xi A^T - Q = 0 \tag{4.137}$$

Real symmetric positive semi-definite solutions of the Algebraic Riccati Equation are said to be stabilizing solution if the corresponding filter state transition matrix A_t has all its eigenvalues inside the unit circle. The properties of the recursive Kalman filter are numerous and are worth mentioning to ensure the connection with optimum filtering.

4.4.2.6 Properties of the Kalman Filter

Since the Kalman filtering recursion is a solution to the causal linear MMSE estimation problem, it meets the solution produced by the causal Wiener filter applied on the same problem. The difference is that Wiener process requires that the observation signal be stationary and exist for all time whereas Kalman filter is formulated with a finite origin state. If the process $w(n)$ is a white Gaussian stationary process testifying of innovations and that the descriptive model equations are time-invariant, the Kalman filter will exhibit first a transient behavior and converge to a time-invariant response identical to that generated by the Wiener filter.

Similarly to Wiener solution, the predictive observation error in a Kalman filter generates a sequence called the *innovations sequence* defined consequently as

$$\epsilon(n) = Y(n) - C(n)\hat{X}(n) \tag{4.138}$$

The consequence is that $\epsilon(n)$ represents the new information contained in the observation sequence $y(i)$; $i = n_0, ..., n-1$ since the expected past-conditioned value is equal to zero

$$E\{\epsilon(n)|Y(n-1),, Y(n_0)\} = 0 \tag{4.139}$$

this leads to restating the $y(n)$ sequence in another formulation which motivates the appellation of innovations sequence; that is

$$y(n) = C(n)\hat{X}(n) + \epsilon(n) \tag{4.140}$$
$$= E\{y(n)|y(n-1),, y(n_0)\} + \epsilon(n) \tag{4.141}$$

Referring further to the sequence of $\{\epsilon(n)\}$, the Kalman filter can be rewritten as

$$\hat{X}(n+1) = A(n)\hat{X}(n) + B(n)u(n) + K(n)\epsilon(n) \tag{4.142}$$
$$Y(n) = C(n)\hat{X}(n) + \epsilon(n) \tag{4.143}$$

This second way of modeling is called the *innovations model* as previously studied in the Wiener case. A third version equivalent to Kalman and innovations versions is referred to as being the *whitening filter*. In this case, the model is driven by the prediction error and obtained by reversing $Y(n)$ with $\epsilon(n)$ to achieve

$$\hat{X}(n+1) = [A(n) - K(n)C(n)]\hat{X}(n) + B(n)u(n) + K(n)Y(n) \tag{4.144}$$
$$\epsilon(n) = Y(n) - C(n)\hat{X}(n) \tag{4.145}$$

Let us eventually note that the Kalman filter, the innovations model and the whitening filter are simply different ways of writing the optimal filter.

When the noise processes are Gaussian, the Kalman filter minimizes the conditional mean and, consequently, plays the role of a *minimum-variance estimator* or a *non-linear MMSE estimator*. In this case, the state estimator $\hat{x}(n)$ is the conditional mean of $x(n)$ implying that

$$\hat{x}(n) = E\{x(n)|y(n-1),, y(n_0)\} \tag{4.146}$$

and

$$E\{\hat{x}(n) - x(n)|y(n-1),, y(n_0)\} = 0 \tag{4.147}$$

The Kalman gain $K(n)$ and the conditional error covariance $\Xi(n)$ are independent of $\{y(n-1), ..., y(n_0)\}$ provided that A, C, R, Q and S be all independent of $\{y(n-1), ..., y(n_0)\}$. In this case, the error covariance is the lower bound achievable by any other filter as indicated by the estimator appellation.

Removing the Gaussian assumption, the Kalman filter becomes a *linear minimum-variance* estimator of $x(n)$ and, in this case, the state prediction error $[x(t) - \hat{x}(n)]$ is uncorrelated with $y(n-1)$,, $y(n_0)$ i.e.

$$E\{[x(n) - \hat{x}(n)]|y(n-i)\} = 0 \qquad i = 1,, n - n_0 \tag{4.148}$$

The error covariance is minimized.

4.4.2.7 Integrated Model of Coders and Sources

The source model and the coder model can merged to yield one single global Kalman filter which synthesizes the source-entropy-coding process with the quantized entropy bit rates as state variables, with the transmission factor $U(n)$ as a control variable and with the level of buffer occupancy $B(n)$ as an observation variable. Subsequently, two equations will be deduced one for the state and the other for the observation. More remarkably, these equations are so general as to apply to either constant or variable-bit-rate applications without any difference. The CBR transmission mode is the particular case of a VBR transmission where one single bit rate is permitted onto the channel.

Due to the quantization entropy model, the resulting stochastic state equation is non-linear given by a function Υ

$$H_q(n+1) \;=\; \Upsilon[A(n)H_i(n), U(n)] + w(n) \tag{4.149}$$

the observation equation is given in the case of the CBR coder by

$$B(n) \;=\; B(n-1) + C(n)H_q(n) - R_c \tag{4.150}$$

and generalized in the case of the VBR coder by

$$B(n) \;=\; B(n-1) + C(n)H_q(n) - R_c(n) + v(n) \tag{4.151}$$

where the channel bit rate is here variable as a function of $H_q(n)$ according to a predefined police function $P_\nu(n)$: $R_c(n) = min[H_q(n), P_\nu(n)]$. The additional noise $v(n)$ takes into account the precision of output bit rate estimates.

At this point, an optimum algorithm has to be designed to define the optimum strategy of control i.e. the sequence of the future values of $U(n)$ over the whole horizon of prediction. This strategy will be elaborated using the current observed values of buffer level occupancy in order to minimize the cost function on the horizon.

4.4.2.8 Prediction Algorithms Using LMS Methods

In this section, an implementable version of the Kalman filter is investigated to express the algorithm into a tractable, non-stationary predictor exploiting a two-dimensional auto-regressive filtering approach. In the present application for TV coders, a prediction of the future stripe bit rates is intended to be performed during each stripe interval to cover an horizon equivalent to one coming image. The predictions of each individual source stripe bit rate $x_i(n)$ can be set in practice by specific auto-regressive models given by

$$\hat{x}_i(n) = \sum_{j=j-k}^{j+k} a_{ij}(n)x_j(n - N + j) + b_i(n)\epsilon_i(n) \tag{4.152}$$

where

n is the sampling instant. That corresponds here to the end of the stripe period.

N is the horizon or the number of stripes within one image and i the index of the stripe predictor $1 \leq i \leq N$. Hence, there is one dedicated predictor per stripe to predict the stripe bit rate.

k is the number of neighbor samples taken into account to predict the stripe bit rates. Practically, k equal to 2 is the optimum value.

$\epsilon_i(n)$ is a Gaussian noise, ideally, the $N(0,1)$.

$a_{ij}(n)$ and $b_i(n)$ are the model parameters to be permanently updated according to the existing correlation.

N identical equations can be written for the N different stripes. The prediction equation is updated once during each stripe period when a new value of the stripe bit rate is made available. The error of prediction $\epsilon(n)$ is computed as the difference between the previous observed and estimated value

$$\epsilon_i(n) = x_i(n - N) - \hat{x}_i(n - N) \tag{4.153}$$

The N prediction equations lead to a system of N equations written in a matrix form as

$$X(n + 1) = A(n)X(n) + b(n)w(n) \tag{4.154}$$

where the matrix $A(n)$ is expressed as

$$A(n) = \begin{vmatrix} a(1,1) & a(1,2) & & & & \\ a(2,1) & a(2,2) & a(2,3) & & & \\ & a(3,2) & a(3,3) & a(3,4) & & \\ & . & . & . & . & . \\ & & a(N\text{-}1,N\text{-}3) & a(N\text{-}1,N\text{-}2) & a(N\text{-}1,N\text{-}1) & \\ & & & & a(N,N\text{-}1) & a(N,N) \end{vmatrix} \tag{4.155}$$

the vector $X(n)$ is that one of the values $x_i(n)$, the vector $w(n)$ stands for the $\epsilon_i(n)$. The values of the $a_i(n)$ and the $b_i(n)$ are provided by a Least-Mean-Squared research (LMS) or a Stochastic-Gradient algorithm (SG). Both algorithms are described in Reference [3]. This leads to the working diagram presented in Figure 4.19.

4.4.3 Optimum Control Algorithm

The purpose of this paragraph is to develop one version of the optimum control algorithm of the stripe bit rate based on both cost function and optimum prediction filter. Dynamic programming theory will be used as an efficient alternative to the classical approach of the optimum control founded on calculus of variations, it is in fact suited to solve the control problems with non-linear and time-varying systems and, as a powerful property, it has straightforward implementations using the graph theory.

The fundamental statement of dynamic programming theory is based on Bellman's principle of optimality which can be summarized by two statements

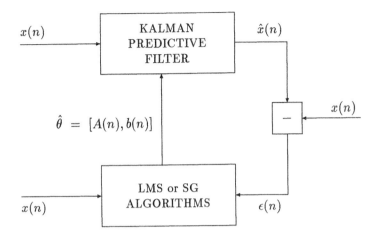

$$\hat{\theta} = [A(n), b(n)]$$

\hat{x} : estimated bit rates

x : observed bit rates

$\hat{\theta}$: set of estimated coefficients

Figure 4.19: Implementation of a predictive filter for non-stationary signals.

Any substrategy from the state X_i to the state X_j [the sequence $S_{i,j}(X_i, X_j) = (X_i, X_{i+1},, X_j)$] extracted from an optimum strategy from the state 0 to the state N [$S_{0,N}(X_0, X_N)$] is also optimum.

At any current state, an optimum strategy has the property that no matter what the previous values of the control have been anteriorly, the remaining decisions must constitute an optimum strategy with regard only to the current resulting state.

The optimum algorithm will be deduced as an application of the principle of optimality. The prediction filter yields source stripe bit rates on horizons of a whole image. At the occurrence of each stripe, the predictions are reactualized and a graph can be constructed corresponding to the values of U(n) for which decisions will have to be taken. Over the horizon of one image, N decisions have to be taken (Figure 4.20) as follows. At each instant (i=n,.., n+N), a node corresponds to each value of U. All the transitions are a priori possible at the expense of the cost function defining distances of the connecting arrows. The predicted stripe bit rates (optimum expected past-conditioned rates) enable computing distances to be appended on the graph. The optimum sequence of control is given by the shortest path starting from the current state n given by U(n) and proceeding instant by instant up to the state n+N at $\tilde{U}(n + N)$.

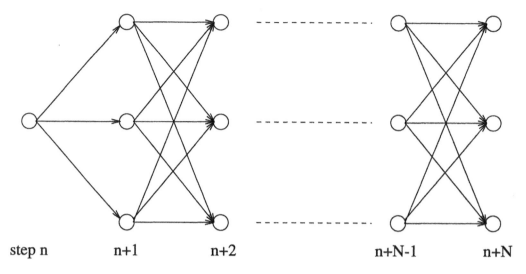

step n n+1 n+2 n+N-1 n+N

4.4.3.1 Forward Algorithm

The shortest path is established in two phases. The first consists in scanning future starting with the current state n and running forwards up to horizon applying the principle of optimality on sub-trajectories which span from origin to consecutive prevision points. The second phase consists in scanning the whole horizon backwards to deduce the optimum path. The next paragraph describes the implementation of the search algorithm for shortest path. The most intuitive way to present the algorithm is by describing the forward version. Let us notice that an equivalent backward algorithmic version could have been similarly described.

Phase 1

The first phase is composed of N periods at which the subtrajectories are successively considered from $j = n$ to the future instants $j = n + i$ (i=1 to N). $\Gamma_i[U(n)]$ stands for the set of all admissible values of U(n+i) starting from U(n) and proceeding i steps forward (the i step transitive closure). Conversely, $\Gamma_i^{-1}[U(n)]$ stands for the set of all the admissible values of U(n) starting from U(n+i) and proceeding i steps backward. Let us remark that the condition $[B(n) < 1.0]$ limits the content of set of the admissible values of $U(n)$. The set ψ is thereafter defined as follows

$$U(n + i) \in \psi_1[U(n + i - 1), U(n + i + 1)] = \Gamma_1[U(n + i - 1)] \cap \Gamma_1^{-1}[U(n + i + 1)]$$

Period 1

The current U(n) value is known and constitutes the origin node of the graph, the associate transition costs V are given by

$$V[U(n), U(n+1)] = [U(n+1) - U(n)]^2 + \vartheta[B(n+1) - B_r]^2 \quad U(n+1)\epsilon\Gamma_1[U(n)]$$
(4.156)

Period 2

$$\tilde{V}[U(n), U(n+2)] = \min_{U(n+1)\epsilon\psi_1[U(n),U(n+2)]}\{V[U(n), U(n+1)] + V[U(n+1), U(n+2)]\}$$
(4.157)

The value of $\tilde{U}(n+1)$ is obtained as a function of $[U(n),\ U(n+2)]$ at each value of $U(n+2)$, one can associate a corresponding value of $U(n+1)$ generating an optimum strategy over the sub-trajectory $[U(n),\ U(n+2)]$. An associated expected buffer level of occupancy obtained by the optimum sub-trajectory is appended at each node of $U(n+2)$.

Period i

$$\tilde{V}[U(n), U(n+i)]$$
$$= \min_{U(n+1)\epsilon\psi_1[U(n+i-1),U(n+i+1)]}\{V[U(n), U(n+i-1)] + V[U(n+i-1), U(n+i)]\}$$
(4.158)

The value of $\tilde{U}(n+i-1)$ is obtained as a function of $[U(n),\ U(n+i)]$.

Period N

$$\tilde{V}[U(n), U(n+N)]$$
$$= \min_{U(n+N-1)\epsilon\psi_1[U(n+N-2),U(n+N)]}\{V[U(n), U(n+N-1)] + V[U(n+N-1), U(n+N)]\}$$
(4.159)

The value of $\tilde{U}(n+N-1)$ is obtained as a function of $[U(n),\ U(n+N)]$.

Phase 2

The second phase consists in reviewing backwards sequential optimum subtrajectory relations to eventually extract the global sequence of optimum control values $U(n)$, $\tilde{U}(n+1),.....,\ \tilde{U}(n+N-1),\ \tilde{U}(n+N)$.

Implementation

The implementation of a search towards the shortest path in a graph is well-known problem in the literature, let us cite here the algorithm of Dijkstra described in Reference [2] which is well suited to achieve the present problem. The hardware implementation of that algorithm requires at least N^2 cost function computations at each update of the horizon (N is the number of admissible levels for the transmission factor). A realistic way to implement a graph consists of considering an accessible technological subsampled version in order to reach feasibility. Simplified versions of prediction can considered an AR(1) model. The current research in the field of Kalman filters investigates algorithms to use neural networks as non-stationary learning predictors simultaneously coupled to a shortest-path search on the graph.

4.4.4 Properties of Optimum Control

The optimum control is referred to a cost function composed of two distinctive actions

1. the *freeze action* $E\{\Delta U^2(n)\}$ locking the value of the dynamic control.

2. the *control forcing action* $E\{[B(n) - B_r]^2\}$ inducing a dual control action necessary to cope with the uncertainty.

Both opposed actions are balanced by the parameter ϑ. Two important topics are analyzed in the sequel. They are namely the *dual control*, which is derived as an intrinsic property of optimum control, and the *adaptivity*, which stands as a property issued from the hierarchical bit-rate model decomposition. The adaptivity balances both *control* and *freeze* actions by acting on two parameters ϑ and B_r (Figure 4.21) according to functions defined at outer model layers.

4.4.4.1 Dual Control

The concept of dual control is involved when the controller is alternatively forced between a *regulation* and a *learning* action. This behavior is intrinsically necessary to deal with non-stationary input sources.

1. the *regulation* action has to be effective in certainty horizon (stationarity) when the prediction works efficiently. The regulation consists in this case in forcing the buffer level to tend to the reference value.

2. the *learning* action has to be triggered in uncertainty horizon when the covariance of the prediction errors begins to increase. The learning is forced when choosing the paths which minimize the cost function. The prediction errors are a fraction of the partial cost as demonstrated in the following paragraph and, consequently, the system tunes itself towards refining knowledge in model parameters during uncertainty horizons. Moreover, during *learning* periods, the controller puts into the balance an additional *caution* action meaning that it tends to decrease the control action to cope with uncertainty (in this case, to increase the value of the transmission factor).

It is demonstrated below that the optimum controller automatically balances both actions. To demonstrate those properties, we can rewrite the equations as follows taking the linear approximation

1. for the one-dimensional state-equation deduced from Equation 4.149

$$H_q(n) = H_q(n - N) + a(n)\Upsilon[A(n), \Delta H_i(n - N), \Delta U(n)] + w(n) \qquad (4.160)$$

The $H_q(n+1)$ are the source bit rates at the consecutive instants $n+1,....,N+n+1$. The optimum search algorithm is performed on the N components of $H_q(n+1)$. More synthetically, Equation 4.161 can be rewritten and linearized as

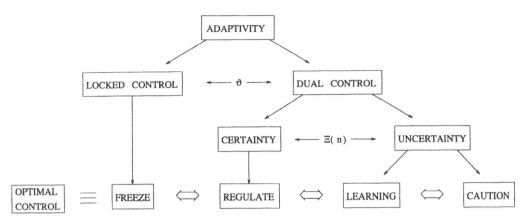

Figure 4.21: **Summary of optimum control properties.**

$$y(n) = y(n - N) + a(n)u(n) + w(n) \qquad (4.161)$$

where u(n) is the control parameter.

2. for the observation equation (one-dimensional) expressed in Equation 4.151

$$B(n) - B_r = B(n - 1) - B_r + C(n)H_q(n) + v(n) \qquad (4.162)$$

or more synthetically

$$x(n) = x(n - 1) + c(n)y(n) + v(n) \qquad (4.163)$$

A *control strategy* [u(i)=F(U(i); i=n,...., i=n+N] is sought as a function of the past observations x(i) [x(i); i=n, n-1, ...,0] in a way to minimize the cost function

$$V(n) = E\{ \sum_{i=n+1}^{n+N+1} x^2(i) \} \qquad (4.164)$$

Let us now calculate some expected optimum partial cost S_κ associated with trajectories spanning from the instants j+1 (with $n + 1 < j < n + N - 1$) up to the instant n+N+1 following the shortest path

at time (n+j+1)

$$S_\kappa(n + j + 1) = \min_{u(n+j)} E\{x^2(n + j + 1) + S_\kappa(n + j + 2)|x(0), .., x(n + j - 1)\} \qquad (4.165)$$

using Equations 4.161 and 4.163

4.4. Optimum Control Algorithm 341

$$S_\kappa(n+j+1)$$

$$= \min_{u(n+j)}\{[x(n+j) + c(n+j+1)y(n+j+1-N)$$

$$+c(n+j+1)\bar{a}(n+j+1)u(n+j)]^2$$

$$+c^2(n+j+1)u^2(n+j)P_a(n+j+1)$$

$$+\sigma_v^2 + \sigma_w^2$$

$$+E[S_\kappa(n+j+2)|x(0), .., x(n+j)]\} \tag{4.166}$$

where

$$\bar{a}(n+j+1) = E\{a(n+j+1)|x(0), ..., x(n+j)\} \tag{4.167}$$

is the conditional mean of a(n) at time n

$$P_a(n+j+1) =$$
$$E\{[a(n+j+1) - \bar{a}(n+j+1)][a(n+j+1) - \bar{a}(n+j+1)]^T|x(0), ..., x(n+j)\} \tag{4.168}$$

is the conditional covariance which measures the amount of uncertainty in the estimate of $a(n)$ i.e. it indicates the degree of knowledge of the source behavior and the divergence from stationarity. Its contribution is expected to be important at scene changes and to decrease within the scenes.

at time (n+N+1)

$$S_\kappa(n+N+1)$$

$$= \min_{u(n+N)}\{[x(n+N) + c(n+N+1)y(n+1)$$

$$+c(n+N+1)\bar{a}(n+N+1)u(n+N)]^2$$

$$+c^2(n+N+1)u^2(n+N)P_a(n+N+1)$$

$$+\sigma_v^2 + \sigma_w^2\} \tag{4.169}$$

The optimum control at the horizon n+N is obtained by differentiating the cost S_κ(n+N+1) with respect to U(n+N) and equating to zero

$$\tilde{u}(n+N) = -2\bar{a}(n+N+1)\frac{x(n+N) + c(n+N+1)y(n+1)}{c^2(n+N+1)P_a(n+N+1) + \bar{a}^2(n+N+1)} \tag{4.170}$$

back *at the time (n+N)*

$$S_\kappa(n+N)$$

$$= \min_{u(n+N-1)}\{ [x(n+N-1) + c(n+N)y(n)+$$

$$c(n+N)\bar{a}(n+N)u(n+N-1)]^2 \qquad \text{term [1]}$$

$$+c^2(n+N)u^2(n+N-1)P_a(n+N) \qquad \text{term [2]} \tag{4.171}$$

$$+\sigma_v^2 + \sigma_w^2 \qquad \text{terms [3-4]}$$

$$+E\{\frac{P_a(n+N+1)\times[x(n+N)+c(n+N+1)y(n+1)]^2}{P_a(n+N+1)+\bar{a}^2(n+N+1)}|x(0), .., x(n+N-1)\} \ \} \qquad \text{term [5]}$$

The optimum control of $\tilde{u}(n + N)$ in Equation 4.170 demonstrates the influence of the uncertainty by the presence of $P_a(n + N + 1)$.

Let us now distinguish the periods of certainty from the periods of uncertainty

1. in *certainty equivalence control* ($P_a(n + N) = 0$, referring to Equation 4.170, the optimum control at the horizon n+N is a function of both the observed variable x(n+N) and the state variable y(n+1). The negative sign demonstrates the correct *regulation action* of $\tilde{u}(n)$ [$\propto -\alpha \Delta U(n + N)$] with x(n) [$\propto B(n + N) - B_r$] and y(n+N) [$\propto H_q(n + N)$].

2. in *uncertainty horizon* when the predictive parameters of source bit rates are poorly known (Equation 4.171). The covariance matrix reaches high values forcing the controller to reduce u(n+N) (This actually means that the transmission factor U(n+N) increases) and the controller manages with *caution* to cope with the uncertainty. Equation 4.171 demonstrates all the actions which influence optimum control and are optimally balanced by the minimization of the cost function. These are namely the *regulation* action (expressed in Term 1), the *caution* action (expressed in Term 2), the *learning* action (expressed in Term 3) and the potential effect of the uncertainty parameter over the future horizons which can be referred to as being the *prevision* action (expressed in Term 5) .

Due to the implementation of the optimum search, the algorithm always imposes the path with the minimum cost and therefore tries to minimize the most important terms of Equation 4.171. This leads to an optimum balance of all the described actions with respect to the cost function.

4.4.5 Adaptivity

The TV source model has been described in Chapter 3 as a construction of embedded layers corresponding top down to programmes, scenes, images, stripes. Accordingly, semi-Markov processes have been used at scene level, autoregressive models at image level and cyclo-stationary processes at stripe level. The optimum algorithm has been performed at stripe level. The adaptivity consists in modifying the two parameters ϑ and B_r of the core optimum stripe bit rate regulation by means of the outer layers i.e. image, scene or programme levels.

Both parameters ϑ and B_r can be adapted to the degree of non-stationarity of the input source. Mainly, this non-stationarity is characterized by the mean image bit rate per scene and the duration of the scenes. The way to adapt the regulation is as follows

1. the parameter B_r determines the reserve of bit rate to be available to cope with any incoming new scene and should be as low as possible (20 % for example) when complex scenes are expected to occur.

2. the parameter ϑ determines the strength of the control. As a matter of fact, ϑ has to be increased in programmes with a high scene variability i.e. short scenes and high bit rate variabilities (highly non-stationary sources). The value of ϑ can be decreased during slow moving programmes.

The parameter ϑ plays an important role in VBR applications since it supplies the ability to switch on the regulation when the incoming source entropy rate exceeds the policed rate. Furthermore, ϑ is a variable acting as a continuous and a gradual potentiometer from VBR mode with $\vartheta = 0$ to a strict CBR mode with $\lambda > 0$. This optimal regulation can therefore accommodate any kind of policing function and incorporate the preventive police function in the control algorithm. Both parameters ϑ and B_r have to be imposed in order to maximize the mean image quality or to minimize the expected cost of the cumulated T values over the whole horizon $V(n) = E[\frac{1}{n} \sum_{i=1}^{i=n} T(n)]$.

4.5 Regulators against Controllers

An example of response of the regulator and the controller algorithms is depicted and compared in Figure 4.22. The source rates originate from the database of actual TV. The coder behavior is simulated by the non-linear modeling equations. The PID regulator is not an optimum filter and therefore fluctuations due to randomness of input stripe bit rate remain in the control parameter U. The controller can achieve maximally flat command with only smooth and graceful evolutions of transmission factor whenever it is required by an inevitable long term variation in the density of the source information.

The PID is a sub-optimum solution in any case. It requires the adaptation of its parameters when changing of source format, of channel constraints of bit rates and of transmission mode (CBR-VBR). The PID needs moreover a study of the non-linear system behavior to overcome any occurrence of overflow. Nevertheless, it is worth noticing that a PID algorithm is extremely simple to implement and that it achieves the main goal of controlling both level of buffer occupancy and quantization step size. Let us remark that it is always possible to add an algorithm computing the PID parameters (q_p, q_i and q_d) in real time according to any cost function to achieve a more flexible sub-optimum solution.

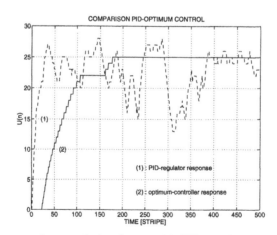

Figure 4.22: Response of transmission factor with PID regulator and optimum control.

The controller is optimum with respect to a cost function and self-adaptive to real

time source variations (the non-stationarities), to channel constraints of bit rates and to source formats. Moreover, this scheme accommodates directly CBR and VBR transmission mode without any modification in the algorithm. Nevertheless, this optimum controller is more heavy to implement than a PID regulator.

4.6 The Use of Neural Networks

The neural network is an implementation of algorithms originally inspired from the research onto the brain [9]. In fact, the neural networks have opened a new field in control technology where controllers learn directly and autonomously from the input data. One major contribution brought by that technology is to provide the estimation and the control engineering with adaptive and self-learning tools. To be convinced of the interesting properties of neural networks, the resulting benefits are worth mentioning

1. they can process data and learn from them without any dependence on a prior programmed knowledge.

2. they can handle data embedded in noise and data presenting only a broad similarity to those on which they were trained.

3. the neural networks are non-linear in a sense that they can capture complex interactions among input variables. As a matter of fact, in non-linear systems, the output changes depend not only on each individual input variation but also on the values of all other inputs with relationships relevant to higher-order functions.

4. the neural networks are highly parallel, numerous identical operations can be executed simultaneously and independently. Hence, they carry out computations thousands of times faster than the conventional digital signal processors.

5. as a benefit from the high degree of connectivity, neural networks are robust in presence of noise and errors in a sense that they will degrade gracefully and, usually, the presence of errors in a few terms turns out generally to be unconsequential.

Neural networks bring to technology new systems in which control strategies can be learnt directly from incoming data. One major benefit brought from that technology is adaptivity in estimation and control since the neural networks can follow data and learn from them without any dependency on the prior programmer knowledge. As a matter of fact, neural networks are ideal for process control because they can build predictive models of the process directly from collecting multidimensional data from sensors even if the equations steering the system are not known or even more elusive.

4.6.1 Basic Neural Cells and Architecture

The *unit cell* of a neural network is modeled in similarity with a *neuron* (nerve cell). The cell computes a weighted sum of its inputs themselves connected to the outputs of other similar cells. In the original model proposed by McCulloch and Pitts (Figure 4.23), in

1943, the neural cell output was zero or one according to whether the weighted sum is above or below a given threshold μ_i. The resulting equation is given by

$$n_i(n+1) \;=\; \theta(\sum_{j=1}^{n} w_{ij}n_j(n) - \mu_i) \qquad\qquad (4.172)$$

with

$$\theta(x) \;=\; \begin{cases} 1 & \text{if } x \geq 0 \\ 0 & \text{otherwise} \end{cases} \qquad\qquad (4.173)$$

the step function. In this basic version, n_i is either 0 or 1 representing the states of neuron i as firing or not firing respectively. The weight $w_{i,j}$ stands for the strength of the synapse connecting neuron i to neuron j.

To show how far the similarity between biological neurons and neural cell models can be pursued, the biological neuron is sketched in Figure 4.24. Morphologically, a biological neuron is composed of a cell body or a soma, a single axon and a collection of nerve fibers, the dendrites. The dendrites (the inputs) are organized as a treelike network and collect excitations from the transmitting ends of synaptic junctions or, simply termed, synapses. These establish connections with other neurons by means of axons. The axon is a single long fiber which extends and arborizes into other neuron strands.

Figure 4.23: Schematic diagram of a McCulloch-Pitts neuron.

Figure 4.24: A typical biological neuron.

Though very simple, the McCulloch-Pitts neuron is capable of universal computations (like ordinary computers) when assembled in a synchronous organization with suitably chosen weights w_{ij}. A straightforward generalization of the model consists of using continuous n_i variables and a general non-linear function $g(x)$ instead of the previous step function $\theta(x)$. The function $g(x)$ is referred to as the *activation function* or the *gain function*. The update of the n_i is performed asynchronously (in random order and at random instants). The neuronal model is now

$$n_i(n+1) \;=\; g\left(\sum_{j=1}^{n} w_{ij}n_j(n) - \mu_i \right) \qquad\qquad (4.174)$$

This simplified model of the actual biological cell working behavior is used to operate artificial electronic neural network. It is worth remarking that the typical cycle period of a biological neuron is of the order of a few milliseconds and is therefore about a million times slower than the electronic component speed. Nevertheless, owing to parallelism, the brain performs tasks in real time like vision with a speed far beyond the capacity of the present fastest Cray computer. Neural networks have already developed very powerful tools for numerous applications; let us mention for instance, pattern recognition, dynamic modeling, sensitivity analysis and control systems. In this textbook, the algorithm of back-propagation is presented since it encompasses the applications of monitoring dynamic systems. In fact, it allows one to calculate the derivative needed when optimizing an iterative analysis procedure to control a dynamic system by minimizing a performance cost over time. The basic foundations of the back-propagation algorithm are studied in next section.

Two fundamental problems remain to be explored in this introductory section. The first deals with the question of how to choose the connection weights in the neural network so as to be ensured that the neural network performs a specific task. The second topic concerns the way to structure a neural network i.e. how to interconnect the neurons. As a general rule, the choice of the weights is performed by teaching the neural network to perform the desired algorithm. This is achieved by iterative adjustments of the weights according two learning paradigms, namely the supervised learning and the unsupervised learning.

1. the *supervised learning procedure* consists of comparing the output of the network with known correct answer. Two methods may be employed, the first requires a teacher to train the network and is called *learning with a teacher*. The second uses a feedback from the system to tell the neural network whether or not the answer is correct and it is called *reinforcement learning*.

2. the *unsupervised learning procedure* refers to cases where the learning goals are not defined in terms of correct responses. The information is contained into correlations within the input data. The work performed by the neural network consists of successively segmenting the data according to these correlations, creating category and identifying the categories. One of the most important examples of application in digital signal processing is probably learning the classes or the code-book of a vector quantization algorithm.

The neuron arrangement is generally structured into layers and may include loops of connections. The structure in layers refers to a particular architecture called the *layered feed-forward networks* and the learning process is easy to understand in this case. Let us mention that the brain is highly layered but not totally. Some other networks include direct or indirect loops of connections, they belong to the family of recurrent networks.

4.6.2 Back-Propagation and Neuro-Control

Conceptually, a back-propagation network is made of interconnected nodes arranged in at least three layers. The *input layer* is merely passive and collects the data patterns

i.e. the input vectors passing into the network. The number of input nodes consequently equals the number of measured data values presented to the network by example those indicating the buffer occupancy during the past N stripes. The hidden layer and the output layer both actively process data. The *central hidden layer* permits the back-propagation algorithm to model non-linear functions of greater complexity. The *output layer* produces network results as a set of continuously variable values i.e. the output vector. The output vector can be used as a control sequence of transmission factors.

Figure 4.25: Layered neural network for the back-propagation algorithm.

Figure 4.25 draws a two-layer network. The back-propagation algorithm is explained in the sequel and based on Figure 4.25 to show how the gradient descent is applied to give the prescription for adapting the network weights to learn a training set of input-output pairs. The back-propagation algorithm plays a central role in training neural networks. The notational conventions used in the demonstration are those shown in Figure 4.25. The pairs of input-output signals are denoted by (I_O, O_O) at the output nodes and by (I_H, O_H) at the hidden node, the signal at the input layer is denoted I. Two indexes are given into parenthesis, the input pattern and the unit in the layer. The connections from the input to the hidden units are weighted by coefficients $w(i, j)$ and the connections from the hidden to the output units by coefficients $W(i, j)$. Given a pattern μ of N bit rates $n = 1,, N$ applied on the input layer, the hidden unit j receives an input in form of

$$I_H(\mu, j) = \sum_{k=1}^{N} w(j, k) I(\mu, k) \tag{4.175}$$

and produces an output as

$$O_H(\mu, j) = g[I_H(\mu, j)] = g[\sum_{k=1}^{N} w(j, k) I(\mu, k)] \tag{4.176}$$

At the output layer, unit i receives

$$I_O(\mu, i) = \sum_{j} W(i, j) O_H(\mu, j) = \sum_{j} W(i, j) g[\sum_{k=1}^{N} w(j, k) I(\mu, k)] \tag{4.177}$$

to produce the final output

$$O_O(\mu, i) = g\{\sum_j W(i,j)\, O_H(\mu, j)\} = g\{\sum_j W(i,j)\, g[\sum_{k=1}^{N} w(j,k)\, I(\mu, k)]\} \quad (4.178)$$

The error between the ideal $\iota_O(\mu, i)$ and the observed $I_O(\mu, i)$ outputs is measured by the mean-square error

$$E[w] = \frac{1}{2}\sum_{\mu, i}[\iota(\mu, i) - g\{\sum_j W(i,j)\, g[\sum_{k=1}^{N} w(j,k)\, I(\mu, k)]\}]^2 \quad (4.179)$$

which is readily a differentiable function of each weight and a gradient descent algorithm can be exploited to learn the appropriate weights.

Given the error measure $E[w]$, the set of weights can be improved by sliding downhill on the surface defined in w space. Specifically, the usual gradient descent algorithm can be used to learn the appropriate weights and consists of changing each weight by an amount $\Delta w(a, i, j)$ proportional to the gradient of E at the present location. Let ν denote the coefficient of proportionality. When applying the gradient descent rule to the hidden-output connection, the gradient descent correction to $W(i,j)$ is given by

$$
\begin{aligned}
\Delta W(i,j) &= -\nu\, \frac{\partial E[w]}{\partial W(i,j)} \\
&= \nu\, \sum_\mu [\iota(\mu, i) - O_O(\mu, i)]\, O_H(\mu, j)\, g'[I_O(\mu, i)] \\
&= \nu\, \sum_\mu \delta(\mu, i)\, O_H(\mu, j) \quad (4.180)
\end{aligned}
$$

Proceeding back to the input-hidden connection, the gradient descent correction to $w(1, i, j)$ is as follows

$$
\begin{aligned}
\Delta w(1, j, k) &= -\nu\, \frac{\partial E[w]}{\partial w(1, j, k)} \\
&= \nu\, \sum_\mu \frac{\partial E[w]}{\partial O_H(\mu, j)}\, \frac{\partial O_H(\mu, j)}{\partial w(1, j, k)} \\
&= \nu\, \sum_{\mu, i} [\iota(\mu, i) - O_O(\mu, i)]\, g'[I_O(\mu, i)]\, W(i,j)\, g'[I_O(\mu, j)]\, I(\mu, k) \\
&= \nu\, \sum_{\mu, i} \delta(\mu, i)\, W(i,j)\, g'[I_O(\mu, j)]\, I(\mu, k) \quad (4.181)
\end{aligned}
$$

The update rule presents similar forms in both layers. In whole generality, when implementing an arbitrary number of layers, the back-propagation update rule is derived from application of the chain rule and take the following form

$$\Delta w(n, p, q) = \nu \sum_{patterns} \delta_{output} V_{input} \quad (4.182)$$

4.6. *The Use of Neural Networks* 349

where *output* and *input* refer to two ends of the concerned connection.

Though written as sums over all patterns μ, the updating rules are used incrementally as described in the following procedure. Patterns are consecutively presented and the weights are updated before considering the next pattern. Choosing the sequence of pattern in a random order widens the exploration of the cost surface by using a stochastic path through weight-space. Finally, the back-propagation learning procedure can be summarized by the following steps: the *initialization of the weights* to small random values, the *application of the first test pattern*, the *propagation through the network*, the *computation of the correction deltas* and the *update of the weights*. Another pattern re-activates the procedure and so on.

This section has illustrated several properties and capabilities of the neural networks to achieve the main functions described in the optimum control algorithm, namely the state prediction and the search towards optimum control sequences in the expected coming states. These procedures can be incorporated into only one neural network performing simultaneously both functions.

4.7 Conclusions

Three different regulation schemes have been here successively investigated. They can be exploited to monitor one-layer TV coders and individual layers in multi-layer coders as either CBR or VBR applications. The drawbacks of a simple linear feedback relation have been evidenced and removed by the adjunction of either a PID regulator or an optimum controller both located in the reaction loop. In any case, the purpose of controlling gracefully the subjective quality has been achieved in this textbook. In the framework of modeling the whole transmission chain, this chapter has also brought contributions in deriving an equation set which describes the inner coder functions.

The adjunction of a PID regulator turns out to be the simplest solution which enables resolving most of the disadvantages of simple linear feedback responses. It introduces just enough capabilities to deal with non-stationary input signals. Its main advantage is overall the simplicity of its hardware implementation. Nevertheless, this solution suffers from some remaining inefficiency. Indeed, it cannot implement an optimum balance between buffer regulation and uniform quality, it is not self-adaptive since each particular application needs an intrinsic set of PID parameters (to cope with different channel rates, to shift from CBR to VBR applications, to admit new image formats). This solution has nevertheless been implemented industrially in real-time coders and provides users with quite satisfactory results.

The optimum controller is one of the most advanced solutions which can also be implemented. It offers most of the properties expected by a regulation in charge of controlling a non-stationary signal. Indeed, it has been demonstrated as a tool able to achieve an optimum balance of the following properties: *learning* the statistical parameters, *caution* during the uncertainty, *regulation* during certainty, *freeze* during foreseeable periods of still or slow moving pictures. No matter how a CBR application or a VBR application may be involved, the controller builds itself the adequate optimum strategy through an expected horizon of future bit rates. Owing to the use of a predictor, the buffer is utilized

more efficiently and leads to subsequent transient responses which are potentially more gracefully monitored. Let us however remark that numerous intermediate sub-optimum solutions are always feasible and can be obtained, for instance, by combining a PID regulator with a predictor and a outer control which adapts in real time the PID parameters within the domain of stability.

As a matter of final remark, the idea of an optimum control of the buffer and the transmission factor can be extended and generalized to monitoring the whole TV-coder system in the sense that a statistical analysis of the future incoming images (a whole spatio-temporal analysis as a generalization of motion estimation) can lead to determine the optimum local coefficients for the decorrelation operation (for instance, the impulse response of the subband filters in two or even in three dimensions), the motion estimation, the adaptive quantization functions, the buffer regulation, the coding modes and the VLC tables. The global cost to be optimized is a maximum subjective quality constrained by the specified capacities of both the transmission channel and the output buffer capacity.

4.8 Bibliography

[4.1] K. J. Åström, B. Wittenmark "Adaptive Control", *Addison-Wesley, 1989.*

[4.2] E. W. Dijkstra "A Note on Two Problems in Connection with Graphs", *Numerical Mathematics, Vol. 1, pp. 269-271, 1959.*

[4.3] G. C. Goodwin, K. S. Sin "Adaptive Filtering Prediction and Control", *Prentice-Hall, 1984.*

[4.4] Y. Grenier "Time-Dependent ARMA Modeling of Nonstationary Signal", *IEEE Transactions on ASSP, Vol. 31, No. 4, August 1983.*

[4.5] I. Gumowski, C. Mira "Sur un algorithme de détermination du domaine de stabilité d'un point double d'une récurrence non linéaire du deuxième ordre à variables réelles", *C. R. Acad. Sc. Paris, t. 260, pp. 6524-6527, June 21, 1965.*

[4.6] A. Halanay "Un théorème de stabilité dans la théorie des systèmes non linéaires discrets", *C. R. Acad. Sc. Paris, t. 256, pp. 4818-4821, 1963.*

[4.7] S. Haykin "Adaptive Filter Theory", *Prentice-Hall, 1991.*

[4.8] J. Hertz, A. Krogh, R. G. Palmer "Introduction to the Theory of Neural Computation", *Addison-Wesley Publishing, 1991.*

[4.9] T. Kailath "A View of three Decades of Linear Filtering Theory", *IEEE Transaction on Information Theory, Vol. IT-20, pp. 146-181, 1974.*

[4.10] R. E. Kalman "A new approach to linear filtering and prediction theory", *J. Basic Eng., Vol. 82, pp. 34-45, March 1960.*

[4.11] F. Laurent " Sur la stabilité globale et le temps de réponse d'un système échantillonné non linéaire", *C. R. Acad. Sc. Paris, t. 260, pp. 4444-4447, 1965.*

[4.12] F. Laurent " Sur une majoration en amplitude des oscillations limites des systèmes échantillonnés non linéaires", *C. R. Acad. Sc. Paris, t. 262, pp. 659-661, 1966.*

[4.13] J.-P. Leduc "Buffer Regulation for Universal Video Codec in the ATM Belgian Broadband Experiment", *Proceedings of the Third International Workshop on Packet Video, Morristown, USA, session c, 6 pages, March 1990.*

[4.14] J.-P. Leduc, O. Poncin "Quantization Algorithm and Buffer Regulation for Universal Video Codec in The ATM Broadband Experiment", *Proceedings of the fifth European Signal Processing Conference: EUSIPCO-90, Barcelona, pp. 873-876, September 1990.*

[4.15] C. Mira "Méthode de détermination du domaine de stabilité asymptotique d'un point double d'une récurrence non-linéaire", *congress of theoretical control, Paris, 4-7 May 1965.*

[4.16] A. Papoulis "Predictable Processes and Wold's Decomposition: A Review", *IEEE Transactions on Acoustics, Speech, and Signal Processing, Vol. ASSP-33, No. 4, pp. 933-938, August 1985.*

[4.17] G. Szegö, R. Kalman "Sur la stabilité absolue d'un système d'équations aux différences finies", *C. R. Acad. Sc. Paris, t. 257, pp. 388-390, 1963.*

[4.18] G. Szegö "Sur la stabilité absolue d'un système non linéaire discret", *C. R. Acad. Sc. Paris, t. 257, pp. 1749-1751, 1963.*

[4.19] S. Węgrzyn and P. vidal "Critère de stabilité des systèmes échantillonnés non linéaires par rapport aux conditions initiales", *C. R. Acad. Sc. Paris, t. 261, pp. 4990-4993, 1965.*

[4.20] S. Węgrzyn, P. Vidal, O. Palusinski "Critère d'instabilité des systèmes échantillonnés non linéaires par rapport aux conditions initiales.", *C. R. Acad. Sc. Paris, t. 264, pp. 477-479, 1967.*

[4.21] P. J. Werbos "Backpropagation Through Time: What It Does and How To Do It", *Proceedings of IEEE, Vol. 78, No. 10, pp. 1550-1560, October 1990.*

[4.22] B. Widrow, S. D. Stearns "Adaptive Signal Processing", *Prentice-Hall, 1985.*

[4.23] B. Widrow, J. M. McCool, M. C. Larimore, C. R. Johnson "Stationary and Non-stationary Learning Characteristics of the LMS Adaptive Filter", *Proceedings of IEEE, Vol. 64, No. 8, August 1976.*

[4.24] B. Widrow, E. Walach "On the Statistical Efficiency of the LMS Algorithm with Non-stationary Inputs", *IEEE transactions on Information Theory, Vol. IT-30, No. 2, March 1984.*

[4.25] B. Widrow, M. A. Lehr "30 Years of Adaptive Neural Networks: Perceptron, Madaline, and Backpropagation", *Proceedings of IEEE, Vol. 78, No. 9, pp. 1415-1442, September 1990.*

Appendix

4.A Complements on the Non-Linearities

This appendix develops an additional way of studying non-linearities exploiting Banach's theorem of contraction which considers a stable area as a region of contraction and an unstable region as a region of dilatation. Results obtained with that method are presented in Figures 4.13 and 4.14 which presents the upper and the lower limits of the domain of stability with respect to the variable values.

4.A.1 Banach's Contraction Theorem

Banach's contraction theorem is valid for spaces where a distance metric d with symmetry, identity, positivity and triangular inequality has been assumed. Let us define an operator F associating any vector X_1 belonging to space \mathcal{X} to another vector X_2 belonging to the same space \mathcal{X} by the relation

$$X_2 = F(X_1) \quad with \ \ X_1 \in \mathcal{X} \ \ X_2 \in \mathcal{X} \tag{4.183}$$

If the operator is such that

$$d[F(X_1), F(X_2)] \leq s \times d(X_1, X_2) \tag{4.184}$$

$$with \quad 0 < s < 1$$

then, in space \mathcal{X}, exists one and only one point having the property that

$$X_f = F(X_f) \tag{4.185}$$

X_f is called the fix point of the operator and the operation is named a contraction. Hence in a domain of contraction, the suite of the successive points originating from anywhere in the domain generates a suite converging to X_f.

Chapter 5

Statistical Multiplexing

5.1 Introduction

As mentioned in Chapter 1, the key characteristic of the ATM networks is the capability of statistically multiplexing variable bit rate sources on transmission links at constant bit rate. This operation is carried out in each switching node of the network. It is mainly composed of three successive functions, namely a decomposition, a switching and a multiplexing.

1. the *decomposition or demultiplexing function* has the task to collect the cells entering at the input ports, to read the cell headers and to separate them according to their respective destination.

2. the *switching function* is in charge of routing the demultiplexed cells to the output ports of the virtual path to which they belong.

3. the *multiplexing function* is responsible to pool the cells destinated to the same output port into a common queue in order to wait to be served i.e. to be transmitted on the same output connecting link.

In this chapter, the network aspect to be examined is the local exchange node positioned at the entrance of n TV sources (Figure 5.1). The traffic at the input node is made in this particular case of the cells generated by individual TV sources connected to dedicated ports. At this stage of the study, no source enforcements are implemented, the sources are therefore freely variable. A buffer may be possibly implemented at the entry of the switching node. Chapter 7 will thereafter tackle the aspects of TV traffic transmissions along the whole ATM network and adjoin enforcement actions on the transmitting sources. Output queueing architectures are considered in this chapter since they have been proven to be more efficient than input queueing architectures (Chapter 1). The individual traffic is therefore routed according to its destination and, eventually, multiplexed into one output queue with the other sources.

The ATM multiplexer is evidently nothing else than an output queueing system. This explains the tremendous research efforts which have been consecrated to modeling

realistic queueing systems in the past decade. In the early beginning, the Poisson process and the Bernoulli processes were the first analytic source models to be commonly used in the field. However, these models do not incorporate important statistical traffic characteristics such as the serial correlation structure, the periodicity and the burstiness. As queueing system performances are highly sensitive to these parameters, realistic multiplexer models have to take them into account in any case. Moreover, it turns out that the superposition of non-Poisson traffics leads inevitably to general point processes with correlation structures. The challenge of modeling ATM multiplexers is to include the discrete-time nature and the other basic properties of the cell traffic while still being analytically tractable. These short introductory explanations justify the motivation expressed in this chapter to develop analytical models of queueing systems. The simulation techniques on computers have several limitations which drastically reduce their applicability for the performance study of ATM multiplexers and reinforce the need to queueing models. These limitations arize from the requirement of both the measurement of extremely small probabilities, especially below 10^{-6}, and the extremely long runtimes yielded for complex traffic structures even on efficient computers.

The problem addressed in the chapter consists of three successive important topics to be developed in full depth

1. analyzing the traffic obtained by pooling TV and HDTV sources and comparing in similar circumstances with voice sources.

2. modeling the ATM queueing systems when fed by the multiplexed traffic of TV sources.

3. deriving the queueing performances of such traffic in terms of cell loss probabilities, transmission jitter and statistical gain of multiplexing.

The first and second topics are complementary since the input of the ATM multiplexers is a superposed traffic issued from pooling several TV sources. As a consequence of the importance of both subjects, they will be treated theoretically in whole depth starting with elementary systems to explain the basic phenomena involved in the field and extending to state-of-the-art models to tackle the ATM realm.

According to the topics shortly discussed in this introduction, this chapter is readily organized in a three-fold structure. In a first step, the source superposition will be theoretically characterized and thereafter confronted with the experimental data collected in Chapter 3 to accurately characterize the resulting traffic, especially the conditions under which the arrivals are Poisson or point processes. When considering inter-arrival processes, the pooled traffics are studied and modeled as the superposition of the individual component sources and, when dealing with counting processes, the pooling is viewed as the summation of the individual sources. Secondly, different queueing models will be studied starting with the classical M/M/1 system which stands as the simplest nontrivial queueing system. Though elementary, the M/M/1 queueing theory presents some great importance coming from its historical influence as well as from its ability to introduce behaviors, concepts and foundations that are necessary to understand and use the more complex queueing system. Successively, different intermediate models will be studied

to progress by understandable steps to more intricated models and to open the path towards present state-of-the-art approaches. These systems are namely the continuous-time M/G/1, the M/D/1 and the discrete-time Geo/D/1. Advanced models are finally presented to reach the actual field of multiplexing traffics on the ATM networks. According to their underlying properties, theoretical models for superposed traffics are considered in conjunction with the corresponding queueing models in order to enable the estimation of the ATM multiplexing performances. The different traffic models deduced from experimental TV source characteristics are eventually considered to evaluate the multiplexing performances.

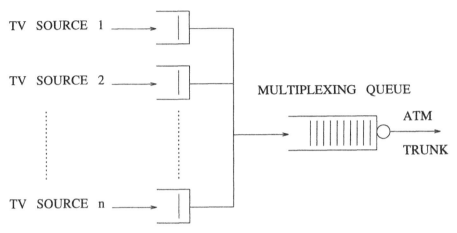

Figure 5.1: Multiplexing n TV sources.

5.2 Superposition of ATM Traffics

The *superposition* of the individual ATM traffics and, especially that of TV sources, is performed into an ATM multiplexer where n different sources are *pooled* before accessing a common multiplexing queue (Figure 5.2). The switching procedure routes several TV sources towards the same output port according to their respective destination. At the output port, the different sources aiming at being transmitted on the same link will be pooled to share one output queue (the multiplexer). The action of *superposing* different sources also called *pooling* or *aggregation* is first studied and three approaches are taken into consideration: the first is theoretical, the second, experimental and the third uses models in agreement with those developed in Chapter 3.

1. in the theoretical approach, two different points will be examined

 1. a synthesis of the existing theory presenting the central position held by the Poisson process. In fact, it will be demonstrated that the Poisson process plays a fundamental limit position in the field of superposing arrival processes with a status similar to that of the Gaussian process for the PDF of a sum of different random variables.

2. a study of the statistical characteristics of superposed traffic will be first addressed by the calculation of both the probability density functions and the auto-correlation functions resulting from n independent stationary sources.

2. in the experimental approach, several indexes will be defined and used to determine which arrival processes and which models characterize the most accurately the superposition.

3. in the approach by modeling, the superposition of the arrival processes will be studied with correlated inter-arrivals. Three ways of modeling will be proposed: the first is based on renewal processes, the second exploits the Markov modulated Poisson processes and the third uses the semi-Markov processes. Those three models will correspond to different ways to apprehend the traffic configurations of TV sources transmitting on ATM channels.

A final comparison is drawn with similar experimental results derived with the aggregation of voice sources to objectify both video and voice multiplexing characteristics.

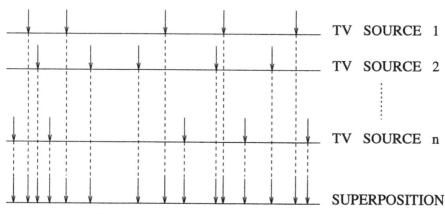

Figure 5.2: Superposition of n different sources.

5.2.1 Fundamental Limit Theorem of Superposition

In the three following subsections, the superposition of independent arrival processes will be considered to demonstrate the convergence of the pooled process to a Poisson process if the number of sources increases under the constraint of maintaining constant the total cell arrival rate. The individual processes are successively supposed to be Poisson processes, renewal processes and point processes. By progressively generalizing the convergence theorem, the three types of arrival processes will be covered in the following. This convergence theorem can be thought of as the counterpart to the convergence of counting processes to the Gaussian process.

5.2.1.1 Superposition of Poisson Processes

The superposition of independent Poisson processes is strictly a Poisson process. A mathematical demonstration is found in Reference [16]. The rate λ of the resulting Poisson process is equal to the sum of the rates of the individual Poisson processes $\lambda = \sum_{i=1}^{n} \lambda(i)$. No constraints are necessary in this case to demonstrate the proposition.

5.2.1.2 Superposition of Renewal Processes

Let n independent equilibrium renewal processes $\{N_{i,n}(0,t); t \geq 0\}$ with i=1 to n be superposed to form a pooled process $\{N_n(0,t); t \geq 0\}$

$$N_n(0,t) = N_{1,n}(0,t) + N_{2,n}(0,t) + \ldots + N_{n,n}(0,t) \tag{5.1}$$

As a matter of mathematical rigor, it is assumed implicitly in this chapter that all the sources have had a renewal at t=0 and that the intervals of counting are large enough. Practically, all the transient periods are extinct and do not contribute any more in the results.

The superposition of independent renewal processes is, in general, not a renewal process but an intricated point process with correlated inter-arrivals [5]. Nevertheless, a Poisson process can still be obtain in two circumstances

1. if and only if all the component processes are Poisson.

2. by convergence in distribution, under the assumptions which will be stated in the sequel.

Let us use the following assumptions

- *assumption 1:* for any n sufficiently large, the mean arrival rate is given by

$$\forall n \quad \lambda = \lambda_{1,n} + \lambda_{2,n} + \ldots + \lambda_{n,n} = \text{constant} < \infty \tag{5.2}$$

this assumption means that, when n increases, the component processes are rearranged in such a way that the total renewal rate remains constant and equal in all cases to λ.

- *assumption 2:*

$$\lim_{n \to \infty} \sup_{1 \leq i \leq n} \{Pr[N_{i,n}(0,t) \geq 1]\} = 0 \tag{5.3}$$

where the notation 'sup' stands for the upper bound and Pr for the probability. This means that the probability that any component source contribute as a renewal into the pooled process tends to zero on any finite interval [0,t], as the number of components tends to infinity, or restated in other words, that the individual processes have renewals more and more unfrequently.

Under assumption 1, Palm's theorem states that the PDF of superposed process tends to a negative exponential law [16]

$$\lim_{n \to \infty} Pr[N_n(0, t) = 0] = e^{-\lambda t} \tag{5.4}$$

This theorem is necessary but not sufficient to assert that the pooled process is a Poisson process. It proves only that the convergence to a negative exponential PDF is to be observed independently from any assumption on the correlation within the inter-arrival time process. Therefore, a resulting negative exponential PDF does not allow inferring that the resulting inter-arrival times are uncorrelated or Poisson. Using the second assumption, a complementary demonstration reaches the sufficient condition. This originates from Khintchine who showed the independence of the time intervals between consecutive events under the additional assumption 2 [16] to deduce that

$$\lim_{n \to \infty} Pr[N_n(0, t) = k] = \frac{e^{-\lambda t}[\lambda t]^k}{k!} \tag{5.5}$$

meaning a Poisson arrival.

5.2.1.3 Superposition of Point Processes

Palm-Khintchine's theorem has been generalized by Franken and Grigelionis [1969] to take into account inter-arrival time processes with general PDF's and serial correlation. Let $N_{i,n}(0, t)$ be the counting process associated with the i^{th} component point process (i= 1,..,n) and denote by $N_n(0, t)$ the counting process obtained from pooling n component processes

$$N_n(0, t) = \sum_{i=1}^{n} N_{i,n}(0, t) \tag{5.6}$$

We will say that the component processes are uniformly sparse and fulfill the two assumptions of previous paragraph. This means that the probability of any component to contribute as a point into the pooled process tends to zero on any finite interval as the number of components tends to infinity. Under these two assumptions previously stated, Franken and Grigelionis have proved the convergence in distribution of $N_n(0, t)$ to a non-homogeneous Poisson process meaning that, in this general case, the resulting process is not necessarily stationary. A typical example of application is the sequence of calls received at a large telephone exchange which is the pooled income of individual sequences arising from single subscribers.

5.2.1.4 Discussion about the Limit Theorem

As a matter of partial conclusions, two noticeable features have been pointed out so far:

1. the convergence of the resulting inter-arrival time PDF's towards a negative exponential of the form $f(x) = \lambda e^{-\lambda x}$ is obtained independently from the correlative structure of pooled inter-arrival times.

2. the assumption 1 on a constant mean arrival rate λ cannot be invoked when superposing TV sources. The individual cell arrivals are cumulated and the resulting rate increases in proportion to the contribution of the individual components. This apparent uncompatibility with the hypotheses required for convergence to a Poisson process can be removed by focusing on the arrival time scales and by rescaling the time axis in order to maintain constant the pooled arrival rate. This tricky way of counteracting the hypotheses means nothing else that all the individual source contributions become sparser and sparser and that no sources dominate the pooled arrival process to satisfy both assumptions 1 and 2 for a convergence to a Poisson process. This points out the concept of time scale inherent in the limit theorem of superposition. When superposing TV sources, the behavior of the pooled arrival process can be considered like a Poisson process only over short time intervals relatively to the contribution and the number of the different sources involved in the multiplexing. This effect will be of direct application when queueing the pooled arrivals.

5.2.2 Theoretical Approach of Superpositions

In this subsection, more enlightenment is going to be devoted to refine the knowledge about superposed traffics. Let us therefore consider n cell inter-arrival processes resulting from n independent and stationary sources for which the inter-arrival time PDF's are known to be $f_i(r)$ with i=1,.. ,n the number of sources involved in the multiplexing and r the interval between two consecutive cells. As presented in the previous subsection, the superposition of different TV sources is a complicated process of which eventually the resulting PDF and autocorrelation function will be determined here analytically.

5.2.2.1 PDF of Superposed Processes

Let the *repartition function* of the inter-arrival of the source i be defined as

$$F_i(r) = \int_{u=0}^{u=r} f_i(u)du \qquad (5.7)$$

its complementary function is given by

$$\mathcal{G}_i(r) = P_{0,i} = 1 - F_i(r) = \int_{u=r}^{u=+\infty} f_i(u)du \qquad (5.8)$$

and is called the *survivor function* to express the probability of observing an inter-arrival greater than r. Clearly, $\mathcal{G}_i(0) = 1$, $\mathcal{G}_i(\infty) = 0$ and $\mathcal{G}_i(x)$ is a non-increasing function. The mean inter-arrival time is given for source i and expressed by

$$M_i = \int_{u=0}^{u=+\infty} u f_i(u)du \qquad (5.9)$$

The goal is to find the probability density function $f(r)$ issued from the superposition of n initial sources. Let us begin with considering some elementary configurations before composing a final formula

1. let first suppose that, at time t_k, an arrival occurs caused by source i, the probability that a next arrival from source i occurs in the interval $[t_k+r, t_k+r+dr]$ (Figure 5.3) is given by

$$P_{1,i} = f_i(r)dr \qquad (5.10)$$

Figure 5.3: Cell arrival in configuration 1.

2. let secondly suppose that, at time t_k, an arrival occurs caused by source j with $j \neq i$, the probability that the first arrival produced by source i occurs in the interval $[t_k + r, t_k + r + dr]$ (Figure 5.4) is rigorously calculated in Appendix 1 and given by

$$P_{2,i} = \frac{\mathcal{G}_i(r)}{M_i}dr \qquad (5.11)$$

Figure 5.4: Cell arrival in configuration 2.

3. let third suppose that from instant t_k we expect to observe an arrival from the sources $j \neq i$ in the interval $[t_k + r, +\infty]$ after an arrival at t_k of a cell of source i (Figure 5.5)

$$P_{3,j \neq i} = \prod_{\substack{k=1 \\ k \neq i}}^{n} \int_{u=r}^{u=+\infty} \frac{\mathcal{G}_k(u)}{M_k}du \qquad (5.12)$$

4. let fourth come back to the case 1, an arrival at time t_k of one cell of source i, the probability that a next arrival results from source i occurs in the interval $[t_k+r, t_k + r + dr]$ without any other arrival in between t_k and $t_k + r$

Figure 5.5: Cell arrival in configuration 3.

$$P_4 = P_{1,i} \times P_{3,j\neq i} = f_i(r)dr \times \prod_{\substack{k=1 \\ k\neq i}}^{n} \int_{u=r}^{u=+\infty} \frac{G_k(u)}{M_k} du \qquad (5.13)$$

which expresses that, successively, a cell of source i is sent at t_k, that no cell occurs within the interval $[t_k, t_k+r]$, that one cell of source i occurs in the following interval dr and, eventually, that all the other cell occurrences are spaced after this second arrival (Figure 5.6).

Figure 5.6: Cell arrival in configuration 4.

5. let fifth suppose in case four that the event occurring in the interval $[t_k+r, t_k+r+dr]$ is due to another source j with $j \neq i$, then the probability of this configuration (Figure 5.7) is given by

$$P_5 = \sum_{\substack{j=1 \\ j\neq i}}^{N} P_{2,j} \times P_{0,i} \times P_{3,k\neq i,j} \qquad (5.14)$$

$$= \sum_{\substack{j=1 \\ j\neq i}}^{N} \frac{G_j(r)}{M_j} dr \times G_i(r) \times \prod_{\substack{k=1 \\ k\neq i,j}}^{n} \int_{u=r}^{u=+\infty} \frac{G_k(u)}{M_k} du \qquad (5.15)$$

which expresses a summation, over each potential j source different from i, of the probability to observe successively no arrival between t_k and $t_k + r$, an arrival from source j in the interval $[t_k, t_k + dr]$ and any other cell occurrences spaced after this second arrival.

The probability that the cell at t_k belongs to the i^{th} source is expressed as

$$\frac{M_i^{-1}}{\sum_{k=1}^{n} M_k^{-1}} = M_i^{-1} \times M \qquad (5.16)$$

5.2. *Superposition of ATM Traffics* 363

Figure 5.7: Cell arrival in configuration 5.

which defines a weighting factor to compute the resulting probability density function $f(r)$ of the superposition. This is found by summing over the n different sources the weighted quantity $P_4 + P_5$ and considering therefore all the possible combinations

$$f(r) \quad = \quad M\{ \sum_{k=1}^{n} [\frac{f_k(r)}{M_k} \prod_{\substack{j=1 \\ j \neq k}}^{n} \int_{u=r}^{u=+\infty} \frac{\mathcal{G}_j(u)}{M_j} du \tag{5.17}$$

$$+ \frac{\mathcal{G}_k(r)}{M_k} \sum_{\substack{j=1 \\ j \neq k}}^{n} \frac{\mathcal{G}_j(r)}{M_j} \prod_{\substack{l=1 \\ l \neq k,j}}^{n} \int_{u=r}^{u=+\infty} \frac{\mathcal{G}_l(u)}{M_l} du]\} \tag{5.18}$$

Different cases can be considered but, in the present study, the experimental PDF's measured on the actual TV data are of the utmost interest. Therefore, Figure 5.4. pictures the probability density function of the cell inter-arrival for an actual TV source at U=10 after 2, 5, 10, 16 consecutive superpositions of the same source. It shows experimentally that after 10 superpositions, the resulting PDF is rather negative exponential.

To be convinced of that convergence towards a negative exponential PDF and to study how rapidly the limit is approached, it is more useful to consider the survivor function of the superposed processes. For the shake of simplicity, the convergence is demonstrated in the case of n identical sources with survivor function \mathcal{G}_i and mean M_i. Invoking P_3 in Equation 5.12, the probability that the inter-arrival time r of the superposed process be superior to x is given by

$$Pr[r > x] \quad = \quad \prod_{i=1}^{n} \int_{x}^{\infty} \frac{\mathcal{G}_i(u)}{M_i} du \tag{5.19}$$

The resulting survivor function of the superposed process is obtained by equating probability P_2 in Equation 5.11 expressed for \mathcal{G} with the differential of Equation 5.19. It is also supposed that the intervals in the superposition are scaled by a factor of n so that their mean is the same as the mean interval in a component process.

$$\frac{\mathcal{G}(x)}{M} \quad = \quad -\frac{d}{dx} \{ \int_{\frac{x}{n}}^{\infty} \frac{\mathcal{G}_i(u)}{M} du \}^n \tag{5.20}$$

$$= \quad \frac{\mathcal{G}_i(\frac{x}{n})}{M} \{ 1 - \int_{0}^{\frac{x}{n}} \frac{\mathcal{G}_i(u)}{M} du \}^{n-1} \tag{5.21}$$

Considering the expansion about the origin of the common inter-arrival survivor function \mathcal{G}_i in form of

$$\mathcal{G}_i(x) = 1 - f_0 x - \frac{1}{2} f_1 x^2 + \dots \tag{5.22}$$

Therefore, by substitution in Equation 5.21 and extracting the negative exponential fraction, it follows that

$$\mathcal{G}(x) = e^{-\frac{x}{M}} \{ 1 + \frac{1}{n}(1 - f_0 M)(\frac{x}{M} - \frac{1}{2}\frac{x^2}{M^2}) + \mathcal{O}(\frac{1}{n^2}) \} \tag{5.23}$$

to assess the rapid convergence in distribution to the negative exponential limit when n increases.

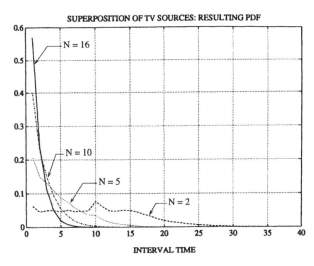

Figure 5.8: Superposing of actual TV sources: PDF after n superpositions.

5.2.2.2 Autocorrelation Function

In this section, the autocorrelation function for counts for a stationary and ergodic arrival process will be addressed and Appendix 5.B will present further results in a more general context. To introduce the analytical exposition, two alternative and mathematically equivalent ways of representing the event arrival moments will be apprehended. The first insight is the *infinitesimal or differential approach* of arrivals and the second is the *integral approach* obtained through counting diagrams. Figure 5.9 depicts the link between both approaches

1. the cell occurrence can be expressed for the source i as a train of infinitesimal impulses with unitary magnitudes

$$C(t) = \sum_{i=0}^{+\infty} \delta(t - t_i) \tag{5.24}$$

where the t_i are the random instants of arrivals defining the location of Dirac functions δ with unitary intensity at the instants of cell occurrences. The literature intensively uses that representation, especially concerning the study of shot noise and photon detection [17] [7].

2. the integral version or counting process is given by

$$N(0,T) = \int_{t=0}^{t=T} C(t)dt \tag{5.25}$$

and

$$S_p = \sum_{i=1}^{p} X_i \quad \text{with} \quad X_i = t_i - t_{i-1} \tag{5.26}$$

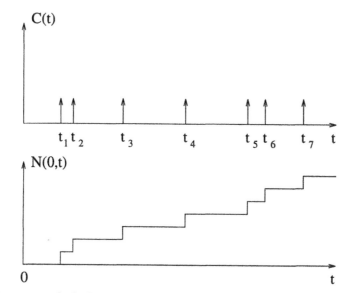

Figure 5.9: Arrival process: dual representation, infinitesimal-integral.

Assuming stationarity and ergodicity, the autocorrelation for counts $R_{CC}(\tau)$ of the superposed process can be computed by the time average limit

$$\begin{aligned} R_{CC}(\tau) &= \lim_{T\to\infty} \frac{1}{T} \int_{t=0}^{t=T} C(t)C(t+\tau)dt \tag{5.27}\\ &= E[N(0,T), N(0,T+\tau)] \tag{5.28} \end{aligned}$$

by expressing the arrivals $C(t)$ by Dirac functions [10], Distributions theory [17], [7] or more generally Stieltjes's measure theory leads to derive

Chapter 5. Statistical Multiplexing

$$R_{CC}(\tau) = \lim_{T \to \infty} \frac{1}{T} \sum_{k=1}^{N(0,T)} \sum_{l=1}^{N(0,T)} \delta(t_k - t_l - \tau) \tag{5.29}$$

where $N(0,T)$ denotes the number of arrivals into the interval $[0,T]$. A further insight on the calculation with ensemble averages is presented in the Appendix 5.B where the autocorrelations for counts are studied in a whole generality and a practical derivation is also expressed. In that part, the integral approach has been followed in the calculations. By rearranging here the double summation to separate groups of regularly spaced arrivals, the time averaged autocorrelation function becomes

$$
\begin{aligned}
R_{CC}(\tau) &= \lim_{T \to \infty} \frac{1}{T} \{ \sum_{p=1}^{N(0,T)-1} \delta(t_{p+1} - t_p - \tau) && \text{term} \quad [1] \\
&+ \sum_{p=1}^{N(0,T)-2} \delta(t_{p+2} - t_p - \tau) && \text{term} \quad [2] \\
&+ \quad \dots\dots \\
&+ \sum_{p=1}^{N(0,T)-m} \delta(t_{p+m} - t_p - \tau) && \text{term} \quad [m] \\
&+ \quad \dots\dots \}
\end{aligned}
\tag{5.30}
$$

At this stage, it becomes important to remark the proximity of Term 1 with probability density functions considered at $r = \tau$ as

$$
\begin{aligned}
f_1(\tau)d\tau &= \sum_{p=1}^{\infty} Pr[\tau - \delta\tau < S(t_p + 1) - S(t_p) < \tau + \delta\tau] \tag{5.31} \\
&= \lim_{T \to \infty} \sum_{p=1}^{N(0,T)-1} \frac{\delta(t_{p+1} - t_p - \tau)}{N(0,T)} \tag{5.32}
\end{aligned}
$$

Similarly, the probability density function that m consecutive arrival be equal to τ is related to term m,

$$
\begin{aligned}
f_m(\tau)d\tau &= \sum_{p=1}^{\infty} Pr[\tau - \delta\tau < S(t_p + m) - S(t_p) < \tau + \delta\tau] \tag{5.33} \\
&= \lim_{T \to \infty} \sum_{p=1}^{N(0,T)-1} \frac{\delta(t_{p+m} - t_p - \tau)}{N(0,T)} \tag{5.34}
\end{aligned}
$$

therefore, by extracting $\frac{N(0,T)}{T}$ from the summation 5.30 and by noticing that

$$\lim_{T \to \infty} \frac{N(0,T)}{T} = \frac{1}{M} \tag{5.35}$$

5.2. Superposition of ATM Traffics

the autocorrelation function becomes

$$R_{CC}(\tau) \;=\; \frac{1}{M}\{\sum_{m=1}^{\infty} f_m(\tau)d\tau\} \tag{5.36}$$

$$=\; \frac{1}{M}\sum_{m=1}^{\infty}\sum_{p=1}^{\infty} Pr[\tau - \delta\tau < S(t_p + m) - S(t_p) < \tau + \delta\tau] \tag{5.37}$$

where $f_m(\tau)$ is the probability density function that m consecutive intervals equal to τ. In the case of negative exponential PDF's, the autocovariance is independent of τ, as depicted in Figure 5.10 obtained by numerical computation based on actual arrival PDF's. That constant value, directly derived analytically by summing Erlang functions, is equal to λ^2.

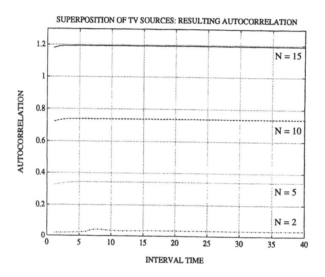

Figure 5.10: Superposing actual TV sources: autocorrelation function of the counts after n superpositions.

5.2.3 Experimental Study of Superposition

This section is devoted to the experimental characterization of the superposition of TV sources. To characterize the cell arrival process, different comparative indexes will be defined referring to the counting processes and the inter-arrival time processes. These indexes measured on the database of actual TV signal will precisely define and confirm the short term windows where the superposition can be considered as a Poisson process or a point process as announced by the limit theorem of superposition. To reach that goal, let us now define some comparative indexes based on both counting and inter-arrival modeling.

5.2.3.1 Counting Processes

For a counting process, the index of dispersion is based on the number of cell arrivals observed in the interval [0,t], referred to as $N(0,t)$, and is defined as the ratio of the variance to the mean of the random process $N(0,t)$

$$I(n,t) = \frac{Var[N(0,t)]}{E[N(0,t)]} \tag{5.38}$$

where n represents the number of sources to be multiplexed and t the time span for counting. For a Poisson process, $I(n,t)$ equals to 1. The notation 'var' symbolizes the variance. If m and $r(t)$ stand respectively for the mean and the covariance function of the rate of occurrence $\lambda(t)$, it has been demonstrated in Chapter 1 that, in case of a doubly stochastic Poisson process, the index of dispersion for counts verifies asymptotically

$$\lim_{t\to\infty} \frac{Var[N(0,t)]}{E[N(0,t)]} = 1 + \frac{2\int_0^\infty r(t)dt}{m} \tag{5.39}$$

which decomposes the limiting value into a first term for Poisson process and a second term for the influence of the covariance of $\lambda(t)$. When long term positive covariances matter, the Poisson approximation does not work due the underestimation of the burstiness on the arrival process. This index of dispersion measures therefore how far the arrival process diverges from the pure Poisson and the necessity to consider models with bursty arrivals.

5.2.3.2 Inter-Arrival Time Processes

For an inter-arrival time process, let us define S_k as the sum of k consecutive inter-arrival times $S_k = X_1 + + X_k$ where the X_i are consecutive inter-arrival times. In relation with S_k, the parameter $c_{k,n}^2$ is defined as the 'k-interval squared coefficient of variation' of S_k

$$c_{k,n}^2 = \frac{kVar[S_k]}{[E(S_k)]^2} \tag{5.40}$$

where n characterizes the number of sources to be superposed and k the number of consecutive inter-arrivals on which to compute the index. When the inter-arrivals are correlated

$$c_{k,n}^2 = \frac{Var[S_k]}{k[E(X_1)]^2} \tag{5.41}$$

$$= c_{1,n}^2 + \frac{\sum_{\substack{i,j=1 \\ i\neq j}}^{k} cov[X_iX_j]}{k[E(X_1)]^2} \tag{5.42}$$

where $cov[X_iX_j]$ is the covariance between the intervals X_i and X_j. As a matter of fact, $c_{k,n}^2$ is a measure of the cumulative covariance among k consecutive inter-arrivals. The notion of cumulative covariance will turn out to be very important for multiplexing

5.2. Superposition of ATM Traffics

applications because, under heavy loads, the burstiness (long empty periods followed by grouped arrivals) results from the cumulative effect of many small individual covariances.

As an interesting result, an asymptotic link for point processes is demonstrated herein below between the k-interval squared coefficient of variation of its inter-arrival representation and the index of dispersion of its counting representation. In conformance to intuition,

$$\lim_{k \to \infty} c_k^2 = \lim_{t \to \infty} I(t) \tag{5.43}$$

The subscript n disappears from the equation since the proposition is valid for any point process and for any kind of superposition. To prove this result, let us assume that S_k is asymptotically normally distributed with a variance which is of order k, meaning $var(S_k) = ka_k$ where a_k is bounded away from zero and $\mathcal{O}(1)$ as $k \to \infty$. It is also convenient to assume that the process has a point at the origin and to use the relationship

$$Pr[N(0,t) < k] = Pr[S_k > t] \tag{5.44}$$

with k and t related by the equation

$$k = \frac{t}{E[X]} + \frac{b(ta_k)^{\frac{1}{2}}}{(E[X])^{\frac{3}{2}}} \tag{5.45}$$

for any fixed b. Then

$$Pr[N(0,t) < k] = Pr\left[\frac{S_k - kE[X]}{\sqrt{ka_k}} > -b\left(1 + b\sqrt{\frac{a_k}{tE[X]}}\right)^{-\frac{1}{2}}\right] \tag{5.46}$$

Therefore, approaching the limit, when t and k tend to infinity, the right-hand side of the equation tends to the cumulative normal distribution function $\Phi(b)$. Let us remark that k is an integer whereas t is a real number and that, if $k \to \infty$, then $t \to \infty$ since b is fixed. Consequently, $N(t)$ is also asymptotically normally distributed and the asymptotic index of dispersion is eventually given by

$$\lim_{t \to \infty} I(t) = \lim_{k \to \infty} \frac{a_k}{(E[X])^2} = \lim_{k \to \infty} c_k^2 \tag{5.47}$$

This completes the proof.

5.2.3.3 Discriminating Criteria for Arrival Processes

The different indexes allow an experiment to discriminate between a Poisson process, a renewal process and a point process by computing I(n,t), $c_{1,n}^2$ and $c_{k,n}^2$ as follows

1. for a Poisson process, $I(n,t) = 1 = c_{k,n}^2 = c_{1,n}^2 \ \forall k, t$ because the variance and the mean of the counting version of a Poisson process are equal and the consecutive inter-arrival times are independent.

2. for a renewal process, $c_{k,n}^2 = c_{1,n}^2$ $\forall k$ expressing the fact that there is no correlation between consecutive inter-arrivals. $I(n,t) \neq 1$ for renewal processes.

3. for a point process, $c_{k,n}^2 \neq c_{1,n}^2$.

Two additional indexes will be taken into consideration in the study, namely the third and the fourth moment of the PDF's defined in Chapter 3 by the non-dimensional skewness and kurtosis.

5.2.3.4 Comments about the Experimental Results

This subsection reports some results on TV sources carried out in the framework of the experiments conducted on TV sources. As a matter of comparison, similar results for voice sources are also presented. These latter experiments have been performed by K. Sriram and W. Whitt and presented in [35].

Supporting Figures

The following experimental discussion refers to Figures 5.11, 5.12 and 5.13. Figure 5.11 gives the evolution of the index of dispersion for one TV source at U=10, Figure 5.13 depicts the same index for superposed traffics and Figure 5.14 presents the k-interval squared coefficient of variation for TV superposed traffics. Voice source characteristics are presented in Figures 5.14 and 5.15.

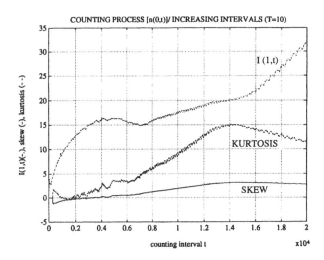

Figure 5.11: Counting processes on one single TV source: index of dispersion I(t), skewness S and kurtosis K at increasing counting intervals.

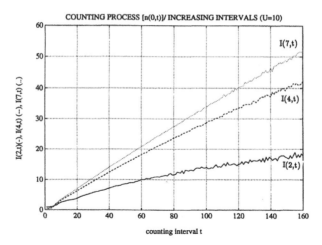

Figure 5.12: Index of dispersion of superposed TV traffics on short range counting intervals.

Interpretation

Referring to Figure 5.13, all the curves start by small flat left-hand portions at $c_{k,n}^2 = 1$ and $k < 10$ meaning that nearby inter-arrivals are independent. When n increases, that initial portion extends towards higher values of k. That behavior agrees totally with the microscopic concept developed for the limiting Poisson process on small periods of a few inter-arrivals: the pooled process will be at a microscopic scale closer and closer to a Poisson process as the number of component sources increases

1. Figure 5.8 shows experimentally the convergence of the inter-arrival times towards a negative exponential PDF.

2. Figure 5.13 shows the independence between consecutive intervals.

None of the experimental results for individual source has never depicted a flat curve with $c_{k,1}^2$ constant for all k and larger than one. This means that TV sources cell arrivals do not generate renewal processes but rather definite point processes.

 The period k, where $c_{k,n}^2$ is equal to unity, has to be compared with the size of the ATM multiplexing queues to determine how the effect of the covariance will matter in the queue. The ATM multiplexing queues are foreseen to have a capacity of 64 cells. This means that, at low loads with a few cells in queue, the buffer behaves like a M/D/1 system with Poisson arrival. On the contrary, at heavy loads, the effect of the covariances will matter and especially their cumulative effects which will create, in this case, the burstiness of the arrival and also the burstiness of the evolution of the queueing occupancy and, eventually, the burstiness of the cell losses. As it appears in this discussion, the experimental curves of the $c_{k,n}^2$ are closely connected to the physical phenomena which take place in the multiplexers and degrade the queueing performances.

 Figure 5.11 presents the index of dispersion for counts in the particular case of one source. That index determines the variability of the counts with respect to that

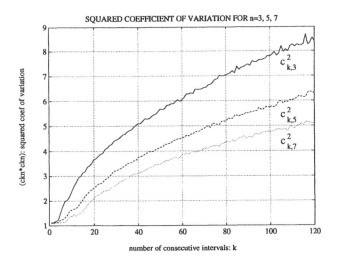

Figure 5.13: k-interval squared coefficient of variation for superposed TV traffics.

of a Poisson process. It is to be noticed that the variation of the index of variation will cumulate two effects: the shift from Poisson process and the time scale effect of considering the pair variance and mean instead of the pair standard deviation and mean. Nevertheless, this index is frequently used because of its remarkable limiting value given in Equation 5.39. This shows again that the cell arrival process can be considered as a Poisson process over small counting intervals but diverges significantly from that behavior when the counting increases. $t = 188$ and $t = 14200$ represent respectively the counting spans of, respectively, the stripe and the image. It can be observed in Figure 5.11 that a first stair of variability is reached after a counting span of about 20 stripes, that the image counting interval maximizes the kurtosis and that a new increase of variability starts beyond the horizon of one image. This index demonstrates how far the Poisson process can underestimate the variability of the arrival process and overestimate the queueing performances. The index of dispersion shows that at macroscopic time scales the arrival process deviates from Poisson process.

Figure 5.12 presents the increase of the variability of the counts when superposition is involved. Superposing cell arrival processes induces on the pooled process paradoxical effects: convergence to Poisson process at microscopic time scales and divergence from Poisson process at macroscopic time scales.

So far, it can be inferred clearly that the free variable cell rates TV source correspond to point processes, the Poisson process is obtained as a particular limiting case. This means that, when dealing with such sources, the traffic burstiness generated by accumulating small covariances will degrade the queueing performances known for the Poisson process.

Figures 5.14 and 5.15 originate from K. Sriram and W. Whitt in Reference [35] and deal with voice-packet arrival processes. Figure 5.14 presents the index of dispersion for the number of arrivals in the interval $(0, t)$ and Figure 5.15 the k-interval squared coefficient of variation curves for the superposition of n voice sources. These figures show

clearly that single voice source is a renewal process, that the superposition of two or a few voice sources can no longer be considered as a renewal process but as a point process. The convergence to a limiting Poisson process is also assessed by experiment. Observing both results on speech and TV sources leads to conclude that the superposition of stochastic traffics displace the burstiness and the correlation: these parameters estimated on the inter-arrival time processes decrease in intensity when proceeding from single source to superpositions, in contrast to the counting processes which increase correlation and bursti-ness. The superposed traffics recover memoryless properties on small counting windows when observing a few successive inter-arrivals, but over longer length the superposition process deviates significantly in Figure 5.12 from Poisson process to display a more bursty behavior than that of a single-source arrival process.

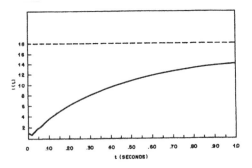

Figure 5.14: Index of dispersion for num-
ber of arrivals in (0,t) for voice
sources (©IEEE).

Figure 5.15: k-interval squared coefficient
of variation for n voice sources
(©IEEE).

5.2.4 Modeling Source Superpositions

The object of this section is to show how far it is possible to model a traffic superposition with renewal, point traffic equations and with semi-Markov processes. These models have to correspond with those of realistic TV sources (Chapter 3) and to be the adjunct of those of the queues in order to compute the multiplexing performances. As it will be demonstrated in Chapter 7, an accurate computation of the bandwidth will require the knowledge of, first, the cell arrival traffic (inter-arrival time processes) of, secondly, the bit rate PDF's and of, third, a queueing model to deduce a precise computation of the bandwidth.

5.2.4.1 Superposition with Renewal Processes

Here, we assume the cell inter-arrival process from a single source as being a simple renewal process. The cell stream of a single voice source has been demonstrated as being a renewal process in Chapter 1. Strong approximations could also lead to model a TV

source with renewal processes. To reach tractable calculations and to consider a single voice source, the inter-arrival time PDF is decomposed into three parts

1. no possibility for inter-arrival ranging in the interval [0,T].

2. one probability mass at the interval T to consider, for instance, a policing function with a minimum allowed interval of T.

3. a negative exponential PDF for the intervals greater than T.

Let α be a weighting parameter between the second and the third active parts. The resulting PDF of the arrival process is given by

$$F(t) = \{(1 - \alpha T) + \alpha T(1 - e^{-[\gamma(t-T)]})\}u(t - T) \tag{5.48}$$

The Laplace transform is given by

$$\mathcal{F}(s) = \{1 - \alpha T + \alpha T\gamma(\frac{1}{s+\gamma})\}e^{-sT} \tag{5.49}$$

The mean cell arrival is given by

$$\lambda = -\frac{1}{\mathcal{F}'(0)} = \frac{1}{T + \frac{\alpha T}{\gamma}} \tag{5.50}$$

The symbol (') stands for the derivation.

To connect the inter-arrival time process to its counting process, let N(0,t) denote the number of renewals of a stationary process in the interval [0,t] and denote the moments of order 1,...,r by

$$M_1(t) = E[N(0,t)] = \lambda t \qquad M_r(t) = E[N^r(0,t)] \tag{5.51}$$

The index of dispersion for the counting processes I(t) has the following limit

$$\lim_{t\to\infty} I(t) = \lim_{t\to\infty} \frac{var[N(0,t)]}{M_1(t)} \tag{5.52}$$

$$= \frac{var[X]}{E^2[X]} \tag{5.53}$$

$$= \frac{1 - (1 - \alpha T)^2}{(\alpha T + \gamma T)^2} \tag{5.54}$$

where X stands for the inter-arrival time process and Equation 5.52 is demonstrated earlier in this chapter.

Considering the superposition of n identical renewal sources, the counts of arrivals on interval $(0, t]$ is expressed as

$$N^s(0,t) = \sum_{i=1}^{n} N_i(0,t) \tag{5.55}$$

where the superscript s denotes the superposition variables. The resulting mean is simply

$$M_1^s(t) = E[N^s(0,t)] = nM_1(t) \tag{5.56}$$

The indexes of dispersion for the resulting counting process

$$I^s(t) = \frac{var[N^s(0,t)]}{E[N^s(0,t)]} = \frac{var[N(0,t)]}{E[N(0,t)]} \tag{5.57}$$

The third moment is obtained as

$$\mu_3^s(0,t) = E\{[n^s(0,t) - E(N^s(0,t))]^3\} = n[M_3(t) - 3M_2(t)M_1(t) + 2M_1^3(t)] \tag{5.58}$$

Let us notice that the variance-time curve $V^s(t) = var[N^s(0,t)]$ completely characterizes the correlation structure of the superposed arrival by Equation 5.344 of Appendix 5.B. Therefore, to approach accurately the correlation properties of the superposition, it is important that the approximate process provides a good match to the variance-time curve.

This shows the relative easiness to compute the parameters of the pooled process in this practical example. In this case, the source and their superpositions are characterized by a set of tractable parameters: the mean, the variance to mean ratio, the third moment over finite intervals and the variance to mean ratio over infinite intervals.

5.2.4.2 Superposition with Point Processes

As already studied in Chapter 3, a Markov Modulated Poisson Process (MMPP) is a doubly stochastic Poisson process in which the arrival rate varies according to the state of a m-state irreducible Markov process. Whenever the Markov process is in state i during a mean sojourn time r_i, the cell arrivals occur according to a Poisson process of rate λ_i. The MMPP is defined by three elements

1. a diagonal matrix Λ of dimension (m,m) with diagonal elements equal to the arrival rates $\lambda_1, \lambda_2,...., \lambda_m$; $\Lambda = diag(\lambda_1, \lambda_2, ...\lambda_m)$.

2. a matrix Q generator of the underlying Markov process with a dimension [m,m].

3. the initial state probability vector γ of the Markov process taken as the limiting stationary version.

In this section, a technique to approximate the superposition of several traffics is conducted with an aim of analytic simplicity and a desire for versatility. These considerations have led to employing MMPP processes. The particular model considered here will be the MMPP with two states denoted MMPP(2) which has been successfully exploited as an approximating process for point processes originating from computer data and voice streams [34]. Four parameters need to be estimated in this case, they are referred to as two arrival rates (λ_1, λ_2) and two mean sojourn times (r_1, r_2) corresponding to the two Markov states. A set of four statistical parameters characterizing significantly the sources has to be adequately chosen to evaluate the Markov process parameters. In Chapter 3, that model provides the designer with an adequate tool to characterize free VBR TV inter-arrival times. The problem to cope with is two-fold

1. to determine a 'one to one' mapping relation between, in one end, the four MMPP(2) parameters and, in the other end, the four source traffic descriptors.

2. to formulate cumulative relations with the individual source traffic descriptors in order to express the resulting traffic descriptors obtained after the superposition.

For instance, let us consider the mean m, the variance v and the third moment μ_3 of the resulting intensity $\lambda(t)$. The parameter τ_c, symbolizing a *time constant* of the intensity process, is defined as a quantity proportional to the integral of the covariance function $r(t)$ of $\lambda(t)$. For any source j, a correspondence can be easily established between the traffic parameters defining the statistics of $\lambda(t)$ $[m_j, v_j, \mu_{j,3}, \tau_{j,c}]$ and the MMPP(2) parameters $[\lambda_{j,1}, \lambda_{j,2}, r_{j,1}, r_{j,2}]$. These relations are decomposed as follows

1. the equations of the univocal transformation to map the traffic descriptors with the MMPP parameters are given as

$$m_j \quad = \quad \frac{\lambda_{j,2} r_{j,1} + \lambda_{j,1} r_{j,2}}{r_{j,1} + r_{j,2}} \qquad \text{mean of } \lambda(t) \qquad (5.59)$$

$$v_j \quad = \quad \frac{r_{j,1} r_{j,2} (\lambda_{j,1} - \lambda_{j,2})^2}{(r_{j,1} + r_{j,2})^2} \qquad \text{variance of } \lambda(t) \qquad (5.60)$$

$$\mu_{j,3} \quad = \quad \frac{\lambda_{j,1}^3 r_{j,2} + \lambda_{j,2}^3 r_{j,1}}{r_{j,1} + r_{j,2}} \qquad \text{third moment of } \lambda(t) \qquad (5.61)$$

$$\tau_{j,c} \quad = \quad \frac{1}{v_j} \int_0^\infty r_j(t) dt \quad = \quad \frac{1}{r_{j,1} + r_{j,2}} \qquad \text{time constant of } \lambda(t) \qquad (5.62)$$

$$(5.63)$$

The time constant is such that the exponential covariance function approximating the time function $r_j(t)$ results in

$$r_{j,app}(t) \quad = \quad v_j \, \exp\left(-\frac{t}{\tau_{j,c}}\right) \qquad (5.64)$$

As an example, referring to the Figure 5.11, the set of parameters has been estimated as ($\lambda_1 = 0.537$, $\lambda_2 = 0.032$, $r_1 = 0.078$, $r_2 = 0.012$). These estimations lead to $I(1, \infty) = 14.8$. The value of the index of dispersion when t tends to infinity is of the same order of magnitude relatively to the first stair of the curve displayed in Figure 5.11. The present parameters have been estimated on t=10000 [slot times].

2. the superposition of n sources leads to the following cumulative equations on the four traffic descriptors

$$m = \sum_{j=1}^n m_j \quad v = \sum_{j=1}^n v_j \quad \mu_3 = \sum_{j=1}^n \mu_{j,3} \quad \tau_c = \sum_{j=1}^n \frac{v_j}{v} \tau_{j,c} \qquad (5.65)$$

5.2. Superposition of ATM Traffics 377

They allow computing the MMPP parameters of the superposed arrival process with the description of all the individual sources to be pooled.

Another set source parameters has been proposed by Rossiter [34] who has established a correspondence between the set $[\lambda_{j,1}, \lambda_{j,2}, r_{j,1}, r_{j,2}]$ and three parameters issued from the inter-arrival process referring to the mean, the squared coefficient of variation, the asymptotic variance to mean ratio and the asymptotic covariance of the number of arrivals in adjacent time intervals.

Realistic source models reflecting the main correlation structure are necessary to investigate the ATM performances since the queueing systems are highly sensitive to the characteristics of the arrival process. Evidently, MMPP's of order m should bring better match to the arrival processes investigated in the ATM multiplexing. These will be presented in the following sections dealing with the multiplexer models. Continuous and discrete time models will be addressed. Even more general models, referred to the versatile point processes, extend the modeling issue to batch arrivals. The next section starts with another approach. From long term TV models which embody successions of scenes, it will turn out that the study of the superposition matches to modeling arrival with high order MMPP's.

5.2.4.3 Superposition with Semi-Markov Processes

In this subsection, the TV sources are identified with semi-Markov processes modeling the image bit rate evolution at the scene level. Each level of the process represents an intensity which is function of the complexity of the images being encoded and constitutes a state in a Markov chain. Each state of the embedded Markov chain determines a cell rate which may correspond to an enforced Poisson process ($\lambda_i, i = 1$ to m) easily achieved when the TV encoder accumulates in a buffer the quantized data stream over the span of one image and transmits the cumulated amount of bits during the following image span spreading the cell according to a Poisson process. The instants of scene change have been modeled with remarkable accuracy by renewal processes. This conducts the modeling to Markov renewal processes. The scene change occurrence is renewal with nearly Gamma-distributed inter-arrivals and the states are distributed according to a Gaussian process. At this level of analysis on long term length, the experience is quite well reconciliated with analytically tractable models.

The superposition of the semi-Markov processes originating from n sources is obtained by considering the superposition of both the state change instants and the state levels of the component processes

1. the superposition of the renewal processes (general, independent and identically distributed processes) generates a negative exponential PDF to approximate a Poisson process at least over the span of a few inter-arrivals. The time scale is here of some importance. The mean time between renewals being of several tens of seconds, therefore, when superposing fifteen sources, the resulting mean inter-arrival time in between two consecutive scene change moments will be of the order of the second. The conditions of the limiting theorem are fulfilled to assume from the multiplexer

time scale point of view that the superposition of the source renewals is close to a Poisson process.

2. the superposition of the Markov chains implies the sum of independent variables, the image cell rate within a scene, which converges to a Gaussian-distributed process. This multiplies tremendously the range and the number of discrete states to be included in the process.

The resulting model can be assumed to be a Markov process driven by a Poisson process treated in Çinlar [3]. As a consequence, the MMPP(m) models studied in Appendix 5.A of Chapter 3 are back a center of interest. The asymptotic state probabilities

$$P_i(\infty) = Pr[\lambda(t) = \lambda_i] \tag{5.66}$$

can derived by convolving the PDF of the image cell rate of each individual source (presented in Chapter 3). In the following section, this important modeling approach will be coupled to a queueing model using fluid-flow approximation.

5.2.4.4 Superposition with Versatile Point Process

Realistic ATM traffics entering ATM multiplexers naturally exhibit random fluctuations of the arrival rates and oscillate between periods of heavy, medium and light rates. The superposition of several independent asynchronous traffics leads inevitably to bursty and batch arrivals. The arrivals by bursts and batches differ fundamentally from each other in the sense that *bursts* of cell arrivals refer to groups of consecutive cells whose length (the number of cells in the group) is also a random process to be characterized and that *batches* determine a set of different cells arriving simultaneously with an intensity equal to the number of concomitant cells and subject to another stochastic characterization. Frequently, only one single cell may at once come into queue, then for physical reasons batches are behaved like bursts in those cases. This means that distinguishing batches from bursts is not always a relevant problem when modeling the ATM cell superposition. In the whole general framework of defining tractable point processes, the N process has been introduced by Neuts as a *versatile Point process* whose cell arrival rate varies according to a continuous-time Markov process and where batches of cell arrivals may occur during the state transitions. The Markov process is composed of (m+1) states of which m are *transient* and one (m+1) is *absorbent*.

To describe the N process, this presentation intends to proceed in three steps consisting successively of

1. generalizing the family of *exponential distributions*, a Markov process is first defined as a basis of study on $m + 1$ states of which m are transient $\{i = 1 \text{ to } m\}$ and one $\{i = m + 1\}$ is absorbent.

2. defining *continuous-time probability distributions* and *renewal processes of phase type*, a phase refers to a sojourn in one state of the Markov chain.

3. constructing the *versatile point process* also termed the N process and deriving its probability generating function.

The N process formalism combines astutely the theory of point processes with the linear algebra of the Markov processes to encompass simple previous families of arrival processes and to extend the modeling towards further generalizations.

The Finite m-State Background Markov Process

Let us define a continuous-time Markov process with m transient states $\{1, 2, ..., m\}$ and one absorbent state $m+1$. The generator Q of this (m+1)-state, continuous-time Markov process is expressed as

$$Q = \begin{vmatrix} T & \mathbf{T^0} \\ \mathbf{0} & 0 \end{vmatrix} \tag{5.67}$$

where T is a non-singular $m \times m$ matrix in which the diagonal elements $T(i, i)$ are negative and the non-diagonal elements $T(i, j)$, $i \neq j$ are non-negative. $\mathbf{T^0}$ is a non-negative m-component vector which fulfills $T\underline{u} + \mathbf{T^0} = \underline{0}$ with $\underline{u} = (1, ..., 1)^T$.

Let moreover $\{\underline{\alpha}, \alpha_{m+1}\} = \{\alpha_1, \alpha_2, ..., \alpha_m, \alpha_{m+1}\}$ be the vector of the initial probabilities such that $\underline{\alpha}\,\underline{u} + \alpha_{m+1} = 1$. The state $m+1$ is absorbing, then λ_{m+1} is assumed to be equal to zero in the following, all other states are transient and $\lambda_i > 0$, $i = 1, ..., m$. The necessary and sufficient condition to have this is that the inverse T^{-1} exists.

The probability distribution F(x) of the time elapsed until absorption in state $m+1$ is easily derived as

$$F(x) = 1 - \underline{\alpha}\, e^{Tx}\, \underline{u} \qquad x \geq 0 \tag{5.68}$$

since the unconditional state probability vector at time x, $\underline{\nu}(x)$, verifies the equation $\underline{\nu}(x) = \underline{\alpha}e^{Tx}$ as solution of the system differential equation $\underline{\nu}'(x) = \underline{\nu}T$ governing the system and therefore $F(x) = 1 - \underline{\nu}(x)\, \underline{u}$.

Probability Distribution of Phase Type

The probability distribution $F(x)$ proposed hereinabove where x is defined on the continuous interval $[0, \infty)$ is called a *probability distribution of phase type* and provides the family of the Erlang distributions with a generalized and unified matrix formalism owing to the linear algebra underlying the Markov process. The pair (α, T) is referred to be the *representation* of $F(x)$. The probability distribution has a jump of height α_{m+1} on the origin and a density function $f(x)$ defined on $[0, \infty)$ by

$$f(x) = F'(x) = \underline{\alpha}\, e^{Tx}\, \mathbf{T^0} \tag{5.69}$$

The Laplace-Stieltjes transform $f(s)$ is easily expressed as

$$f(s) = \alpha_{m+1} + \underline{\alpha}\, (sI - T)^{-1}\, \mathbf{T^0} \tag{5.70}$$

The non-central moments μ_k, $k \geq 1$ of $F(x)$ are therefore deduced as

$$\mu_k = (-1)^k\, k!\, \underline{\alpha}\, T^{-k}\, \underline{u} \tag{5.71}$$

To illustrate the actual generalization brought by the distribution of phase type in the field of the renewal processes, some elementary examples can be readily considered in the light of the *probability distribution of phase type*

1. *the exponential distribution with rate λ* where

$$Q = \begin{vmatrix} -\lambda & \lambda \\ 0 & 0 \end{vmatrix} \tag{5.72}$$

and $\alpha_1 = 1$, $\alpha_2 = 0$; the representation is given by $(1, \lambda)$.

2. *the generalized Erlang distribution*
 which has a PDF composed of the convolution of m different exponential PDF's with respective parameters $\lambda_1,..., \lambda_m$. The representation therefore is as follows: $\underline{\alpha} = (1, 0, ..., 0)$,

$$T = \begin{vmatrix} -\lambda_1 & \lambda_1 & 0 & \cdots & 0 \\ 0 & -\lambda_2 & \lambda_2 & \cdots & 0 \\ \vdots & \vdots & \vdots & & \vdots \\ 0 & 0 & 0 & \cdots & -\lambda_m \end{vmatrix} \tag{5.73}$$

and $\mathbf{T}^0 = (0, 0, ..., \lambda_m)^T$.

3. *the hyperexponential distribution* where the distribution is given by
 $F(x) = \sum_{i=1}^{m} \alpha_i (1 - e^{-\lambda_i x})$, $x \geq 0$; the representation is consequently expressed by $\underline{\alpha} = (\alpha_1, 0, ..., \alpha_m)$, $\mathbf{T}^0 = (\lambda_1, ..., \lambda_m)^T$, and, $T = diag[-\lambda_1, ..., -\lambda_m]$.

Discrete-time phase distribution may also be characterized by considering an (m+1)-state Markov chain P of the form

$$P = \begin{vmatrix} T & \mathbf{T}^0 \\ \mathbf{0} & 1 \end{vmatrix} \tag{5.74}$$

where T is a sub-stochastic matrix ensuring that (I - T) is a non-singular matrix. The PDF of phase type $\{p_k\}$ is derived as

$$p_0 = \alpha_{m+1} \tag{5.75}$$
$$p_k = \underline{\alpha} \, T^{k-1} \, \mathbf{T}^0 \quad \text{for } k \geq 1 \tag{5.76}$$

and enables expressing the probability generating function and the moments respectively as

$$P(z) = \alpha_{m+1} + z \, \underline{\alpha} \, (I - zT)^{-1} \, \mathbf{T}^0 \tag{5.77}$$

and

5.2. Superposition of ATM Traffics *381*

$$\mu^k(1) \;=\; k! \; \underline{\alpha} \, T^{k-1} \, (I-T)^{-k} \, \underline{u} \tag{5.78}$$

For instance, the discrete-time version of the Erlang distribution is called the *Pascal or negative binomial distribution* with

$$Pr[x = k] \;\;=\;\; \begin{pmatrix} -n \\ k \end{pmatrix} p^n \, (-q)^k \tag{5.79}$$

$$\;\;=\;\; \begin{pmatrix} n+k-1 \\ k \end{pmatrix} p^n \, (q)^k \quad k = 0, 1, \dots \tag{5.80}$$

with mean and variance equal to $\mu = n\frac{q}{p}$ and $\sigma = n\frac{q}{p^2}$. This discrete-time analogy withstands potential further generalizations.

Some elementary properties are sometimes useful when modeling classical discrete-time queueing systems. In fact, it is easily verified that any density with finite support on the non-negative integers is of phase type. All the left-shifted densities are still of phase type, so does the negative binomial density since the density may be simply shifted to the left by r steps by changing the initial probability vector. Let us also notice that the density $q_0 = \underline{\alpha} T^{r-1} \underline{\mathbf{T}}^0 = p_r$ and $\{q_k\}$ is still of phase type with representation $(\beta = \underline{\alpha} T^r, T)$.

Renewal Process of Phase Type

To construct a renewal process with inter-arrival times distributed as $F(x)$, let us consider that, upon absorption occurring into state $m + 1$ of the Markov chain, an event is generated and that moreover a multinomial trial is performed instantaneously with probabilities $\alpha_1, \dots, \alpha_{m+1}$ until one outcome 1, .., m occurs to restart the Markov process in the corresponding initial state. This procedure is indefinitely iterated. The Markov chain thereby obtained has $m + 1$ states where the state $m + 1$ is ephemeral or instantaneous. The inter-arrival times, delimited by consecutive visits to state $m + 1$, are independent and identically distributed according to $F(x)$. They define a *renewal process of phase type*. The generator Q^* of the Markov process is derived as

$$Q^* \;=\; T + \underline{\mathbf{T}}^0 A^0 \tag{5.81}$$

where T is $m \times m$ matrix with m identical columns vectors given by the vector $\underline{\mathbf{T}}^0$ and the matrix $A^0 = (1 - \alpha_{m+1})^{-1} \; \mathrm{diag}(\alpha_1, \dots, \alpha_m)$. The matrix Q^* is supposed irreducible without loss of generality. The steady-state probability vector of the irreducible Markov process Q^* is the unique solution to the equations

$$\underline{\pi}(T + \underline{\mathbf{T}}^0 A^0) \;=\; 0 \qquad \underline{\pi} \, \underline{u} = 1 \tag{5.82}$$

This leads to a stationary limiting state probability vector $\underline{\pi}$ given by

$$\underline{\pi} \;\;=\;\; -(\underline{\pi} \, \underline{\mathbf{T}}^0 \, A^0) T^{-1} \tag{5.83}$$

$$\;\;=\;\; -(1 - \alpha_{m+1})(\underline{\pi} \underline{\mathbf{T}}^0) \underline{\alpha} T^{-1} \tag{5.84}$$

and

$$\underline{\pi}\,\mathbf{T}^0 \;=\; (1-\alpha_{m+1})\mu_1 \tag{5.85}$$

where μ_1 is the mean of $F(x)$. In the sequel, we will suppose $\alpha_{m+1} = 0$. The stationary renewal process of phase type is obtained by starting the Markov process Q^* with the initial state probability vector $\underline{\pi}$.

The representation $(\underline{\alpha}, T)$ is called irreducible if and only if the matrix Q^* is irreducible. If $F(x)$ is the phase-type-distribution with irreducible representation $(\underline{\alpha}, T)$, then $F^*(x)$, the phase-type-distribution for the representation of $(\underline{\pi}, T)$, is given by

$$
\begin{aligned}
F^*(x) \;&=\; \frac{1}{\mu_1}\int_0^x \underline{\alpha}\,e^{Tv}\,dv\,\underline{u} \tag{5.86}\\[4pt]
&=\; \frac{1}{\mu_1}\,\underline{\alpha}\,T^{-1}\left[e^{Tx}-1\right]\underline{u}\,dv\,\underline{u} \tag{5.87}\\[4pt]
&=\; 1-\underline{\pi}\,e^{Tx}\,\underline{u} \tag{5.88}
\end{aligned}
$$

and also

$$F^*(x) \;=\; \frac{1}{\mu_1}\int_0^x [1-F(v)]\,dv \qquad x \ge 0 \tag{5.89}$$

The moments of F^* are given by $\mu_i^* = (-1)^i\,i!\,\underline{\pi}\,T^{-i}\,\underline{u}$. This completes the description of the renewal process of phase type. This process will be exploited to lay down the foundation of a general point process, the N process also called the versatile point process, where the events may be made of either single arrivals or sizeable-length bursts.

Neuts' Versatile Point Process

The description of the versatile point process is addressed in this paragraph. The Markov process Q^* and the renewal process of phase type lay the foundations to define the N point process. In this process, three different types of arrival time have to be mentioned, they will occur

1. during any sojourn in a state i, $1 \le i \le m$, of the Markov chain, the arrivals are Poissonian with rate λ_i. These events occur either as single points or as batches of length k with densities $p_i(k)$, $k \ge 0$. Let the probability generating function of $\{p_i(k)\}$ be denoted φ_i. We let $\underline{\varphi}(z) = (\varphi_1, ..., \varphi_m)$.

2. at state-transitions between states i and j, $i \ne j$ also called, (i,j)-*Markov transitions*, they may be associated with one batch arrival of length k with densities $\{r_{ij}(k),\ k \ge 0\}$. The probability generating function of $\{r_{ij}(k)\}$ is denoted $\phi_{ij}(z)$, for $1 \le i,j \le m$. The matrix with elements $\{\phi_{ij}(z)\}$ is denoted $\phi(z)$.

3. at renewal transitions corresponding to the instants of absorption in state $(m+1)$, they are called the (i,j)-*renewal transitions* to characterize resulting transitions from state i to j through absorption. They may be associated with one batch of length k with densities $\{q_{ij}(k),\ k \ge 0\}$. The probability generating function of $\{q_{ij}(k)\}$ is denoted $\psi_{ij}(z)$, for $1 \le i,j \le m$. The matrix with elements $\{\psi_{ij}(z)\}$ is denoted $\psi(z)$.

It is further assumed that the different kinds of batch arrival are conditionally independent and that the Poisson processes acting in each Markov state are homogeneous and mutually independent. The *states* of the underlying Markov process Q^* is called the *phases* of the N process. The N process is thereafter defined assuming three types of arrival times, the three *modes of cell generation* are as follows

1. the Markov chain Q^* defines m *states* where the cells are randomly generated according to a Poisson process of rate λ_i in state i $(1 \leq i \leq m)$.

2. the (i,j)-*Markov transitions* define the arrival of a burst of cells with a probability density function of burst lengths $p_{i,j}$ specific for each transition from state i to state j. The matrix probability generating function of the $p_{i,j}$'s is denoted $\phi(z) = \phi_{(i,j)}(z)$.

3. the (i,j)-*renewal transitions* of absorption from state i to state j define a burst of cell arrivals with another probability density function of burst length $q_{i,j}$ specific to each transition from state i to state j. The matrix probability generating function of the $q_{i,j}$'s is denoted $\psi(z) = \psi_{(i,j)}(z)$.

Let $N(t)$ and $J(t)$ for $t \geq 0$ denote respectively the number of cell arrivals in intervals $(0, t]$ and the state of the Markov process Q^* at time t. The process $\{N(t), J(t), t \geq 0\}$ is a Markov process with a two-dimensional state space $\{k \geq 0\} \times \{1, ..., m\}$.

Defining the $m \times m$ matrices of conditional probabilities as $P_{ij}(\nu, t) = P\{N(t) = \nu, J(t) = j | N(0) = 0, J(0) = i\}$ with $1 \leq i, j \leq m$, a recursive system of differential equations for the matrices $P(\nu, t) = \{P_{ij}(\nu, t)\}$ for $\nu \geq 0$.

$$P'(\nu, t) = P_{ij}(\nu, t)\,(T_{jj} - \lambda_j) + \sum_{k=0}^{\nu} P_{ij}(k, t)\,\lambda_j\,p_j(\nu - k)$$
$$+ \sum_{\substack{h=1 \\ h \neq j}}^{m} \sum_{k=0}^{\nu} P_{ih}(k, t)\,T_{hj}q_{hj}(\nu - k) + \sum_{h=1}^{m} \sum_{k=0}^{\nu} P_{ih}(k, t)\,T_j^0\,\alpha_j\,r_{hj}(\nu - k)$$

for $1 \leq i, j \leq m$ and $\nu \geq 0$. Going to matrix notations,

$$P'(\nu, t) = -P(\nu, t)\,\Delta(\underline{\lambda}) + \sum_{k=0}^{\nu} P(k, t)\,\Delta(\underline{\lambda})\,\Delta[\mathbf{p}(\nu - k)]$$
$$+ \sum_{k=0}^{\nu} P(k, t)\,[T \circ q(\nu - k)] + \sum_{k=0}^{\nu} P(k, t)\,[\mathbf{T}^0 A^0 \circ r(\nu - k)] \quad (5.90)$$

The symbol \circ denotes the Schur (entry-wise) product of two matrices as $[A \circ B]_{ij} = a_{ij}b_{ij}$. The matrices $q(k)$ and $r(k)$ have entries $q_{ij}(k)$ and $r_{ij}(k)$. For any vector \mathbf{a}, the notation $\Delta(\mathbf{a})$ holds for the diagonal matrix $diag(a_1, ..., a_m)$. For instance, $\Delta(\underline{\lambda}) = diag(\lambda_1, ..., \lambda_m)$. The matrix generating function

$$\tilde{P}(z, t) = \sum_{n=0}^{\infty} P(n, t)z^n \qquad |z| \leq 1, \qquad (5.91)$$

satisfies the differential equation

$$\frac{\partial}{\partial t} \tilde{P}(z,t) = -\tilde{P}(z,t) R(z) \tag{5.92}$$

with the initial condition $\tilde{P}(z,0) = I$. This leads readily to

$$\tilde{P}(z,t) = e^{R(z)t} \tag{5.93}$$

with

$$R(z) = \Delta(\underline{\lambda})\Delta[\underline{\varphi}(z)] - \Delta(\underline{\lambda}) + T \circ \psi(z) + \mathbf{T}^0 A^0 \circ \phi(z) \tag{5.94}$$

The expression of Equation 5.93 brings a direct generalization of the generating function of the ordinary Poisson process $\tilde{P}(z,t) = e^{-\lambda t(1-z)}$ to versatile point processes.

The N process can be exploited with either continuous-time or discrete-time arrival processes. As a powerful tool, the N process embodies all the arrival processes defined so far in this textbook and provides the field with such a generalization that it encompasses all the possible traffic configurations entering an ATM multiplexer. To complete the study, let us compute the moments of the N process.

1. *the mean matrix* is calculated by differentiating Equation 5.93 to the matrix

$$M(t) = [\frac{\partial \tilde{P}(z,t)}{\partial z}]_{z=1} \tag{5.95}$$

$$= \sum_{n=1}^{\infty} \frac{t^n}{n!} \sum_{\nu=0}^{n-1} Q^{*\ \nu}\ R'(1)\ Q^{*\ n-1-\nu} \tag{5.96}$$

where

$$R'(1) = \Delta(\underline{\lambda} \circ \underline{\gamma}] + T \circ C + \mathbf{T}^0 A^0 \circ D \tag{5.97}$$

with $\underline{\gamma} = \underline{\varphi}'(1-), C = \psi'(1-)$, and $D = \phi'(1-)$ and $\Delta(\underline{\lambda} \circ \underline{\gamma}) = \text{diag}\ (\lambda_1 \gamma_1, ..., \lambda_m \gamma_m)$. To decompose analytically the respective contribution of each type of arrival, let N_1 represent the arrivals of type 1

$$E(N_1) = \sum_j \int_0^{\infty} [\underline{\alpha} e^{Tx}]_j\ \lambda_j\ \gamma_j dx = -\underline{\alpha} T^{-1} \Delta(\underline{\lambda} \circ \underline{\gamma})\underline{u} \tag{5.98}$$

let N_2 represent the arrivals of type 2

$$E(N_2) = \sum_j \sum_k \int_0^{\infty} [\underline{\alpha} e^{Tx}]_j\ T_j^0\ \alpha_j\ D_{jk} dx = -\underline{\alpha} T^{-1}(\mathbf{T}^0 A^0 \circ D)\underline{u} \tag{5.99}$$

let N_3 represent the arrivals of type 3

$$E(N_2) = \sum_j \sum_k \int_0^\infty [\underline{\alpha} e^{Tx}]_j\, T_{jk}\, C_{jk} dx = -\underline{\alpha} T^{-1}(T \circ C)\underline{u} \tag{5.100}$$

Summing the three arrival components leads to defining a generalized arrival rate μ^* for the N process as

$$\frac{E[N_1 + N_2 + N_3]}{\mu_1} = \underline{\theta} R'(1)u = \mu^* \tag{5.101}$$

obtained from Equations 5.98, 5.99, 5.100.

2. *the second-moment matrix is calculated from 5.93 as*

$$
\begin{aligned}
M_2(t) &= [\frac{\partial^2 \tilde{P}(z,t)}{\partial z^2}]_{z=1} \tag{5.102}\\[2mm]
&= \sum_{n=1}^\infty \frac{t^n}{n!} \sum_{\nu=0}^{n-1} Q^{*\,\nu}\, R''(1)\, Q^{*\,n-1-\nu}\\[2mm]
&\quad +2\sum_{n=2}^\infty \frac{t^n}{n!} \sum_{\nu=0}^{n-2} \sum_{r=0}^{\nu} Q^{*\,r}\, R'(1)\, Q^{*\,\nu-r}\, R'\, Q^{*n-2-\nu} \tag{5.103}
\end{aligned}
$$

3. *the covariance of $N(t)$ and $N(t + t_1 + T') - N(t + t_1)$*

$$
\begin{aligned}
cov(t) &= [\frac{\partial^2 e^{R(z_1)t}\, e^{Q^* t_1}\, e^{R(z_2)t'}}{\partial z_1\, \partial z_2}]_{z_1=z_2=1} \tag{5.104}\\[2mm]
&= \underline{\pi}\, M(t)\, e^{Q^* t_1}\, u - \mu^* tt' \tag{5.105}
\end{aligned}
$$

Then, $\lambda^* = \underline{\theta} \frac{R(z)}{\partial z}|_{z=1}\underline{u}$ where θ is the steady-state probability of the Markov process Q^* given by $\underline{\theta} = \underline{u\alpha} T^{-1}\underline{u}(\underline{\alpha} T^{-1})$.

This model stands as one of the most general traffic model to characterize the traffic generated by pooling sources to be queued into an ATM multiplexer. For that model, tractable numerical algorithms can still be developed to estimate the ATM multiplexing performances. This powerful modeling tool can be used to describe the superposed traffic of TV sources. The easiness according to which mean, variance and covariance formulae can be calculated in this general point process, has turned out to be a promising and thrustful way of investigations, especially through numerical and computer methods. The MMPP(m) process is a particular case of this process where no batch arrivals are considered. As a matter of fact, the MMPP(2) which has been considered earlier for the description of cell inter-arrival times is also a particular case of that general approach where only two states are appended to describe the Markov chain m=2.

5.3 Queueing Models for ATM Multiplexers

The problem addressed in this part of the chapter consists of modeling the multiplexer of an ATM switch. The topic is of major importance and justifies to spend a large development and to restate the foundations of the queueing systems. The process which multiplexes all the TV sources at one output port of the ATM switching node is a queue of finite capacity with a departure service performed by a transmission on internodal connection links. As this transmission is made at fixed bit rate, the cell service times are constant or deterministic. The cell arrival into the multiplexing queue is made of the superposition of the individual TV sources in the way studied in the previous sections. Figure 5.1 outlines the multiplexing operation. The expected queueing load is defined by the ratio $E(\rho) = \frac{E(\lambda)}{c}$ of the expected arrival rate and the service rate c. A stable system therefore requires that $0 \leq E(\rho) < 1$.

The effort towards modeling the multiplexing queues in conjunction with modeling the cell arrivals of superposed sources will enable us to deduce in the following the expected multiplexing performances. Several state-of-the-art queueing models will be derived, some will be first presented in this textbook as learning references but others will be of direct interest as tractable model to deal with the TV transmission on ATM. These latter models will provide the study of the TV transmission on ATM with different ways of conjugating cell arrival processes with queueing systems. Despite some respective constructive assumptions and limitations of validity, these modeling approaches allow covering a wide diversity of practical cases. The analysis of queueing systems can be carried out either by theoretical calculations as presented in this work or by computer simulations. Once developed, theoretical models enable quite efficient studies and yield very small queueing probabilities measuring extremely rare events, for instance, mean cell loss probability of 10^{-8} to 10^{-12}). On the contrary, computer simulations are rather confined to high defect arrivals by inherent limits of run-times and accuracy. They become more and more impracticable when the events to be estimated have probabilities ranging in the order of 10^{-6} to 10^{-12}. The number of arrivals to be considered to approach a level of probability of 10^{-n} is at least of the order of 10^{n+2} and the amount of computations becomes quite fast prohibitive. However, computer simulations allow working with much more elaborated queueing systems than theoretical models do.

Before deriving realistic models able to accurately describe the ATM multiplexing of TV sources, it is fairly necessary to make a short excursion in the world of the elementary and intermediate queueing systems. That introduction will lay down the foundation to understand the behavior of queues fed by stochastic arrival processes. The knowledge acquired during that initial learning phase will be exploited not only in this chapter dedicated to multiplexing but also in Chapter 7 for the study of queueing networks and of congestion control with leaky buckets.

5.3.1 Introduction to Queueing Models

This introduction to queueing theory aims at familiarizing the reader with basic concepts before plunging headlong into the advanced materials developed during the past decade especially in connection with the N process. As known already from Chapter 1, the ATM

multiplexers are queues and, more particularly, G/D/1-s queueing models to recall that the system into consideration admits general inter-arrival time PDF's i.e. point processes, a service time which is deterministic i.e. constant according to the transmission rate on the node output connection and output ports which are either associated to an individual dedicated queue or pooled on one shared buffer i.e. one single queue emptied by s servers. Though rather simple to be pictured, the G/D/1 queue modeling requires advanced concepts of stochastic theory. Therefore, simple but significant results will be first proposed to introduce the actual world of queueing systems. Some important concepts and models are examined. These are successively Little's and Pollaczek-Khintchine's formulae, Poisson arrivals and time averages, successively, the continuous-time M/M/1, M/G/1, M/D/1 queueing systems and, eventually, the discrete-time Geo/D/1 model. In this study, the main focus is quasi-only devoted to the queue length distribution which leads to the calculation of the cell probability and the random transfer delay. These topics stand as key features towards the estimation of multiplexing performances.

5.3.1.1 Little's Formula

Little's formula is the most basic relationship of queueing systems. It relates, in terms of average, the number of cells waiting in queue, the incoming cell arrival rate and the time spent in the system before service or departure from queue. No special assumptions need to be made here about the arrival or departure processes, the theorem stands in whole generality. Nevertheless, for the shake of simplicity, a FIFO queueing discipline is first considered. This constraint is thereafter easily released to show the general extend of Little's formula.

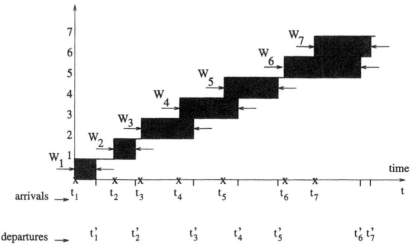

Figure 5.16: **Arrival process and departure process in queues.**

To figure out the underlying queueing behavior, it is usual in this case to draw on a diagram the cumulative cell arrival process $A(t)$ as observed at the queue input and the cumulative cell departure process $D(t)$ as counted at the system output to display $N(t)$ the number of cells present in the system, clearly, $N(t) = A(t) - D(t)$. The cumulative

cross-hatched area (Figure 5.16) in between arrival and departure curves in the time interval $[0, \tau]$ is equal to

$$\gamma(\tau) = \int_0^\tau N(t)dt \tag{5.106}$$

Measured in units of customer-seconds, this formula represents the total time that all visiting cells have spent in queue. The cross-hatched area is composed of a series of rectangles with unity height and random widths W_i. Over the time interval $[0, \tau]$, let us add λ_τ to denote the average cell arrival rate, T_τ the average system sojourn time per cell evaluated over all the visiting cells and N_τ the average number of cells in queue. Successively, these three global system averages lead straightforward to three relationships as follows

$$\lambda_\tau = \frac{A(\tau)}{\tau} \tag{5.107}$$

for the average cell arrival rate (in cell per second),

$$T_\tau = \frac{\gamma(\tau)}{A(\tau)} \tag{5.108}$$

for the average system time per customer derived as the ratio of the accumulated cell-seconds up to time τ to the number of arrivals within the same interval and,

$$N_\tau = \frac{\gamma(\tau)}{\tau} \tag{5.109}$$

for the average number of cells in queue obtained by dividing the accumulated number of cells by the interval length. These three equations enable us to derive the average number of cells in queue expressed over intervals $[0, \tau]$ in terms of the two other averages, that is

$$N_\tau = \lambda_\tau T_\tau \tag{5.110}$$

Considering the limit as $\tau \to \infty$ and assuming that these limits effectively exist

$$\bar{N} = \lim_{\tau \to \infty} N_\tau, \qquad \bar{T} = \lim_{\tau \to \infty} T_\tau, \qquad \bar{\lambda} = \lim_{\tau \to \infty} \lambda_\tau \tag{5.111}$$

Little's formula simply expresses that

$$\bar{N} = \bar{\lambda}\bar{T} \tag{5.112}$$

This result is of fundamental importance in queueing systems since it enables one to calculate the average time spent in the system once the average number of cells in the system is known and conversely. As a further major point, the formula holds nonetheless in whole generality for any kind of queueing discipline. In fact, it is easily to see that

$$\sum_{i=1}^{n(\tau)} W_i = \sum_{i=1}^{n(\tau)} (t_i' - t_i) \tag{5.113}$$

with t_i and t_i' the respective arrival and departure times of cell i. Furthermore, the equation can be rewritten as

$$\sum_{i=1}^{n(\tau)} W_i = \sum_{i=1}^{n(\tau)} t_i' - \sum_{i=1}^{n(\tau)} t_i \tag{5.114}$$

to show that $\sum_i W_i$ depends only on the sum of the departure times but not on the differences as initially used in the FIFO discipline.

The *average queue load* is a basic parameter extensively used in queueing systems, it is also called the *utilization factor* and defined as the product of the average arrival rate of cells with the average service time \bar{x} i.e. $\rho = \bar{\lambda}\bar{x}$. Another parameter to be mentioned is the rate at which cells enter the queueing system which is termed the *traffic intensity*, and, usually expressed in *Erlangs*. As long as $0 \leq \rho < 1$, the system is stable meaning that the steady-state queue occupancy does not tend to be infinite. To interpret the physical sense of the queueing load ρ, let us consider an arbitrarily long time interval τ, the number of cell arrivals within that interval τ will tend progressively to $\bar{\lambda}\tau$ (with probability one according to the law of large numbers). If p_0 stands for the probability that the server be idle, the server is busy for $\tau - \tau p_0$ seconds and the number of cells served during the interval τ is close to $\frac{\tau - \tau p_0}{\bar{x}}$ with probability one. In equilibrium, the number of arrivals may be equated to the number of cells served during the same interval

$$\bar{\lambda}_\tau \simeq \frac{\tau - \tau p_0}{\bar{x}} \tag{5.115}$$

that is $\bar{\lambda}\bar{x} = \rho = 1 - p_0$. This means that ρ merely represents the fraction of time the server is busy and, therefore, the average number of cells in the service facility.

5.3.1.2 The M/M/1 Queueing System

In the M/M/1 model, the cell inter-arrival times and the service times are both stochastic processes with negative exponential with mean value equal to $\frac{1}{\lambda}$ and $\frac{1}{\mu}$ respectively. For the shake of easiness, an infinite queueing space is provided and a FIFO discipline is considered as in vigor in the ATM multiplexers. The M/M/1 queueing system is the simplest and straightforward non-trivial case that turns out to be modeled by a Markov process where each state consists of an individual level of queue occupancy. The states are denoted E_k with $k = 1 \rightarrow \infty$ to consider an infinite queue length where the admitted state transitions span only between neighbor states. Quite clearly, this defines a birth-death process, as already mentioned in Chapter 1. The respective birth and death rates are denoted by λ_k and μ_k and depicted in Diagram 5.17. Concentrating upon one state E_k, intuitive means allow one to derive immediately at time t a steady-state equation which expresses that the flow rate entering the state Φ_{in} equals the flow rate leaving the state Φ_{out}. These rates are respectively

$$\Phi_{in}(t) = \lambda_{k-1} P_{k-1}(t) + \mu_{k+1} P_{k+1}(t) \tag{5.116}$$

and

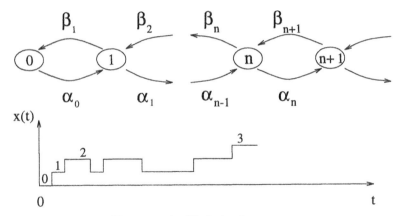

Figure 5.17: Birth-death process.

$$\Phi_{out}(t) = (\lambda_k + \mu_k)P_k(t) \tag{5.117}$$

where $P_k(t) = Pr[X(t) = k]$ denotes the probability that the continuous-time Markov process $X(t)$ be in state k at time t. Hence, the equilibrium state-space equation is deduced from the difference between the two previous equations as

$$\frac{dP_k(t)}{dt} = \lambda_{k-1}P_{k-1}(t) + \mu_{k+1}P_{k+1}(t) - (\lambda_k + \mu_k)P_k(t) \tag{5.118}$$

In this study of queueing systems, only steady-state solutions are investigated and, consequently, the limiting probabilities are considered. Accordingly, these limits are assumed to exist as $p_k = \lim_{t\to\infty} P_k(t)$. Hence, as $\lim_{t\to\infty} \frac{dP_k(t)}{dt} = 0$ and the birth-death system of forward equations is reduced to

$$\lambda_{k-1}p_{k-1} + \mu_{k+1}p_{k+1} - (\lambda_k + \mu_k)p_k(t) = 0 \quad k \geq 1 \tag{5.119}$$
$$-\lambda_0 p_0 + \mu_1 p_1 = 0 \quad k = 0 \tag{5.120}$$

under the condition that the probability density function be conserved

$$\sum_{k=0}^{\infty} p_k = 1 \tag{5.121}$$

By simple inspection, Equation 5.119 may understood as an equilibrium difference equation relative to state E_k expressing the equality of the input flow rate with the output flow rate. Similar equations can be written for any state k with $k \geq 1$. The Equation 5.120 may be further viewed as a boundary condition from which p_1 is solved in terms of p_0 as

$$p_1 = \frac{\lambda_0}{\mu_1} p_0 \tag{5.122}$$

5.3. Queueing Models for ATM Multiplexers 391

By induction, using Equations 5.119, the set $\{p_k : k = 2, ...\infty\}$ can be iteratively obtained leading to the steady-state birth-death process where the solutions are expressed in terms of p_0

$$p_k = p_0 \prod_{i=0}^{k-1} \frac{\lambda_i}{\mu_{i+1}} \qquad k = 0, 1, 2, ... \qquad (5.123)$$

To determine p_0, the additional condition on normalizing to derive a probability density function allows one to obtain

$$p_0 = \frac{1}{1 + \sum_{\infty}^{k=1} \prod_{i=0}^{k-1} \frac{\lambda_i}{\mu_{i+1}}} \qquad (5.124)$$

The solution obtained for p_k in this elementary queueing system is referred to as the *product-form* solution. Although elementary, this result is remarkable and constitutes a point of reference to study more advanced queueing systems including networks of queues. The property of queueing networks which qualify them as *insensitive* means that, under given assumptions to be stated, the global system parameters have expected values which are independent of the effective local G/G/1 queue behavior and, consequently, they may be deduced from any kind of model, therefore, from simple M/M/1 representation.

In the M/M/1 queueing system, the birth and death coefficients are selected as follows

$$\lambda_k = \lambda \quad k = 0, 1, 2, ... \qquad (5.125)$$
$$\mu_k = \mu \quad k = 1, 2, 3, ... \qquad (5.126)$$

meaning that all birth and death coefficients are respectively set equal to each other. This leads immediately to the following steady-state equations

$$p_k = p_0 \left(\frac{\lambda}{\mu}\right)^k \qquad k = 0, 1, 2, ... \qquad (5.127)$$

The problem of the existence of the steady-state probabilities p_k for that queueing system must be addressed first to derive the conditions on the birth-death process coefficients which guarantee stability. To achieve that goal, two additional parameters S_1 and S_2 can be defined as

$$S_1 = \sum_{k=0}^{\infty} \frac{p_k}{p_0} = \sum_{k=0}^{\infty} \left(\frac{\lambda}{\mu}\right)^k \qquad (5.128)$$

to express the limit of convergence of the p_k's, and

$$S_2 = \sum_{k=0}^{\infty} \frac{1}{\lambda \left(\frac{p_k}{p_0}\right)} = \sum_{k=0}^{\infty} \frac{1}{\lambda}\left(\frac{\mu}{\lambda}\right)^k \qquad (5.129)$$

All the states of this birth-death process will be clearly

1. *ergodic* if and only if $S_1 < \infty$ ans $S_2 = \infty$.

2. *null-recurrent* if and only if $S_1 = \infty$ ans $S_2 = \infty$.

3. *transient* if and only if $S_1 = \infty$ ans $S_2 < \infty$.

The ergodic case gives rise to the equilibrium probabilities p_k. The conditions to ergodicity will be satisfied if $\frac{\lambda}{\mu} \leq 1$ i.e. if the queueing load $\rho = \frac{\lambda}{\mu}$ is inferior to one. In this case, the probabilities to have an empty queue converge to

$$p_0 = \frac{1}{1 + \sum_{\infty}^{k=1} (\frac{\lambda}{\mu})^k} \tag{5.130}$$

that is

$$p_0 = \frac{1}{1 + \frac{\frac{\lambda}{\mu}}{1 - \frac{\lambda}{\mu}}} = 1 - \frac{\lambda}{\mu} \tag{5.131}$$

and, the probability to have k cells in the queue, to

$$p_k = (1 - \rho)\rho^k \tag{5.132}$$

This fundamental result shows that the queue length distribution is geometric and shares the fundamental memoryless property. All the subsequent stochastic variables which will be further developed about the M/M/1 continue verifying that important characteristic.

The average number of cells into the queue is given by

$$E\{W\} = \sum_{k=0}^{\infty} kp_k \tag{5.133}$$

$$= (1 - \rho) \sum_{k=0}^{\infty} k\rho^k \tag{5.134}$$

$$= (1 - \rho)\rho \frac{\partial}{\partial \rho} \sum_{k=0}^{\infty} \rho^k \tag{5.135}$$

$$= (1 - \rho)\rho \frac{\partial}{\partial \rho} \frac{1}{1 - \rho} \tag{5.136}$$

$$= \frac{\rho}{1 - \rho} \tag{5.137}$$

Similarly, the variance of number of cells in queue is given by

$$\sigma_W^2 = \sum_{k=0}^{\infty} [k - E\{W\}]^2 p_k \tag{5.138}$$

$$= \frac{\rho}{1 - \rho^2} \tag{5.139}$$

5.3. Queueing Models for ATM Multiplexers

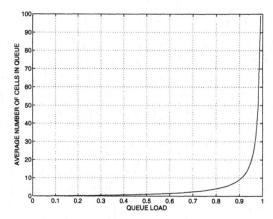

Figure 5.18: Mean waiting times in M/M/1 queueing systems in terms of load.

This behavior, common to almost every queueing system, demonstrates clearly the non-linear and unbounded dependence of the first two moments and the dramatic increase of the queue length with the system loading. Figure 5.18 sketches the average queue length as the load ρ approaches the limit of stability. The mean time spend in queue is given by Little's formula which implies

$$E\{T\} = \frac{\frac{1}{\mu}}{1-\rho} \qquad (5.140)$$

Finally, the probability of exceeding a finite limit B is given by the density of finding more than B cells in an infinite length queue i.e.

$$Pr[W \geq B+1] = \sum_{i=B+1}^{\infty} p_i \qquad (5.141)$$

$$= \rho^{B+1} \qquad (5.142)$$

The probability of exceeding a finite threshold is a geometrically decreasing function. This quantity is nevertheless slightly different from the cell loss probability which is smaller in fact than $Pr[W \geq B+1]$. Indeed, let us consider a queue of size B. When cells arrive and see a queue loaded up to B, they are discarded instead of increasing the queue occupancy up to B+m. If, after a service period, another cell arrives, it is accepted since the queue occupancy is at that moment equal to B-1 instead of B+m-1. Limiting an infinite queue down to B modifies and skews the resulting queue length PDF at least around B. Concentrating all the probability mass of exceeding a finite threshold B on the length B without reshaping all the residual PDF and equating $Pr[W \geq B+1]$ to the cell loss probability is an approximation of the actual queue behavior. As already observed in the M/M/1 queue, we remark finally that $\rho = 1$ imposes the limit of unstability.

5.3.1.3 Poisson Arrivals See Time Averages

It is worth mentioning here a general property of Poisson processes which finds application in any arbitrary stochastic model and, more particularly in our context, in the field arrival and departure time from queueing systems. It is well known that, in the case of the M/G/1 queue, the fraction of arrivals who find n customers in queue is equal to the fraction of time there are n cells in the system. To perceive the whole general sense of *Poisson arrivals see time averages*, two distinct quantities have to be first defined, they will turn out finally to be equal. These quantities are referred to as

1. the *sojourn time*. Since any continuous-time stochastic process applies to the theorem, the process may be in some state, not necessarily in the Markov sense, a certain fraction of time called the sojourn time.

2. the *fraction of Poisson arrivals* which interact with the first stochastic process while it is visiting the above-mentioned state.

Then it is true, in whole generality even in non-stationary cases, that the fraction of arrivals that finds the process in a state is equal to the corresponding fraction of time spend by the process in that state. The proof which depends on a martingale characterization of Poisson process originates from Wanatabe in 1964. The M/G/1 queue with non-stationary Poisson arrivals has been treated by Bremaud and Jacod in 1977 [3], concomitantly to Harrison and Lemoine [13].

Let us first define adjunct processes in order to compare the fraction of time a stochastic process $N : \{N(t), t \geq 0\}$ spends in some state to the Poisson process of rate λ $A : \{A(t), t \geq 0\}$ which sees the system in that state. The processes $A(t)$ and $N(t)$ are typically dependent since it is expected that the arrival process affect the system in any way. Hence, $A(t)$ and $U(t)$ are dependent, however, it is assumed that both stochastic processes fulfill the property of *a lack of anticipation* to signify that, for each $t \geq 0$, both stochastic variables $\{A(t + u) - A(t), u \geq 0\}$ and $\{U(s), 0 \leq s \leq t\}$ are effectively independent. For an arbitrary state B in the state-spaces of $N(t)$, let $U(t)$ be defined as

$$
U(t) \quad
\begin{aligned}
&= \quad 1 \quad \text{if} \quad N(t) \in B \\
&= \quad 0 \quad \text{otherwise}
\end{aligned}
\tag{5.143}
$$

The fraction of time $V(t)$ within the interval $[0, t]$ where $N(t)$ is in state B is expressed as

$$
V(t) \quad = \quad t^{-1} \int_0^t U(s) ds
\tag{5.144}
$$

The number of arrivals $Y(t)$ in the interval $[0, t]$ that finds $N(t)$ in B is formulated as

$$
Y(t) \quad = \quad \int_0^t U(s) dA(s)
\tag{5.145}
$$

And, eventually, the fraction $Z(t)$ of arrivals, that finds $N(t)$ in B, is given in the interval $[0, t]$ by

$$Z(t) = \frac{Y(t)}{A(t)} \qquad (5.146)$$

Those derivations lead to restate the assertion *Poisson arrivals see time averages* into a theorem expressed as

Under the assumption of a lack of anticipation, $V(t) = \frac{Y(t)}{A(t)}$ converges in probability to $V(\infty)$ if and only if $Z(t)$ converges to $V(\infty)$ when $t \to \infty$. This theorem is therefore true whenever convergence occurs.

The variable $U(t)$ is supposed to be a jointly measurable function of $(\omega, t) \in \Omega \times [0, \infty)$ and to have a finite number n of discontinuities on any finite interval. Hence for each ω in a set that has probability one, $Y(t)$ can be approximated arbitrary closely in terms of a summation on a sufficiently large n

$$Y_n = \sum_{k=0}^{n-1} U(\frac{kt}{n}) \left[A\left(\frac{(k+1)\,t}{n}\right) - A\left(\frac{(k)\,t}{n}\right) \right] \qquad (5.147)$$

From the hypothesis of a lack of anticipation, the expected value of Equation 5.147 is

$$E\{Y_n\} = \lambda t\, E\{\sum_{k=0}^{n-1} \frac{U(\frac{kt}{n})}{n}\} \qquad (5.148)$$

Calculating the expectation on $Y(t)$,

$$\begin{aligned} E\{Y(t)\} &= \lim_{n \to \infty} E\{Y_n(t)\} & (5.149) \\ &= \lambda t\, E\{V(t)\} & (5.150) \\ &= \lambda\, E\{\int_0^t U(s)ds\} & (5.151) \end{aligned}$$

This means that the expected value of number of arrivals observing the stochastic process in state B is equal to the product of the arrival rate with the expected length that the stochastic process has been in state B during the interval of measurements $(0, t]$. This does not yield the expected result yet since the random processes need to be equated to each other as a limiting result whenever $t \to \infty$. The trick so far to yield the theorem consists of defining an intermediate process $R(t)$ defined as

$$R(t) = Y(t) - \lambda t V(t) \qquad t \geq 0 \qquad (5.152)$$

and to prove first that $R(t)$ is a martingale and secondly that $\frac{R(t)}{t} \to 0$ when $t \to \infty$. Invoking the later property of $R(t)$ and recalling the convergence in probability of $\frac{A(t)}{t}$ to λ, it follows that

$$\frac{R(t)}{t} = \left(\frac{Y(t)}{A(t)}\right)\left(\frac{A(t)}{t}\right) - \lambda\, V(t) \qquad (5.153)$$

Therefore, when $t \to \infty$,

$$Z(t) = \frac{Y(t)}{t} \to V(\infty) \tag{5.154}$$

This completes the proof. To be further convinced, let us verify both propositions left without demonstration.

1. $R(t)$ is a continuous-time martingale.
 This meaning that the increments of $R(t)$ have the property

 $$E\{R(t+h) - R(t)|R(s), 0 \le s \le t\} = 0 \tag{5.155}$$

 by definition of the martingale. From the argument of a lack of anticipation and from the independent-increment property of the Poisson process, we have

 $$E\{Y(t+h) - Y(t)|\mathcal{F}_t\} = \lambda E\{\int_0^{t+h} U(s)ds|\mathcal{F}_t\} \tag{5.156}$$

 on the σ-field \mathcal{F}_t generated by $\{A(s), U(s); 0 \le s \le t\}$.

2. the ratio $\frac{R(t)}{t}$ tends to 0 when t tends to ∞
 Remarking that $Y(t) \le A(t)$ and that $V(t) \le 1$, it follows that

 $$E\{R^2(t)\} \le E\{A^2(t)\} + \lambda^2 t^2 = \lambda t + 2\lambda^2 t^2 \equiv k(t) \tag{5.157}$$

 The process $\{X_n : R(nh) - R[(n-1)h], n = 1, 2,\}$ is a discrete-time martingale for any $h > 0$ as derived from item 1.

 From similar bounding than in 5.157,

 $$E\{X_n^2\} \le k(h) \tag{5.158}$$

 $$\sum_{n=1}^{\infty} \frac{E\{X_n^2\}}{n^2} < \infty \tag{5.159}$$

 therefore, $\frac{R(nh)}{n} \to 0$ with probability one as demonstrated in [9],p. 243, Th. 3. The proposition follows thereafter from

 $$R(nh) - \lambda h \le R(t) \le R[(n+1)h] + \lambda h \quad t \in [nh, (n+1)h] \tag{5.160}$$

 dividing by t and forcing $t \to \infty$ where $n(t) \equiv \frac{t}{h} \to \infty$.

 The theorem according to *Poisson arrivals see time averages* holds also for Bernoulli and the non-stationary Poisson arrivals. For instance, two interesting queueing systems verify the proposition, namely the M/G/1 queue with non-stationary Poisson arrivals where $\lambda(t)$ is a periodic function [13] and the GI/M/1 queue. Other general correlated arrival processes, like the point processes, do not profit in whole generality from that property since they *can anticipate themselves*, that is to say that they fail to the assumption of a lack of anticipation. Nonetheless, the literature in the field mentions some particular instances where non-Poisson arrivals see time averages (for example, see Burke 1976 [4]).

5.3. Queueing Models for ATM Multiplexers 397

5.3.1.4 The M/G/1 and M/D/1 Queueing Systems

The study of the M/M/1 queue has turned out to be rather elementary since both arrival and service processes enjoy the memoryless property. Nevertheless, this offers the opportunity to exploit directly the Markov chains and the birth-death processes. Even more, the state-space description is not only one-dimensional but also countable and finite in some configurations. Unfortunately, in the case of M/G/1 queueing systems, the memoryless property does no longer withstand and the entire past history of the system cannot be summarized in the specification of the number of cells present in queue.

In the M/G/1 queue, the cell arrival remains a Poisson process and the service-time distribution $B(x)$ is arbitrarily defined with a PDF denoted $b(x)$. The state description is non-Markovian since it requires not only the number $N(t)$ of cells which are present in queue at time t but also the service time $W_0(t)$ which has already been devoted to the cell in service. The latter parameter intervenes as a consequence of the lack of the memoryless property involved by the arbitrary service-time PDF. The vector $[N(t), W_0(t)]$ summarizes all the past system history relevant to future evolution and generates a Markov process with a two-dimensional state description. The number of cells in queue $N(t)$ is still a countable variable but the time expended $W_0(t)$ for the cell in service is a continuous-time variable leading to a continuous-state description. Among the numerous techniques to handle that difficulty, one method, originally proposed by Palm, allows us to keep on exploiting the Markov chains. It consists of having recourse to the so-called embedded Markov chains. Consequently, the following sections will deal with the way of how to exploit these embedded chains in the context of an M/G/1 queue and, subsequently, to derive the queueing length distributions by means of the Pollaczek-Khintchine formula. Applying Little's result allows us in a second step to deduce the average time spent in the queueing system. The M/D/1 queueing model which directly applies on ATM multiplexers stands as a particular case of the M/G/1 where $b(x)$ is deterministic. The effects of the service randomness on the queueing performances will be clearly pointed out from the physical interpretations of the equations.

The Embedded Markov Chains and Transition Probabilities

The way to construct an embedded Markov chain consists of identifying a set of points along the time axis such that, specifying only the number of cells in queue at these particular instants, enables one to calculate again future inputs to the systems without having to take into account the expended service times. The embedded point locations and their inter-arrivals loose the memoryless property of the Markov process, the points may correspond to any kind of point process. However, the number of cells in queue at well-chosen embedded points still defines a Markov chain. This process is referred to as a semi-Markov process when the inter-arrival times are general, independent and identically distributed. In general, there are several sets of admissible points satisfying the property. Conveniently, the set of departure times from service meets the required property. Clearly, the specification of the number of cells left behind by a departure from service characterizes a discrete-state space such that a Markov chain makes possible to calculate the same quantity at the next departure instant (Figure 5.19). These departure instants support an embedded Markov chain equivalent to a semi-Markov process where the state transition

occurs precisely at the cells departure instants. It is intuitively appropriate to choose the points corresponding to the G arrival process as the embedded Markov transitions. Since the cell arrival in queue is Poisson and therefore easily amenable to formal calculations. With similar reasoning, the study of a G/M/1 queueing model would have taken the instants of cell arrivals in queue as the set of embedded points.

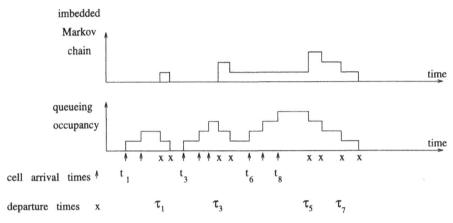

Figure 5.19: **Embedded Markov chain.**

Defining the one-step transition probabilities as $p_{i,j} = Pr[q_{n-1} = j | q_n = i]$ where q_n represents the number of cells left behind after the departure from service of the n^{th} cell, the structure of the transition probability matrix $P = p_{ij}$ is easily evidenced. As a matter of fact, all transitions such that $q_{n+1} < q_n - 1$ are not permitted. A state-transition diagram of the embedded Markov chain is rather straightforward sketched as that of Figure 5.19. If α_k denotes the probability that the k cells arrive during the service period, the transition matrix is given by

$$
P = \begin{vmatrix}
\alpha_0 & \alpha_1 & \alpha_2 & \alpha_3 & \cdots \\
\alpha_0 & \alpha_1 & \alpha_2 & \alpha_3 & \cdots \\
0 & \alpha_0 & \alpha_1 & \alpha_2 & \cdots \\
0 & 0 & \alpha_0 & \alpha_1 & \cdots \\
0 & 0 & 0 & \alpha_0 & \cdots \\
\vdots & \vdots & \vdots & \vdots & \ddots
\end{vmatrix}
\tag{5.161}
$$

Referring to a Poisson arrival process and to the PDF $b(x)$ of the service-time process, the calculation of the α_k can be performed analytically. Since the arrival process has a rate λ independent of both the queueing states and the service-times. Therefore, the number of arrivals v_n observed during the n^{th} service-time depends only upon the length of the service-time x_n of cell n. The subscripts on v_n and x_n may be discarded and replaced by random variables with notations V and X. The α_k are deduced as follows

$$
\alpha_k = Pr[V = k]
\tag{5.162}
$$

$$= \int_0^\infty Pr[V = k, \ x < X \leq x + dx]dx \tag{5.163}$$

$$= \int_0^\infty Pr[V = k \mid X = x] \ b(x)dx \tag{5.164}$$

$$= \int_0^\infty \frac{(\lambda x)^k}{k!} \ e^{\lambda x} b(x)dx \tag{5.165}$$

and characterize completely the transition matrix. From Markov chain theory, the stationary probabilities of an irreductible chain are obtained from the eigenvector of matrix P with the equilibrium equation $p = pP$ and $\sum_i p(i) = 1$. The limiting probability that a departure from service leave behind k cells is given by $Pr[Q = k] = p(k)$.

Queue Length Distribution

Pollaczek-Khintchine's equation (PK) has been found independently by both researchers in 1930 and 1932 respectively. It yields a z-transform equation for the number of cells in queue in the M/G/1 model. For the shake of the exposition, the calculation will be conveniently segmented in several steps consisting successively of

1. calculating the z-transform $V(z)$ of the random variable V standing for the number of cells arriving in queue during a service time X.

2. identifying a relationship between the Laplace $B(s)$ transform of the service time PDF with the z-transform of the random variable V.

3. expressing the one-step transition equation of the embedded Markov chain, describing the evolution of buffer occupancy at departure times, to derive the final version of the P-K equation by exploiting the z-transforms.

The importance of the Pollaczek-Khintchine formula is to yield a relationship giving access by calculations to the moments of the queue length distribution.

The Cell Arrival in Queue

The z-transform of the probability distribution of the number V of cells arriving in queue during one service time is given by

$$V(z) \quad = \quad \sum_{k=0}^\infty Pr[V = k] \ z^k \tag{5.166}$$

$$= \quad \sum_{k=0}^\infty [\int_0^\infty \frac{(\lambda x)^k}{k!} \ e^{-\lambda x} b(x)dx \] \ z^k \tag{5.167}$$

$$= \quad \int_0^\infty e^{-\lambda x} \ [\sum_{k=0}^\infty \frac{(\lambda z x)^k}{k!} \] \ b(x)dx \tag{5.168}$$

$$= \quad \int_0^\infty e^{-\lambda x} \ [\ e^{\lambda z x} \] \ b(x)dx \tag{5.169}$$

$$= \quad \int_0^\infty e^{-[\lambda - \lambda z] \ x} \ b(x)dx \tag{5.170}$$

$$\tag{5.171}$$

and deduced successively by referring to the Poisson arrival, and by interchanging the summation with the integration.

The Service Length PDF

Writing, at this stage, the Laplace transform $B(s)$ of the service time PDF, it stems straightforward from the definition that

$$B(s) = \int_0^\infty e^{-sx} b(x)dx \tag{5.172}$$

to identify immediately the important result

$$V(z) = B(\lambda - \lambda z) \tag{5.173}$$

which relates the Laplace transform of the service time PDF evaluated at the critical point $(\lambda - \lambda z)$ with the z-transform of the number of cells arriving in queue during a service time. Expressing the derivatives of this last equation leads us to pick up extremely useful moment relationships which are worth mentioning.

1. the moments are evaluated from the appropriate derivative at $s = 0$ and $z = 1$. As a matter of fact, these are

$$\frac{dV(z)}{dz}\Big|_{z=1} = V^{(1)}(1) = E[V]$$

$$\frac{d^2V(z)}{dz^2}\Big|_{z=1} = V^{(2)}(1) = E[V^2] - E[V]$$

$$\frac{d^k B(s)}{ds^k}\Big|_{s=0} = B^{(k)}(0) = (-1)^k E[X^k]$$

exploiting the conservation of probability

$$B(0) = V(1) = 1$$

2. the Equation 5.173 leads in first derivation to

$$\frac{dV(z)}{dz} = \frac{dB(\lambda - \lambda z)}{dz} \tag{5.174}$$

$$= -\lambda \frac{dB(y)}{dy} \tag{5.175}$$

with $y = \lambda - \lambda z$. Letting $z = 1$, it follows $y = 0$

$$\frac{dV(z)}{dz}\Big|_{z=1} = -\lambda \frac{dB(y)}{dy}\Big|_{y=0} \tag{5.176}$$

or $V^{(1)}(1) = -\lambda B^{(1)}(0)$, meaning $E[V] = \lambda E[X]$.

3. the Equation 5.173 leads in second derivation to

$$\frac{d^2 V(z)}{dz^2} = \frac{d^2 B(\lambda - \lambda z)}{dz^2} \tag{5.177}$$

$$= \lambda^2 \frac{d^2 B(y)}{dy^2} \tag{5.178}$$

Setting $z = 1$,

$$\frac{d^2 V(z)}{dz^2}\Big|_{z=1} = \lambda^2 \frac{d^2 B(y)}{dy^2}\Big|_{y=0} \tag{5.179}$$

or $V^2(1) = \lambda^2 B^{(2)}(0)$ and, therefore, $E[V^2] - E[V] = \lambda^2 E[X^2]$. A direct interpretation is that the variability of the queue occupancy is proportional to that of the service and is minimized for the M/D/1 queue model where $E[X^2] = 0$.

The Pollaczek-Khintchine Transform Equation

The queue length at the service departure moments evolves as an embedded Markov chain from which the state descriptive evolution can be expressed in terms of state probabilities and transitions into a one-step transition equation at the n^{th} departure time relating the probabilities

$$Pr[q_n = i] = Pr[q_{n-1} = 0] \, \alpha_i + \sum_{n=1}^{i+1} Pr[q_{n-1} = n] \, \alpha_{i+1-n} \tag{5.180}$$

where $\alpha_i = Pr[v_n = i]$. The stochastic processes are restricted to be stationary. Equation 5.180 can be used to calculate transient behaviors of the probabilities $Pr[q_n = i]$. However, in this particular case, the stationary solutions are examined i.e. $Pr[Q = i] = \lim_{j \to \infty} Pr[q_n = i]$. Stationary solutions exist only under the condition of stability i.e. whenever $\lambda = E[\alpha_j] < 1$ is satisfied. Allowing $n \to \infty$ in Equation 5.180, it is found

$$Pr[q = i] = Pr[q = 0] \, \alpha_i + \sum_{n=1}^{i+1} Pr[q = n] \, \alpha_{i+1-n} \tag{5.181}$$

The z-transform is a powerful mathematical tool to deal with infinite systems of recurrence equations. Indeed, defining

$$Q(z) = \sum_{i=0}^{\infty} Pr[q = n] \, z^i \tag{5.182}$$

and

$$V(z) = \sum_{i=0}^{\infty} \alpha_i \, z^i \qquad (5.183)$$

it follows after some algebraic calculations that

$$Q(z) = V(z) \, \frac{Pr[q=0] \, (z-1)}{z - V(z)} \qquad (5.184)$$

Down to this stage, the features which have been exploited are successively the one-step transitions of a Markov chain and the assumption of stationarity. Going to the M/G/1 queueing model, Equation 5.173 and $Pr[q=0] = 1 - \rho$ introduced in Equation 5.184

$$Q(z) = B(\lambda - \lambda z) \, \frac{(1-\rho) \, (z-1)}{z - B(\lambda - \lambda z)} \qquad (5.185)$$

which is the Pollaczek-Khintchine transform equation. It yields the moments for the distribution of the number of cells in queue.

Using the moment-generating properties developed so far, the average queue size \bar{q} at cell departure given by $Q^{(1)}(1)$ is easily calculated. As a matter of fact, using both properties and formulae of the derivatives in conjunction with L'Hospital's rule leads to the relationship

$$\bar{q} = \rho + \frac{\lambda^2 \, \bar{x}^2}{2 \, (1-\rho)} \qquad (5.186)$$

$$= \rho + \rho^2 \, \frac{1 + C_b^2}{2 \, (1-\rho)} \qquad (5.187)$$

where \bar{x} and $C_b^2 = \frac{\sigma^2}{(\bar{x})^2}$ are respectively the average and the squared coefficient of variation of the service time. It turns out that the average depends only on the two first moments of the service-time PDF and, remarkably, grows linearly with the squared coefficient of variation i.e. the variance of the service-time distribution. The M/M/1 and M/D/1 queues are both particular cases of the M/G/1 model and furnish respectively

1. for the M/M/1 queue, the coefficient of variation of the negative exponential distribution is equal to one. Hence,

$$\bar{q} = \frac{\rho}{1 - \rho} \qquad (5.188)$$

2. for the M/D/1 queue, the coefficient of variation of the service-time is clearly equal to zero. Hence,

$$\bar{q} = \frac{\rho}{1 - \rho} - \frac{\rho^2}{2 \, (1 - \rho)} \qquad (5.189)$$

5.3. Queueing Models for ATM Multiplexers

These important results on three different models, namely the G/D/1, the M/D/1 and the M/M/1 allow some conclusions to be stated as follows. It has been demonstrated that a queue with a deterministic service offers, in terms of mean queueing occupancy, the best performances among all the M/G/1 systems. In any case, the mean queueing increases with the coefficient of variation of the service-time by an amount of $\frac{\rho^2 C_b^2}{2(1-\rho)}$.

For the ATM multiplexers, the M/D/1 queue model is a particular case of the G/D/1 queue. As a matter of fact, it will turn out that the M/D/1 presents the best performances within the G/D/1 families. Restated in other words, among all the possible stochastic arrival processes, the Poisson process minimizes the mean queueing occupancy among all the possible stochastic arrival processes. Even more, a D/D/1 queue which is the complete deterministic model, performs better than any other queueing system since, here, $\bar{q} = 0$, the system is moreover stable up to $\rho = 1$ and does not involve any cell losses by queueing overflow up to the limit of stability, a configuration truly observed in the case of STM transmissions. Considering variable, stochastic and non-stationary traffics in an ATM multiplexer implies inevitably a degradation of the queueing or multiplexing performances. This constitutes the major drawback of the ATM multiplexing leading to cell losses by overflow of its finite queue capacity. This drawback is to be balanced by a gain obtained by concentrating the variability around the mean cell rate of the multi-plexed traffic, as mentioned in Chapter 1, as a consequence of the Bienaymé-Tchebitchev inequality. Supporting stochastic traffics, multiplexers are modeled, in whole generality, by G/D/1 models. The knowledge of the circumstances when ATM multiplexers are suitably modeled by a M/D/1 queue turns out to be extremely valuable since it induces a memoryless behavior and the best random performances. After having described the queue with discrete Bernoulli arrivals, more general and advanced queueing models will be apprehended to tackle the unavoidable G/D/1 models.

Applying Little's formula, the mean times spent in the queueing system are easily deduced for M/G/1, M/M/1 and M/D/1 models as

$$
\frac{W}{\bar{x}} = \begin{cases} \rho \frac{1+C_b^2}{2(1-\rho)} & \text{for M/G/1} \\ \frac{\rho}{(1-\rho)} & \text{for M/M/1} \\ \frac{\rho}{2(1-\rho)} & \text{for M/D/1} \end{cases}
\tag{5.190}
$$

where the time are referred to units of average service intervals. Once again, the system with constant service time M/D/1 has half the average waiting time of the system with exponentially distributed service times.

5.3.1.5 The Geo/D/1 Queueing System

Coming back to the discrete-time Bernoulli process where the inter-arrival times are mem-oryless and have consequently geometric PDF's, the waiting time in queue is first calcu-lated as presented in [21]. Arrivals occur at times $k\theta$ (k integer) with arrival probability q and no arrivals are observed with probability $1 - q$. The service times are constant at multiples of the elementary time, that is $p\theta$. Consequently, the offered load is $\rho = qp$.

A discrete version of the Lindley's formula is first deduced from the comparison of the waiting times in queue $W(n)$ and $W(n + 1)$ of two successive cells n^{th} and $(n + 1)^{th}$ spaced of an inter-arrival time $I(n + 1)$ as

$$\{W(n+1) \le i\theta\} = \{W(n) \le i\theta + I(n+1) - p\theta\} \tag{5.191}$$

and Lindley's formula applies as follows on independent geometric variables

$$Pr[W \le i\theta] = \sum_{j=\max[0,i+1-p]}^{\infty} Pr[W \le j\theta] \, q(1-q)^{(j+D-i-1)} \tag{5.192}$$

Lindley's formula belongs in fact to the family of the Wiener-Hopf equation usually utilized in the field of optimum predictors. This discrete equation solved by induction leads to deriving the complete distribution of the $W(n)$. The equation is first solved for the set $\{0, 1, \ldots, p-1\}$ and then exploited to derive the next set of size p. The case of the infinite queue length is first considered.

$$Pr[W \le i\theta] = \frac{1-\rho}{(1-q)^{i+1}} \sum_{k=0}^{j} [q(1-q)^{p-1}]^k \binom{kp-i-1}{k} \quad jp \le i \le (j+1)p-1 \tag{5.193}$$

The PDF of the customer number in queue N is deduced from that of W by invoking the relationship between the number of cell in queue N and the waiting time W $\{N \le j\} = \{W \le (jp-1)\theta\}$ if $j > 0$. Therefore, Equation 5.193 gives for $j = 0$ and $j = 1$,

$$Pr[N = 0] = 1 - \rho \tag{5.194}$$

$$Pr[N = 1] = (1-\rho) \left[(1-q)^{-p} - 1 \right] \tag{5.195}$$

and further for $j \ge 2$

$$Pr[N = j]$$
$$= (1-\rho) \left[(1-q)^{-jp} - \sum_{k=1}^{j-1} (-1)^k (1-q)^{-(j-k)p} \right.$$
$$\left. \left\{ \binom{(j-k)p+k-1}{k} (\tfrac{q}{1-q})^k + \binom{(j-k)p+k-2}{k-1} (\tfrac{q}{1-q})^{k-1} \right\} \right] \tag{5.196}$$

As mentioned in Chapter 1, Bernoulli PDF converges in distribution towards Poisson PDF. Consequently, the Geo/D/1 queueing model will tend towards a M/D/1 under similar conditions. Indeed, for fixed time-slot period θ, we yield the proposition when the service length $p\theta$ tends to infinity while the arrival probability q approachs to zero (law of rare events) conditioning the product $pq = \rho$ to remain constant. A similar figure to that pictured in Chapter 1, 1.35 for all the families of arrival processes Y, could be elaborated with the families of ./D/1 queueing models. The following sections will deal with carefully chosen state-of-the-art queueing models which have relevance to coping with video-sequence sources. Consequently to the fact that video sources introduce structures at different time scales, different time scales are examined in the sequel involving successively cell inter-arrival times and counting processes spanning over different image periods.

The finite queueing length is easily derived from the infinite system using the property *geometric arrivals see time averages* as performed in [25]. In essence, it may be demonstrated that the distribution of the number of cells in the finite and infinite queues is related to each other in terms of equal proportions. Using the superscripts K and ∞ to characterize the finite queue length K and infinite queue length respectively, the proportions may be written as

$$\frac{Pr[N^K = j]}{Pr[N^\infty = j]} = \frac{Pr[N^K = 0]}{Pr[N^\infty = 0]} \qquad j = 0, 1, \ldots, K-1 \tag{5.197}$$

Therefore, Equations 5.194 to 5.196 allow resolving the finite problem and writing successively

$$Pr[N = 0] =$$
$$\left[1 + \rho \sum_{k=0}^{K-2} (-1)^k \, (1-q)^{-(K-1-k)p} \left(\tfrac{q}{1-q} \right)^k \left(\begin{array}{c} (K-1-k)p + k - 1 \\ k \end{array} \right) \right]^{-1} \tag{5.198}$$

$$Pr[N = 1] = Pr[N = 0] \left[(1-q)^{-p} - 1 \right] \tag{5.199}$$

for $2 \le j \le K-1$,

$$\begin{aligned} & Pr[N = j] \\ & = Pr[N = 0] \left[(1-q)^{-jp} - \sum_{k=1}^{j-1} (-1)^k \, (1-q)^{-(j-k)p} \right. \\ & \left. \left\{ \left(\begin{array}{c} (j-k)p + k - 1 \\ k \end{array} \right) (\tfrac{q}{1-q})^k + \left(\begin{array}{c} (j-k)p + k - 2 \\ k-1 \end{array} \right) (\tfrac{q}{1-q})^{k-1} \right\} \right] \end{aligned} \tag{5.200}$$

$$Pr[N = K] = 1 - \frac{1 - Pr[N = 0]}{\rho} \tag{5.201}$$

and, finally,

$$Pr[N = j] = 0 \qquad \text{for } j \ge K \tag{5.202}$$

This completes the calculation path. Let us further mention that the PDF of the waiting time W may be derived in a similar way from the Lindley's equation without geometrical density function. Figure 5.20 reports the mean cell loss probability in terms of both the queueing load and the queueing length. The ATM multiplexing queueing lengths have been fixed to a size of 64 cells to ensure a mean cell loss probability of about 10^{-11} at a load of 0.85 under the assumption of a Geo arrival process.

5.3.2 Modeling ATM Multiplexers

Three different approaches to model ATM multiplexers are presented in the following on the basis of different classes of assumptions and configurations. The models are sorted in an increasing order of complexity to ease the understanding of advanced and general models. The models can be classified into three families

1. *queueing models with discrete-time arrival processes and a discrete-space length.* Three different models are presented in this modeling approach reflecting the discrete-time nature of slotted traffics.

 The first model considers general discrete-time arrival processes with possibility of simultaneous arrivals within a given slot period. These arrivals occurring during the

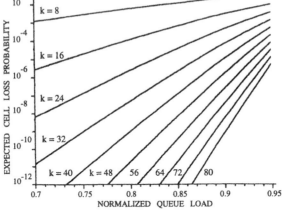

Figure 5.20: Geo/D/1 model: mean cell loss and queueing lengths.

same period are also referred to as being *clustered* or *batch arrivals*. They are likely to be observed since several sources originating from different input ports of the switching network concur simultaneously and independently in the multiplexing. The discrete distribution of the cell inter-arrival times and that of the potential clusters are parameters remaining free to be specified. This enables studying any kind of discrete-time independent and identically distributed arrival processes with the possibility of clustering the arrivals. The restrictive assumptions inherent to this model will be further released, namely the independence of consecutive inter-arrivals and the absence of clustered arrivals. This model is referred to as the GI/D/1-s to tell that the inter-arrival times are renewals, independent (I) and generally distributed (G) events, that the service times are deterministic (D) and that the number of servers is one or any given s. The family of Bernoulli arrivals mentioned in above sections can be processed by this model.

The second model deals with discrete-space queueing systems fed by n identical elementary sources which are modeled with independent Markov modulated discrete-time Bernoulli processes of order 2 [MMBP(2)]. These models are perfectly suited to tackle the multiplexing of computer data and voice sources. They roughly approximate the multiplexing of TV sources.

The third model is a more general issue which still provides the analysis with analytically and numerically tractable concepts. The model deals with discrete-time Markovian arrival processes (DMAP) and holds as a discrete-time version of the Markov modulated Poisson processes of order m [MMPP(m)]. The DMAP is a very general arrival process which covers many discrete-time processes without batch arrival. As a key point, it leads to an exact analysis of the general discrete-time single server queueing model with correlated input. It allows to take into account the

5.3. Queueing Models for ATM Multiplexers *407*

Markov models obtained when multiplexing several TV sources and to study the influence of serial correlations on the cell loss probability. This discrete model can be generalized to encompass the potentiality of cell arrivals in batch and consequently to cover all the cell arrival configurations to be observed in an ATM multiplexer. Since this latter process is nothing else than a discrete-time version of the N process, this approach with batches is introduced subsequently and studied in the following sections dealing with the continuous-time versatile Markovian point processes which can actually take into account very complex and general non-renewal processes.

2. *queueing models with continuous-time inter-arrivals and a discrete-space length.* This modeling approach allows taking into account more intricated inter-arrival time PDF's. The inter-arrival time is supposed in this case to be continuous-time point processes and, more specifically, doubly stochastic Poisson processes with bursty arrivals. The cases to be investigated in this work are the Markov Modulated Poisson Process (MMPP) with two states for which four parameters have to be specified and taken among the characteristics of either the inter-arrival or the counting processes. Correlated inter-arrival time processes can be taken into consideration. The more general point process, which leads to procedures still amenable to numerical algorithms, is the N process also called the versatile point process which has been originally imagined by Neuts. The process is presented in this section with the related N/G/1 queueing analysis of which the efficient numerical material to solve the problem has been recently proposed in the literature.

3. *queueing models with continuous-time arrival times and a continuous-space queue.* The assumption of a continuous queue restricts the use of that queueing model to heavy traffic systems ($\rho > 90\%$) because, in order to validate the assumption, the waiting times in queue are required to be large compared to the service time. This approximation is known as the assumption of *continuous-time fluid-flow.* It enables studying transients and overloaded queueing behaviors with partial differential equations of the diffusion type. In this model, the inter-arrival times will be modeled by continuous-time Markov processes with M states corresponding each to a given arrival rate. The state-transition probabilities and the asymptotic PDF of the arrival states are parameters to be dimensioned in this model.

The last two modeling approaches mentioned in item 2 and 3 are particularly quite adapted and useful to model the multiplexing originating from superposed TV traffics: first, the MMPP(m), which models free VBR TV traffics, belongs to the queue modeling reported in item 2, secondly, the approach to a superposed traffic characterized by a continuous-time homogeneous Markov process with m states (each of them being characteristized by a specific Poisson arrival) falls within the scope of the fluid-flow approximation developed in the third queueing model family.

5.3.2.1 Discrete-Space Queue with Discrete-Time Inter-Arrivals

This model analyzes a simple queueing system assuming a discretized time axis. The time reference unit along the temporal axis is the interval of length Δt equal to the slot time or

the deterministic service duration. Let B_M denote the maximum capacity of the queue. To carry out this analysis (Figure 5.21), two privileged instants will be considered: the moments immediately prior to the cell arrival time and those ones immediately posterior to the arrival instants. The following random variables are considered in the model

1. $U_p(n)$, the variable representing the number of cells into the queue just prior to the n^{th} arrival and $u_p(k)$ be the probability density function of $U_p(n)$ i.e. $u_p(k)$ is the probability that $U_p(n)$ equal k, $(u_p(k) = Pr[U_k(n) = k]; 0 \leq k \leq B_M)$. The upper case letters will stand for the random variables and the lower case letters for their respective probability density function.

2. $U_a(n)$, the variable representing the number of cells into the queue just after the n^{th} arrival and $u_a(k)$ be the probability density function of $U_a(n)$ i.e. $u_a(k)$ is the probability that $U_a(n)$ equal k $u_a(k) = Pr[U_a(n) = k]; 0 \leq k \leq B_M$.

3. $D(n)$, be the random variable representing the number of cells arriving at the n^{th} arrival, and $d(k)$ be the probability density function i.e. $d(k) = Pr[D(n) = k]$. A group of more than one cell arriving at once is termed a *batch*. Hence, let $d(k)$ denote the PDF of the batch arrival lengths k.

4. $I(n)$, the variable representing the cell inter-arrival times between the n^{th} and the $(n+1)^{th}$ arrivals, and $i(k)$ be the probability density function i.e. $i(k) = Pr[I(n) = k]$.

Figure 5.21 depicts the queue behavior with the predefined variables and allows writing two equations of continuity which are formulated as follows

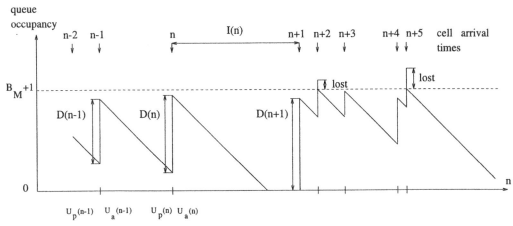

Figure 5.21: Discrete time arrival and discrete queue model: queue occupancy versus time.

1. the state of the queue immediately after the n^{th} batch arrival is given by

$$U_a(n) = \min[U_p(n) + D(n), B_M] \tag{5.203}$$

2. the state of the queue just before the $(n+1)^{th}$ batch arrival is given by

$$U_p(n+1) \;=\; \max[U_a(n) - I(n), 0] \tag{5.204}$$

To derive an easy and numerically tractable algorithm, it is worthwhile re-expressing the equations in terms of the probability density function as follows

$$u_a(k) = \Pi^{B_M+1}[u_p(k) * d(k)] \tag{5.205}$$

$$u_p(k) = \Pi_0[u_a(k) * i(-k)] \tag{5.206}$$

where the original operators on random variables are transformed into operators on probability density functions. The summation of independent random variables becomes a convolution denoted here by the symbol *, the min and max operators are transformed into corresponding operators on probability density functions symbolized by Π^{B_M+1} and Π_0. When applied on a probability density function $v(k)$, these operators are defined by

$$\Pi^{B_M+1}[v(k)] \;=\; \begin{cases} v(k) & if \quad k < B_M + 1 \\ \sum_{i=B_M+1}^{\infty} v(i) & if \quad k = B_M + 1 \\ 0 & if \quad k > B_M + 1 \end{cases} \tag{5.207}$$

In the case to study, Π^{B_M+1} gathers into the level $B_M + 1$ all the probability masses beyond the queue capacity. As a matter of fact, the mass of probability concentrated at the level $(B_M + 1)$ approximates the probability of cell losses and stands the survivor function of v at $k = B_M + 1$.

$$\Pi_0[v(k)] \;=\; \begin{cases} 0 & if \quad k < 0 \\ \sum_{i=-\infty}^{0} v(i) & if \quad k = 0 \\ v(k) & if \quad k > 0 \end{cases} \tag{5.208}$$

In our case, Π_0 gathers into the level zero of occupancy all the probability masses leading to an underflow of the queue. The probability concentrated at the level zero approximates the probability of having an empty queue.

As a matter of conclusion on this model, the field of application covers any kind of renewal arrivals. Nevertheless, as no assumptions on the model stationarity have been made so far when developing this algorithm, the applicability of this method can be extended as well to the non-stationary cases i.e. when the PDF's of $d(n)$ and $i(n)$ are both non-stationary. Diagrammatically, the algorithm is summarized in Figure 5.22 as an iterative computational loop. Figure 5.23 presents the queue performances with a discrete Poisson process and the influence of batch arrivals (short-term correlation) on the queueing performances. Curve 1 refers to an arrival process modeled as discrete-time Poissonian process and Curve 2 considers the same process except that batches are present with the following length PDF. The number of cells within a batch have the respective density $Pr[D(n) = 1] = 0.801$, $Pr[D(n) = 2] = 0.160$ $Pr[D(n) = 3] = 0.032$, $Pr[D(n) = 4] = 0.0064$.

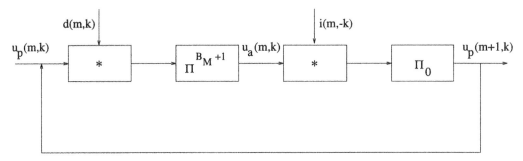

Figure 5.22: Iterative numerical loop for computation of discrete time and queue model.

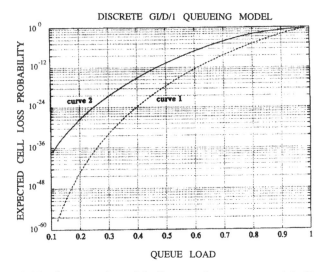

Figure 5.23: Computation with discrete time-space model, $B_M = 64$.

5.3.2.2 Multiplexing Discrete MMBP(2) Sources

In this section, a discrete version of the MMPP(2) source system is investigated. The modeling approach uses the Markov Modulated Bernoulli Process (MMBP) to describe the individual sources. For a shake of simplicity, the analysis is restricted here to considering N independent and identically distributed sources whose traffics are characterized by two-state MMBP(2) models. The goal is to determine the steady-state queue length distribution and the cell loss probability for a finite capacity ATM multiplexer with queue size B_M and FIFO discipline. Following this approach, each source is represented by a two-state Markov process which modulates the intensity of the Bernoulli process responsible of the cell generation. The state transitions are permitted to occur at each time slot boundary with probabilities

$r_{1,2}$ to be in state 1 at slot n and to transit to state 2 at slot $n + 1$

$r_{2,1}$ to be in state 2 at slot n and to transit to state 1 at slot $n + 1$

The probability that no transitions occur in state 1 is given by $r_{1,1} = 1 - r_{1,2}$ and similarly in state 2 with probability $r_{2,2} = 1 - r_{1,2}$. Arising from the memoryless property of Markov process, the sojourn times in each state are geometrically distributed as

$$\sigma_1(k) = Pr[\Delta t = k] = (1 - r_{1,2})^{k-1} r_{1,2} \tag{5.209}$$

$$\sigma_2(k) = Pr[\Delta t = k] = (1 - r_{2,1})^{k-1} r_{2,1} \tag{5.210}$$

where $\sigma_1(k)$ and $\sigma_2(k)$ are the probabilities of staying k consecutive slots in state 1 and 2 respectively. In state 1, the slots are emptied or filled by one cell according to a Bernoulli trial (fail-success). The success and fail probabilities are respectively equal to λ_1 and $1 - \lambda_1$. Similarly, state 2 is characterized by a success probability of λ_2. The resulting average sojourn times in states 1 and 2 are given by $\bar{\sigma}_1 = \frac{1}{r_{1,2}}$ and $\bar{\sigma}_2 = \frac{1}{r_{2,1}}$.

In this modeling approach, the ATM multiplexer is fed by N similar MMBP(2) sources assumed to be in steady-state transmission. The construction of this queueing model is achieved by considering four consecutive topics, namely the state-space evolution of the sources, the amount of cells generated within one slot, the steady-state queue length distribution and, eventually, the cell loss probability performances.

The State Evolution of the Sources

Let $a(k)$ and $q(k)$ define respectively the number of sources in state 2 and the number of cells in the multiplexer during slot k. Hence, a transition matrix A can be constructed in order to describe the evolution of $a(k)$ in terms of the number of sources in state 2 at time k+1 conditioned to observing at time k $a(k)$ as

$$A(i, j) = Pr[a(k + 1) = j | a(k) = i] \tag{5.211}$$

The number of sources $a(k + 1)$ in state 2 during slot $k + 1$ can be decomposed into a sum of two terms as $a(k + 1) = U + V$ where

1. U is the number of sources remaining in state 2 during slots k and $k + 1$, that is $U = \sum_{i=1}^{a(k)} c_i$.

2. V is the number of sources transiting from state 1 to state 2 between slots k and $k+1$, that is $V = \sum_i^{N-a(k)} d_i$.

The c_i and d_i define two sets of Bernoulli trials with success probabilities respectively equal to $(1 - r_{2,1})$ and $r_{1,2}$. Consequently, the variables c_i and d_i generate each a distinct binomial distribution,

1. for c_i, that is $\{f_1(n) : n = 0, ..., i\}$

$$f_1(n) = \binom{i}{n}(r_{2,1})^{i-n}(1 - r_{2,1})^{n-i} \quad \text{with} \quad 0 \geq n \geq i \tag{5.212}$$

2. for d_i, that is $\{f_2(n) : n = 0, ..., N - i\}$

$$f_2(n) = \binom{N-i}{n}(r_{1,2})^{N-i-n}(1 - r_{1,2})^n \quad \text{with} \quad 0 \geq n \geq N - i \tag{5.213}$$

Therefore, the PDF $\nu(i)$ of sum $U+V$ leads by the source independence to the convolution of both discrete PDF's

$$\nu_i = f_1^{(i)} * f_2^{(N-i)} \qquad 0 \geq i \geq N \tag{5.214}$$

where $f_i^{(n)}$ represents the n-fold convolution of f_i and $*$ the symbol of the convolution operator.

The Number of Cells Generated within one Slot Period

The second step consists of relating the number of sources in state 2 (meaning implicitly that the other sources are in state 1) with the number of cells generated in a slot period $b(k)$. Let us define a matrix B whose elements $B(ij)$ represent the probability to observe j cell arrivals conditioned to having i active sources in state 2 i.e.

$$B(i,j) = Pr[b(k) = j | a(k) = i] \tag{5.215}$$

As a matter of fact, $B(i,j)$ is an $N \times N$ transition matrix whose PDF's $\kappa(j)$ of the i^{th} row are given once again by the convolution of two PDF's $\kappa(j) = g_1 * g_2$ with

1. the binomial distribution resulting from the contribution of i sources in state 2, with PDF $\{g_1(n) : n = 0, ..., i\}$

$$g_1(n) = \binom{i}{n}(1 - \lambda_2)^{i-n}(\lambda_2)^n \quad \text{with} \quad 0 \geq n \geq i \tag{5.216}$$

2. the binomial distribution resulting from the contribution of $N - i$ sources in state 1, with PDF $\{g_2(n) : n = 0, ..., N - i\}$

$$g_2 = \binom{n-i}{n}(1-\lambda_1)^{i-n}(\lambda_1)^n \quad \text{with} \quad 0 \geq n \geq N - i \tag{5.217}$$

B is reduced to an identity matrix in the case of ON-OFF source models since each active source generates a cell every slot. Interrupted Bernoulli sources may also be considered, in this case, the number of arrivals ranges between 0 and $a(k)$ according to a binomial distribution and B is a lower-triangular matrix with elements given by

$$B(i,j) = \begin{cases} \binom{i}{j}(1-\lambda_2)^{i-j}(\lambda_2)^j & 0 \leq j \leq i \\ 0 & j > i \end{cases} \tag{5.218}$$

In the following, we proceed with the discrete-time MMBP(2) system which encompasses all these simplified models.

The Steady-State Queue Length Distribution

Assuming that a cell entering an empty queueing system cannot be served before the beginning of the next slot, the number of cells $q(n+1)$ in the queue at slot $n+1$ is given by

$$q(n+1) = \min\{\max[q(n)-1,0] + b(n+1), B_M\} \tag{5.219}$$

As a matter of fact, the evolution of $q(n)$ is related to that of $b(n)$ and, by consequence, to the evolution of $a(n)$. This suggests building a two-dimensional discrete-state space and irreducible Markov chain to describe the system with the stochastic transition matrix such that

$$\pi_{i,j} = Pr[q(n) = i, a(n) = j] \tag{5.220}$$

represents the probability to observe a queue filled at level i with j sources in state 2. Let $\underline{\pi}$ denote the vector built by concatenating the rows of matrix $\pi_{i,j}$ ($\pi_{0,.}, \pi_{1,.}, ..., \pi_{B_M,.}$) which represents the state distribution associated with the Markov chain and its transition matrix P. Consequently, the Markov chain fulfills the relation $\underline{\pi}(n+1) = \underline{\pi}(n)\,P$. The steady-state π fulfills the conditions

$$\underline{\pi}\,P = \underline{\pi} \qquad \sum_{i,j}\pi_{i,j} = 1 \tag{5.221}$$

requiring to solve a system of $(N+1) \times (B_M+1)$ square linear equations. The calculation of the steady state queue occupancy distribution is rather immediate

$$Pr[q = i] = \sum_{j=0}^{N}\pi_{i,j} \tag{5.222}$$

The problem of how to construct P has to be examined; P has the form

$$P = \begin{vmatrix} C_0 & C_1 & C_2 & \cdots & C_{B_M-1} & C_{B_M} \\ C_0 & C_1 & C_2 & \cdots & C_{B_M-1} & C_{B_M} \\ 0 & C_0 & C_1 & \cdots & C_{B_M-2} & C_{B_M-1} + C_{B_M} \\ 0 & 0 & C_0 & \cdots & C_{B_M-3} & \sum_{i=B_M-2}^{B_M} C_i \\ \vdots & \vdots & \vdots & \cdots & \vdots & \vdots \\ 0 & 0 & 0 & \cdots & C_0 & \sum_{i=1}^{B_M} C_i \end{vmatrix} \qquad (5.223)$$

where the C_i are $(N+1) \times (N+1)$ sub-matrices with indices $0 \geq i \geq B_M$. The sub-matrices C_i describe the changes in the distribution of the number of sources visiting the state 2 for the case of i cell arrivals. Denoting $diag[B\ e_i]$ a square matrix built as follows

$$diag[B\ e_i](i,j) = \begin{cases} [B\ e_i](i) & \text{if } i = j \\ 0 & \text{otherwise } i \neq j \end{cases} \qquad (5.224)$$

where e_i stands for a zero vector with 1 in position i, the sub-matrix

$$C_i = A\ diag[B\ e_i] \qquad (5.225)$$

meaning that C_i is calculated with the columns of A which represent the probability of having i sources in state 2, with the j^{th} column weighted by the $B(i,j)$ which holds for the probability to observe j arrivals with i sources in state 2.

The Cell Loss Probability

The cell loss probability is derived by examining the probability component which is wrapped in by summations in the rightmost columns of P. Especially, given the state of the queue in slot k we would like to know the distribution of arrivals in the following slot. Therefore, let us define

$$\begin{aligned} D_{ij} &= Pr[b(k+1) = j | a(k) = i] & (5.226) \\ &= AB & (5.227) \end{aligned}$$

since matrix A maps the number of sources active in slot k to k+1 and B gives distribution of the number of arrivals conditioned on the number of sources. Using the steady state distribution π we can find

$$p = \pi D \qquad (5.228)$$

where

$$p_{i,j} = Pr[q(n) = i, b(n+1) = j] \qquad (5.229)$$

For the pair (i,j) the number of cells which are lost is given by the modified Hankel matrix,

$$L_{i,j} = N\{\text{cells lost} | q(n) = i, b(n+1) = j\} \qquad (5.230)$$

Remarking that $L_{i,0} = L_{i,1}$ because a cell arriving at an empty queue cannot be served until the following slot and the system behaves in the same manner as a queue containing one cell

$$
\begin{aligned}
L_{i,j} &= max[0, (N-i) + (B_M - j) + (N-1)] \quad \text{if } 0 \le i \le N, \ 1 \le j \le B_M \\
&= max[0, (N-i) + (B_M - 1) + (N-1)] \quad \text{if } 0 \le i \le N, \ j = 0
\end{aligned}
$$

Eventually, the probability of cell loss is expressed by the expectation

$$
l = \sum_{i=0}^{B_M} \sum_{j=0}^{N} L_{i,j} p_{i,j} \tag{5.231}
$$

Conclusions about the Model

To illustrate this method, an interrupted Bernoulli process is supposed to feed a multiplexer with a finite buffer of 25 cells. We follow the experimental study performed by Hughes, Anido and Bradlow in [18]. The relationship between burst intensity $I = \lambda_2$ and cell loss is investigated in Figure 5.24. The burst lengths and intensities are respectively denoted L and I, the queue length N. It turns out that as the intensity of a burst approaches one, significant higher losses are inevitable for a given utilization. The effect is effect is relatively independent of the number of sources but is influenced by the burst length as clearly depicted in Figure 5.25 where the probability of queue overflows increases dramatically as the burst length exceeds 5 consecutive cells. As a major concluding statement, all the queue modeling results indicate so far that, in order to achieve any significant degree of gain in statistical multiplexing, the sources will have to be requested not to transmit long bursts of high intensity. Indeed, Figures 5.24 and 5.25 show that the statistical operation would be more advantageous in the regions below the knees in the curves. Traffic with a low burst intensity-burst length product offers at given utilization loads much lower cell loss probabilities. Similar results were presented by Woodruff in [37] who shows the drastic effect of long bursts and high intensities.

5.3.2.3 The Discrete-Time Markov Arrival Process

As foreknown since Chapter 3, the traffic superposition of n TV sources can be modeled by a Poissonian arrival process whose rate $\lambda(t)$ is driven by an irreductible Markov chain with m states. In this framework, the Discrete-time Markov Arrival Process (DMAP) is a stochastic arrival process based on an irreductible discrete-time Markov chain with m state spaces. When the process sojourns in state i at time $n\Delta t$ (Δt being the slot period), it moves to state j at time $(n+1)\Delta t$ with probability p_{ij}. That probability is further decomposed in at least two exclusive components

1. c_{ij}, the probability that the transition from state i to state j occurs without any arrival.

2. d_{ij}, the probability that the same transition generates an arrival event.

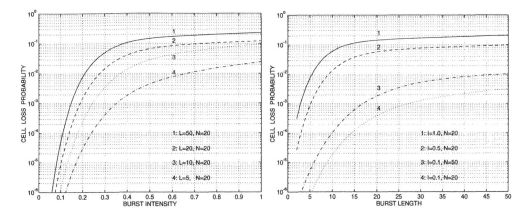

Figure 5.24: Influence of the burst intensity. Figure 5.25: Influence of the burst length.

Noticing that $p_{ij} = c_{ij} + d_{ij}$, the process is completely defined in terms of the matrices $C = [c_{ij}]$ and $D = [d_{ij}]$. If batch arrivals had to be considered, additional terms would have to be added in the summation to take into account the events $e_{2,i,j}$, ..., $e_{n,i,j}$ where 2, ..., n cells arrive in batch. For the shake of simplicity, the batch arrivals are not tackled in this presentation but treated in the following sections.

The transition matrix of the underlying Markov chain is $C + D$ with the condition that $\sum_{j=1}^{m} c_{ij} + d_{ij} = 1$, $\forall i$. It is clear from the definitions that d_{ij} represents the probability that, in the next time slot, there is an arrival and that the process will proceed in state j, conditioned to having i as the current state. Similarly, the c_{ij} stands for the probability that, in the next time slot, there is no arrival event and that the state of the Markov chain be j, conditioned to having the momentary state in i.

The modeling path will proceed as follows. The moment generating functions for counting and inter-arrival time processes are first calculated. The infinite capacity queueing model, the embedded Markov chain and the queue length distribution will be successively studied. The study terminates with considering the finite capacity queueing model and its cell loss probability.

Moment Generating Functions

The conditional probability $Pr[n, k]_{i,j}$ to observe n arrivals in the interval $(0, k]$ and that the process is in state j at the end, conditioned to starting from state i at time 0. The matrix $P(n, 1) = P[n, 1]_{i,j}$ characterizes the probability to observe n arrivals in the interval of a single time slot. That is

$$P(n,1) = \begin{cases} C & \text{if } n = 0 \\ D & \text{if } n = 1 \\ 0 & \text{otherwise} \end{cases} \qquad (5.232)$$

Consequently, the moment generating function of $P(n, 1)$ is

$$\pi(z,1) = \sum_{n=0}^{\infty} P(n,1)\, z^n = C + Dz \tag{5.233}$$

Invoking the memoryless Markov property of the DMAP, the expression for the moment generating function of the counting processes $P(n,k)$ is given by

$$\pi(z,k) = [\pi(z,1)]^k = [C + Dz]^k \tag{5.234}$$

The general expression of $P(n,k)$ is rather difficult to derive since the matrix multiplication is not a commutative operation. However, $P(n,k)$ can be computed numerically.

Moving now to the inter-arrival time processes, let $f_{ij}(k) = Pr[x = k]$ be the conditional probability that the inter-arrival time is k time slots and that the state of the DMAP at the next arrival is j, conditioned to observing the state i at the precedent arrival. If the inter-arrival time has a k time slot length, k-1 slots without any arrival have been necessarily counted in between consecutive arrival events. Therefore, the probability matrix $f(k) = [f_{ij}(k)]$ is

$$f(k) = \begin{cases} C^{k-1}\, D & \text{if } k \geq 1 \\ 0 & \text{otherwise} \end{cases} \tag{5.235}$$

and its generating function

$$\phi(z) = \sum_{n=1}^{\infty} f(n)\, z^n = z \sum_{n=1}^{\infty} [Cz]^n\, D = z\,[I + Cz]^{-1}\, D \qquad |z| < 1 \tag{5.236}$$

The moments of the inter-arrival time process are deduced from the derivatives of $\phi(z)$ at $z = 1$. The n^{th} derivative of $\phi(z)$ is expressed as

$$\phi^n(z) = n!\,(I - Cz)^{-(n+1)}\, C^{n-1}\, D \tag{5.237}$$

From this relationship, the mean is derived as

$$\frac{d\phi(z)}{dz}\Big|_{z=1} = (I - C)^{-2}\, D \tag{5.238}$$

This completes the search towards the moment characterization.

The DMAP/G/1 Queue with Infinite Capacity

The queueing system consists of a discrete-time single server queue with infinite capacity and FIFO discipline. The arrival process is supposed to be a DMAP characterized by matrix C and D. The service time has a general discrete-time distribution $\{h(k) : k \geq 0\}$, with moments defined by the discrete version of the integral i.e. $\mu^n = \sum_{\nu=0}^{\infty} \nu^n\, h(\nu)$ and $\mu^1 = \bar{h}$. The arrival process and the service process are assumed to be mutually independent of each other. Arising from the discrete nature of the queueing, a cell arrival and a cell departure from service may occur simultaneously. It is further assumed that, in this case, the arriving cell enters the system immediately prior to the departure time.

Let τ_n be the time until the n^{th} departure in the above queueing model, given $\tau_0 = 0$. The phase of the arrival process contains its own memory. Let L_j be the number of cells in queue and J_n be the phase of the DMAP at time τ_n, the sequence $\{(L_n, J_n, \tau_{n+1} - \tau_n) : n \geq 0\}$ generates a semi-Markov chain with state space $\{(L, J) : L \geq 0, 1 \leq J \leq m\}$. The transition probability matrix has the same structure as an $M/G/1$ queue and is given by

$$
Q = \begin{vmatrix}
B_0 & B_1 & B_2 & \cdots \\
A_0 & A_1 & A_2 & \cdots \\
0 & A_0 & A_1 & \cdots \\
0 & 0 & A_0 & \cdots \\
\vdots & \vdots & \vdots & \ddots
\end{vmatrix}
\tag{5.239}
$$

where the $m \times m$ matrices A_r, B_r and U have the meaning which follows

1. matrix A_r is expressed as

$$
A_r = \sum_{\nu=0}^{\infty} P(r, \nu)\, h(\nu)
\tag{5.240}
$$

The elements $A_r(i, j)$ are the conditional probabilities that there be r arrival during a service time and that the DMAP be in phase j at the departure time, conditioned to leaving an non-empty system after last departure with the DMAP in phase i.

2. matrix B_r is calculated as

$$
B_r = U A_r
\tag{5.241}
$$

3. matrix U stands as the matrix of the phase transition probabilities between the beginning and the end of an idle period, which is the time between a cell departure leaving the queue empty and the next arrival.

$$
\begin{aligned}
U &= \sum_{\nu=0}^{\infty} C^\nu D & \text{(5.242)} \\
&= \pi(z)|_{z=1} & \text{(5.243)} \\
&= (I - C)^{-1} D & \text{(5.244)}
\end{aligned}
$$

The study of this model requires, in whole generality, the matrix analytic methods as those developed in References [23], [26], [31].

5.3. Queueing Models for ATM Multiplexers *419*

The State Probabilities

The calculation of the stationary state vector \underline{x}_0 is first carried out to derive the state probabilities at service departures. The component $x_0(i)$ stands for the probability that a departure leaves the system empty with a DMAP in phase i. To path the coming calculation, the topics to be examined in order to derive the stationary state vector \underline{x}_0 are successively the mean arrival rate, the mean length of the idle and busy periods and the queueing load. These are as follows

1. the mean arrival rate λ of the DMAP is determined by

$$\lambda = \underline{\pi} \, D \, \underline{e} \tag{5.245}$$

where the stationary phase vector $\underline{\pi}$ is given by

$$\underline{\pi} \, (C + D) = \underline{\pi}, \qquad \underline{\pi} \, \underline{e} = 1 \tag{5.246}$$

with $\underline{e} = (1, 1, ..., 1)^T$.

2. the mean length f of an idle period (expressed in time slots) is given by

$$
\begin{aligned}
f &= \underline{l} \, (I - C)^{-2} \, D \, \underline{e} &\tag{5.247}\\
&= \underline{l} \, (I - C)^{-1} \, \underline{e} &\tag{5.248}
\end{aligned}
$$

where \underline{l} is the stationary phase vector at departure instants which leave the system empty.

3. the mean length b of a busy period (time between two consecutive idle periods) is expressed as

$$b = \bar{h} k \tag{5.249}$$

where k stands for the mean number of departure in a busy period.

4. the queueing load ρ is given by

$$\rho = \frac{\bar{h}}{\lambda} = 1 - \frac{f}{f + b} \tag{5.250}$$

These considerations lead readily to a first expression of \underline{x}_0 as

$$
\begin{aligned}
\underline{x}_0 &= \frac{\bar{h}}{\lambda} &\tag{5.251}\\
&= \frac{1 - \rho}{\lambda} \frac{\underline{l}}{\underline{l} \, (I - C)^{-1} \, \underline{e}} &\tag{5.252}
\end{aligned}
$$

To eliminate \underline{l} from Equation 5.252, let us introduce the matrix $G(k)$ with components $G_{i,j}(k)$ corresponding to the conditional probability that a busy period end after exactly k departures leaving the DMAP in phase j, conditioned to being in phase i at the beginning of this busy period. As a consequence of the structure of Q, this is equal to the probability that the first departure leaving n cells in the system occur exactly after k transitions with the DMAP in phase j, conditioned to the embedded Markov chain starting in state $(n + 1, i)$. This probability is independent of n, $n \geq 0$. Hence, denoting $\gamma(z) = \sum_{n=0}^{\infty} G(n)z^n$, for $|z| \leq 1$,

$$\gamma(z) = z \sum_{n=0}^{\infty} A_n [\gamma(z)]^n \tag{5.253}$$

$$= z \sum_{n=0}^{\infty} \pi[\gamma(z), n] \, h(n) \tag{5.254}$$

$$= z \sum_{n=0}^{\infty} [C + D\gamma(z)]^n \, h(n) \tag{5.255}$$

assuming that $C + D$ is irreductible and that a stable system $\rho < 1$, the matrix G is expressed as

$$G = \sum_{n=0}^{\infty} G(n) \tag{5.256}$$

$$= \gamma(z)|_{z=1} \tag{5.257}$$

$$= \sum_{n=0}^{\infty} [C + DG]^n \, h(n) \tag{5.258}$$

Therefore, G is stochastic and represents the phase transition matrix of a busy period. Its stationary vector is given by

$$\underline{g} \, G = \underline{g} \qquad \underline{g} \, \underline{e} = 1 \tag{5.259}$$

The matrix G may be computed by successive substitutions in Equation 5.258. An efficient algorithm is provided by Gün [12] to reduce the number of iterations at high queueing loads. Since there is always an idle period followed by a busy period between two successive departures leaving the system empty, \underline{l} is determined by

$$\underline{l} \, UG = \underline{l} \qquad \underline{l} \, \underline{e} = 1 \tag{5.260}$$

Furthermore, calculations from Equation 5.258 imply readily that

$$\underline{g} \, (C + DG) = \underline{g} \tag{5.261}$$

Arguing on Equation 5.260, it follows that

$$\underline{l} = [\underline{g} \, (I - C) \, \underline{e}]^{-1} \, \underline{g} \, (I - C) \tag{5.262}$$

And, hence

$$x_0 = \frac{1-\rho}{\lambda} \, \underline{g} \, (I - C) \tag{5.263}$$

Reference [32] presents the way to compute the vectors \underline{x}_i, $i > 0$ exploiting numerically stable recursive procedures

$$\underline{x}_i = [\underline{x}_0 \, \bar{A}_i + \sum_{r=1}^{i-1} \underline{x}_r \, \bar{A}_{i+1-r}] \, (I - \bar{A}_1)^{-1} \qquad i \geq 1 \tag{5.264}$$

where $\bar{A}_r = \sum_{i=r}^{\infty} A_i \, G^{i-r}$ and $\bar{B}_r = \sum_{i=r}^{\infty} B_i \, G^{i-r}$, for $r \geq 1$.

The stationary queue length distribution at the end of an arbitrary time unit is hereafter calculated from the state probabilities at queue departures. First, the probability $y_{0,j}$ that the system be empty at the end of an arbitrary time slot with the DMAP in phase j is addressed. This is only possible if the last departure has left the system empty and if there were no further arrivals. Hence, the element $\frac{[\sum_{n=0}^{\infty} C^{\nu}]_{ij}}{E[T_A]}$ is the conditional probability that the system be in state $(0, j)$ at the end of an arbitrary time unit, conditioned to the last departure leaving the system empty with the DMAP in phase i. Let us remark that the mean number of time units between successive departures is given by $E[T_A] = \frac{1}{\lambda}$ in a queueing system without losses. This leads to

$$\underline{y}_0 = \lambda \, \underline{x}_0 \sum_{n=0}^{\infty} C^n \tag{5.265}$$
$$= \lambda \, \underline{x}_0 \, (I - C)^{-1} \tag{5.266}$$
$$= (1 - \rho) \, \underline{g} \tag{5.267}$$

Similarly, the calculation of the vectors \underline{y}_i, $i \geq 1$, is deduced as follows

$$\underline{y}_i = \lambda \, \underline{x}_0 \sum_{n=0}^{\infty} \sum_{l=0}^{\infty} C^l \, DP(i-1, n) \sum_{m=n+1}^{\infty} h(m)$$
$$+ \lambda \sum_{k=1}^{i} \underline{x}_k \sum_{n=0}^{\infty} P(i-k, n) \sum_{m=n+1}^{\infty} h(m) \tag{5.268}$$

After some additional calculations

$$\underline{y}_{i+1} = [\underline{y}_i \, D + \lambda \, (\underline{x}_{i+1} - \underline{x}_i)] \, (I - C)^{-1} \qquad i \geq 0 \tag{5.269}$$

The DMAP/G/1 Queue with Finite Capacity

In order to estimate the cell loss probability of the finite queueing system, the stationary state probabilities at departures denoted \underline{x}_i^f with a superscript f to indicate the use of a finite capacity buffer and the probability \underline{y}_{s+1}^f, that the system is full at the end of an arbitrary time slot.

State Probability at Departure Times

For a system with finite buffer size s, the transition matrix of the Markov chain is given by

$$
Q^f = \begin{vmatrix}
B_0 & B_1 & B_2 & \cdots & B_{s-1} & \sum_{k=s}^{\infty} B_k \\
A_0 & A_1 & A_2 & \cdots & A_{s-1} & \sum_{k=s}^{\infty} A_k \\
0 & A_0 & A_1 & \cdots & A_{s-2} & \sum_{k=s-1}^{\infty} A_k \\
0 & 0 & A_0 & \cdots & A_{s-3} & \sum_{k=s-2}^{\infty} A_k \\
\vdots & \vdots & \vdots & \ddots & \vdots & \vdots \\
0 & 0 & 0 & \cdots & A_0 & \sum_{k=1}^{\infty} A_k
\end{vmatrix}
\tag{5.270}
$$

The state probabilities \underline{x}_i^f, $i < s$, are computed from \underline{x}_0^f likewise to the system with finite capacity. The transition probabilities differ only for the vector \underline{x}_s^f. Therefore, the probabilities \underline{x}_i, $i < s$ of the infinite capacity system are taken as an approximation for \underline{x}_i^f, $i < s$. The vector \underline{x}_s^f is thereafter calculated using the transition probabilities of Q^f. This leads to

$$
\underline{x}_s^f \simeq [\underline{x}_0^f \, B_{sum}^s + \sum_{i=1}^{s-1} \underline{x}_i^f \, A_{sum}^{s-i+1}] \, [I - A_{sum}^1]^{-1}
\tag{5.271}
$$

where $A_{sum}^n = \sum_{k=n}^{\infty} A_k$ and $B_{sum}^n = \sum_{k=n}^{\infty} B_k$. Since the vector $\sum_{i=0}^{s} \underline{x}_i^f$ is stochastic, the vectors \underline{x}_i^f have to be normalized. An alternative possibility is a direct or an iterative solution of

$$
(\underline{x}_0^f, \, ..., \, \underline{x}_s^f) \, Q^f = (\underline{x}_0^f, \, ..., \, \underline{x}_s^f)
\tag{5.272}
$$

Unfortunately, these methods are either time or memory consuming for large m and s.

Cell Loss Probability

Assuming to know the vector \underline{y}_{s+1}^f expressing the probability that the queue is full at the end of an arbitrary time slot, the cell loss probability P_{cl} is determined by

$$
P_{cl} = \frac{1}{\lambda} \, \underline{y}_{s+1}^f \, D \, \underline{e}
\tag{5.273}
$$

The vector \underline{y}_{s+1}^f can be derived from the state probabilities at departure times and from the loss probability by considerations similar to Equation 5.268

$$
\begin{aligned}
\underline{y}_i^f &= (1 - B) \, \lambda \, \{ \sum_{n=s}^{\infty} \sum_{l=0}^{\infty} \underline{x}_0^f \, [I - C]^{-1} \, D \, P(i,n) \, \sum_{m=n+1}^{\infty} h(m) \\
&\quad + \lambda \sum_{k=1}^{s} \sum_{n=0}^{\infty} \sum_{i=s+1-k}^{\infty} \underline{x}_k^f \, P(i,n) \, \sum_{m=n+1}^{\infty} h(m) \}
\end{aligned}
\tag{5.274}
$$

Eventually, both Equations 5.273 and 5.274 enable computing the cell loss probability.

5.3. Queueing Models for ATM Multiplexers 423

Conclusion on the DMAP Model

A general discrete-time queueing system with single server has been studied in this section as a model to analyze ATM multiplexers and leaky bucket algorithms in charge of source monitoring. The DMAP is a general arrival process which embodies a large variety of simple discrete-time processes. Among them, the Bernoulli process is directly derived by letting $D = p$ and $C = 1 - p$ with p the probability of success. Other classes of deterministic arrival process are covered by the DMAP, for example, the General Modulated Deterministic Process (GMDP) a class containing special cases like the Markov Modulated Deterministic Process (MMDP) which is a burst-silence arrival process. Among all the characteristics tractable by this family of general model, it is worth mentioning the ability to investigate the influence of serial correlations within the cell arrival process. As a matter of illustration, let us consider the Discrete-time Modulated Deterministic Process (DMDP) case and deduce the queueing performances when this arrival process feeds with a traffic intensity of 0.5 Erlang (Er), a queue characterized by constant service time h=5 and different buffer sizes (B=10, 30, 50). The effects of the correlation between consecutive inter-arrival times $-1 < \rho < 1$ are reported on Figure 5.26 which displays the cell loss probability for coefficients of correlation ranging from -1 up to +1 referring to several finite queue lengths. The MMDP considered in the example here is composed of two phases with constant inter-arrival times T_1 and T_2 respectively. The mean $E[T]$, the coefficient of variation c and the coefficient of correlation ρ of the inter-arrival time are respectively expressed by

$$E[T] \;=\; \frac{1}{2}\,(T_1 + T_2) \tag{5.275}$$

$$c \;=\; \left| \frac{1 - \frac{T_1}{T_2}}{1 + \frac{T_1}{T_2}} \right| \tag{5.276}$$

$$\rho \;=\; 2\left(p - \frac{1}{2}\right) \tag{5.277}$$

The cell loss probability increases rapidly with the coefficient of correlation since the phase durations of the arrival process approach infinity when ρ tends to +1. Inversely, the process is composed of highly frequently alternating sequences if ρ tends to -1. Pure random behaviors are met at $\rho = 0$ and deterministic evolutions at $\rho = \pm 1$.

5.3.2.4 Discrete-Space Queue with Continuous-Time Inter-Arrivals

One of the most general point process which leads to tractable numerical algorithms in order to model queueing systems and derive performances is referred to being the N process or the versatile point process as developed in Reference [2]. As mentioned earlier, the Markov modulated Poisson processes are in fact particular cases of this general point process. In this section, the general N process will be presented to show how far numerical algorithms have progressed in that field during the past decade as presented in References [27], [28] and [22]. For what concerns the cell arrival process on ATM networks, MMPP processes have turned out to be significant modeling approaches which are able to

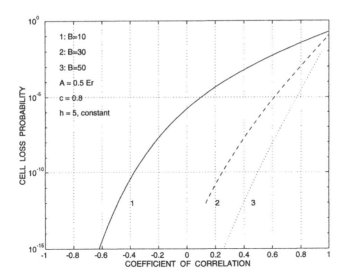

Figure 5.26: Influence of the serial correlation.

take into account the high cell inter-arrival time variabilities. The aspects of multiplexing the MMPP's in ATM queues will thereafter be illustrated in the section.

When an arrival N process feeds a queueing system with a finite queue of length B_M and a general service time distribution $G(t)$ characterized by a mean μ, the model is qualified as an N/G/1 system. This is addressed in the presentation which follows. Let us indeed consider a queue at the service departure moments $t = 0$, t_1, t_2, Let L_n be the number of cells into the queue at time t_n therefore $0 \leq L_n \leq B_M$ with B_M the queue capacity. Let $J_n \epsilon[1, 2, ..., m]$ be the phases of the N process in the case of m Markov states.

As previously operated with non-Poisson arrivals, an embedded Markov chain can be extracted to lead to a finite two-dimensional state space (L_n, J_n) : $\{0, ..., B_M\} \times \{1, ..., m\}$. As the transitions from state to state occur at the random moments of departures, the process is no longer a Markov chain but rather a semi-Markov chain. Let $\bar{\pi}$ denote the stationary queue length probability density at the departure times

$$\bar{\pi} = [\bar{\pi}_0,, \bar{\pi}_{B_M-1}] \tag{5.278}$$

where the vectors $\bar{\pi}_n$ are further decomposed according to the different phases as

$$\bar{\pi}_n = [\pi_{n,1}, ..., \pi_{n,m}] \qquad 1 \leq n \leq B_M - 1 \tag{5.279}$$

with limiting probability densities given by

$$\Pi_{n,i} = \lim_{k \to \infty} Pr[L_k = n, J_k = i] \tag{5.280}$$

The transition matrix Q of the semi-Markov chain is given by

$$Q = \begin{vmatrix} B_0 & B_1 & B_2 & \cdots & B_{B-1} & \sum_{k=B}^{\infty} B_k \\ A_0 & A_1 & A_2 & \cdots & A_{B-1} & \sum_{k=B}^{\infty} A_k \\ 0 & A_0 & A_1 & \cdots & A_{B-2} & \sum_{k=B-1}^{\infty} A_k \\ \cdot & \cdot & \cdot & \cdots & \cdot & \cdot \\ 0 & 0 & 0 & \cdots & A_0 & \sum_{k=1}^{\infty} A_k \end{vmatrix} \tag{5.281}$$

where A_n and B_n are [m,m] sub-matrices to be estimated. The $(i,j)^{th}$ element of A_n is the conditional probability that at the end of a service period there have been n arrivals and the phase of the N process is j, conditioned to starting this period in phase i.

The matrices B_n's are furthermore defined as

$$B_n = \sum_{k=1}^{n+1} U_k A_{n-k+1} \tag{5.282}$$

with the element (i,j) of U_k expressing the conditional probability that the arrival which starts a busy queue period of size k and arrives at the system with the N process in phase j, conditioned to the N process being in phase i at the last departure from the previous busy period. No explicit or formal expressions for those sub-matrices A_n and B_n really exist, except in the case of the Poisson process. Therefore, intricated but efficient algorithms have been developed for the computation of those sub-matrices [22]. The computation of the stationary probability vector Π is deduced from the eigenvector of the matrix Q since in this case

$$\bar{\Pi} = \bar{\Pi}Q \qquad \bar{\Pi}u = 1 \tag{5.283}$$

with $u = [1....1]$.

To illustrate the characteristics of a particular case of N process, the performances of the MMPP(2) are reviewed in terms of the influence of the moments. The queue length PDF at any time t has been obtained by application of the key renewal theorem [27]. The queueing performances have been deduced in different configurations of rate of traffic arrival. Figure 5.27 presents the influence of the queue load, Figure 5.28, the third moment of the arrival rate and Figure 5.29, the variance of the arrival rate.

5.3.2.5 Liquid Models

Liquid or fluid-flow modeling refers to continuous-space queue with continuous-time inter-arrival times. Let q(t) be the level of queue occupancy and c the constant depletion rate. The input flow is continuous-time and driven by a Markov process with M states. Each state i is characterized by a specific arrival rate λ_i, $0 < i \leq M$. The $M \times M$ matrix Q is the infinitesimal generator of the Markov process and contains probabilities $r_{i,j}$ of transition from the state i with rate λ_i to the state j with rate λ_j. Another matrix of the same size called Γ can be defined as a diagonal matrix built with the M different filling rates associated to each Markov state. Therefore, $\Gamma = \text{diag} \{\gamma_1, \gamma_2, ..., \gamma_m\}$. The total system is completely characterized by three parameters $[M, \Gamma, c]$.

Let r, f_i and $F(t)$ be defined as respectively,

1. the stochastic state : r.

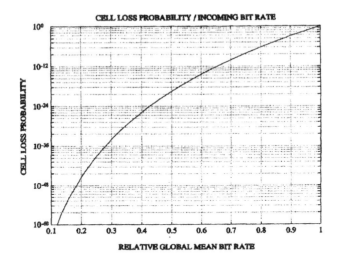

Figure 5.27: Model based on MMPP(2): $var = 0.06$, $\tau = 10$, $\mu_3 = -10$, $B_M = 64$.

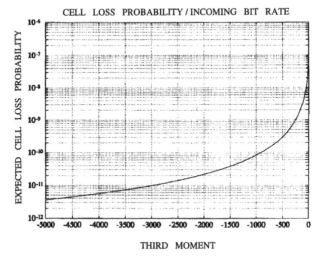

Figure 5.28: Model based on MMPP(2): influence of the third moment, $B_M = 64$.

5.3. Queueing Models for ATM Multiplexers *427*

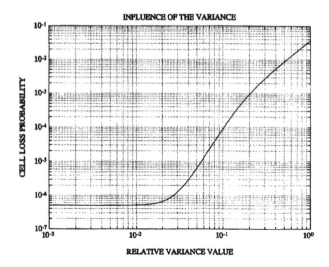

Figure 5.29: Model based on MMPP(2): influence of the variance $B_M = 64$.

2. the probability to sojourn in state r : $f_i = Pr[r = i,$ at time t, $1 \geq i \geq M]$.

3. the state probability vector : $\bar{F}(t) = (f_1, f_2,, f_M)$.

According to the Markov process, the model

$$\frac{d\bar{F}(t)}{dt} = M\bar{F}(t) \tag{5.284}$$

Furthermore, let a new set of stochastic variable be defined

1. the stochastic queue occupancy : $q(t)$.

2. the probability $P_i(t, x)$ that at time t the level of queueing occupancy $q(t)$ be lower or equal to x with respect to an input flow in state i. That is

$$P_i(t, x) = Pr[\lambda(t) = \lambda_i \wedge q(t) \leq x] \tag{5.285}$$

where the sign \wedge stands for the logical AND operation.

3. the stochastic vector of probability : $\bar{P}(x, t) = [P_1(t, x), P_2(t, x), ..., P_M(t, x)]$

Any elementary transition from time t to time $t + \Delta t$ leads in the first order approximation to a balance formulated as M equations

$$P_i(t + \Delta t, x) = \sum_{j \neq i} r_{j,i} \, P_j(t, x) \, \Delta t \tag{5.286}$$

$$+ (1 - \Delta t \sum_{j \neq i} r_{i,j}) \, P_i[t, x - (\lambda_i - c)\Delta t] \tag{5.287}$$

$$+ \mathcal{O}(\Delta t^2) \tag{5.288}$$

Taking the limit of an elementary time variation ($\Delta t \to 0$) and defining $\bar{P}(t, x)$ as the vector with the M components $P_i(t, x)$, the model ends up with the matrix partial differential equation

$$\frac{\partial \bar{P}(t, x)}{\partial t} + (\Gamma - cI) \frac{\partial \bar{P}(t, x)}{\partial x} = M \bar{P}(t, x) \qquad (5.289)$$

where the matrices I, Γ and M are respectively the identity matrix, the diagonal matrix of the arrival rates $\Gamma = diag(\lambda_1,, \lambda_m)$, the rate transition matrix with elements

$$m(i, j) = \begin{cases} r_{j,i} & \text{if } i \neq j \\ -\sum_{\substack{j=1 \\ j \neq i}}^{M} r_{i,j} & \text{if } i = j \end{cases} \qquad (5.290)$$

In the stationary case,

$$\frac{\partial \bar{P}(t, x)}{\partial t} = 0 \qquad (5.291)$$

As a consequence,

$$(\Gamma - cI) \frac{d\bar{P}(x)}{dx} = M \bar{P}(x) \qquad (5.292)$$

If none of the arrival rates λ_i equals the service rate, then the differential equation admits m modes to be the eigenvalues of the matrix $(\Gamma - cI)^{-1} M$. Let γ_i and $\bar{\phi}_i$ be the eigenvalues and eigenvectors. Hence, it follows

$$\{M - \gamma_i(\Gamma - cI)\}\bar{\phi}_i = (0, ..., 0)^T \qquad 0 \geq i \geq M \qquad (5.293)$$

by definition of the eigenvalues and also, in terms of a determinant equation of degree m in both γ and c

$$\det\{M - \gamma(\Gamma - cI)\} = 0 \qquad (5.294)$$

The M eigenvectors and eigenvalues are attributed to the system $[M, \Gamma, c]$.

The general solution is given by

$$\bar{P}(x) = \bar{P}(\infty) + \sum_{\forall i | re(\gamma_i) < 0} a_i \bar{\phi}_i \exp \gamma_i x \qquad (5.295)$$

where the coefficients a_i are yet unknown. $\bar{P}(\infty)$ must be finite meaning that terms pertaining to eigenvalues with positive real part must be absent. The column sums of matrix M being zero, there is one zero eigenvalue which contributes in Equation 5.295. Now, $\bar{P}(\infty)$ are easily deduced from what follows

$$
\begin{aligned}
P_i(\infty) &= Pr[r = i \wedge x \geq \infty] & (5.296) \\
&= Pr[r = i] & (5.297) \\
&= Pr[\lambda(t) = \lambda_i] & (5.298) \\
&= f_i(t) & (5.299)
\end{aligned}
$$

Thus, $\bar{P}(\infty) = \bar{f}$. The determination of the remaining coefficients a_i is carried out exploiting the obvious fact that an empty queue is inconsistent with filling at a rate γ_i exceeding the depletion rate c. Hence,

5.3. Queueing Models for ATM Multiplexers

$$P_i(0) = 0 \qquad \forall i \mid \gamma_i - c > 0 \tag{5.300}$$

It follows directly that

$$\sum_i a_i \phi_i(j) = -P_j(0) \qquad \forall i \mid \gamma_i - c > 0 \tag{5.301}$$

According to a lemma demonstrated in Reference [20], if the condition of stability is fulfilled, the number of eigenvalues γ_i of $(\Gamma - cI)^{-1}M$. with negative real part equals the number of elements γ_i exceeding c. Owing to that lemma, the number of limit equations is expected to be equal to the number of unknown coefficients a_i. This completes the model characterization.

The steady-state distribution of the buffer of occupancy x is given by

$$F(x) = Pr[q(x0 \le x] = \sum_{i=1}^{M} P_i(x) \tag{5.302}$$

and the probability that the buffer exceeds a certain length is given by the survivor function of the distribution as $1 - F(x)$. The model leads to an asymptotic approximation of the PDF g(x) that the buffer level exceeds a given value x when the level increases. The asymptotic approximation is given as $g(x) = Ce^{-\alpha x}$ as $x \to \infty$. That negative exponential rate is forced by the dominant eigenvalue. As a major contribution brought by the liquid approximation. This model enables to consider non-stationary and transient queueing behaviors. It is illustrated in Figure 5.30 where it presents the cell loss probability in the following configuration

1. the $P_i(\infty) = Pr[\lambda(t) = \lambda_i]$ are distributed according to a Gaussian PDF with a shape specified in the figure by different coefficients of variation i.e. standard-deviation-to-mean ratios.

2. the elements $r_{i,j}$ of the Markov transition matrix were such that the transition probabilities in negative exponentials with a decay factor of 0.7 on both sides of the current state i.

3. 20 Markov equidistant states were considered. Each state represents a given slice of bit rate.

5.3.3 Contribution of the Study of Multiplexing

The progress accomplished so far in the chapter will be discussed first on the point of view of the queueing processes and, thereafter, in conjunction with the superposition. To begin with, Table 5.1 presents a comparative description of the different queueing representations. The models are numbered in the order of presentation in this chapter as retrospectively model 1, the discrete-space queue and discrete-time inter-arrivals, model 2, the MMBP(2), model 3, the DMAP, model 4, the N/G/1 and model 5, the fluid-flow system. Let us remark that all the five previous models have been numerically developed

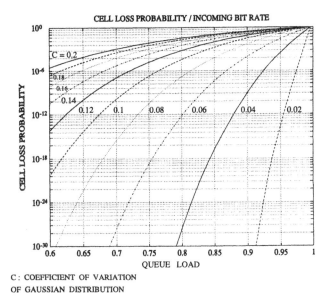

CELL LOSS PROBABILITY / INCOMING BIT RATE

C : COEFFICIENT OF VARIATION
OF GAUSSIAN DISTRIBUTION

Figure 5.30: Cell loss rate at different relative mean bit rates. Model based on fluid-flow approximations, $B_M = 64$.

Modeling tool	relevance for TV traffic	cell loss characteristics range	accuracy of the model
Model 1	poor	mean, $10^{-30} \leftrightarrow 1$	high
Model 2	medium	mean, $10^{-30} \leftrightarrow 1$	high
Model 3	high single TV traffic	mean, $10^{-30} \leftrightarrow 1$	high
Model 4	high single TV traffic TV multiplexing	mean, $10^{-30} \leftrightarrow 1$	high
Model 5	high similar to 4	mean, $10^{-30} \leftrightarrow 1$	approximation
Computer simulations	high	mean, $10^{-6} \leftrightarrow 1$, cell loss configurations	moderate

Table 5.1: Comparison of multiplexing models for TV applications.

on computer in the framework of this textbook and have not been taken as granted from the literature. As a matter of comparison, the performances of computer simulations have been taken into consideration in the table.

The modeling issue has proceeded here one step further by deriving queueing models which match to TV source superposition and arrival characteristics i.e. model 3, 4 and 5. These models correspond to the superposition of Markov modulated Poisson processes and model 3 with the superposition of semi-Markov processes. The first option corresponds to the ATM free VBR transmission and the second model will turn out to correspond to the optimum way of transmitting TV on an ATM channel.

The influence of the short term serial correlations, of the second and third moments of $\lambda(t)$ on the queueing performances has been clearly evidenced through the queueing performances. The Poisson process turns out to be an upper bound reference for queueing performances since it turns out to be the most efficient random process to access a queueing system when the serial correlation coefficient is positive as observed in the bit rate measurements.

Experimentally, two working modes have been evidenced when superposing and queueing TV sources. They depend on the capacity of the correlative interaction among the inter-arrival times

1. for slightly loaded multiplexers (0 to about 10 cells), the arrival process behaves approximatively like a Poisson process, the queueing system is M/D/1 and the cell losses are random. This applies for loads ranging in the interval $\rho \in [0, 0.8]$.

2. for heavy loaded multiplexers (10 to 64 cells), the arrival process is bursty as a consequent of the cumulative correlations, the queueing system is G/D/1 and the cell losses are bursty.

The multiplexing turns out so far to be very sensitive to the characteristics of the superposed source traffic. This means that source statistics have to be precisely known by the network management when free variable bit rate sources are intended to be transmitted on the network. The need to accurately describe the source statistics at several time-scale resolution constitutes the Achille's heel of the ATM multiplexing and the price to be paid to yield the maximum gain. From Chapter 3, it is indeed already known that the statistical description of the sources will require to take into account several moments of the PDF and eventually the correlation structure. Nevertheless, despite that effort of source description, the performance sensitivity to misappreciation is also likely to remain non-negligible. As a partial conclusion, enforcements of the source variability at several time-scale will turn out to be necessary to cope with those problems. Imposing bit rate gauge eliminates the potentiality of misappreciation and ease the source description.

5.4 Performances of ATM Multiplexers

Three performances of a multiplexer are going to be investigated in the following. These are namely the random transmission delays, the gain in statistical multiplexing and the cell loss rate.

5.4.1 Random Transmission Delay

As a consequence of the ATM network transmission in queues, the cell transfer from the encoder to the decoder is affected by a random delay. Two components characterize this delay

1. the *delay to access the network* i.e. the delay between the moment when the cells are assembled in the packetizer and the moment when they find access into the network in an empty time slot and are launched for transmission.

2. the *delay of transmission* i.e. the delay for the cells to transit through the switching nodes and the multiplexing queues of the network.

In this section, an emphasis is given only to the second component of the delay since the value of the first component is a quantity accessible in the encoder and corrigible in the decoder.

The ATM transmission delay is in fact composed of deterministic and stochastic quantities. The deterministic part is a function of several parameters referring to the end-to-end distance, the mean network load and the number of switching nodes. The stochastic part is a function of the mean network load and the number of switching nodes along the virtual path.

1. the *deterministic delay* is made of a constant (the transmission on the optical fiber links, the switching delay) and of a variable contribution function of the load (the switching delay increases with the load).

2. the *stochastic delay* arizes from the queueing waiting times $D_{N,i}$ in the successive multiplexers i: $D_N = \sum_{i=1}^{N} D_{N,i}$. It is therefore tributary of all the parameters influencing the PDF of the queue occupancy at cell arrival, namely the load, the traffic of all the individual sources involved in the multiplexing, the correlation function of the superposed inter-arrival times i.e. the correlations between and within the user sources. As a matter of fact, the sum of independent random variables $D_{N,i}$ has a PDF which converges to a Gaussian PDF according to the central limit theorem. The resulting PDF is computed in case of independence among the random variables as the convolution of the individual PDF's

$$
f(D_N) = \overset{N}{\underset{i=1}{*}} \; f(D_{N,i})
\tag{5.303}
$$

In the case of dependence of two variables, the PDF of the sum $z = D_{N,i} + D_{N,i+1}$ is given by

$$
f_z(z)dz = \int_{-\infty}^{+\infty} f_{D_{N,i},D_{N,i+1}}(z - D_{N,i+1}, D_{N,i+1}) \, dD_{N,i+1} \, dz
\tag{5.304}
$$

As the waiting times have always positive values, the waiting PDF's for one queue will inevitably present a positive skewness and the resulting PDF after N nodes will always be skewed. Let us remember that the central limit theorem states a convergence in distribution to signify that this convergence can be fulfilled weakly in some part of the repartition function. To help understanding the problem, Berry-Esseén's theorem is of interest to give an upper bound of deviation from normality for the normalized PDF $f(D_N)$. Indeed, if

$$E\{D_{N,i}^3\} \leq c\sigma_i^2 \quad \text{for all i} \tag{5.305}$$

where c is some positive real value, then for all D_N the normalized PDF of $f(D_N)$ is close to the normal PDF $G(D_N)$ in the sense of the following bound

$$|f(D_N) - G(D_N)| < \frac{4c}{\sqrt{\sum_{i=1}^{N} \sigma_i^2}} \tag{5.306}$$

Figure 5.31 presents the PDF of the stochastic delay for a transmission on 20 nodes (in practice, ATM networks are not intended to introduce more than 20 nodes between transmitters and receivers).

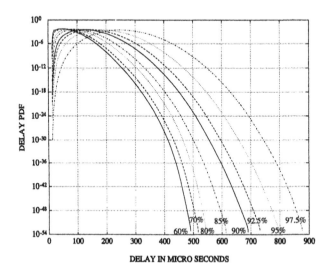

Figure 5.31: PDF of the random delay with 20 nodes in the network with Poisson traffic.

Chapter 5. Statistical Multiplexing

5.4.1.1 Definition of Jitter

Two random delays have been defined when transmitting on ATM networks, namely the delay to access the network and the delay to be transmitted. The problem of the delay is crucial when wanting to build a clock recovery algorithm within the decoder. For this purpose, time stamps are sent regularly spaced in time from the encoder and received affected by a random variable delay superposed on the proper period of origin.

Figure 5.32 presents the different delays. Let T_C be the period of time stamp generation (500 μs in practical TV applications). How to characterize the resulting period at the input of the decoder? Let $D_P(k)$ and $D_N(k)$ be the random delays of the k^{th} cell respectively in the packetizer and in the network. The resulting period T_J observed by the decoder corrupted by random delays is given by

$$T_J = T_C + [D_P(k+1) + D_N(k+1)] - [D_P(k) + D_N(k)] \tag{5.307}$$

the delays $D_P(k)$ and $D_P(k+1)$ can be removed in the decoder by inserting in one data field of the time stamp the most significant LSB's of the reference encoder clock at the exact instant of launching the cell into the networks. As a matter of fact, the equation becomes

$$T_J = T_C + D_N(k+1) - D_N(k) = T_C + \Delta D_N(k+1) \tag{5.308}$$

The difference of two consecutive transmission delays is the random process to be removed i.e. $J(k) = \Delta D_N(k)$ which is called the *jitter*. The PDF of the jitter is given by the convolution $f(J) = f(D_N) * f(-D_N)$ which extends the PDF simultaneously towards negative and positive values of the axis $J(k)$ without any skewness in this case. The PDF converges closely to a Gaussian shape when considering a minimum of 5 to 10 queueing sojourn times.

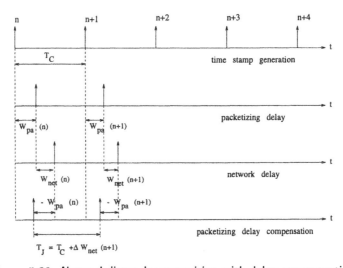

Figure 5.32: Network jitter decomposition with delay compensation.

5.4.2 Gain in Statistical Multiplexing

The gain in statistical multiplexing G_{SM} can be defined according to two different points of view, namely the *network side* and the *image coding side*. In both cases, the gain is defined at constant quality. This means respectively at constant cell loss rate and at constant subjective image quality.

5.4.2.1 The Network Side

According to the layered TV models developed in Chapter 3, the gain can be defined statistically at different levels depending on which layer the TV models refer. Consequently, four different gains can be considered to correspond to four layers, namely the cell inter-arrival level, the stripe level, the image level and the scene level. In any of these, the gain is defined at constant network quality as the ratio of

1. the sum of the bandwidths to be allocated to each source individually.

2. the bandwidth to be allocated to the multiplexed resulting source.

Let us notice that the definition of the bandwidth has to be identical in both numerator and denominator. The definition of the optimum bandwidth is a topic studied in Chapter 7. In any case, the bandwidths have to be estimated at constant network quality and it will turn out in Chapter 6 precisely that the mean cell loss rate is the major parameter relevant to specify the quality of an ATM channel aiming at transmitting TV information. The bandwidth has therefore to be defined at constant cell loss rate.

Gain at the Cell Level

Each individual source is characterized by an inter-arrival process defined as a traffic characteristic. The resulting effect of the network on the sources is eventually the cell loss occurrence induced when enqueued in the multiplexers. As a function of both the traffic characteristics and the queueing models defined with finite queue length, the deterministic rate of queueing service represents the total bandwidth which can be allocated to achieve a given cell loss (defined the network QOS). This topic is studied in Chapter 7. The superposition of two sources furnishes a new traffic with computable characteristics. This results in a traffic equation which requires a determined service rate to yield an identical mean cell loss rate according the same queueing conditions. At this stage, the bandwidth to be allocated to a traffic can be defined as the rate of service necessary for the queue to achieve the required QOS at a fixed queue length and the gain in statistical multiplexing as a ratio of those bandwidths

$$G_{SM} = \frac{\sum_{i=1}^{N} c(i)|_{QOS=cte}}{c_T|_{QOS=cte}} \tag{5.309}$$

where $(c(i)|_{QOS=cte})$ is the service rate related to the traffic generated by the source i and $(c_T|_{QOS=cte})$ the service rate of the multiplexed traffic at equal queue length. All are determined at constant cell loss rate. As evidenced in Chapter 7, the bandwidth depends

of the cell inter-arrival characteristics and of the bit rate PDF's as well. The optimum allocation will turn out to be quasi-optimum when evaluating bit rate on image spans. For the shake of simplicity, both components are not merged in the sequel.

Gain at Stripe/Image/Scene Levels

In this case, the bandwidths are obtained from the bit rate PDF evaluated on spans equal to stripe, image or scene (in terms of mean image bit rate). The bandwidths are all computed with the same QOS i.e. with a mean cell loss rate of 10^{-n} by considering the survivor function of the bit rate PDF at 10^{-n}. In the case of a Gaussian PDF, the survivor function at 10^{-n} is given by the quantity: $m + f_{\epsilon}\sigma$ where f_{ϵ} is the ϵ fractile given in Table 5.2, m is the mean bit rate value and σ is its standard deviation. The estimations to be performed here do not take into account the queueing performances and derive gains as if the queues were optimally monitored. The thorough computation of the bandwidth will be presented in Chapter 7.

n	$P = 10^{-n}$	f_{ϵ}
4	10^{-4}	3.8
5	10^{-2}	4.6
6	10^{-3}	4.8
7	10^{-7}	5.2
8	10^{-8}	5.6

Table 5.2: Fractile values for Gaussian PDF.

The gain in allocating bandwidths in the network stems from the property of contraction of VBR PDF's when multiplexing as deduced from the Bienaymé-Tchebitchev inequality. The contraction is lowered down to zero in cases where the PDF correlation factor approaches $+1$. The allocation of a first source at $m_1 + f_{\epsilon}\sigma_1$ requires that exact amount of bandwidth, but when allocating a second source at $m_2 + f_{\epsilon}\sigma_2$, it allows reserving a global bandwidth equal to $m_1 + m_2 + f_{\epsilon}\sigma$ which is smaller that the sum of those two bandwidths taken separately because $\sigma \leq \sigma_1 + \sigma_2$, equality being reached only for perfectly correlated sources. The bandwidth allocated to each source may be virtually lower than that one allocated if they were alone. The gain is higher when more sources are multiplexed. When the source is alone, the requested bandwidth equals the rate $m + f_{\epsilon}\sigma$ at 10^{-n}. When the number of sources in the multiplexing is incremented, the virtual bandwidth is decreased. In the case of Gaussian PDF's, the gain at equal QOS is given by

$$G_{SM} = \frac{\sum_{i=1}^{N}[m(i) + f_{\epsilon}\sigma_i]}{\sum_{i=1}^{N} m(i) + f_{\epsilon}\sigma_{res}} \tag{5.310}$$

where the value f_{ϵ} of the fractile is related to the required QOS of 10^{-n} in Table 5.3. and $\sigma_{res} = \sqrt{\sum_{i=1}^{N} \sigma_i^2}$. The G_{SM} increases when n, f_{ϵ} and σ_i increase and when the mean decreases. In any case, the G_{SM} is greater or equal to unity. As observed in the study of the source models, the mean image bit rate per scene is Gaussian and the G_{SM} matches perfectly with the Formula 5.310. At the scene level, the gain arizes from the

wide diversity of mean image bit rates displayed when multiplexing independent scenes. The variance of stripe bit rates is larger than that of image bit rates, therefore the gain is higher when multiplexing at the stripe level but at the expense of allocating larger bandwidths as shown in Chapter 7.

Table 5.3 gives an example of such gain obtained at U=10 with 15 different actual sources of TV. The gain was computed with image bit rates. Each time, the gain increases of 7%, the bandwidth for an additional source is gained.

B_W: 10^{-n}; n=	2	3	4	5
Gain	1.47	1.43	1.39	1.33

Table 5.3: Gain in statistical multiplexing.

Tables 5.4 and 5.5 examine the question of how the gain in statistical multiplexing diminishes when correlation is introduced among TV sources. To be enlightened with some gain figures, correlation coefficients ρ of 0.2, 0.4, 0.6 and 0.8 were successively considered as if the sources would be correlated two by two of the same amount. The stripe bit rate is here taken as reference and the bandwidths ensure a cell loss of 10^{-8}. All the sources were supposed to behave like the sequences *TEMPETE* and *MOBILE AND CALENDAR*. In addition, the bottom of the tables indicates the global mean bit rate and the deviation necessary for the individual bandwidths to reach the cell loss probability of 10^{-8}.

Number of sources	5	10	15	20	25
Correlation Coefficient					
$\rho=0$	1.416	1.571	1.651	1.703	1.740
$\rho=0.2$	1.270	1.334	1.359	1.372	1.380
$\rho=0.4$	1.174	1.206	1.218	1.224	1.228
$\rho=0.6$	1.103	1.119	1.125	1.127	1.129
$\rho=0.8$	1.046	1.053	1.055	1.056	1.057
mean bit rate (Mbits/s)	91.99	183.98	275.97	367.56	459.945
$5.61 \times N \times \sigma$	164.4	208.8	313.2	417.7	522.1

Table 5.4: G_{SM} for the sequence *TEMPETE*, U=86, coder-model 2.

5.4.2.2 On Coding Side

The gain is defined here at equal subjective image quality (with reference to score notes defined in Chapter 2) or objective image quality (with reference to signal to noise ratio) and compares CBR transmissions to VBR ones. The gain in statistical multiplexing is defined as the ratio of the bandwidths, B_W, to be dedicated if the transmissions were performed in CBR mode to the bandwidths to be dedicated if the transmissions were performed in VBR mode.

$$G_{SM} = \frac{B_W[N \ SOURCES \ CBR]}{B_W[N \ SOURCES \ VBR]} = \frac{\sum_{i=1}^{N} CBR(i)}{\sum_{i=1}^{N} m(i) + f_e \sigma_{res}} \qquad (5.311)$$

Number of sources	5	10	15	20	25
Correlation Coefficient					
$\rho=0$	1.326	1.438	1.493	1.528	1.553
$\rho=0.2$	1.217	1.265	1.264	1.294	1.300
$\rho=0.4$	1.142	1.167	1.176	1.181	1.184
$\rho=0.6$	1.085	1.098	1.102	1.105	1.106
$\rho=0.8$	1.039	1.044	1.046	1.047	1.047
mean bit rate (Mbits/s)	114.75	229.50	344.25	459.00	573.75
$5.61 \times N \times \sigma$	92.0	184.1	276.1	368.2	460.2

Table 5.5: G_{SM} for the sequence *MOBILE AND CALENDAR*, U=86, coder-model 2.

Let us remark that in the balance of the quality, both effects of cell losses and quantization noise have to be taken into account in the comparison and that it has to be specified that the cell loss protection was activated. Table 5.6 presents an estimate of the G_{SM} at different values of the transmission factor U.

U	72	84	98
mean bit rate (Mbit/s)	30.0	22.5	17.0
Gain	1.48	1.51	1.62

Table 5.6: Gain in statistical multiplexing at 10^{-8}.

Table 5.7 presents the peak signal to noise ratio measured on a coded sequence (coder-model 2) in a CBR mode with bit rates ranging from 9.0 up to 31.5 Mbit/s. The signal to noise ratio is defined as $SNR = 10 \log \frac{256^2}{MSE}$ where $MSE = \frac{\sum (x_{cod} - x_{or})^2}{M}$ is the mean squared error, x_{or} and x_{cod} represent the original and the coded pixels, the summation is performed per component on all the image pixels. Table 5.8 presents the signal to noise ratio measured on the same sequence of real time TV in a VBR mode at various constant value of the transmission factor. The mean bit rates given in Table 5.8 correspond to the mean achieved by the TV programme of 1.5 hour which contains that sequence.

constant bit rate (Mbit/s)	31.5	23.0	19.5	15.8	12.0	9.0
luminance	32	28	24	22	19	17
chrominance CB	31	30	29	29	19	17
chrominance CR	32	33	31	30	30	28

Table 5.7: Component SNR values in [dB] to qualify image objective quality in CBR modes.

5.4.3 Cell Loss Probability

Although the network management will qualify the cell losses in terms of a mean probabilistic value, this parameter is not actually satisfactory to characterize completely cell loss occurrences. The knowledge of the temporal repartition of the loss occurrences is indeed of importance and, precisely, the question is to know how far it is random, bursty

transmission factor	10	20	30	40	50
mean bit rate (Mbit/s)	24.30	21.06	12.11	7.03	5.42
luminance	31	30	24	20	18
chrominance CB	30	30	30	27	18
chrominance CR	33	33	33	31	28

Table 5.8: Component SNR values in [dB] to qualify image objective quality in VBR modes.

or both and, further, to know which parameters will influence the phenomenon. The cell losses have been computed according to the queueing models developed previously in the chapter. Each of them allows determining mean expected values of the cell loss probability in one queue according to the different characteristics of the superposed cell arrival processes. None of those models can furnish an explanation of how cells are lost in a multiplexer. In fact, bursty and random losses can be expected to occur concurrently in different proportions as bursty losses during queue congestions which result from persistent traffic correlations and random losses during temporary insulated overflows. Simulations have to be performed to foresee the PDF's of bursty arrivals. Therefore, the section is organized as follows. A discussion is initiated about the mean cell loss rate, an experiment to characterize the cell loss occurrence is thereafter described, to end up, models for the cell loss occurrence are proposed out of the literature.

5.4.3.1 Analysis of Mean Cell Loss

The analysis of the mean cell loss probability has been performed with various theoretical queueing models and had led to the following indications

1. the central reference position held by the queue with Poisson arrivals has turned out to achieve the best queueing performances since serial correlations expected in traffic are non-negatively valued. The performance degradations arising from bursty arrivals, in other words strong effects of the short-term correlations, have been evidenced.

2. the statistical-parameter influences of the incoming traffic presented either through the inter-arrival times or through the counting process have been put forward in terms of short-term and long-term correlations, second and third moments,...

3. the shape influence of the multiplexed traffic PDF has been shown by means of fluid-flow models.

All those performance results demonstrate the high sensitivity of the mean cell loss rate to the statistical characteristics of the input traffic. Some main partial conclusions can be pointed out as follows

1. the importance of precisely characterizing the input traffics and of performing accurate computations of bandwidth to be allocated in order to ensure a mean level of transmission quality.

2. the importance of enforcing the source traffic to guarantee its keeping the same characteristics and, therefore, to avoid too long network congestions.

3. the importance of achieve an optimum throughput in the network by a refined knowledge of TV traffic. It is not a negligible problem to be taken into consideration since TV and HDTV sources intend to occupy the major portion of the available transmission bandwidth. An effort towards an optimum transmission of variable-bit-rate sources can allow gaining the admission of additional TV sessions on the same bandwidth while maintaining the same transmission quality.

This shows the importance to implement an enforcement function into the coder packetizers as preventive policing and into the network on the source connection as repressive policing.

5.4.3.2 Experimental Approach to Cell Loss Occurrence

Four different simulations are mentioned here and referred to as *ex1*, *ex2*, *ex3* and *ex4*. They have involved the multiplexing of 15 different TV sources taken among the bit rate database of the actual time TV presented in Chapter 3. The transmission factor was fixed and equal to 10. The mean cell loss rate aimed to be 10^{-3}. The rate of service (of a queue of 64 cells) has been computed and adapted to reach that target. Let us denote by D the generation obtained when a *Deterministic time division* of the period is of concern: D means that the cells are generated with fixed intervals of time computed according to the amount of cells to transmit over a given time extent. Let F signify *Free to fluctuate* and let R denote the *Random generation* obtained when the cell generation is performed according to a pure Poisson process i.e. independent intervals with an exponential PDF. In the experiment, three different time scales of bit rates will be taken into consideration, namely the image, the stripe, the cell inter-arrival time. The way of launching cells into the network within each time scale is introduced in a notation built as follows [image/stripe/inter-arrival time]. Four experiments are reported as follows

1. [*ex1*: F/D/D] the image bit rate is free to fluctuate and is collected into a buffer. The amount of data stream corresponding to one image is packetized and sent with equal cell interval times during the following image period. The starting time of the different sources is randomly distributed.

2. [*ex2*: F/R/R] the conditions are identical to case 1, except that here the cell generation is randomly distributed within the next image period.

3. [*ex3*: F/F/D] both image and stripe bit rate are let free to fluctuate. The bit stream is collected into a buffer and the amount of data stream corresponding to one stripe is packetized and sent with equal cell interval times during the following stripe period. The different sources start with randomly distributed times.

4. [*ex3*: F/F/R] the conditions are identical to case 3, except that the cell generation is here randomly distributed within the next stripe period.

EX1	EX2	EX3	EX4
1.50 E-03	1.03 E-03	4.41 E-03	3.40 E-03

Table 5.9: Mean cell loss rates in the experiments.

Table 5.9 demonstrates the gain obtained by sending randomly cells into the network. The performances are also higher when the periods of cell accumulation span over image intervals. The way by which the bursts should occur depends on the algorithms to allocate the bandwidths for multiplexing as follows. If allocation is based on mean image bit rates per scene, the bursts have an higher probability to be large and localized within entire consecutive difficult images or scenes. On the contrary , when allocating on a stripe bit-rate basis, the bursts could be shorter and more spread at the expense of requiring a somewhat larger bandwidth. A further discussion of the problem will take place in Chapter 7.

As an important point to be mentioned, this section has demonstrated the importance of smoothing the cell traffic at the output of coders and of temporarily accumulating the data stream in a buffer over the long time spans before launching cells on networks. These conditions contribute to increase the mean multiplexing performances since they allow the generation of pure Poisson arrivals i.e. removing the serial correlation produced by the variable length entropy coders and the smoothing of the short-term sub-image bit-rate variabilities.

5.4.3.3 Models for Cell Loss Arrivals

Cell losses characterizing telecommunication channels occur partially in bursts and partially as isolated random defects. Models with clustered errors have already been considered in the literature. Some of the best known models are namely the Gilbert model, the Neyman (type A) model, the Pareto model and the Mandelbrot model.

1. Gilbert's model suggests that a channel has a Markovian transition probability between two states referred to as one *single good state* with small error probability and one *single high state* with large error probability [11].

2. Neyman's model assumes a Poisson error occurrence with error propagation around each of them, the length of the extent being also Poisson with a specific mean [30].

3. Pareto's model proposes a probability of the inter-error interval U in the form of $P(u) = Pr(U \geq u) = u^{-\theta}$ with $0 < \theta$. To express burstiness, it attributes, to small and to large values of inter-error intervals, probability density superior to those given by the geometric PDF [24].

4. Mandelbrot's model uses fractal theory. Mandelbrot began with studying the behavior of rivers in terms of the epochs where floods and droughts occur. He notably showed how to explain long term statistics and burstiness with the accumulation of small short term correlations. According to Mandelbrot's theory [24], experimental statistics of error occurrences indicate that errors are grouped in bursts (or clusters), these ones are in turn grouped also in bursts and so on. to constitute a whole

hierarchy of bursts at different time scales. Only a few stochastic processes can take into account such behaviors. These are known as fractional Brownian motion or diffusion processes with correlated increments. The set of the loss occurrence instants is a fractal set with a given Hausdorff dimension specifying the density of the losses. These accumulations of short term correlations look similar to those described experimentally by the $c_{k,n}^2$ which has contributed to explain the burstiness effects of cell arrivals and those of queue level fluctuations. Further work should be devoted to investigating whether or not, on heavy load conditions, the queueing level of occupancy behaves as coarsely discretized hydrologic problems.

Unfortunately, none of those models are completely satisfactory and, consequently, further work on that subject will be proposed in Chapter 7 using computer simulations performed on the database of the actual TV signals.

5.5 Conclusions

This chapter plays in some sense a key role in this textbook, indeed

1. in Chapter 3, TV sources have been practically characterized by statistical descriptions and modeling efforts.

2. in this chapter, the main aspect of the ATM transmission has been tackled, that is the statistical multiplexing.

3. in Chapter 7, source characteristics and multiplexing will be conjugated in the effort of searching an optimum way to transmit TV sources on ATM channels. This will allow defining a precise bandwidth, characterizing efficient source traffic descriptors and deriving policing actions.

The chapter has been decomposed into three consecutive topics of study which have dealt with source superposition, queueing models and performance evaluations. The source superposition and the queueing have been modeled in agreement with the source models developed in Chapter 3. The performances have evaluated advantages and drawbacks of the statistical multiplexing.

Concerning the superposition of the source arrivals, theory, experiment and modeling have been merged in order to explain the nature of the phenomenon and its related time scales and to infer realistic models of superposed traffics. At least two models turn out to be of importance, the superposition with Markov modulated Poisson processes and the superposition with semi-Markov processes. They characterize either free VBR sources or enforced VBR sources. Both models will be of interest in Chapter 7.

The field of modeling queueing systems has tremendously progressed during the eighties, this chapter has presented an in-depth study of the field which is still covered with numerical solutions (a current active subject of research). Five families of models have been presented, the first one as a starting reference and the other ones as link to the previous models of superposed traffics. These are respectively the queueing model for MMPP(2) traffic and the queue fluid-flow approximation for Markov modeled traffic.

The queueing characterization terminates the search towards modeling ATM statistical multiplexing. Some refinements of an additional order of precision are left as further work i.e. the precise modeling of queueing system with MMPP(m) instead of the fluid-flow approximation.

As a major achievement obtained from the performance evaluations, it can be definitively stated that, in comparison with constant-bit-rate transmissions, a gain in coding and transmission efficiency can definitely be expected when multiplexing statistically VBR TV sources on ATM channel. A gain of the order of 1.30 is foreseeable when multiplexing for instance fifteen different sources of 15Mbit/s. This opens a space to add four new TV channels on the same bandwidth while maintaining transmission quality. To characterize again the performances of a multiplexer, some main features are to be recalled

1. the gain in statistical multiplexing has been estimated. Owing to the expected contraction property of the PDF when multiplexing the sources, a significant gain is always foreseeable, especially if a sufficient number of sources is involved. This will be actually observed when hundreds of different TV sources will be multiplexed along worldwide communications. The degradation of the performances has also been evaluated when correlated sources are multiplexed.

2. the cell loss probability has been depicted has a function of the queueing load with respect to different parameters of the incoming superposed traffics. Mean cell loss probabilities have been derived. A more important achievement will consist in characterizing the configurations by which cells are lost by bursts or at random. The ratio of the two phenomena depends on how frequently network congestions are induced, on how strongly the intervening sources are correlated and on how tightly the transmission bandwidths are allocated. These deductions are important to characterize the strategies of protection against cell losses to be implemented in the encoders (developed in Chapter 6). Chapter 7 will refine the configuration by which cells are lost and, especially, show how two modes are involved referring to short and long term bursts.

3 the transmission delay has been characterized to enable deducing the jitter characteristics. This parameter is important to design a digital clock recovery algorithm in the decoder (to be developed in Chapter 6).

The core stochastic operation of the network has been characterized and analyzed for variable bit rate sources. Chapter 6 will investigate the strategies to be implemented within the coders to cope with the drawbacks of the multiplexing. Chapter 7 will cover the different problems involving the whole transmission channel i.e. the transmission through different multiplexers, the definition of bandwidths, the traffic descriptors and the effect of police functions. Answering each of those problems will lay the stepping-stones to deduce an optimum solution for the coding-transmission function of TV sources on ATM networks.

5.6 Bibliography

[5.1] A. Arneodo "Les Fractales: des concepts mathématiques aux observations physiques", *Course UCL/PHYS 3419, Academic Year 1990-1991.*

[5.2] C. Blondia "The N/G/1 finite capacity queue", *Communications on Statistics-Stochastic Models, 5(2), 273-294, 1989.*

[5.3] P. Bremaud and J. Jacod "Point Processes and Martingales: recent Results on Modeling and Filtering", *Advances in Applied Probability, 9, pp. 362-416, 1977.*

[5.4] P. J. Burke "Proof of a Conjecture on the Interarrival-Time Distribution in a M/M/1 Queue with Feedback", *IEEE Transactions on Communications, Vol. 24, pp. 575-576, 1976.*

[5.5] E. Çinlar "Superposition of Point Processes", *Superposition of Point Processes: Statistical Analysis, Theory, and Applications, pp. 549-606, P.A.W. Lewis, John Wiley & Sons, New York.*

[5.6] D. R. Cox and V. Isham "Point Processes", *Chapman and Hall, London, 1980.*

[5.7] D. R. Cox and H. D. Miller "The Theory of Stochastic Processes", *Chapman and Hall, 1965.*

[5.8] D. R. Cox and P.A.W. Lewis "Statistical Analysis of Time Series", *Methuen & CO LTD, London, 1968.*

[5.9] W. Feller "An Introduction to Probability Theory and its Applications", *Vol. II, Wiley, NY, 1971.*

[5.10] W. A. Gardner "Introduction to Random Processes", *Macmillan Publishing Company, 1986.*

[5.11] E. N. Gilbert "Capacity of a Burst-Noise Channel", *Bell System Technical Journal, pp 1253-1265, September 1960.*

[5.12] L. Gün "Experimental Results on Matrix-Analytical Solution techniques - Extensions and Comparisons", *Communications on Statistic-stochastic Models, Vol. 5, pp. 669-682, 1989.*

[5.13] J. M. Harrison and A. J. Lemoine "Limit Theorems for Periodic Queues", *Journal of Applied Probability, 14, pp. 566-576, 1977.*

[5.14] H. Heffes and D. M. Lucantoni "A Markov modulated characterization of the packetized voice and data traffic and related statistical multiplexer performance", *IEEE J. Select. Areas Commun., Vol. SAC-4, No. 6, pp. 856-868, September 1986.*

[5.15] H. Heffes "A class of data traffic processes - Covariance function characterization and related queueing results", *Bell Syst. Techn. J., Vol. 59, No. 6, pp. 897-929, July-August 1980.*

[5.16] D. P. Heyman and M. J. Sobel "Stochastic Models in Operations Research", Mc Graw Hill, Vol. 1.

[5.17] Hisashi Kobayashi "Application of the Diffusion Approximation to Queueing Networks", Journal of A. C. M., Vol. 21, No. 2, pp. 316-328, April 1974.

[5.18] D.A. Hughes, G. Anido, H.S. Bradlow "Queueing analysis for multiplexed bursty traffic with application to ATM switch performance", private communication.

[5.19] L. Kleinrock "Queueing Systems", Wiley, Vol. 1 & 2, 1975.

[5.20] L. Kosten "Liquid Models for a Type of Information Buffer Problems", Delft Progress Report, 11, pp. 71-86, 1986.

[5.21] J. R. Louvion, P. Boyer, A. Gravey "A Discrete-time single Queue with Bernoulli Arrivals and constant Service Time", Teletraffic Science, Networks and Services, ITC-12, M. Bonatti Editor, Elsevier, pp. 1304-1312, 1989.

[5.22] D. M. Lucantoni and V. Ramaswami "Efficient algorithms for solving the non-linear matrix equations arising in phase type queues", Communications on Statistics-Stochastic Models, 1(1), pp. 29-51, 1985.

[5.23] D. M. Lucantoni, K. S. Meier-Hellstern, M. F. Neuts "A Single Server Queue with Server Vacations and a Class of Non-Renewal Arrival Processes", Working Paper 88-008, Systems and Industrial Engineering Department, The University of Arizona, 1988.

[5.24] B. Mandelbrot "Self-Similar Error Clusters in Communication Systems and the Concept of Conditional Stationarity", IEEE Transactions on Communications, pp. 71-90, March 1965.

[5.25] T. Meisling "Discrete-time Queueing Theory", J. Operations Research, Vol. 6, 1957.

[5.26] M. F. Neuts "Structured Stochastic Matrices of M/G/1 Type and their Applications", Marcel Dekker Inc., N Y, 1989.

[5.27] M. F. Neuts "A versatile Markovian Point Process", Journal of Applied Probability, 16, pp. 764-779, 1979.

[5.28] M. F. Neuts "Matrix-geometric solutions in stochastic models - An algorithmic approach", The John Hopkins Univ. Press, Baltimore and London, 1981.

[5.29] Neuts M. F. "Renewal process of phase type", Naval Res. Logist. Quart. 25, pp. 445-454, 1978.

[5.30] J. Neyman "On a New Class of Contagious Distributions Applicable in Entomology and Bacteriology", Ann. Math. Statist. Vol. 10, pp. 35-57, 1939.

[5.31] V. Ramaswami "The N/G/1 Queue and its Detailed Analysis", Advances in Applied Probability, Vol. 12, pp. 222-261, 1980.

[5.32] V. Ramaswami "Stable Recursion for the Steady State Vector in Markov Chains of M/G/1 type", *Communications on Statistic-stochastic Models, Vol. 4, pp. 183-188, 1988.*

[5.33] M. Reiser and H. Kobayashi "Accuracy of the Diffusion Approximation for some Queueing Systems", *IBM Journal of Research and Development, pp. 110-124, March 1974.*

[5.34] M. H. Rossiter "Sojourn Time Theory and Switched Poisson Processes", *Telecom Australia, Research Laboratories Report 7835, 1986.*

[5.35] K. Sriram, W. Whitt "Characterizing Superposition Arrival Processes in Packet Multiplexers for Voice and Data", *IEEE J. Select. Areas Commun., Vol. SAC-4, No. 6, pp. 833-846, September 1986.*

[5.36] P. Tran-Gia and H. Ahmadi "Analysis of a Discrete-Time $G^{[X]}/D/1$-s Queueing System with Applications in Packet-Switching Systems", *Proceedings of Infocom, New Orleans, pp. 861-870, 1987.*

[5.37] G. M. Woodruff, R. Kositpaiboon, G. Fitzpatrick, P. Richards "Control of ATM Statistical Multiplexing Performance", *ITC Specialist Seminar, Adelaide, September 1989.*

Appendix

5.A Properties of Renewal Processes

This appendix will proceed in three subsections to deduce the probability density function of the forward recurrence time in a renewal process i.e. the probability that starting to observe arrivals at the instant t_n, the first arrival of source i be in the interval $(t_n + r, t_n + r + \Delta r)$.

5.A.1 Key Integral Equation of Renewal Theory

The renewal density function is a function $h(t)$ defined at any time t as

$$h(t) = \lim_{\Delta t \to 0} \frac{E[N(t, t + \Delta t)]}{\Delta t} \qquad (5.312)$$

to specify the mean number of renewals $N(t, t + \Delta t)$ to be expected in an infinitely small interval Δt at time t. The quantity $[h(t)\Delta t]$ has to be interpreted as the probability of a renewal in the interval $(t, t + \Delta t)$. A renewal is assumed to have occurred at t=0.

Mathematically, $h(t) = \sum_{r=1}^{\infty} k_r(t)$ which means that $h(t)$ is the sum of the probability density functions $k_r(t)$ that a r^{th} renewal occurs within $(t, t + \Delta t)$. Reexpressed with the Laplace transform

$$H(s) = \sum_{r=1}^{\infty} \{F(s)\}^r \qquad (5.313)$$

$$= \frac{F(s)}{1 - F(s)} \qquad (5.314)$$

where $H(s)$ is the Laplace transform of $h(t)$ and $F(s)$ that one of $f(t)$ the probability density function of the inter-arrival times. Retuning in the temporal domain, we may write

$$h(t) = f(t) + \int_{u=0}^{u=t} h(t - u) f(u) du \qquad (5.315)$$

This well-known equation is the key integral equation of the renewal theory. A probabilistic interpretation is obtained by noting that the probability of a renewal in the interval $(t, t + \Delta t)$ is the sum of

1. the probability $[f(t)\Delta t]$ that the first renewal after $t = 0$ be in $(t, t + \Delta t)$.

2. the sum over all the values of u ranging from 0 to t that the probability of a renewal near $(t - u)$ be followed by an inter-arrival time of length u.

This has expressed that a renewal of probability $h(t)$ is due to the two exclusive events previously stated.

5.A.2 Limiting Value of h(t)

Let m be the mean value of the inter-arrival times X $[E(X) = m]$. The limit of $h(t)$ in an equilibrium renewal process is given in [16] by

$$\lim_{t \to \infty} h(t) = \frac{1}{m} \tag{5.316}$$

The demonstration is obtained by

1. using the key renewal integral equation

$$
\begin{aligned}
h(t) &= f(t) + \int_{u=0}^{u=t} h(t-u)\, f(u)\, du \tag{5.317}\\
&= f(t) + \int_{u=0}^{u=t} f(t-u)\, dH(t) \tag{5.318}
\end{aligned}
$$

where $H(t) = \int_{u=0}^{u=t} h(u)du$ i.e. the repartition function of h(t).

2. using the fact that $\lim_{t \to \infty} f(t) = 0$

$$\lim_{t \to \infty} h(t) = \lim_{t \to \infty} \int_{u=0}^{u=t} f(t-u)\, dH(t) \tag{5.319}$$

3. assuming that $f(t)$ is Riemann-integrable [16]

$$
\begin{aligned}
\lim_{t \to \infty} h(t) &= \frac{1}{m} \int_{u=0}^{u=\infty} f(u)\, du \tag{5.320}\\
&= \frac{1}{m} \tag{5.321}
\end{aligned}
$$

This means that, at the limit, one can not identify when the renewal began, and so, the rate at which renewals occur is equal to the inverse of the average time between renewals m.

5.A.3 Probability Density Function of Recurrence Times

The probability that, starting to observe arrivals at the instant t_n, the next arrival of source i be in the interval $[t_n + r, t_n + r + \Delta r]$ is to be decomposed into two exclusive parts

1. either that the first arrival lies in the interval $[t_n + r, t_n + r + \Delta r]$.

2. or that, for some u, a renewal occurs in the interval $[t_n - u, t_n - u + \Delta u]$ and that the next inter-arrival time equal to $[u + r, u + r + \Delta r]$.

Therefore, the probability density function is given by

$$l(r) = f_1(t_n + r) + \int_{u=0}^{u=t_n} h(t_n - u) \, f(u + r) \, du \qquad (5.322)$$

The probability density function $f_1(t_n + r)$ can be decomposed into the probability that no renewal occurs from time 0 up to time $[t_n + r]$ which is given by the survivor function of $f(t)$ in the assumption of an equilibrium process and the probability to observe a renewal in the interval $[t_n + r, t_n + r + \Delta r]$ given by $h(t_n + r)$. Therefore, the equilibrium process provides the following results

$$f_1(t_n + r) = h(t_n + r) \, \mathcal{G}(t_n + r) \qquad (5.323)$$

hence,

$$
\begin{aligned}
l(r) &= \lim_{t_n \to \infty} \left[f_1(t_n + r) + \int_{u=0}^{u=t_n} h(t_n - u) \, f(u + r) \, du \right] && (5.324) \\
&= \frac{\mathcal{G}(t_n + r)}{m} + \frac{1}{m} \int_{u=0}^{u=t_n} f(u + r) \, du && (5.325) \\
&= \frac{\mathcal{G}(r)}{m} && (5.326) \\
&&& (5.327)
\end{aligned}
$$

For the equilibrium process at remote times from the origin, it turns out that, starting to observe at any moment t, the probability of a renewal after a period r is independent of the inter-arrival time PDF and equal whether prospecting backward or forward. The arrival process behaves as if it were uniformly distributed.

5.B Autocovariance of Counting Processes

In this appendix, the autocovariance of the counts in an arrival process will be computed by ensemble averaging under the assumption of stationarity. The goal is to add some generalizations to the material demonstrated in Section 5.2.2.2 of this chapter, the covariance of the counts is computed under different forms. The formulae deduced in this appendix are robust to the reference case of the Poisson process and to the general case of point processes. Let S_n denote the sum of n consecutive inter-arrivals X_k i.e. $S_n = \sum_{k=1}^{n} X_k$, $N(0,T)$ be the number of arrivals in the interval [0,T]. In other words,

$$
\begin{aligned}
N(0,T) &= sup\{n : S_n \leq t\} &\quad (5.328)\\
&= \sum_{n=1}^{\infty} \delta_{\{S_n \leq T\}} &\quad (5.329)
\end{aligned}
$$

where $\delta_{\{S_n \leq t\}}$ an element, which belong to a Dirac train of unity-magnitude impulses, in the set of all the arrivals meeting the condition $\{S_n \leq t\}$ i.e. the element represents an arrival counted in $N(0,T)$. The mean number of arrivals in the interval [0,T] is given by the renewal function

$$
\begin{aligned}
H(T) &= E[N(0,T)] &\quad (5.330)\\
&= \sum_{n=1}^{\infty} Pr[S_n \leq T] &\quad (5.331)
\end{aligned}
$$

This third relation is derived from the second by applying the integration over impulse Dirac functions. Invoking the theory of Stieltjes's measure, it refers to the reasoning already developed in Appendix 5.A.

The autocovariance of the counting process is computed by first considering the counts over $N(0,T)$ and $N(0,T+s)$.

$$
\begin{aligned}
E[N(0,T),N(0,T+s)] &= E[\sum_{k=1}^{\infty} \delta_{\{S_k \leq T\}} \sum_{l=1}^{\infty} \delta_{\{S_l \leq T+s\}}] &\quad (5.332)\\
&= \sum_{k=1}^{\infty}\sum_{l=1}^{\infty} Pr[S_k \leq T, S_l \leq T+s] &\quad (5.333)\\
&= \sum_{k=1}^{\infty}\sum_{l=1}^{k} Pr[S_k \leq T] &\quad (5.334)\\
&\quad + \sum_{k=1}^{\infty}\sum_{l=k+1}^{\infty} Pr[S_k \leq T, [S_k + (S_l - S_k)] \leq T+s]\\
&= \sum_{k=1}^{\infty} k\, Pr[S_k \leq T] &\quad (5.335)\\
&\quad + \sum_{k=1}^{\infty} E[\sum_{l=k+1}^{\infty} Pr[S_l - S_k \leq T+s - S_k \mid S_k]\, \delta_{\{S_k \leq T\}}]
\end{aligned}
$$

$$= \sum_{k=1}^{\infty} k \, Pr[S_k \leq T] \tag{5.336}$$

$$+ \sum_{k=1}^{\infty} E[H(T + s - S_k) \, \delta_{\{S_k \leq T\}}]$$

$$= \sum_{k=1}^{\infty} k \, Pr[S_k \leq T] \tag{5.337}$$

$$+ \int_{u=0}^{u=T} H(T + s - u) dH(u)$$

using the theory of Stieltjes's measure which enables expressing the expected value of impulse Dirac functions as probability density in Equation (107), Equation (109) is obtained by decomposing the probability into two terms. By using conditional probabilities, the Equation (110) applies the impulse Dirac functions in the reverse sense to derive an expected value.

$$E\{N(0,T)[N(0,T+s) - N(0,T)]\} = \int_{u=0}^{u=T} \{H(t+s-u) - H(t-u)\} dH(u) \tag{5.338}$$

expresses a general formulation for the covariance of the counts. Let us more particularly introduce the variance-time curve $Var(T)$

$$Var(T) = E[N(0,T)^2] - \{E[N(0,T)]\}^2 \tag{5.339}$$

Let us further denote by $C_i(\tau)$ the covariance between the counts in two intervals of length τ and separated by $i - 1$ similar intervals. The covariance-time curve is referred to as $C_1(t)$. According to Cox [5.23 p 72]

$$C_1(k\tau) = \sum_{i=1}^{k} i C_i(\tau) + \sum_{i=k+1}^{2k} (2k - i) C_i(\tau) \tag{5.340}$$

$$Var(k\tau) = k \, Var(\tau) + 2 \sum_{i=1}^{k-1} \sum_{j=1}^{i} C_j(\tau) \tag{5.341}$$

$$= k \, Var(\tau) + 2 \sum_{i=1}^{k-1} (k - i) C_i(\tau) \tag{5.342}$$

$$C_1(t) = E[N(0,t), N(t,2t)] \tag{5.343}$$

$$= \frac{Var(2t)}{2} - Var(t) \tag{5.344}$$

It can be concluded that the variance-time curve completely defines the correlation structure of an arrival process like those obtained by superposition. Thus, to accurately approximate the correlation properties of the superposition, it is important that the approximating model provides a good match to the variance-time curve.

Chapter 6

ATM Adaptation Layer

6.1 Introduction

As explained in Chapter 1, the ATM Adaptation Layer (AAL) is in charge of protecting the TV information against the drawbacks of ATM networks originating from the statistical multiplexing and from the asynchronous transmission mode. These disadvantages are referred to as

1. the cell losses in the multiplexers.

2. the absence of any common reference clock available from the network and shared among the network and the encoders and decoders to synchronize decoders with encoders. The single timing reference shared between network and users is the time slot where to launch or to pick up the ATM cells.

The tasks devoted to AAL type 1 and 2 interest the real-time video transmissions on ATM, they have already been defined and outlined in Chapter 1. Let us further remark that the bit errors are generated in the transmission medium and as such are not typical of the statistical multiplexing since they originate from a lower OSI layer.

In Chapter 5, the study of the free VBR TV source multiplexing has allowed deriving how cells are lost. Chapter 7 will refine this study in the case of policed VBR sources. Essentially, cells are lost in two ways, namely by random and bursty occurrences. The case of recurrent cell losses described in reference [6.5] is not taken into account in this work. This first problem will be addressed and solved by the use of error correcting codes and related tools like the interleaving of the data and the product of error correction codes. When dealing with error correcting codes, different questions can be raised

1. which kind of error correcting codes to implement taken into account the hardware complexity, the correcting performances and the overhead cost?

2. which kind of interleaving should be implemented? How far is interleaving necessary?

In Chapter 5, the problem of random transmission delays has been put into evidence. Because of both the absence of a network reference clock and the transmissions with

random delays, it is required to implement an algorithm with the task to synchronize a decoding procedure locked to the encoder timing. A synchronization algorithm of the decoder will be therefore presented working on two levels

1. a coarse timing synchronization to couple the regulation of the input decoder buffer with that of the output encoder buffer.

2. a fine reconstruction of the decoder clock locked to that of the encoder in order to minimize the final jitter on the decoder display in agreement with the CCIR 656 Recommendation.

This chapter intends to address successively the problem of the cell loss correction and the synchronization of the decoder.

6.2 Cell Losses and Bit Errors

This part of the chapter will tackle the different problems of correcting conjointly the cell losses and the bit errors. It has been shown that the cell losses occur by bursty and random events. A burst can be defined as a period where the cell loss probability is tremendously increased in such a way that almost all cells are lost during that period. The bursts can last during a short or a long term. Short-term periods last a few cells (for example 1 to 10 cells). Long-term periods last several tens of cells. The correction of long-term bursts stays out of range for the correcting policy and can involve losses of several consecutive images. Solutions to correct the losses will be presented for random losses and thereafter generalized to short-term bursty losses. The use of the error correcting codes can be enhanced by the adjunction of three additional tools, namely the cell numbering, the interleaving and the code products.

6.2.1 Error Correcting Codes

The error detection and correction codes are based on the principles which follow. The binary information to be transmitted on a noisy channel is segmented into words of k binary symbols. Each word can represent 2^k different messages. To reduce the transmission errors, the 2^k possible messages out of k symbols are transformed into 2^n distinct messages contained in words of n symbols. As a matter of fact, n is larger than k and only 2^k words taken among the 2^n correspond actually to useful messages, the other possibilities $(2^n - 2^k)$ are a reserve of redundancy available for control operations. The result is an (N,K) code where K symbols carry information and (N-K) symbols allow error-detection and correction controls. The code rate of a block is defined by the ratio $\frac{K}{N}$.

Error correcting codes provide coders with a tool to recover lost information such as errors, erasures and deletions. The *errors* are false code symbols transformed by the transmission channel, the *erasures* are lost portions within the transmitted code symbols for which the location is known and the *deletions* are lost portions in the code symbols for which the location is unknown.

In the ATM networks, the cell losses and the bit errors have to be taken into consideration. The cell losses can be considered as bit deletions with fixed length; by an

adequate cell numbering, these deletions can be transformed into erasures of the code. It is known from the error correcting theory that locating the error requires twice less redundancy to ensure the correction. In other words, half the information of error correcting codes are devoted to locate errors. Let us define some parameters of the error correcting codes as follows

1. K the length of the information messages (also called the dimension referring to the number of linearly independent symbols in each message).

2. N-K the redundancy digits to reach a (N,K) code with N being the length of the block, the relative overhead is given by $\frac{N-K}{K}$.

3. d the distance to signify that any two distinct words of the code differ at least from d symbols.

The goal of the error correcting codes is to perform different tasks: detect and correct E_c erroneous symbols among N, correct E_e erasures or detect E_d errors among N without their correcting. These operations are not exclusive and the limitation of the information theory is $2E_c + E_e + E_d \leq d - 1$. The Reed-Solomon codes (RS codes) reach the upper bound of $d = N - K + 1$. Let us notice the basic properties of some interesting error correcting block codes

1. the Bose-Chaudhuri-Hocquenghem codes (BCH) are linear cyclic codes characterized by their ability of correcting any combination of E_e or fewer errors in a block code of length $N = 2^m - 1$ where m is any integer value. Their properties are as follows

 1. a block length $N = 2^m - 1$.
 2. a number of parity-check digits $N - K \leq mE_e$.
 3. a minimum distance $d \geq 2E_e + 1$.

2. the RS codes are a subset of the BCH family. To characterize their properties, let us define p a prime number and q any power of p. Furthermore, let us consider a q-ary symbol alphabet. Then, for any choice of a positive integer e, there exists a q-ary BCH code of length n=q-1 which corrects any combination of E_e or fewer errors and requires no more than $2E_e$ parity-check digits. The properties are given by

 1. a block length $N = q - 1$.
 2. a number of parity-check digits $N - K = 2E_e$.
 3. a minimum distance $d = 2E_e + 1$.

A commonly used family of RS codes is that defined on the Galois Field $GF(2^8)$ which allows correcting fields of a minimum entity of 8 bits. This family corrects the bytes and one byte is declared erroneous when, at least, one bit is erroneous. More generally, an E_e-error correcting RS code from a Galois Field $GF(2^m)$ leads to a binary code corresponding to m-bit bytes with the following parameters

6.2. Cell Losses and Bit Errors

1. a block length $N = m(2^m - 1)$.

2. a number of parity-check $N - K = 2mE_e$.

This code is called an E_e-byte correcting code. Since a burst of length $[(E_e - 1)m + 1]$ can not affect more than E_e bytes, an E_e-byte correcting code can correct any single burst of length $[(E_e - 1)m + 1]$ or less. It enables correcting any combinations of bursts with shorter lengths mixed with random errors. In general, an E_e-byte correcting binary RS code is capable of correcting any combination of

$$w = \frac{E_e}{1 + \frac{\Lambda + m - 2}{m}} \tag{6.1}$$

bursts of length Λ or any single burst of length $(E_e - 1)m + 1$ or less. Simultaneously, it corrects any combination of E_e or fewer random errors.

In practice, the maximum relative overhead to be allocated to the protection codes is a given design factor. Five to ten per cent are commonly admitted as being the maximum acceptable loads. Models of erasure arrivals have been studied in Chapter 5 and lead to a maximum length for bursts. If M represents the maximum number of erasures that an error correcting code is susceptible to restore, the maximum value O_M of the relative overhead O is in this case

$$O = \frac{M}{N - M} \leq O_M \tag{6.2}$$

$$1 \leq M \leq \frac{N \, O_M}{1 + O_M} \tag{6.3}$$

This equation gives a lower bound to the maximum relative overhead admitting an M-erasure correcting code.

A further step to combine correcting codes is to build product codes in a two-dimensional array where the rows are constructed using an (N_1, K_1) code C_1 with respectively a minimum distance d_1 and a burst error correcting capability Λ_1 and where the columns are constructed with a (N_2, K_2) code C_2 characterized by d_2 and Λ_2. This product code can correct either bursts of a maximum length Λ given by $\Lambda \geq max[N_2\Lambda_1, n_1\Lambda_2]$ or any combination of $\frac{d_1 d_2 - 1}{2}$ random errors.

In this study of error correcting codes conjugated with interleaving, the assumption of a classical bursty channel is retained as a working hypothesis, the channel has two modes of behavior. Accordingly, periods of poor transmission capability are followed by periods with the highest quality. This clearly defines two states which are called respectively the burst and the guard space. In the burst state, the channel output carries no recoverable information. In the guard, the channel is considered as being error-free. Thanks to cell numbering, the bursts may be regarded as erasure bursts and the channel is referred to as an erasure-burst channel. In principle, the channel never stays in burst mode for more than B symbols, nor does it ever stay in the guard space mode for fewer than G symbols. This way of representing the channel is not a crippling idealization of the ATM channel since cell losses are most likely to occur by bursts when congestion develops within the

network and that, out of those particular times, the losses are of very small probability and occur at random.

The capacity C of a channel is defined as the maximum continuous rate of transmission for which arbitrarily low error probability is achievable. Let C_0 define the zero-error capacity which signifies the maximum rate for which zero-error probability is achievable. Let us also recall that on all memoryless channels $C_0 < C$ except for the erasure channel where $c_0 \leq C$. Intuitively, as the bursty channel may wipe out B from every $G + B$ transmitted symbols, its capacity in symbols per transmitted symbol must be bounded by $\frac{G}{G+B}$. In fact, the capacity of the classic bursty channel and the zero-error capacity of the classic erasure-burst are bounded by the same quantity $C \leq \frac{G}{G+B}$.

Theorem 6.2.1 *Any code capable of correcting erasure bursts of length B separated by guard spaces of length G has rate $R \leq \frac{G}{G+B}$. This corresponds to the zero-error capacity of the classic erasure-burst channel which is bounded by $C_0 \leq \frac{G}{G+B}$.*

This theorem is demonstrated and discussed in Reference [4].

6.2.2 Application to ATM Transmissions

ATM transmissions undergo two types of errors: the bit errors and the cell losses. Each of these defects originates from two different layers of the network: the bit errors are generated in the lowest layer of the hardware medium of transmission and the cell losses are mainly due to overflows in multiplexing queues. As generated by two independent processes, the occurrence of cell losses should rather be independent of the occurrence of bit errors except when bit errors occur in the cell header. This event misguides the cell potentially towards another transmission session and induces an inserted cell. Cell losses should arrive in two modes: random and bursty occurrences. These two modes can never be really dissociated and random defects are merged in between the occurrence of bursts. As it will be derived in Chapter 7, the burst mode is either of short term due to temporarily disadvantageous cell arrival characteristics or of long term due to concurrent source with high bit rates.

To apprehend the problem, Table 6.1 presents some orders of magnitude in the case of a transmission channel with a mean cell loss probability is equal to $5 \; 10^{-11}$ and the mean bit rate probability to $5 \; 10^{-9}$, the data field is of 48 bytes per ATM cell. No protections are implemented and the whole available field is dedicated to data. Three services are examined, namely the audio at 44.1 KHz stereo (352.8 Kbit/s), the TV (20.0 Mbit/s) and the HDTV (60.0 Mbit/s). Table 6.2 gives the mean time between bit errors and cell losses in terms of some referenced mean arrival rates in cases where no error correcting codes are activated.

The correction of both bit errors and cell losses is now addressed in the next sections. The cell numbering is first discussed. Thereafter, two different correcting strategies will be described

1. the first to be implemented in the users plan i.e. not in the AAL but in the outer OSI layer of the image coding. It will use interleavers and RS codes merged within the TV data field.

service	HDTV	TV	AUDIO
cells per second	$1.56\ 10^5$	$5.2\ 10^4$	919
mean delay between consecutive cells	$6.4\ \mu s$	$19.2\ \mu s$	$1.09 ms$
mean delay between bit error	2.2 hours	6.5 hours	356.5 hours
mean delay between cell loss	8.9 hours	26.7 hours	$1.5\ 10^3$

Table 6.1: **Some orders of magnitude for distributed services.**

service	Mean Bit rate (Mbit/s)	Bit error rate			Cell loss rate		
		10^{-8}	10^{-7}	10^{-6}	10^{-8}	10^{-7}	10^{-6}
TV - CCIR 601	25	4s	400 ms	40ms	28 min	2.8 min	17s
HDTV - HDI	75	1.3 s	133 ms	13.3 ms	9.3 min	56 s	5.6 s
HQ stereo audio	0.4	4.2 min	25 s	2.5 s	1 day	3 hours	17 min

Table 6.2: **Mean time between bit errors and cell losses.**

2. the second to be implemented in the AAL when packetizing. It will use product codes in the framework of the cell delineation (the error correcting field encapsulates the TV data).

It will turn out that correcting cell losses up to a probability of 10^{-6} is rather easy, especially when dealing with random defects. In the range of 10^{-6} up to 10^{-3}, the corrections are achieved at the expense of more powerful efforts requiring RS codes and interleaving to correct bursts of losses with an overhead constrained at 5% of the total bit rate.

6.2.2.1 Cell Numbering

The cell numbering is an important piece of information: it transforms the cell deletions into erasures which are more easily corrected with half the redundancy required for unlocated errors. This numbering implies to label the cells at the encoder side and to check the entireness of the received sequence of the consecutive labels. The label is implemented as a b-bit counter modulo $c = 2^b$ incremented by one at each cell generation. The cell numbering enables to discriminate among different defects, especially cell insertions, random losses, single and multiple bursts of cell losses. Each of these different defects has specific signatures with possible ambiguities. It can easily be demonstrated that all the ambiguities can be removed if $c \geq 2 + \Lambda$ where Λ represents the total cumulated length of cell bursts subject to be corrected. For example, a field of 2 bits to code the cell sequence should suffice when correcting random cell losses. To go beyond and suppose losses in multiple bursts, 4 bits will be necessary to discriminate up to 16 different consecutive cells. Total burst lengths longer than 14 cells are not intended to be corrected in that configuration.

6.2.2.2 Interleaving with RS Codes before Packetizing

The main idea to perform protection against the bursts of errors is to organize the transmitted symbols in a way that consecutive errors on the transmission channel are spread among several blocks and that the resulting number of erroneous symbols in each block

remains below or equal to the correction capability of the code. The cell erasures are here supposed corrected with RS codes.

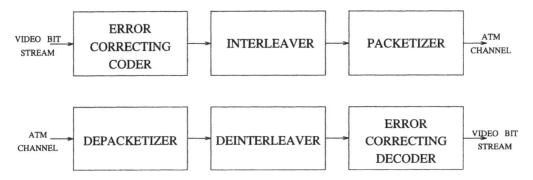

Figure 6.1: Error correcting codes and interleavers.

The interleavers (Figure 6.1) operate by rearranging the ordering of a sequence of symbols (bits or bytes) in an one-to-one reversible mapping. The interleavers are characterized by two parameters as

1. the coding delay $D_{c,i}$ is the maximum delay spent in the error correcting procedure by any symbol before its being inserted into the output sequence.

2. the storage capacities S.

Two main kinds of interleavers can be taken into account: the block interleavers and the convolutional interleavers.

The Block Interleaver

The usual block interleavers write the incoming symbols in a $A \times B$ matrix according to a column-by-column order and transmit on a row-by-row order. This technique implies that two symbols consecutively lost during their transmission are separated at the de-interleaver output by at least A symbols. The end-to-end processing delay introduced by the block interleaver with including the transmission is given by $D_{c,i} = \Delta t = t_1 - t_2 = 2AB$ with N the number of rows and B the number of columns.

If an error has a length of Λ consecutive symbols, the number of lines within the block to be affected is equal to $\lceil \frac{\Lambda}{B} \rceil$ ($\lceil x \rceil$ denotes the integer value just superior to x). If N denotes the block code length, each word of the code encompasses at most $\lceil \frac{N}{A} \rceil$ columns of the matrix. Hence, if such r bursts of errors occur, the number M of erroneous symbols per code word is given by

$$M \leq r \lceil \frac{\Lambda}{B} \rceil \lceil \frac{N}{A} \rceil \tag{6.4}$$

The Convolutional Interleavers

The convolutional interleavers (also called synchronous interleavers) shuffle (Figure 6.2) the input code symbols according to the following rules

- in the encoder, the code symbols are shifted by a bank of registers whose lengths are in arithmetic progression. The progression is characterized by a step equal to m. The shift registers are addressed and read out cyclically with a period b.

- in the decoder, a mirrored operation takes place.

The storage capacity required in the interleaver and the de-interleaver is equal to $S = \frac{b(b-1)m}{2}$ in each of them. The coding delay $D_{c,i}$ is equal to $b(b-1)m$ symbol times.
 The use of an erasure-correcting (N, K) RS code with a $B \times N$ interleaver on the classic erasure-burst channel succeeds in correcting all erasure bursts of length approximatively $(N-K)B$ separated by guard spaces of approximatively KB, for a guard-space-to-burst ratio of nearly $\frac{K}{N-K} = \frac{R}{1-R}$, which is the zero-error-capacity bound for the classic erasure-burst channel.
 Let us denote by x the status of both interleaver and de-interleaver counters. A symbol loaded into the de-interleaver at time x will be read out at its output at time y with

$$y = x + bm(b - 1 - x\mathrm{mod}[\mathrm{B}]) \tag{6.5}$$

Two symbols entering the de-interleaver at times $t_{i,1}$ and $t_{i,2}$ will be available at the output respectively at times $t_{o,1}$ and $t_{o,2}$. Let $\Delta t_i = t_{i,2} - t_{i,1}$ and $\Delta t_o = t_{o,1} - t_{o,2}$.

$$
\begin{aligned}
\Delta t_o &= [t_{i,2} - t_{i,1}] + Bm[(B - 1 - t_{i,2}\mathrm{mod}[\mathrm{B}]) - (b - 1 - t_{i,1}\mathrm{mod}[\mathrm{B}])] &(6.6) \\
&= \Delta t_i - Bm\Delta t_i\mathrm{mod}[\mathrm{B}] &(6.7)
\end{aligned}
$$

The fundamental property of the convolutional interleavers follows as

$$\mathrm{if} \quad \Delta t_i \le B(m - 1) \quad \mathrm{then} \quad \Delta t_o \ge B \tag{6.8}$$

To prove this relationship, let $\epsilon_i = t_{i,i}\mathrm{mod}[\mathrm{B}]$, therefore

$$\Delta t_o = \Delta t_i - Bm\Delta(\epsilon) \qquad \Delta t_i > 0 \tag{6.9}$$

As $\Delta(\epsilon) \le (B - 1)$, $\delta(t_o)$ is always greater or equal to B if $\Delta t_i \ge G = B(1 + BM - M)$. This guard space corresponds to the arrival case of symbols separated by more than $(m + b - 1)$ symbols. Let us now consider that $\Delta t_i < B(1 + BM - M)$. Let us enumerate exhaustively all the possible configurations that $\delta(\epsilon)$ may take

1. $\delta(\epsilon) = 0$ or equivalently stated $\Delta t_i = kb$ with $k \in \mathbf{R_+}$ i.e. a positive integer, therefore

$$|\Delta t_o| = \Delta t_i = kb \ge b \tag{6.10}$$

INTERLEAVER DEINTERLEAVER

Figure 6.2: Convolutional interleavers.

2. $\delta(\epsilon) \neq 0$, therefore

$$|\Delta t_o| = |\Delta t_i - bm\Delta(\epsilon)| \tag{6.11}$$

2.1 $\delta(\epsilon) < 0$, therefore

$$|\Delta t_o| = \Delta t_i - bm|\Delta(\epsilon)| \geq B \tag{6.12}$$

2.2 $\delta(\epsilon) > 0$,

$$\Delta t_i \leq bm\Delta(\epsilon) \quad \Rightarrow \quad |\Delta t_o| = bm|\Delta(\epsilon)| - \Delta t_i \tag{6.13}$$

therefore

$$\Delta t_o \geq b \tag{6.14}$$

under the condition that $\Delta t_i \leq b(m\Delta(\epsilon) - 1)$ which is always fulfilled if $\Delta t_i \leq b(m-1)$

This completes the proof.

This property can be easily extended as follows. Let $\Delta t_i \leq p[1 + b(m-1)]$ with p a positive integer. The $\Delta t_i + 1$ symbols can be organized into p contiguous slices whose lengths are at most equal to $1 + b(m+1)$ symbols. At the output of the de-interleaver, the distance between any symbols belonging to the same input slice is greater or equal to B. Consequently, at the output of the de-interleaver, each slice of B contiguous symbols contains at most p symbols among any $p[1 + b(m-1)]$ symbols presented contiguously at its input.

At this stage of the presentation, it is worth digressing somewhat to discuss of the problems relevant to the processing delay. The delay introduced by the error protection mechanisms can be split in two parts, namely the error correcting code generation and decoding and the interleaving and de-interleaving procedures. Usually, the latter part is by far the predominant component of delay. Another special attention has to be paid to the

6.2. Cell Losses and Bit Errors

461

processing delay when dealing with multicomponent services as the relative phases of the different components have to be restored at the receiver. This operation implies to memorize the fastest component and as such the most memory consuming components until the slowest becomes available. This buffering action has to be carried out on the decoded data. For given protection level and overhead, the optimal processing delay expressed in terms of symbols is independent of the considered component. Nevertheless, in such a case, the absolute delay is inversely proportional to the bit rate of the coded component. Let us consider for instance the HDTV service and assume that all the components of the video part are globally protected. The audio part is specifically protected. The protection levels are assumed to be identical for both components. As the order of magnitude of the bit rate ratio between the video and the audio components is about 200, the absolute processing delay of the sound (compression/decompression excluded) is then 200 times greater than the video processing delay. From this, it is clear that the processing delay should be kept as low as possible since each ms of processing delay requires about 700 Kbit of high speed memory.

Design of an Interleaver

The following parameters are to be considered to dimension any interleaver

1. the length of the cell is fixed.

2. the maximum relative overhead (δ_M) of the bit rate as a price to be paid by the introduction of the error correcting codes.

3. the maximum length of a burst of cell losses as assumed from simulation Λ.

It is assumed that the lost cells and, as a consequence, the lost symbols are accurately located. As far as the protection against cell loss is concerned, the error correcting code has thus to cope only with erasures. Nevertheless, the same code has to recover at least one random error per code word. This implies that the minimum number of check symbols is equal to 2. For a given maximum overhead, this gives a lower limit to the length of the code

$$N \geq \frac{2\,(1+\delta_M)}{\delta_M} \tag{6.15}$$

For instance, $\delta_M = 5\%$ implies $N \geq 42$. Let us denote the maximum number of erasures that the error correcting code is able to restore. The relative overhead is then

$$\delta = \frac{S}{N-S} \leq \delta_M \tag{6.16}$$

This leads to the bounding relationship

$$2 \leq S \leq \frac{N\,\delta_M}{1+\delta_M} \tag{6.17}$$

from which interleavers may be constructed.

1. the block interleaver
 if r bursts occur, the number M of erroneous symbols per code word is given by

$$M = r \lceil \frac{\Lambda}{b} \rceil \lceil \frac{N}{a} \rceil \leq \frac{N\,O_M}{1 + O_M} \tag{6.18}$$

which represents a design equation for block interleaver. The third term is extracted from the Inequality 6.18. Table 6.3 gives some ATM examples of admissible values in the case of cell lengths of $\Lambda = 48$ bytes, a maximum error correcting overhead of O_M, the use of RS codes correcting bytes, and r cell loss to be recovered.

O_M	r	Λ	M	N	a	b
5 %	4	48	4	84	84	48
5 %	4	48	8	84	168	48
5 %	4	48	8	84	168	24

Table 6.3: **Block interleavers and error correcting codes.**

2. the convolutional interleaver
 As earlier derived, $S_M = p\lceil \frac{N}{B} \rceil$. Let us remark that repeated bursts of cell losses separated by less symbols than the guard space have to be considered as a continuous burst which covers the different ones.

The relationship

$$p \lceil \frac{N}{B} \rceil \leq \frac{N\,O_M}{1 + O_M} \tag{6.19}$$

has to be verified. As p is an integer at least equal to 1, any given n must satisfy with B_{min} to the following inequality

$$\lceil \frac{N}{B_{min}} \rceil \leq \frac{N\,O_M}{1 + O_M} \tag{6.20}$$

Table 6.4 gives some ATM examples of admissible values. As a matter of fact, the design equations show for the convolutional interleaver a substantial reduction in both processing delay and amount of storage memory.

O_M	r	Λ	M	N	b
5 %	4	48	2	42	21
5 %	4	48	3	63	21
5 %	4	48	4	84	21
5 %	4	48	5	105	21
5 %	4	48	10	210	21

Table 6.4: **Convolutional interleavers and error correcting codes.**

The drawbacks of an interleaver are both an additional encoding delay and a storage memory. In a convolutional interleaver, a burst of a maximum b consecutive cells can be rearranged into the decoder and corrected. The maximum length of the erasure correction is b. The value b determines the storage capacity to be implemented in the encoder and the processing delay to be added to the global transmission delay. A significant reduction of processing delay and of storage memory requirement is achieved by means of exploiting the convolutional interleavers; this reduction is about 40 %.

The use of error correcting codes in conjunction with interleavers brings synergy in the correcting abilities. Interleaving a cyclic code (N,K) to a degree i (i.e. its rearranging i code vectors of the original code into i rows of a rectangular array and, thereafter, its transmitting on a column by column basis) produces a new cyclic code (Ni, Ki) whose burst correcting ability is i times that of the original code. Therefore if the (N,K) code corrects any single burst of length Λ or less, the interleaved code will correct any single burst of length $i \times \Lambda$ or less.

6.2.2.3 Error Protection with Redundancy Cells

In this second methodology, the protection is carried out by sending additional redundancy cells with a fixed periodicity. Contrary to the first solution, the error protection is here performed in the AAL and takes into account the cell delineation. In this strategy, the error correcting codes are computed while packetizing.

Correction of Bit Errors

ATM transmissions undergo bit errors generated mainly by the hardware medium of transmission which should be the optical fibers in terrestrial communications. The literature shows that a normal well-behaving optical fiber connection induces a random error rate no higher than $10^{-10} - 10^{-9}$. Higher rates should rather signify a transmission defect. It can be even more assumed that the bursts of bit errors should be of a lower order of probability than that of random errors.

The bit errors can interfere with cell losses in the case of bit errors in the cell header (5 bytes) which produce, at least, one cell loss, and possibly, one cell insertion into another decoder. This event occurs randomly (one bit error in the header) with a probability of 40×10^{-8} assuming the worst 10^{-8} bit error probability. Thus, the header should be protected by an error correcting code for one bit minimum to guarantee a mean cell loss probability inferior to 10^{-9} with of TV or HDTV sources, the probability of loss should be then given for one corrected bit by

$$P_{non\ corrected\ bit} = \binom{40}{2} P_B^2 (1 - P_B)^{38} < 10^{-12}$$

i.e. more than 700 error-free hours at 140 Mbit/s. The symbol $\binom{j}{i}$ represents the number of combinations of i elements into a set of j and P_B the bit error probability. Inserted cells in the decoder should be corrected rather easily by the use of a cell sequence number.

In practice, the bit errors and the cell losses originate from different OSI layers and they can be considered as being independent events i.e. with a global occurrence of defects (bit error + cell losses) in the order of the sum of both cell loss and bit error probabilities.

Since a product-code protection is intended to be implemented by means of exploiting BCH codes located within each cell and additional redundancy cells, the location of single errored bits will be completely ascertained when occurring in the data field and when no cells are lost in the same correcting field, bursts of bit errors with a length as long as a cell can be corrected. When mixed with cell losses in the same correcting field, the cell-internal error correction can recover very small bursts: for example, at least one bit corrected with a BCH (502,511) code and the probability of having two bit errors within a cell is given with $P_B = 10^{-9}$ by $P_{B,rand}(2bits/1cell) = \binom{424}{2}P_B^2(1 - P_B)^{422} < 10^{-11}$ and can not be corrected. Due to the low random occurrence of bit errors, no interleaving seems necessary to protect this kind of transmission errors.

Cell-based Protection against Random Cell Losses

The protection against random cell losses is performed by the cell numbering and the insertion of one additional redundancy cell in every data field of 31 consecutive cells to allow correcting one lost cell in the field. Let us notice again that it ensures also the correction of burst of bit errors lower than 384 consecutive bits. The probability of two cell losses within a field of 32 cells is given by

$$P_{i=2} = \binom{m}{2}P_{CL}^2(1 - P_{CL})^{m-2} \tag{6.21}$$

where m is the size of the field i.e. m=32 and P_{CL} is the cell loss probability. The protection against inserted cells is easily performed by the cell numbering. No special bit protection is required for this piece of information, the BCH implemented in each cell is sufficient. Table 6.5 gives a few numerical values of the probability of one and two cell losses.

P_{CL}	$P_{i=1}$	$P_{i=2}$
10^{-6}	$3.2\ 10^{-5}$	$4.9\ 10^{-10}$
10^{-9}	$3.2\ 10^{-8}$	$4.9\ 10^{-16}$

Table 6.5: Cell loss probability.

Cross Protection for End-to-End-User QOS

Combining both previous protections leads to a two-hour-error-free end-to-end-user QOS (restated in other words, a global mean time uncorrected errors) under the assumption of a bit error probability and a cell loss probability both inferior to 10^{-6}. To demonstrate the proposition, all the configurations of bit errors and cell loss have to be enumerated. After having eliminated all trivial cases, three critical configurations inducing eventual non corrected errors remain under investigation.

1. among a field of 32 cells, two of them have simultaneously a double bit error, this event occurs with a probability

$$P_1 = \binom{m}{2}P_{DBE}^2(1 - P_{DBE})^{m-2} \tag{6.22}$$

with m=32 and P_{DBE} the probability of a double bit error within one cell which is given by

$$P_{DBE} = \binom{v}{2}P_B^2(1 - P_B)^{v-2} \simeq \binom{v}{2}P_B^2 \tag{6.23}$$

with $v = 384$.

2. among a field of 32 cells, two different cells are lost, the event has the probability

$$P_2 = \binom{m}{2}P_{CL}^2(1 - P_{CL})^{m-2} \tag{6.24}$$

3. among a field of 32 cells, one cell is lost and another presents a double bit error, the event has the probability

$$P_3 = P_{DBE}P_{1CL/32} = P_{DBE}\binom{m}{1}P_{CL} \tag{6.25}$$

It turns out immediately that the third case occurs with a probability negligible with respect to the first two cases. Table 6.6 outlines some results for protection at 140 Mbits/s in the first two worst configurations.

$Nb\ of\ hours\ error\ free$	$Nb\ of\ cells\ at\ 140Mbits$	P_B	P_{CL}
2 hours	2.63 10^9	3.5 10^{-6}	8.8 10^{-7}
24 hours	31.5 10^9	1.8 10^{-6}	2.5 10^{-7}
96 hours	126.0 10^9	1.3 10^{-6}	1.3 10^{-7}

Table 6.6: Resulting protection at 140 Mbit/s.

To conclude about random errors, it has been proved that a resulting end-to-end user transmission quality with a mean value of two error free hours can be obtained quite easily with overheads lower than 6 % (down to 2 Mbit/s for the critical bound) with cell losses and bit error probabilities both lower than 10^{-6}. For higher limits of losses, stronger techniques are required like RS codes and interleaving.

Cell-Based Protection against Random and Bursty Cell Losses

Let us suppose that losses occur as random and bursty events and that the burst lengths have a negative exponential PDF. Let us then split the error probability in two parts $P_t = P_r + P_b$ where P_r is the probability of a random loss (i.e. of errors occurring alone) and P_b is the probability of a burst of losses (i.e. of losses occurring by groups of two or more). Let β be the exponential decay for the burst length probability ($\beta \simeq 1$ is the range of realistic values as experimented in Chapter 7). The probability relative to each burst length i $P_{b,i\ losses}$ is therefore given by

$$P_{b,2\ losses} = \frac{P_b}{K}$$

$$P_{b,3 \; losses} = \frac{P_b}{K} e^{-\beta}$$

$$P_{b,4 \; losses} = \frac{P_b}{K} e^{-2\beta}$$

$$...$$

$$P_{b,(n+1) \; losses} = \frac{P_b}{K} e^{-(n-1)\beta}$$

The distribution of the burst lengths is such that $\sum_{i=0}^{\infty} \frac{e^{-\beta i}}{K} = 1$ therefore $K = \frac{1}{1-e^{-\beta}}$ is a normalizing factor to derive a probability density weight.

If the error correcting code can correct n_1 random cells in a field of m_1 cells, the non-correcting probability is given by

$$P_{rand \; non \; corrected} = \sum_{i=1}^{m_1 - n_1} C_{m_1}^{n_1+i} P_r^{n_1+i} (1 - P_r)^{m_1-n_1-i} \tag{6.26}$$

Similarly, if the error correcting code can correct bursts of length up to n_2 cells in a field of m_1 cells, the probability of a non corrected burst is given by

$$P_{burst \; non \; corrected} \approx \sum_{i=1}^{\infty} C_{m_1}^{1} \frac{P_b}{K} e^{-(n_2-2+i)\beta} = m_1 P_b e^{-(n_2-1)\beta} \tag{6.27}$$

These two formulae giving the probability of non-corrected losses show that the correction of bursty losses is evidently more critical than that one of random losses: at a cell loss probability of $P_{CL} = 10^{-3}$, it suffices to be able to correct up to 4 random losses in the correcting field to guarantee an acceptable end-to-end user QOS of the order of 10^{-9}.

Different solutions will be investigated to ensure as far as possible an end-to-end user QOS guaranteeing mean inter-error performances longer than two hours at 70 Mbit/s up to a cell loss of 10^{-3}. The performances of the ATM Adaptation Layer will be compared separately for both random and bursty losses with a sketch of the end-to-end user QOS (error probabilities of non-corrected events) versus the network QOS (network error probabilities); the whole scale ranging from 10^{-9} to 10^{-3} is here considered.

solution 1: let us first consider the solution for random losses in Figure 6.3. (N=32, K=31). Cell interleaving seems to be necessary to extend this short correcting field to the correction of cell losses in bursts. For example, a sub-field of 4 cells plus 1 redundancy cell interleaved into a field of 32 cells enable to correct bursts of 3 consecutive cells as depicted in Figure 6.4 and generalize the previous ALL (N=4, K=3) which ends up with ($N = 8 \times 4$, $K = 8 \times 3$) when interleaved 8 times.

solution 2: another way of performing cell loss correction is by considering a E_e error correcting Reed-Solomon code with code symbols from a $GF(2^m)$. If each symbol is represented by its corresponding m-bit byte, then we obtain a binary code to be applied on bits identically located on consecutive cells, this code has the following characteristics

$$N = m(2^m - 1) \text{ (binary code)}$$

6.2. Cell Losses and Bit Errors

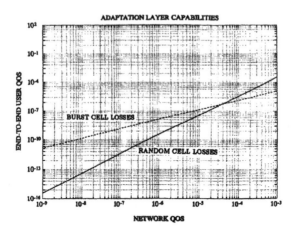

Figure 6.3: Characteristic of random cell loss protection.

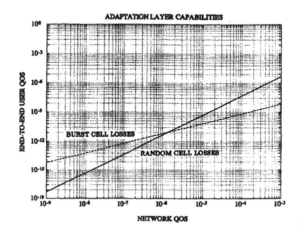

Figure 6.4: Protection of the preceding figure (4,1) 8-times interleaved.

$$N - K = 2mE_e \text{ (binary redundancy)}$$

This code is able to correct any pattern that affects E_e or fewer m-bit bytes. Thus, if an error pattern affects E_e or fewer bytes, it affects E_e or fewer symbols in a Reed-Solomon code. Obviously, that error pattern can be corrected and the code is called a E_e-byte correcting code. Actually, it can correct any E_e or fewer random errors and any burst of length $E_e m - m + 1$.

Let us consider m=6 and E_e=2 i.e. $N = 378$ and $N - K = 24$. this solution decreases the overhead cost of the code to 6.3 % without interleaving, that code can correct up to 4 random losses, one burst of 3m+1=19 cells and any combination of two bursts of length m+1=7 or less. The code capabilities are presented on Figure 6.5 ($\beta = 1.1$).

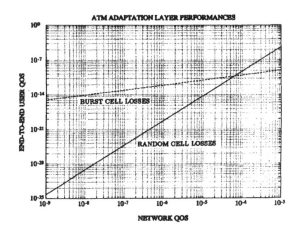

Figure 6.5: Reed Solomon code with m=6, t=4 i.e. (378,354).

Interleaving of degree i increases the burst correction capability L of the code to a $L \times i$ burst correcting capability. It increases the hardware complexity, the storage delay and, unfortunately, it does not really increase random error correcting capabilities.

As a matter of conclusion, the method of correcting with redundancy cells introduced in the packetizer is well suited at low level of cell losses. For higher loss levels, the cell interleaving is difficult to implement and not optimally efficient in this case. The first method with an interleaver before the packetization turns out to be more efficient and more flexible to cope with bursty losses.

Let us illustrate realistic performance achievable when using interleaving conjugated with RS codes. Table 6.7 summarizes the end-to-end protection proposed for distributed services. The design characteristics are the following

1. ability to cope with defects.

 1.1 4 lost cells among 128 for video services.

 1.2 1 lost cell among 14 for audio services.

6.2. Cell Losses and Bit Errors

service	bit rate (Mbit/s)		relative	mean cell loss probability				processing
	range	mean	overhead	$5\ 10^{-9}$	10^{-8}	10^{-7}	10^{-6}	delay (ms)
TV	2-50	25	7.5 %	570 Y	142 Y	426 D	36H	<15
HDTV	2-80	50	7.6 %	190 Y	47 Y	142D	12H	<7
AUDIO	0.3-0.5	0.4	13.7 %	29Y	7Y	26D	6.3H	<25

Table 6.7: Performances of error correction systems.

1.3 1 intruder among 5 cells for both services.

2. error correcting code: RS over GF(256).

 2.1 code length: 128 (video), 28 (audio).

 2.2 code dimension: 124 (video), 26 (audio).

 2.3 distance: 5 (video), 3 (audio).

This demonstrates the necessity of error correction to achieve for TV and HDTV viable transmissions of high quality. The resulting corrected quality is highly acceptable. Nevertheless, these results still require a good knowledge of the potential figures of cell losses. This peculiar problem will be treated in Chapter 7. Anyway, this system based on using Reed Solomon codes presents a high immunity against bursts of bit errors and cell losses. It is actually implementable with today technology and reaches the highest capability in conformance to the currently known error correcting codes.

6.3 Synchronization of Decoders

The problem addressed in this section is to synchronize the timing of the decoder work to that of the encoder. Let us recall that ATM interconnects customer services without distributing any common reference clock. The goal of synchronizing the receivers on the encoder source is two-fold

1. to synchronize the decoder buffer regulation to that of the encoder buffer.

2. to ensure the display of the decoded pictures with limited timing distortions.

When dealing with ATM transmissions, the synchronization of the decoder is a major problem to be solved as a consequence of two main reasons which follow. First, as already mentioned, no network reference clock is available to both encoder and decoder since the transmissions are asynchronous and that users and network share only time slot references which are synchronized independently on a link-per-link basis aiming at providing users with a window where to launch or to pick up cells. Secondly, the end-to-end cell transmission undergoes differential random delays called the jitter as already defined in Chapter 5. Both previous reasons prevent the decoder from synchronizing its reference clock directly to that of encoder and from regulating the decoder input buffer in synchronism with the encoder output buffer. The solution of those two problems is addressed in what follows and a mechanism based on two levels of synchronization is presented

1. the synchronization of the data extraction from the decoder buffer with the data filling rate in the encoder buffer is carried out by a coarse mechanism based on integrals of bit rates. It couples the decoder buffer regulation with that one of the encoder. This mechanism is useful to start the synchronization of the decoder timing in different circumstances, especially at transmission set-up, at channel swapping and during the entire transmission to maintain a coarse decoder work timing locked to that of the encoder. The synchronism error does not intend to exceed data-extracting timing shifts higher than two stripes.

2. the generation of the decoder clock (in TV, 27 Mhz) is carried out by a phase-locked loop and guarantees a jitter so small as to fulfill a somewhat alleviated CCIR 656 Recommendation which specifies to avoid a pixel jitter exceeding a margin of 3 ns over field intervals on the decoder display. The aim is evidently to prevent the decoded from reconstructing images with flicker and distortion. This task is performed by means of time stamps sent by the encoder at fixed periods of its reference clock (for example in TV, every 500 μs, a period which corresponds to divide the reference clock by factor of 13×1024).

In what follows, the notion of synchronism will be first defined to face the problem of regulating the evolution of the decoder buffer content. Let us remark that the transmission delays under investigation in this chapter are only stochastic delays; the deterministic fractions of the transmission delay are supposed constant or very slowly fluctuating relatively to the phenomena under study. The section proceeds by deriving a timing conservation equation to be complied to when a synchronized transmission is aimed at being established. Since the equation is necessary and sufficient, an algorithm in the decoder is in charge of forcing this relationship to be fulfilled by coupling the buffer regulation of the decoder with that one of the encoder. The analysis proceeds presenting how to construct a decoder clock with a phase-locked loop in order to comply to a less stringent CCIR 656 Recommendation.

6.3.1 Decoding Synchronism

By principle, the *synchronism* between encoder and decoder is based on the following assertion

let t_n with $\{n = 0, 1, ...\}$ be the instant when the n^{th} piece of data is pushed into the encoder buffer and r_n with $\{n = 0, 1, ...\}$ be the instants when the n^{th} piece of data is extracted from the decoder buffer. When the synchronism is reached between the encoder and the decoder buffers, the expected value of the time interval $E[t_n - r_n]$ remains constant

$$E[t_n - r_n] \;=\; D_{sync} \;=\; E[D_E + D_P + D_N + D_D] \tag{6.28}$$

D_{sync} is called the delay of synchronism, D_E, D_P, D_N and D_D are respectively the random delays spent in the encoder buffer, in the packetizer buffer, in the network queues and in the decoder buffer.

The delay of synchronism will be investigated in the two transmission modes allowed in ATM networks: the CBR and VBR applications.

6.3.1.1 Synchronism in CBR Transmissions

Let B_E and B_D be respectively the levels of buffer occupancy into the encoder and the decoder, B_P the mean amount of bit stream stored in the packetizer and $B_{N,i}$ $i = 1,..,n$ the mean amount of bit stream temporarily stored in the network queues i. Figure 6.6 traces the path followed by a piece of data pushed at t_{in} in the encoder buffer and extracted at t_{out} from the decoder buffer and depicts the evolution of the buffer occupancies in terms of a virtual address counter indexing. Since the buffer server reads at constant rate, the piece of data under interest is read or served after a time $\frac{B_E}{R}$ and transmitted on the network (sketched by the central inclined line). It undergoes several delays in successive queues, they are $\sum_i \frac{B_{N,i}}{R}$. Eventually, the cell arrives at destination in the decoder buffer where a period equal to $\frac{B_D}{R}$ is elapsed before being extracted by the local server. Finally, the data are delivered to the variable length decoder.

When expressing synchronism for a transmission at constant bit rate, the relationship between the delay of synchronism D_{sync} and the channel bit rate R is as follows

$$D_{sync} = \frac{E[B]}{R} \simeq \frac{E[B_E + B_D]}{R} \tag{6.29}$$

where B is the global buffered bit stream, B can be decomposed into $B = B_E + B_P + \sum_i B_{N,i} + B_D$.

First of all, to give some magnitude orders, D_{sync} is constrained to the order of one or two frames (40 to 80 ms), D_P depends on the load of the network frame to be accessed (practically from one to about ten time slots i.e. 3 to 30 μs for a link at 150 Mbit/s), T_N has a maximum of 500 μs. The contributions of the coder and the decoder buffer are practically dominant. The sum of B_E and B_D is equal to one or two coded frames. The capacity of the encoder and the decoder buffers is therefore also of one or two coded frames (in TV, 1 - 2 Mbit). The contributions of B_P and of the $B_{N,i}$ are negligible (a few thousands of bits). The averages are computed on a stripe-by-stripe basis to adjust in the decoder the timing conservation relationship.

At synchronism, the sum of the mean buffered bit stream equals the amount of the mean bit stream exchanged during the interval of time equal to the delay of synchronism. As a consequence, the levels of occupancy of encoder and the decoder buffer fluctuate in a mirror way (Figure 6.7). Avoiding respectively underflow and overflow into the coder buffer implies avoiding overflow and underflow in the decoder buffer. To synchronize the decoder buffer, the procedure performed as follows

- at the coder end, the level of buffer occupancy is sent to the decoder at the occurrence of each stripe by means of data fields of a data field encapsulated in the stripe synchronization words.

- at the decoder end, the input buffer control tracks synchronization words, fetches the value of the buffer level in its dedicated data field and regulates by speeding up or slowing down the data extraction in order to fulfill synchronism relationship.

The regulation of the occupancy level of the decoder buffer is not really critical. This algorithm is simply enslaved to the encoder regulation scheme. Its task is to respond

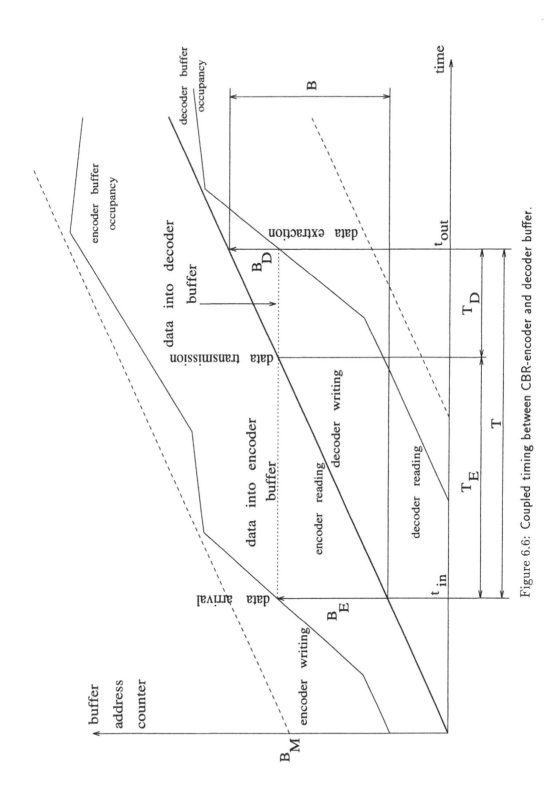

Figure 6.6: Coupled timing between CBR-encoder and decoder buffer.

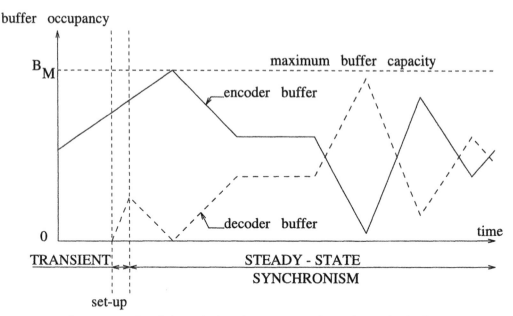

Figure 6.7: Coupled regulations between encoder and decoder buffer.

quickly to any potential shift of the synchronism equation. The magnitude orders derived for transmission delays in this section allow inferring that, for TV and HDTV, the random transmission delays on ATM networks are not critical with respect to their maximum values (as in speech and interactive video-telephony) but rather to their jittering effect.

6.3.1.2 Synchronism in VBR Transmissions

In free VBR applications, the encoder buffer is emptied at the rate data arrives in the buffer i.e. the VLC generation rate. When a policing function controls the output transmission rate, the rate of extracting data from the buffer is also variable but preventively controlled, the buffer may remain partially filled. The definition of the synchronism is kept unchanged in all the transmission modes. The evolution of the different parameters is pictured in Figure 6.8 in a way similar to that presented on Figure 6.6 except that here the transmission is variable as testified by the broken central inclined line. Once synchronized, the mean delay of propagation remains constant. As a matter of fact, in the case of variable bit rate transmissions, the following synchronism equation can be deduced from relationship 6.29

$$B = B_E + B_D = \int_{t_0}^{t_1} R(t)dt \qquad T = t_1 - t_0 \qquad (6.30)$$

where the channel bit rate R is transformed here into an integral of bit rate. The procedure to lock the synchronism can therefore be described as follows

- in the encoder, the variable length bit stream is encapsulated within a video-multiplex and marked with delimiters by frame and stripe synchronization words.

- the observed values of the level of the encoder buffer occupancy are sent to the decoder inscribed in each stripe synchronization word.

- the integral of bit rate is either transmitted by the decoder or computed in the decoder.

- the buffer regulation in the decoder adjusts the rate of data extraction to fulfill an average transmission synchronism.

Upon transmission set-up or change swapping, the decoder empties its input buffer, awaits for the occurrence of a stripe synchronization word to read the value of the level of the encoder buffer occupancy and starts to regulate its buffer occupancy to tune to the synchronism equation. This mechanism allows establishing the synchronism between the relative buffer timings within two frame periods (80 ms). The uncertainty on the synchronism in steady state has a maximum of two stripe durations i.e. about one ms.

6.3.2 Phase Locked Loop for Decoder Clock

The second mechanism aims at recovering in the decoder the phase of the encoder clock. The method is based on sending to the decoder periodically spaced time stamps directly derived from the encoder clock. In TV coders, the reference clock is at $f_r = 27$ Mhz and the time stamps are sent with a fixed period issued from division of the clock, for example 500 μs. The goal is therefore to reconstruct in the decoder a clock with a phase jitter so low as to fulfill the CCIR 656 Recommendation for a jitter on the decoder display inferior to 3 ns on the field duration (20 ms) and, as a consequence, to avoid image deformations and flickers. This stringent recommendation will be somewhat alleviated by interpreting the specification in a slightly different way. The bandwidth of the phase-locked loop will turn out to be small and the jitter to vary slightly during 20 ms. Therefore, under a realistic assumption of jitter characteristics fluctuating slowly during one field, the goal will be to consider the recommendation as a constraint on a maximum relative error. The resulting jitter $J(t)$ on the decoder clock should fulfill in steady state a constraint on its variation $\delta(t)$ as

$$u(t) \; = \; \delta(t) \; = \; \frac{\Delta J(t)}{\Delta t} \; < \; \frac{3ns}{20ms} \; = \; 1.5 \; 10^{-7} \tag{6.31}$$

to limit the temporal derivative of the output jittering.

The phase-locked loop must be designed to response to transients with a satisfactory behavior. Transients occur at receiver switch-on and at channel changes. The nominal source frequency may change of ∓ 50 ppm from its 27 MHz reference. This implies a frequency error $f_e(t)$ in the decoder which must converge to zero. Reasonable transient performances should force the receiver to satisfy the steady-state constraints with a maximum set-up time of one minute after the channel switch-on. During the transient responses, a second constraint imposes a limit on the potential shifts of the reconstructed frequency with respect to the encoder reference frequency. At $t = 0$, the maximum shift of relative frequency is equal to $\pm 50 \; 10^{-6}$ and the steady-state requirement of $\pm 1.5 10^{-7}$ has to be satisfied within one minute following set-up. In fact, the locking time will turn

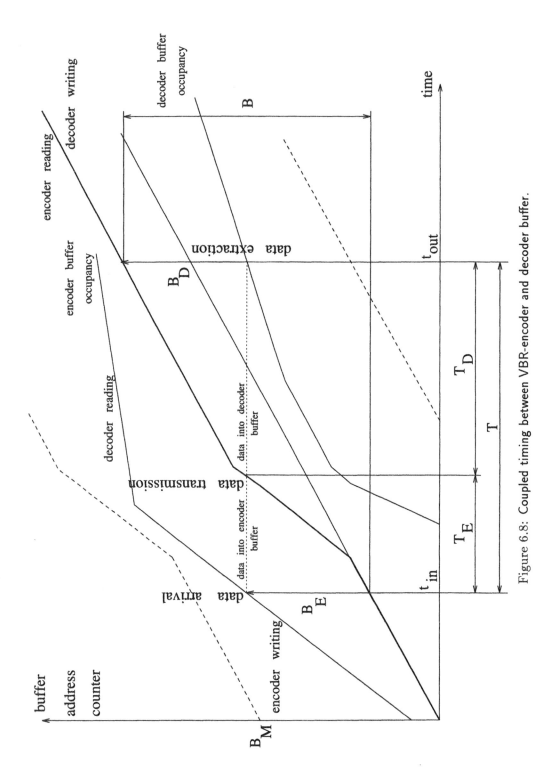

Figure 6.8: Coupled timing between VBR-encoder and decoder buffer.

Chapter 6. ATM Adaptation Layer

out to be non-critical. Finally, the residual steady-state phase error has to be limited in order not to interfere with the synchronism established between the buffers (one ms).

The description of the algorithm to recover the reference clock is subsequently addressed. The paragraph starts with the description of the time stamps and proceeds with the mechanism of the phase-locked loop.

6.3.2.1 Time Stamps

Time stamps are inserted into special cells termed the *re-synchronization cells*. Let us illustrate the case of a TV transmission exploiting two-byte time stamps. They have to provide the decoder with three fields of information (with an example on two bytes for TV) as follows

1. field 1 is charged with the LSB's of the reference clock counter at the instant when the cell is launched on the network [one byte].

2. field 2 contains a modulo-N counter to sequence the time stamps [5 bits - modulo-32].

3. field 3 represents an identifier of the period span between two consecutive time stamps [3 bits - 8 possible configurations].

The signal of the time stamps can be modeled at the input of the coder by periodic pulses corrupted by a white Gaussian distributed jitter

$$X(t) = \sum_{n=-\infty}^{+\infty} g(t - nT_c - D(n) - X_c) \tag{6.32}$$

with $g(t)$ the pulses, T_c the time stamp period, $D(n)$ the network transmission delay of the n^{th} pulse and X_c a random variable with uniform distribution on the interval $[0, T_c]$ to take into account the original clock phase. The spectrum density function of $X(t)$ is derived after some calculations by

$$\gamma_X(\omega) = \frac{1}{T_c}|G(\omega)|^2[1 - \phi_D^2(\omega)] + \frac{2\pi}{T_c^2}\sum_{k=-\infty}^{\infty} |G(k\omega_c)|^2\phi_D^2(k\omega_c)\delta(\omega - k\omega_c) \tag{6.33}$$

where $\omega_c = 2\pi f_c$, $G(\omega)$ is the Fourier transform of the impulse $g(t)$

$$G(\omega) = \frac{T_c}{2} \frac{\sin(\frac{\omega T_c}{4})}{\frac{\omega T_c}{4}} \tag{6.34}$$

and $\phi_D(\omega)$ the characteristic function of the Gaussian PDF of standard deviation σ_D s i.e.

$$\phi_D(\omega) = e^{-\frac{\omega^2 \sigma_D^2}{2}} \tag{6.35}$$

6.3. Synchronization of Decoders 477

The resulting spectrum density function of $X(t)$ contains an impulse train embedded in the continuous-frequency noise spectrum generated by the jittering action. Reasonable assumptions lead to demonstrate that the noise spectrum is relatively weak at low frequencies around the frequency line $\frac{2\pi}{T_c}$ of the useful information and merely concentrated over high frequencies. As a matter of partial conclusions, the digital phase-locked loop will track the spectrum line of frequency f_0 with a small bandwidth to fulfill the CCIR 656 Recommendation. Since the PLL is digital with a sampling frequency f_e, a filter shield is required to prevent the high frequency noise spectrum from aliasing and folding back within the PLL bandwidth.

6.3.2.2 Phase-Locked Loops

This paragraph investigates how to implement a phase-locked loop which ensures the generation of a decoder clock fulfilling the put-forward specifications. The locking system is composed of an analog time-stamp preprocessing and of a digital phase-locked loop. The preprocessing consists of two consecutive processes, namely a time-stamp pulse shaping and an anti-aliasing prefiltering. The digital Phase Locked Loop (PLL) is constructed by assembling a phase comparator, a loop filter and a voltage-controlled oscillator.

The main frequencies to be referred to in the description are as follows

1. f_r the reference encoder clock frequency.

2. f_t the time stamp generation frequency. For example, in TV, $f_t = \frac{f_r}{13 \times 1024}$ i.e. a stamp every 500 μs.

3. $f_o = \frac{f_t}{32}$ the frequency of generation of the decoder synchronization pulses. The decoder buffer generates one synchronization pulse to the phase-locked loop every 32 arrivals of time stamp.

4. f_e the sampling frequency of PLL comparator.

The analog preprocessing and the digital phase-locked loop are now addressed into some details.

The Analog Preprocessing

The preprocessing is made of a pulse shaping process to generate one pulse of a given shape upon arrival of each successive 32 time stamps and of a prefilter procedure to cancel all the potential aliasing effects susceptible occurring during the comparator sampling (Figure 6.9).

Figure 6.9: Phase-locked loop: preprocessing.

1. the pulse shaping has no primordial function. It is in charge of generating an analog impulse at the arrival of every 32 time stamps ($N_1 = 32$). Moreover, an adequate choice of the impulse shape can facilitate the next prefiltering process. Therefore, a rectangular impulse of width $\frac{1}{2f_0}$ will be chosen to suppress from the jitter spectrum the frequency lines around all the multiples of $2f_0$ and filter the high-frequency noise. The Fourier transform of the pulse is given by

$$G(\omega) = \frac{T_0}{2} \, sinc(\frac{\omega T_0}{4}) \qquad (6.36)$$

2. the prefiltering aims at eliminating the high frequency noise components susceptible to generate an aliasing effect during the comparator sampling operation. The goal is to select the frequence f_o. Therefore a low-pass filter with a bandwidth B_W of $\frac{3f_o}{2}$ will be employed to avoid aliasing. To give some practical values in TV applications, the sampling rate of the microprocessor has a frequency of $f_e = 63.38KHz$. The pulse frequency on which the PLL has to be locked will be of the order of $f_o = 63$ Hz i.e. the time-stamp frequency divided by 32. This prefiltering is performed with a low-pass filter of bandwidth $B_W < \frac{3f_o}{2}$ and, in the present application, $f_o \cong \frac{f_e}{1000}$.

The Digital Phase-Locked Loops

The purpose of the digital phase-locked loop is two-fold and consists of providing the receiver with a reference clock affected by a resulting jitter which fulfills the constraint imposed on the temporal output-jitter derivative of the output jitter $u(t)$ expressed in Equation 6.31 and of guaranteeing efficient transient responses. After some calculations, the relationship between the bandwidth of the PLL B_L and the variance of $u(t)$, σ_u^2 turns out to be

$$\sigma_u = \frac{\pi^2 B_L^3 \sigma_D^2}{6f_0} \qquad (6.37)$$

Therefore, $f_0 = 63.38 \, Hz$ requires a bandwidth of 0.144 Hz.
The phase-locked loop (Figure 6.10) is composed of

1. a phase comparator which samples the phase θ_i of the prefiltered signal S_i of the time stamps and the phase θ_r of the reconstructed decoder clock S_o to generate the signal S_e of the phase error θ_e. Before sampling the preprocessed impulse, an integrator ($\frac{1}{s}$) generates the input phase θ_i. The gain of the comparator is K_1.

2. a digital loop filter in charge of imposing the loop characteristics in terms of a transient response and a residual steady state error. The gain of the filter is K_2.

3. a voltage-controlled oscillator to generate the locked reference clock of $f_r = 27MHz$ under the control of the filtered version of the error signal S_e. The gain of the oscillator is K_3.

6.3. Synchronization of Decoders

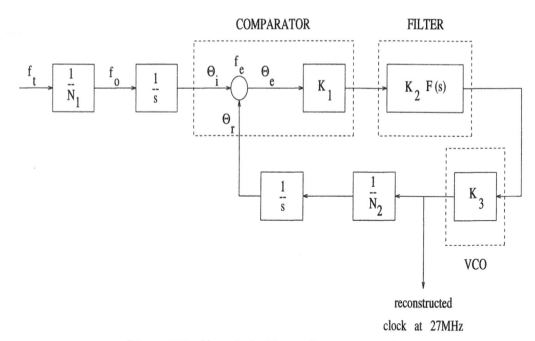

Figure 6.10: Phase-locked loop: diagram processing.

4. a clock divider to obtain the frequency f_0 by division with a factor $N_2 = 32 \times 13 \times 1024$ and to enable the comparison with the preprocessed input signal. The divider is therefore followed by an integrator ($\frac{1}{s}$ in Figure 6.10) to generate the phase signal θ_r.

If the Laplace transform of the loop filter transmittance is $F(s)$, the PLL open loop transmittance is given by

$$G(s) = \frac{KF(s)}{s} \qquad (6.38)$$

where $K = 2\pi K_1 K_2 K_3$ and the PLL closed loop transmittance is given by

$$H(s) = \frac{G(s)}{1 + G(s)} \qquad (6.39)$$

The PLL bandwidth $B_{W,l}$ is formulated using the Fourier version and given by

$$B_{W,l} = \frac{1}{2\pi} \int_0^\infty |H(e^{j\omega})|^2 d\omega \qquad (6.40)$$

The variance of the jitter is intended to be reduced by filtering. It is worth calculating the variance obtained after filtering by a low-pass filter of bandwidth B_W. The output signal variance is given in $[rad^2]$ by

$$\sigma_P^2 = \frac{\sigma_N^2}{A^2} \tag{6.41}$$

where σ_N^2 is the noise power and A^2 the power at the frequency line f_0, respectively expressed by

$$\sigma_N^2 = \frac{1}{2\pi} \int_{-\pi B_W}^{\pi B_W} \frac{1}{T_0} |G(\omega)|^2 \, (1 - \phi_D^2) \, d\omega \tag{6.42}$$

and

$$A^2 = \frac{4}{T_0^2} |G(\omega_0)|^2 \, \phi_D^2(\omega_0) \tag{6.43}$$

Assuming $\omega << \frac{1}{\sigma_D}$ leads to some approximations in the calculations

$$\phi_D^2(\omega) \simeq 1 \qquad 1 - \phi_D^2(\omega) \simeq \omega^2 \, \sigma_D^2 \tag{6.44}$$

Therefore, the different contributions in σ_P are as follows

$$A^2 = \frac{4}{T_0^2} \left(\frac{T_0}{2}\right)^2 \frac{\sin^2(\frac{\omega_0 T_0}{4})}{(\frac{\omega_0 T_0}{4})^2} = \frac{4}{\pi^2} \tag{6.45}$$

and

$$\sigma_N^2 = \frac{1}{2\pi T_0} \int_{-\pi B_W}^{\pi B_W} \frac{T_0^2}{4} \frac{\sin^2(\frac{\omega_0 T_0}{4})}{(\frac{\omega_0 T_0}{4})^2} \frac{1}{T_0} |G(\omega)|^2 \, \omega^2 \, \sigma_D^2 \, d\omega \tag{6.46}$$

$$= \frac{8\sigma_D^2}{\pi T_0^2} \left(\frac{\pi B_W T_0}{4} - \frac{\sin(\frac{\pi B_W T_0}{2})}{2}\right) \tag{6.47}$$

The jitter variance expressed in $[rad^2]$ becomes readily

$$\sigma_P^2 = \frac{2\pi \sigma_D^2}{T_0^2} \left(\frac{\pi B_W T_0}{4} - \frac{\sin(\frac{\pi B_W T_0}{2})}{2}\right) \tag{6.48}$$

and, expressed in time unit $[s^2]$

$$\sigma_P^2 = \frac{\sigma_D^2}{2\pi} \left(\frac{\pi B_W T_0}{4} - \frac{\sin(\frac{\pi B_W T_0}{2})}{2}\right) \tag{6.49}$$

This illustrates how jitter is transformed by a low-pass filtering effect, for instance in our case of study, the PLL.

The Comparator

The comparator samples with a frequency of $f_e = 63.38 KHz$ the phases of two signals

1. the resulting shaped time stamp signal.

2. the decoder clock generated by the voltage-controlled oscillator and further divided by $N_2 = 32 \times 13 \times 1024$ to match with the frequency of the time stamp signal.

The comparator generates an error signal as the difference of both phases.

The Loop Filter

In practical applications, the loop filter is a digital filter which eventually determines the order of the PLL; here, a filter of the first order has been chosen. The Laplace transform of this filter transmittance takes the form of

$$F(s) = \frac{1}{1 + T_1 s} \tag{6.50}$$

and the PLL closed loop transmittance is given by

$$H(s) = \frac{1}{(T_n s)^2 + 2\eta T_n s + 1} \tag{6.51}$$

with

$$T_n = \sqrt{\frac{T_1}{K}} \qquad \eta = \frac{1}{2\sqrt{KT_1}} \qquad B_l = \frac{K}{4} \tag{6.52}$$

The loop is designed with the following values $\eta = 1.0$, $T_1 = 0.434$, $K = 0.576 Hz$ and $B_{W,l} = 0.144 Hz$. The digital filter to be implemented is calculated by a bilinear transformation of Equation 6.51.

The Voltage-Controlled Oscillator (VCO)

It generates the reconstructed clock at 27 Mhz with the filtered error signal as command of phase. Its frequency stability is of the order of $25.0 \ 10^{-6}$.

PLL Performances

PLL performances are given by three characteristics: the residual steady-state phase error, the transient set-up times and the maximum residual phase error. They are valued as follows

1. the residual steady-state phase error is the sum of three components to be enumerated as

 1.1 a network jitter σ_N of $\pm 250 \ \mu s$ becomes from Equation 6.49 at the output of the time stamp preprocessing equal to

 $$\sigma_P = \sigma_N \sqrt{\frac{1}{2\pi} \left[\frac{\pi B_{W,l}}{4 f_o} - \frac{\sin[\frac{\pi B_W}{2 f_o}]}{2} \right]} \tag{6.53}$$

 to express the jitter resulting of a low-pass filtering with bandwidth $B_W = \frac{3 f_o}{2}$. In this practical case of study, the resulting jitter σ_P is equal to $\pm 90 \ \mu s$.

 1.2 the steady-state behavior of a PLL of order one leads to a residual error [ref 7-8]

$$\epsilon_\infty = \frac{2 \pi \Delta f f_0}{4 B_l} \tag{6.54}$$

where $\epsilon_\infty = 87 \ \mu s$ with a relative frequency shift Δf of 50 10^{-6}.

 1.3. the contribution due to the unstability of the VCO which is of the order of 43 μs by design specifications.

The global steady-state phase error is therefore of about \pm 220 μs.

2. the transient response of the PLL must be designed to limit the maximum phase error to 1 ms and to reach the steady state after a maximum of one minute and a relative frequency error inferior to $\mp 1.5 \ 10^{-7}$.

2.1 the Laplace transform of the phase error arising from a frequency shift of magnitude ω_Δ is given by

$$\frac{\omega_\Delta H(s)}{s^2} \tag{6.55}$$

The temporal response of the phase error is derived from the inverse transform. This response is drawn in Figure 6.11 ($\eta = 1$, $B_l = 0.144 Hz$) and shows that a PLL of order one fulfills the requirement.

2.2 the Laplace transform of the frequency error arising a frequency shift of magnitude ω_Δ is given by

$$\frac{\omega_\Delta H(s)}{s} \tag{6.56}$$

The temporal response of the frequency error is presented in Figure 6.12. This shows that a PLL of order one with a bandwidth $B_{W,l} = 0.144 Hz$ comply to the transient specifications. According to the PLL performance calculations, it turns out that the initial stringent specifications concerning the residual jittering effect acting on the reconstructed image are easily fulfilled with the use of a PLL.

6.4 Conclusions

Chapter 5 has put into evidence positive and negative effects of multiplexing statistically the TV sources. As a main issue, the present chapter has developed all the strategies to cope with the drawbacks of ATM multiplexing. This chapter has definitively demonstrated that the cell losses and specially their configuration stand as the only major problem to be faced with. Let us, first, enumerate the conclusions about each individual problem and, secondly, develop the main consequence about the cell loss correction.

 1. the protection against bit errors can be easily handled and does not constitute any problem as far as optical terrestrial transmissions are taken as assumption.

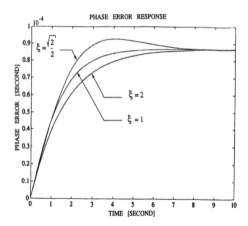

Figure 6.11: **Phase error transient.**

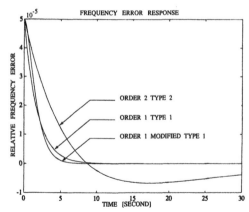

Figure 6.12: **Frequency error transient.**

2. the synchronism between encoders and decoders is easily achieved with high working margins owing to the use of integrals of bit rate, time stamps, enslaved control of the input decoder buffers and PLL's. In fact, the maximum value of the transmission delay is not a critical parameter being inferior to 2% of the nominal delay of synchronism. The jitter associated with the random delays has been easily mastered and an algorithm to synchronize the decoder clock has been derived despite the stringent CCIR constraints on the decoder display. A PLL of order one enables fulfilling with a high working margin somewhat alleviated CCIR specifications. The regulation of the decoder buffer has been presented as locked to that one of the encoder leading to a synchronism principle between the encoder and the decoder.

3. the protection against cell losses is guaranteed for random losses and short-term bursts. The long-term bursts lasting more than fifteen cells will not be covered by error correcting codes. The non-corrigible cell loss defects are relegated to concealment algorithms to be implemented in decoders.

This enumeration signifies that the transmission quality expected from an ATM network transmitting TV information has to be expressed in terms of cell loss characteristics. The other drawbacks are not critical in the framework of the assumptions drawn in the thesis.

This chapter has also demonstrated the way and the cost to build an error protection against random and bursty cell losses. Two methods have been proposed

1. RS codes conjugated with interleaving before packetizing.

2. product codes combining BCH codes with redundancy cells when packetizing.

The interleaving strengthens the correcting abilities with an adjustable tool to reach variable levels of bursty loss correction.

Eventually, the conclusions of the chapter can assess that it is possible to build error correcting codes to enhance the network QOS of distributed TV sources. The resulting transmissions are guaranteed with a quality which can be eventually expressed in terms

of mean time intervals in between two consecutive unrecoverable and perceptible defects. This mean interval will be nominally for HDTV in a range of several tens of days (20-60) depending on cell loss characteristics and on correcting abilities. Maximum bit rate overheads necessary to add error correcting codes are not higher than 5%.

6.5 Bibliography

The Error Correcting Codes

[6.1] E. R. Berlekamp "Algebraic Coding Theory", *Mc Graw-Hill, New-York, 1968.*

[6.2] R. E. Blahut "Theory and Practice of Error Control Codes", *Addison-Wesley, 1984.*

[6.3] G. C. Clark, J. B. Cain "Error-Correction Coding for Digital Communications", *Plenum Press, 1988.*

[6.4] G. D. Forney "Burst-Correcting Codes for the Classic Bursty Channel", *IEEE Transactions on Communications Technology, Vol. com-19, No. 5, pp. 772-781, October 1971.*

[6.5] J.-P. Leduc "Error correcting policy when encoding for ATM transmissions" *internal RACE HIVITS report, WPB2/UCL/80, May 1991.*

[6.6] B. C. Mortimer, M. J. Moore, M. Sablatash "The Design of High-Performance Error-Correcting Coding Scheme for the Canadian Broadcast Telidon System Based on Reed-Solomon Codes", *IEEE Transactions on Communications, Vol. com-35, No. 11, pp. 1113-1123, November 1987.*

[6.7] P. Piret "Introduction to finite fields and 1-error correcting codes", *Philips Research Laboratory Brussels, Technical note N179, June 1988.*

[6.8] V. Ramaswami and W. Willinger "Efficient Traffic Performance Strategies for Packet Multiplexers", *ITC Specialist Seminar Adelaide, 1989, paper no 4.2. reprinted in Computer Networks and ISDN Systems, Vol. 20, No. 1-5, pp. 401-408, December 1990.*

[6.9] J. Voisin "Error Protection of High Video and Audio Distributed Services: on Solutions for the Belgian Broadband Experiment", *Proceedings of the Third Workshop on Packet Video, Morristown, USA, March 1990.*

The Synchronization

[6.10] P. Delogne, S. Comes "Synchronization of a TV decoder using Time Stamps: the steady state conditions", *internal UCL report, March 1990.*

[6.11] P. Delogne, S. Comes "ASD: ATM Synchronization De-jittering, a Study of the Clock Synchronization Process in a TV Decoder", *internal UCL report, April 1990.*

[6.12] L. Descamps "La Stratégie de resynchronisation en VBR et FBR", *Alcatel-Bell-SDT, internal report LD-ET-89-9.1, October 1989.*

[6.13] F. M. Gardner "Phase-lock Techniques", *John Wiley and Sons, 1979.*

[6.14] N. Wells "Integral of Bit Rate", *Race Hivits Private Communication, March 1989.*

Chapter 7

Transmission on ATM Networks

7.1　Introduction

This chapter will deal with general problems relative to the transmission of TV sources on ATM channels. Each node of the transmission network is composed of set of multiplexers or queues associated to each transmission link resulting in what is called a queueing network. In connection oriented applications, the virtual route connects two nodes, the source to the sink, via an explicit route which is the route proper to path control. An example composed of three links is presented in Figure 7.1. The study of connection oriented transmissions enables mesh network topologies to be simplified by extracting simplied topologies made of the L links used by the explicit route and known as tandem queueing models. As portrayed in Figure 7.2, the source S_1 connected to the network is first multiplexed with $(N_1 - 1)$ other sources for the transmission from node 1 to node 2. In the second node, the source will be successively demultiplexed, routed and again multiplexed with $(N_2 - 1)$ other sources. This procedure is repeated at each multiplexing node along the virtual path. The aims of this chapter consist therefore of considering the complete transmission chain with coders and ATM channels and of gathering results obtained in the previous chapters to determine the optimum way of transmitting TV information on ATM channels.

During the set-up of the TV transmission path in a connection oriented application, a routine to allocate resources (also called bandwidths) has to take place into each multiplexer along the candidate virtual path. A multiplexer behaves as a random operator on cell inter-arrival time process. As a consequence, the way how source traffic descriptors are transformed when applied to a set of consecutive multiplexers can be taken into account to achieve a precise computation of optimum resources to be allocated in the following multiplexers. Connectionless transmissions require more global allocations of resource on the network and constitute a typical example of queueing networks.

In queueing networks, cell flows are major problems to be discussed; especially in the aim of obtaining optimal control policies, it is required to know the nature of the flow as Poisson, renewal or point process. Aggregations or superpositions of flows have already be studied in Chapter 5. In a node, the cell flow may also be decomposed by the switching mechanisms into subflows. Ultimately, a statistical analysis of the output data requires knowledge of input-output process considering the queueing functions as a

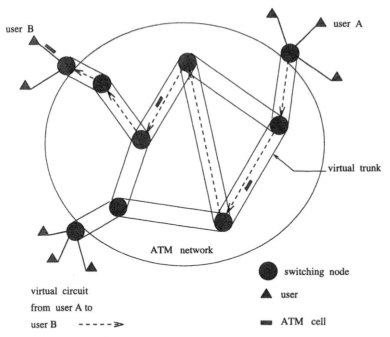

Figure 7.1: Transmission of TV sources on ATM networks.

non-linear random operators or transfer functions acting on random arrival processes.

Consequently, to cover the topics treated in this introduction, the material of this chapter is therefore exposed and structured as follows

1. the principles of queueing networks.

2. the optimum algorithms to allocate bandwidth in a multiplexer.

3. the definitions of the bandwidth.

4. the optimum bandwidth for TV sources.

5. the TV traffic descriptors.

6. the source enforcement algorithms.

7. the optimum coding-transmission function.

8. the input-output switching and multiplexing relations.

9. the congestion control strategies.

The search towards an optimum transmission is an important topic discussed in this chapter. It is subdivided into two consecutive phases. The first concerns the resource allocation which is executed at call establishment and the second refers to the optimum

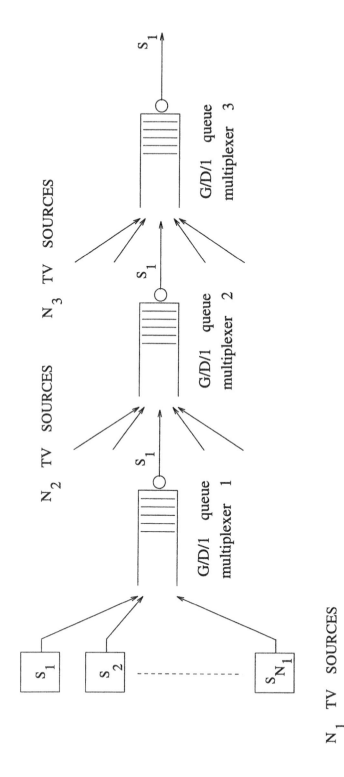

Figure 7.2: Transmission of TV sources on an ATM virtual path.

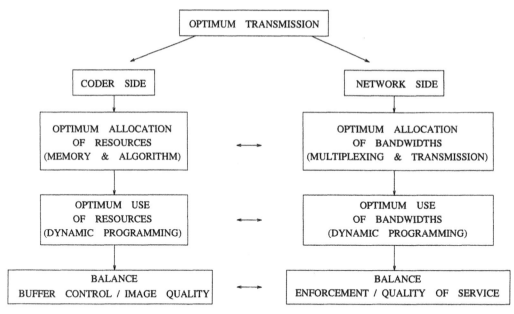

Figure 7.3: Overview of the optimum transmission.

way to use the available resources which is performed in real time over the whole transmission (Figure 7.3). As a major point, a parallelism of operating actions can be drawn between the operations to be carried out into a TV coder and those to be accomplished in the network in order to derive in each other an optimum control of the transmission. That similarity opens the path towards elaborating a unique global optimum control for the whole transmission chain (coding and transmission) as a straightforward extension of the optimum search to minimize a cost function developed in Chapter 4. Indeed, let us introduce the relevant features under concern.

The resources allocation within the coder are frozen during the design phase and consist mainly of an amount of memory to be devoted to the decorrelation process (prediction memory) and to the output buffering (coding control). As a matter of fact, increasing the storage capacity into the coder improves the temporal decorrelation and the control of the coder. The resources in a network are referred to as the bandwidth which will be defined as a fraction of the queue service rate i.e. of the output transmission bit rate. Because of its relation with the cell losses, the bandwidth is also dependent on the amount of memory available into the queueing system. As this bandwidth has to be shared with all the other sources competing for transmission on a common virtual path, an optimum algorithm has to be processed into the network management to operate at each call set-up an optimum bandwidth allocation into the multiplexers located along the elected virtual path.

Once allocated, the resources have to be used in an optimum way simultaneously within the coder and the network. In Chapter 4, an optimum control algorithm has been described for a coder to balance the requirement for a constant image quality with the constraints of both limited buffer capacity and specified constant (CBR mode) or variable

(enforced VBR mode) channel cell rate. Coupled with this first algorithm, a second in the network is in charge of exploiting optimally the bandwidth in order to balance the enforcement action with the requirement of a constant network quality of service. In the case of TV transmissions, the enforcement means a policing of the traffic and a way to control the filling of multiplexing queues. The network QOS refers here definitely to the mean cell loss probability. As presented in Chapters 5 and 6, the transmission delay has nearly no influence on TV quality. In this chapter, the cost function to be optimized will be similar to that one of the coding control algorithm in order to achieve a general expression of an optimal balance for a TV transmission.

To introduce this research towards an optimum use of the available resources, let us consider two extreme cases of transmission i.e. CBR mode and free VBR mode

1. in the CBR mode, subjective image quality after quantization is variable, buffer control and network enforcement are both used with a maximum strength, network quality of service is constant due to the constant load of multiplexers.

2. in the free VBR mode, subjective image quality after quantization is maintained constant, buffer control and network enforcement are both inactive, network quality is variable due to the variable load of multiplexers.

On a queueing point of view, the first solution may reach the quasi-maximum throughput offered by the D/D/1 system at constant multiplexing QOS at the expense of loosing the benefit of a gain in statistical multiplexing. A CBR service has a predictable and uniform cell rate allowing the network utilization of the multiplexing queues (the load) to achieve about 100% without gain in statistical multiplexing. Let us however recall from Chapter 1 that multiplexing VBR sources leads to assigning a transmission bandwidth which converges to the resulting mean bit rate owing to the actual concentration effect of the PDF's instead of allotting a bandwidth equal the peak or the constant and mean-superior cell rate in CBR transmissions. The gain to be expected from the statistical multiplexing is far to be a negligible parameter at least of the economical point of view of allowing the insertion additional customer channels in a given bandwidth. Defining an index of traffic mixes to characterize the percentage of VBR services in a traffic volume composed of both CBR and VBR customers, Figure 7.4 depicts the network utilization i.e. the network exploitable load at different traffic mix indexes and different network QOS's. To achieve identical cell loss performances, pure VBR transmissions induce a decrease from 100% to about 85% of the network utilization (with a mean cell loss probability of 10^{-9}) i.e. loosing 15% of resources. In the balance, VBR transmissions enable the network to allocate the mean cell rate instead of the peak cell rate i.e. asymptotically gaining in TV at least 25% up to 50% of the allocatable resources. On the encoder point of view, the second solution achieves a constant subjective image quality at the expense of bursty and random cell losses. A global optimum transmission should therefore stand somewhere in between a pure free VBR mode and a CBR mode. This mean an enforced VBR transmission. Figure 7.5 outlines the different aspects relevant to the question. The use of a network enforcement should allow reaching that intermediate optimum solution and improving the multiplexing performances in terms of both mean cell loss probability and burst lengths at the expense of degrading slightly the image quality. Let us finally

remark that the algorithms proposed to allocate the transmission bandwidth are based on the expected cell loss probability (mean value). It is indeed supposed that the cell losses are very likely to occur by bursts arising from local congestions within the network, that congestion may inevitably occur when all the customer services will require at once their maximum bandwidth. It is further admitted that the network management has the attribution to deal with the congestion by implementing appropriate policing functions and by providing the virtual channels with temporarily additional switches and links to cope with the congestions. This approach is justified by the fact that the source non-stationarities leads to an intrinsic difficulty of predicting accurately how long a given source will require its maximum bandwidth and that correlations between sources may inevitably appear momentarily for foreseeable or unforeseeable reasons (like in any road traffic).

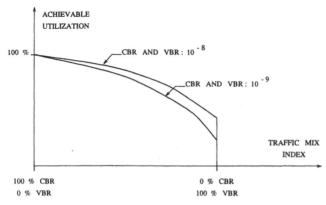

Figure 7.4: Mixing VBR and CBR transmissions.

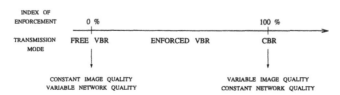

Figure 7.5: ATM transmission modes.

7.2 Principle of Queueing Networks

When discussing in the introduction about the cell transmission on ATM virtual circuits, a particular focus has been put on a new class of problems which involves more generally the interconnection of a multiplicity of queues. For obvious reasons, this kind of networking facilities is called a *queueing network*. Actually, the ATM packet-switched networks performing connectionless or connection oriented data transmission under study in this textbook belong to the family of the queueing networks.

A *communication network* is modeled as a *graph* where the *switching elements* are located in the *nodes* and the *communication trunks* are represented by *arcs*. Let $V = \{1, 2, ..., N\}$ be the set of nodes in the graph and let L denote the set of communication links in the network. For each link $l \in L$, the capacity is C_l packets/sec. In each node, one multiplexing queue is joined to each outward-bound link.

In the case under interest, the ATM networks support *multiclass applications* since they may accept different classes of services; each of them is characterized by a specific transmission quality of service. As in any general queueing network, the nodes include queueing systems of the type G/G/s with FIFO discipline. The study of the queueing networks starts with a case which offers more tractable computations and more amenable calculations; it assumes memoryless arrivals and services i.e. M/M/1 queueing models with Poisson arrivals and exponentially distributed service times. Similarly to the sudy of single queueing systems, this elementary configuration aims at introducing with a rather easy support all the basic concepts involved in the foundation of the queueing networks. Moreover, it is worth mentioning that the M/M/1 system plays a major role even when modeling complex systems. Indeed, a concept of *insensitivity* is defined and developed in the following. Accordingly, it will turn out that *insensitive stationary probability distributions* for a queue length process do not depend on the whole service time distribution but only on the mean value. Under sensitivity, no precise distribution assumptions about service times are actually relevant and, therefore, PDF's with negative exponentials can be exploited without further theoretical restrictions in order to ease the modeling work and the performance computations. Moreover, the insensitivity property is coupled with the existence properties expressed in *product form* solutions. Both tools provide powerful analysis and performance modeling of subnetworks with extremely valuable methods which replace a whole subnetwork, for instance a virtual path, by one single composite queue.

A queueing network consists, in principle, of a finite number of nodes where the queueing capacities are supposed to be either finite or infinite. Though general models require to exploit G/G/s queueing systems, for the shake of simplicity, the arrivals are first restricted to be Poisson processes and generalizations are admitted in a further stage of the study. Furthermore, the arrival processes entering the network are assumed to be independent of each other and independent of the queueing service processes. All entering cells are supposed to leave the network eventually. Such systems are said to be *open networks* in opposite to *closed networks* where a fixed number of cells flows within the system from node to node without either entering or departing from the network. *Mixed networks* may be open for given types of cells and closed for others. For instance, an ATM network is open for a major number of end-to-end-user cells and closed for a minor number of signaling and management cells.

The structure of the open network model is currently defined by considering the following parameters

1. J $(< \infty)$ nodes with either infinite or finite queueing capacity numbered arbitrarily as the nodes i=1, 2, 3,..., J.

2. the service requirement has a general distribution function $F(x)$ or an independent and exponentially distributed times with parameters μ_i according to the restrictions

in vigor.

3. the exogenous arrival process to node i is assumed to be Poisson with rate λ_i. Since the total entering process is considered as a collection of mutually independent Poisson processes, only just one source can be assumed to feed each node i with a resulting rate λ_i.

Upon leaving node i, a given cell is directed somewhere, either to another node in the network or to the receiver. The outside world of the network, which encompasses all the transmitters and the receivers, may be conveniently modeled without loss of generality by two special nodes, namely the *source* Σ and the *sink* Δ.

The queueing networks dwelled in this textbook are supposed in equilibrium and stationary. Some descriptive processes may commonly be investigated

1. the *queueing length process* of the network which defines a vector of the J queueing lengths at time t, $\{N_1(t), N_2(t), ..., N_J(t) : t \geq 0\}$. Embedded queue length processes may also be considered if, for instance, the entering-cell processes are Poisson, the node queue lengths gather in a multi-dimensional Markov chain embedded at the entering times $t_e(m)$ of the m^{th} cells.

2. the *waiting time process* $W_i(m)$ which refers to the time the m^{th} cell spends in the queue of node i. Actually, the total waiting time refers to a sequence of $\{W_1(m), ..., W_N(m)\}$ and is defined as the sum of these N individual waiting times necessary to traverse each node. In queueing networks, they are usually no independent random variables.

3. the *sojourn time process* which defines the total time $S(m)$ elapsed from entry until exit from the network of the m^{th} cell.

4. the *cell flow process* which covers several distinct processes, namely the arrival and departure processes of the individual services in the queues and the global input and output traffics. The loss process due to overflows in the system belongs to some extent to a type of departure process.

The current topics of interest dealing with queue lengths are as follows: the distribution and the mean value, the presence of *product forms*, the field of application for the *insensitivity property* to answer the question of whether the queue length distributions have to be characterized by their complete distribution of the service times or only by their mean service time. The thorough understanding of the cell flow process is a subject under intensive research. There are questions about which kind of flow to consider, Poisson, renewal or point, which relationships to apply between arrival and departure processes, which dependence and cross-covariance to consider among the flows.

As a first step in this study, the particular case of the exponentially distributed service times is explored to deduce a product form solution. The general approach of the multiclass queueing networks as pursued in the ATM philosophy is thereafter investigated and related properties of irreductibility and insensitivity are emphasized. Eventually, Little's and Norton's formulae are resurrected and exploited as a useful general tool to apprehend the problems related to the cell transmission through a network of queues.

7.2.1 Exponentially Distributed Service Times

As above mentioned, the queueing network with exponential distribution service times plays an important role in the queueing network models because of not only the simplicity but also the insensitivity theorem which allows complex queueing systems to be substituted by the present model and, as a consequence, to be studied with simple and easily tractable procedures.

In this context, let $\{Y_m : m = 1, ..., J\}$ be a homogeneous Markov chain with finite state space such that the path of each cell routed through the network is governed by this Markov chain. It follows that

$$Pr[Y_m = k | Y_{m-1} = j] = p(j, k) \qquad k = 1, ..., J \qquad j = 1, ..., J \tag{7.1}$$

$$Pr[Y_m = \Delta | Y_{m-1} = k] = p(k) = 1 - \sum_{j=1}^{J} p(j, k) \qquad k = 1, ..., J \tag{7.2}$$

$$Pr[Y_m = \Delta | Y_{m-1} = \Delta] = 1 \tag{7.3}$$

are the one-step transition probabilities of the chain which represents internodal routing probabilities. The sink node Δ is obviously an absorbing state and it is assumed that the chain has no other absorbing state. Every state may be visited from any other and they are said to intercommunicate. For the purpose of ensuring a transmission, a cell can not return to the same node and $p(j, j) = 0 \quad \forall j$. The switching probabilities depend on the current node where the given cell is routed and, at the instant when the switching decision is made, Y_m is otherwise independent of anything going on in the network. Nevertheless, it is possible that a cell returns to a previously visited node but this cannot be done in a single step. ATM connectionless mode may be modeled by this routing method. All the network node are transient (as having a probability which is non-zero but inferior to one to be revisited) except the sink which is absorbent. The routing is different from cell to cell and aims at spreading the traffic over the whole network to minimize congestion occurrence and maximize the network performances. The sojourn times are different from cell to cell.

The equations

$$\alpha_i = \lambda_i + \sum_{k=1}^{J} \alpha_k p(k, i) \qquad i = 1, 2, ..., J \tag{7.4}$$

have a unique solution $\alpha = (\alpha_1, \alpha_2, ..., \alpha_J)$, with $\alpha_j > 0 \quad \forall j$. They are called the traffic equations of the network. The α_i represent the cell arrival rates to node i. The exogenous fraction of the arrival rate is made of the λ_i while the other fractions of the rate are originating from the other nodes of the networks.

Let the random process $\mathcal{N} = \{N_1(t), N_2(t), ..., N_J(t) : t \geq 0\}$ be the set of the queue lengths N_i at node i and time t; let furthermore $\{n = n_1, n_2, ..., n_J\}$ be the network state defined at time t as $N_1(t) = n_1$, $N_2(t) = n_2,...$, $N_J(t) = n_J$. Three distinct networking operations can be taken into account in the state-space of \mathcal{N}. They are respectively the routing of a cell from one node into another, the departure from the network and the entry into a given node

1. the change of state wherein a cell completes service at node j and proceeds to node k is referred by the operator, $T_{jk}(n) = (n_1, n_2, .., n_j - 1, ..., n_k + 1, ..., n_J)$.

2. the change of state wherein a cell completes service at node j and leaves the queueing network, $T_{j.}(n) = (n_1, n_2, .., n_j - 1, ..., n_k, ..., n_J)$.

3. the change of state wherein a cell enters the network at node k,
$T_{.k}(n) = (n_1, n_2, .., n_j, ..., n_k + 1, ..., n_J)$.

\mathcal{N} is a continuous-time homogeneous and stationary Markov chain whose transition rates are given by

$$r[n, T_{jk}(n)] = p(j, k)\mu_j(n_j),$$

$$r[n, T_{j.}(n)] = p(j)\mu_j(n_j),$$

$$r[n, T_{.k}(n)] = \lambda_k,$$

$$r[n, n] = -\sum_{m \neq n} r[n, m],$$

$$r[n, m] = 0, \qquad \text{otherwise.}$$

The matrix Q whose elements are the $r[n, m]$ is the generator of the Markov chain which leads to the equation

$$\pi Q = 0 \tag{7.5}$$

which represents the global balance equation or the equilibrium equation with a unique stationary vector π whose components correspond to the stationary state distribution of the process such that $\sum_n \pi(n) = 1$. The global balance equation of the queueing network takes finally the form which follows

$$\pi(n)\{\sum_j r[n, T_{j.}(n)] + \sum_j \sum_k r[n, T_{jk}(n)] + \sum_k r[n, T_{.k}(n)]\}$$

$$= \sum_j \pi[T_{j.}(n)]r[T_{j.}(n), n]$$
$$+ \sum_j \sum_k \pi[T_{jk}(n)]r[T_{jk}(n), n] \tag{7.6}$$
$$+ \sum_k \pi[T_{.k}(n)]r[T_{.k}(n), n]$$

These considerations lead to the important theorem of the product form solution as stated as follows. The above described Markov queue length process \mathcal{N} has the stationary distribution π given by

$$\pi(n) = \prod_{j=1}^{J} \pi_j(n_j) \tag{7.7}$$

where

$$\pi_j(n_j) = \frac{b_j \, \alpha_j^{n_j}}{\prod_{r=1}^{n_j} \mu_j(r)} \tag{7.8}$$

since \mathcal{N} has been assumed to be stationary, $\pi_j(n_j) = Pr[N(j) = n_j]$ independent of t. Here

$$b_j = \sum_{i=0}^{\infty} \left[\frac{b_j \alpha_j^i}{\prod_{r=1}^{i} \mu_j(r)}\right] \tag{7.9}$$

the distribution $\pi(n)$ turns out to be the product of the nodal probabilities $\pi_j(n_j)$. This solution, known for obvious reasons, as the product form solution asserts that the elements within the vector process are mutually independent for each t. This does not mean, however, that \mathcal{N} at t_1 and \mathcal{N} at t_2 are independent, although their stationary probabilities are identical.

At this stage, some potential confusions are to be released. Let us indeed assume that $\mu_i(n_i) = \mu_i$ for all $n_i > 0$, $\mu_i(n_i) = 0$ for $n_i = 0$, and $i = 1, 2, .., J$. Then

$$\pi_i(n_i) = (1 - \rho_i)\rho_i^{n_i} \qquad n_i = 0, \ 1, \ 2, ... \tag{7.10}$$

where $\rho_i = \frac{\alpha_i}{\mu_i} < 1$ where α_i is the internal arrival rate to node i. This result looks like that given for an M/M/1 queue, especially when exchanging α_i with λ the queue arrival rate. Indeed, the M/M/1 queue length has stationary probabilities expressed as

$$\pi(n) = (1 - \rho)\rho^n \qquad n = 0, \ 1, \ 2, ... \tag{7.11}$$

and, here, $\rho = \frac{\lambda}{\mu} < 1$. Here stands the major remark about the interpretation of Equation 7.10 in which the queue lengths behave as if they were produced by an M/M/1 queue. But, this is actually not the case since, nowhere, it has been assumed that the process was an M/M/1 and, in fact, the internal arrival processes are not necessarily always Poisson processes and might belong to any other family of arrival processes as exemplified latter. Let us remark that the network involved in Equation 7.10 supposes its queue lengths mutually independent for each t.

7.2.1.1 Embedded Queue Length Processes

Similarly to what has been developed for individual queues, there exist useful probabilities for queue lengths among all to be defined at an arbitrary point in time; they are precisely those embedded just prior to cell arrival or just posterior to cell departure from queues. The stationary continuous-time queue length probabilities imply that

$$Pr[N(t) = n] = \pi(n) \qquad \forall t \geq 0 \tag{7.12}$$

The embedded processes refer to special times t_m^d and t_m^a, respectively, the instants just posterior to cell departure and prior to cell arrival. Let $N(t_m^d)$ and $N(t_m^a)$ be the embedded queue lengths at the corresponding moments. The embedded stationary queue length distribution probabilities at arrival and departure instants are defined as

$$Pr[N(t_m^a) = n] = \pi^a(n) \qquad \forall m = 1, 2, .. \tag{7.13}$$

$$Pr[N(t_m^d) = n] = \pi^d(n) \qquad \forall m = 1, 2, .. \tag{7.14}$$

in a similarly way to that followed previously for the individual queueing systems.

In the case where the arrival processes and the departure processes are Poisson processes, the continuous time stationary queue length probabilities and the embedded queue length probabilities prior to arrival times or posterior to departure times are all identical. If cell flows are non-Poisson processes, then embedded points play an important role since they maintain the Markov properties and product form developed for the stationary queue length processes with Poisson processes. These latter embedded cases are sometimes referred to being arrival or departure stationary.

7.2.2 Multiclass Queueing Networks

In this part, the concepts developed in the previous sections are extended to suppose first that the cell traffics are of I distinct types of service, and secondly that the individual queueing models have the general form of G/G/s models with any arbitrary discipline. Choosing to consider a fixed node j, a system state g_j among the finite set G_j of all such system states is defined by

$$g_j = [(i_m, a_m) : m = 1, 2, ..., n_j]$$

where n_j is the number of cells in node j, i_m the type of the m^{th} cell, a_m the state of the m^{th} cell. Let $T = \{1, 2, ..., I\}$ be the set of all the types of cells. The state a_m is composed in whole generality of different components among which it is worth mentioning the queueing server to be attributed to the m^{th} cell, defined here as being the station of a_m, and the position of the m^{th} cell in the queueing system.

To interpret these concepts in the light of the ATM, it is to be remark that, upon entering the first ATM node, all the user cells loose the information (memoryless behavior) not only about the nature and the content of the service to be transported but also about the location of the source i.e. the origin node of entry. What remains accessible at this stage is the header which specifies a request for a destination and for a quality of service, the level of priority. In the ATM nodes, the types i_m have to be interpreted as the priority levels (up to now, I=2) and the stations of a_m as the destinated internodal connection.

As a generalization of the ATM concept of priority, the service requirement of the m^{th} cell of type i_m at station a_m is a random variable with distribution function

$$F(x) = F(i_m, a_m, x) = Pr[X(i_m, a_m \leq x]$$

with a mean value

$$m(i_m, a_m) = E[X(i_m, a_m)] = \mu^{-1}(i_m, a_m).$$

The service requirement is satisfied at a speed $\gamma_j(n_j, l)$ which is defined for a cell in position l in node j, when there are n_j cells present and $n_j \geq l$. When a cell leaves node j from position l, the cells in position $l+1$, $l+2$, .., n_j move down to positions l, $l-1$, .., $n_j - 1$ and conversely when a cell arrives at node j and is put into position l. The service requirements are such that $\gamma(g, a_m) \geq 0$. As a matter of fact, the speed of service depends on the state of the m^{th} cells and on the state g of the node. When constant and equal to one for all g and a_m, the speed is called the service time as usually agreed in queueing terminology.

The balance equation already defined as Equation 7.5 is generalized split into two categories of equations. The first category of equations, called the local balances, states a balance equation for each fixed type i of service and the second category of equations, called the station balance, tackles the balance conditions on stations.

In this part, the important property of insensitivity will be developed according to which a stationary probability distribution for a queue length process is defined to be insensitive when it depends only on the mean value of the service time distribution instead of depending on the whole distribution characteristics. If a node or a portion of the complete network profits from that property, then the queue length distributions can be substituted by anyone and thus those with exponentials so as to ease computations.

To guarantee the uniqueness of stationary queue length distributions for every node, it is assumed that the queueing system at each node has the *irreductibility property*. For each pair of states g, $g' \in G$ there is a finite sequence of states $g = g^1, g^2, ..., g^k = g'$ with each $g^l \in G$, $l = 1, 2, ..., k$, having the properties $P^a(g^l, i^l, g^{l+1}) > 0$ or $P^d(g^l, (i^l_m, a^l_m), g^{l+1}) > 0$ for some $i^l \in T$ with $\alpha(i^l) > 0$ and for some $(i^l_m, a^l_m) \in g^l$ and for $n^l(i) \leq \max[n(i), n'(i)]$ for all $i \in T$. $n^l(i)$ is the number of cells of type i in g^l. This requirement is stronger than the usual irreductibility for Markov chains.

7.2.2.1 Balance Equations for a Single Node

In this section, the node is considered in equilibrium. As being an arbitrary node, the subscript j disappears to consider only n, g and G. Thus, let $\pi(g)$ be the stationary probability of state g at the node under consideration. Let $P^a(g, i, g')$ be the probability that a cell of type i arrives at the node and forces state g to change in g' and, similarly, let $P^d(g, (i, a), g')$ be the probability that a cell of type i and attached to station a leaves the node and changes the state g into g'. Two new kinds of balance equations are considered, namely the local balance and the station balance.

The Local Balance Equations

Expressed at any node of a network, the local balance equations equilibrate the rate of the upward jumps into state g and the downward jumps out of state g. Therefore,

1. for each state $g \in G$ and arbitrary station

$$\pi(g) \sum_{(i_m, a_m) \in g} \gamma(g, a_m) \mu(i_m, a_m) = \sum_{i_m | \alpha_{i_m} > 0} \sum_{g' \in G} \alpha(i_m) P^a(g', i_m, g) \pi(g') \quad (7.15$$

with $n'(i_m) = n(i_m) - 1$.

2. for each fixed type $i \in T$ with $\alpha(i) > 0$ and for each $g \in G$

$$\alpha(i)\,\pi(g) \quad = \quad \sum_{g' \in G}\,\sum_{(i,a_m) \in g'}\,\alpha(i)\,P^d(g',(i,a_m),g)\,\pi(g') \tag{7.16}$$

with $n'(i_m) = n(i_m) + 1$.

If these two equations are successively added together and summed on all $i \in T$, the global balance equation is derived showing that local balance implies global balance. However, the converse is not true. The local balance equations are sometimes called the direction balance equations.

The Station Balance Equation

The station balance equations relate the rates of termination of a service requirement of the m^{th} cell of type i_m at station a_m in state g to the cell arrival rates of type i_m at station a_m which cause a transition from state g' where there is one less cell of type i_m i.e. $n'(i_m) = n(i_m) - 1$. This means that for each fixed $g \in G$ and each pair $(i_m, a_m) \in G$

$$\gamma(g, a_m)\,\mu(i_m, a_m)\,\pi(g) \quad = \quad \sum_{g' \in G}\,\alpha(i_m)P^a(g', i_m, g)\,\pi(g') \tag{7.17}$$

if summed over (i_m, a_m), these station balance equations give the local balance equations. This means that, if $\pi(g)$ satisfies the station balance equations, they satisfy the local balance equations. The converse is not true. A queueing system may fulfill global balance equations but not the local balance equations and, therefore, not the station balance equations. The local balance equations may be verified; this implies that the global balance equations are satisfied but not necessarily the station balance equations.

7.2.2.2 Insensitivity

Insensitivity is a quite powerful property of queueing networks which, in many circumstances, allow rather complex queueing model to be substituted by a simple tractable model, not as an approximation but, to produce exactly the same stationary distributions. Therefore, under some conditions to be specified, the stationary state probabilities $\pi(g)$ depend only on $m(i_m, a_m)$ and not specifically on anything else concerning the service times. The stationary state probabilities are said to be insensitive to the form of the service distribution. This means that properties concerning complex service processes can be inferred from the properties of exponential service processes which are among the most easily tractable systems; for instance, this means computing the $\pi(g)$ only by solving a system of linear algebraic equations instead of exploiting quite complex models.

Three main theorems deal with the insensitivity property, they are stated for a single node and left without demonstration.

Theorem 7.2.1 *Under assumption that*

1. *the arrival processes of cells belonging to type i are Poisson with rate $\alpha(i)$ such that $\pi(g)$ exists.*

2. *the service requirements $X(i_m, a_m)$ are stationary dependent for fixed i_m, a_m and independent for different i_m, a_m.*

3. *the random process describing the time evolution of the queueing system is stationary and ergodic.*

the insensitivty theorem *states that the stationary state probabilities $\pi(g)$ are insensitive with respect to the form of the distribution function $F(i_m, a_m, x)$ at station a_m [given $m(i_m, a_m) < \infty]$ if and only if for each $g \in G$ and $(i_m, a_m)s \in g$, the station balance equations are fulfilled.*

Hence, to reach the insensitivity property in a queueing network, it is only required to show that the station balance equations hold for that system with independent exponentially distributed service times. Then, theorem 7.2.1 states then that, under the three previous assumptions, insensitivity and station balance are equivalent for the general class of queueing systems under consideration. This includes insensitivity for service requirements which are dependent on each other. In particular, the sequence of service requirements for each fixed type and each station may be stationary dependent assuming that

$$Pr[X_{m_1} \leq x_1, X_{m_2} \leq x_2, ..., X_{m_n} \leq x_n] = Pr[X_{m_1+k} \leq x_1, X_{m_2+k} \leq x_2, ..., X_{m_n+k} \leq x_n]$$

for every n, $k \geq 0$, $(m_1,, m_n)$. Another example of service requirement dependence is that of all service requirements on a fixed station.

Examples of queueing systems with Poisson arrival process which have insensitive stationary queue length probabilities are numerous; for instance, the queueing systems M/GI/1, the M/G/s with stationary dependent service times for every fixed server,.. Let us remark that some queueing systems like the M/M/s with FCFS discipline do not benefit from insensitivity.

Theorem 7.2.2 *Under assumption that*

1. *the arrival processes of cells belonging to service i are Poisson with rate α_i such that the $\pi(g)$ exists.*

2. *the service requirements $X(i_m, a_m)$ are positive with probability one, $m(i_m, a_m) < \infty$, and service requirements to be realized at the same time are independent, but the $X(i_m, a_m)$ may be stationary dependent for fixed (i_m, a_m).*

3. *the random process describing the time evolution of the queueing system is stationary and ergodic.*

4. *for all $(i_m, a_m) \in G$ the local and the station balance conditions are satisfied, which must be proven only for independent and exponentially distributed service times.*

the station balance theorem *states that*

I. *the departure processes of subsets T_i, referring to either served or lost cells, are stationary Poisson processes with rates equal to the corresponding arrival intensities.*

7.2. *Principle of Queueing Networks* *501*

II. *the insensitive state probabilities $\pi(g)$ have the following structure*

$$\pi(g) \;=\; q(g)\,\pi(0) \prod_{(i_m,a_m)\in g} \mu^{-1}(i_m, a_m) \tag{7.18}$$

where $\pi(0)$ is the stationary probability that the system is empty, and $q(g)$ is independent of the values $\mu(i_m, a_m)$.

III. *for the stationary embedded state probability $\pi^a(g,i)$ and $\pi^d(g,i)$*

$$\pi^a(g,i) \;=\; \pi^d(g,i) \;=\; \pi(g) \tag{7.19}$$

Consequently, the embedded probabilities are insensitive. $\pi^a(g,i)$ denotes the stationary probability of state g embedded just after a cell arrival of type i and $\pi^d(g,i)$ denotes the stationary probability of state g embedded just after a departure of a cell of type i. They are stationary with respect to shifting from one arrival or departure to the other.

IV. *statements (I), (II) and (III) are verified for systems which can be represented as limits of sequences of systems fulfilling the assumptions of the theorem.*

This theorem, known as the *station balance theorem*, implies that the $\pi(g)$, themselves for an individual node, have a *product form*. Conversely, if the $\pi(g)$ are of the *product form*, then they are *insensitive*. This establishes equivalence between product form and insensitivity. This theorem is also valid under weaker assumptions of local balance but do not involve insensitivity in this case.

Theorem 7.2.3 *Under assumption that*

1. *the arrival processes of cells belonging to service i are Poisson with rate α_i such that the $\pi(g)$ exists.*

2. *the service requirements $X(i_m, a_m)$ are independent and exponentially distributed for all i_m, a_m.*

3. *the local balance condition is fulfilled.*

the local balance theorem *states four consequences which hold as*

I. *the departure processes (served or lost cells) of service i are Poisson with rate $\alpha(i) > 0$ and are independent for different i.*

II. *the stationary continuous time Markov process $\{N(t), t \in \mathbf{R}\}$ of the number of cells of each fixed type served at arbitrary stations is reversible; i.e., the process $\{N(t_0 - t), t \in \mathbf{R}\}$ for fixed t_0 has the same distribution as $\{N(t), t \in \mathbf{R}\}$.*

III. *the departure instants prior to an arbitrary fixed point t_0 are independent of the state of the queueing system at t_0.*

IV. $\pi^a(g,i) = \pi^d(g,i) = \pi(g)$, $g \in G$.

The theorem shows that queueing systems with independent and exponentially distributed service times which transform Poisson arrival processes into Poisson departure processes. Furthermore, if the service times are arbitrarily distributed and either independent or stationary dependent, then, the stronger assumptions of the station balance theorem are necessary for the same transformation to be true. The *station balance assumption* also gives the *insensitivity property*.

7.2.2.3 Properties of Queueing Networks

Let $\pi_j(g_j)$ and $\pi(g)$ be respectively the stationary probability of state g_j at node j and the stationary probability of the state g of the whole network. Therefore, $g = (g_1, g_2, ..., g_J)$.

Theorem 7.2.4 *Assuming that the queueing system in each node $j \in U$ of the network is irreductible and fulfill the assumptions of the station balance and the local balance theorems or can be represented as limits of a sequence of queueing systems fulfilling these assumptions. Then the following properties hold*

1. *the stationary state probability $\pi(g)$ of the network is of product form*

$$\pi(g) = B^{-1}(n) \prod_j \pi_j(g_j) \qquad g \in G \tag{7.20}$$

 $\pi_j(g_j)$ are the stationary state probabilities at node j in isolation with Poisson input. $B(n)$ is a normalizing parameter function of the number of cells of type i T_i present in the network denoted $n(T_i)$; therefore, $B(n) = B[n(T_1), ..., n(T_J)]$ and, particularly, $B[\infty, ..., \infty] = 1$.

2. *$\pi(g)$ is insensitive to the form of the distribution function $F_j(i_m, a_m, x)$ if $\pi_j(g_j)$ is insensitive.*

3. *the marginal probabilities $\pi_j^R(g)$ of $\pi(g)$ for the stationary state probabilities of the queueing system in node j are given as $\pi_j^R(g) = \pi_j(g_j)$.*

4. *the embedded probabilities of the network $\pi^a(g, j, i)$, $\pi^d(g, j, i)$ which represent respectively the embedded stationary probabilities of the network state at the instants when a cell of type i arrives or leaves the node j, have also the same insensitivity properties as the $\pi(g)$ themselves. Hence,*

$$\pi^a(g, j, i) = \pi^d(g, j, i) = B^{-1}(n^*) \prod_j \pi_j(g_j) \qquad g \in G \tag{7.21}$$

 where $n^ = [n^*(T_i)]$, $i = 1, ..., I$*

$$n^*(T_i) = n(T_i) - 1 \quad for \ (j, i) \in Z_i \tag{7.22}$$
$$= n(T_i) \quad otherwise \tag{7.23}$$
$$\tag{7.24}$$

This theorem maintains the existence of product form solutions and insensitivity of the stationary queue length distribution for general queueing networks. The main interpretation is two-fold

1. queueing networks with Poisson arrivals and arbitrarily distributed service times which can be stationary dependent, the station balance is sufficient to derive both product form and insensitivity. It remains true if the service requirements of different nodes are dependent on each other.

2. queueing networks with Poisson arrivals and independent, exponential service times at each node, the local balance equations are sufficient and necessary to derive the product form $\pi(g)$. There stands no examples where $\pi(g)$ has product form and where local balance is not verified.

If a queueing network has nodes of both kinds and that respective conditions hold, then the network has product form and insensitivity.

The product-form networks profit from interesting theorem very useful to utilize. One of them , originally due to K. M. Chandy, U. Herzog, and L. S. Woo states in [1] and [2] that any subnetwork may be replaced by one composite queue with state dependent service rates without modifying the statistical behavior of the rest of the network. The theorem called Norton's theorem on account of the analogy to the theory of electrical networks holds for a class of queueing networks which satisfy local balance. This theorem may provide an extremely valuable simplification in order to simplify the amount of computations. Accordingly, in an open network, all the queues of a subsystem may be replaced by a single composite Poisson source which generates customers of all classes, where each class is generated independently. The rate at which the composite source generates customers of a given class is set equal to the throughput of customers of that class through the short of the subsystem under consideration.

7.2.3 Little's Formula

Consider an arbitrary queueing network be considered as a whole system. From Little's formula, the network time delay $E(t)$, averaged over the entire queueing system i.e. over all M links, is given by

$$\gamma E(t) \ = \ E(n) \tag{7.25}$$

where γ stands for the total arrival rate into the network and $E(n)$ the average number of cells transmitted in the network. If M queues are involved, then $E(n) = \sum_{i=1}^{M} E(n_i)$ where $E(n_i)$ is the average number of cells either in service or in queue at link i. Here, only the stochastic delay is considered and neither the physical link transmission delay nor the switching delay. $E(n_i)$ is given by $\lambda_i T_i$. The time delay T_i incurred by a Poisson arrival process moving through an M/M/1 queues is expressed by

$$T_i \ = \ \frac{1}{\mu_i - \lambda_i} \ = \ \frac{\frac{1}{\mu_i}}{1 - \rho_i} \tag{7.26}$$

with $\rho_i = \frac{\lambda_i}{\mu_i}$ the load of node i due to a local arrival λ_i served with an exponential service time with mean μ_i. Going to a simple illustrative example of six node network, figure cc shows routing probabilities q_{ij} and the link loads in cell/unit of time; the exogenous service rates are referred to as λ_i and the internal rate by α_i

$$E(t) \quad = \quad \frac{1}{\gamma} \sum_{i=1}^{M} E(n_i) \tag{7.27}$$

$$= \quad \frac{1}{\gamma} \sum_{i=1}^{M} \lambda_i T_i \tag{7.28}$$

$$= \quad \frac{1}{\gamma} \sum_{i=1}^{M} \frac{\lambda_i}{\mu_i - \lambda_i} \tag{7.29}$$

A general routing problem for packet-switched networks consists of assigning the flows λ_i and α_i to minimize the probability of local or nodal congestion, the mean cell loss probabilities and, eventually, the mean time delay $E(T)$.

7.3 Allocation of Network Resources

This section will present the problem of allocating resource on an ATM channel. The content is structured as follows in five subsections. First, the basic foundations are introduced for an optimum bandwidth allocation to be achieved at call establishment in each multiplexer along the transmission path. Secondly, two definitions of transmission bandwidth are proposed. Third, an optimum use of a bandwidth with respect to the throughput is investigated. Fourth, a search towards the minimum bandwidth is performed. Fifth, traffic descriptors are deduced from the previous definition of the bandwidth.

7.3.1 Optimum Allocation of Bandwidth

Bandwidth allocation for any new TV source is performed at each transmission call set-up in all the multiplexers located on the elected virtual path [1]. This allocation is carried out after each transaction i.e. any source admittance, any bandwidth renegotiation or deletion. The purpose of an admission control based on allocating bandwidth is to establish a fair blocking against any new coming user and to ensure that the resources or the bandwidth available to each admitted connection remains sufficient to meet the performance objectives (cell loss in TV, but also, maximum transmission and jitter for other services). An algorithm based on the Dynamic Programming theory will be processed to optimize the allocation with respect to a cost function at each transaction. Indeed, any new connection can be admitted to the network only if sufficient resources are available to support the connection in conformance with a relevant performance objective to be optimized. The particular cost function to be considered here estimates the sum of three components: the first is based on the bandwidth to be admitted, deleted or renegotiated,

[1]The algorithm in charge of admitting or rejecting the user requests to establish a transmission path through ATM network is termed the Call Admittance Control (CAC) in the literature.

the second on a Markov chain giving the potential bandwidth at the horizon of the next transition and the third on a management criterion. The parameter description can be resumed as follows

1. the expected bandwidth $B_W(k)$ resulting from multiplexing the new source or the new configuration (i.e. an admission, a deletion or a bandwidth renegotiation) with all the sources already currently connected on the network node.

2. the expected supplement of bandwidth $B_{W,F}$ that could be involved at the next transaction i.e. a call admission, a deletion or a renegotiation. The evolution of the assigned bandwidth can be modeled by a semi-Markov process: the instants of transaction have random occurrences and the transitions of the instantaneous allocated bandwidth give rise to a Markov chain embedded in the process.

3. a weighted sum of expected rejection probabilities in the case of admitting the present requesting service k. The summation is performed over all the potential types of customer services n_c. These blocking probabilities, $P_{rej}[k, i]$, determine the resulting network *grades of service*. It is necessary that the usage of high-bandwidth services not consume available resources to such extent that lower-bandwidth-consuming services experience an uncontrolled increase in blocking probability.

The present optimization supposes the existence of m different states in the embedded Markov chain and n_c different categories of services (VT, TV, HDTV,..). The cost function $V(k)$ to be minimized at the call admission of any new source can be reported as

$$\min\{B_W(k) + \sum_{i=1}^{m} Pr[k, i] B_{W,F}(k, i) + \sum_{i=1}^{n_c} \lambda_i P_{rej}[k, i]\} \tag{7.30}$$

where the weights λ_i correspond to economical values to privilege the connection of some customer services when a potential shortage of bandwidth can be induced by the admission of the new source k, the $Pr[k, i]$ are the transition probabilities from the state k reached by the present admission to the future state i susceptible to be attained at the next transaction. These transition probabilities are either initiated by the network management or adaptively learnt on the basis of on-going statistics.

The bandwidth to be allocated to a TV transmission in each multiplexer will be expressed in [bit/s] and defined as a fraction of the transmission bit rate which empties the multiplexing queue with a deterministic service time (for example, 600 Mbit/s). Moreover, the definition of the bandwidth has to be referred to a QOS expressing a cell loss probability in 10^{-n}.

The criterion for the decision of source admittance or rejection is mainly a function of two factors

1. the remaining available multiplexing capacity (also called the *reserve of bandwidth*) to ensure a QOS inferior to 10^{-n}.

2. the resulting grade of service for each customer service category.

In the case of an admission, the decision about the bandwidth to be allocated $B_W(k)$ has to minimize the cost function. The following sections will therefore be devoted to defining bandwidths and searching conditions and traffic descriptors which lead to a minimum allocation.

As a final remark, let us distinguish the connection oriented mode from the connectionless mode. In the former transmission case, bandwidth is allocated on each multiplexer along the virtual path requiring routing algorithms to be activated to support the resource allocation along the shortest and the most appropriated end-to-end path in the network. Routing algorithms may be found in several references, let us cite Gallager and Golestaani in [10] and [12] who showed that the joint routing and flow control problem for cell network can be formulated as a convex programming problem and converge to a global optimum solution. Gavish and Hantler in [11] formulated the routing problem for virtual circuit as a combinatorial optimization problem. They applied the Lagrangean Relaxation method to obtain good heuristic solutions. Jaffe in [14] and [15] proposed an elegant distributed algorithm to allocate capacity to user pairs in a virtual network. In [13], Hayden presents a maximum flow control scheme to find a capacity allocation algorithm. The latter connectionless case supposes that an implicit connection has been established through subscription without any routing but rather by calculating attributing a bandwidth over the whole network in conformance with a similar cost function to be minimized.

7.3.2 Bandwidth Definition

The multiplexers have been studied in Chapter 5 and defined as a queue with a fixed length and a fixed deterministic service rate equal to the internodal transmission rate. To optimize the switching performances, the multiplexers are most likely located at the output port of switching nodes. As a matter of fact, the bandwidth to be allocated for the superposition of different sources of traffic is a fraction of the deterministic service rate. The transmission management task consists mainly in guaranteeing on the virtual paths a network QOS of 10^{-n} as constant as possible along the communication session, the bandwidth has to be defined in reference to a given level of QOS. The maximum value of the bandwidth available to transmit all the multiplexed sources at 10^{-n} is equal to the link service rate. When N sources have been allocated, the deterministic rate of service which achieves the QOS of 10^{-n} represents the effective requested bandwidth. The value of that rate of service is somewhere in between the mean and the peak value of the resulting bit rate PDF depending on both the statistics and the number of sources involved in the multiplexing. Let us recall that, in Chapter 1, the law of the large numbers and Bienaymé-Tchebitchev inequality have allow demonstrating that the resulting PDF of a multiplexed cell stream will definitely squeeze around the mean especially when a large amount of sources is assumed to be merged for transmission. This is actually the purpose of ATM to multiplex hundreds of TV transmission sessions around the world. The computation of this rate depends on three terms

1. the architecture of the queueing system i.e. a single queue, a shared buffer.

2. the cell inter-arrival time process issued from superposing the different sources involved in the multiplexing.

3. the probability density function of the source bit rates considered as a counting process and evaluated on a time interval remaining to be specified (a span in between stripes, images and scenes).

The terms 1 and 2 enable evaluating the queueing performances to express the cell loss probability in terms of the multiplexer load as those proposed in Chapter 5 i.e. a relationship between the network QOS and the load, $QOS = M(\rho)$. The third term differentiates the CBR applications from the VBR applications. In the two following subsections, the definition of bandwidth will be presented starting with the CBR modes and generalized to the VBR modes.

7.3.2.1 TV Bandwidth in CBR Modes

In CBR applications, the curve of the QOS performance $[QOS = M(\rho)]$ versus the load supplies the numerical measure of the load ρ required to achieve a QOS of 10^{-n}. The bandwidth $B_{W|QOS}$ of N CBR sources is defined as the queue service rate to process those pooled sources at a given QOS. This is a deterministic variable defined as

$$B_{W|QOS} = \frac{1}{\rho_{traffic,n}} \sum_{i=1}^{N} R(i) \qquad (7.31)$$

where the $R(i)$'s correspond to the constant bit rate value of each source i and the quantity

$$\rho_{traffic,n} = \frac{\lambda}{B_{W|QOS}} = M^{-1}(QOS) \qquad (7.32)$$

stands for the multiplexer load obtained with the performance curve M of the superposed traffic at the abscissa corresponding to the specified QOS. λ is here a constant arrival rate.

7.3.2.2 TV Bandwidth in VBR Modes

In VBR applications, the bandwidth can take two more general definitions, the CBR source being in both cases a particular instance. One is a virtual and the other, an effective bandwidth. Similarly to the CBR case, the cell traffic characteristic determines a performance curve of cell loss probability expressed in terms of the load. The cell rate is here variable and can be characterized by a counting process evaluated over spans of stripes, images or scenes. Each observable value of the discrete cell-rate PDF accessing a multiplexer implies a specific traffic, a specific queue load and a specific cell loss probability. Hence, the traffic, the multiplexer load and the cell loss probability take instantaneous realizations depending on the corresponding instantaneous arrival cell rates and are random variables distributed according to the resulting cell rate PDF.

Let *the virtual bandwidth* be defined for a QOS of 10^{-n} as the random variable representing, for each realization of its cell rate probability density function, the requested

bandwidth necessary to reach the QOS. The value of the bandwidth for a given QOS is here a stochastic process fluctuating with the instantaneous bit rate. According to that definition, the mean virtual bandwidth is given by the expected value

$$E\{B_{W|QOS}\} = \sum_{i=1}^{m} B_{W|QOS}(i)P_{R(i)} \tag{7.33}$$

$$= \sum_{i=1}^{m} \frac{1}{\rho_{traffic,n}} R(i)P_{R(i)} \tag{7.34}$$

$$= \sum_{i=1}^{m} C(traffic,n)R(i)P_{R(i)} \tag{7.35}$$

where $P_{R(i)}$ is the probability density that the cell rate equals $R(i)$ over the considered time span (the probability density function of $R(i)$ is discretized over m values $P_{R(i)}$ with $i = 1..m$), $B_{W|QOS}(i)$ is the bandwidth (i.e. the temporary rate of service) required to multiplex the traffic with a cell rate $R(i)$. The multiplexing load $\rho_{traffic,n} = M^{-1}(QOS)$ is computed with the performance curve $M(\rho)$ to ensure a QOS of 10^{-n} and can be interpreted as a yield of multiplexing at 10^{-n}. The parameter $C(traffic,n)$ represents a cost factor of the multiplexer which measures, on a scale ranging from 1 to infinity, the ability to multiplex statistically a given traffic in order to achieve a specified QOS. The parameter C is function of the inter-arrival time statistics and depends strongly on the serial correlations of the superposed inter-arrival time process. As a matter of fact, both the inter-arrival time and the counting processes contribute in the bandwidth evaluation reported in Equation 7.35. Figures 5.20 to 5.30 give some examples of such performance curves $[QOS = M(\rho)]$. In this definition of the bandwidth, the service rate is virtually adapted to each cell rate configuration such to produce a QOS of 10^{-n} therefore the QOS is constant, the multiplexer load fluctuates according to the traffic performances, the rate of service is a random variable adapted to maintain a constant value of the QOS. In this case, the QOS is formulated as

$$QOS = 10^{-n} \tag{7.36}$$

$$= M[\sum_{i=1}^{m} P_{R(i)}\rho(i)] \tag{7.37}$$

$$= M[\sum_{i=1}^{m} P_{R(i)}\frac{R(i)}{S(i)}] \tag{7.38}$$

$$= M[E(\rho)] \tag{7.39}$$

$$= QOS_{\bar{\rho}} \tag{7.40}$$

to re-express that the rate of service $S(i)$ is adapted for each value of the bit rate in such a way to match a constant QOS.

Let *the effective bandwidth* be defined as the deterministic constant rate of service computed to achieve the required QOS by the following equation [2]

[2]The third equation 7.43 is the discrete version of Equation 5.28 p. 106 in Reference [17]. This equation could have been directly written as a sum over exclusive events where each term represents the probability of observing a bit rate and its corresponding cell loss rate.

$$E(QOS) \;=\; 10^{-n} \tag{7.41}$$

$$=\; \sum_{i=1}^{m} P_{QOS(i)} \, QOS(i) \tag{7.42}$$

$$=\; \sum_{i=1}^{m} P_{\rho(i)} \, P_{CL|traffic}(i) \tag{7.43}$$

where $P_{\rho(i)}$ is the multiplexer load probability density function and $P_{CL|traffic}$ is the cell loss probability for a given traffic. Let us recall that the cell loss probability is a function of the inter-arrival-time process statistics. According to this definition, the service rate which achieves the QOS is constant and represents the effective bandwidth, the multiplexer load is variable according to the cell rate. The instantaneous QOS $[QOS = M(\rho)]$ is variable in such a way that the mean value reaches the required QOS. The effective bandwidth represents the rate of service required to achieve the specified mean QOS.

In any case, the effective bandwidth represents a lower bound for the mean value of the virtual bandwidth. Referring to Jensen's inequality [26], the performance curve is a convex ∩ function and implies the following bound

$$E\{QOS\} \;=\; \sum_{i=1}^{m} M[\rho(i)] P_{\rho(i)} \tag{7.44}$$

$$\leq\; M[\sum_{i=1}^{m} \rho(i) P_{\rho(i)}] \tag{7.45}$$

$$\leq\; M[E\{\rho\}] = QOS_{\bar{\rho}} \tag{7.46}$$

Moreover, the bandwidth can be computed at different levels depending on which span the counting process is referred to i.e. the stripe layer, the image layer or the scene layer. This level remains to be defined and stands as a major point in the search towards an optimum bandwidth. In the subsequent, the effective bandwidth will be therefore the only one considered in the search.

A notion of *reserve of bandwidth* can be easily defined as the difference between the current effective bandwidth already allocated to a multiplexed traffic and the rate of service of the internodal link (representing the maximum value of the bandwidth to be allocated). In other words, this reserve is a quantity to be maximized at each call set-up and transaction.

7.3.3 Optimum Use of Effective Bandwidth

The optimum use of the bandwidth is obtained when adapting both the cell inter-arrival times and the counting processes to achieve the network QOS with the criterion of the maximum throughput. Intuitively, this configuration should be reached at constant or nearly constant cell rate on the curve yielding the best cell-loss-probability performances as observed in the D/D/1 queueing system. This optimum should moreover depend on the convexity of the performance curve corresponding the multiplexed traffic. The conditions on the cell arrival process to achieve that optimum can be stated respectively as follows

1. the inter-arrival time process giving the best performances i.e. the Poisson arrival to be queued in a single or a shared output buffer.

2. the optimal PDF of the counting process thereafter deduced from the following maximization of the mean load value $E\{\rho\}$ under the constraint of a fixed QOS

$$max \ [\sum_{i=1}^{m} P_{\rho(i)}\rho(i)] \tag{7.47}$$

where $\rho(i)$ is the multiplexer load and $P_{\rho(i)}$ is the associated density of probability discretized on m values.

1. under the constraint of a multiplexing QOS of 10^{-n}

$$10^{-n} \ = \ \sum_{i=1}^{m} P_{\rho(i)} P_{CL \ | \ traffic}(i) \tag{7.48}$$

2. under the constraint of a probability density function

$$\sum_{i=1}^{m} P_{\rho(i)} \ = \ 1 \quad \text{with} \quad 0 \le P_{\rho(i)} \le 1 \quad \forall i: \quad 1 \text{ to m} \tag{7.49}$$

To take the example of a single queue per output port with a resulting Poisson traffic, the simplex algorithm applied in this case enables deriving the optimum count PDF to be achieved for the superposed process. Table 7.1 presents the results at different values of the $QOS = 10^{-n}$.

QOS: n	ρ_1	ρ_2	P_{ρ_1}	P_{ρ_2}	$\bar{\rho}$
2	0.954	0.944	0.934	0.066	0.954
3	0.925	0.916	0.851	0.149	0.917
4	0.887	0.878	0.739	0.261	0.884
5	0.859	0.849	0.504	0.496	0.854
6	0.831	0.822	0.412	0.586	0.826
7	0.804	0.795	0.424	0.575	0.799
8	0.777	0.768	0.512	0.488	0.773
9	0.751	0.741	0.686	0.314	0.748

Table 7.1: **Optimum PDF of multiplexer loads.**

As far as this example is demonstrative, the throughput within a given effective bandwidth will be optimized for a CBR mode or for a VBR mode with a cell rate probability density function as concentrated as possible around its mean. VBR transmissions will be asymptotically optimum when the number of sources increases owing to the effect of the PDF concentration around the mean.

7.3. Allocation of Network Resources 511

7.3.4 Minimum Bandwidth for Given QOS

Similarly to the research towards a potential gain in statistical multiplexing, the bandwidth can also be defined at the inter-arrival time level, the stripe-count level, the image-count level or the scene level. In TV coding, the statistical gain is merely obtained at the bit-rate-count levels by the resulting PDF concentration around the total mean when independent sources are superposed.

7.3.4.1 QOS Sensitivity to Cell Rate PDF's

This section presents how the QOS is dependent and sensitive to the spread of the multiplexer load PDF, the goal being to demonstrate the existence of an optimum spread and how far the standard deviation remains quasi-optimum. To illustrate this effect of the resulting bit rate PDF spread, Figure 7.6 presents at a constant service rate the evolution of mean QOS in function of standard deviation of cell rate PDF's. Different values of the mean multiplexer load have been considered, each of them defines a particular starting level of quality. The multiplexing performance curve refers to a Poisson arrival process and the load PDF (cell rates) is considered as a discrete Gaussian density of probability. The resulting mean QOS is computed as:

$$E(QOS) = 10^{-n} \tag{7.50}$$

$$= \sum_{i=1}^{m} P_{\rho(i)} P_{CL|traffic}(i) \tag{7.51}$$

As a matter of fact, the more the PDF is concentrated around the mean, the more efficient will be the mean QOS. The curves of the QOS at different mean loads turn out to be as reversed bell-shaped curves showing that multiplexer performances remain quasi-optimum for small values of standard deviations computed on resulting PDF's. As a conclusion, the multiplexing of VBR sources reaches an asymptotical optimum simultaneously for QOS and throughput by the effect of bit rate concentration when a lot of independent sources have to be multiplexed together.

7.3.4.2 Bandwidth in Function of Counting Spans

Concentrated PDF's achieve a better QOS than wide spread ones: this implies that it is preferable to allocate bandwidth on spans as long as possible: bit rates evaluated over one or several images or mean image bit rates per scene. As the mean image bit rate per scene looses information of scene duration (which induces correlations in image bit rates), the PDF of the mean image bit rate per scene does not effectively represent the percentage of time during which image bit rates will stay and trespass some QOS threshold and, hence, can not be used to allocate the bandwidth. Therefore, the question is now to determine on which span to count the cell rate. To start with an illustration, the multiplexing of 15 different real time TV sources each of 90 minutes will be considered: the effective bandwidth will be estimated at several values of mean QOS. The multiplexer performance curve has been chosen to be a Poisson process and the counting interval is made variable

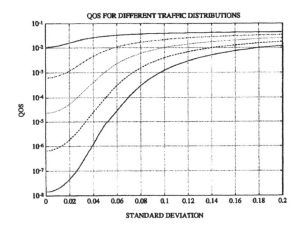

Figure 7.6: Network QOS versus the pooled-cell-rate PDF spreading.

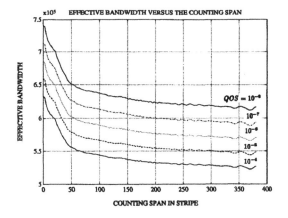

Figure 7.7: Effective bandwidth versus counting span.

ranging from stripe up to several images (Figure 7.7). To be complete, variance, skewness and kurtosis are also presented in Figures 7.8. The effective bandwidth turns out to be sensitive to the counting span up to about 70 stripes i.e. about one image: this means that a quasi-minimum is reached for a span of one to several images. The study of the PDF shows interesting opposite effects revealed by the different moments: the spread of the PDF (standard deviation) increases after 50 stripes but the fourth moment increases so much that the resulting PDF shrinks around the mean (positive kurtosis) and displays a large basis (standard deviation).

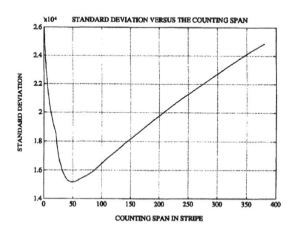

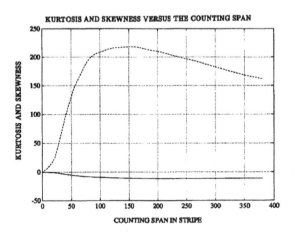

Figure 7.8: Evolution of the first most important moments versus the counting interval.

7.3.4.3 Drawbacks of Bandwidth Allocation

The drawbacks of allocating bandwidth with image cell rates are as follows

Chapter 7. Transmission on ATM Networks

1. worst cell loss figures with potential extension of congestions over several images due to the high correlations between consecutive image cell rates.

2. higher sensitivity of the mean QOS to misallocations resulting from the sharpness of the bit rate PDF's (high positive value of the kurtosis makes cell rate PDF more peaky than Gaussian PDF).

The configuration of cell losses (burst size) is to be put in balance with bandwidth allocation strategy and will be different whether bandwidth allocation is based on image cell rate PDF or on stripe cell rate PDF. To compare at equal QOS,

1. allocating bandwidth at image level will concentrate cell losses during whole images and induce propagations during several consecutive images owing to the high correlations demonstrated at this level. Here stands the first drawback of allocating at image level.

2. allocating bandwidth at stripe level implies higher bandwidths and potentially more disseminated losses with a probably shorter propagation of congestion.

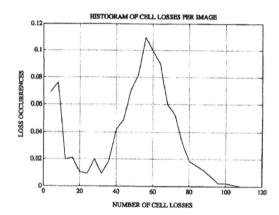

Figure 7.9: Histogram of occurrences of cell losses within affected images (QOS=10^{-2}).

This study points out two modes of congestion. Figure 7.9 presents an histogram of the number of cell losses occurring in affected images at a QOS of 10^{-2}. Two peaks show the presence of short-term congestions with bursts shorter than 10 cell losses and long-term congestions of more than fifty cells involved in one burst. The burst length PDF is depicted in Figure 7.10; it indicates clearly two modes in the negative exponential

1. the long-term mode is influenced by the bit rate PDF's which induce network congestions for long periods. Figure 7.10 shows the effect of the enforcement on the long-term congestion mode. Curve indexed 1 refers to a configuration without any enforcement and Curve 2 to an enforcement of image cell rate at half level between peak and mean rates. The enforcement on the image cell rate will damp the long-term mode.

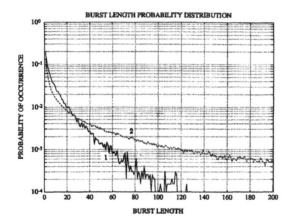

Figure 7.10: Burst length PDF at a QOS=10^{-2}.

2. the short-term mode is influenced by the inter-arrival process and, as a consequence, a smoothing of the traffic i.e. an enforcement of a minimum time interval between consecutive cells (a few cell periods) can slightly diminish the contribution of the short-term congestion mode (5 to 10 %).

As a matter of partial conclusion, it has been shown that the allocation of an effective bandwidth on the base of image spans leads to an optimum bandwidth allocation strategy at the expense of worst cell loss figures i.e. configurations with a potentiality to observe the occurrence of longer bursts.

7.3.5 Traffic Descriptors

The traffic descriptors of a TV source on ATM network should define both source inter-arrival traffic and bit rate PDF as finely as possible.

The traffic has to be described by microscopic parameters specifying the cell inter-arrival time process leading to the definition of a multiplexer performance curve (CBR and VBR modes) of the mean cell loss probability versus the queue load. The sources can be self-enforced or free variable. For example

1. an enforced Poisson cell inter-arrival process.

2. a constant regularly spaced cell inter-arrival process.

3. a free variable cell inter-arrival process described by MMPP(2) which requests to declare four parameters

 1. the mean of $\lambda(t)$.

 2. the variance of $\lambda(t)$.

 3. the covariance of $\lambda(t)$ expressed with the characteristic time constant computable from the asymptotic variance to mean ratio defined on counts (Chapter 5, Section 5.2.3.1).

4. the asymptotic squared coefficient of variation computed on inter-arrival times (Chapter 5, Section 5.2.3.2).

To describe the macroscopic source behavior and compute the optimum bandwidth, the cell rate PDF to be taken into consideration is that counted on image spans

1. one way to describe a PDF is to process by approximating with the successive moments. In this case, four of them lead to the best approach: mean, standard deviation, skewness and kurtosis. A sub-optimal description should supply two of them, mean and variance: this implies to consider the PDF as a Gaussian law and leads to overdimension the bandwidths. Moreover, the nearly constant ratio of standard deviation to mean ($\simeq 0.2$) could be roughly exploited for further extremely coarse approximations.

2. one other way to describe a PDF can be carried out by supplying bit rates at characteristic values of the survivor function; for instance, the survivals at 10^{-n} with n=9, 7, 5,...

In any case, as described in the study of the superposition, individual source traffic descriptors have to be pooled with those of the other sources to be multiplexed in order to come out with two functions

1. the probability density function of the multiplexer load resulting of the summation of the individual source contributions.

2. the performance curve of the resulting superposed inter-arrival time process expressing the cell loss probability as a function of the multiplexer load.

A computation of the resulting bandwidth has to be performed at each call admission and updated at any renegotiation and at the end of the communication when the source withdraws from the network. Let us notice that the admission or the deletion of a source does not involve an equal amount of bandwidth. In fact, due to contraction of the resulting bit rate PDF's when the number of source increases, the part of bandwidth allocated to a given source shrinks when new users are admitted to share the channel. When a source withdraws from the network, its bandwidth is different and can be smaller or greater than the portion originally allocated owing to the past history of admissions and withdrawals during the session. In other words, the bandwidth allocation process is neither memoryless nor additive but rather a process with a memory summarized into present by the characteristics of the sources currently connected on the multiplexer.

To conclude about the traffic descriptors, it can be inferred that a Poisson traffic can be easily enforced (simple algorithms) to cancel useless correlations in between consecutive cell inter-arrival times. This leads to unifying the description of the inter-arrival time processes which has been observed as a signature of coder VLC's and packetizers i.e. highly dependent on any particular coder realization. At this stage, the meaning is that the source generates a non-homogeneous Poisson process with rate $\lambda(t)$ variable with the incoming TV source information. Here two options remain possible

1. no additional buffering is involved within the coder and the arrival rate fluctuates continuously.

2. an additional buffering is allotted to a source self-enforcement. The optimum is, in this case, to accumulate the quantized bit stream on image spans and to send that amount of data during the next image span spread as a Poisson process.

Renegotiations of the bandwidth should be allowed at time scale of TV programmes (hours) to enable some coders to redefine adequately their traffic parameters and to adjust as far as possible their level of image quality.

7.4 Enforcement Actions

In order to maintain and guarantee a given QOS within virtual paths, a flow enforcement is needed to supervise the source compliance to respect the statistical characteristics declared at call establishment and counter any violation to the initial contract. The enforcement action should bound the statistical characteristics of connected users and prevent the admission control from underestimating the load state of a link. Clearly, the purpose of the traffic enforcement or policing is to monitor a connection's resource usage for compliance to appropriate limits and to act on violations of those limits.

As a matter of fact, enforcing actions have to be considered for several reasons

1. to improve and to control the mean transmission quality on the network.

2. to prevent the network QOS from degrading when a source transgresses the negotiated bit rate statistics.

3. to lower the probability of network congestion.

Let us treat in the following those three features into some details

Improving the quality of VBR transmissions means to diminish the mean cell loss probability and also the bursty losses as well as the length of the bursts by reducing the strength of the congestions. For example, enforcing the value of the maximum admissible image cell rate will increase the mean network QOS. This improvement originates from the fact that all temporary cell rates would have been superior to the policed value have been reduced to join the enforced lower level. This action induces a decrease in the mean cell loss probability and forces an exchange of quality between network and images. A strong network enforcement will upgrade transmission QOS but, as a counterpart, will increase the strength of the encoder buffer regulation by an action of the transmission factor on the quantizer step sizes. Eventually, this will induce a degradation of the mean subjective image quality during the scenes with a high information density. The CBR mode of transmission has to be considered as the mode where enforcement is maximum.

The goal of enforcing is secondly to protect the network QOS from any source attempting to infringe the rules of transmission established at the negotiation of traffic descriptors.

The third effect of the enforcing action is to reduce the congestion probability within the network. As already mentioned, enforcement decreases the potentiality and the strength of the congestions and, hence, the lengths of the bursts of cell losses. By definition, the congestion within a multiplexer occurs when the resulting bit rate is superior to the queue rate of service. As a consequence, the congestion probability P_{CONG} associated with a superposed traffic is the survivor function \mathcal{F} computed with the PDF f_{SUP} of the multiplexed traffic bit rate r

$$P_{CONG} = \int_{r=c}^{r=r_{MAX}} f_{SUP}(r)dr = \mathcal{F}(c) \qquad (7.52)$$

where c is the multiplexer service rate. The allocation of the bandwidth using image time interval as counting span presents some drawbacks in the case of congestion: the congestion is more likely to last out for a long time duration (i.e. several images) due the strong correlation between consecutive images as it has been put into evidence in Chapters 3 and 5. The remaining part of this section devoted to the enforcement will deal with the aspects of the optimum exchange of quality in between network and coders. Other topics related to the traffic enforcement, for instance the tagging actions and the multipoint connection needs, will be tackled in the section relative to the congestion control algorithms since enforcement is relevant to congestion control problems

As a matter of fact, the enforcement action plays an important role to determine the optimum way to use the resources (defined as the bandwidth) allocated to the transmission. The enforcement action plays a role in controlling both the network quality and the queueing congestion which is similar to the action of controlling performed in TV coders on the image quality and the level of buffer occupancy. On one side, the network quality control is accomplished by the enforcement parameter updated at each bandwidth renegotiation (open loop control) or, more frequently, if a closed loop control is established to feed back the multiplexer load information of the network-connecting node to the enforcement parameter. On the other side, the image quality control is managed by the transmission factor. As a matter of important consequence, an optimum control algorithm in the network can be described as a mirrored version to that one described for the TV coders. Globally, both optimum controls will lead to a global formulation for an optimum TV transmission on the ATM channels (or virtual paths).

Those two optimum controls are not totally independent of each other. This section will indeed first describe the exchange of quality between the network (QOS) and the coder (image quality). This exchange can be considered as a coupling effect between both optimum controls. The section will thereafter proceed presenting which parameters have to be enforced and which optimum choice of enforcement has to be made at each bandwidth negotiation to control TV transmissions on the network.

7.4.1 Exchange between Image and Network Quality

The subjective image quality at the decoder side results from two effects: first, distortions produced by the encoder quantizer which are not recovered into the decoder and, secondly, from cell losses which can eventually be regenerated by an appropriate strategy of error correction and concealment. Those two distortions concur to a final image

degradation. This section will demonstrate that, once the bandwidth has been allocated, the network enforcement contributes to an exchange between quantizer distortions and network quality. Some coupling actions will be illustrated. To begin with, those two components influencing the transmission of subjective image quality are considered and the interactions on decoded picture are presented. Let consider successively the network side and the coder side

1. *On the network side*, one quality law has to be defined: when source traffics and PDF's of cell rate are precisely determined, the law relating the mean network QOS (i.e. the mean cell loss probability) as a function Φ of the enforcement to be applied to the sources connected on the entry node is given by

$$E\{QOS\} = \int_{QOS=QOS_{MIN}}^{QOS=QOS_{MAX}} QOS \, f_{QOS} \, dQOS \qquad (7.53)$$

$$= \int_{\rho=\rho_{MIN}}^{\rho=\rho_{MAX}} M(\rho) \, f_{\rho|ENF} \, d\rho \qquad (7.54)$$

$$= \Phi(p_{\nu,ENF}) \qquad (7.55)$$

where ρ is the multiplexer load, the resulting PDF $f_{\rho|ENF}$ is obtained by convolving the individual bit rate PDF $f_{s|ENF}$ of the individual sources to be superposed after their having been enforced. The multiplexing performance curve is given by $QOS = M(\rho)$. Let $p_{\nu,ENF}$ be the enforcement parameter defined as the percentage of bit rate values to be policed or, in other words, the percentage of bit rate values constrained to be shifted or displaced to an enforcement level (for CBR mode, $p_{\nu,ENF} = 1$; for free VBR mode, $p_{\nu,ENF} = 0$). The simplest way to enforce consists here in policing a maximum image bit rate value. The consequence is that bit rate densities of probability $f_s(r)$ for any individual source beyond that policed threshold are gathered on the enforcement value as a mass of probability

$$f_{s|ENF}(r) = \begin{cases} f_s(r) & \text{if } r < r_{\nu,ENF} \\ \int_{r=r_{\nu,ENF}}^{r=r_{MAX}} f_s(r)dr & \text{if } r = r_{\nu,ENF} \\ 0 & \text{if } r > r_{\nu,ENF} \end{cases} \qquad (7.56)$$

A more general way of considering the enforcement action would be to impose a whole gauge of bit rate PDF like a Gaussian gauge.

2. *On the coder side*, three quality laws can be considered: the first interconnects the network QOS with the end-to-end users network quality of service. The second joins the coding entropy rate with the transmission factor and can be referred to as a rate distortion function. The third relates the transmission factor to the value of the constant subjective image quality.

2.1 the ATM Adaptation Layer transforms the network QOS into an end-to-end users network quality. The use of error correcting codes in Chapter 6 has enabled deducing the curves which relate the end-to-end users network QOS in function of the network QOS. In TV applications, the resulting end-to-end users network QOS after correction ensured error free transmission much longer than one hour between consecutive non-corrected perceptible cell losses.

2.2 the rate distortion function: in Chapter 2, the compression performed by quantizer and VLC on the entropy bit rate originating from the decorrelative operation has been characterized by a negative exponential law to be considered as a rate distortion function. The factor of distortion is here the transmission factor U. The minimum distortion is obtained at $U = 0$ corresponding to the finest quantization step size; the entropy rate H_i at this level is considered as the input image entropy rate on the point of view of the encoder. In any case, this entropy rate is related to the source entropy $H(\mathcal{U})$ by the relation:

$$H_i(n) \leq H(\mathcal{U}) \tag{7.57}$$

The maximum distortion is obtained for the maximum value of transmission factor. In between these two extreme points, the function is convex \cup, continuous and strictly decreasing and takes benefit of all the properties presented in [26].

2.3 the third relation is that relating the value of transmission factor to that of subjective image quality. This law is highly dependent on the quantization algorithm: in Chapter 3, magnitude orders have been given for the coder subject to statistics.

An example of exchange of quality is now addressed. Fifteen different TV sources have been considered (Table 3.9). The enforcing action is gradually adapted from the value of the peak image bit rate (maximum observable) down to that of the mean image bit rate. As the image bit rate PDF is different for each source, the enforcement parameter has been preserved equal for each source at each experimental point. The mean network QOS and the mean variation of transmission factor have been computed for each value of enforcement parameter. The enforcement parameter has been considered here as ranging from 0 to 0.5. The mean value of the QOS is computed according formulae 7.53 to 7.55 by convolving enforced PDF's, with a multiplexer performance curve supposed to be that one of the Poisson process. The mean variation of transmission factor is deduced as follows: at each value of the image bit rate beyond the policed rate, the subjective degradation of quality is estimated using the rate distortion function $\Delta U = \frac{1}{k} \ln \frac{r(n)}{r_{\nu,ENF}}$. The final relation is expressed as

$$E\{\Delta U\} = \frac{1}{k} \sum_{r=r_{\nu,ENF}}^{r_{MAX}} f_s(r) \ln[\frac{r}{r_{\nu,ENF}}] \tag{7.58}$$

To illustrate, the case of 15 TV sources with U=10 and a constant bandwidth is presented in Figures 7.11 and 7.12 where the reference QOS_{FREE} of the free VBR sources

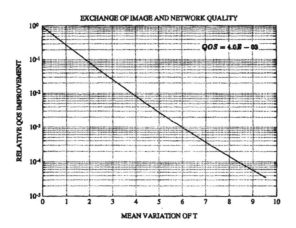

Figure 7.11: Exchange of image quality with network quality at $E\{QOS_{FREE}\} = 4.0\ 10^{-3}$.

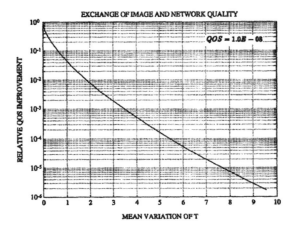

Figure 7.12: Exchange of image quality with network quality at $E\{QOS_{FREE}\} = 1.0\ 10^{-8}$.

Chapter 7. Transmission on ATM Networks

is respectively of 4.0 10^{-3} and 1.0 10^{-8}. The relative QOS improvement $\frac{E\{QOS_{ENF}\}}{E\{QOS_{FREE}\}}$ is drawn in function of the mean variation of U. The resulting law of exchange between cell loss probability and image quality $\frac{E\{QOS_{ENF}\}}{E\{QOS_{FREE}\}} = f[E\{\Delta U\}]$ has a logistic form

$$\{\frac{E\{QOS_{ENF}\}}{E\{QOS_{FREE}\}}\} = ke^{-bE\{\Delta U\}} \tag{7.59}$$

which is traced in Figures 7.11 and 7.12. This shows the exponential nature in the exchange of quality between the mean subjective image degradation and the network QOS. QOS_{ENF} is the QOS after enforcement. This section has demonstrated how to control the mean network QOS by an enforcing action: when the strength of the network enforcement increases to impose a reduction of the maximum admissible rate from the peak value down to the mean cell rate value, the the mean QOS will improve for a given fixed bandwidth.

7.4.2 Enforcement Parameters

So far in the chapter, it turns out clearly that the enforcement has to be performed on a multi-level basis when transmitting TV sources on ATM networks

1. one action is relevant to the inter-arrival process to reduce the probability of short-term congestions i.e. random microscopic congestions originating from bursty arrivals of cells into the multiplexer.

2. the other action is relevant to cell rate PDF's with the goal to control the resulting level of the mean QOS and to reduce the probability of long-term congestions i.e. macroscopic congestions originating from the conjunction of two factors behaving in synergy: high cell rates generated simultaneously from different sources and high correlation factors among consecutive image cell rates.

As traffic characteristics strongly influence multiplexer performances, it requires a strategy of microscopic enforcement acting on the cell inter-arrival process to smooth traffic, to protect multiplexers from short-term congestions and, therefore, to guarantee the multiplexing performances. At the inter-arrival level, the enforcement will consist in policing a minimum interval of time between two consecutive cells belonging to the same TV source.

To protect the network against long-term congestions, the shape of the image cell rate PDF should be enforced in VBR transmissions: this means enforcing at least a mean image cell rate and a peak image cell rate. The image cell rates higher than the policed one are constrained down to the enforced peak value. As deduced in Chapter 3 from the statistics of both image cell rate and scene duration, the estimation of a correct mean image cell rate should take into account several tens of different scenes and be estimated over time scales of hours or tens of minutes. So far, the differences of effects between inter-arrival and counting processes has been clarified

1. the inter-arrival process referred to as the traffic determines with high sensitivity the multiplexing performance curves. It performs a major role in bandwidth allocation.

2. the counting process contributes at two levels

 1. when allocating the bandwidth (the main resulting gain in statistical multi-plexing is determined at this level).

 2. while transmitting cells, by several features: the exchange of qualities, the control of network congestions and the search towards optimum transmission conditions.

As a matter of conclusion on the traffic parameters to be enforced, a multi-threshold strategy turns out to being necessary to cope with the multiple-time-scale content of TV sources, namely the inter-arrivals, the image cell rate PDF's, the scene lengths and the programmes. Each of them and at least the first two parameters need to be enforced. The leaky bucket algorithm is needed to police cell rate on CBR virtual circuits and to police peak, mean bit rates and burstiness on VBR virtual channels. The credit counter or manager algorithms allow the enforcement of counting PDF's, this action must be performed at least on the image span basis. Optimum queueing performances lead to enforce the generation of Poissonian arrival processes whose rate may be up-dated on an image-per-image basis according to the occurrence of potential scene change.

7.4.3 Optimum Decision for Enforcement

The aim is now to draw a parallelism between the control of the image quality and that of the network quality to provide the TV transmission with a path towards a general formulation. The aim is to balance the network enforcement to obtain a network quality as constant as possible with the coder buffer regulation acting towards uniform image quality. The inclination towards a rather constant network QOS depends on several factors in VBR transmissions

1. the relative importance of the new source to be connected: a HDTV source can significantly influence the resulting cell rate PDF to be issued from multiplexing, the probability of congestion has to be controlled as well as the tendency of QOS to digress too far from the mean value.

2. the number of VBR sources already multiplexed: as the number of VBR sources increases, the relative concentration of the resulting bit rate PDF of the superposition increases around the mean in such a way that any new admitted source requires less and less enforcement.

3. the network congestion control requires to adapt the enforcement according to the trend of the mean occupancy of all multiplexing queues located on the elected virtual path for transmission. As a matter of fact, the current mean level of queueing occupancy along the virtual path of a TV transmission is an estimator of the tendency or the potentiality of congestion. Due to a positive trend in the mean queue occupancy value, the enforcement should be dynamically increased and conversely. This implies two new ideas: the enforcement should be updated or adapted according to the previsions of congestion. A theoretical refinement of the control should

be performed by permanent actualizations of the enforcement action: at call set-up, the network declares the enforcement to be applied according to its current and foreseeable states; during the transmission, the enforcement is updated (on periods of the image scale) according to the trend in multiplexer queue occupancies with a variable strength ranging from no policing up to the value declared at call set-up.

As obtained in Chapter 4, an optimum control of the network transmission is to be based on a cost function to be minimized. A predictive adapted model of the network tendency of the queue occupancy can allow to build a stochastic graph (Markov modeling). An algorithm to search the optimum path has to be designed considering present and potential future states to make the optimum decision of enforcement at call set-up.

7.4.4 Cost Function for Enforcement

The cost function should minimize as far as possible the variation of network QOS balanced with the increase of enforcing action

$$\min\{E[(\Delta QOS)^2] + \lambda E[(r - r_{\nu,ENF})^2]\} \qquad (7.60)$$

where r is the bit rate to be enforced to the value $r_{\nu,ENF}$. The first term of the cost function represents the expected variation of network QOS to be undergone by TV transmission on image based intervals. This term can be determined with the knowledge of superposed source PDF to compute a mean variation of QOS. The value of λ is to be adapted by the network according to its tendency towards congestion or vacuity. A value of λ equal to zero forces the decision to minimize the expected variation of the network QOS down to zero whatever the enforcement i.e. this value represents the case for a request to a CBR transmission when the risk of congestion increases. A high value of the factor λ tends to privilege free VBR transmissions against variable network quality. For any current value of the parameter λ, the minimum corresponds to a balance between the two opposite tendencies expressed in the cost. When the image bit rate to be enforced goes top down from the peak to the mean value, more and more images have a bit rate superior to the enforcing value and need therefore to be policed down to the enforced bit rate. This means that any increase of the second term of the cost is put in the balance with an expected decrease in the variation of network QOS expressed in the first term of the cost (both terms are computed on superposed traffic). A constraint to be added in the search concerns a limit to the probability of congestion $P_{CONG} \leq 10^{-n}$.

7.4.5 Optimum Control of TV Transmissions

Both optimum controls lead to a general optimum encompassing coder and ATM channel. The control should minimize the weighted sum

$$\min\{\lambda_1 E[(\Delta U)^2] + \lambda_2 E[(B - B_{ref})^2] + \lambda_3 E[(\Delta QOS)^2] + \lambda_4 E[(r - r_{\nu,ENF})^2]\} (7.61)$$

with a search to maximize the mean value of both subjective image and network qualities

$$\min E\{\sum_{n=0}^{+\infty} U(n)\} \tag{7.62}$$

$$\max E\{\sum_{n=0}^{+\infty} QOS(m)\} \tag{7.63}$$

with n and m being respectively the stripe and the image indexes of period.

Under the constraints of limited resources within both coder and network (i.e. all the queues i located on the virtual path)

$$B(n) < 100\% \qquad \text{the limited buffer} \tag{7.64}$$

$$P_{CONG} < 10^{-k} \quad or \quad Q_i(n) \leq 100\% \quad \forall i \quad \text{the limited queueing capacity } Q \tag{7.65}$$

This last equation supposes that the traffic is well described leading to a known multiplexer performance function.

Under the constraints of a coupling κ between both controls due the enforcing action

$$0 \leq \kappa = 1 - \frac{E(QOS_{ENF})}{E(QOS_{FREE})} = 1 - ke^{-bE(\Delta U)} \leq 1 \tag{7.66}$$

The coupling effect increases with the enforcement strength and is therefore maximum for CBR transmissions and minimum and null for free VBR transmissions. The optimum coupling is to be adapted to balance the variation of the quality with that one concerning the use of storage capacities. The coefficient λ_2 is adapted according to the incoming characteristics of TV sources and the parameter λ_4 according to network queue states. From a theoretical point of view, an optimum control of the global TV transmissions (coder+network) would be reached in a case where the enforcement action is continuously updated by the network with a period of one or a few images taking into account the state of the network. In this latter case, each new condition for the enforcement action should be transmitted to the coder.

So far, two features argue in favor of renegotiating the bandwidth and the enforcement on a TV programme-to-programme basis (i.e. every two or three hours)

1. the statistics and, first of all, the mean image bit rate can significantly change according to the category of programme that the encoder plans to transmit. Indicative values are given in Tables ?? and ??.

2. the long-term evolution of the network and, especially, the state of the queues determines new probability figures for congestion requesting to update values of the applied enforcement.

To end the study of the transmission on ATM networks, the input-output relations in switches and multiplexers and the strategies of congestion control are successively treated in the following.

7.5 Switching Operations on Traffics

A queueing system can be regarded as a *random operator or a random transfer function* which transforms one point process into another. The *input process* or *arrival process* with inter-arrival $\{T_n\}$ is operated by a random mechanism, the queueing system, defined by a queueing discipline and a service process with times $\{S_n\}$ to produce the *output or departure process* with inter-departure $\{D_n\}$. The purpose of this section is to study the effect of the multiplexers on the the global process arising from the superposition of N sources to be multiplexed and transmitted on a common link. This yields a multiplexed output process out of the switching node which constitutes the entry into the next switching node. Upon arrival in the switching node, the multiplexed arrival process is decomposed into subprocesses or customer processes under a certain switching mechanism according to the output port of destination. Each component in the superposition processes corresponds to an individual source which undergoes successively a superposition and a queueing when multiplexed, a transmission on an internodal link at constant rate and, finally upon arrival in a switching node, a component extraction. This latest operation intends to decompose the flow process to route and multiplex the sources according to their destined link. In this switching framework, the section examines problems not yet tackled so far in the textbook, namely the queueing departure processes, the input-output queueing relations with the random translation effect on traffic and the decomposition of flow process.

7.5.1 Departure Processes

Different theorems have been demonstrated so far in the literature merely dealing with the first two moments and the correlation of the departure process in the case of nearly all the queueing models up to the most general G/G/1. The results to be cited are in [19], [20], [17] and [6]. Some of the most important theorems may be reported as follows.

Theorem 7.5.1 (Daley 1968). *The inter-departure intervals $\{D_n\}$ in a stationary GI/G/1 queueing system have the property that*

$$var[S_n] \geq var[D_n] \tag{7.67}$$

with equality if and only if both the service times and the inter-arrival times are constant in which case $var(D_n) = 0$ and the queueing model is D/D/1.

Theorem 7.5.2 (Marshall 1968). *Under the assumptions of Theorem 7.5.1, it can be shown that*

$$var[S_n] \leq var[D_n] \leq var[T_n] + 2\{var[T_n] + \epsilon E[T_n - S_n]\} \tag{7.68}$$

where ϵ is the unique positive solution of $\epsilon = \int_{-\epsilon}^{\infty} Pr[S_n - T_n]dx$. As a particular result for the M/G/1 queue, the inequality 7.68 yields

$$var[D_n] = var[S_n] + (1 - \rho^2)\, var[T_n] \tag{7.69}$$

These equations show the effect of transforming a stationary renewal arrival process into a stationary departure process by means of a single-server queueing system. According to the sign of $var[D_n] - var[T_n]$, the resulting effect can be either variance-increasing or variance-decreasing within the GI/G/1 class.

Theorem 7.5.3 (Daley 1974). *The inter-departure intervals $\{D_n\}$ in a stationary GI/G/1 queueing system for which $E(T_0^2) < \infty$ and $E(S_0^3) < \infty$ have*

$$\frac{var[D_0 + D_1 + ... + D_n]}{var[T_0 + T_1 + ... + D_n]} \to 1 \qquad n \to \infty \tag{7.70}$$

if the denominator remains bounded then, probably, the numerator does similarly.

$$var[D_0] + 2 \sum_{n=1}^{\infty} cov[D_0, D_n] = var[T_0] + 2 \sum_{n=1}^{\infty} cov[T_0, T_n] \tag{7.71}$$

As further stated in *[Daley 1976]*, Equations 7.70 and 7.71 are true in whole generality in stable stationary G/G/s systems. The proof is not entirely trivial.

Theorem 7.5.4 (Pack 1975). *The steady-state correlation structure of the M/D/1 with arrival rate λ and service time c is such that*

$$var(D_n) = \frac{[1 - (\lambda c)^2]}{\lambda^2} \tag{7.72}$$

and, defining the steady-state correlation coefficient between inter-departure times of lag r as

$$\gamma_r = \frac{cov(D_n, D_{n+r})}{\sqrt{var(D_n)var(D_{n+r})}} \tag{7.73}$$

if $Z(n) = \sum_{i=1}^{n} D_i$, then

$$var[Z(n)] = \sum_{i=1}^{n} var[D_i] + 2 \sum_{i=1}^{n-1} \sum_{j=i+1}^{j=n} cov[D_i, D_j] \tag{7.74}$$

$$\frac{1}{\lambda^2} (1 - \rho^2) \left[n + 2 \sum_{l=1}^{n-1} (n - l)\gamma_l \right] \tag{7.75}$$

The general expression of the correlation coefficient of lag $n = 1, 2, ...$ is finally given by

$$\gamma_n = frac\{-1 + \rho + e^{-\rho n}\} \sum_{i=0}^{n-1} \frac{(\rho)^i (n - i) n^{i-1}}{i!} - 1 + \rho \tag{7.76}$$

with $\rho = \lambda c$ being the queueing load. Generally speaking, the correlation coefficient for M/G/1 queue is either positive but small or negative. The upper bound is attained in the M/D/1 model given by $\gamma_1 = \frac{e^{-\rho} + \rho - 1}{1 - \rho}$ and at $\rho = 1$ by $\frac{e^{-1}}{2} \simeq 0.18$. The lower bound is -1. *[Pack 1975]*

The inter-departure times of a stationary M/G/1 queue are uncorrelated if and only if the service distribution is negative exponential i.e. $\gamma_n = 0, \ \forall n$ if and only if the queueing system is M/M/1.

Theorem 7.5.5 *Let an M/GI/1/L queueing model (the queue length $L \leq \infty$) be determined by an arrival rate of λ and a service time distribution $F(t) = Pr[X_m \leq t], \ t \geq 0$ where X_m is the m^{th} served cell and F has finite mean and variance; the departure process is a renewal process if and only if the queue length process is stationary and only if any of the four following cases holds*

1. *the service times are identically zero, then*

$$Pr[D_m \leq t] = 1 - e^{-\lambda t} \qquad (7.77)$$

2. *L=0 and the service times are GI (independent and generally distributed), then*

$$Pr[D_m \leq t] = (1 - e^{-\lambda t}) * F(t) \qquad (7.78)$$

 where the symbol $$ denotes the convolution operator.*

3. *L=1 and the service times are D (constant or deterministic), then*

$$Pr[D_m \leq t] = (1 - e^{-\lambda t}) * \delta_d(t) \qquad (7.79)$$

 where $\delta_d(t) = 0$ or 1 according to whether $t < d$ or $t \geq d$ as the Dirac function.

4. *$L = \infty$ and the service times are M, then*

$$Pr[D_m \leq t] = 1 - e^{-\lambda t} \qquad (7.80)$$

In cases 2 and 3, the input and the output processes bear little resemblance to each other except that they have identical mean rates. The sequence of the inter-arrivals S_n is a sequence of independent random variables while the sequence of inter-departures D_n; $m = 1, 2, ...$} is not.

As an interesting remark to be noticed, the bivariate sequence (N^o, D^o) constructed respectively with the queue length process N^o embedded at the point where the m^{th} cell leaves the node and the inter-departure times D^o is a Markov renewal process whose kernel $Q_o(t)$ is determined by the queueing arrival rate λ and the service time distribution F. The stationary joint distribution of any sequence of intervals is given by

$$Pr[D_1 \leq t_1, \ D_2 \leq t_2, \ ..., \ D_l \leq t_l] = \pi \, Q_o(t_1) \, Q_o(t_2) \, ... \, Q_o(t_l) \, U \qquad (7.81)$$

where π is the stationary distribution of the Markov chain N^o and U a vector with all the components equal to one. On account of that result, any joint distribution, auto-covariance or auto-correlation functions can be derived quite easily.

7.6 Input-Output Relations in Multiplexers

This section aims at characterizing the effect of a multiplexer on the traffic of individual customer sources. The individual output inter-departure process should be expressed in terms of the corresponding input inter-arrival process. The impetus to study the input-output relations is explained by the fact that, on a virtual path in the connection-oriented-transmission mode, the cell inter-arrival process of each individual source is iteratively transformed by a multiplexer acting as a random operator of translations on the arrivals. In fact, the transmission bandwidth to be allocated at each multiplexer should take into account the potential evolution of the customer-source traffic along the virtual path especially if the transformation is significant. Indeed, the traffic descriptors can possibly become different after one or several multiplexing operations from the descriptors originally defined by the source connected on the channel. The mean rate is conserved but the serial correlation may be modified. This case is significant when connecting a TV source generating a free variable cell rate traffic whose inter-arrival process is highly correlated. The original source point process will be smoothed by the successive random-translation effect of multiplexers; the cell arrival process turns out to approach asymptotically a Poissonian arrival process in any case of source independence.

7.6.1 Component Inter-Departure Process

The problem of calculating the single-source-inter-departure-time PDF f_d as issued from a multiplexer is succinctly addressed in this subsection. Let us therefore consider one single source i with a known inter-arrival distribution defined by a PDF $f(r)$. The source i is multiplexed with (N-1) other sources into the multiplexer. The queueing model for the multiplexer is $G/D/1$, the service time is taken as time unit of reference. To ease the presentation, an infinite queue length is considered, nonetheless releasing the restriction to treat the finite length queue is not an intricated problem. The effect of the queue on the inter-arrival process may be decomposed into two exclusive modes depending on whether the previous cell sent by the source is still waiting in queue or has been served and transmitted upon arrival of a cell in queue. Therefore, these two exclusive modes can be defined as

1. in *mode 1*, the n^{th} cell arrives into the queue when the $(n-1)^{th}$ cell is either still busy waiting for transmission or being processed by the server. In this mode, the cell inter-departure time is equal to the number of cells produced by the superposition of the N-1 other sources during the cell inter-arrival of the source i. The random translations imposed to the arrival process originate from the (N-1) multiplexed input sources. This case is dominant when the source i has its inter-arrival-time probability densities relatively lower than the queue-waiting-time densities.

2. in *mode 2*, the n^{th} cell arrives into the queue when the $(n-1)^{th}$ cell has already been served. In this mode, the inter-departure time is the sum of the source inter-arrival time and the queue waiting jitter i.e. the difference between two consecutive queue waiting times. The random translations imposed to the arrival process are here

due the waiting time in queue. This mode is predominant when the queue-waiting-time probability densities are relatively lower than the inter-arrival-time probability densities of the source.

Let now express the PDF $f_d(d)$ of the inter-departure times for source i as a function of the corresponding inter-arrival PDF $f(r)$. On account of the splitting in two modes, the PDF $f_d(d)$ that the inter-departure time equal d is the sum of two terms

$$f_d(d) = f_{d_1}(d) + f_{d_2}(d) \tag{7.82}$$

Let $P_S(r)$ denote the probability that the inter-arrival time r be superior to the waiting time in queue and $P_I(r)$ denote the probability that the inter-arrival time r be inferior to the waiting time in queue, therefore, $P_I(r) = 1 - P_S(r)$.
The two multiplexing modes are now considered

1. *in mode 1*, the contribution in the PDF of d is mainly dependent on the inter-arrival f(r) process and given by

$$f_{d_1}(d) = \sum_{r=1}^{\infty} P_I(r) \times f(r) \times k[N_{N-1}(0,r) = d] \tag{7.83}$$

where the $k[N_{N-1}(0,r) = d]$ is the probability that the superposition of the (N-1) sources generates d cells in a time interval equal to r. This counting process can be deduced from the arrival models developed in Chapter 5 [like the MMPP(m)]. The summation is performed over all the admissible values of r. Each integer value of r determines a window over which the corresponding counting process k furnishes the probability to observe d cells.

2. *in mode 2*, the component of the inter-departure time d is mainly dependent on both the queueing jitter and on the inter-arrival process, it is given by

$$f_{d_2}(d) = \sum_{r=1}^{\infty} P_S(r) \times f(r) \times l(w = d - r) \tag{7.84}$$

where w stands for the waiting time jitter, $l(w = d - r)$ is the probability density that the waiting time jitter w be such that w+r=d. Then, $l(w = d-r)$ is determined by the queueing models developed in Chapter 5 in relation with the arrival models.

In the case of queues with limited size B_M, additional terms of cell loss probability leading to increase the density at $d = \infty$ have to be extracted from f_{d_1} when $k[N_{N-1}(0,r) > B]$ and from f_{d_2} when $l(w > B)$ to derive the new density at $d = \infty$.

7.6. Input-Output Relations in Multiplexers

7.6.2 Translations in Arrival Processes

The point arrivals of each individual source traffic traverse a queueing network with random velocities as already characterized in Chapter 5 by jittering curves. The cell arrival instants are subject to translations and the queueing network is said to translate the arrival points. In connection oriented transmissions, the initial cell ordering is preserved and the inter-arrivals are limited to be non-negative. In connectionless applications, the initial ordering of the point is likely to be lost on translation. To experimentally characterize the translation, a study similar to that presented for the traffic superposition could be carried out to show the evolution of the k-interval squared coefficient of variation after N independent translations of given PDF.

If $f(x)$ denotes the translation PDF, it follows that the probability generating function of the translated version N^t of the original counting measure N is given by

$$G^t[\xi] = G[\int_{-\infty}^{+\infty} \xi(x+u)f(u)du] \qquad (7.85)$$

where G is the generating function of N.

The covariance density of counts c is obtained by writing

$$\psi(\omega) = \frac{1}{2\pi} \int_{-\infty}^{+\infty} c(u)e^{-i\omega u} du \qquad (7.86)$$

$$= \frac{\lambda}{2\pi} + \frac{\lambda}{2\pi} \int_{-\infty}^{+\infty} \{h(u) - \lambda\}e^{-i\omega u} du \qquad (7.87)$$

where $h(u)$ is the conditional intensity function of the arrival process and λ the rate of the process. For a Poisson process and for any general process with $h(u) = \rho$, the spectrum is white with $\psi(\omega) = \frac{\rho}{2\pi}$.

The Poisson process turns out in fact to be invariant under independent translations of its points and the mixed Poisson process has been shown [Goldman, 1967] as being the only process to be invariant under translations. Similarly to the study of superposition, the limiting behavior of the translated process N^t should intuitively be approximated by a Poisson process at least on small time scales if, in translating the points, the dependencies between points in the original process have been effectively removed. This behavior should be expected if the translation PDF is suitably dispersed. The mean rate and the stationarity of the original process are not affected by translation. The proof of that convergence theorem is due to Stone [1968] to show that Poisson process is obtained if the operation of translation is iterated a large number of times. Let the translation distribution be F^t and the translated process be $N^{t,n}$ after n translations. As $n \to \infty$, $N^{t,n}$ converges in distribution to a Poisson process.

The rate, the stationarity and the orderliness of the arrival process are preserved by translation. Hence, the mean and the conditional intensity of N^t are given respectively as

$$E[N(0,t)] = \lambda t \tag{7.88}$$

$$h^t(u) = \int_{-\infty}^{\infty} h(u-v) f_w(v) dv \tag{7.89}$$

where f_w is the density of the difference between two independent translations each with density f, that is the jitter. The second-order properties of N^t can be derived from 7.88 and 7.89 as follows using 7.87 to express the spectrum $\Psi^t(\omega)$ of N^t.

$$\Psi^t(\omega) - \frac{\lambda}{2\pi} = \frac{\lambda}{2\pi} \int_{-\infty}^{\infty} f_w(v) \, dv \int_{-\infty}^{\infty} e^{-i\omega v} \left[h(u-v) - \lambda \right] dv \tag{7.90}$$

$$= [\Psi(\omega) - \frac{\lambda}{2\pi}] f_w^t(\omega) \tag{7.91}$$

with $\psi(\omega)$ the spectrum of N and

$$f_w^t(\omega) = \int_{-\infty}^{\infty} f_w e^{-i\omega v} dv \tag{7.92}$$

the characteristic function of w which is real by symmetry of f_w. Hence, the difference between the spectrum of the translated process N^t and that of the Poisson process is given by the corresponding difference for the original process reduced by a factor equal to the characteristic function of w. Let us consider again the spectrum of N^t given in 7.91 and study how 7.91 depends on the dispersion of the displacement distribution, it is convenient to write $f_w(v) = \frac{f_w'(\frac{v}{\sigma})}{\sigma}$, where σ is a scale parameter. Then

$$f_w^t(\omega) = \int_{-\infty}^{\infty} e^{-i\omega\sigma x} f_w^t(x) dx \tag{7.93}$$

By Riemann-Lebesgue lemma, $f_D^t(\omega) \to 0$ as $\sigma \to \infty$ for $\omega \neq 0$, and thus $\psi^t(\omega) \to \frac{\rho}{2\pi}$, the spectrum of a Poisson process. The rate of approach depends on the analytic behavior of f^t. If, in particular, f^t is a normal density function, then $f_w^t = e^{-\frac{\omega^2\sigma^2}{2}}$, so that $\psi^t(\omega) - \frac{\rho}{2\pi}$ is very small as soon as $\omega\sigma \gg 1$.

7.6.3 Decomposition of Flow Processes

In the ATM queueing network, upon entrance into any node, the incoming traffic is submitted to a switching process which determines the path where each component cell out of the multiplexed stream has to proceed to reach its destined output port. The arrival sub-processes are extracted and routed to their dedicated output port. They effectively correspond to individual customer flows which are recovered from multiplexing. As a matter of fact, decomposing arrival processes into a set of distinct sub-processes is the inverse operation of the superposition which has been already described in Chapter 5. The decomposition belongs to the theory of *thinning point processes*. The resulting processes from which cells have been extracted is called the *thinned processes*. Once again, study and

theory can be performed on thinned processes in whole similarity to that of superposition showing the limiting convergence properties to a Poisson processes when the deletion probability tends to one. Indeed, let us assume that N is a stationary orderly point process with mean rate ρ and conditional intensity function h. It is straightforward to write down the properties of the thinned process N_d derived by deleting each point of N independently of each other with probability (1-p). The index of dispersion $I_d(t)$ of the thinned process evaluated over the interval $(0, t]$ is given by

$$
\begin{aligned}
I_d &= \frac{var[N_d(t)]}{E[N_d(t)]} & (7.94)\\
&= 1 + \frac{2p^2}{t}\int_0^{\frac{t}{p}}(\frac{t}{p} - u)[h(u) - \rho]du & (7.95)\\
&= 1 + 2p\int_0^\infty (h(u) - \rho)du + \mathcal{O}(p) & (7.96)\\
&= 1 + p(I(\infty) - 1) + \mathcal{O}(p) & (7.97)\\
& & (7.98)
\end{aligned}
$$

When p tends to zero, the deleted process converges to a Poisson process. $I(\infty)$ is the limiting index of dispersion of $N(t)$ as $t \leftrightarrow \infty$. This completes the proof.

To formulate the decomposition problem in the framework of the ATM switching, it is of interest to study the decomposition of, for instance, that of a Markov renewal process with a semi-Markov process or that of a Markov modulated Poisson process with a semi-Markov process. It has been shown earlier in this part that the Markov renewal process was the output process of the M/GI/1 queue. In the ATM point of view, the input process to a switch experiences a decomposition which distributes the cells to distinct output ports; the decision of where to send the next cell depends on the sequence of the different customer cells embedded in the input multiplexed process. The question then is to characterize the individual switched processes. To proceed towards formal notions, let us define two additional sequences, namely I={I_m : $m =$ 1, 2, ...} the sequence of the customer types and F={t_n : $n =$ 1, 2, ...} the times of arrival to the switch of the m^{th} cell. Let us remark that, at the stage of the transmission, the discrimination among distinct customers is based only on the destination and, possibly, on the transmission QOS required inside the virtual path i.e. the size of the set {$m =$ 1, ..., $N \times J$} equals all the different accessible output ports N multiplied by the different levels of transmission QOS J allocated to the switching node. Let us further assume that the bivariate sequence (I, F) is a Markov renewal process and define a Markov renewal switching process $(I, Y, F) =$ {I_m, Y_m, t_m} where $Y_m = k$ when the m^{th} arrival to the switch is assigned to the subprocess k. Let us further give this process the following two properties independent of m

$$
\begin{aligned}
&Pr[I_{m+1} = i', Y_{m+1} = k, t_{m+1} - t_m \leq t\\
&|I_m = i, Y_m = j, I_{m-1}, \ldots, I_1, Y_{m-1}, \ldots, Y_1, t_m, \ldots, t_1]\\
&= Pr[I_{m+1} = j, Y_{m+1} = k, t_{m+1} - t_m \leq t|I_m = i, Y_m = j]
\end{aligned} \quad (7.99)
$$

$$
\begin{aligned}
&Pr[I_{m+1} = i', t_{m+1} - t_m \leq t|I_m = i, I_{m-1}, \ldots, I_1, Y_m = j, \ldots, Y_1, t_m, \ldots, t_1]\\
&= Pr[I_{m+1} = i', t_{m+1} - t_m \leq t|I_m = i]
\end{aligned} \quad (7.100)
$$

The second property characterizes the input process as a Markov renewal process and includes the renewal process as a particular case. These assumptions result in the following theorem

Theorem 7.6.1 *The $N \times J$ subprocesses that result from a stationary Markov renewal switching process are Markov renewal processes.*

Çinlar considers in his textbook and Ph.D. thesis dissertation cases where a Markov renewal process decomposed with a Markov switching process meaning that $\{Y_m : m = 1, 2, 3, ...\}$ is a homogeneous, recurrent, aperiodic, finite Markov chain.

7.7 Congestion Control Strategies

Flow and congestion control procedures have to be incorporated in any data network at the network layer to prevent congestion from developing. When it occurs, congestion manifests itself in two ways as follows. Transmission delays will increase markedly in the network, and the throughput, measured in packet per time unit delivered to their destinations, may begin to decrease as offered load increases. Moreover, if the offered load is high enough, a deadlock situation may prevail meaning that all the buffers are filled, traffic ceases to flow and the throughput drops to zero. Strategies have therefore to be proposed to prevent the network from locally congesting or in extreme situation from falling into deadlock. Congestion is recognizable from several features at least at three levels. At the *connection level*, the tendency to congestion can prevent the establishment of new calls and increases the blocking probability since new connections must be withheld from portions of the network inclined to congesting or being nearly in a congested state. At the *ATM transmission level*, congestion increases the transmission delays and the amount of cell losses. At the *cell-operating resource level*, an excessive cell flow loads the concentrators and the switching processes resulting in larger operating delays and in additional lost or mishandled cells.

Window-type mechanisms have been widely adopted for end-to-end control in order to regulate the traffic flow. In ATM broad-band-ISDN, the high speed of the communication links and the varied nature of the carried traffic makes such schemes inappropriate. In particular, conventional mechanism to control congestion within the network based on end-to-end windowing schemes [A], [B], [C] are not really suitable. Therefore, simpler and more efficient schemes have to be proposed to fully exploit the large available bandwidths; they will refer to open loop and closed loop strategies.

Window-type mechanism typically relies on end-to-end exchange of control messages in order to regulate the traffic flow. The control messages originating from the receiving node contain sometimes additional congestion information added by the intermediate nodes are used as feedback by the source node to regulate its traffic. In high speed networks, the propagation delay across the network is dominated by the switching and the buffering delays since the transmissions are supported by fiber optics or by satellite microwave communications. Feedback from the network may not be outdated otherwise any action the source would take will be too late to resolve the buffering and switching congestion. This argues for mechanisms that do not rely so heavily on network feedback

and less on feedback cells sent from the receiving end to warn a remote source of information. It is important that the congestion control mechanism operates at the speed of the communication links and that not too computationally intensive control schemes be developed to provide the control mechanisms with high-speed hardware solution. The nature of the traffic affects the design of the congestion control mechanisms. While past data traffic might have been slowed down in order to cope with network congestion, the real-time nature of the broad-band traffic made of voice and video will require some higher levels of bandwidth guarantee. Moreover the real-time traffics have intrinsic information rate determined by external non-stationary factors that are outside the control of the network. Typically, this rate can be estimated by the network prior to establishment of the connection. It is not really possible to slow down such traffic and the only way to deal with those sources is to exploit their stochastic nature by multiplexing a high number of them together on common links. If it is not guarantee that any source will keep individually to its specified average rate, the diversity of other multiplexed sources and the absence of correlative actions will ensure with some high likelihood that other sources will require instantaneously lower bandwidths while other exceed temporarily their admissible thresholds.

Congestion control strategies can be classified into open loop or preventive control and closed loop or reactive control schemes as presented here in the sequel. The difference between the two approaches is that with closed loop schemes, information about the network or the connecting node congestion is available to the end user or to the policing functions. In contrast, the open loop schemes take their control actions locally and irrespectively of the state of the network.

An important thrust has been devoted on developing open loop scheme in the framework of the ATM network. The elements of this framework are namely an admission control and a traffic enforcement. The traffic enforcement is carried out by the network at its access points in order to ensure that each traffic source is compliant with the traffic descriptors supplied at call establishment. Since traffic enforcement is performed in real-time on a per-connection basis, the enforcement algorithm must be simple enough to be implemented in hardware and not penalize the connections behaving according to their traffic descriptors. To allow the use of the network to spare capacity, violation tagging has been introduced. *Violation tagging* is a mechanism by which traffic that exceeds the specified limit is tagged and admitted to the network on the promise that it will be carried only if the network is not congested. Upon congestion, this excess traffic will be dropped. Hence, open loop schemes may rely on either dropping immediately or tagging the excess traffic.

Closed loop control schemes have been also proposed and, especially for high speed data networks, explicit congestion notification have emerged in the literature. The network node determines its congestion state by monitoring the utilization or the length of the switching queues or multiplexers over fixed observation interval. If the observed measure exceeds a certain threshold, the node declares itself congested and sends a throttling signal through the transmission frames to the traffic sources and the network nodes that have the congesting traffic passing through them. Explicit congestion notification seems appropriate since it allows early detecting and predicting the occurrence of congestion and provides an effective way for traffic sources to recognize congestion and react to it.

However, reactive control requires immediate feedback to the source node at the onset of congestion instructing them to throttle their traffic and its is difficult to detect the onset of congestion with sufficient lead time to react effectively. Care has to be taken that rapid buffer level fluctuations expected in a bursty traffic environment could unnecessarily trigger undesirable oscillations. As a matter of factor preventive and reactive controls may be considered in some extent as complementary. The former as a rapid technique of counter local congestion by dropping tagged cells and the latter as a long-term control parameter acting on the user sources to balance the need of guaranteeing a stable transmission QOS with that of enforcing the source variability.

The most well-known flow enforcement algorithms made for preventive load control have been mentioned in Chapter 1 as the *leaky bucket* and the *credit manager gauge*. A large number of alternative algorithms has also emerged. Nevertheless, it turned out that TV transmissions will require enforcement at several time-scales, the cell inter-arrival times, the mean image cell rate and that a gauge of image cell rate implemented in form of a *credit manager algorithm* will be required in conjunction with other methods like leaky buckets to control mean and peaks.

In summary, a suitable, general and efficient set of control functions should include the following algorithms: an admission control algorithm (already discussed), a traffic enforcement or policing which implements the preventive control (partially discussed so far, it requires that some additional topics be clarified), a multiplexing queue management to supervise and foreseen the traffic load evolutions, and, to close the loop, a reactive control. To outline the concepts accumulated so far, the purpose of the admission control is to establish a fair basis of blocking probabilities and to ensure and reserve the optimum resources to meet the management objectives. The purpose of buffer and queue management is to order cells for ATM-processing and to enable the coding-transmission systems to cope with the non-stationary variabilities under the constraint of limited coding-transmission delays. The purpose of traffic enforcement is to monitor the connection's resource usage for compliance with appropriate limits and to act on violations of those limits. The purpose of the reactive control is to relieve congestion once it has occurred in some part of the network and to balance the long-term equilibrium enforcement-QOS in compliance with the observed queue length evolutions.

7.7.1 Preventive Congestion Control

In this section, the preventive control is examined in the framework of the leaky bucket. As evidenced in Chapter 1, the leaky bucket presents interesting properties which demonstrate its efficiency when compared to other simple methods of enforcement. The example treated hereupon is the token-controlled leaky bucket. The basic operation performed by a leaky bucket is to enter the source traffic into a queue before being allowed to proceed in the network. When the bucket queue is filled up, the cells are discarded from the traffic. To eventually enter the network, the cell at the head of the queue must receive a token from a token pool. The token pool is fed by a token generator that generates tokens at fixed time intervals that correspond to the specified policed average rate of the customer source. The number of tokens is however limited to a maximum value M. The way of operating that policing scheme ensures that over any interval of length T, the

number of cell entering the network does not exceed the sum of a specified rate times the interval length T and a constant M that is independent of T. The token-controlled leaky bucket guaranties that a long-term average rate does not exceed a predefined value and that, over short periods, bursts do not exceed given rates. As a matter of fact, the parameter M controls the burstiness of the traffic and yield a maximum strength when M=1 since, in that situation, the maximum smoothness is reached on the ATM entry link. The queueing model for an input regulation with leaky bucket and pool of tokens is sketched in Figure 7.13. This policing scheme is exploitable in either open or closed loop controls. It is indeed rather easy to modulate the token generation by the network node where the source is connected and create a feedback action depending on the multiplexer load. In the sequel, the token generation will be supposed to be deterministic, meaning that each D second a new token is introduced and stored in a pool if it contains less than M tokens. Otherwise, the newly generated token is discarded. In the following, the queueing model of the token-controlled leaky bucket fed by a Poisson process with rate λ. The characteristic of the inter-departure process will also be characterized.

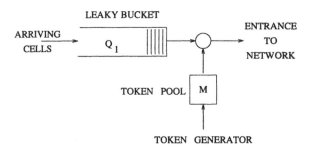

Figure 7.13: **Leaky bucket with token pool.**

7.7.1.1 Model Analysis

Let $P^t(m, i)$ be the probability of having m tokens in the pool and i packets in the buffer at time t (t= 0, D, 2D, ...), just prior to the token generation instance. The number of tokens cannot exceed M and the cells wait in queue if and only if there are no tokens in the pool. For convenience, let $p_0^t = P^t(M, 0)$, $p_1^t = P^t(M - 1, 0)$, ... , $p_M^t = P^t(0, 0)$, ... , $p_{M+i}^t = P^t(i, 0)$, and $p_i = \lim_{t\to\infty} p_i^t$. Moreover, a_i will denote the probability of i arrivals during a token generation period D, $a_i = e^{-\lambda D} \frac{(\lambda D)^i}{i!}$.

Considering a finite queue size limited to length K, cell can be discarded by overflow. The steady-state equations are in this case

$$p_i = \begin{cases} 0 & \text{if } i < M + K \\ p_0 a_i + \sum_{j=0}^{i} p_{j+1} a_{i-j} & \text{if } 0 \leq i \leq M + K - 1 \end{cases} \tag{7.101}$$

Solving this equation is rather simple by induction. A value of p_0 is first assumed. Then the p_i's are computed recursively as

$$p_i = \frac{1}{a_0}(p_{i-1} - p_0 a_{i-1} - \sum_{j=0}^{i-2} p_{j+1} a_{i-1-j}) \tag{7.102}$$

Eventually, all the quantities are normalized as PDF.

$$\sum_{i=0}^{M+K} p_i = 1 \qquad (7.103)$$

The throughput of the system is

$$T = p_0\left(\sum_{i=0}^{K+M} ia_i + (M+K)a_{M+k}^c\right) \qquad (7.104)$$

$$+ \sum_{j=1}^{M+K} p_j\left(\sum_{i=1}^{M+K-j+1} ia_i + (M+K-j+1)a_{M-K-j+1}^c\right) \qquad (7.105)$$

with $a_j^c = 1 - \sum_{i=0}^{j}$. The cell loss probability is given, for a Poisson arrival, by

$$P_{loss} = 1 - \frac{T}{\lambda D} \qquad (7.106)$$

The case $k = 0$ corresponds to the leaky-bucket scheme. The steady-state equations in this case are the same as 7.101 except that they hold for all i,

$$p_i = p_0 a_i + \sum_{j=0}^{i} p_{j+1} a_{i-j} \qquad i \geq 0 \qquad (7.107)$$

Let $G(z) = \sum_{i=0}^{\infty} p_i z^i$. Simple computations yield

$$G(z) = \frac{p_0 \, A_D(z) \, (z-1)}{z - A_D(z)} \qquad (7.108)$$

where $A_u(z) = e^{\lambda u(z-1)}$ for $u > 0$. The value of P_0 is determined from the normalization of $G(z)|_{z=1} = 1$, and $P_0 = 1 - \lambda D$ and the condition of stability is $\lambda D < 1$. When p_0 is known, other probabilities can be computed recursively from 7.107.

7.7.2 The Inter-Departure Process

In this section, the Laplace transform of the inter-departure time ν is derived. Since each departing cell is linked to a token, the cell departure process is the same as the process of the token departure. Hence, the time between two consecutive token.

In the following ϵ denotes inter-arrival time (exponentially distributed with mean $\frac{1}{\lambda}$). In addition, R_i^j ($i \geq 1$, $1 \leq j \leq i$) denotes the time between the j^{th} arrival instant in a slot until the end of the slot, given that exactly i packets arrived in that slot. The density function of R_i^j for $0 \leq r \leq D$, $1 \leq j \leq i$, $i \geq 1$ is given by

$$f_{R_i^j}(r) = \frac{i!}{(j-1)!\,(i-j)!} \left(1 - \frac{r}{D}\right)^{j-1} \left(\frac{r}{D}\right)^{i-j} \frac{1}{D} \qquad (7.109)$$

and the k^{th} moment of R_i^j is

$$E[(R_i^j)^k] = \frac{(i-j+1)(i-j+2)...(i-j+k)}{(i+1)(i+2)...(i+k)}D^k \qquad (7.110)$$

The time between the departure time of the tagged token and the subsequent departure is the inter-departure time ν.

When a tagged token joins the token pool, it finds the token pool in one of the four exclusive cases which follow

1. there are $q \geq 2$ cells and no tokens in the system. In this case, the tagged token leaves immediately at time t and the next departure will occur at time $t + D$. therefore, $\nu = D$.

2. there is one cell and no token in the system. In this case, the tagged token departs immediately at time t and the next departure will occur at time $t + D$ if at least one cell arrives during $(t, t + D)$, or it will occur upon the next arrival, i.e. at time $t + D + \epsilon$ if no packets arrive in $(t, t + D)$. Hence, $\nu = D$ with probability $1 - a_0$ and $\nu = D + \epsilon$ with probability a_0.

3. there are m $(0 \leq m \leq M - 2)$ tokens and no packets in the system. If i $(0 \leq i \leq m)$ packets arrive during $(t, t + D)$ then $\nu = \epsilon$ since the tagged token will depart at some time after $t + D$ due to a packet arrival and the token that arrived at time $t + D$ will depart afterwards upon the next packet arrival. If $(m + 1)$ packets arrive during $(t, t + D)$, then the tagged token will depart upon the $(m + 1)^{st}$ arrival and the time until the next token arrives is R_{m+1}^{m+1}. When the next token arrives at time $t + D$, there are no packets in the system, hence it will depart upon the next packet arrival and therefore $\nu = R_{m+1}^{m+1} + \epsilon$. If i $(i \geq m + 2)$ packets arrive during $(t, t + D)$ then $\nu = R_i^{m+1}$ since the tagged token departs upon the $(m + 1)^{st}$ arrival and the next token departs at time $t + D$.

4. there are $M - 1$ tokens and no packets in the system. This case is similar to that treated here above, except that, until there is a slot in which at least one packet arrives the state of the system does not change since subsequent tokens cannot join the token pool. Conditioned to the event that at some slot at least one packet arrives, we have that $\nu = \epsilon$ if i $(0 \leq i \leq M - 1)$ packets arrive during that slot. $\nu = R_M^M + \epsilon$ if M packets arrive during that slot and $\nu = R_i^M$ if i $(i \geq M + 1)$ packets arrive during that slot.

In summary, the Laplace transform of the inter-departure time $V^*(s) = E[e^{-s\nu}]$ is given by sum covering the four cases

$$(1 - p_0) \, V^*(s)$$

$$= \textstyle\sum_{q=2}^{\infty} p_{M+q} \; e^{-sD}$$

$$+ \; p_{M+1} \, (a_0 \, E[e^{-s(D+\epsilon)}] \; + \; (1-a_0)e^{-sD}$$

$$+ \; \textstyle\sum_{m=0}^{M-2} p_{M-m} \, \{\textstyle\sum_{i=0}^{m} a_i \, E[e^{-s\epsilon}] \; + \; a_{m+1} \, E[e^{-s(R_{m+1}^{m+1}+\epsilon)}] \; + \; \textstyle\sum_{i=m+2}^{\infty} a_i E[e^{-sR_{m+1}^{i}}]\}$$

$$+ \; \tfrac{p_1}{1-a_0} \, \{\textstyle\sum_{i=1}^{M-1} a_i \, E[e^{-s\epsilon}] \; + \; a_M \, E[e^{-s(R_M^M+\epsilon)}] \; + \; \textstyle\sum_{i=M+1}^{\infty} a_i E[e^{-sR_M^i}]\}$$

(7.111)

Let us remark that if the buffer size is finite but non-zero, then the first summation needs just to be limited to K instead of infinity in the case of a finite buffer. The particular case without any input buffer (K=0) corresponds exactly to the departure process of a D/M/1 queueing model with a finite buffer of size M, a model already well-documented in the literature.

The expected value of ν is $\frac{1}{\lambda}$ when the buffer is infinite and $\frac{1}{T}$ when the buffer is finite, since the rate at which packets depart the system equals the input rate. The second moment of ν is given by

$$\lambda D \; E[(\nu)^2]$$

$$= D^2[1 - \textstyle\sum_{m=0}^{M} p_m] \; + \; \tfrac{2}{\lambda^2} \, p_{M+1} \, a_0 \, (\lambda D + 1)$$

$$+ \; \tfrac{2}{\lambda^2} \, \textstyle\sum_{m=0}^{M+2} p_{M-m} \{\textstyle\sum_{i=0}^{m}[2a_i - a_{i+2}(m-i)(m-i-1)] \; + \; 2a_{m+1} \, [1 \; + \; \tfrac{2\lambda D}{(m+2)(m+3)}]$$

$$+ \; (\lambda D)^2 - 2(m+1) \, (\lambda D - a_1) \; + \; (m+1) \, (m+2) \, (1 - a_0 - a_1)\}$$

(7.112)

$$+ \; \tfrac{2}{\lambda^2} \tfrac{p_1}{1-a_0}\{-2a_0 \; + \; \textstyle\sum_{i=0}^{M-1}[2a_i - a_{i+2}(M-i-1)(M-i-2)]$$

$$+ \; 2a_M \, [1 \; + \; \tfrac{2\lambda D}{(M+1)(M+2)}]$$

$$+ \; (\lambda D)^2 - 2M \, (\lambda D - a_1) \; + \; M \, (M+1) \, (1 - a_0 - a_1)\}$$

The variance of the inter-departure time is $Var(\nu) = E[(\nu)^2] \; - \; (\frac{1}{\lambda})^2$ and the squared coefficient of variation is $C^2 = \lambda^2 Var(\nu)$.

7.7.3 Reactive Congestion Control

The purpose of reactive control is either to relieve already congested multiplexers or even more to prevent congestion from occurring when the queues are close to saturation. Strategies to counter congestion are numerous, among them, let us quote the alternate routing technique and network management methods aiming at cancelling tagged cells, the use of explicit notification messages sent to sources in the transmission frame. This latter solution means that the network automatically notifies a user when the network is in a congested state to increase the enforcement parameters and contribute in the global coding-transmission optimum. The alternate routing technique consists in adding temporary transmission resources out of a common reserve to support the transient excesses. The reactive control turns out to be the outer layer of a long-term multi-threshold traffic

enforcement strategy built with a preventive action on two inner layers which exploit tagging and dropping actions. It relies on throttling signal sent back to users and policing function within a given virtual path. The action of the reactive control is the mirror in the network of the optimum coding control algorithm. Similarly to the development presented in Chapter 4, it may be based on a three-pillar system as follows

1. a cost function to be minimized in order to optimally balance graceful variations of network QOS and enforcement actions according the distance measure

$$\sum_{i=1}^{T} \{E[(\Delta QOS)^2] + \varphi E[(r - r_{\nu,ENF})^2]\} \tag{7.113}$$

 T stands as the foreseeable horizon of network loads. If φ is set to zero, the network leads towards exploiting CBR transmissions.

2. a queue load predictor based on a learnt Markov chain to build an expected horizon of loads. In the case of TV transmission, the image cell rate is rather efficiently predicted within scenes since they correspond to well-characterized auto-regressive models (Chapter 1 and 3).

3. a search of the partial or global optimum strategy which may eventually take into account the video quality if the video sources declare the coupling factor κ between subjective image quality and enforcement strength.

This control algorithm profits from properties similar to those already developed for the coding control, that is an optimum balance in between a set of interesting properties which are the frozen CBR transmissions, the learning and the caution in uncertain horizons and the regulation in certain horizons.

7.8 Conclusions

This chapter has demonstrated the optimum way to transmit TV sources on ATM networks. This optimum is decomposed in a sequence of two consecutive actions

1. an allocation of resources within the network and the coder.

2. an efficient use of these allocated resources.

The resources for the data transmission are provided in the network at each multiplexer, they have been referred to under the generic name of "bandwidth". These resources include both memory available (i.e. the size of the multiplexer queues) and inter-node transmission rates offered to the multiplexer by means of queue service rates.

The resources in a TV coder are allocated once at the building of the hardware. They encompass a compression algorithm and a given amount of memory to be subdivided in two parts

1. the *memory to compress bit rates* is a memory used to achieve the highest compression by a temporal prediction algorithm. Higher amounts of memory will strengthen respectively the decorrelative action, the bit rate compression and the variability of the output source cell rates.

2. the *memory to control output rates* is a memory used as buffering capacity. It has been shown to be optimum for an amount, at least, equal to the bit stream generated by one coded image and, preferably, by several ones. This optimum turns out to be consistent with both coder control action (Chapter 4) and bandwidth allocation strategy (Chapter 7).

The physical constraint put on the memory storage capacity is the necessity to achieve an acceptable delay of processing and transmission between the encoder and the decoder. This delay should not be higher than a few images (10-15 max).

The network resources encompass queueing capacity and transmission rate. However, both the queueing capacity and the multiplexer queueing service rate are not actually independent. They are rather linked together by means of the multiplexing performances to guarantee a network QOS under the constraint of a maximum transmission delay of a few hundreds of microseconds (Chapter 5). This optimum has oriented the design of ATM networks towards small cells (53 bytes) and small queueing capacities (64 cells).

If there were no constraints of delay and memory, the CBR mode with a rate equal to the long-term mean value related to the required level of subjective image quality would be the only mode required for transmission. The optimum transmission would be reached in this case immediately according to information theory based on the stationarity assumption which states that the capacity of the channel equals the coding rate corresponding to the long-term average distortion. The constraints put on both the coding-transmission delays and the coding-transmission storage capacities induce the necessity of exploiting variable-bit-rate sources. On the opposite to CBR modes, free VBR modes correspond therefore to the case where no resource is available for control and is, as such, not optimum when storage capacities are available. In this free VBR, the statistical astute to allocate asymptotically bandwidth equal to the long-term mean rates is to exploit the Bienaymé-Tchebitchev inequality in statistically multiplexing an amount as large as possible of independent source. in intermediate cases, when resources are available, the optimum allocation of memory should correspond to the maximum amount of memory to accept the longest admissible delay for the coding and the transmission. The optimum use of the resources has also to take into account the maximum amount of the resources to output a variable rate as slowly as possible. With such considerations, it turns out that the bit rate variability and the research of a well balanced optimum are the consequences of inherent physical constraints.

The optimum use of the memory resources implies a control to make provisions against potential uncertainties. The strength of this control has to be balanced with the requirement of ensuring a coding and a transmission quality as constant and stable as possible.

As an important conclusion, the source output bit rate variability should be as slow as possible with regard to the available resources and enforced as weakly as possible with regard to the potential non-stationarities, the goal being to ensure coding and transmission

quality as constant as possible. These considerations have allowed the development of an optimum algorithm to monitor the whole coding-transmission chain.

7.9 Bibliography

[7.1] K. M. Chandy, U. Herzog and L. S. Woo "Parametric Analysis of Queueing Networks", *IBM Journal of Research and Development, Vol. 19, No. 1, pp. 36-42, January 1975.*

[7.2] K. M. Chandy, U. Herzog and L. S. Woo "Approximate Analysis of General Queuing Networks", *IBM Journal of Research and Development, Vol. 19, No.1, pp. 43-49, January 1975.*

[7.3] E. Çinlar "Decomposition of a semi-Markovian process under a Markovian rule ", *Australian Journal of Statistics, 8, pp. 163-170, 1966.*

[7.4] E. Çinlar "Decomposition of a semi-Markov process under a state dependent rule ", *SIAM Journal on Applied Mathematics, 15, pp. 252-263, 1967.*

[7.5] C. A. Cooper and K. I. Park "Toward a Broadband Congestion Control Strategy", *IEEE Network Magazine, pp. 18-23, May 1990.*

[7.6] D. J. Daley "The correlation structure of the output process of some single server queueing systems", *The Annals of Mathematical Statistics, Vol. 39, No. 3, pp. 1007-1019, 1968.*

[7.7] D. J. Daley "Queueing Output Process", *Advances in Applied Probability, 8, pp. 395-415, 1976.*

[7.8] R. L. Disney and D. König "Queueing networks: a survey of their random processes", *SIAM, Vol. 27, No. 3, pp. 335-403, September 1985.*

[7.9] A. E. Eckberg, D. T. Luan, D. M. Lucantoni "Meeting the challenge: congestion and flow control strategies for broadband information transport", *IEEE Globcom, pp. 1769-1773, 1989.*

[7.10] R. G. Gallager and S. J. Golestaani "Flow control and routing algorithms for data networks", *Proceedings of the Vth International Conference on Computer Communications, pp. 779-784, 1980.*

[7.11] B. Gavish and S. L. Hantler "An algorithm for optimal route selection in SNA networks", *IEEE Transactions on Communications, COM-31, Vol. 10, pp. 1154-1160, October 1983.*

[7.12] S. J. Golestaani "A unified theory of flow control and routing on data networks", *Ph.D. thesis, MIT, Department of Electrical Engineering and Computer Science, Cambridge, MA, 1980.*

[7.13] H. Hayden "Voice flow control in integrated packet networks", *Technical report, MIT Laboratory of Information and Decision Systems, Cambridge, MA, Report LIDS-TH-1152, 1981.*

[7.14] J. M. Jaffe "A decentralized optimal multiple-user flow control algorithm", *Proceedings of the Vth International Conference on Computer Communications, pp. 839-844, 1980.*

[7.15] J. M. Jaffe "Bottle-neck flow control", *IEEE Transactions on Communications, COM-29, pp. 954-962, 1981.*

[7.16] S. Jordan and P. Varaiya "Control of Multiple Service, Multiple Resource Communication Networks", *IEEE Transaction on Communications, to appear.*

[7.17] F. P. Kelly "The departure process from a queueing system", *Proceedings of Cambridge Philosophical Society, 80, pp. 283-286, 1976.*

[7.18] C. J. Neill "A Method for Congestion Control in ATM Networks", *Australian Fast Packet Switching, Melbourne, pp. 113-123, 9-11 July 1990.*

[7.19] D. C. Pack "The output of an M/D/1 queue", *Operation Research, 23, pp. 750-760, 1975.*

[7.20] D. C. Pack "The output of multiserver queueing systems", *Operation Research, 26, pp. 492-509, 1978.*

[7.21] P. Pancha and M. El Zarki "Bandwidth-Allocation Schemes for Variable-Bit-Rate MPEG Sources in ATM Networks", *IEEE Transactions on Circuits and Systems for Video Technology, Vol. 3, No. 3, pp. 190-198, June 1993.*

[7.22] M. Reiser "Performance Evaluation of Data Communication Systems", *Proceedings of the IEEE, Vol. 70, No. 2, pp. 171-196.*

[7.23] G. Rigolio and L. Fattra "Input Rate Regulation and Bandwidth Assignment in ATM Networks: an Integrated Approach", *Teletraffic and Data Traffic, ITC-13, pp. 141-146.*

[7.24] J. W. Roberts "Variable-Bit-Rate Traffic Control in B-ISDN", *IEEE Communication Magazine, pp. 50-55, September 1991.*

[7.25] M. Schwartz "Telecommunication Networks: Protocols, Modeling, and Analysis", *Addison-Wesley Publishing Company, 1987.*

[7.26] M. Sidi, W. Z. Liu, I. Cidon, I. Gopal "Congestion control through input rate regulation", *IEEE Globcom, pp. 1764-1768, 1989.*

[7.27] A. J. Viterbi and J. K. Omura "Principles of Digital Communication and Coding", *McGraw-Hill, New-York, 1979.*

[7.28] T. L. Vlach and R. L. Disney "The departure process from the GI/G/1 queue", *Journal of Applied Probability, 6, pp. 704-707, 1969.*

Glossary

This glossary provides the reader with the most important notation conventions and abbreviations used in the textbook.

Notational Conventions

P(λ) ... Poisson process with arrival rate λ
N(0,1) ... normal process
B(n,p) ... Bernoulli process
Pr[] ... probability of a random variable
Var[] ... variance of a random variable
cov[] .. covariance function
diag[] ... diagonal matrix elements
max[] ... maximum value
min[] .. minimum value
sup[] .. upper bound value
inf[] ... lower bound value
exp[] .. natural exponential function e^x
log[] ... decimal logarithm
ln[] .. naperian or natural logarithm
lim ... limit
$E\{ \}$... mathematical expectation
MMPP(m) Markov modulated Poisson process
PG() .. programme number
SB() .. subband number
$\binom{n}{k}$.. combination of k elements among n
M/D/s queue model: Poisson arrival, deterministic service, s servers
G/D/s queue model: general arrival, deterministic service, s servers
$G^{[x]}$/D/s queue model: discrete general arrival, deterministic service, s servers
* ... convolution operator
\times .. multiplication operator
\wedge .. logical AND operator
o ... Schur product
\otimes .. Kronecker product
| | ... absolute value
A^T .. transpose of a matrix A
\hat{x} ... estimated value of

\bar{x} .. mean value x

\tilde{x} ... optimum value of x

x^* .. complex conjugated value of x

$f(x)$.. probability density function of x

$F(x)$.. repartition function of x

$\mathcal{F}(x)$.. survivor function of x

dx .. differential of x

∂x ... partial differential of x

Δx .. difference on x

Abbreviations

AAL	ATM Adaptation Layer
ACVLC	Arithmetic Computed Variable Length Codes
AR	Auto-Regressive
ARMA	Auto-Regressive Moving Average
ASD	ATM Synchronisation De-jittering
ATD	Asynchronous Time Division
ATM	Asynchronous Transfer Mode
ATRL	Adaptive Truncated Run-Length codes
BBA	Belgian Broadband Association
BCH	Bose-Chaudhuri-Hocquenghem codes
BT	Block Transform
CAC	Connection Admission Control
CBR	Constant Bit Rate
CCIR	International Radio Consultative Committee
CCITT	International Telegraph and Telephone Consultative Committee
CSMA	Carrier Sense, Multiple Access
CT	Cell Type
DAMA	Demand-Assignment Multiple Access
DBE	Double Error
DCT	Discrete Cosine Transformation
DFT	Discrete Fourier Transformation
DMAP	Discrete-time Markov Arrival Process
DNSPP	Discrete Non-Stationary Periodic Process
DPCM	Differential Pulse Code Modulation
DQDB	Distributed Queue Dual Bus
DSPP	Doubly Stochastic Poisson Process
DST	Discrete Sine Transformation
EDI	Enhanced Definition Interlaced image format
EDP	Enhanced Definition Progressive image format
ELT	Extended Lapped Transform
EWMA	Exponential Weighted Moving Average
FBR	Fixed Bit Rate
FCFS	First Come First Served
FDMA	Frequency-Division Multiple Access
FDS	Format Dependent Splitting
FEC	Forward Error Correction

PRM .. Protocol Reference Model
PRMF Perfect Reconstruction Modulated Filter
PR-QMF Perfect Reconstruction-Quadrature Mirror Filter
Q ... Quantizer
QMF .. Quadrature Mirror Filter
QOS ... Quality of Service
RACE Research for Advanced Communications in Europe
RMS ... Root Mean Squared
RS .. Reed Solomon codes
SAR Segmentation and Reassembly Sublayer
SB .. SubBand filter
SG ... Stochastic Gradient
SNR .. Signal to Noise Ratio
STDEV .. Standard Deviation
STFT ... Short-Time Fourier Transform
STM ... Synchronous Transfer Mode
TDMA .. Time-Division Multiple Access
TV ... Television
UVLC .. Universal Variable Length Codes
VBR ... Variable Bit Rate
VCO ... Voltage Controlled Oscillator
VLC ... Variable Length Coder
VLD .. Variable Length Decoder
VT .. VideoTelephony
W ... Weighting
WP .. Wavelet Packets
WSNR ... Weighted Signal to Noise Ratio

Index

Hilbert space, 100, 140, 322
horizon, 320
hybrid coding, 101, 214

image bit rate, 251
imaging, 116
in-band prediction, 219
index of dispersion, 369
innovations, 102, 104, 326, 333
input queueing scheme, 28
input smoothing scheme, 28
insensitivity, 392, 493, 495, 500
integral of bit rate, 471, 474
integrator, 305
inter-arrival time process, 238
interactive connection, 4
interconnection networks, 18
interleaver, 453, 459
interpolator, 111
interscale basis coefficient, 151
irreductibility, 382, 499

Jain's measure of efficiency, 108
jitter, 435, 475
jumping window policing, 72

Kalman filter, 331
Karhunen Loeve Transform, 106
key renewal theorem, 448
Kintchine theorem, 50
Kolmogorov-Smirnov, 245
kurtosis, 246

Laplacian pyramid, 160
lapped orthogonal transform, 131
lattice
 representation, 165
 sampling, 92
law of large numbers, 50
law of rare events, 53
layer management, 11
leaky bucket, 73, 537
learning action, 340
Levy theorem, 45
Lindeberg-Levy theorem, 52
linear transformation, 104, 109

link, 18
Little's formula, 388, 494
Ljapounov
 equipotential, 318
 theory, 317
local balance equation, 499
locked control, 340

management plane, 11
Mandelbrot's model, 442
Markov chain, 257
Markov modulated Poisson process, 57
maximum likelihood, 296
memoryless property, 48, 393
Mexican hat, 145
minimum-mean-squared-error estimate, 322
mixed network, 493
model of queues, 387
modulated filter bank, 138, 166
modulated lapped transform, 132
moment-generating function, 44, 45
Morlet wavelet, 145
mother wavelet, 144
motion
 block-matching, 218
 compensated filtering, 221
 compensation, 217
 estimation, 201, 219
 pixel-recursive, 217
moving window policing, 72
multi-point connection, 3
multi-rate connection, 4
multi-resolution connection, 4
multicast switching network, 30
multipath network, 22
multistage interconnection network, 18

negative binomial distribution, 382
network transmission delay, 435
neuron, 345
Neyman's model, 442
nominal mode, 311
non-blocking
 definition, 18
 network, 22
non-homogeneous Poisson process, 57

Printed and bound by CPI Group (UK) Ltd, Croydon, CR0 4YY

03/10/2024

01040330-0010